The Destruction of Art

PICTURING HISTORY

Series Editors
Peter Burke, Sander L. Gilman, Ludmilla Jordanova,
†Roy Porter (1995–2002), †Bob Scribner (1995–8)

In the same series

The Destruction of Art

Iconoclasm and Vandalism since the French Revolution

Dario Gamboni

REAKTION BOOKS

Published by Reaktion Books Ltd
33 Great Sutton Street, London EC1V 0DX, UK

www.reaktionbooks.co.uk

First published 1997, first paperback edition 2007

Designed by Humphrey Stone
Jacket designed by Ron Costley
Photoset by Wilmaset Ltd, Wirral
Printed and bound in Great Britain by Biddles Ltd, King's Lynn

British Library Cataloguing in Publication Data

Gamboni, Dario
 The destruction of art: iconoclasm & vandalism since the
 French Revolution – (Picturing history)
 1. Art, Modern – 19th century 2. Art, Modern – 20th century
 3. Art – Mutilation, defacement, etc. 4. Iconoclasm
 I. Title
 709´.034
 ISBN-13: 978 1 86189 316 1
 ISBN-10: 1 86189 316 7

Contents

Acknowledgements

A book can have many debts as well as causes. Fourteen years ago Georg Germann generously welcomed a somewhat unorthodox essay for inclusion in the publications of the Swiss Institute for Art Research; over the years he has been unflinching in his encouragement and support of my explorations in various topics and languages. Pierre Bourdieu spurred my interest in destroyers of art and devised theoretical tools essential for the understanding of contemporary 'vandalism'. Peter Burke and Bob Scribner offered an ideal home for the present study by asking me to contribute to their 'Picturing History' series.

I owe thanks to the Institut Universitaire de France for financial help for research over the past three years and a reduction in my teaching obligations. During the Spring term of 1995–6, my stay as an Ailsa Mellon Bruce Senior Fellow at the Center for Advanced Study in the Visual Arts of the National Gallery of Art, Washington, DC, helped me greatly to complete the task of verifying references and tracking down material relating to the illustrations. My students in Lyon have enriched my documentation and sharpened my concepts. The structure of the book and a number of hypotheses have benefited from responses to my lectures and to conference papers delivered at the invitation of Maurice Agulhon, Isabela Conde, Kurt Forster, Philippe Fritsch, Walter Grasskamp, Sergiusz Michalski, Stanislaus von Moos, Raymonde Moulin, Michael Petzet, Marie-Félicie Pérez and Dominique Poulot. Johannes Kraan and Margaret van Oosten kindly helped me to find my way through the files of the Rijksbureau voor Kunsthistorische Documentatie in The Hague. Luciano Cheles, Olivier Christin and Bob Scribner read a first version of my text; I owe many helpful suggestions and corrections to them, as well as to Garry Apgar, Antoine Baudin, Gaby Dolff-Bonekämper, Thierry Dufrêne, Agnes Fiévé, François Loyer and Martin Schubarth, who read various chapters and passages. Though it is impossible to list all the friends and colleagues who generously provided me with information, I want to thank in particular the persons already named as well as Oskar Bätschmann, Lázló Beke, Carel Blotkamp, Philippe Bordes, Richard

Calvocoressi, Enrico Castelnuovo, Richard Cork, Ivor Davies, Erica Deuber-Pauli, André Ducret, Thierry de Duve, Eberhard Elfert, Etienne Fouilloux, David Freedberg, Pierre Georgel, Jacques Gubler, Nathalie Heinich, Antoine Hennion, Klaus Herding, John House, Shigemi Inaga, Paul-André Jaccard, Philippe Junod, Joseph Jurt, Ekkehard Kaemmerling, Sebastian Laubscher, Catherine Lepdor, David Lowenthal, Neil McWilliam, Michel Melot, Christian Michel, Laura Mulvey, Anne Pingeot, Ada Raev, Antoinette Romain, Pierre Vaisse and Richard Wrigley. Last but not least, this book would not exist but for the patience, criticism and support of Johanna and Vasco.

Introduction

In 1980 a gardener placed an advertisement in a Swiss local newspaper in which he explained that he badly needed fourteen old television screens in order to 'restore a sculpture . . . not recognized as such and for this reason removed to the refuse-dump'. The story seemed too beautiful to be true; it had about it something of a joke or *topos*, one that appeared to be as rich in meaning as the *Witz* that Freud had collected for his *Jokes and their Relation to the Unconscious* (1905) or the stereotypes that Kris and Kurz discovered in the anecdotes of artists' lives.[1] I met the gardener, the artist and the organizers of the open-air exhibition in which the work had been shown. Although reluctant at first, they became talkative, and each had a different version of the events. I also discovered that half the sculptures exhibited at the 8th Swiss Sculpture Exhibition held in Bienne had been wilfully, and anonymously, damaged or destroyed. The show was a highly controversial one, and the substantial body of evidence that had resulted from this allowed me to probe the history and the meaning of the assaults on the sculptures. The gardener's 'mistake' (presented here in chapter Fourteen) and this particular case of 'vandalism' (chapter Nine) thus suggested the subject for a book in which I have made a first attempt at understanding the relations that exist between modern art and its destruction.[2]

I must confess, however, that I would probably have abandoned this topic early on in favour of other art-historical pursuits had not invitations to conferences in Marseille, Münster, Lisbon and elsewhere prompted me to continue to revise and extend my research, and during the same period generous correspondents contributed to my ever-growing documentation. After 1989 a different kind of material began to join it, as monuments from the Communist era began to tumble in Central and Eastern Europe. The large-scale destruction, explicitly political in motivation, that swept through the former Communist bloc seemed to question accepted views on the history of iconoclasm. In his remarkable introduction to a collection of essays on the destruction of art that ranges from Byzantium to the Third Reich, Martin Warnke wrote in 1973 that 'the conditions that had, for millenia, made iconoclasm a legitimate form of expression have become today obsolete'.[3] Was this

really so? If so, how was this fresh iconoclastic wave to be explained? As a be-
lated repetition of things thought past? As a guide, perhaps, to understanding
those earlier, less well-documented events? As a new formulation of the links
between power, images and the mass media? What were the relationships, if
any, between these recent, politically motivated, attacks and those that had to
do with the aesthetic notions of a public and the works that confronted it? And
what of the countless other instances of official or covert attacks directed by
both individuals and groups against works of art, monuments and images?
Were they essentially disparate actions that could only be classified as all of a
type by reference to the nature or status of their targets? Or were there other
links between them, which some research might shed light on? And could one
apply some coherent ordering to them, or must 'the image of a disorder'
remain, as Paul Valéry supposed, 'a disorder'?[4]

These were some of the questions that prompted this book. It may seem
strange that they have not been asked – let alone answered – before. But little
critical attention has been given to the destruction of art in the nineteenth and
twentieth centuries. Indeed, one can simplify the historiographical situation
by saying that the more recent an iconoclastic episode is, the less likely it is
that it has been studied. The major moments of iconoclasm that have been
dealt with are, of course, Byzantium, then the Reformation, then (much less
thoroughly) the French Revolution; after that, only the spectacular persecu-
tion by the Nazis of what they considered to be *Entartete Kunst* (degenerate
art) has been extensively researched (and, recently, exhibited). There is some-
thing paradoxical about the differing depths to which various iconoclastic
phases have been plumbed by historians, since research seems to have been
undertaken in an inverse proportion to the amount of information that could
possibly be gathered about the events under scrutiny. Of course, an overabun-
dance of data can be paralyzing, but I do not think that this is the point. Rather,
the explanation seems to me to be that serious interest in destruction decreases
as the object attacked is more completely and unanimously conceived – both at
the time and in retrospect – as the product and source of an autonomous, self-
sufficient activity. In the context of a purely aesthetic conception of art, aggres-
sion must appear as irrational, meaningless, irrelevant, and of course
threatening. Nothing can be learnt from it, and it must be condemned, or
better still ignored. The Byzantine and Protestant attacks can be explained by
the religious functions that images then fulfilled, just as revolutionary 'vandal-
ism' can find its source – if not its justification – in politics. But with the advent
and spread of the modern conception of the work of art as an end in itself – art
freed from every extrinsic goal or purpose – aggression can only be understood
as an expression of ignorance and incomprehension, a barbaric regression.

This is precisely what gives aggression directed against art its heuristic
value, if one considers the autonomy of art not as an atemporal essence but as

a historical and historiographical construct, an element of complex and changing configurations of status and use. Of course, works of art are rarely – though not never – meant to be degraded or destroyed. It follows that attacks generally represent a break in the intended communication or a departure from the 'normal' attitude shown towards them. As such, they can prove particularly useful for illuminating those 'normal' attitudes and modes of communication as well as the preconditions underlying them, much like the way that crises and dysfunctions have served, and continue to serve, the interpretative strategies of the medical sciences, psychoanalysis, linguistics or sociology. In our case they can help us better to realize and understand the plurality of functions (the aesthetic being one among them) that works of art – or objects defined as works of art by certain people under given circumstances – go on fulfilling, the plurality of corresponding attitudes, the relations that exist and the conflicts that arise between them.[5]

We are required, then, to be watchful of labels such as 'work of art', 'image', 'monument' or 'cultural object', since the allocation or not of a given artefact to one or other of these categories is very much at stake in the battles that are studied in this book, in particular as a means to claim or deny protection, to condemn or justify destruction. Moreover, it can be argued that these categories really overlap, and that an object's 'identity', the set of values with which it is endowed, is as multiple and at times as contradictory as that of its authors and spectators, friends and foes. One last point must be made here: research on the destruction of art does not only concern its reception; its creation is involved as well, insofar as the two are interrelated. This is particularly the case, as we shall see, with modern and contemporary art.

Geographically and chronologically, this study concentrates on a *hic et nunc* – the Western world after the Second World War; but it aims at questioning the historicity and specificity of the situation in which we find ourselves by dealing with the nineteenth and early twentieth centuries as well as (though to a much lesser extent) other parts of the world. In fact, based on the generally accepted assumption that the French Revolution marked a decisive shift in the history of the destruction and preservation of art, but also on the fact that the subsequent developments have never been studied as a whole, one of the main issues of this book is what it is that has changed worldwide since the Revolution in the way works of art have been wilfully attacked or eliminated, and what this teaches us about the way they have been defined, produced, valued and devalued.

After a discussion of theories, methods and terminology (chapter One), an attempt is made to sketch the long historical development of the phenomenon labelled 'iconoclasm' or 'vandalism' and to identify its main articulations (chapter Two). Chapters Three to Five deal with acts of aggression for which political motivations and justifications have been put forward: the elimination

of Communist monuments and symbols (chapter Three), isolated cases in democratic societies (chapter Four), and a tentative look at the uses and abuses of images outside the Western world (chapter Five). The changing relations, since the nineteenth century, between images and political strategies on the one hand, industrially produced images and works of art on the other, are examined in chapter Six. Chapter Seven stresses the political dimension of the idea of the liberty of art, as opposed to, and paralleled by, its propagandist use in the then Communist states, as well as the conflictual reception of 'free art' in the West. The aggressive expressions of this conflict are then examined according to their perpetrators and contexts: destructions executed or ordered by the owners of works or by legal authorities challenging the artist's moral right and freedom of speech (chapter Eight), destructions perpetrated – mostly anonymously – in open, public spaces (chapter Nine) or, by the action of stigmatized individuals, in the hallowed and protected arenas of museums (chapter Ten). At the other extreme of social legitimacy are those destructions justified by reasons of embellishment, hygiene, modernization or profit (chapter Eleven). In ecclesiastical art, aesthetic and liturgical changes contribute to a formulation of the autonomy of art in its relation to the sacred (chapter Twelve). Chapter Thirteen is dedicated to the special links relating the theory and history of modern art to the metaphorical and actual destruction of works. The cases in which elimination is explained by the fact that the works have allegedly not been recognized as art are analysed in chapter Fourteen. Finally (chapter Fifteen), I propose to consider physical degradation or destruction as extreme forms of a much wider phenomenon – the disqualification of art, a continuous process that can be understood as the negative side of the making of cultural heritage.

Needless to say, a study of a topic this vast can never be exhaustive. This one aims at mapping the field rather than establishing the minutiae of any portion of it. The chances and hazards of life and research could not but play a role in the gathering and selection of information. Nevertheless, I have tried to account for both the exceptional and the representative. Notwithstanding my generalizing intention, I have striven for the greatest possible precision, and where the amount and quality of documentation, as well as space, allowed, examples have been developed into case studies that should help better illustrate the identity and interplay of factors involved in complex situations. But every reader will doubtless know of facts and ideas that can complete, and maybe contradict, the data, interpretations and conclusions presented here. The conclusions are meant as provisional, and it is my hope that in time the work of others will refine or supersede them.

1 Theories and Methods

As has been noticed by those few authors who have dealt at some length with iconoclasm, the destruction of art is a subject that most art historians prefer to ignore: Louis Réau saw it as a kind of taboo; Peter Moritz Pickshaus as a 'non-theme'. David Freedberg, who considered that 'in this case lack of interest is the same as repression', explained that this was because iconoclasm 'sears away any lingering notion that we may still have of the possibility of an idealistic or internally formalist basis for the history of art', that is, the belief in an absolute autonomy of art (which, as we shall see, benefited much from iconoclasm).[1]

Images of iconoclasm

The sparse historiography on the subject that does exist belongs to the richer history of the condemnation of iconoclasm, a subject that has been explored even less, but can be traced in images as well as in texts.[2] In Byzantium, iconoclasts were typically denounced as blasphemers, whose violence against religious imagery struck at the sacred prototype (illus. 3). But by the Reformation they tended to be exposed as ignorant as well as brutal, and art, just as much as religion, was seen to be their victim. The threat they represented thus played a negative but necessary part in *kunstkamer* paintings, programmatic representations of rooms displaying art, antiquities and natural curiosities painted by Flemish artists following the late sixteenth-century revolt of the Netherlands and the concurrent iconoclastic violence: several of these works include gesticulating figures with donkeys' ears or faces – derived from allegories of Ignorance – menacing or destroying pictures with their clubs.[3]

Ignorance is a key concept in the stigmatization of iconoclasm. Encouragement of the arts, a feature of enlightened government, is presumed to dissipate the ignorance that fosters the destruction of art. Iconoclasts are presented as blind not only to the value of what they destroy, but to the very meaning of the acts they perform. Goya has supplied a striking expression of this idea (illus. 1). A man with his eyes shut tight is balanced precariously on a ladder, still waving the pickaxe he has just used to smash a bust; the caption reads: 'He

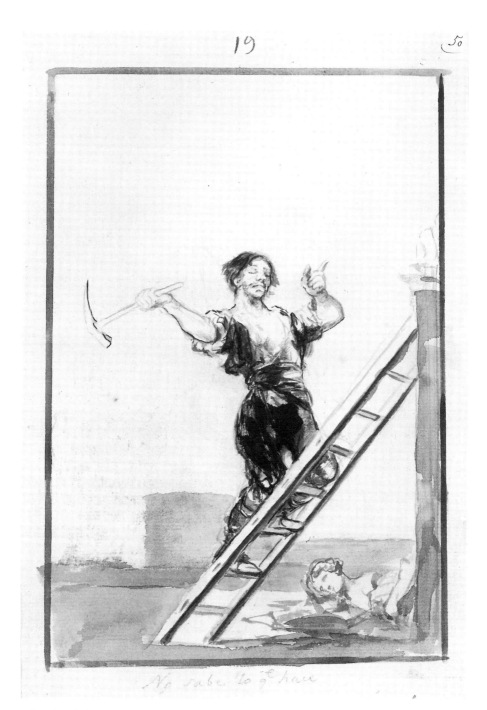

1 Francisco de Goya, *No sabe que hace, c.* 1814–17, brush drawing. Kupferstichkabinett, Berlin.
The drawing may allude to the anti-parliamentary violence that took place in Madrid in 1814 on
Fernando VII's return from France.

2 H. Baron, *The Breaker of Images*, etched by L. Massard, published in A. Challamel and Wilhelm Ténint, *Les Français sous la Révolution* (Paris, 1843).

doesn't know what he's doing.' Goya probably had in mind attacks directed against liberal institutions (represented by the smashed allegorical sculpture) rather than against art,[4] but the opposition between destructive ignorance and creative enlightenment is the same. In his *History of the Revolt of the Netherlands*, written shortly before the French Revolution, Schiller attributed iconoclasm to the lowest sort of people caught up in riotous situations.[5] Similar arguments were used by the Revolutionary defenders of the artistic heritage of the Ancien Régime, and the term 'vandalism' was coined to serve that end. A little-known engraving from the series of 1843 entitled *Les Français sous la Révolution* illustrates this common view of the destroyers of art (illus. 2). The gross appearance and 'primitive' features of the *sans-culotte* stress not only his low extraction but his underdeveloped nature (and, in the physiognomic and phrenological tradition, perhaps his criminal nature too); the elegant, demure and politically rather inoffensive character of the sculpture he is about to deface defines him as an enemy of beauty and culture much more than of tyranny.

Art destruction and art history

Since the history of art history is so closely associated with that of the growing autonomy of art, the historiography of iconoclasm cannot but possess a nor-

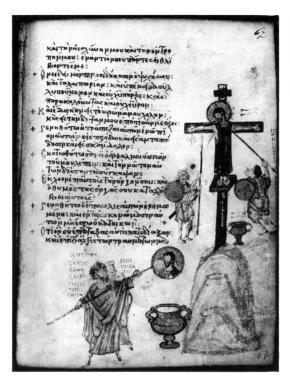

3 Comparison of the effacement of an image of Christ with the Crucifixion, from the *Chludov Psalter*, mid-9th century. State Historical Museum, Moscow.

mative, even programmatic dimension. One major work belongs to the tradition of condemnation – Louis Réau's *Histoire du vandalisme* (1959). Réau really had two aims: one was to complete the history of French art, and especially of French architecture, with an inventory of works that had been lost; the other was to denounce the destruction, regardless of its causes, and prevent its continuation, or rather, to delegitimize in advance any future actions of that sort. His political ideal was obviously a stable hierarchic society in which the 'base instincts of the crowd' could be kept under control and where a high culture enjoyed the discriminating support and protection of the knowing and powerful. Not surprisingly, the 'vandalism' of the French Revolution is given pride (or better, shame) of place in his 'interminable obituary', although none of the governments that followed is exempted from his reproaches.[6] Réau's polemical and pedagogical stance makes his 'history' an heir to the pamphlets by authors like Abbé Grégoire and Montalembert, who aimed at 'inflicting publicity' on the persons or institutions deemed responsible for destruction, 'in order to mark out the guilty ... and to caution ceaselessly the good citizens against errors of this kind'.[7]

At the opposite end, both theoretically and politically, is an equally important but incomparably more useful book, the collection of essays Martin Warnke edited in 1973 that bears the generalizing title *Bildersturm* (icono-

clasm). This anthology was the result of the critical questioning of the idea of the autonomy of art in the context of the Ulmer Verein für Kunstwissenschaft, a radical university institution founded in West Germany in 1968. In his introduction Warnke stated that the authors' common point of departure was the search for the historical roots of the idea, according to which any critical approach towards art amounted to a kind of 'iconoclasm'.[8] In a study of the 'wars of images from late Antiquity to the Hussite revolution' that was published two years later, Horst Bredekamp treated art as a 'medium of social conflicts' and saw their methodological value in the way they revealed how far what we consider retrospectively as pure 'art' had historically possessed other functions and significances.[9] The war of reviews that followed these two books demonstrated that central issues were at stake.[10]

In a first attempt at a general history of the destruction of art, published in 1915, the Hungarian historian Julius von Végh ascribed the relevance of his book to art as culture, or a part of culture, rather than to art as such.[11] This was not only a way of justifying his enterprise and paying tribute to Jacob Burckhardt, for the conclusion of Végh's *Bilderstürmer* (iconoclasts), after pointing out the shortcomings of Tolstoi's criticism of modern art, nevertheless defended the necessity for art to remain a part of broader 'culture'.[12] Most modern studies of iconoclastic episodes – which it is not my aim to enumerate here – are at least partly social histories of art and consider the violent treatment of the artefacts they examine as a special kind of reception and an indicator of functions, meanings and effects. Michael Baxandall thus resorted to an analysis of the destruction of statues in his book on the limewood sculptors of Renaissance Germany because of 'what they imply about the status of the image before reformation'.[13] David Freedberg integrated his interpretation of iconoclasm into the broader project of a 'history of response' that reclaimed for the history of images a 'rightful place at the crossroads of history, anthropology and psychology'.[14] Iconoclasm obviously stays on the agenda of a history of art that understands itself as part of the human and social sciences, and which is open to interdisciplinary exchanges. In recent years sociology and religious anthropology have greatly contributed to our understanding of the violent 'uses of images', as Olivier Christin acknowledged in his major study of Protestant iconoclasm in France.[15] Unfortunately, destructive acts of the nineteenth and twentieth centuries have tended to be examined only superficially as elements of comparison, with the danger of postulating transhistorical continuities.

'Iconoclasm' and 'vandalism'

So far, I have used the term 'iconoclasm' as equivalent to the 'wilful destruction of art', but the terminology must be examined here. English, like most

European languages, has two terms to describe the kinds of destruction with which we are concerned: 'iconoclasm' and 'vandalism'. Their perpetrators can be correspondingly identified as 'iconoclasts' or 'vandals'. German proposes three possibilities in each case: *Ikonoklasmus*, *Bildersturm* and *Vandalismus*, and in turn the *Ikonoklast*, *Bilderstürmer* and *Vandal*. 'Iconoclasm' and its associates and equivalents come from the Greek terms for 'breaking' and 'images'. They were used first in Greek in connection with the Byzantine 'Quarrel of the Images'. During the Reformation they were translated into vernacular languages to give us *Bildersturm* and *Bilderstürmer*; a French equivalent for 'iconoclast', *brisimage*, did not survive.[16] 'Vandalism', an adaptation from the French *vandalisme*, is generally associated with the French Revolution and more specifically with Abbé Grégoire, who boasted in his *Memoirs* of inventing it, writing in 1807–08 that 'I coined the word to kill the thing'. But it derives from a metaphorical use of the term 'Vandal', chosen from among other candidates to symbolize barbaric conduct, already in use in England by the early seventeenth century.[17]

Both terms have witnessed an important widening of their semantic field. 'Iconoclasm' grew from the destruction of religious images and opposition to the religious use of images to, literally, the destruction of, and opposition to, any images or works of art and, metaphorically, the 'attacking or overthrow of venerated institutions and cherished beliefs, regarded as fallacious or superstitious' (sometimes replaced in the latter sense in English by 'radical').[18] 'Vandalism' went from meaning the destruction of works of art and monuments to that of any objects whatever, insofar as the effect could be denounced as a 'barbarous, ignorant, or inartistic treatment' devoid of meaning.[19] Indeed, the reckoned presence or absence of a motive is the main reason today for the choice of one or the other term. 'Iconoclasm' is always used for Byzantium, and is the preferred term for the Reformation; for the French Revolution, 'vandalism' remains in favour, although sometimes it is offered (in quotation marks) as 'Revolutionary vandalism'. 'Iconoclasm' implies an intention, sometimes a doctrine: Thus Julius von Végh, for example, opposed individual vandalism to systematic iconoclasm.[20] 'Vandalism' represents the prototype of the 'gratuitous action', so that a sociologist aptly described it as a 'residual category'.[21] Whereas the use of 'iconoclasm' and 'iconoclast' is compatible with neutrality and even – at least in the metaphorical sense – with approval, 'vandalism' and 'vandal' are always stigmatizing, and imply blindness, ignorance, stupidity, baseness or lack of taste. In common usage this discrimination may often be unconscious and amount to a social distinction, comparable to the one between 'eroticism' and 'pornography'. (Alain Robbe-Grillet is said to have declared, with reference to the cinema, that 'pornography is the others' eroticism'.) But the same distinction remains true (and may not always be conscious) in scientific usage, as John Phillips neatly expressed

when he wrote that 'iconoclasm for the iconoclasts was an act far different from our later understanding of it as vandalism'.[22] The polemical and performative character of 'vandalism' could not have been more plainly stated than in Grégoire's proud explanation. The word aimed at excluding the 'vandal' – and at menacing potential 'vandals' with exclusion – from the community of civilized mankind, or more specifically, according to circumstances, of neighbourhood, city, nation, etc. Réau chose to write a history of 'vandalism' (and not of 'iconoclasm') for precisely this reason, and explained that 'any attack whatever against a work of beauty ... deserves the excommunication' implied by this term.[23]

Needless to say, the origin and connotations of 'vandalism' make it particularly inappropriate for use in a scientific context aiming at interpretation. Moreover, even if the wilful degradation of works of art may in some cases have something in common with assaults on telephone booths, the broadening of the field of destruction attributed to 'vandalism' tends to refute the likelihood that the destruction of art is a specific phenomenon. In contrast, 'iconoclasm' and 'iconoclast' have the advantage of implying that the actions or attitudes thus designated have a meaning. Unfortunately, the term presents other difficulties. Even if a religious character regarding the images attacked or rejected is no longer automatically assumed, 'iconoclasm' does raise the expectation that attack and rejection concern images (Réau justified his rejection of it by stressing the importance of architecture), and the signified rather than the signifier; these limitations are lifted in the metaphorical sense, but it suppresses altogether artefacts as targets and introduces another limitation by regarding the critique and rejection of traditional authorities and norms only, and not that of anti-traditional manifestations..

Given this, one might think that the only terminological solution is a standard phrase like the one adopted for the title of this book. But even if *the destruction of art* avoids or delays judgement, it is only apparently neutral and descriptive. The first problem is 'destruction', which cannot account for significant differences in the treatment of an object, so that in chapter Two I resort to the broader notion of 'misuse'. To employ a binary precision and mention but a few possibilities, a work may be 'damaged' rather than 'destroyed' in order to make it a token of the violence it was subjected to and of the infamy of anything with which it is associated; or it may be 'destroyed' rather than 'degraded' in order to eliminate any trace of these and of the intention that had lain behind its creation and installation. Of course, one may fail to destroy completely, or accidently destroy while having aimed only at degrading; such a discrepancy between intention and result is more likely to happen in the case of modern art, where – as I shall show – determining whether and how far a work is whole or damaged can be a tricky and arbitrary endeavour. Major theories of modern art, as we shall see (chapters Eight and Fifteen), con-

sider that a work is only integral in the context for which it was created, so that it may be 'damaged' and even 'destroyed' by being displaced or by its context being modified, without having been itself physically transformed. This certainly increases the possibility that a 'destruction' can be effected without any intention to destroy, but it does not preclude the possibility of a wilful destruction using such means; obviously, the limits between 'damage' and 'destruction' become even more vague or flexible when looked at from this point of view.

When 'destruction' reveals itself to be an oversimplifying concept, what should one say of 'art'? If, following Nelson Goodman, one replaces 'what is art?' with 'when is art?',[24] the question becomes 'is there art when it is destroyed?' And, of course, there is the question of 'art for whom?' One may, for example, destroy something that one reckons to be bad art, or not art at all, that others do consider to be art, even good art; and do so because one resents this difference of opinion or for reasons that have nothing to do with it. More generally it may be wondered whether art is being destroyed 'as such', which depends again on definition and agreement. Obviously, as modern art has stretched the question of what art is or can be to every limit and paradox, the predicate *art* in *the destruction of art* cannot be but a chronic oversimplification.

For earlier periods other terms, such as 'iconophobia', 'iconomachy' and 'aniconism', have been proposed to distinguish between various related attitudes.[25] I personally doubt that reducing the situations that we shall be dealing with to a kind of logical grammar and coining a phrase for each type would be of much help. To my eyes the most important contribution to the understanding of 'vandalism' (in the broad sense) has been made by adepts of the 'labelling theory of deviance', who in a way analogous to Goodman have replaced the definitional question 'what is vandalism?' by the situational one: 'when is an action labelled vandalism?' (see chapter Nine).[26] It may seem frustrating to renounce using or devising an 'objective' terminology, but terms are inevitably part of our object of study as well as the tools we must employ in order to understand it. Moreover, a nominalist rather than realist approach to vocabulary is in accordance with a central tenet of the modern theory of art as well as with modern aesthetics and sociology (see chapter Fifteen). In this book I shall try to characterize as far as possible every situation studied. When, for practical reasons, a generalizing phrase is called for, I will invoke 'destruction' and 'art', assuming that the reader bears in mind the reservations I have set forth, and resort to 'iconoclasm' rather than 'vandalism' for the reasons explained.

Approaches and disciplines

If the destructions of art in the nineteenth and – more particularly – the twentieth century have been neglected by art historians, they have been approached

by others, notably sociologists, criminologists, psychiatrists and psychoanalysists. With few exceptions, sociology and criminology have considered aggression against works of art in the context of 'vandalism' in the broad sense, and often only in passing.[27] This is not the case with psychiatry and psychoanalysis, understandably given the importance they give to art as symbolizing process; from these quarters have come both general theoretical reflections and case studies, mostly dealing with attacks perpetrated in museums.[28] Even if these approaches, grounded in different questionings and with diverse methodologies and aims, may often appear unsatisfactory to the art historian or historian, they nevertheless have much to contribute to an understanding of the phenomenon or phenomena under consideration, and I make use of them in the following chapters. Indeed, contemporary 'iconoclasm' might be considered a privileged field of research for interdisciplinary exchange and collaboration. But one must start from somewhere. The fact that the present study's primary affiliation is art history means that the historicity and specificity of the destruction of works of art is postulated. A greater attention will be given to chronology and historical transformations than is usually the case in the contributions of other disciplines. The collective and conscious dimensions or elements of the acts performed will receive more emphasis here than they do in psychiatric and psychoanalytical interpretations. And the fact that works of art – with the reservations already mentioned – are attacked rather than (or parallel to) other artefacts will be considered as potentially relevant for the attackers, the actions and the works, and, indeed, for art in general. In the end, the main problem will be to weigh the relative importance of the various motives or factors illuminated by one or more observers as well as to articulate them, for they are rarely mutually exclusive. Here again, my appreciation will necessarily be influenced by theoretical and methodological preferences and affiliations.

One transdisciplinary concern – if not 'method' – to which any study of the destruction of art is necessarily related is the question of 'reception'. Even if an attention to the way works of art have been perceived, interpreted, valued and handled can be traced in major early art-historical contributions, it is well known that, as a systematic approach, the study of reception has its origin in literary history and criticism.[29] Moreover, what the exponents in Germany of the so-called Konstanz School have advocated and developed is less a history of the actual reception of works than an 'aesthetic of reception', i.e. the internal analysis of the way a text predetermines its perception and its public.[30] In a provocative and stimulating critique of iconography, a historian of Roman antiquity, Paul Veyne, made a useful contribution to this discussion by stating that there exist works of art without spectators just as rites can be performed without belief, and that most works of art, at least the ones situated in public spaces, are generally perceived – if at all – at a very low degree of attention.[31]

Among the examples Veyne featured were the Trajan and Vendôme columns, and his article received a reply concerning the former from Salvatore Settis,[32] who made use of a kind of 'aesthetic of reception' to reconstruct a more complex perception of the Roman monument at the time it was erected than the one Veyne had postulated. (The destruction of the Vendôme column by the Commune in 1871 will call for a separate comment on the basis of the history of reception.) It must be added that, far from being only expressions or symptoms of reception, the often elaborately staged destructions of works of art must be considered as means of communication in their own right, even if the 'material' they make use of is – or was – itself a tool of expression and communication.[33]

Typologies

In a major collection of essays on vandalism in the broad sense (works of art are not mentioned), Colin Ward identified two myths about this topic that he and his colleagues had to explode: its meaninglessness and its homogeneity.[34] The fundamentally polemical and normative character of Réau's unifying use of 'vandalism' has already been mentioned. But how can one do justice to heterogeneity without renouncing the benefits of a general approach? One solution may be to elaborate a typology. This is what Stanley Cohen did in Ward's volume: he resorted to motive and intention as structuring elements, and distinguished between 'ideological vandalism' and 'conventional vandalism', subdividing the latter into 'acquisitive vandalism', 'tactical vandalism', 'vindictive vandalism', 'play vandalism' and 'malicious vandalism'.[35] The criminologist Friedrich Geerds, who concentrated on the destruction of art, divided what he significantly called by a re-narrowed term *Kunstvandalismus* (art vandalism) according to 'background', which could be social or political, artistic or aesthetic, incomprehensible or individual.[36] Many other typologies have been proposed. Réau mentioned a number of them before concluding that they were unsatisfactory and justifying his choice of a chronological order of presentation, the best instrument of homogenization. His own proposal was nevertheless revealing and formed a basis for his interpretations: he resorted to a 'psychology of vandals' and distinguished between 'avowable' and 'unavowed motives', the former tending to be but a pretext for the latter.[37] The 'avowable motives' were religious, prudish, sentimental, aesthetic; the 'unavowed motives' read like a catalogue of vices: greed, envy, intolerance, stupidity and the 'bestial instinct of destruction'. Réau, who did not hesitate to take sides, was particularly – though indirectly – illuminating when he stated that 'beauty offends inferior beings who are conscious of their inferiority', for this uneuphemized violence did express something of the violence that the culture he intended to defend could exert or represent.

The question of power forms the basis of another distinction, one much simpler and more useful, which has been defined in various ways by several authors but most forcefully by Warnke. It is the distinction between iconoclasms 'from above' and 'from below'. Warnke noticed that the former, corresponding to the interests of those in power, tended to lead to a replacement of what they destroy by new symbols and to the prohibition of further destruction, whereas the latter, springing from political impotence, mostly failed to establish new symbols of their own. Taking a critical stance towards his discipline, he added that by ending in surpassing the aesthetic quality of the eliminated works, the 'iconoclasms from above' managed to be celebrated among the great dates of the history of art, while 'iconoclasms from below' were denounced as 'blind vandalism': iconoclasm thus became 'a privilege for the victors, and a sacrilege for the vanquished'.[38] A case in point, cited by Warnke, was the destruction in Rome under Pope Julius II of Old St Peter's and the construction of New St Peter's. On the side of the oppressed, one could mention the revolution of 1848 in Lyon, where the workers renounced pulling down the statue of Louis XIV when the Latin inscription to the glory of that monarch was replaced by one in French honouring the sculptor and the Republic, but erected an enormous effigy of the 'Peuple souverain' as an armed *sans-culotte* treading on the monarch's crown and asking, by means of an inscription, 'Who will dare pick it up?'. It proved easy to displace rapidly and eventually eliminate this fragile monument.[39] Réau was original in stressing the destructive component of 'iconoclasms from above', but he made no mystery of his taking the final aesthetic result into account in order to evaluate, in the name of posterity, the actions of individuals, movements or regimes. Needless to say, for him, 'the mob is always vandalistic'.[40]

This distinction is akin to the one proposed in 1833 by Montalembert between 'destructive vandalism' and 'restorative vandalism', or to the one between 'negative' and 'positive' destruction recently adopted by Françoise Choay.[41] Its symmetry, the origin of which is polemical, should not be pushed too far, as the amount of destructive intention and the status of destruction are extremely varied in the 'iconoclasms from above' thus understood. Restricting himself to cases of power shifts where dominant institutions were primarily animated by their objections to extant images, Olivier Christin made useful observations about typical ways of destruction 'from above' and 'from below': whereas the latter tend to make a partial and brutally executed assault visible in order to symbolize the new situation, the former prefer total elimination and seek to impose a systematic and legal procedure regulating the listing of the objects concerned, their treatment and the reuse of materials.[42] It must also be noted that, since the French Revolution, the progressive autonomization of the various social fields, in particular the cultural one, has led to a multiplication of specific, competing hierarchies and, there-

fore, to a more complex situation as regards the question of 'power'.[43] We may thus have to distinguish, for example, between the motives and methods of destroyers of art who are politically and economically as well as culturally dominated and those of politically and economically powerful but culturally dominated iconoclasts.

Generally speaking, typologies are useful insofar as they point out regularities or discrepancies and enable one to discern structuring factors in the maze of individual data. But they imply a risk of de-historicizing, and may lead the interpretation astray by leaving out relevant elements of context; their classifications should always be considered as indicative poles rather than fixed categories. Even types so broadly defined as 'institutional' and 'individual', 'structural' and 'conjunctural' should not prevent the observer from probing how closely and intricately institutions and individuals, structures and conjunctures can be connected.[44] The construction of this book will also be mixed in as far as such categories are concerned: matter will be distributed according to motive (political) in chapters Three to Five, actor (endowed with political, administrative or economic power) in chapter Eight, spatial and institutional context (public space, museums) in chapters Eight and Ten, motives again (embellishment, modernization, profit) as well as genre and function (architecture, ecclesiastical art) in chapters Eleven and Twelve. It will be possible to observe distinctions and nuances in each case: aggressive motives can be explicit or implicit and of a more 'ideological' or more 'private' nature; aims can be equated with the physical result of the attack or go far beyond it; assailants can be individual or collective, make themselves known or remain anonymous, possess or not different kinds of power and authority; their actions can be more or less violent and destructive, direct or indirect, visible or clandestine, legal or illegal; the targets can be private or public property, deemed attractive or 'offensive', acknowledged as art or not, appear as 'autonomous' or associated with certain groups or values; the context, finally, can be variously accessible and be permanently dedicated to the display of art or not. However, even these abstract oppositions are relative and mutually dependant. At best they can represent a set of possibilities to which each concrete situation gives a different shape and meaning.

2 A Historical Outline

Preservation, use, and symbol

A few general remarks are necessary at the outset of this historical summary. Horst Bredekamp stressed the value that the study of 'wars of images' possesses because they question the universal validity of the modern concept of 'art'. I would say that dealing with the destruction of works of art means seeing them in the broader context of artefacts, objects, even – to pay a tribute to George Kubler – 'things'.[1] Some prejudices may be better fought against in this way. First, the binary opposition between creation and destruction. Unfortunately, the very word 'destruction' that I have to employ, notwithstanding its simplifying character, contributes to this symmetry and tends to evoke the idea that the mistreatment it denotes is – after 'creation' or 'production' – the second, and the last, one that any object has been subjected to, unless the object still exists. From this point of view, in summary, an object is made, it exists, and it may, ultimately, be destroyed. Now, a closer examination of the history of any object shows that the bad treatments in question take place in a long series of interventions of which they may or may not be the final ones. 'Creation' itself may be constituted of several of these interventions, as every ancient building attests (of how many depends on the stage or state at which one chooses to situate the 'standard' existence of the object). Some of these interventions aimed at lengthening its existence, others (the iconoclastic ones) at terminating it, and many – maybe all – at modifying it. Intention in this respect, it must immediately be remarked, is not everything, and judgement may differ considerably from it. That every intervention, whatever its purpose, implies a modification, derives from the fact that on a technical and aesthetic as well as physical level, there is no conservation without transformation; what varies, and certainly matters, is the kind, extent and duration of this transformation. As far as 'bad treatments' are concerned, and taking into account the possible discrepancy between intention, effect and judgement, it may be better to call them 'misuse', as the term makes clear that it is but a kind of 'use', and that the distinction between 'misuse' and 'use' depends on what is defined as 'proper use' at any time, for any object, for any person and in any circumstance.

A second point that must be made about the life of artefacts is that it is their normal fate to disappear. A number of factors contribute to determining the

duration of objects, including the materials employed in their making and the way these are combined, the physical context in which they are placed and its changes, as well as the uses to which they are submitted and the way they are considered. Regarding materials and their combination, it may be sufficient for the moment to remind the reader that the length of time they are expected to survive is generally one of the reasons for their selection, and that the hope they will last is traditionally associated with works of art as well as with monuments. The question of use is even more crucial, but more complex. Most of the time, using an object means wearing it out. For example, in 1836 Ludovic Vitet expressed his regret that French cathedrals, unlike English secularized churches, still fulfilled religious functions, since 'use is a kind of slow, imperceptible, unheeded vandalism, which ruins and defaces almost as much as a brutal devastation'.[2] One may, however, oppose symbolic to practical use in this respect, and stress that whereas the latter surely leads to physical damage, the former does not necessarily, or does less; or distinguish objects and uses that involve direct physical contact from those (such as images and the act of contemplation) that do not. The matter is obviously not a simple one, as Vitet's attitude towards ecclesiastical architecture makes clear. Many religious images were meant to be kissed and caressed in the West and elsewhere – indeed, curators in India are obliged to prohibit the performance of religious practices in their museums that involve the statues of gods in their care.[3] Still, uses that rely less directly on the physical properties of an object and more on its relation to something it represents or refers to, are less liable to cause its degeneration. Moreover, insofar as what it stands for (person, institution, belief, value, norm) is endowed with a permanence and as its relation to it remains effective, the object may benefit from the permanence in question and thus escape the general effects of physical, technical and aesthetic obsolescence, i.e. replacement or destruction, or relegation to a 'baser', less specific use or to a less central place.[4] In the case of works of art, and in particular modern art, 'what it stands for' may be thought to be purely inherent in the object, but the symbolic relation exists none the less.[5]

Of course, an object may – it generally does – fulfil several functions simultaneously or successively, and changes of function may contribute to its conservation (and modification) just as easily as they might to its destruction. Most artefacts that are now regarded as works of art, monuments or 'cultural property', and which are preserved for that reason, owe their present status and continuing existence to such a transformation. It may have been more or less progressive or brutal, minor or radical, and is too often defined as a 'defunctionalization', but it really is a change of function and use or a redistribution in the system of functions and uses. However, this type of preservative functional change has long remained an exception, and many authors have stressed how normal it was until modern times to eliminate what we would

call a monument or a work of art when it was outmoded or no longer suited the needs and expectations it formerly satisfied.[6] Moreover, the symbolic relationship is not in itself preservative: it rather tends to make the object share the fluctuating fate of what it symbolizes, unless the relationship comes to be regarded as ineffectual or marginal. Thus, the portrait of a sovereign has a good chance of being preserved, so long as it is deemed worthy (as an effigy and work of art) of the sovereign, but it runs the risk of being discarded or destroyed if the sovereign falls from power or fame, unless it is considered to be too good a picture – rather than as too bad a portrait – to abandon. Suffice it here to mention, in order to point out that the same can be true of 'pure' art, that a painting may be removed from the exhibition rooms of a museum and thrust into its storerooms when the artist, movement or period that it exemplifies falls into disgrace, or when it ceases to exemplify them properly; or it may on the contrary keep its privileged status thanks to other properties that it possesses and can exemplify. But the solidarity and interaction between the object and what it symbolizes (as well as between sign and signified in general) can work in both directions, and this is precisely what accounts for iconoclasms among other kinds of treatments. One may act upon the shape and fate of an object in order to let what it symbolizes partake of this fluctuation, either metaphorically or – by one means or another – literally. Again, 'what it symbolizes' may be an artist, an artistic movement or a definition of art as well as a monarch, a dynasty or a kind of regime.

The portrait of a sovereign is a paradigm of the symbolizing power of images in general as well as of their political function in particular.[7] In this domain, use and misuse can easily be shown to determine each other: it is because images are used to express, impose and legitimize a power that the same images are misused in order to challenge, reject and delegitimize it. It was thus argued that the French Revolution would not have been so extreme in its iconoclasm had the French monarchy not resorted to art as a political instrument to the degree that it did, while the link between Communist monumental propaganda and the wholesale pulling down of statues in Central and Eastern Europe after 1989 is readily apparent.[8] This means that iconoclasm implies some degree of competition in the political and social situation; characteristically, André Chastel proposed to explain the importance of acts of destruction in the history of French art by the fact that France was a land of civil war.[9] As far as images of sovereigns (or other persons embodying power) are concerned, the political function can be closely connected with others, such as commemorative and funereal ones. *Damnatio memoriæ* has been known – if one may say so – from time immemorial, and, in various guises, has remained common practice. The fact that images were for a long time conceived of as real substitutes for the persons represented (replacing those persons on a legal and ritual as well as cognitive plane), and the fact that this is no longer the case, changes

matters as far as the more literal or metaphorical status of image use and misuse are concerned; but it does not follow that degrading or eliminating portraits and effigies in modern times should represent a relapse into 'animism' or other 'primitive' ways of thinking and acting.[10]

Byzantium and the Reformation

In the case of religious images, the immaterial character of what is symbolized and the fact that ritual or theology often encouraged a fusion of image and prototype made the issue of the adequacy and legitimacy of the symbolizing relationship particularly critical. The iconoclasts of eighth- and ninth-century Byzantium did not mean to attack Christ through his images, even though their enemies implied that they did (illus. 3), but they did object to the use of images as cult objects as well as to related circumstances, such as the wealth and power that their production and exploitation bestowed on the Church, and particularly on the monks. The relative importance of, and the relation between, the overt theological motives that provoked the 'Quarrel of the Images' of 726–843, and its political, economic, social and military implications, have been abundantly discussed, but since the arguments put forward by the iconoclasts have reached us only via their opponents (who were finally the victors in the struggle), the full circumstances of the Iconoclastic Crisis will probably have to remain conjectural.[11] The iconoclasts accepted, in fact promoted, abstract rather than figurative symbols and called for an even stricter submission of images to religious function. This point may indicate the – admittedly minor – presence of a crucial factor in the history of later iconoclasms, i.e. conflicting definitions of, and attitudes towards, an autonomy of art. But this aspect becomes really explicit with the destructions organized by Savonarola in fifteenth-century Florence, during which works of art furnished by their owners, and in some cases by their authors, were piled on top of various other objects and burnt as instruments of sensual pleasure and symbols of an immoral and unjust society.[12] The form of the *bruciamenti* prefigures one of the techniques employed for the elimination of 'emblems of the old order' in Revolutionary France, but, what is more important, so does the widening spectrum of symbolic contents involved and the corresponding spectrum of objects attacked.

The conquest of the New World also had an important iconoclastic dimension, one that has only begun to be officially recognized – the Pope very recently begged for pardon in a Mexican church built on the ruins of a Mayan temple – and can only be briefly touched on here.[13] Following the initial conquest, the images made and used by the New World's inhabitants were interpreted as 'idols' and mostly destroyed, as were many buildings and towns, among which was Tenochtitlán, the Aztec capital of 300,000 inhabitants that Cortés

razed to the ground in 1521. In this war of images, the necessity of both neutral-izing the instruments of indigenous belief and practice and of appropriating their symbolic potential led the invaders to make use of the same sacred places and to accept syncretic artistic forms.[14] But the ethnocentric attributions of 'idolatry' and 'primitivism' continued to justify assaults on the material cul-tures of colonized societies, so that one author has called Westerners 'the greatest destroyers of history' and considers that 'vandalism characterizes the way in which developed societies have communicated with archaic societies'.[15] It must be added that the notions of art and of 'cultural property' that have since been universalized and opposed to such 'ethnocides' share the same Western origin, and that fact may in itself raise comparable problems.

The theological arguments presented for and against images during the Reformation were generally the same as those made previously – although here one can at least study the reasoning of both sides at first hand – with the exception of a new insistence on the question of the Eucharist.[16] Some of the prototypes (the saints) or their properties (miracle working) were criti-cized, but the attacks concentrated again on the adequacy and legitimacy of their relation to images and other objects such as relics, as well as on the uses (denounced as superstitious misuses) that found their source and justification in this relation. In order to prove their powerlessness, images were not imme-diately destroyed: first they were profaned and degraded – often in ways that mimicked judicial processes of the day or the martyrdom of the saints they represented – and summoned to react. The idea was to reduce them to a ma-terial status of non-symbolic objects (wood, stone), and a rigid distinction between the profane and the utterly immaterial, non-human realm of the sacred was redrawn.[17] Nevertheless, compared to the Byzantine iconoclasm, the ethical, social, political and aesthetic elements of the Reformation were far more explicit, and certainly weightier. There was the critique of art as luxury and of artistic investment as economic waste detrimental to the inter-ests of the poor, an argument that has remained central to the reception of public patronage down to the present. The role played by iconoclasm in the political dynamics of the Reformation is also of considerable interest for com-parative purposes. In the case of France, for instance, Olivier Christin has shown that isolated and precocious iconoclastic acts could be used as a means of radicalizing activism, compelling fellow believers to proclaim their faith and take sides; at the other extreme, the Protestant authorities were chiefly anxious to prevent extremism and keep the revolutionary potential of iconoclasm in check.[18] This 'official' iconoclasm also led to a process of selection based on distinctions between images that were considered to be dangerous and those that were not. As for aesthetic factors, the coincidence between the Reformation and the development of new techniques for the multiplication of images and of new forms and standards of realism has

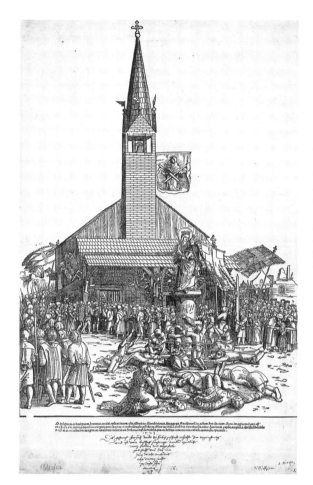

4 Michael Ostendorfer, *The Pilgrimage to the Image of the Beautiful Virgin in Regensburg*, 1520, woodcut. Kunstsammlungen der Veste Coburg. *The bottom of the print bears Albrecht Dürer's handwritten comment of 1523, condemning the idolatrous practice of pilgrimages to the statue of the Virgin by Erhard Heydenreich and the supposedly miraculous picture attributed to St Luke.*

often been stressed. Cheap, popular prints made images ubiquitous, whereas the skill of great artists promoted both the fusion of image and prototype and a distinction between unique images of the same prototype (illus. 4). The inhibiting effects of Protestant aniconism on the imagination and artistic production of a significant part of Europe are well known. But the consequences of the Reformation for the general development of art are more far-reaching and less one-sided, as Werner Hofmann has convincingly demonstrated. According to Hofmann, Luther's assumption that images were not themselves responsible for the uses to which they were put amounted to a liberation, and the expulsion of images from religious services eventually led not only to the flowering of profane art but to Kant's definition of art as the object of 'disinterested enjoyment', to the condemnation of iconoclastic attitudes as archaic, and to the establishment of a 'religion of art'.[19] Similarly, John Phillips has seen in the 'Reformation of images' in sixteenth- and seven-

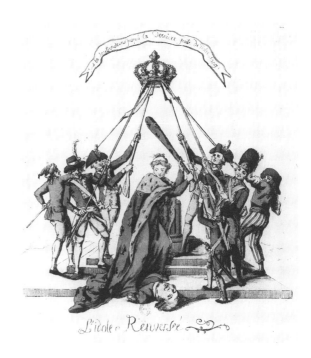

5 *The Overthrown Idol*, 1791, etching and aquatint. Bibliothèque Nationale de France, Paris. *The print attacks the person of the monarch (the bust of Louis XVI) but defends the monarchy (the fleur-de-lis mantle, the crown), with the caption 'We shall support it to the last drop of our blood'.*

teenth-century England the origin of 'the move from art as a handmaiden of religion to its conception as an autonomous activity'.[20]

The French Revolution

The French Revolution is generally recognized as a turning-point in the history of both the destruction and the preservation of art. In an attempt at summarizing the evolution of iconoclasm, with the Byzantine 'Quarrel of the Images', the Reformation and the Revolution as its main stages, Karl-Adolf Knappe saw in the Revolution the culmination of a threefold process involving a dilution of the 'spiritual content' of the attacks, a widening of their targets and a growth in the importance of aesthetic components.[21] André Chastel noted that the very notion of *patrimoine* (heritage) was 'born out of the unheard-of disasters of the Revolution'.[22] The contradictions and paradoxes of this Janus have been open to interpretation and controversy, for the destruction of art became a major argument in the evaluation of the Revolution as a whole. Unfortunately, and characteristically, the destructive side has remained much less studied than the conservative one.[23]

The importance of symbolic objects and their manipulation during the Revolution can be related, as has already been mentioned, to their importance under the Ancien Régime. Desecrating images contributed to the delegitimization of the King before his eventual elimination (illus. 5).[24] In contrast to the

Reformation, it was less to the images than to their symbolic content that the Revolutionaries objected. This fact could allow works to be preserved, provided that their symbolizing relationship was broken or reinterpreted. But since the whole order of society rather than just some of its members was questioned, the 'symbolic content' objected to was defined in an all-embracing sense that endangered a correspondingly wide spectrum of objects: not just arms, portraits and effigies of the monarch, the members of the nobility and the Church – although such objects were the ones most directly and systematically attacked – but any work that they had commissioned, possessed and displayed and was thus understood as participating in the rhetoric of power and hierarchy. Towers could be deemed enemies of equality, and the ashes of renewed *bruciamenti* mixed with the dust to produce the 'beautiful effect of a perfect equality'.[25] When the Terror and civil war further radicalized the struggle, a whole town could be denied the right to exist. Lyon was deprived of its name (in favour of 'Commune-affranchie') as well as of some of its citizens, monuments and major buildings, one of which was addressed in these terms: 'In the name of the Sovereignty of the people . . . we strike with death this abode of crime whose royal magnificence was an insult to the poverty of the people and to the simplicity of republican morals' (illus. 6).[26] The 'emblems' of feudalism' and 'of superstition', 'toys' and 'spoils of prejudice and arrogance' were everywhere, as was the ambition to renovate. The break in communication and tradition could not be better expressed than by the way these 'emblems' were denounced as 'insults', 'offences' to a free 'republican eye'. Many Revolutionary prints show the figure of Time himself smashing material symbols of the Ancien Régime.[27]

The pedagogical, political and even economic potentialities of destruction were exploited from the start. The Bastille for example, which had been perceived both as a military threat and as a symbol of royal arbitrariness, was given to a private entrepreneur who proclaimed himself 'citoyen Palloy', demolished it (illus. 7) and produced – allegedly out of bits of the walls – profane relics representing the fortress and commemorating its fall.[28] Major destructions tended to be elaborately presented or at least represented in such a way (illus. 8, 9). Iconoclasm played a role at every stage of the Revolutionary process – to foster it, to incite conviction or fear, and to make the change appear and become irreversible. But just as the individual actors, aims and circumstances varied, so did the actual ways in which objects were handled. Klaus Herding has recently proposed a typology of these treatments, distinguishing between the replacements of visual signs and inscriptions on monuments, their renaming or rededication; the transformation or replacement of whole works; the burial, beheading or banishment of statues, treated as if they were real persons; the removal of monuments from their public sites to special rooms – museums possessing their own aura; and annihilation. As can be noted, total elimination

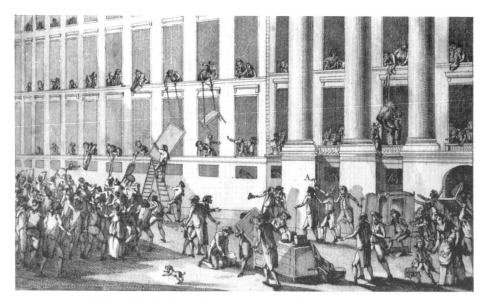

6 Lafosse, *The demolition of Two Proud Façades in the Place de Bellecour in Lyon*, 26 October 1793, engraving. Musée historique de Lyon. *The engraving shows the aftermath of the failed resistance of 1793. Beneath the 'A' on the left-hand column is the Representative of the People Georges Couthon, giving the first symbolic blow to the building with a silver hammer, saying 'I condemn you to be demolished in the name of the law'.*

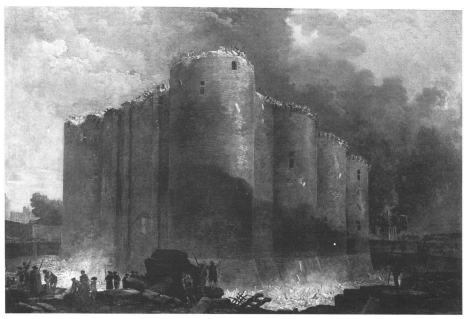

7 Hubert Robert, *The Bastille during the First Days of its Demolition*, 1789, oil. Musée Carnavalet, Paris.

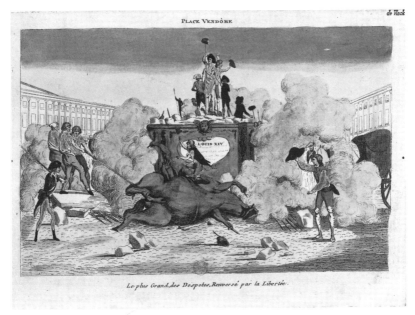

Le plus Grand des Despotes, Renversé par la Libertée.

8 *The Greatest of Despots, Overthrown by Liberty*, 1792, coloured etching. Bibliothèque Nationale de France, Paris. *A symbolic representation of the pulling down of François Girardon's equestrian statue of Louis XIV in the Place Vendôme, 12 August 1792.*

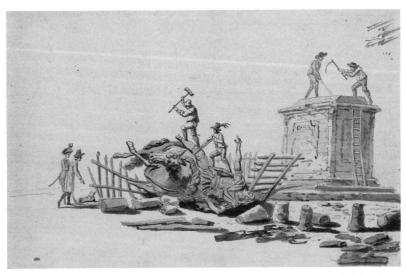

9 Jacques Bertaux, *Destruction of the Equestrian Statue of Louis XIV*, 1792, pen and ink drawing. Musée du Louvre, Paris.

was but one solution. Richard Wrigley has rightly insisted on the importance of transformation and reuse, proposing to apply to this category Derrida's concept of 'rature'.[29] Erasures and modifications mostly concerned coats of arms and inscriptions, thus dissociating the works from their original places or functions and redefining them. Reuse of fragments, materials or sites aimed at further symbolizing and commemorating the epochal annihilation and replacement of the old order.[30]

Like the Protestant authorities, the Revolutionary ones were anxious to give iconoclasm a legal frame of justification, execution and control. It had an aesthetic component, with the critique of art as luxury – unnecessary, even pernicious for mankind – to which Jean-Jacques Rousseau had particularly contributed on a theoretical plane and which could be summarized with the iconoclastic formula 'monument of vanity destroyed for utility'.[31] But a positive view of the moral, political and economic as well as aesthetic potential of art was even more important for the approach to extant works and for the (mostly unrealized) artistic projects of the Revolution. Fundamental was the possibility of distinguishing between the sign and the signified. In several instances one can observe the shift of content to which an object, a motif or a type was submitted and which justified its preservation. Dussaulx declared on 4 August 1792 before the National Convention that the Porte St-Denis in Paris, being 'dedicated to Louis XIV . . . deserves the hate of free citizens, but this gate is a masterpiece'; a report on the royal tombs in St Denis proposed to except from melting the top of a sceptre of gilded silver, 'not as part of a sceptre but as a piece of fourteenth-century goldsmith's art'; and a member of the Convention, Gilbert Romme, pointed out that the fleur-de-lis had been both 'a token of pride for the kings and a national stamp for the arts', so that the work of French artists was wrongly attacked because of the first function.[32] The values to which objects became attached and which, as historical testimonies and works of art, they were shown to share or exemplify, were opposed to the particular and to the class-bound: they were national and even – at least virtually – universal. This applied first to certain objects that were exempted from destruction because of their 'interest for art' or 'for history', and permitted a process of selection and purification that was part of the state-controlled politics of memory; but the arguments put forward for preservation implied a general validity. As far as (more or less) moveable works were concerned, public museums became the privileged places where refunctionalizing took place. Neither the idea of collective heritage nor the institution of the museum were invented by the Revolution, but the redefinition of nation and state, the dispossession of the Crown, the nobility and the Church, gave them an unheard-of importance.[33]

The stigmatization of iconoclasm was the other instrument of this refunctionalizing. Destroyers were thus accused of misusing objects that they

misunderstood and of acting in a way unworthy of the regenerated nation to which they belonged. One member of the Convention, Abbé Grégoire, who has already been mentioned in this respect, was by no means the first or only person to condemn 'vandals' and 'vandalism' publicly (illus. 10), but his three *Rapports* of 1794 were of particular notice. The other main hero of the fight for preservation was Alexandre Lenoir (illus. 11), a painter who obtained the former convent of the Petits-Augustins to locate his Musée des Monuments Français, an immensely influential collection of decontextualized mediaeval art that he was ready to enrich by any means possible.[34] Iconoclasts were also accused of destroying public wealth, of defaming the image of Revolutionary France and of working for its enemies, *émigrés* in particular. With the fall of Robespierre, 'vandalism' was associated with the Terror and became an instrument of its condemnation, even if the secularized and nationalized estates continued to fall prey to their new owners. As Klaus Herding synthetically formulated, the transformation by Lenoir of the notion of monument from an instrument of domination into one of instruction, together with Grégoire's appropriation of monuments as works of art and his condemnation of their destruction as 'vandalism', made it possible – at least in theory – to go beyond destruction and to renounce it. It is not by chance that Schiller, who in 1788 had attributed Netherlandish iconoclasm to the mob, should have ended his drama *Wilhelm Tell* (1804) with the question of what was to be done with Gessler's hat, the crudest example of a humiliating sign of power. Several voices called for its destruction, but Walter Fürst, representing a social and moral elite among the insurgents, replied: 'No! let it be preserved! It had to be the instrument of tyranny, let it be the eternal symbol of liberty!'[35]

The defence and erosion of heritage

Later political re-establishments could not nullify those profound transformations, on which the situations that we shall examine in the following chapters are all predicated in one way or another. Museums, at first a refuge for so many objects wrenched from their original contexts, progressively became the 'natural' place for historical testimonies to be apprehended and, even more, for works of art to be enjoyed and studied 'for their own sake'. This meant also that the most prestigious *destination* (in terms of function as well as site) of new works would be the museum, denounced by conservative-minded critics like Quatremère de Quincy as the negation of art and a source of its decadence.[36] The definition and evaluation of the autonomy of art was to remain, down to the present, an issue whose importance cannot be overrated, and we shall encounter some of the numerous attempts at re-socializing or re-instrumentalizing art that would follow. The new public space, already apparent in the eighteenth century, and the state's control over cultural matters (particu-

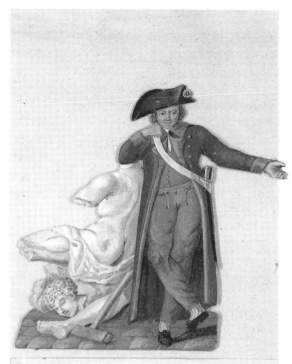

10 E. Le Sueur, *Vandal, Destroyer of the Products of the Arts*, *c.* 1806, gouache. Musée Carnavalet, Paris.

Vandaliste, destructeur des productions des Arts. *Se*

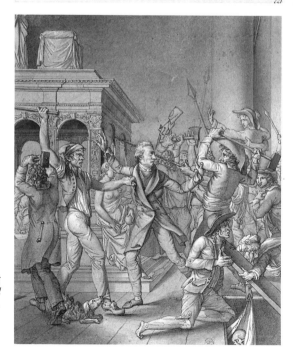

11 P.-J. Lafontaine, *Alexandre Lenoir Opposing the Destruction of the Royal Tombs in the Church of St-Denis*, 1793, drawing. Musée Carnavalet, Paris.

larly in France), led to the development of specific institutions and of an 'artistic field' in Pierre Bourdieu's sense.[37] Culture manifested the shortcomings of the universalism inherited from the Enlightenment and the Revolution: theoretically the spiritual and – through the museum – material property of everyone, art represented a set of socially determined and distinctive practices. It could thus contribute to a naturalization of inequalities – insofar as the unequal use of art was explained by innate differences of sensitivity – and to a 'symbolic violence' that would provoke at times, as we shall see, violent reactions. The growing autonomy of art meant also specialization and an ever narrower distribution of competence and specific (cultural) power. From the beginning of the nineteenth century on, the recourse to violence against art must therefore also be understood in relation to the possibility or impossibility of access to legitimate means of expression, as a dark spot in the economy of the relationship between art and the public.

For reasons of time and money, the main artistic realizations of the Revolution were not the huge monuments that had been projected but rather prints and feasts.[38] Nevertheless, the idea of art as propaganda remained very much alive, and neither Napoleon nor later rulers and governments renounced it. It was affected, however, by shifting ideas of art and power. With art defined as an end in itself, susceptible by its own virtues of enlightening humanity (or even, later on, by being essentially free of any such purpose), the functions it used to fulfil could be regarded as extrinsic, accessory, and eventually undesirable. This was true for religious (see chapter Twelve) as well as political art. *Auftragskunst* (commissioned art) would not disappear, but it tended to decrease in legitimacy, prestige, and therefore – this being said in full awareness of the bias inherited from modernist historiography – in quality. As far as republics, parliamentary monarchies and democracies are concerned, the relatively depersonalized and abstract character of power made political self-representation difficult, as the competition in France in 1848 for an official image of the Second Republic clearly demonstrated.[39] Certainly, important differences according to regime as well as country must be acknowledged here – a case in point being the Third Republic, which developed a pedagogical artistic programme, the aesthetic evaluation of which would become an index of opinion about political art.[40] However, this politological aspect combined itself with the artistic one to limit the recourse to art for direct political use, granted that the possession and promotion of great art could bring indirect political benefit and that, as Martin Warnke stressed, industrial images offered new possibilities for propaganda as compared to handmade ones.[41]

During the nineteenth and twentieth centuries, enormous losses were inflicted on the heritage defined in the wake of the Revolution, in particular on unmovable works of architecture and arts 'applied to' it. Apparently, these destructions were not caused by any objection to what these objects stood for.[42]

But it may be more correct to say that the symbolic content that provoked their elimination or prevented them from being preserved was of an even more general nature than the symbolization of the Ancien Régime that had widened the targets of Revolutionary iconoclasm. It was their belonging to – and thus exemplifying – an obsolete state of the world in technical and aesthetic terms (a counterpart to Riegl's 'antiquity value', as we shall see later).[43] The 'ideology' that fostered and justified the destructions was also wide-ranging and tended to transcend traditional political cleavages: it was the primacy of economy and the 'religion' of progress. Consequently, this kind of 'iconoclasm' was more a matter of daily business than of violent outbreaks; it was rather performed 'from above' in a legal frame, and was mainly due to owners and authorities. Nor did it spare the New World, which generally escaped the large-scale destructions caused in Europe by wars and political events. Montalembert, one of the main opponents to this 'barbarism', could thus classify it according to its authors: government, mayors and municipal councils, priests and Church committees, owners. He rejoined Victor Hugo in the fight for the material support of collective memory, affirming that 'long memories make great peoples', and characteristically opposed art to power as such: 'power has the faculty of degrading and depopularizing art'.[44] Ironically, transformations of works intended – at least allegedly – to preserve them appeared to him and other influential defenders of heritage as amounting to destructions, so that he baptized a variety unknown to Grégoire, 'restorative vandalism'.[45] Conceptions and the practice of restoration would evolve towards a greater respect but also to a more problematic view of the 'original state' of objects, ultimately including their previous restorations.

The fall of the Vendôme column

This does not mean that attacks, modifications and destructions motivated by the specific function and content of works disappeared. To the same extent that political art continued to be commissioned, it was further abused as a matter of bureaucratic procedure or at times of upheaval.[46] In France, where conflicting regimes rose and fell in rapid succession, one can find any number of such *ratures*, the best known and most remarkable palimpsest being the *lieu de mémoire* identified alternately as the 'église Sainte-Geneviève' and the secular 'Panthéon'. The exterior (pediment, inscription and crowning statue) and interior decoration kept being adapted to these conflicting purposes.[47] Nevertheless, and even if the artistic status of monuments slowly decreased, the idea of heritage and the general condemnation of 'vandalism' tended to strip iconoclastic actions, as well as their authors and motives, of legitimacy. This was more easily done if those actions came 'from below' and could be socially opposed to the world of civilization and culture.

A major case in point is the damage caused during the struggle between the Paris Commune and the Versailles government in 1871.[48] The destruction was chiefly of buildings set on fire as a means to stop the advance of the enemy – a new technique of street-fighting since identified as an unexpected consequence of Baron Haussmann's introduction of broad avenues that aimed, among other things, at preventing insurgents from building barricades. But symbolic elements were also at stake, for example the burning of the Hôtel de Ville; in *L'année terrible*, Victor Hugo defined the destruction as a kind of suicide and summarized his interpretation of its social background with this response by an incendiary, to whom he had explained what a library meant for the emancipation of mankind: 'I cannot read'.[49] The most symbolically loaded target of the Commune was the Colonne Vendôme, a derivation of Trajan's Column, erected by Napoleon I on the site previously occupied by a royal statue and refurnished with an effigy of the Emperor by his nephew Napoleon III. It was condemned by the Commune as a nationalistic 'symbol of tyranny and militarism' and solemnly pulled down on 16 May 1871 (illus. 12), possibly also as a substitute for military victories. The justification for, and comments on, the destruction supply ample evidence that the monument deemed invisible by Paul Veyne could elicit, under particular circumstances, very strong and specific responses.[50] One of the most interesting aspects of this episode is the price Courbet had to pay for the role he had played in it.[51] Politically engaged in the Commune, the painter had publicly pleaded on 14 September 1870 for a *déboulonnage* (screwing off) of the column, a neologism with which, he later explained, he had only meant a dismantling of elements that could be displayed in a less central place for those interested. The final decision was taken without Courbet's participation, but caricaturists did not fail to interpret the destruction of the column as a fresh manifestation of his alleged megalomania (illus. 13), and the government of the Third Republic ordered him to pay the 323,091 gold francs required for its reconstruction. Two facts are of particular note in our context: first, Courbet mentioned in his defence that the monument was of low aesthetic value; second, whereas the metaphorical 'iconoclasm' already attributed to him as a result of his outspoken artistic anti-traditionalism eventually became a title of glory, this literal one resulted in excuses, explanations, but no defence.[52]

The World Wars

Technical progress allowed unprecedented destructions (as well as constructions) in the twentieth century. One need only think of the 'adaptation' of cities and landscapes to motor-car traffic, of the elimination of archaeological material through underground construction and tunnelling, or of the effects of air pollution on stone monuments. In most cases, apart from the unspecific

12 D. Vierge, *The Fall of the Vendôme column*, 16 May 1871, engraving by F. Méaulle,
published in Victor Hugo, *L'année terrible*, Paris, 1874.

LE CITOYEN COURBET PAR BERTALL

Ah! qu'on est fier d'être Courbet
Quand on devine la colonne!

HUMBLE SUPPLIQUE DES HOMMES DE BRONZE DE PARIS, QUI DEMANDENT A NE PAS ETRE FONDUS.
Le citoyen Courbet demande a réflechir. N'y a-t-il pas la un moyen d'arriver à la fusion des partis?

13 Bertall, *Citizen Courbet*, cartoon in *Le Grelot*, 30 April 1871. *The caption reads 'Humble petition of the bronze men of Paris, who ask not to be melted'.*

objections to the past that I have already mentioned, no intention to destroy may seem to have been – or to be – at stake. What about the wars, during which the national dimension of the idea of heritage was bound to come into conflict with its supranational one? The systematic inclusion of civil targets and the use of ever-more massive means of destruction that characterized the two World Wars obviously had disastrous consequences for art, and in particular for immovable objects; movable ones could be better protected, as well as plundered in the traditional way.[53] The same factors make it difficult to ascertain to what extent works of art were deliberately targeted, but what seems to me to be the important point here is that accusing the enemy of having done so became a major propaganda weapon. During the First World War, the ethno-historical connotations of the concept of 'vandalism' were exploited to the full, and German aggression was defined by the French as an attempt on the part of 'Teutonic barbarism' to annihilate 'Latin civilization'. The damage caused to major Belgian and French works of architecture, especially the Library in Louvain and the cathedral in Rheims (illus. 14), became an instrument of national and international mobilization, a symbol of the enemy's negative identity. The bombing of Rheims cathedral led to a worldwide protest, to which the Germans replied mainly with military justifications.[54] George Bernard Shaw pointed out that Rheims's towers inevitably made it a target, and

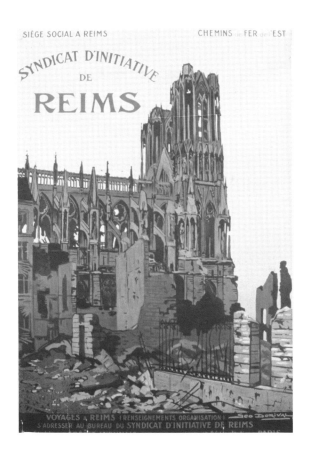

14 Géo Dorival's
1919 poster for the
Chemins de Fer de
l'Est advertising train
trips to Rheims and
showing the cathedral
in ruins. Collection
Maillon-Dorival,
Lyon.

that it was stupid to call the Germans barbarians since there was every evidence that they were not, and because they very well knew what the English had done to their own medieval heritage in peacetime; but his voice was almost a lone one.[55] A war of images raged: the Germans rejoined with accusations of vandalism, while damaged works were exhibited in Paris as 'Assassinated Art' in order to underline their sacrilegious and brutal martyrdom (illus. 15).[56]

This propagandist use of the charge of 'vandalism' was further developed by all parties in the Second World War. The Germans, who resorted to aerial bombing in order to terrorize and demoralize entire populations (illus. 93), were called 'modern Herostratuses' as well as 'twentieth-century cannibals'.[57] At a later stage, a further step was pointed out in an English cartoon that denounced a German use of famous works of art as hostages with the warning 'Barbarians!' (illus. 16). Italians forged fake evidence of damage to art made by the Allies on Cyrene, and stylized the Liberation campaign in their country as a 'war against art' (illus. 17).[58] The prevailing awareness of heritage, thus instrumentalized, led after the War to the signing, in 1954, of The Hague

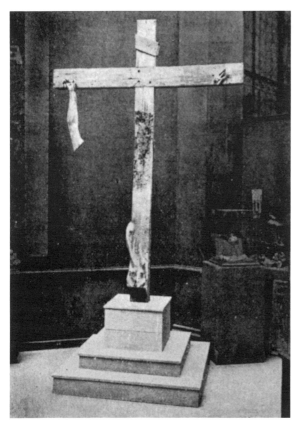

15 Large wooden crucifix from the church of Revigny (Meuse) burnt in the fire of 8 September 1914, as shown in the *Assassinated Art* exhibition at the Petit Palais, Paris, 1917, and in the special issue of *L'art et les artistes*.

16 Leslie Illingworth, *Who's a Vandal?*, cartoon in the *Daily Mail*, London (March 1944).

17 Cover of *La guerra contro l'arte* ('The War against Art'), an illustrated account of damage caused to works of art in Italy through bombardment during the Second World War (Milan, 1944).

Convention (and maybe to the conception of thermo-nuclear bombs that would destroy lives yet spare things).[59] Despite instructions intended to limit damage, the Liberation had indeed been very destructive, importing into Germany the *Blitzkrieg* and experimenting with nuclear weapons in Japan. Fifty years later, the polemics in Germany provoked by the War's commemoration, the erection in London of a statue to 'Bomber' Harris, and a historical exhibition in Washington on the destruction of Hiroshima show how controversial these issues have remained.[60] In the cities that had been only partially damaged, reconstruction often proved to be even more destructive than the War had been, not only because of insufficient financial means but because the circumstances favoured a radical modernization.[61]

Nazism and 'degenerate art'

As far as the destruction of modern art was concerned, the Nazi politics of images had effects comparable in importance to those of the French Revolu-

tion for 'vandalism' in general.[62] The Nazis did indulge in traditional icono-clasm, both in Germany and in the occupied countries. An interesting case in point is France, where the Vichy government ordered the melting down of a great number of public statues under the pretext of reusing their materials to meet the needs of agriculture and industry; the monuments and parts of monuments made of stone were spared, but later official declarations admitted that 'recovery' furnished a welcome occasion for a 'purification of the national glories' (illus. 97).[63] But their main target was the autonomy of art, and their influential originality consisted in their objecting primarily to form and style, which they denounced as expressions or symptoms of artistic, moral, 'racial' and genetic 'degeneration'.

This was not really an invention, and their theory of 'degenerate art' prof-ited from a traditional critique of modern art that can be traced back to the second half of the nineteenth century. Major milestones had been Max Nor-dau's *Entartung* of 1893, a widely translated and discussed libel against European avant-garde innovations in all domains of culture, and Paul Schulze-Naumburg's *Kunst und Rasse* ('art and race') of 1928, which was par-ticular effective in its naturalization of traditional conventions of repre-sentation of the human body and its equation of modernist expressive or form-alist 'deformations' with photographs of people displaying physical or mental aberrations (illus. 18).[64] On the other hand, modern German art had been sup-ported by prominent members of the upper classes and by official institutions of the Weimar Republic, whereas resistance to it was actually or potentially widespread in large sectors of the population, particularly the middle classes. The persecution of 'degenerate art' thus represented, like other aspects of Nazism, a conscious exploitation of the situation for political ends. But it also had less instrumental, more profound roots: Hitler himself was an unsuccess-ful painter; some highly placed members of the Party advocated other attitudes towards modern art; and the fear of 'decadence' was central to the Nazis' view of the world.[65] In any event, artists were libelled, forbidden to work, forced to flee and sometimes killed; works were declassified from mu-seums and sold outside Germany or burnt. The *gesundes Volksempfinden* ('sound popular feeling') was cynically employed against the values, institu-tions and independence of the artistic field.[66] This persecution was the destructive side of a re-instrumentalization of art for propaganda purposes that developed its own destructive aspects in the realm of architecture and town-planning. This symmetry was nowhere more apparent than in the two exhibitions simultaneously presented in Munich in 1937: the 'Große Deutsche Kunstaustellung' and the 'Entartete Kunst' exhibition.[67] The latter, which successfully toured other German cities, was the major example of a defamatory exhibition, in which the works on show were degraded to the role of proof and exemplification of the very reproaches addressed to them.

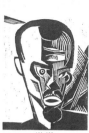

Abb. 109.

Abb. 110.

Abb. 113. Paralyse, 114. Mongoloide Idio-
typie, 115. Lähmung der Augenbewegungs-
nerven. 116. Mikro-Cephalie, idiotie

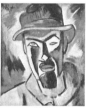

Abb. 111.

Abb. 112.

Die Abb. 109—112, 117—119, 123—125, 129—130 und 133—136 sind Ausschnitte
aus Bildern der „modernen" Schule, die besonders bezeichnende Gestalten darstellen.
Die ihnen gegenüberstehenden Abb. 113—116, 120—122, 126—128, 131—132 und
137—140 zeigen körperliche und geistige Gebrechen aus der Sammlung einer Klinik

90

getreues Bild von dem Zustand unseres Volkskörpers und den Zu-
ständen seiner Umwelt, so gäbe es kaum ein Wort, das das Grauen-
hafte dieses Prüfungsergebnisses deutlich genug zu bezeichnen ver-
möchte. Es bestehen hier drei Möglichkeiten:

Entweder ist das, was als Kunst auf Märkten und sonst überragend
in Erscheinung tritt, tatsächlich ein Ausdruck des Wesens der Gesamt-
heit des ganzen Volkes. Dann erschiene allerdings unsere Kulturwelt zum

91

18 Double-page spread comparing 'details of pictures of the "modern" school' (including works
by Modigliani and Schmidt-Rottluf) with photographs of physical and mental abnormalities,
from Paul Schulze-Naumburg's *Kunst und Rasse* (Munich, 1928).

Interestingly, the section of the exhibition devoted to Dadaists (illus. 19)
turned against them the 'iconoclastic' weapons they had themselves forged,
and reproduced the Dadaist slogan 'Nehmen Sie Dada ernst!' (illus. 20): as
Peter-Klaus Schuster has remarked, Hitler did take Dada seriously.[68]

Modern 'archaisms'

The Nazi attempt at re-instrumentalizing art contributed to the discrediting of
state art, commissioned art, political art, and even, to some extent, of public
art. So did its Soviet counterpart, theorized as 'Socialist Realism', particularly
during the Cold War.[69] But the persecution of 'degenerate art' was even more
important for entrenching the idea of the illegitimacy of attacking art, and
especially modern art, in the West. After the Liberation, the Nazis' iconoclasm
would be frequently evoked not only to assess physical aggression, but to si-
lence verbal critiques of progressively officialized avant-gardism. Illegitimacy
did not mean that (modern) art ceased to be attacked, but it tended to give such
aggression an anonymous and clandestine character. These aspects will be ex-
amined in the following chapters. But before embarking on this exploration, a

47

19　The Dada wall in the *Entartete Kunst* ('Degenerate Art') exhibition, Munich, 1937; the inscription *Nehmen Sie Dada ernst!* ('Take Dada seriously!'), was ascribed to George Grosz.

20　Opening of the Erste Internationale Dada–Messe (First International Dada Fair) at the Burchard Gallery, Berlin, July 1920. *In the upper left corner* Nehmen Sie Dada ernst *appears again; Grosz is standing on the right, with his hat on.*

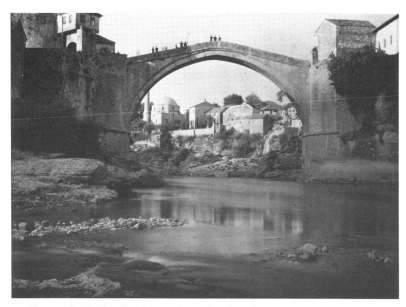

21 The 1557 Old Bridge (Stari Most), Mostar, Bosnia, in October 1912; the bridge was destroyed by shellfire in November 1993.

last general question must be raised: does the history that has been sketched – with due reverence to lacunae, hypotheses and question marks – imply that iconoclasm, notably politically motivated iconoclasm, represents today an anachronism or at least an archaism? It is a view that is often expressed about every kind of attack against art, and to which Martin Warnke's introduction of 1973 adhered.[70] This may be wishful thinking, however, based on sociocentric assumptions about humanity's unidirectional and irreversible progress, as well as a way, like the 'vandalism' concept, to repress the thing by locating it elsewhere, in time (the past) as in space (barbarism). The end of the Soviet empire and of the Cold War 'balance' have made it difficult to hold to such a position. We see daily how the misuse (and use) and the destruction (and creation) of objects, among which are works of art, play a frequent and sometimes crucial role in the transformation of societies. We may stick to the conception that sees our world as the goal of mankind and the end of history, and consider these phenomena as a temporary relapse into earlier stages of development, or we may use them to revise our understanding of ourselves and of the importance of 'symbolism' in our societies.[71] The primary role of identities – as opposed to territories – in recent conflicts is precisely a reason for the rampant destruction of 'cultural objects'. In the former Yugoslavia, buildings (particularly churches) and images suffered in the course of 'ethnic purification', and the concentration on urban targets has justified use of the neologism 'urbicide'.[72] The primarily symbolic dimension of destruction was

49

nowhere more apparent than in the case of the Old Bridge of Mostar (illus. 21) in the south of Bosnia on 9 November 1993, which was accompanied by moving testimonies made by the town's inhabitants, who expressed regret that they, or persons dear to them, had not been destroyed instead.[73] This proximity of works to persons is further illustrated by the fact that authors can be persecuted in the place of, or together with, their works, as the persecution of Salman Rushdie or the destruction of the statue of the sixteenth-century poet Pir Sultan Abdal and the burning of forty writers and artists in Sivas (Anatolia) on 2 July 1993 demonstrate.[74] The menace represented by such violence makes it all the more important to remember that even if there are many worlds of interpretation, they come into conflict in one and the same world.

3 The Fall of the 'Communist Monuments'

Since the fall of the Berlin Wall in November 1989, statues and monuments have been widely featured in the Western media. Indeed, although statues and monuments tend now and again to be used and misused for political purposes, they had not collectively benefited from such a paradoxical resurrection for a long time.[1] I have already alluded to Paul Veyne's estimation that monuments mostly belong to the species of 'works of art without spectators'. Back in 1927 Robert Musil had stated even more strongly that they are, so to speak, 'impregnated against attention' and 'withdraw from our senses'.[2] Neither had the end of other dictatorships in southern Europe or Latin America, which had included the destruction of statues, given them a comparable publicity. This has, of course, to do with the number of objects concerned and with their significance in the Communist states, a topic to which I shall return. But it also has to do with the visual and symbolic effectiveness of the imagery that was abused, defaced, pulled to the ground or thrown aside. The literal *fall* of a monument seems to be predestined to symbolize the metaphorical fall of the regime that had ordered its erection. The opposition of high and low, large and small, and the reversal of their hierarchical relationships, evoke stories and images of David and Goliath or Gulliver and the Lilliputians (illus. 22, 24, 29), as well as *vanitas* connotations comparable to those eighteenth-century landscape-garden follies designed by architects that recalled ruins in the Roman Campagna. The fall of images seems to tell of a revenge of the numerous and powerless over the few and mighty, of the living over the petrified, a process with which every spectator can only sympathize. And once the statue has gone, the pedestal that is left possesses its own symbolic potentialities. On the subject of the melting down of bronzes during the Second World War, Paul Claudel observed that 'a Mallarméan Paris was suddenly peopled with pedestals dedicated to absence'; Russia could similarly be defined in 1993 as 'the land of empty pedestals'.[3] It should be noted in passing that the widespread abandonment of the use of pedestals by modern sculptors has often been associated with a critical rejection of monumentality and of its hierarchical connotations; Daniel Buren, opposing modern sculptures to traditional statues, once asked whether 'a statue lying flat – for example, one

that is knocked down during a revolution – automatically becomes a sculpture'.[4]

Yet for all this visibility, very little is known about the destruction that has occurred. Generally, even in specialist publications, only the minimum amount of information is supplied, along with photographs without captions.[5] This contrast points to the primarily symbolic use of this topic in the media, where it is called on to bear witness to 'the end of communism' without closer regard for time and place, as well as to a remarkable lack of interest in its objects: one author reckoned that 'it is the polemic around them that deserves attention, not the statues'.[6] The very phrase 'Communist monuments', which I have resorted to for practical reasons, shares this simplification, insofar as it makes political ideology an immediate attribute of the works and bundles together various kinds of objects that did not always possess a commemorative function. This state of the art obviously makes any attempt at interpretation difficult, and at best provisional. Michael Baxandall wrote, in connection with the Reformation, that iconoclasm represents 'quite a confused social event' and 'the kind of historical shift of mind least possible to reconstruct'.[7] In the face of such confusion or complexity, one needs as much precise data as possible on the circumstances and development of every episode – on the identity of the actors involved, their mutual relationships, the political, social, economic and geographic context. On a more general level, which could be limited to a region, country or period, systematic research and statistical data are also completely lacking. Comparative studies would have to outline significant variations according to chronology, typology and geography, for which I venture a few preliminary remarks.

Chronology, typology, geography

The breach and the beginning of the destruction of the Wall separating West and East Berlin on 9 November 1989 (illus. 26) had immense repercussions, as this fortification had come to symbolize the political division of the world, the absence of freedom in the 'Communist bloc', and the Cold War. For the Soviet Union, two major dates were the decree 'on the prevention of defacing monuments that are linked to the history of the state and its symbols' published by Mikhail Gorbachev on 13 October 1990 and the officially authorized removal from its pedestal of the statue of Felix Dzerzhinsky outside the KGB headquarters in Moscow on 22 August 1991, at the end of the failed coup (illus. 22). The decree mentioned the recent multiplication of acts ridiculing and defacing monuments (to Lenin or other personalities of public life, as well as memorials to the October Revolution, the Civil War or the Second World War), military graveyards and symbols of the state (arms, flags and hymns); it defined them as a 'vandalism' provoking the indignation

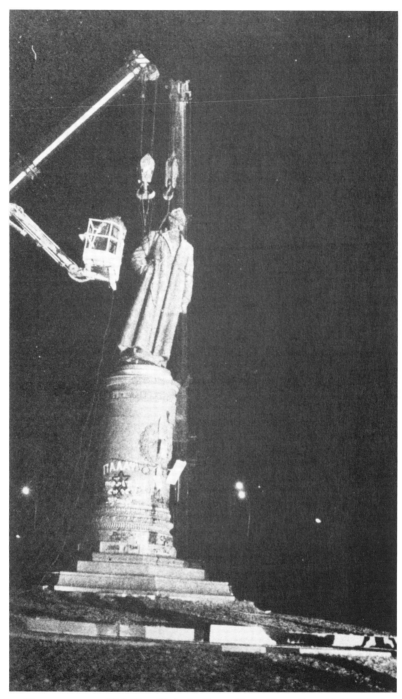

22 The 14-ton statue of Felix Dzerzhinsky (by Evgeny Vuchetich, 1958) outside KGB head-
quarters in Moscow being removed from its pedestal on 22 August 1991.

of 'large parts of the population', and as incompatible with the traditions of the people, the respect due to the history of the country, and the moral norms of a civilized society.[8] The overturning of the monument to Dzerzhinsky, on the other hand, was perceived as a signal and marked the beginning of a second iconoclastic wave on an international level. As with earlier iconoclasms, dates were sometimes chosen for their symbolic weight, or else they contributed to provoke such an action. On the second anniversary of the failed coup, for instance, a 10-ton statue of Lenin was 'stolen' in the city of Sestafoni in West Georgia – where the figure of Lenin, unlike that of Stalin, was regarded as a symbol of occupation; on 7 November 1993, the commemoration of the October Revolution was prohibited in Moscow's October Square.[9] Generally speaking, apart from ephemeral attacks that tend to escape mention, the first targets seem to have been mainly what were often referred to as 'emblems', i.e. replicated objects, commemorative plates or small statues, before major monuments could be attacked with the necessary means and in suitable circumstances; a wider and more systematic discarding was then allowed to take place. On the typological level, special mention must be made of effigies – especially those of Lenin – that have crystallized a good deal of aggression and an even greater amount of attention in the media, and of the memorials and military graveyards that, notwithstanding their obvious political dimension in the case of the 'Great Patriotic War' (as the Second World War was called in the Soviet Union) and of the 'liberation' of the people of the 'East bloc', have been relatively spared because of the more universal values attached to their funereal function and to the events they commemorated.[10]

As for geography, the way monuments of the Communist era have been treated in each of the states involved (old or new) depended heavily on the history of this or that state and in particular on the way the era began and was maintained in each of them.[11] Where the heritage and expression of national culture had been wholly repressed, or even destroyed – in the Baltic states and Ukraine, for instance – and where 'Communist monuments', with their Brobdingnagian dimensions and huge pedestals, had been imposed as an expression of the power relationship and as a means of intimidation, no reinterpretation was likely to take place in the weeks and months that followed the collapse of the dictatorship.[12] In the case of Ukraine, an exceptional statistical analysis shows a clear correlation between the fate of Communist monuments and the political, cultural and economic orientation of the population. In Western Ukraine, which only became a part of the Soviet Union in 1939, all monuments to Lenin had been removed by the autumn of 1991, most of them between the Ukrainian declaration of sovereignty in July 1990 and October of the same year; the elimination was still in progress in Central Ukraine, a large part of which was characterized by a 'passive, meditative attitude towards the monuments'; and it had not taken place in the Eastern regions, whose Rus-

sian-speaking or Russified inhabitants probably regarded the figure of Lenin as a guarantee of protection, and where the economic crisis had fostered a revival of Communism.[13] Tito's Yugoslavia had escaped the Soviet-inspired monumental propaganda, and, since the end of the Fifties, the art world's greater independence had allowed artists the choice of more modern forms and ideas; as a result, the monuments were less frequently attacked.[14] Geographical extensions may be far-reaching too: a colossal statue of Lenin, which had been given by the Soviet Union in 1984 to commemorate the 10th anniversary of the Ethiopian revolution, fell in May 1991 in Addis Ababa on the occasion of the overthrow of President Mengistu Haile Mariam, and in Punta-Arenas, near Cape Horn, the inscription on a monument honouring Yugoslavian immigrants was rewritten in Croatian.[15]

Soviet iconoclasm, propaganda, cult and art

Obviously, what happened to the monuments of the Communist era after 1989 depended not only on the decline and fall of Communism but on the monuments themselves, their forms and (changing) significations, the intentions associated with their erection and conservation as well as the functions they fulfilled.[16] The history of Communist monuments begins with an earlier revolution, that of October 1917. To what extent this revolution was iconoclastic or aimed at and managed to preserve cultural heritage is a disputed question with distinctly ideological implications, and may need a re-examination in the light of newly accessible source-material.[17] Well-known texts and events indicate a twofold attitude, comparable in its logic to that of the French Revolution but making an immediate use of the heritage concept to justify the protection of monuments against war damage and plunder, the inventorization, nationalization and public opening of galleries, castles and private collections, and the ban on the exportation of ancient objects and works of art.[18] Deliberate and authorized destruction, at the time and later, seem to have been limited to emblems, public statues and churches (illus. 23). Lenin's decree of 12 April 1918 'on the monuments of the Republic' ordered monuments to the tsars and their servants – an elastic concept – that had no historical or artistic value to be removed from squares and streets and either stored or recycled. A commission was to decide on the monuments concerned and organize a competition for projects for new monuments commemorating the Russian Socialist revolution as well as to replace the old inscriptions, emblems, street names, coats of arms etc. by such as would reflect the ideas and feelings of Revolutionary Russia.[19] The monuments to Alexander II and – in 1921 – to Alexander III were disposed of in Moscow, but Falconet's celebrated equestrian statue of Peter the Great in St Petersburg, commissioned by Catherine II and executed in 1766–8, was preserved and remained a major 'national' model of monumental sculpture.[20]

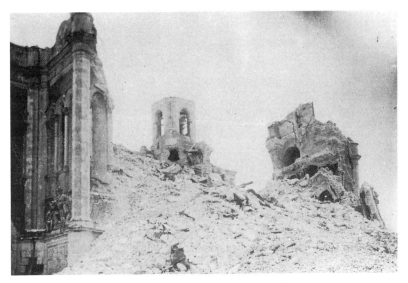

23 The destruction of the Church of Christ-the-Saviour, Moscow, in 1931.

Several documents tell of the meaning Lenin attributed to the replacement of official symbols: his decree required the 'ugliest' extant monuments to be removed and the first models for new ones to be exhibited for the 1 May festival; he wrote a letter to the commissars for Public Education and State Property (members of the commission) on 15 June 1918 to denounce 'two months of useless evasion' in the execution of a decree 'of importance on the plane of propaganda as well as of the employment of the workless', and further sent an inflamed telegram to Lunacharsky (first of the two commissars) to the same effect on 18 September.[21] It must be added that at a later stage, in the republics or countries where the cultural heritage was considered an obstacle to the integration into a homogeneous Soviet reality, iconoclasm decidedly took precedence over preservation; in Estonia, for instance, no less than 500 'monuments' were destroyed during the first years of Soviet power.[22]

Another disputed question with ideological implications is the amount of responsibility that Lenin (and thus the 'original' revolution) had in the development of Communist propaganda and specifically of the personality cult. Among others, Albert Boime considers that Lenin would have been content with the erection of 'temporary monuments that would never exist long enough to outlast their topical significance'.[23] But the ephemeral character of the first revolutionary monuments, in the wake of the agit-prop movement, may have been due to a lack of time and means more than to any objection to permanence. In any case, Lenin's death in 1924 and the dispute among the leading Bolsheviks about the embalming of his corpse saw the defeat of the rationalists like Trotsky, who considered that the veneration of relics belonged

to the abolished practices of the Eastern Church, and the victory of Stalin, who made deliberate use of religious rhetoric and channelled the emotions and symbolism of mourning to the advantage of his power and legitimacy.[24]

The evolution and extent of the cults of Lenin and Stalin need not detain us here.[25] What is important for our purpose is their quasi-religious character, which may have benefited from both the heritage and repression of Orthodox Christianity, notably in the realm of images and their use. Many authors stress the cult-like rather than artistic status of official Communist portraits and monuments, and witnesses point to the fusion of image and prototype on which their intended function was based.[26] A retired Russian explains, for instance, how in Magnitogorsk, in April 1938, workers were terrified by the unexpected task of having to erect a seven-ton bronze statue of Stalin and were interrupted by the representative of authority when they passed a cable around its neck to that purpose.[27] Another related trait is the inflation of images and the statue-mania that spread throughout the whole Soviet Union, and, after the Second World War, throughout the other Communist countries. The figure of Lenin, which later took on the role of substitution in the context of de-Stalinization, was paramount, and the number of 'monuments' (including busts and effigies) dedicated to him in Russia alone could be estimated in 1994 at 70,000.[28] But Lenin and (for a time) Stalin were not alone, and leaders and martyrs as well as local and national heroes of Communism were selected for monumentalization, not to speak of the countless emblems and verbal elements of official memory and propaganda, such as street names. The purpose of contributing to the formation of a new man and a new society had developed into a permanent historical and ideological legitimation of party and state, and a menacing affirmation – expressed by the trend to gigantism, even if allegories were abandoned for 'personalized' representations – of the primacy of the collective over the individual.

These characters, functions and aims hardly called for an innovative and independent art. It is therefore not surprising that sculpture in particular would have been submitted to the political control that progressively extended over all the visual arts and culture in the Soviet Union and the countries of 'existing socialism'.[29] But this was not only a matter of 'propaganda' in the narrow sense. In conformity with the Leninist theory of 'reflection', art had to give adequate and legible images of 'Soviet reality'. The doctrine of Socialist Realism required its strict subordination to a discursive message, reducing as far as possible the ambiguity and specificity of visual communication.[30] Not only was the self-proclaimed avant-garde eliminated, but modern Western models (ultimately including Impressionism) were rejected as decadent and 'formalist', to the benefit of a classicizing 'realism' inspired by nineteenth-century Russian painting. As far as sculpture was concerned, the requirements of 'typical generalization' and 'detailed legibility' condemned all previous

geometrizing experiments, while the use of concrete, frequent before the War, was rejected in favour of materials traditionally regarded as artistic, such as bronze, marble and granite.[31] Homogeneity and consensus were obtained by means of a state monopolization of artistic life and institutions, and the Russian model – sometimes including its works and artists – was imposed on the whole Communist world.

Were the monuments of the Communist era received as intended, or did they also prove to be in the long run 'immunized against attention'? Answers to such a question are bound to be not only diverse but contradictory. According to a witness from Prague, statues had to be protected by the police against misuse, but failed to attract any attention apart from apparatchiks and pigeons.[32] For other categories of the public, a broad reinterpretation seems nevertheless to have taken place, transforming the symbols into symptoms, for instance the figure of the leader showing the masses the way into an allegory of the people's oppression.[33] Even if only implicit, or even unconscious, by necessity, irony thus transformed the statues spiritually and paved the way to their physical transformation or displacement once the power they stood for could no longer prevent it. Signs of this desecration and of an ironical distancing typical for the 'humour culture' of resistance in totalitarian regimes can be found in the deflationary nicknames spontaneously given to emphatic works, such as 'The Sad Ones' for the monument to the fraternity of arms erected immediately after the War to the 'glory of the heroes of the Soviet army' in Warsaw.[34]

Budapest 1956

Under favourable circumstances, monuments were probably the object of isolated attacks before 1989, particularly after the beginning of perestroika in 1985.[35] In fact, they had always been subjected to modifications, removals or eliminations that followed in the wake of the evolution of Soviet power and the Soviet pantheon. But the only real antecedents to the iconoclasm following 1989 must be sought for after Stalin's death in 1953 and in the context of the de-Stalinization ordered in 1956 by Khrushchev. In the vast majority of cases, the elimination of the effigies of Stalin was organized and executed 'from above', and a renewed Lenin cult was called for to prevent any break in the iconic and political continuity.[36] In Hungary, however, the revolution of 1956 began with a major iconoclastic action performed 'from below' – the pulling down of the statue of Stalin in Budapest (illus. 24). The event is now relatively well documented, and deserves to be summarized.[37] The erection of the monument in 1950–51 had meant the destruction of the Regnum Marianum, a church built under the reactionary regime of Admiral Horthy (1920–44) to commemorate the victims of the leftist Republic of Councils (1919–20).[38] Part of the

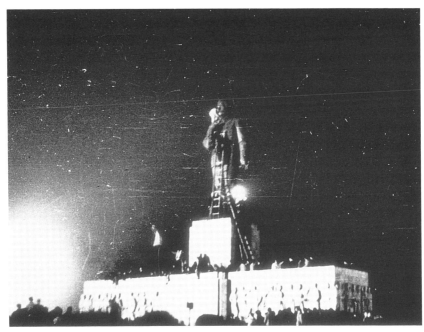

24 Preparations for the removal from its pedestal of Sándor Mikus's 1950–51 Stalin Monument, Budapest, on 23 October 1956.

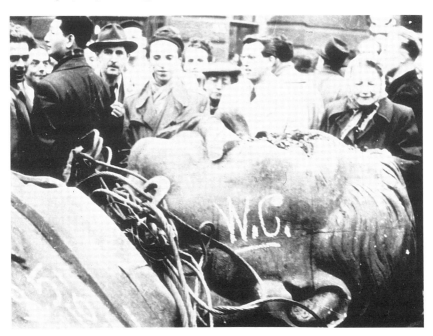

25 Stalin's statue lying on the street, with 'W.C.' graffito on the left cheek. Budapest, 24 October 1956.

20,840 kg. of bronze needed for the statue of Stalin was melted down from other monuments that had been damaged or removed for political reasons. Twenty-five of Hungary's best sculptors were invited to compete; the winner was Sándor Mikus.[39] The finished bronze standing figure measured 8 metres in height, while its stone pedestal was some 26 metres long and 9 metres high. All major political parades were held in front of it.

The idea of the demolition hovered in many minds on the eve of the rising; it was expressed in a tract found on 20 October 1956, showing the crowd pulling down the statue with ropes. Young people obtained tractors from a factory with the help of a Politburo member, and brought them to the monument on 23 October, the day of the great students' demonstration. During the afternoon, somebody hung a board on the figure's neck with the inscription 'Russians, if you take to your heels, please do not leave me behind'. Wire ropes were put round the statue but a torch was needed to cut the statue's leg above the knee before the tractors could pull it down, at 9.30 p.m. As the boots had remained attached to the pedestal, the journal of the students of the faculty of philosophy proposed that they stay there for some time as a memento; others wished them to stay forever and demanded that Stalin Square be re-named 'Boot Square'. The statue had been hauled by a tractor to the front of the National Theatre, where it was mocked, attacked and cut into pieces by people looking for relic-like 'tokens of remembrance of the heretic October days' (illus. 25). The pedestal was later deprived of its reliefs and given a neutral-looking casing to serve as a tribune on parades; all remaining pieces of the monument ended up in museums. Not far from the dismantled monument two new monuments were erected, one to Lenin in 1965 and the other commemorating the Republic of Councils in 1969 (illus. 34). Both were transported in 1993 to the newly created statue park on the periphery of Buda-pest, and a cross was planted to commemorate the destruction of the Regnum Marianum church.[40]

The Bastille, the Wall, and the church of Christ-the-Saviour

Analogies between the fall of the monuments of the Communist era and earlier iconoclastic episodes were drawn by observers and participants alike. The great favourite was the French Revolution, the 200th anniversary of which had been celebrated during the summer of 1989. Of course, comparisons dealt with the whole process of change, and were meant, like the use of the term 'revolution' iself, to stress its depth, suddenness and universal, epoch-making importance. But another coincidence helped strengthen the parallel: the fact that, in both cases, the seizure of a fortification had given a major signal to the movement. Like the Bastille (illus. 7), the Berlin Wall was an 'un-intentional monument', but it had assumed contradictory symbolic functions

from the start.[41] By 1789 the Bastille was almost empty of prisoners, but was felt to be a threat to the people of Paris. The Wall enclosed West Berlin on all sides, but it also constituted a prison for the inhabitants of the Eastern part. In the evening of 9 November 1989, after the DDR government's spokesman had mentioned the lifting of all travel restrictions, East Berliners rushed to the Wall and passed through it without hindrance, made breaches into it and danced on top. What they did under the motto 'We are the people' deprived the Communist Party of any legitimacy, and the historian Robert Darnton, who was present, felt further convinced that in the eighteenth century as in the twentieth, this delegitimization represented the decisive moment.[42] The next day, one of the demonstrators on Alexanderplatz carried a placard with the inscription '1789–1989'.[43] The fate of the Wall also bears a resemblance to that of the Bastille. Its 'metaphorical fall' made it a symbol of (the new) liberty as well as of (the former) submission, and it was immediately and spontaneously broken and sawn into pieces that were taken, given or sold as souvenirs, relics and tokens of the end of the Cold War (illus. 26). Although some East Germans who had been critical of their government subsequently began to consider the now permeable Wall as a part of their menaced identity and a defence against the economic domination of the West, the breaking up continued on a large scale and in more official ways, even becoming a spectacle on television.[44] Large pieces were used for various purposes, for instance to neutralize a monument in East Berlin (illus. 32), or as a political gift to be installed in the Vatican Garden or near the Grande Arche de la Défense in Paris.[45] Of the 160 km (of which 42 km crossed the city) of the Wall, only a few fragments were preserved *in situ*. In order to become a memorial, the one in Bernauer Straße will be further shortened from 210 to 60 metres, surrounded by two six-metre-high walls of polished steel and completed with a watch-tower saved from another part of the Wall, according to the results of a 1994 competition that are being opposed by the curators of monuments, who plead for historical authenticity.[46]

Of course, there were differences between the event in Berlin and the one in Paris. Two that will be discussed later concern the typology of the objects questioned and the kind of arguments used for and against their preservation. A major one is the 'reactionary' dimension of a significant part of this new iconoclasm, which was directed against the symbols of regimes that were (more or less) born out of revolutions, understood themselves as 'revolutionary' and had partially destroyed the previous cultural heritage. We have even seen that, in many cases, the Communist monuments had been erected on the site occupied by their predecessors – a very old practice that has to do with recycling, neutralization and the embezzlement of symbolic resources. It follows almost naturally that many of the Communist monuments disposed of were replaced not by brand-new monuments but by the same ones they had

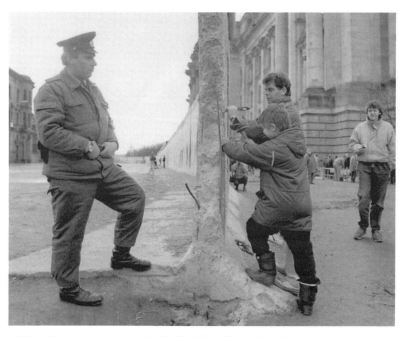

26 Demolition of a portion of the Berlin Wall after 9 November 1989.

repressed, where these had been stored, and where not, by reconstructions or substitutes. Needless to say, the meanings attached to such *revenants* had been transformed and supplemented accordingly, so that one may only superficially speak of a return to the *status quo ante* – even if, as one commentator remarked, the statues that had survived as works of art proved to be re-instrumentalized as political signs.[47]

To that extent, the iconoclasm of the October Revolution was much nearer to that of the French Revolution, whatever one may think of the differences in socio-political relationships.[48] Moreover, reactionary elements did play a role in the further political development, particularly in Russia where the Ortho-dox Church regained a greater influence.[49] A cyclical interpretation of Russian iconoclasm and history could thus be proposed at the Venice Biennale in 1995 by means of a film, shown continuously, using archive material. The inaugu-ration by the clergy of the monument to Alexander III in front of the church of Christ-the-Saviour in Moscow (built between 1843–1883 to commemorate the victims of the war against Napoleon) was followed by the destruction of the statue (1923) and of the church (1931; see illus. 23). Then came the pro-jects for the gigantic Palace of the Soviets – crowned by a personification of the proletariat or an effigy of Lenin – that was to replace the church, but which the ground could not support; the Moskva swimming-pool that was built instead; then its closure and the inauguration by priests and politicians of the substruc-

ture for the replica of the church planned to be completed by 1997.[50] But such interested 'resurrections' are not limited to the former Communist countries, as the reconstruction of the 14-metre high equestrian statue of the German emperor Willhelm I in Koblenz, where it had been originally erected in 1897 and destroyed by the Allies in 1945, showed in 1993. Denounced by opponents as an 'untimely glorification of Prussian militarism', it was inaugurated on 2 September, the date of Germany's victory over France in 1870 that was celebrated annually in Germany until the Second World War.[51]

From below, from above

Other analogies with earlier periods have been pointed out in regard to the methods employed in abusing monuments. The fact that figures were often mishandled as if they were living persons harks back to abuses that range from the Late Antique's *executio in effigie* to the martyring of statues of saints during the Reformation.[52] One of the favoured ill-treatments was hanging, which was also a practical, though informal, way of transporting a heavy statue. As for the frequent recourse to inscriptions and adjuncts to extant inscriptions fostered by the easy use of the spray-can, Petra Roettig has shown that they could be considered as an extension of the little-known history of comments on monuments. In two remarkable examples, the graffiti allowed statues to speak, and in one case to proclaim its innocence (illus. 27, 28). The latter reminds one of a woodcut of 1520 by Erhard Schön in which the holy images reproach the iconoclasts for having themselves made idols of them, for punishing them instead of the real guilty and for being ready to fall prey to other idols, such as money and prostitutes.[53]

What about the distinction between iconoclasms 'from below' and 'from above'? As we might expect, these categories are not always found in a pure form. The fall of the Communist monuments shows how complex (if retraceable) the implication of social groups and forces can be. Moreover, the fact that specific forms of legitimacy are, according to political positions and circumstances, attached to the opposite paradigms of the 'spontaneous destruction by the people' and of legal and regular elimination, calls for a cautious approach to the events.

Individual attacks may be simpler to deal with. In March 1991, for instance, the bust of Stalin on his tomb in Moscow's Red Square was struck several times with an iron bar by a man who was later arrested; but the Soviet news agency Interfax described the iconoclast as both homeless and unemployed, thus discouraging a political interpretation of his action.[54] A good candidate for a collective destruction in which the authorities took no part is the pulling down of the statue of Enver Hoxha on 20 February 1991 in Tirana (illus. 29), which was carried out by the crowd during a giant demonstration against the

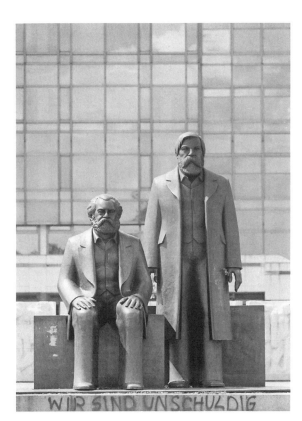

27 *Wir sind unschuldig* ('we are innocent') on the central pedestal of Ludwig Engelhardt's 1977–86 statue of Marx and Engels in front of the Palast der Republik, Marx-Engels-Forum, Berlin, on 12 May 1991.

Albanian government and which was condemned on television by Chief of State Alia as 'vandalism'.[55] The situation seems more complicated in the case of the removal on 5 March 1990 of the statue of Lenin in Bucharest (illus. 30): an orthodox priest, Sorin Grecu, then on a hunger strike, had demanded its removal, and this was promptly carried out by the new authorities.[56] Finally, one could not wish for a better example of a 'confused social event' than the removal of the statue of Felix Dzerzhinsky on 22 August 1991 in Moscow (illus. 22). Following the failure of the Russian *putsch*, a crowd of demonstrators gathered in the evening in Dzerzhinsky Square, chanting slogans against the KGB around the monument to the founder of the Bolshevik secret police and in front of its headquarters, the Lubyanka. Once the decree of Moscow's mayor, Gavril Popov, authorizing the removal of the statue was made known, a representative for Boris Yeltsin intervened against a demonstrator's attempt to pull it down and workers appeared with a crane that dragged it from its pedestal, an action approved by many, though some judged it 'vandalism' against 'a part of our history', wanting the statue to be kept there, even if only because – as one woman put it – she would ' be able later to tell her son that this guy was a bastard'.[57] For Albert

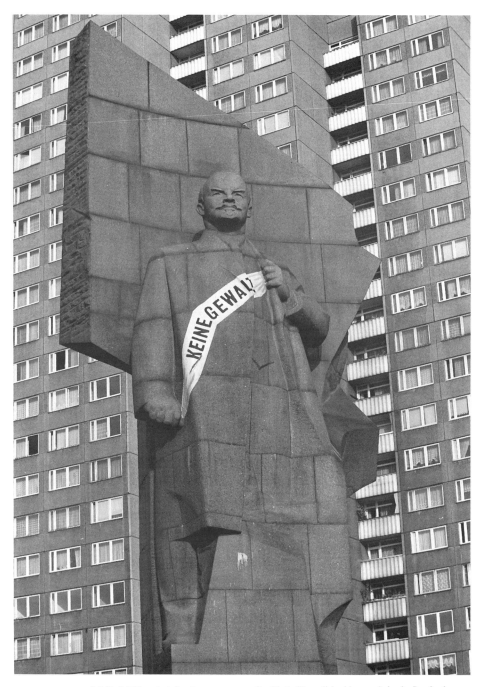

28 Nikolai Tomsky's Lenin monument of 1968–69 (demolished in 1991), in the Leninplatz,
Friedrichshain, Berlin, with an inscription 'No violence' protesting against its planned demoli-
tion.

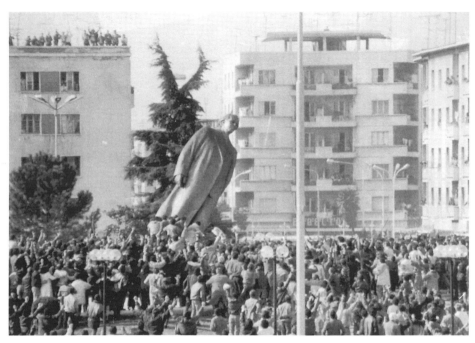

29 The statue of Enver Hoxha being pulled down on 20 February 1991 in Tirana, Albania.

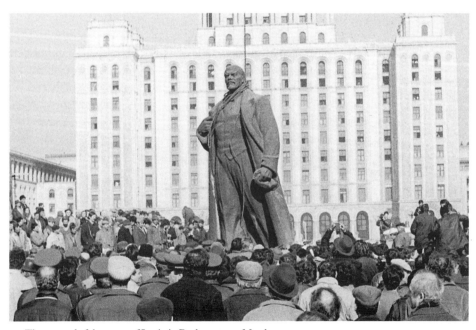

30 The removal of the statue of Lenin in Bucharest on 5 March 1990.

Boime, 'the local leaders channeled anger into a constructive destructive act and thereby controlled the crowd's outrage', for participants had threatened to storm the Lubyanka.[58] According to one art critic who was present, the demonstrators would have been content with playful, provisional abuses of the statue, whereas the officially sanctioned removal had signified the end of the 'performance' and the start of the 'mechanism of history'.[59]

A rather clearcut instance of 'iconoclasm from above' will be discussed later in this chapter with the disposal of the main monument to Lenin in East Berlin, commented on by a West German journalist as a painful attempt at 'making up by a cold and calculated administrative action for what the people's wrath had spared'.[60] It must be added that the meaning of an iconoclastic action 'from below' or 'from above' depends not only on the exact nature of the forces thus referred to, but on their mutual relationships as well. The removal of the statue of Dzerzhinsky (who was a Pole) in Warsaw on 17 November 1989, for example, although decided on and carried out by the authorities in the context of constructing a subway, seems to have had a real popular character. The statue was meant to be stored, but it proved to have only a coat of copper covering a heart of cement – probably because of its hasty erection – and did not survive its removal.[61]

Arms and names, paintings and buildings

Monuments were privileged targets because of their ideological function and public accessibility, as well as because statues may be deformed and thus transformed into monuments of their own degradation.[62] But it is also as part of the larger class constituted by all signs, tokens and traces of the Communist era that they were abused. Closest to them were the 'symbols' and 'emblems' of party and state. In Bulgaria in August 1990, the National Assembly ordered the 'elimination of symbols of foreign origin from buildings, flags and anthems'; the large emblem attached to the headquarters of the Communist Party in Sofia was the first to be removed.[63] In Hungary, the use of Communist and Nazi symbols was prohibited by Parliament on 14 April 1993, in the wake of neo-Nazi agitation but with the official claim that 'they embody organizations responsible for the death of millions of persons'.[64]

Symbols of the state, such as arms, flags and anthems, called for replacement and raised the questions of re-establishment and conflicting memories. In July 1990 the Hungarian Parliament eventually decided to return to the pre-Communist arms with the crown of King Stephen, despite objections to this monarchic association and to their use under the authoritarian regime of Admiral Horthy.[65] The same problems were raised by verbal – although by no means visually insignificant – elements such as city and street names. The attempt by Communist regimes to erase not only politically unpleasant but also

local, regional or national memories in favour of a unified and stereotyped model had created as many Lenin streets as Lenin monuments, so that renaming boomed after 1989.[66] Sixty-six street names were changed in Warsaw between June 1990 and March 1992, and in Budapest, 428 new names were proposed between 1989 and November 1993.[67] In some cases, changes were decided by the authorities alone, although private initiatives could be taken into account. In others, commissions were set up and consultations held. The citizens of Budapest were allowed to send complaints about extant names to a 'Commission for the protection (later embellishment) of the image of the city', which transmitted its judgements to the Town assembly. An interesting, though naïve, argument was put forward by an inhabitant of Leninallee, who wrote that with such an address he would eternally be recognized as an East Berliner even beyond the city.[68] A commission mainly composed of historians eventually refused to rename streets dedicated to Rosa Luxemburg and Karl Liebknecht, but the Wilhelm Pieck Street became Turmstraße (Tower Street), and the Marx-Engels-Platz returned in part to Schloßplatz (Castle Square).[69] The principle adopted in the Hungarian capital was to choose the street names in use at the time of the unification of Buda and Pest, evoking the golden age of the 1930s, but in general the selection of the relevant fragments from the past proved more often than not to be ideologically loaded and conflictual. The rejection of anything that sounded 'Communist' also led to many hypercorrections and historical absurdities, such as the elimination of all Russian names; the most economic solution was certainly found in Poznań, where the hero of the Paris Commune, General Jaroslav Dabrovsky, was replaced by the founder of the Polish Legion, General Henryk Dabrovsky, so that Dabrovsky Street became Dabrovsky Street.[70] Street, square and even town names often had their monumental counterparts, causing name and image to disappear together – but not always: the inhabitants of Karl-Marx-Stadt voted almost unanimously to rename it Chemnitz in 1990, but they did not join the campaign launched by a tabloid for the removal of the seven-metres-high head of Marx dominating the main square.[71]

This broader context could be very broad indeed, since it tended to include everything reminiscent not only of the Communist regimes but of the whole period – the 'era' – and way of life that they had shaped. Yet, an analogy with the extent of the targets of iconoclasm under the French Revolution does not seem quite appropriate. One reason for this may be that as the Communist era was incomparably shorter than that of the monarchy, nobility and Church, its material legacy was accordingly smaller, although the amount of reconstruction following the Second World War weakens the argument. Another reason is that the Communist authorities and elites, despite their love of decorum and propaganda, had not commissioned as many buildings (apart from monuments) whose purposes died along with the power of their users. A third

reason, on which more will be said later, is that the artistic status of their reali-zations was paradoxically more fragile than those of the Ancien Régime.

The question of what to do (destroy, sell, store, study, exhibit) with the moveable art objects inherited from the Communist states and organizations has been much discussed, particularly in Germany. But no one seems to have seriously proposed eliminating them, and no major attacks on paintings or sculptures in galleries have been reported.[72] As for the numerous historical museums and exhibitions that used to present the official view of the past and might now document it, they were mostly closed and dismantled, or adapted to new legitimizing purposes.[73] But architecture is, of course, after public sculpture, the most exposed genre. The means and time necessary for the de-molition or major transformation of a building presuppose – even more than for large monuments – at least the collaboration of authorities and administra-tions, and better allow for debate and the conserving influence of curators of ancient monuments.

A controversial case in point is the Palast der Republik in Berlin (illus. 31), constructed in 1973–6 by Heinz Graffunder on the site of the celebrated royal castle built by Andreas Schlüter for the king of Prussia, which had been da-maged at the end of the War and completely destroyed – instead of restored – by the Communists in 1950. Stylistically one of the most Western-oriented buildings of East Berlin, the Palace was meant to symbolize an open society and housed, in addition to the Parliament, mainly cultural institutions and events. The emblem of the state was removed from its front after the opening of the Wall. In 1990, shortly before the reunification of Germany, the building was found to be full of asbestos and was closed. The question of whether to make it habitable or to demolish it was entangled with plans and debates on the restructuring of the historical centre of the reunified city, the installation of the official and administrative buildings of the new capital of Germany, and a possible reconstruction or architectural evocation of the Castle. The pro-visions of the last competition organized by the Federal government and the City senate included the elimination of the Palace, and the architect chosen planned to reconstitute the dimensions if not the actual form of the Castle.[74] There is no room here to mention all the arguments put forward. The replace-ment of Palace with Castle was advocated as a restoration of historical and urban continuity and quality at the expense of a mediocre, atypical and, in its current state, dangerous building, or on the contrary denounced as a falsifica-tion of the past justifying the elimination of a symbol and document of East German identity and history.[75] Meanwhile, another official building of the DDR, the Ministerium für Auswärtige Angelegenheiten (Ministry of Foreign Affairs) built in 1964–7 by Josef Kaiser was destroyed to allow the reconstruc-tion of Karl Friedrich Schinkel's Bauakademie, but the Palace is still there, and asbestos has been discovered in its West Berlin counterpart, the Inter-

31 Aerial photograph of central Berlin in May 1995, with (on the left) the former DDR Palast der Republik, 1973-6, and, on the other side of the Marx-Engels-Platz, the former Ministry of Foreign Affairs, 1964-7.

national Congress Centrum (ICC) constructed in 1975–9 by Ralf Schüler and Ursulina Schüler–Witte.[76]

Conflicting memories

The authors of *A l'Est, la mémoire retrouvée*, a major work on the symbolic situation in Central and Eastern Europe after 1989, consider that after the time of erasure and manipulation of memory under Stalinism and existing Socialism has come the time of 'disputed memory'.[77] Another author makes use of E. J. Hobsbawm's well-known phrase and speaks of 'the invention of tradition'.[78] Yet, if every tradition is invented, it does not follow that all inventions are equally fictional. Alain Brossat and his colleagues distinguish between the very different norms to which the desire of the past can obey – the call to ancestors, the mystique of earth and blood, or the will to re-establish a constitutional state – and note that some feed a justified nostalgia for a stage of their society and institutions compared to which the Stalinist period can only be perceived as a startling regression.[79] They also point to the want of

legitimacy affecting the present time and modernity in Eastern Europe – the notorious difficulties Germany has with its national identity and symbols, partly due to the Nazi period, may be compared to the effects of this deficiency.[80] Some examples of conflicting memories and monumental palimpsests (such as the ones built on the church of Christ-the-Saviour in Moscow or the Regnum Marianum in Budapest) have been given, and others will follow.[81] But whatever past one was prone to referring to, there remained the question formulated immediately after the collapse of the Wall by the singer Wolf Biermann: 'What is to be done with the legacy of tyranny?'[82] Inevitably, this meant very different things according to age, social and political position, as well as personal history. Again, Germany is a special case, since the reunification made this legacy the literal property of both the former victims, collaborators and members of the Communist regime, and of their cousins and (with important nuances) long-time enemies.

Explanations and justifications for the elimination of symbols of the Communist era have come from every side. It was said to spring from the spontaneous and legitimate anger of the people at its oppressors, was supposed to free the politically liberated citizens from the debilitating influence – ideological or aesthetic – of the past, or to enable them to recover in one way or another what this past had destroyed. Albert Boime, who concentrates on the 'transition phase', sees in iconoclasm the possibility of a 'concrete expression of participation in historical change', providing a 'momentary feeling of self-realization in the collective act' and contributing to the 'provisional creation of a real public space'. But he also points to some psychological complications when, as already mentioned, he speaks of 'self-detestation projected outwardly on the hollow icon' or of 'self-flagellation for having been so gullible'.[83]

As time passed and the opening to the West proved to be disappointing or ambivalent, even hated symbols of a hated past could become elements of an identity perceived as menaced or vanishing. Advocates of a preservation of this legacy often made use of psychological or psychoanalytical metaphors to define the dangers of destruction: the disappearance of all traces of the Communist era would amount to a repression of individual and collective memory, preventing the necessary mourning (and historical research) from taking place and allowing for a future return of the repressed.[84] A commentator applied this apparent paradox to Berlin's statue of Lenin (illus. 28, 35–9) by affirming that when preserved, it would be a good defence against 'his own return'.[85] Some of these defenders were historians, art historians or professional heritage curators – and some, particularly in Germany, belonged to the West, but many others were simply neighbours, inhabitants and users of this legacy.[86] Whereas several persons in favour of elimination saw a justification in the destructions performed from 1918 on by the Communists, their opponents considered this precedent as another reason to proceed otherwise and guard

against the repetition of history.[87] Moreover, any appreciation of removal was tinged by fear of what might replace the removed. An examination of the relatively few attempts at commemorating the Communist era, or rather its victims, would take us too far out of our way, but one cannot fail to note that for many witnesses, what was perceived as taking the place of Communist monuments and emblems were advertisements, i.e. unofficial but unmistakable symbols of the Western way of life and economic supremacy.[88]

Ways of treating monuments

It has already become apparent that the spectacular removals publicized by the mass media were certainly not the only way monuments of the Communist era have been treated since 1989. As a matter of fact, opponents to an indiscriminate clearing away usually stressed the fact that possibilities other than removing or preserving them unmodified *in situ* could be envisaged, and pleaded for a differentiated attitude towards objects and contexts. The 'Commission for dealing with the post-War political monuments in former East Berlin' established by the Berlin Senate in 1992 thus recommended, according to the various cases, to maintain the work *in situ*; to study it further and leave the decision to the neighbourhood, or to consult foreign experts (in the case of memorials to foreign soldiers); to complement, modify, replace the textual part of the monument or to add to it a comment; if necessary to displace it; or to dismantle it and to redesign the site.[89] Before I examine the different 'treatments' documented according to their form, I must make a few preliminary remarks.

In the first place, formally similar interventions were liable to reflect differing authors, motives and intentions. A written comment could thus be added anonymously to deface a monument, but also, more or less officially, to 'neutralize' it or to clarify and transmit its historical significance – surely, a more precise definition of form might show this, since a spontaneous and defacing inscription is more likely to be handwritten than a considered, explanatory one. Other differentiating criteria that could be systematically applied but will only be mentioned in passing are the more or less provisional or enduring character of an intervention, the extent to which it modified the material substance of the work, its visibility or invisibility, and the technical and financial means it required. Destructions are expensive, and the impact of cost and equipment on the various 'solutions' adopted, according to authors and context, should not be underestimated.

The relationship of visibility and invisibility to different attitudes towards the past is obvious. But again, an intervention could be made or left visible in order to lengthen in time the appearance and effect of degradation, or, on the contrary, to prevent falsifications and promote an informed access to history.

As for durability, curators of monuments were not alone in objecting to defini-
tive measures. Christine Hoh-Slodczyk, former curator of ancient monuments
in East Berlin and advocate of preservation, warned that these would prevent
the 'historically necessary confrontation with the object' and would not allow
the passing of time to make 'out of a symbol of power a symbol of impotence,
out of a menacing gesture an expression of abandon, out of an affirmation of
victory an image of defeat'.[90] But transience, a characteristic of spontaneous
and sometimes playful or performance-like actions, often served as a prelude
to more lasting, even definitive interventions. Such concatenations (for
example, the common succession of inscription–removal–storage) and com-
binations were not always planned and logical, but could result from the
unforeseeable interaction between interventions and 'the public'.

With few exceptions, the preservation *in situ* of an unmodified monument
does not make news, and is thus less often documented. Exceptions result
from consultations and controversies. The case of Chemnitz has already been
mentioned. In Berlin, the art journal *Pan* organized an inquiry about the
monument to Marx and Engels (illus. 27) situated on the rear side of the
Palace of the Republic: 67 per cent of those consulted held the view that it
was a token of their own history and deserved to be preserved; 23 per cent ad-
vocated immediate removal. The commission later proposed conserving the
monument (of which the statue is but the central part) while removing the
base so as to integrate it in the surrounding green space and diminish 'its dom-
inance and undesired ideological function' or, if the restructuring of the square
demanded it, to reconstruct the monument at some other place.[91] Naturally,
preservation may also be considered an index to an unchanged situation, as in
the south Russian town of Voronezh, where a 'reformer' still in power ex-
plained that the ideological traces of the totalitarian regime would 'die on
their own with time', or in Moscow itself, where the number of monuments
to Lenin still in place gained a new significance in the light of the political re-
inforcement of Communists and nationalists.[92] In some cases, the change of
site was enough to make monuments acceptable: they were particularly ex-
posed in the central spaces they were meant to dominate and could survive in
'less pretentious or demanding places'.[93]

The easiest way to interfere with a monument is to add to it rather than sub-
tract. Paint is handy for this, and colour itself may deliver specific messages.
The hands of the Warsaw statue of Dzerzhinsky, for instance, were painted
red prior to its destruction, visualizing the reasons for the execution in effigy
of 'bloody Felix'. In Prague, an important debate was provoked by the un-
authorized pink-washing of the first Soviet tank allegedly to have entered the
town in May 1945, which had been promoted in 1946 to the status of monu-
ment to the liberation of Czechoslovakia but was considered, especially since
1968, as a symbol of invasion and occupation.[94] As for verbal and iconic in-

scriptions, they were almost ubiquitous. Texts ranged from simple insults –
'hangman' (in Russian) corresponding to, or complementing, hands painted
in red – to elaborate transformations of the inscriptions on pedestals. Photo-
graphs of the monument to Karl Marx in Moscow show two different and
successive appropriations of the original message: to 'Proletarians of all coun-
tries, unite!' was added 'in the fight against communism!', before 'please
forgive me!' was painted over both 'unite!' and the first graffito.[95] We find
here again the 'speaking monument' phenomenon (illus. 27, 28), and it must
be added that the restorative cleaning of such inscriptions could be judged as
amounting to the same 'cleansing of history' as the elimination of other monu-
ments.[96] A very different kind of adjunction, as already indicated, was
constituted by the comments – mostly on boards attached to the monuments
– that aimed to enable a critical confrontation with them. Generally, such in-
terventions also intended to disarm rejection and aggression and to preserve
the monuments (at least provisionally) by correcting offensively false messages
that they could convey and, above all, by loosening or redefining their sym-
bolic relationship and making clear that preserving them did not mean
approving of what they stood for.[97]

In German, terms like *Entfremdung* and *Verfremdung* (estrangement, ali-
enation) were used to define this process, which can be compared to putting a
word between brackets. Many imaginative proposals were made to that pur-
pose. Only some of them could be realized, and still less met with success.
The recent history of the 'Betriebskampfgruppendenkmal' (factory fighters
monument) in Berlin (illus. 32) can serve as an example of such attempts and
failures. Erected in 1983 to commemorate the armed groups that were sup-
posed to 'protect the DDR from the inside and the outside' and who had
participated in the construction of the Wall, it became particularly controver-
sial after the fall of the latter. The first interventions had been spontaneous:
colour, a sprayed ironical comment, an 'artistic action' that consisted of sur-
rounding the monument with ropes and letting plants cover it, the removal
of the bronze figure of a boy handing flowers to the soldiers – which later de-
corated the office of the local mayor. The local government administration
admitted that in the present context of political change the monument was
provocative, but rejected a removal that would repeat the undemocratic way
in which it had been erected and advocated, at least provisionally, a debate, to
which the addition of a critical comment and of two pieces of the Wall were to
contribute. But the plants were pulled out before they could grow, and the
board carrying the comment was anonymously taken away. Further 'alienat-
ing' measures (a white cloth thrown over the statue, and tying it up with
barbed wire from the Wall) did not prevent the assembly of the district repre-
sentatives ordering its removal; it was taken into care by the Deutsches
Historisches Museum in Berlin but still awaits a new location.[98] As far as I

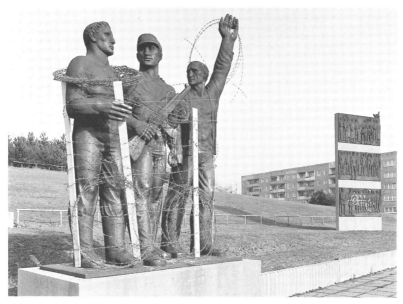

32 Gerhard Rommel's 1983 monument to the *Betriebskampfgruppen* ('factory fighters') in Prenzlauer Berg Volkspark, Berlin, surrounded by barbed wire two days before its removal on 28 February 1992.

know, the intellectually and financially more demanding solution, which consisted of complementing, and neutralizing, a monument by a new enduring 'anti-monument' could nowhere be realized.[99] Neither was the proposal by a West German artist of dismantling the Dresden monument to Lenin and creating out of its parts a new composition evoking 'a museum depository or a field of archaeological ruins', in order to 'make the iconoclasm official and lasting' as well as to 'preserve the monument before its definitive removal'; the town council chose instead the most economic solution and gave the statue to a stonemason from Bavaria who was ready to pay for its removal.[100]

Other ideas, such as Alfred Hrdlicka's proposal to exchange monuments between East and West, or Vitaly Komar and Alexander Melamid's project of leaving a statue dangling from cranes in the air, had even less chance of being realized. The latter was part of an exhibition for projects to preserve the ex-Soviet monuments through transformation. Organized in 1993 by the ex-dissident artists Komar and Melamid, it ran concurrently in Moscow and in New York – in the Courtyard Gallery of Manhattan's World Financial Center – and intended to oppose the recurrent obliteration of Russian history.[101] To some degree, the difference between unrealizable and realizable interventions overlaps that between ephemeral and definitive ones: while the former can express subversion and liberation, the latter must come to terms with management and the law. As deriding one power implies deriding all power,

Stalin's boots might have left 'Stalin Square' even without the arrival of Soviet tanks. And it is characteristic of a libertarian 'revolution', such as the Paris movement of 1968, that it should generally have been content with metaphorical or provisional attacks on works of art, such as advertising for sale Puvis de Chavannes's mural paintings in the Sorbonne.[102] In May 1968 Salvador Dalí had proposed filling 'monuments of bourgeois culture' with 'new information and modifying [their] function' rather than destroying them – for instance by neutralizing the aura of positivism of the monument to Auguste Comte with an erotic reliquary.[103] His proposal could boast of a Surrealist ancestry: in 1933 the group led by André Breton had spontaneously asked itself whether a certain number of Parisian monuments ought to be 'preserved, displaced, modified, transformed or suppressed'. As can be guessed, most proposals were of the modifying type, but Paul Eluard advocated a 'careful repetition' of the 1871 'ceremony' of the fall of the Vendôme column (illus. 12).[104] In the case of monuments of the Communist era, too, most artistic interventions dealt with the images rather than with the objects; but they did represent metaphorical appropriations, alienations and reinterpretations of these monuments in ways sometimes analogous to the ones that we have examined.

The modifications that reinterpretation generally called for during the 'transition phase' could also be achieved by subtraction. Removing the emblem of Party and state could suffice – at least provisionally – for buildings but not for monuments, which had been entirely devised as symbolic. And even freed from inscriptions, these tended to remain prisoners of the semantic univocality postulated by Socialist Realism and by their propagandistic function. In Budapest, a process of generalization via elimination allowed the Liberation monument, erected in 1947 on the summit of Gellért Hill to commemorate the liberation of Hungary by the Soviet army, to become a monument to freedom. The high pedestal was stripped of its five-pointed cross, of its cyrillic inscription – replaced by a celebration of liberty conceived in the broadest terms – and of the bronze statue of a flag-carrying Russian soldier, whereas the surmounting figure of a woman holding a palm-leaf towards the sky and the supporting allegories of progress and destruction remained untouched. Among the reasons for the success of what he defines as a compromise, Ernö Marosi mentions the fact that people had become accustomed to the monument, that it fitted well in the topography and image of the city, the fear of what a removal would have cost, and finally the acceptability of this stylistically conservative work by Zsigmond Kisfaludy Stróbl to conservative taste.[105]

Violent degradations and destructions have been discussed in abundance. The staged or ritualized character of the collective events has also been mentioned, and so have the resemblances to earlier cases and forms of image abuse. It is reported that when workers bound a cable under the arms of the Dzerz-

hinsky statue in Warsaw, the public shouted – 'Hold him by the neck! Hold him!' A particularly interesting photograph of 1991 shows a monument to Stalin opposite to Charles Bridge in Prague with a broken nose, the head torn off and bent at a right angle, and a crucifix placed behind.[106] But it remains to examine the ways in which monuments were stored and yet made accessible (or not). We have seen that those destroyed were generally broken, cut or sawn into pieces and preserved, given, sold or bought – as tokens, relics or souvenirs – by individuals and occasionally or eventually by institutions. Re-cycling of the material itself, with its infinite and often redundant symbolic possibilities, is rarely documented (Hungarians wondered about casting bells from the bronze of the statues so that their chimes would remind people of dictatorship).[107]

Clearly, storage of every kind, including in museums, was considered as a last resort. The director of the Deutsches Historisches Museum in Berlin, Christoph Stölzl, declared to the journal *Pan* – perhaps in part as a way of ad-vocating the preservation *in situ* of the monument to Marx and Engels – that 'transporting to a depository was no aesthetic action but only revealed that one did not know what to do', and Christine Hoh-Slodczyk stated that as with de-struction or removal, the preservation in museums could not replace a real confrontation with the object.[108] Another author noted in 1992 that the 'pro-cess of "museumization" of these objects had just begun', that it did not yet seem to be directly possible, and that the frequent triumphal or ironical way in which they were presented was as much a response to their former cultic use as was ritual destruction.[109] Staging can indeed be another form or a con-tinuation of defacing. This is particularly visible in the open-air spaces in which several East European towns have brought together the statues that had been removed or were to be disposed of. In Moscow, the statue park, situ-ated near the Tretiakov Gallery (in which all Soviet art posterior to Cubo-Futurism had been removed from the exhibition rooms), was conceived as an exhibition of a small part of the stored works and a prefiguration of a 'Museum of Totalitarianism'.[110] But the informal, desultory or absurd presentation – no pedestals, traces of paint, prone position – gave the visitors unmistakable inter-pretative and behavioural hints that this was banishment and not promotion, and that the works were there neither to be venerated nor to be admired but rather to be laughed at (illus. 33). Of course, such paradoxical 'museumiza-tions' may be more an expression of cautiousness or realism (objects in the Prague open-air exhibition were attacked every night) than of will.[111]

A less ambiguous realization can significantly be found in Budapest. The 'Statue Park' (*Szóbórpark*) was opened in the summer of 1993, after a radical-ization of political life and a multiplication of attacks against monuments had made urgent a decision taken eighteen months earlier by the city council. Sixty-one particularly censured monuments were removed from their sites

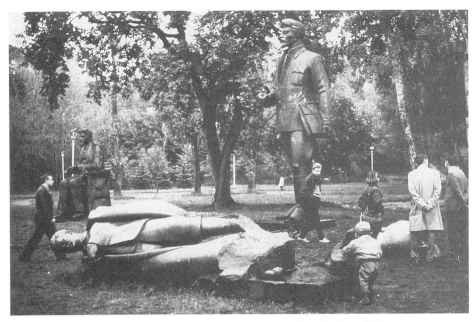

33 The 'Temporary Museum of Totalitarian Art' statue park near the State Tretiakov Gallery, Moscow, in 1992, with statues of, from left to right, Kalinin, Stalin, and Sverdlov.

and brought to an area proposed by a marginal district. The distribution of the statues and the minimal architecture were determined after a competition. Difficulties abounded: neighbours objected, the park had to close after 40 days and could only re-open thanks to the intervention of a private manager. At the entrance, a large plaque has engraved on it (in Hungarian) Gyula Ill-yès's celebrated poem of 1952, *A Sentence on Tyranny*, which mentions 'statues as bombastic as deceitful' among ubiquitous expressions of dictator-ship. But visitors are given information on the date, original site, author and subject of each exhibited work, and a generally neutral presentation allows of the great variety of attitudes and uses that can be observed, from the collected meditation of elderly Hungarians to the playful irony of younger ones and the curiosity, scholarly or journalistic interest of foreigners (illus. 34).[112]

There remain to be mentioned private initiatives of preservation and the role of the market. Information is scarce, and a few indications must suffice here. Many hopes of exchanging a cumbersome legacy for foreign currencies seem to have met with disappointment, particularly for very large monu-ments. But the gallery Regina in Moscow, for instance, which distinguished itself with happenings and performances, has begun to sell 'totalitarian art', almost exclusively to foreigners, and the present location of works included in recent exhibitions shows that institutional buyers are also responding to such offers, among others American university museums.[113] In Germany,

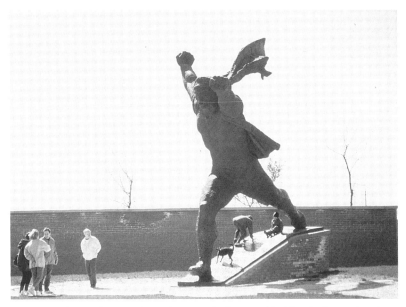

34 The Szóbórpark (Statue Park), Budapest, 17 April 1995, with visitors in front and on the pedestal of the monument to the Republic of Councils by István Kiss (1969).

the public trustee (Treuhandanstalt) in charge of selling the former state property of the DDR decided not to bring to auction the 12,000 art objects that were included – surely a financially as well as a politically wise attitude.[114] The stonemason Josef Kurz, who acquired the Dresden Lenin monument, has already been mentioned; between 1989 and his death in 1994 he collected a number of statues of the Communist era, explaining that he admired their craftsmanship and material, and certainly enjoyed the political provocation represented by their exhibition on his private land in Gundelfingen an der Donau in Bavaria.[115]

Lenin in Berlin

The way monuments were treated in Germany, especially in Berlin, is of particular interest for us, since there 'the West' was directly confronted and involved with 'the East' – or with the former East. To write the history of this question in Berlin alone would require a whole book, and we must be content with examining in some detail the most polemical and influential case, that of the monument to Lenin in Berlin-Friedrichshain (illus. 28, 35–9).[116]

Leninplatz (Lenin Square), with its 1200 flats in three high buildings, had been designed by Hermann Henselmann together with Heinz Mehlan and constructed in 1968–70. Henselmann had planned, in the centre of the square, a functional and semi-abstract monument in the guise of a spiral

79

library evoking a flag and echoing the silhouette of the apartment buildings.[117] But the highest state authorities opposed this aspect of the plans, demanding a figurative monument and directly commissioned the Moscovite sculptor Nicolai V. Tomsky to realize it – a token of the pan-Communist hegemony of Russian art and its government-imposed tutelage on East German artists, whose version of Socialist Realism was among the most modern ones. Tomsky (1900–84), named president of the USSR Academy of Arts in 1968, had been the Soviet sculptor *par excellence* since the War. An advocator of 'typical generalization', he was the author of several major Lenin statues in Soviet towns. Although Soviet sculpture had generally tended to use architecture as a mere pedestal or background, he was required to take the setting of the square into account and proposed another echo to the buildings with the large abstracted form of a flag behind Lenin's effigy. The 19-metres-high monument was inaugurated on 19 April 1970 – the 100th anniversary of Lenin's birth – in front of 200,000 persons (illus. 35). In his speech, the first secretary of the Party and chief of state Walter Ulbricht defined the statue as one of the new symbols needed to replace the old ones in the city (among others the royal castle), and the Soviet ambassador Piotr Abrasimov declared that it was a symbol of the 'unshakeable friendship between the DDR and the Soviet Union' – indeed, the monument may have been meant as a kind of compensation for Ulbricht's programme of economic reform of which Breznev disapproved.[118] For the occasion, Tomsky had somewhat modernized his formal language and resorted to slightly geometrically simplified forms. Lenin's attitude combined human nearness (the hand on the reverse of the coat) with authority and dynamism (the gaze, the flag). Tomsky stated that the solidity of the red Ukrainian granite was to express the victory and immortality of Lenin's ideas; the same characteristics could later be interpreted, as one commentator put it, as symbolizing the coagulation of these ideas, the brutality and petrification of 'existing Socialism'.[119]

But in November 1989, Tomsky's Lenin was no more objected to than the vast majority of DDR (intentional) monuments. In general, polemics and anonymous attacks began to appear in the spring of 1990.[120] Art-history students in West and East Berlin founded an association named 'Initiative politische Denkmäler der DDR' to promote a constructive and critical approach, and demanded from the Senate the creation of an independent commission to examine the monumental legacy of both parts of the city. A documentary exhibition on the monuments of East Berlin, entitled *Erhalten – Zerstören – Verändern?* (preserve – destroy – modify?) was organized in a small museum not far from Leninplatz by the 'Initiative' together with two other Western associations, the 'Neue Gesellschaft für Bildende Kunst' (New Society for the Visual Arts) – a radical organization, born in 1969 of the splitting of the former West Berlin 'Deutsche Gesellschaft für Bildende

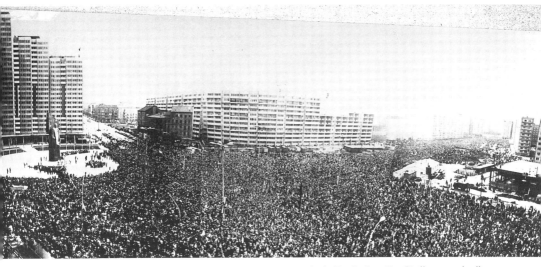

35 The inauguration of Tomsky's Lenin monument in the Leninplatz, East Berlin, on 19 April 1970.

Kunst', which had subsequently defended political art and realistic form – and the 'Aktives Museum Faschismus und Widerstand'.[121] As for the monument to Lenin, a graphic artist proposed to let ivy and vine cover it – an idea approved of by some but the realization of which was, as in other cases, anonymously interrupted.[122] A temporary appropriation and anti-monumental reinterpretation of the statue occurred on 2 and 4 September 1990 in the context of a topical exhibition of contemporary art entitled 'Die Endlichkeit der Freiheit' (the finitude of freedom): the Polish-born artist Krzysztof Wodiczko chose it as the target of one of his 'public projections' and transformed Lenin into a Polish shopper equipped with a cart filled with cheap electronic products, 'to be used as barter back in Warsaw' (illus. 36).[123]

After German unification in October 1990, the decision of the federal Parliament in June 1991 to transfer its seat of government to Berlin, and the failed coup of August 1991 in Moscow with its highly publicized iconoclastic sequels, the removal of 'Communist monuments' became significant politically for the German parties at the various levels of country, city and districts (*Bezirke*), as well as economically for town-planners, architects and property speculators. In the provisions of the coalition agreement made by the CDU (conservative) and SPD (progressive) members of the Senate of reunited Berlin there was mentioned the creation of a commission charged with making proposals for the handling of monuments in (principally East) Berlin; but this commission was not put up until after Tomsky's Lenin had been dismantled, so that it was deprived of its most important object.

On 18 September 1991, the representative assembly of the Friedrichshain

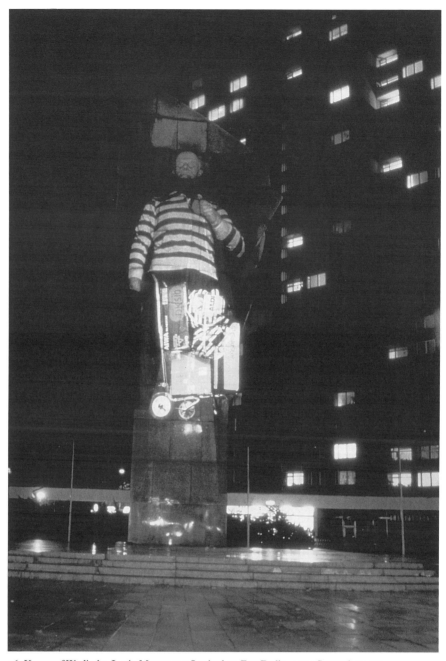

36 Krzysztof Wodiczko, Lenin Monument, Leninplatz, East Berlin, 2 or 4 September 1990,
projection organized by the Deutscher akademischer Austauschdienst in conjunction with the
exhibition *Die Endlichkeit der Freiheit*.

district decided by 40 votes against 33 to request from the Senate a 'total, careful removal of the statue of Lenin from Leninplatz'; but at least 1000 inhabitants of the neighbourhood declared that they wanted it to stay.[124] In conformity with the Berlin 'Überleitungsgesetz' (transition law), the Friedrichshain Lenin was further administratively protected as a historical monument. Nevertheless, the CDU Senator in charge of city development and environment, Volker Hassemer, who was responsible for the preservation of monuments, asked his SPD colleague in charge of buildings to authorize its removal, explaining that it did not stand for Socialism but for 'the reality of despotism', pointing to the danger of 'problematic developments' due to 'popular wrath'. The *Bausenator* disapproved of the procedure – he even compared it with the destruction of the royal castle – but the CDU mayor favoured it, supported among others by Helmut Kohl, and, in the end, no political party opposed it except the minority Left-wing group 'Bündnis 90/Grüne', some members of which put up a provocative proposal to demolish as 'politically loaded' the Victory Column (Siegessäule) in the Western part of the city, a monument erected in 1873 to commemorate Prussian victories over Denmark, Austria and France.

None the less, many objections were raised against what some called 'blind destructive fury' and 'primitive iconoclasm'.[125] Curators of monuments, anxious to preserve coherent wholes rather than isolated objects, warned that the removal of the monument would create a void and provoke a visual collapse of Leninplatz.[126] As one journalist noted, the monument had also become a 'petrified biography' for East Berliners, who felt as if the 'Wessis' wanted to take away everything from them.[127] The 'Initiative politische Denkmäler der DDR', together with an inhabitant of Leninplatz, brought the case before the administrative court and stressed the historical, scientific and urban importance of the monument. Their request was rejected on the grounds that private persons were not entitled to intervene in a matter of general public interest. The city deputies ordered the monument to be taken away carefully so that it might be re-erected elsewhere (the idea of a statue park was also mentioned). On 15 October it was cancelled from the list of monuments enjoying the protection of the state.[128] On 1 November 1991 it was surrounded by barriers and a crane. Artists from the Kreuzberg quarter found imaginative ways of denouncing 'violence' and the 'elimination of history' (illus. 37). One poster on the barriers asked: 'When do books burn?'[129] On 4 November, Tomsky's widow, contacted by the 'Initiative', asserted a moral right to object to the removal of the work from the context for which it had been created. By 8 November her last appeal was rejected by the Berlin supreme court, which considered that the author's interest in the respect due to his work had to yield in this case to the owner's – i.e. the city's – interest in removing the monument as a scandalous symbol of an obsolete system. The court added

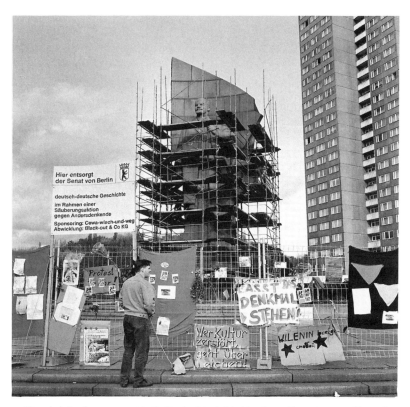

37 Tomsky's Lenin monument in the Leninplatz, behind barriers with posters, on 4 November 1991. *Note in particular a pseudo-official poster from the* Büro für ungewöhnliche Maßnahmen *('Office for Unusual Measures') announcing 'Here the Senate of Berlin removes Germano-German history in the context of a cleansing action against dissenters. Sponsors: Cewa Wipe-and-Go. Receivers: Blackout & Co Ltd'.*

that the author had to take into account the fact that 'with the creation of the monument to Lenin, he had placed his art in the service of a propagandist hero cult' and to 'accept that the current historical events could not as a consequence leave his work untouched', so that even irretrievable damage that might be caused by the dismantling would have to be regarded as 'traces of history, to be accepted by the author, rather than as signs of an artistic depreciation'.[130] Such traces would indeed be produced: once the head was taken down, the dismantling proved to be longer, more difficult and more expensive than had been expected, and it was only finished on 8 February 1992. The pieces of the statue were deposited on a former practice range.[131]

Six months later, United Nations Square (Platz der Vereinten Nationen) – as Leninplatz was henceforward named – still presented yet other traces, those of a quasi-funereal or votive cult to the monument and memories attached to it.[132] Small posters glued to the poles that used to carry flags exhibited a rich

array of texts, poems, photographs and caricatures, some alluding to the replacement of Communist symbols with capitalist ones from the Deutsche Bank or Coca-Cola. Stencil silhouettes of the monument were sprayed on the ground and on the granite plates sometimes in association with another visual symbol of East Berlin, the Television tower (illus. 38). The edge of the plates carried the following inscriptions: 'No violence', 'Against iconoclasts', 'Brecht 1947: freedom and democracy', 'And the earth was formless and empty (Genesis)' (illus. 39).

Criteria of judgement and aesthetic discredit

The history of the Friedrichshain monument to Lenin shows all too clearly that one cannot consider political iconoclasm as a non-Western archaism. In this case – and the observations are valid for Berlin in general – advocates of, and opponents to, the dismantling came from both the West and the East. Certainly, neither were homogeneous groups, and diverse motives could be found on both sides. Political aims and positions obviously played a role, but they do not seem to have been the sole factor of choice. Cultural and social factors must have been just as influential, although they are difficult to retrace. Professional politicians, as we have seen, almost unanimously condemned the monument, whereas most professionals of culture demanded at least the creation of an independent consultative commission (the director of the Deutsches Historisches Museum and the president of the West Berlin Akademie der Künste both objected to the removal).[133] The destructive removal of Tomsky's statue made public the 'conflict between the intentions of a professionally based preservation of cultural heritage on the one hand and daily politics on the other', and provoked the establishment of the above-mentioned commission.[134]

The existence of this commission helped to save time and foster discussion; however, its composition was controversial and its mission was limited to examining the post-War monuments of the Eastern part of the city.[135] Set up in February 1992, the commission published its conclusions and proposals a year later, some of which have been mentioned. The introduction to its report stated, among other criteria, its basic assumptions that deserve to be summarized here: the monuments erected by a regime, insofar as they serve its legitimation and solidification, lose their right to exist when this regime – and particularly a violent, unjust and hated one – collapses or is overthrown; monuments serving only the self-representation and ideological elevation of the Communist dictatorship or the glorification of its leaders have no place in a democratic society; every society has a right to bring to prominence its own view of history – a reply to the argument of the necessary preservation of the monuments as 'historical documents'. It further characterized the monuments

38 The Platz der Vereinten Nationen (United Nations Square, formerly the Leninplatz), in July 1992, with two sprayed stencil silhouettes of Tomsky's Lenin monument, one showing the figure against the flaglike background, the other, as if seen from the other side, next to the Berlin Television tower.

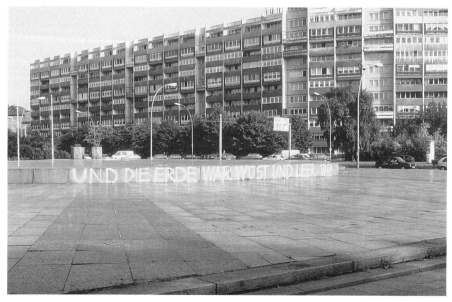

39 The Platz der Vereinten Nationen (United Nations Square, formerly the Leninplatz), Berlin, in July 1992, with the edge of the plinth of Tomsky's Lenin monument carrying the inscription 'And the earth was formless and empty'.

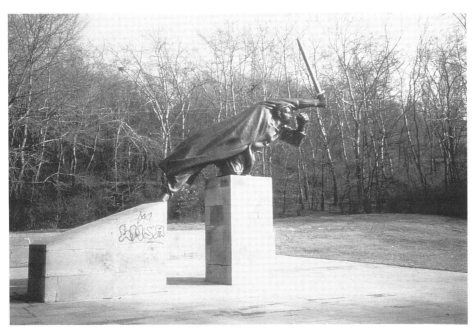

40 Fritz Cremer's 1968 monument in Friedrichshain, Berlin, to the German participants in the Spanish Civil War.

of the DDR era as being 'preponderantly bereft of great artistic signifi-cance'.[136]

This I think is the principal observation to be made on the fall of the 'Com-munist monuments' in relation to the history of iconoclasm: aesthetic arguments were used almost exclusively to advocate or justify their removal or destruction, not their preservation. Differences in artistic quality and authorship do not seem to have played a major role in determining what monuments were or were not attacked, at least before they were examined by commissions.[137] Iconography certainly mattered (one needs only to think of Dzerzhinsky), but together with more or less formal traits such as (enormous) dimensions, (imposing) situation and (domineering) expression.[138] The solid-ity of the material itself, as with Tomsky's Lenin, tended to be reinterpreted negatively. The complexity of a work such as Fritz Cremer's 1968 Berlin monument to the German participants in the Spanish Civil War (illus. 40), of which Gabi Dolff-Bonekämper has convincingly argued that it symbolized a doomed fight rather than glorified heroism, did not prevent it from also being attacked – during the night and anonymously, so that one will probably never know why; but it was exceptionally restored with financial help from the Berlin Senate and re-inaugurated in September 1992 by the mayor of Berlin-Friedrichshain, himself a son of 'Interbrigadisten'.[139] The overall artistic

worthlessness of the statues was often taken for granted, and no need was felt to prove it. In Berlin, a much-cited formula of aesthetic condemnation came from someone who had temporarily been active as an expert in the DDR's cultural policy, and now wrote that an end had to be put to the 'daily deformation of taste provoked by this non-art placed on high pedestals'. Artists joined him to denounce such an effect, particularly on children, and a commentator criticized their patronizing attitude as ignoring individual differences and transformations in reception.[140] Another commentator, fearing the intervention of Western curators of monuments who, he said, would favour a 'postmodern positivism' because they had long ceased to trust their own judgement, stated that these objects had been 'Socialist use-art', were now stumbling-blocks, and would soon become secondary raw materials.[141]

The counterpart to such unnuanced and self-assured verdicts is the cautious and reserved way in which advocates of the preservation entered the discussion – if at all – on the aesthetic plane. The foreword to the exhibition catalogue *Erhalten – Zerstören – Verändern?* made it clear that it did not aim to study the selected monuments 'primarily in regard to their artistic value' and that they had to be preserved and approached as 'important historical documents'. Christine Hoh-Slodczik also postulated that the commission she called for (and eventually belonged to) would have to judge the monuments according to 'historical relationship' rather than 'artistic criteria'.[142] Among art historians, their main defender in Germany was Hans-Ernst Mittig, professor at the West Berlin Hochschule der Künste and author of important studies on the history of monuments in the nineteenth and twentieth centuries.[143] In a plea against the demolition of Tomsky's Lenin, after recapitulating and answering the arguments of his antagonists (the need for a symbol of change, the crimes deriving from Lenin's ideas, the reverence implied in a monument), he too justified its conservation as 'visible witness of history' and 'instrument of identity foundation'.[144] Turning eventually to the idea that it simply was 'a bad work of art', he stressed the formal interest of the integration of pedestal and figure in the statue and the contrast formed by its mass and colour with the environment, but above all, he pointed out that aesthetic evaluation was notoriously subjective and changing, and had been mostly used as a pretext for political motives of aversion. In his introduction to the *Erhalten – Zerstören – Verändern?* catalogue, he stated that for those reasons, one could not follow the example of the French and the October revolutions and judge preservation or destruction by the standards of 'pure artistic value'.[145] In a public debate on the question of what was to be done with the art (mainly paintings) of the parties and mass organizations of the DDR, Martin Warnke underlined the necessity of justifying its preservation and saw no valid historical or aesthetic argument for it, since such works, he considered, did not document but rather falsified history, and since artistic quality, which implied

resistance against the general current, would be recognized by museums anyhow. If it was to be none the less preserved, then it should be in order to document the history of West German art (indirectly), the unrecognized quantitative primacy of 'art to order' (*Bestellerkunst*) in the twentieth century, and the deliberate beguiling of the people by means of images. Among the reactions that he provoked was a statement by the East German art historian Peter Feist, who justly remarked that 'the museums of the world exhibit countless works of art from many centuries that lie about history just the same' and that there had never been 'unquestionable criteria of aesthetic value for the art of the DDR'.[146]

The ambiguous or frankly desecrating character of most 'statue parks' has already been mentioned, and the fact that a history rather than an art museum contributed to the preservation of some East German monuments has become apparent. Equally revealing were the comments and silences of artistic institutions and their representatives. In 1992 Jan Hoet, the curator of the Kassel *Documenta*, a symbol of the Western modernist tradition, declared that paintings of the former DDR were not worth preserving and had nothing to do with art, which could only be created in absolute freedom.[147] The keeper of the state art collections in Dresden shared this essentialist view of things, since he opposed the project of recycling the monument to Lenin in his own town by assuming that 'what is not art cannot be artistically transformed'.[148] As for silence, letters asking for reactions sent by local defenders of the Friedrichshain Lenin to academies of art in Great Britain, Denmark, Austria, Switzerland and The Netherlands remained unanswered.[149]

Obviously, the very status and not just the quality of the art of the Communist era is problematic. Not only did 81 per cent of the persons questioned by *Pan* dislike the Berlin monument to Marx and Engels, but 77 per cent did not regard it as a work of art – which means that they were asked whether they did.[150] For several authors, the fact that these objects cannot easily be (regarded as) art now is explained by the fact that they never were, and that statues of Stalin, for example, 'were not "statues" in the Western, secularized and artistic sense of the term; instead, they were cult objects that served to introduce the great man's mystical presence'.[151] But this explanation, with its characteristic opposition between 'art' and function (cult-like or other), simply postulates a universalization of the Western conception of art as an autonomous activity, and does not do justice to the fact that the Communist regimes promoted an adverse conception of art, which was only progressively assailed and defeated by the Western standards in their own territories.[152] Of course, the point is that by 1989 at the latest, monuments and other works of the Communist era were judged by these standards. One can think that in accordance with the general evolution to which their fall seems an exception, fewer of them would have been attacked, removed or destroyed if this had

not been the case. Ernö Marosi, who shares the view that they were hardly meant as works of art and that their defacing was a last sign of the life for which they had been created, is certainly right when he predicts that they must now enter purgatory and that for them the way to artistic and even historical value is via their rarity value.[153]

4 Political Iconoclasm in Democratic Societies

Examination of the way monuments of the Communist era have been handled since the fall of the regimes that had produced them, above all in Germany, has shown that the illegitimacy of iconoclasm and the taboo it has implied for political bodies and organizations since the French Revolution are relative. The fact that the artistic status of the objects concerned was questionable and indeed questioned enabled politicians as well as representatives of cultural institutions to approve of, advocate or even demand their more or less direct and complete destruction. It must be added that illegitimacy and illegality do not prevent altogether the actions that they qualify; rather, they tend to restrict them to such authors, motives, objects, aims and circumstances as incorporate a rejection of or a challenge to current standards of acceptability. In this chapter, I shall examine examples of such cases, in which political motivations were explicitly put forward by the aggressors.

Lourdes and Rocamadour

In August 1983, in Lourdes, shortly before the Pope made a much-announced visit to the French pilgrimage centre, a night-time bomb destroyed a two-metres-high bronze statue of Pontius Pilate (probably part of a Way of the Cross). A few hours later the French news agency AFP received the following statement, signed by an unknown group named 'Arrêt curés' (Stop Priests, with a pun on 'récurer', clean out): 'We claim responsibility for the Lourdes assault on the occasion of the visit of the general manager of the Vatican multinational company to Soubirous Ltd. Other anti-frock actions will take place during the weekend. Alea jacta est'.[1] In August 1989 four plaster and stone statues representing the Entombment of Christ, part of the Stations of the Cross leading to another pilgrimage site dedicated to the Virgin, in Rocamadour, were beheaded. Another unknown group, 'Les amis du chevalier de La Barre', sent a letter to the AFP in which it protested against the 'revolutionary buffooneries' of the bicentenary festival of the French Revolution and denounced it as the 'celebration of the advent of the middle classes and of representation'. The message further stated: 'Ridiculously hieratic megaloma-

41 A policeman holding a piece of evidence after a bomb attack on 12 August 1983 by the group 'Arrêt curés' destroyed a statue of Pontius Pilate at Lourdes (*Libération*, 13–15 August 1983).

niacs, mafiosi dancing-puppets of politics, degenerate stalinists, corrupt syndicalists, shavelings of the money-market, may the cutting of those few heads, as derisory as yours, remind you that you are but the lamentable successors of the dying aristocracy'.[2]

The two events have much in common and can be discussed together. First, both are humorous. The statements manifest this character unequivocally, and imply that the actions themselves partake of it; the policeman shown holding a piece of evidence in the photograph by William Klein of the place of assault in Lourdes cannot refrain from smiling (illus. 41). Rather than iconoclasm, it seems to be a parody of it. A second point that strengthens this view is the fact that the damaged or destroyed objects were obviously considered to possess little value – artistic, historical or otherwise. Apart from its denotation (Pontius Pilate), not a word was said in the Press about the Lourdes statue, and the Rocamadour ones were defined as being 'without particular value'. Their affiliation to the category of 'St-Sulpice' (industrial late nineteenth- or early twentieth-century religious art) is a significant element of this worthlessness, as we shall see in chapter Twelve, and in the second case, mediocrity (the 'derisory' heads) was part of the message. The targets belonged to groups, and it is difficult to guess whether the attacks on them resulted from a specific choice: Pontius Pilate as a figure of the Pope? The Entombment of Christ as the burial of truly revolutionary hopes? In any case, the explosion and the beheadings are not self-sufficient, and seem rather pretexts for the publication of Press announcements – without which the latter might even have remained

unnoticed or at least unpublished. The use of the rhetoric of political activism ('assault', warning) is itself a parody: the statements mention no objective that the actions might in any way contribute to, and rather define them as expressions ('protests') of very broadly conceived messages to unnamed or unspecified addressees. These are essentially metaphorical actions, one might say, for which (valueless) works of art prove to be suitable instruments.

A third point is that the Catholic religion was among the targets. The Lourdes case need not be commented on in this respect. As for that of Rocamadour, the choice of a pilgrimage site and the statues, as well as the reference to the chevalier de La Barre, involve religion, even though the statement mentions only politicians, trade unionists and capitalists. (The chevalier de La Barre had been arrested in Abbeville in 1756 on suspicion of having mutilated a crucifix on one of the town's bridges; although he was beheaded with the approval of the Parlement de Paris (i.e. civil authorities) before his body was publicly burnt, he was considered to have been a victim of religious fanaticism and the chevalier was used against the clergy, particularly by the freethinkers, in the embittered battles fought over the relations of Church and State around 1900.)[3] The global political protest of the 'Friends of the chevalier de La Barre' is both expressed by, and based on, metaphorical transfers of terms from one realm (religion, politics, crime, economy) to another, for example in the 'shavelings of the money-market', and the same applies – specifically between religion and economy – to the transformation of the Vatican into a multinational company and of Lourdes into a subsidiary. In fact, these marginal (because 'derisive') actions are doubly relevant for the history of iconoclasm, because they belong to it and because they comment on it. The references to the alleged enlightened iconoclasm of the chevalier and to the revolutionary beheadings (and, by implication, 'vandalism') are clear enough. On a deeper level, their parodied violence is implicitly or explicitly directed against what the second one defines as the 'advent of representation'.[4] Both are successful though modest attempts at intervening in the media to oppose what their authors consider as undeserved celebrations – of the Pope's visit to Lourdes and of the Revolution – and denounce, among other things, the use of images to inculcate faith in religious, social and political order.

The Suffrage movement

Less self-reflexive but more serious in intent and consequences were the assaults on pictures and buildings made by British feminists in 1913–14. Julius von Végh mentioned this episode briefly in his book of 1915 on 'iconoclasts', concluding that 'the art-loving world stood indignant but powerless in front of such means of political agitation', but it has been almost totally forgotten since, with the exception of the damage caused by Mary Richardson to Velázquez's

42 Diego Velázquez, *The Rokeby Venus* (detail), *c.* 1640-48, after the attack by Mary Richardson on 10 March 1914. National Gallery, London.

Rokeby Venus in the National Gallery in London (illus. 42).[5] As this case was the one that was discussed most at the time, it will be simpler to begin with it.

The attack happened about 11 a.m. on 10 March 1914. A small woman dressed in a tight-fitting grey coat and skirt, who had been standing in front of the *Rokeby Venus* for some moments, apparently in contemplation of it, suddenly smashed the glass protecting the canvas and was seen 'hacking furiously at the picture with a chopper which, it is assumed, she had concealed under her jacket'.[6] When reached by a constable on duty in the room, she allowed herself to be led away quietly to the inspector's office, saying to a few visitors at the Gallery: 'Yes, I am a suffragette. You can get another picture, but you cannot get a life, as they are killing Mrs Pankhurst.' The reference was to Emmeline Pankhurst (1858–1928), founder of the Suffrage movement and mother of two of its leading exponents, who was then on hunger and thirst strike in Holloway Prison. Mary Richardson was herself, at the time of her arrest, on temporary release from the same prison under the 'Cat and Mouse' Act. She had sent to the Women's Social and Political Union (WSPU) an explanatory statement that was immediately published by the Press and deserves to be quoted in its entirety:

I have tried to destroy the picture of the most beautiful woman in mythological history as a protest against the Government for destroying Mrs Pankhurst, who is the most

beautiful character in modern history. Justice is an element of beauty as much as colour and outline on canvas. Mrs Pankhurst seeks to procure justice for womanhood, and for this she is being slowly murdered by a Government of Iscariot politicians. If there is an outcry against my deed, let every one remember that such an outcry is an hypocrisy so long as they allow the destruction of Mrs Pankhurst and other beautiful living women, and that until the public cease to countenance human destruction the stones cast against me for the destruction of this picture are each an evidence against them of artistic as well as moral and political humbug and hypocrisy.[7]

Before the Court, she added that she had been a student of art but cared more for justice than for art, so that under the present circumstances she believed her action to be understandable, if not excusable.[8]

In an interview given in 1952, almost 40 years later, Mary Richardson gave yet another reason for her action by saying: 'I didn't like the way men visitors gaped at it all day long.' This supplementary statement enabled David Freedberg to analyze her motives in terms of 'moralizing disapproval ... joined to political motivation [and] coupled with fear of the senses'.[9] Lynda Nead, who notices that 'the incident has come to symbolize a particular perception of feminist attitudes towards the female nude' and more generally 'a specific stereotypical image of feminism', concludes from the reactions it provoked that the importance of the painting was not only a matter of financial or artistic worth but 'was also measured in terms of its representation of a certain kind of femininity and its position in the formation of a national cultural heritage'.[10] She also mentions in passing the fact that the Suffragettes were involved in a significant number of other attacks, but more must be said about this.

Since the turn of the century, the Suffrage movement had been engaged in a transformation 'by the establishment of large organizations using novel tactics to maximize their public exposure'.[11] One of these was the WSPU, founded in 1903. Despairing of Parliamentary reform, it organized between 1912 and 1914 a further transition from peaceful campaigning to incidents of civil disobedience, guerilla tactics, and open warfare.[12] This spectacular radicalization involved in particular the destruction of property, for example breaking windows, firing pillar-boxes, burning buildings and attacking pictures. A passage from Sylvia Pankhurst's account of the Suffrage movement gives both a quantitative and qualitative idea of this evolution:

The destruction wrought in the seven months of 1914 before the War excelled that of the previous year. Three Scotch castles were destroyed by fire on a single night. The Carnegie Library in Birmingham was burnt. The *Rokeby Venus*, falsely, as I consider, attributed to Velázquez, and purchased for the National Gallery at a cost of £45,000, was mutilated by Mary Richardson. Romney's *Master Thornhill*, in the Birmingham Art Gallery, was slashed by Bertha Ryland, daughter of an early Suffragist. Carlyle's portrait of Millais [sic] in the National Portrait Gallery, and numbers of other pictures were attacked, a Bartolozzi drawing in the Doré Gallery being completely ruined. Many large empty houses in all parts of the country were set on fire, including Red-

lynch House, Somerset, where the damage was estimated at £40,000. Railway stations, piers, sports pavilions, haystacks were set on fire. Attempts were made to blow up reservoirs. A bomb exploded in Westminster Abbey, and in the fashionable church of St George's, Hanover Square, where a famous stained-glass window from Malines was damaged. ... One hundred and forty-one acts of destruction were chronicled in the Press during the first seven months of 1914.'[13]

The 'choice of weapons' were consciously derived from the kind of 'battle' being fought. Emmeline Pankhurst justified the recourse to violence by referring to the history of 'every advance of men's political freedom', notably suffrage, as well as to the tolerance of the Government towards separatists in Ulster, which she stigmatized as another instance of 'men's double standard of sex morals'. 'Blood-shedding militancy', however, was to be left to men: 'There is something that governments care far more for than human life, and that is the security of property, and so it is through property that we shall strike the enemy.'[14] Art was thus involved as a manifestation of 'the secret idol of property' in at least two ways: because of its high financial value – David Freedberg has noted the obsession of *The Times* with the rise in the value of the *Rokeby Venus* and its consequent reduction after the assault, revealing the degree to which it was a 'commodity fetish' – and because the closure of museums and galleries following the attacks contributed to make 'England unattractive to tourists, and hence unprofitable to the world of business'.[15] But there was more to it. Pictures, thanks to their uniqueness, the fact they portrayed persons, and the emotional charge they engendered, enabled Suffragettes to come as near as possible to 'blood-shedding' without actually endangering human beings. Despite her declaration that 'You can get another picture, but you cannot get a life', Mary Richardson could not but be aware of the fact that, as *The Times* put it on 11 March, Velázquez's work was 'quite a unique picture', as well as of the reactions that led newspapers to represent her deed 'in the visual and written language usually reserved for the sensation murder' and to nickname her 'Slasher Mary', 'the Ripper' or 'the Slasher'.[16] It must be added that the maximum sentence for damaging a work of art was six months imprisonment. Emmeline Pankhurst relates that the magistrate regretfully said to Richardson that if she had smashed a window instead of an art treasure he could have sentenced her to eighteen months, and points out 'one more queer anomaly of English law'.[17]

As for the *Rokeby Venus* itself, we can now recognize that its transformation into a target or 'victim' involved complex, and in part idiosyncratic, operations. As a famous painting acquired (in 1906) for a large sum by the National Gallery, it could appropriately exemplify – provided the necessary reference be established – the national 'idolatry of property'.[18] As far as denotation and expression are concerned, Mary Richardson turned Venus, a symbol of (physical) beauty, an ideal of (passive) womanhood and a voluptu-

ous object of (male) contemplation, into an inverted figure of Emmeline Pankhurst, a model of moral beauty, emancipated womanhood and political militancy. Attacking and mutilating the counter-model allowed her to depreciate it in every respect, as well as to assert symetrically the superiority of her positive model. The 'outcry' that would inevitably result from her action was supposed to further expose the 'hypocrisy' of authorities and of a society that valued a picture more than human life. The deed exploited the double nature of the sign: as signified, it could receive 'wounds' meant to expose and maybe to avenge the pains inflicted on the imprisoned feminists, while as signifier it enabled the dismissal of moral judgments passed on the destruction of what was 'only a picture'.[19]

Were the generic and the specific, the different modes of symbolization combined in the same way in the other cases of assault by Suffragettes on works of art? The reasons for abusing portraits of the King are pretty clear, since the damage occurred after Suffragette attempts to obtain his intervention had failed. But why portraits of Carlyle and Henry James, and what about Romney's *Master Thornhill* and Clausen's *Primavera*? These questions – for which conditions of access, security, etc. should be taken into account – must be left unanswered here. It also remains to be determined to what extent Mary Richardson's remark 'You can get another picture' was disingenuous, and whether her additional statement of 1952 was not also a way of proposing to a later audience an explanation that would by then seem more understandable, if not excusable. The Suffragettes' iconoclasm was perceived as a new phenomenon by Julius von Végh. It corresponded to, and made political use of, the world of museums, tourism, and commodification. The militant feminists were ready to challenge the notion of artistic heritage as part of the primacy of property (public or private), but their defiance and their apparent indifference to the specificity of cultural goods also seems to point out – in England before the First World War – a more partial and fragile consensus on notions of art, preservation and 'vandalism' than might have been expected. A further token of this state of things is a 'story without words' entitled *The Boy who Breathed on the Glass in the British Museum* and subtitled *A Criticism of Life*, published by Henry Mayo Bateman in *Punch* on 4 October 1916 (illus. 43). At a time when, as von Végh noticed, the destruction caused by the War made all previous destruction pale into insignificance, Bateman showed a young boy arrested, held, judged and condemned to hard labour for having breathed on the glass of a show-case containing Egyptian mummies. When he was finally released, an old broken man, he went to the British Museum, found the same show-case, blew his last breath on it, and was found dead by an indignant guard.[20]

THE BOY WHO BREATHED ON THE GLASS IN THE BRITISH MUSEUM
AN ANTE-BELLUM TRAGEDY

43 H. M. Bateman, *The Boy who Breathed on the Glass in the British Museum: An Ante-Bellum Tragedy*, a 1916 drawing from *Punch* reprinted in his *A Book of Drawings* (New York, 1921).

One may gain an insight into the evolution since then by examining a recent case that occurred in Switzerland. Shortly after midnight on 13 October 1986, the polychrome statue surmounting the Fountain of Justice (*Gerechtigkeits-brunnen*) in the centre of Berne (illus. 44) was pulled down by at least four persons by means of a rope and tackle; it broke on the basin (illus. 45), but no one woke up and the gang slipped away without being noticed. The statue, dated 1543, was the work of Hans Gieng, and was considered the most important and beautiful among the eleven fountain figures erected in Berne between 1542 and 1549.[21] In the afternoon of the same day, the city's municipal council publicly condemned the 'vandalism' as 'a shameful action, that nothing could justify and which must remain inexcusable'.[22] Newspapers also received from the Jurassian 'Groupe Bélier' (Ram group) an announcement entitled 'The "Justice" of Berne on the ground', which accused the 'Bernese nation' of being 'the most colonialist of Switzerland' and of subordinating a 'pseudo-justice' to its political power and interests; it was accompanied by a few lines stating that 'the statue of Justice erected in the town of Berne had been laid on the ground' and a request for publication.[23] The destruction provoked intense reactions among the Bernese population and in the Swiss press. On 16 October the government of the canton of Jura publicly declared that it 'categorically disapproved of the latest deed of the Béliers', but 'was not altogether surprised that isolated and desperate elements would commit such actions as a reaction to the silence and immobility of the federal and the Bernese cantonal authorities after the cheating in the plebiscites that had led to the splitting of the Jura'.[24]

A few historical details are now required. As a result of political militancy, particularly active after 1959, the inhabitants of a territory that had become part of the Bernese state in 1815 were asked in 1974–5 to choose their future status. Whereas the northern part voted for autonomy, the southern one rejected it, so that the independence-seekers considered the new canton created in 1978 as incomplete. Religious, economic and political contrasts between the two parts went a long way to explain the situation, but accusations of irregularity concerning the votes were fostered by later revelations that Bernese officials had illegally financed the anti-separatists. At the time of the toppling of the statue, Jurassian militants were outraged by the fact that, in November 1985, the Bernese government had refused to bring to trial the members of parliament involved, as well as by the absence of federal intervention. The 'Groupe Bélier' was a youth organization specializing in the disruption of public order.[25]

On 14 November 1986, a 29-year old motor mechanic and recent recruit of the 'Béliers', Pascal Hêche, admitted participating in the attack on the fountain

44 The Fountain of Justice in Berne, with the 1543 figure attributed to Hans Gieng as it was before 1986.

45 The Fountain of Justice, Berne, after the attack on 13 October 1986.

and provided details of the way it had been carried out. He later retracted this confession, but was sentenced by the Berne court on 16 March 1989 to 22 months confinement for major damage to property and to pay a fine of 170,677 Swiss Francs; the sentence was confirmed on 2 July 1990 by the Supreme Court of the canton of Berne.[26] Both courts agreed that the accused was not being punished for his political convictions, that destroying a statue of great historical and cultural value could only harm a political cause, and that Hêche had acted out of hate for the state of Berne.[27]

After being sentenced Hêche appealed to the Swiss Supreme Court and took refuge in the canton of Jura, asking the authorities there to grant him 'political asylum'. The Jurassian government requested from the Bernese access to his criminal file. The Bernese refused and demanded a decision from the Swiss Supreme Court, and the Jurassians then asked it to establish the political character of the offence, proposing to judge it anew. On 15 December 1992, the Supreme Court authorized the Jurassian government to refuse to extradite the culprit to face Bernese justice, but obliged it to execute the sentence on its territory as already passed (this last condition, however, was not carried out). In its published judgment, the Court discussed two ways of defining 'political offence': either as an act perpetrated to attain political aims by appropriate means, or as an act proceeding from political motives. It considered that in the present circumstances, the second, broader definition had to be preferred, and could be applied to the destruction of the Fountain of Justice. It further considered that, for reasons going back to 'the sharp oppositions that existed in the political and social life of the cantons before 1848', this allowed the canton of Jura to refuse extradition, but not to have the same offence tried a second time or to leave the culprit unpunished.[28]

This destruction was not the first act of violence by the 'Béliers' involving symbols and cultural property. Apart from Bernese – and sometimes Swiss – flags and emblems, their main target had previously been a large stone statue by Charles L'Eplattenier representing a sentinel, erected in 1924 near the border to France as a monument to the national defence maintained during the First World War. It was repeatedly defaced with paint and minor fractures, pulled down twice (in 1984 and 1989), and finally burned in its storeroom in 1990.[29] Shortly after judgment had been passed on Hêche in 1989, a historic wooden bridge on Bernese territory was burned, and newspapers received an anonymous letter claiming the deed was an act of 'revenge' for the trial.[30] Some of this, however, partook of the humorous and metaphorical character of other publicity-seeking actions by the separatists. The first time the *Sentinel* was pulled down, it appears that this had resulted from an attempt to decapitate the statue in order to exchange the head for a traditional stone (the 'Unspunnen Stein') that had been stolen from a Bernese local museum.[31] Such 'symbolic hostage-takings' may remind us of the 'Friends

of the chevalier de La Barre', and it must be noted that L'Eplattenier's *Sentinel*, though artistically more respected than the Rocamadour or Lourdes statues, had been reduced by circumstances to the role of political instrument.[32]

The specificity of this act was stressed by the Press, particularly the French-language newspapers. Commentators missed the former sense of humour of the 'Béliers' and denounced the 'vandalism' that was now depriving them of everyone's sympathy, affirming that 'to destroy art means avowing one's impotence or fanaticism' and that 'an assault against [Berne's] artistic heritage injures us all'.[33] The curator of the city's historical monuments, Bernhard Furrer, reproached German-speaking journalists for showing themselves to be interested chiefly in the copying of the statue and the costs involved, and the Jura for its ambiguous condemnation.[34] To him, the destruction of this outstanding work by members of an organization enjoying the recognition of a canton government – this was before the extradition refusal – 'opened a new chapter for the preservation of monuments and cultural property in Switzerland', in which these would have to be protected not only against the effects of age, degradation, air pollution and inadequate handling, but against 'assaults from blinded terrorists' as well. With the accusation of 'blindness', he referred specifically to the fact that the destroyers had not been able to distinguish between 'justice' as an institution and as a principle, and had destroyed a symbol of the latter in its very name, whereas the statue, created a few years after the iconoclasm of the Reformation, had been spared by all political and military turmoils since, including the entry of the French Revolutionary army in 1798.

There is indeed something deeply ironical in the fact that, at the feet of the fountain's armed figure of Justice, four sovereigns in submission represented temporal power in the forms as defined by humanist political theory: the pope for theocracy, the emperor for monarchy, the sultan for autocracy, and the 'advoyer' (Schultheiss) of Berne for the republic.[35] Yet, there was an ambiguity from the start, as the statue, situated at the political as well as urban centre of the town, was also understood as a symbol of the highest virtue of the state and a symbol of the Republic of Berne itself. It is as such that, in 1798, although the figure was not eliminated (its iconography was probably too generic for that and it did not belong to the arms of the state), its attributes – the sword and the scales – were stolen to mark the end of the Ancien Régime.[36] Both aspects were obviously involved in the 1986 assault. The iconoclasts must have selected the statue to represent 'the justice of Berne', which, in their eyes, had lost its legitimacy by showing itself subordinate to political power; and they attacked it as a famous symbol of the city and state, demonstrating thereby a capacity to strike at the heart of the 'enemy's territory' and to mutilate the town's physical and aesthetic integrity.[37] Now, one wonders to what extent they were conscious of, and took into account, the difference in value (histor-

ical and artistic) between this target and previous ones, whether a copy of the original work, if it had already been placed on the fountain, would have suited them equally or better? It became known during Hêche's trial that, a few years earlier, he had burned a coffin in front of the fountain, in order to show what he thought of Bernese justice.[38] The progression or the transition from meta-phorical to literal abuse may correspond to a radicalization of militancy, which in its turn could be explained by a growing isolation of the activists.[39] In any case, the leader of the 'Béliers' declared in 1993, after a young member of the group had been killed by his own explosives, that one could not impute to them any violent act since the 'incident of the fountain' and that their 'line had changed', even if it resulted in getting less attention from the media.[40]

Questioned on his action, Hêche declared that what had been attacked was not the monument, but 'the symbol represented by the monument'.[41] Of course, this distinction between signifier and signified is rendered ineffective by the literal elimination of the sign. But it need not be disingenuous, and the difference between the pulling down of the *Sentinel* and that of the 'Justice' must be seen as one of degree rather than of nature. Surely, the act and, even more, the attitude of the Jurassian government show that artistic and historical heritage, even today in a relatively old Western democracy, are not totally immune to conflicts of values – politico-moral against cultural, for instance – or of 'value regimes'.[42] But one should not underestimate the importance of the other reactions and of the significant fact that the action was never expli-citly claimed. The press announcement of the 'Béliers' was deliberately ambiguous (the police regarded it as inconclusive), and Hêche consistently re-tracted his first confession, going so far as to adopt the language of his accusers by concluding his trial with the affirmation: 'I have not taken part in this van-dalistic act'.[43] Professed by political activists, such stands cannot be interpreted as proceeding solely from an attempt to minimize risks and penal-ties. Shameful attitudes towards actions more infamous than defaming, they contrast sharply with those of the English feminists at the beginning of the century. They attest a deeply ingrained illegitimacy and bring 'political action' closer to the individual (or pseudo-individual) attacks that we will ex-amine later, or to the 'terrorism' to which Bernhard Furrer referred.

'Cultural terrorism'

It is not by accident that the assault on an object of undisputed historical and artistic value, in the context of a representative democracy, sprang from a sep-aratist movement, since separatism implies conflicts of cultural identity and a questioning of the current source of legitimacy and legality. Numerous other attacks on monuments and works of art imputable to struggles for political in-dependence could thus be cited. Breton autonomists, for example, in August

1932 destroyed an allegory by the sculptor Jean Boucher of the *Union of Brittany with France* placed in 1913 in a niche on the front of the Rennes Hôtel de Ville; not only did the subject appear to them to be a provocation, but the author and the style may have reminded them of a dependence on Paris and on institutional and academic traditions to which they objected.[44] In Wenen, southern Tyrol, a monument to the Tyrolian hero Andreas Hofer was blown up in 1961, and the police suspected an Italian in connection with terrorist assaults in the region.[45] In Ireland, nineteen Old Master paintings were stolen in 1974 from the estate of Sir Alfred Beit, south of Dublin. The authors of this action threatened to destroy the pictures unless £500,000 was handed over for five of them and – in a request that underlined the double status of works of art as both unique cultural treasures and interchangeable commodities – unless the Price sisters, who had been imprisoned in England since the bomb attacks of March 1973, were released.[46]

Such conflicts and methods may appear archaic, and it is logical that the right for a canton not to deliver to another canton one of its citizens found guilty of a political offence should derive, as the Swiss Supreme Court pointed out, from the situation prior to the formation of the modern federal state, when 'the same man could be anathemized as a heretic in one canton, and revered nearly as a saint in the other, prosecuted as a criminal in the former, and considered an honourable man in the latter'.[47] But the sequel of decolonization – and, needless to say, colonization – as well as the disintegration of the 'Communist bloc' have broken old 'balances' (including those of state terror) and given a new currency to intra- and international conflicts based on identity rather than territory.[48] The involvement of cultural property in the process of 'ethnic purification' in the former Yugoslavia, to which a brief reference was made in chapter Two, seems to imply that the 'end of territories' represents a serious menace for works of art too.

The curator of historical monuments of the city of Berne was entitled to speak of 'terrorism' insofar as he considered the destruction of the Fountain of Justice as violence proceeding from a political organization and aiming at intimidating its opponents – thus interpreting in a rational way the apparent discrepancy between the political aims and the means employed.[49] The term 'terrorism' originates in the French Revolutionary politics of the iconoclastic years 1793–4, but its meaning was broadened in the 1920s. It is significant that the phrase 'cultural terrorism' should have been coined – as far as I can ascertain – in the 1980s.[50] It was particularly used in relation to the serious bomb assaults perpetrated in Italy between May and July 1993, at a time of great political transformation, which recalls the blood-shedding 'strategy of tension' developed by Right-wing extremists between 1969 and 1984, but which essentially damaged sacred monuments and works of art, in particular the building and collections of the Uffizi in Florence, the Civico Museo d'Arte Contempor-

46 Andrea Rauch and Stefano Rovai, *The Uffizi born again: Florence is alive*, poster commissioned by the town council of Florence for the reopening of the gallery three weeks after the bomb attack of 27 May 1993.

anea in Milan, and the churches of S Giovanni in Laterano and S Giorgio di Velabre as well as the Palazzo del Vicariato in Rome.[51] Of course, the relative imprecision in the definition of the targets – the second bomb, however, was placed in a car parked three metres away from the entrance of S Giovanni in Laterano – together with the anonymous character of the assaults and the absence of any acknowledgement make any interpretation highly hypothetical. Yet the reactions showed that what had been damaged (and probably targeted) were 'symbolic places, tokens of the very culture and identity of the state and the nation' (illus. 46); a cartoon published in the London *Guardian* showed bundles of dynamite fastened to the silhouette of Italy.[52] It need not be stressed that in the context of criminal strategies of destabilization, the value generally attributed to artistic heritage and the political illegitimacy of its destruction may be considered as advantages. Julius von Végh wrote in 1915 that 'even our age of rational thinking and middle-class self-control' did not prevent art from being endangered as it has always been, 'all the more so as it stands today more than ever at the centre of interest of all civilized people, a world of its

own, a guarantee for the modern spirit and thus, at the same time, its Achilles heel, the point at which the cultivated may most easily be touched'.[53] Whatever its shortcomings, the subsequent 'democratization of culture' has enlarged the social frame of reference of this remark and thus increased its political relevance.

5 Outside the First World

In 1973 Martin Warnke qualified his assertion that 'the history of iconoclasms can be considered as completed' with the remark that they still had some importance left 'on the level of the political practice of underdeveloped countries'.[1] Two years later, Horst Bredekamp more cautiously commented on a press photograph showing a small statue and a framed picture of Buddha near a Cambodian soldier by noting that 'moments of history allegedly left behind' regain significance as objects of reflection because 'problems, which one would naïvely regard as resolved', prove to be 'again *practically* virulent on the level of the Third World', so that, in the context of the post-colonial politics of the industrialized nations, 'aspects of the past of the Western countries enter their own conscience'.[2] We have seen that, even on the level of political practice, iconoclasm was far from having disappeared from the Western scene, and I have tried to question its forms and meanings in relation to the conditions of political and cultural life in the representative democracies of the post-industrial world. Extending this inquiry beyond its limits would represent a much too ambitious endeavour, as the subject is enormous, and largely – to my knowledge – unexplored. But a brief glance is at least needed, if only because the destruction of art is so often interpreted as belonging to stages of civilization supposedly relegated to societies defined successively as 'underdeveloped' and 'developing'. The following observations should be understood as food for thought. They cannot be systematic, and are based on the incomplete and indirect documentation of a reader of Western newspapers.

Chinese Communism

Communism was of course not limited to the 'Soviet bloc'. Mao Zedong's China developed a totalitarian conception of state control over, among other things, cultural production, and a personality cult, partly inspired by the Russian model, as its brand of 'Socialist Realism' makes clear, even though it was intended to be 'nationalist in form'.[3] Mention has already been made of the destructions of the Great Proletarian Cultural Revolution, a complex result

of 'social, economic and political cleavages that had been incubated in Chinese socialism since 1949', which lasted from 1965 to 1968 or, as Hua Guofeng declared after Mao's death in 1976, a whole decade.[4] Struggles among the top leaders and radicalization led, in part, to a way of diverting criticism and violence from Party and Government officials towards other targets, to attacks on the 'four old things' (old ideas, culture, customs and habits) and to the massive destruction of temples, shrines and historical artefacts. Marc Blecher noted ten years ago that 'this aspect of the Cultural Revolution [was] now being condemned vociferously by the present leadership, many of whose supporters actually fuelled it at the time'.[5] Control over the 'mass movement' had to be regained by Mao's call to the army, and in 1968 'an official cult of Mao, reaching new heights of deification, was propagated as a way of defusing radical mass sentiment', before it was criticized in 1973, apparently on Mao's own command.[6]

The destruction of cultural heritage, intended to eliminate the 'feudal past' as well as bourgeois and Western modernism and individualism, could also aim at eradicating the identity in which claims to political independence are rooted. Typically, the annihilation of Tibetan religion and culture, rampant since 1959, thus proceeds (among other ways) under the pseudo-rational guise of the 'modernization' of Lhasa, a site mentioned on the list of 24 protected historical cities of China.[7] The reverse of the medal, 'invention of tradition', is cultivated in North Korea, where a granite monument was recently erected to commemorate the legendary king Tangun (whose remains were allegedly discovered by researchers of the Academy of Social Sciences in 1993) and, maybe, to receive the embalmed body of Kim Il-sung, while the cult dedicated to his personality is transferred to his son and successor, Kim Jong-il.[8] Surely, such methods of power and dynastic legitimation recall the Western pre-revolutionary political doctrine of the 'King's Two Bodies' no less than the Lenin cult. On the level of (two- rather than three-dimensional) images, no 'de-Maoization' seems to have begun, and the *crimen laesæ majestatis* is still harshly punished (long-term and even life confinement for three men accused of having spilled paint on Mao's portrait in May 1989 on Tiananmen Square in Beijing).[9]

This act of defacement was part of the student and popular movement demanding a liberalization of the regime after the death of Hu Yaobang, a movement that literally occupied the 'public space' it was striving to create. Significantly, the personification of liberty or democracy erected by art students in the square and abundantly reproduced in the West was inspired by Bartholdi's famous *Freedom Enlightening the World* inaugurated in 1886 in the harbour of New York City.[10] It was crushed on 4 June 1989 together with the rebellion, in the bloody repression decided by Deng Xiaoping. In 1993, the publication of the third volume of Deng's works was accompanied by the

launching of a cult of his personality, a cult suspected of aiming at diverting attention from the ever increasing social disparities and tensions resulting from his politics of radical economic reform and at reuniting the Party and the nation on the eve of his menacing succession.[11]

On the other hand, an artistic avant-garde is now tolerated, as long as its reception is limited to professional and foreign circles. After the aesthetically and politically contestant 'stars' (Xingxing meizhan) group of the late Seventies and the provocative self-destructions of Xiamen Dada in the Eighties, the post-Tiananmen generation ironically exploits the *topoi* of state art as well as the images of Western publicity.[12] Meanwhile, on 7 October 1995, the celebrated portrait of Mao walking towards Anyuan by Liu Chunchua, of which more than 900 millions of copies and reproductions were produced during the years of the Cultural Revolution, was sold at auction for 6.05 million yuans, officially to a 'Chinese entrepreneur'. The event was interpreted by American newspapers as 'a revenge of capitalism on Mao', while others suspected the Chinese Government of standing behind the anonymous buyer – for as French sign-boards at unmanned level crossings used to say, 'one train may conceal another train'.[13]

Liberations, wars, and religions

In 1997 the handover of Hong Kong's symbolic patrimony by the Chinese authorities after the recovery of the former British colony by the People's Republic will certainly be a test of this evolution. What will become of the effigy of Thomas Jackson, director of the Hongkong and Shanghai Bank at the end of the nineteenth century, on Statue Square? And will Queen's Road be renamed (a sarcastic commentator tips 'One-Country-Two-Systems Avenue' rather than 'People's Avenue')?[14] In Macao, which will be retroceded to China two years later, what was left of the equestrian monument to Joao Ferreira de Amaral, governor of the colony from 1846 to 1849, was sent back to Lisbon in 1992; the Portuguese administration had already received the left hand, then the head of the statue during a rebellion, and the figure of the Chinese whom the Governor was shown whipping had been removed in the Sixties.[15] In 1975, when Angola became independent, symbols of colonialism were attacked and UNITA soldiers were photographed with children sitting on a statue of Norton de Matos, founder of Nova-Lisboa (since then Huambo), that lay on the ground (illus. 47).[16] On 7 February 1986 in Port-au-Prince, when the son and successor of dictator François Duvalier fled from Haïti, the crowd pulled down and threw into the sea the statue of Christopher Colombus, who, in the vicinity in 1492, had founded the New World's first European settlement.[17] In the context of the previous and subsequent history of this, the first Black republic in the world, the event may be considered

47 Soldiers of UNITA and children on 12 November 1975 with a toppled statue of Norton de Matos, founder of Nova-Lisboa, Angola (since renamed Huambo, after an Angolan chief who once had his head village on the site).

as symbolic of the difficulties and ambiguities of decolonization. In South Africa, on the other hand, the new democratic authorities indicated their intention to document and complement rather than repress or eliminate the history of apartheid: in Durban, the Kwa Muhle, administrative centre of apartheid, has become a museum, and ways of commemorating the contribution of Indians and Blacks to the history of the town are sought, while the statues of heroes of the colonial era remain *in situ*.[18]

Abuse of monuments, images and cultural property in the context of intra- or international conflicts can easily be found. In 1984 the Falkland Islands war provoked in Argentina the destruction of several monuments linked in one way or another to Britain.[19] In Colombia recently, at the same time as a bloody assault was under way in Medellin, a statue by Fernando Botero representing a dove and entitled *The Bird* was blown up, probably by drugs dealers objecting to the symbol of peace and to the sculptor's son, Fernando Botero Zéa, Minister of Defence.[20] In Asia, as a Japanese plan to atone for the country's acts during the Second World War (a $1 billion fund for cultural and vocational projects) was rejected as insufficient and inadequate in both parts of Korea, South Korean protesters wrecked an exhibition of traditional arts

48 South Korean protesters tipping over an exhibit of Japanese arts and crafts at a Seoul museum on 2 September 1994.

and crafts by Japanese 'national human treasures' in a Seoul museum and denounced the projected fund as 'a gateway for cultural invasion' (illus. 48).[21]

Fights against religion, for religion and between religions remain motives of, and occasions for, iconoclasms. After 1958, Sekou Touré organized bonfires of thousands of 'cultic objects' as a means to eliminate 'obscurantism' in the independent Republic of Guinea; at the beginning of the same decade, the apparition of a new religion born of Islam, the 'Massa', had provoked a massive destruction of Senufo sculpture.[22] Violence associated with the rise of a militant 'Islamicism' has already been alluded to. In India, the destruction by Hindu fundamentalists of the Babur mosque in Ayodhya, on 6 December 1992, was followed by bloody struggles between Hindus and Muslims as well as anti-Indian riots in Pakistan and Bangladesh; the sixteenth-century mosque was supposed to have been built on the site of a former Hindu temple, and its destruction was the main claim of the opposition Party of the Indian People.[23]

Hand-made images and defaming pictures

Like the war photographer on whom Horst Bredekamp commented, every art historian interested in the broader world of images, indeed any Western lover of images, must be intrigued by the views of handmade public images sometimes transmitted by the mass media, and which seem to be used in contexts where we would expect photographs, posters or no image at all. To give a few examples: 1983 – an Iraqi wallposter in Baghdad showing Saddam Husain as a victorious Arab warrior, thrusting his sword into the body of an Iranian lying

under his foot and raising his shield against a three-headed serpent with the features of the Iranian leader Khomeini, the Libyan President Ghaddafi, and the Syrian President Hafaz Asad; 1989 – a large moveable painting representing the Lebanese general Michel Aoun on horseback, wearing a combat suit, plus a floating national flag as his cape, and holding (again) the head of Asad. And at the political opposite of these celebrations of military leadership: 1990 – a wall painting symbolizing the liberation of Africa, with a text recapitulating the rights of the citizen, in front of which stands Mali's former minister of culture and advocate of a multi-party system, Alpha Oumar Konaré.[24]

The first two examples, as instruments of state and party propaganda, are aimed as much against the foes whom they caricature as they are in favour of those who commissioned them directly or indirectly. In this sense, they are related to the two- or often three-dimensional images used in political demonstrations, to which is literally applied the ill fate wished on their models. In a chapter dedicated to 'infamy, justice, and witchcraft' in *The Power of Images*, David Freedberg includes a photo of the hanging of an effigy of President Mitterand, taken in Teheran in 1987; in Delhi, by January 1991, Hindus demonstrating against Saddam Husain enacted their slogan 'Hang Saddam' on a puppet of the same kind.[25] In both cases, no great pains had been taken to achieve resemblance, and the identity of the model was essentially denoted by a (plastic) mask and an inscription.

One may be tempted to see in this the survival or revival of ancient practices such as image magic, the later Roman *executio in effigie*, the Italian Renaissance *pittura infamante*, or again the *executio in effigie* applied in cases of *lèse-majesté* from the seventeenth century on; so much has been said of comparable abuses of Communist monuments.[26] But such an interpretation would overlook major differences in status and content. Here we are not dealing with legal practices but with informal – even if ritualized – and unofficial modes of political expression and communication, and nothing indicates that puppet hangers believe their self-mandated actions directly harm the persons represented. In fact, numerous analogous instances can be found in 'developed' countries: a man-of-straw referring to the Minister of Education burned by students in a Dutch high school; a large effigy of the ex-candidate for the U.S. presidency, Ross Perot, blinded and hanged by his disappointed supporters with an inscription explaining 'You left us hanging'; or even a puppet representing Edith Cresson publicly decapitated in Tokyo by members of an extreme Right-wing organization, after the French Prime Minister had made declarations that they considered anti-Japanese.[27] Of course, the playful character of a student happening in the first case, the attempt at justifying and blunting the symbolic murder with a joke in the second one, and the authorship of a marginal political group in the last are all indications that in a way parallel to the taboo regarding iconoclasm, image-punishment enjoys little

consideration in the First World and may not be used too seriously without damaging one's own cause. Another parallel can be drawn with hand-made political images, as a giant wall painting glorifying armed and masked Unionist fighters in a Protestant area of Belfast suggests.[28] Nevertheless, these are again differences in degree rather than nature, and whatever their origin, these uses and abuses of images equally exploit their visual and emotional impact to gain access to the media for the causes that they stand for.

'Muralicide' and Husain's monument

Admittedly, the technical and formal quality of even the paintings evoked here seems generally very poor, and one would hardly expect their authors, patrons or spectators to claim them as works of art. However, more ambitious political works have also been created for, and sometimes destroyed in, public spaces. This is particularly the case in Latin America, where the paradigm established in the first half of the twentieth century by the great Mexican muralists, in relation to other attempts at re-socializing art in Europe and the United States, has been cultivated and revived in several later revolutionary contexts, especially in Nicaragua. In Managua, many murals realized from 1979 on under the Sandinista government and celebrating its aims, ideals and victories, were covered up with paint on order of the new mayor, Arnoldo Alemán, after the party's defeat in the elections of 1990 (illus. 49). The aesthetic level of these works, many of which had been executed more or less spontaneously and collectively, was unequal, but their defenders insisted on their artistic status, coined the term 'muralicide' (*muralicidio*) to define and denounce their systematic elimination, and compared Alemán's misdeeds to those of Conquistadores, Huns and Nazis.[29]

The situation in Cuba seems to be characterized by a mixture of authoritarian political control and radical economic liberalization.[30] A fictional case of self-inflicted iconoclasm was recently elaborated by Thomas Gutierrez and Juan Carlos Tabio in their film *Strawberry and Chocolate* as a kind of parable on the traps encountered by art and artists, and deserves to be sketched out here. The stage was Havana, 1979. The main character, Diego, persecuted for his homosexuality and apoliticism, was an art critic, and prepared with the help of an unnamed foreign embassy an exhibition of his friend German. The latter's works, stored in his flat, were painted plasters evoking 'St-Sulpice art' and combined in a doubly provocative way religious and Communist imagery. The exhibition turned out to be prohibited by the Cuban authorities, but the artist was offered a trip to Mexico, provided he made a 'selection' from his works, i.e. excluded the most embarrassing ones. Diego objected twice and asked German whether he was 'an artist or a tourist'. On the second occasion, the sculptor took one of the busts in contention and beat it

49 *Homage to Woman*, a mural painted in 1980 by Alejandro Canales and collaborators on a wall of the Municipal Maintenance and Improvement Service in Luis Alfonso Velásquez Park, Managua, being covered up with paint on 26 October 1990 on the orders of the new mayor.

on the ground until it broke, shouting and weeping 'They are mine, I have made them'. When another friend later found the critic writing beside the fragments and asked whether the show had been forbidden, Diego answered that it was worse than that – 'they had bought' German.[31]

I take my last example from Samir al-Khalil's remarkable study of Saddam Husain's *Monument* (illus. 50), a double 'Arch of Victory' reaching forty metres above the ground and marking the two entrances of a vast new parade-ground in central Baghdad.[32] Conceived by the President of Iraq to commemorate a victory that had not yet been obtained in the Iraq–Iran war, and inaugurated on 8 August 1989 as 'one of the largest works of art in the world', it has not been destroyed – although it may well be once its author is no longer in power – but it thematizes destruction together with power. Both literal and metaphorical reuse was resorted to: 5000 Iranian war helmets fall from various cornucopia to the ground, while the raw steel of the giant sword blades comes from the weapons of Iraqi 'martyrs' that were melted down.[33] This appropriation may be related to Husain's conception of education (and politics), to which the modern idea of the artist as *alter deus* interestingly provided a model: in a speech of 1977, Husain declared that 'the child in his relationship to the teacher is like a piece of raw marble in the hands of a sculptor who has the power to impart aesthetic form, or discard the piece to the ravages of time and the vagaries of nature'.[34] In the recent history of 'totalitarian art', this monument represents a rare instance. It is, as Al-Khalil puts it, 'a concrete physical intervention in the city by the man who is behind all the

50 Saddam Husain (with Khalid al-Rahal and Mohammed Ghani), *The Monument*, with both arches seen along the ceremonial axis, Baghdad, 1989.

other changes', and represents him by way of a synecdoche: the 16-metres long forearms and fists meant to burst out of the ground were enlarged forty times from plastercasts of the President's limbs.[35]

Al-Khalil traces the origins of this climax of the 'kitsch of Baghdad' back to the political and artistic history of Iraq.[36] In 1958, the overthrow of the Hashemites' regime, marked by the toppling of the statues of General Maude and of King Faisal I (the latter has since been replicated on Husain's orders) also meant the end of Western influence inside Iraq. The artists who had come back from Europe and created the first modern, peculiarly Iraqi, visual tradition in the arts between the 1940s and the 1960s were progressively submitted to a restrictive notion of *turath* (heritage), instrumentalized by the Ba'th party in its ideological critique of Imperialism and Zionism, its anti-modernism and populism. At the same time, Al-Khalil's analysis points out relationships and draws parallels with Western contributions and developments. On a simply technical level, the arms had to be cast in a British art foundry. But he also discusses what he considers as 'structural correspondences' between Husain's monument and the 'post-modern' works of Andy Warhol and Robert Venturi, particularly in the way they elevated 'uncritical acceptance of public reality to the point of deification' and strove to obliterate 'the line between [art] and kitsch'.[37] It happens, moreover, that Venturi participated, together with other famous Western architects, in the international competition for a Baghdad State Mosque launched by Husain in 1983. There was, as it turned out, no winner, but the competitors participated in the massive (and destructive) urban renewal programme of the city.[38]

The author of *The Monument* thus accuses Venturi of having, by 1983, 'journeyed from acceptance to glorification to ideologization of vulgarity', and he eventually attributes to Husain's monument 'a message to all cultures that art cannot afford to be divorced from the judgement of what is art, nor morality from the judgement of what constitutes morality'.[39] In my view, his interpretation confirms the idea that if 'archaism' and 'modernity' may be used to name and defend values, they dare neither – for better or worse – be identified with an irreversible march of history, nor be clearly and definitively distributed on the surface of the planet. More prosaically, Al-Khalil's observations attest the world integration of economic and cultural exchanges and networks. Two more recent tokens of this phenomenon may shed light on their blurring of borders and categories: after fourteen years of prohibition, publicity for Coca-Cola was re-authorized in Iran in 1993 and began appearing even in the pages of radical newspapers still denouncing the 'decadent Western cultural invasion'; the leaders of the neo-Zapatist guerilla force in Mexico make a systematic use of the Internet to diffuse, 'in real time' and with the most modern means, true and false information on their fight in one of the country's most underdeveloped regions.[40]

6 Iconoclasm and Multiplication

One of the reasons proposed by Martin Warnke for the end of iconoclasm as a legitimate form of political action is the replacement in modern states of art objects with multiple images and electronic media as means of self-representation and legitimization. In his words, the 'archaic, craftsmanly intuition of artists' has given way to 'the art of manipulation of psychological precision mechanics', and 'the trans-substantiation of power in the categories of consumption aesthetics has given its visualization a degree of generality that takes it out of reach of the classical arts and thus of the classical iconoclasts, as both presuppose material isolation'.[1] A press drawing by Pancho takes this dethronement further: commenting on photographs taken by a member of the Magnum agency while President Mitterand was posing for his bust, the caricaturist shows a sculptor taking the television screen as the model for a monument that, in effect, represents the television together with the head of state's profile.[2] The paradoxical relation thus evoked is not only witty, but the recent revolutionary events in Central and Eastern Europe, as well as an enlarged perspective, call for discussion of this point too.

Iconoclasm and the mass media

Multiple and electronic images also contributed to the personality cults and state propaganda promoted in Communist countries, as in other totalitarian or authoritarian regimes; their lack of uniqueness did not prevent them from being abused as a sequel of their former use. After 1989 they happened to be treated in much the same way as painted or sculpted images. Press photos showed laughing and shouting young people holding a giant portrait of Ceaucescu pulled down to the ground and with its bottom broken, and two equally large photos of Honecker and Brezhnev, 'touched up to make them appear eternally young', taken from the wall in the main building of the East German secret police and supplied with an inscription denouncing their models as 'spies' and 'parasites'.[3] This is of course not specific to the 'Communist bloc', and one may compare the – more violent – assault on a portrait of President Marcos following his overthrow in 1968 as reproduced by David

Freedberg.[4] It must be added that the thousands of busts of Lenin or even major monuments shared the same serial character, and that photography also serves the self-representation of democratic states, for instance in France where the pair formed by the bust of Marianne personifying the Republic and the portrait of the President, displayed in every town hall, may be considered as a contemporary illustration of the 'King's Two Bodies'.[5]

But a more important relationship between the handling of 'isolated' – if not 'unique' – symbols and the (more or less) immaterial media derives from the capacity and propensity of the latter to transmit and reproduce the former. The success enjoyed by movable and fixed pictures of statues defaced, pulled down and banished since 1989 has already been pointed out. There is no doubt that in the countries where the scenes were shot, and in those confronted with the same problems, such images must have played very specific political roles. In the West, in any case, they were characteristically presented with little or no details concerning the circumstances and meanings of the actions and objects depicted, and used to symbolize (a further interpretative instrumentalization) in a generic or even globalizing way the political, social and sometimes economic transformations of which they were a part. The simplification implied has been denounced as ideological by Albert Boime, who wrote that 'the complexities of the statue-mania were glossed over in favor of a broad symbolic association of the collapse of the Soviet Communism and the toppling of statues'.[6] An analogous use, though, can be attributed to the actors themselves in earlier instances – in particular the Hungarian Rising of 1956 – and observed in recent publications of a more analytic nature; however scientifically unsatisfying, it does correspond to the ostentatious and exemplary nature of the actions and to part of the intentions involved.[7]

The fall of the Communist monuments has also supplied Press caricaturists with a gold-mine. Their drawings have rarely commented on the defacing of specific monuments, but some were themselves acts of defacement, and may thus be compared with the metaphorical, indirect, and sometimes preparatory forms of iconoclasm already mentioned. Understandably, the most frequent target was Vera Mukhina's famous *The Worker and the Collective-farm Woman* of 1937, realized to crown the Soviet pavilion in the Paris World exhibition and re-erected in Moscow (illus. 51). A visualization of Soviet social theory, including the Communist emblem and expressing the irresistible progress of the Revolution, it has been submitted to countless adaptations in order to appropriate it to the real or the new situation: the hammer and sickle were replaced by a stethoscope and a hair-drier; the farmer left her partner hanging (or rather falling) to look for more profitable activities on the ground (illus. 52).[8] The simplest and most effective transformation – as well as the closest to literal iconoclasm – was, however, a touched-up photo proposed by the American cartoonist Art Spiegelman as an entry for Komar and Melamid's

51 Vera Mukhina,
*The Worker and the
Collective-farm
Woman*, 1937,
chrome-nickel steel,
Moscow.

52 Cartoon by A.
Chabanov in *Izvestia*,
1992.

53 Cartoon by Serguei in *Le Monde* (21 September 1990).

Monumental Propaganda exhibition: the two figures were pushed forward in relation to the pedestal, and thus shown on the verge of falling.[9]

To return to newspaper cartoons, others denounced iconoclasm as an illusory substitute for real action by showing a statue of Enver Hoxha broken by the crowd that revealed – in the way of Russian puppets – a smaller statue within of the Albanian leader, or Boris Yeltsin rising clothed as tsar between two broken monuments to Lenin and Stalin.[10] Transfers to national or local actuality were to be expected, as when the retirement of Georges Marchais as First Secretary of the French Communist Party was represented as the self-removal of a bronze statue.[11] But the most profound visual comment of this kind that I have encountered was published by Serguei on 21 September 1990, a few weeks before Mikhail Gorbachev's decree 'on stopping the defacing of monuments that are linked to the history of the state and its symbols' (illus. 53). The cartoon accompanied a review of Hélène Carrère d'Encausse's book on the disintegration of the 'Soviet empire' and its national causes.[12] The First Secretary's admission that the Soviet federation was a myth is visualized as a self-injuring assault on a bust of Stalin. The metaphor of the cracks extending to the ground evokes the traditional image of sawing the branch on which one sits, as well as Goethe's apprentice sorcerer; it may also have echoed the reviewer's observation that the historian had privileged in her analysis the importance of cultural over economic and social factors – and thus reversed the classic Marxist view of the relationship between 'superstructure' and 'infrastructure'.

The fact that iconoclastic actions appeal to the media notably increases their public effect, so that the development of the illustrated press and television, rather than contributing to make them definitively obsolete, has supplied them with a new actuality. This is all the more true as the manipulation of

images, practised on a grand scale by some Romanian 'revolutionaries', now disposes of techniques incomparably superior to the retouching notoriously applied to Soviet group portraits, and as the 'law of the image' denounced by a Japanese editor tends to subordinate the choice of the transmissible (or saleable) information to the existence and quality of a photo: 'Some events are only reputed to have taken place if there exist images of them. No picture, no news. Fine picture, long news'.[13] Many commentators on the fall of the Communist monuments, particularly in Germany, have stressed the importance of this visual domination not only for the reception of the events, but for the events themselves.

The fact that actors and promoters of iconoclasm were conscious of its efficiency for the mass media, and could be encouraged or even motivated by it, seems fairly obvious. In some cases, the media launched inquiries, consultations or petitions that helped obtain or justify interventions. The tardy removal of East German monuments has been repeatedly related to the massive transmission of the Russian iconoclastic episode following the failed coup of 1991 and its effect on politicians.[14] It was even suggested that the main addressees of the Moscow 'statue park' may have been photographers.[15] According to Michael Diers, finally, some eliminations were staged on the model of TV show-trials.[16] Such interpretations must probably remain a matter of conjecture. But the narrow mutual relationship established henceforth between the physical interventions on 'isolated' objects and their indefinite visual multiplication is undeniable. One may see a multiple symbol of this in a photo taken in Kiev, where the place of the monument to the Great October Revolution (illus. 54), erected in 1977 – with a paraphrase of Tomsky's East Berlin statue of Lenin as its main element – and destroyed in 1991 after Ukraine had declared its independence, is occupied by a giant advertisement for a store selling imported copiers and cameras (illus. 55).[17]

Uniqueness and iconoclasm

We have seen that two interrelated taboos appeared in the eighteenth century, the one on 'vandalism', the other on the extrinsic finalities of art. To put it differently: art was not to be destroyed, and it was not to serve any master but itself, which can be read as 'art does not serve any master, therefore it must not be destroyed' but also, as the fall of the Communist monuments has recently shown, 'art is not to be destroyed, provided it does not serve any master' or, in a shorter version, 'provided it is art'. Was the multiplication of images also connected to this process? Reflection on the effects on art of replication is marked by Walter Benjamin's celebrated essay on the loss of 'aura' and the transition from a 'cult value' to an 'exhibition value'.[18] Nathalie Heinich has objected to its conclusions: that far from weak-

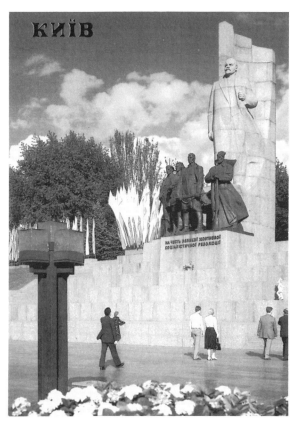

54 The monument to the Great October Revolution (architects A. Malinovsky and N. Skibitsky; sculptors V. Borodai, V. Znoba and I. Znoba) in the central square, Kiev, in 1977.

55 The pedestal of the monument to the Great October Revolution, Kiev, removed in 1991, with an advertisement for a camera shop, August 1992.

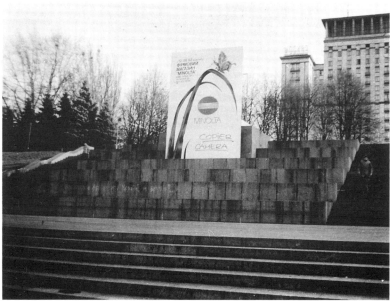

ening the 'authenticity' of the 'original', multiplication has enhanced by contrast those newly conceived qualities of the work of art.[19] Indeed, for Raymonde Moulin, the first Industrial Revolution is at the origin of this transformation: from then on, artists had to defend the specificity of their products against those of industry as well as of handicraft, and this was achieved by eliminating from their practice the utilitarian project common to the other two and by stylizing the uniqueness of every work of art into an essential predicate, opposed to the interchangeability of serially produced industrial objects and to the irrelevant variability of handmade artefacts.[20] The art market, followed by the law, entrenched this definition: to be recognized as a work of art, an object had to be 'the unique product of the undivided labour of a unique creator'. The 'residual rarity' of ancient objects could be artistically promoted after they had been preserved as culturally significant and defunctionalized; for contemporary production, artistic rarity had to be itself 'produced' or 'manipulated'.[21]

To 'produce' artistic rarity implies eliminating, directly or indirectly, potential art. This process is best observed in the artistic techniques that permit (and were developed for) multiplication. Michel Melot has analysed it in the case of printmaking, where artists as well as lovers, collectors and dealers of art elaborated and defined in the second half of the nineteenth century the criteria of a 'gravure originale' against the industrialized image and the previously highly regarded reproductive print. They resorted to the use of archaic methods, autograph signatures, limited editions and the destruction of plates, the numbering of each print, not to mention the countless ways in which prints pulled from the same plate could be made to differ from one another.[22] These operations progressively became standardized, and were justified as a necessity from an aesthetic as well as commercial point of view, and, by and large, they still are.

The destruction of plates, in particular, is never regarded as 'iconoclasm' or 'vandalism', although they are the very objects that the artist worked on. But plates are said to be nothing but stages or instruments in the creation of a work of art (the print), an argument that has been fatal to many original plastercasts but tends to be less so. The work as such may rather be damaged by the poor quality of copies obtained in too large an edition, it is also said, and what could be deemed vandalism is the old practice of employing engravers to rework worn plates – an argument that reminds one of the 'anti-scrape' campaigns against the restoration of buildings and paintings.[23] Besides, plates are 'destroyed' – i.e. defaced so that further copies of the same print cannot be made from it – in a highly euphemistic manner, generally by the artist in person and by means of scoring lines across it, a practice that has tended over time to become less and less obtrusive. Picasso, for instance, integrated the scratches in the original design and added new graphic 'remarks' in a way that makes

56 Félix Vallotton, cancellation sheet from the album *Intimités*, 1897-8, woodcuts. Musée Cantonal des Beaux-arts, Lausanne.

the 'crossed proofs' of his *Métamorphoses d'Ovide*, for example, (rare) works in their own right.

But something of the violence implicit in this Malthusian method can be perceived in another play with the rule – the remarkable print composed of pieces of the chopped-up woodblocks used for the series *Intimités* that Félix Vallotton used in the album as the table of contents and evidence of the limited edition (illus. 56). And it was explicit when the idea of having the plate scored through came to the art critic Philippe Burty. In 1863, the other nine members of the Société des Dix, a group of collectors who commissioned prints directly from artists, indignantly rejected 'the destruction of the plate'; in 1869, when Burty managed to publish the album *Sonnets et eaux-fortes* ('sonnets and etchings'), the artists invited to participate had to obey his request, but Jean-François Millet wrote to another collector: 'I find this destruction of plates the most brutal and barbarous thing. I am not versed enough in commercial schemes to understand what it leads to, but I know well that if Rembrandt and Van Ostade had made one of those plates, they would be annihilated. Enough on that.'[24]

Submission to the criterion of rarity sounds even more absurd in the case of photography, since its multiplication does not entail any degradation of the

negative; yet the painstaking recognition as works of art of products of this mechanical and industrial activity requested such a submission, and the 'second market' of photography (after the sale of reproduction rights), that of photographic prints, was organized on the model of the *gravure originale*, implying sometimes the destruction of negatives.[25] Of course, the history of modern, and particularly of contemporary, art seems to be replete with forms or events that contradict the demands of uniqueness and non-division of labour. But, in many cases, this very contradiction results from the status of rarity in a traditional definition of art that the forms and events in question aimed at questioning; and, according to Moulin, the 'trap of rarity' closes on them in two ways: the limited edition of whatever functions as a substitute for a work, and the uniqueness of the author, on whom rarity is transferred.[26]

Readymades

Typically, the paradigm of twentieth-century avant-garde 'iconoclasm', Marcel Duchamp's Readymade, is an 'assault against rarity'. Duchamp decided in 1915 in New York to designate by the Anglo-American phrase 'ready-made' industrially produced objects or images that he had begun to buy in Paris two years before, and to place in an unusual way in his flat or studio, to inscribe with intriguing words and sometimes to modify slightly – a bicycle wheel, a bottle-drier, and later (to mention only the 'pure', more or less untransformed ones) a snow-shovel, a steel comb, a typewriter cover, a porcelain urinal (illus. 57), a coat- and hat-rack, a glass ampoule. Among the 'rectified Readymades' were two photomechanical reproductions, one of a winter landscape, the other of Leonardo's *Mona Lisa* (illus. 113). Most of them later disappeared and were replaced by fresh examples of the same objects; pointing this out, Duchamp would insist in 1961 on their 'lack of uniqueness' and on 'the replica of a "Readymade" delivering the same message', and declared that they had been 'a way of getting out of the exchangeability, the monetarization of the work of art, which was just beginning about then'.[27] But in notes written between 1912 and 1915, which he published in 1934, appears the indication 'Limit the no. of rdymades yearly (?)', which he followed, and on which he commented in 1961, by saying that he had 'realized very soon the danger of repeating indiscriminately this form of expression'.[28] In 1964 Duchamp collaborated on the production, by the Galleria Schwartz in Milan, of replicas of thirteen Readymades in editions of eight numbered and signed copies. There was much commotion about what some considered was a self-betrayal, but the author declared that the small number made it all right since 'rarity gives the artistic license'.[29]

Judging from other notes that appeared in 1980 only, one basic source of the Readymade was the nominalist idea that there is no such thing as 'similarity' or

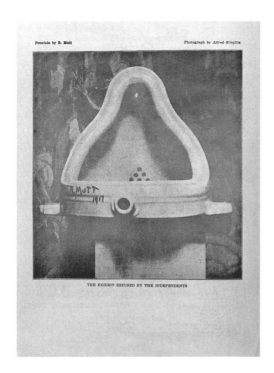

Fountain by R. Mutt Photograph by Alfred Stieglitz

THE EXHIBIT REFUSED BY THE INDEPENDENTS

57 Marcel Duchamp (signed
as R. Mutt), *Fountain*, 1917,
inscribed porcelain urinal on
its back. Photograph by Alfred
Stieglitz, reproduced in *The
Blind Man* (May 1917).

'identity', and that beings, objects or forms designated by the same name or fabricated from the same mould are none the less different. The less apparent this difference – industrial products, for example – the more essential it must be; Duchamp's aim was to 'go into this infra-thin interval which separates 2 "identicals" '.[30] To some extent, his handling of ubiquitous artefacts was a kind of anticipation of 'residual rarity' and may be compared with the mental and physical operations that accompany attempts to alienate or preserve Communist monuments: to quote an anonymous but well-informed defender of *Fountain* in 1917, 'he took an ordinary article of life, placed it so that its useful significance disappeared under the new title and point of view – created a new thought for that object'.[31] In this case too, the mental ties that had to be severed were those of function, 'utility', so that the Readymade actually represented a paradoxical, but all the more efficient, confirmation of the modern definition of the work of art as an emancipated object for a disinterested eye. We shall see later, however, that this very self-sufficiency, combined with modernist anti-traditionalism, was bound to provoke violent reactions.[32] But it must first be reminded that even though it implied a depoliticization, complete aesthetic autonomy could be invested with political meaning and in turn be politically instrumentalized.

7 Free Art and the 'Free World'

We have seen that the advocates of a discriminating and reasoned handling of the monuments of the Communist era in Berlin repeatedly argued that this implied reviewing the post-War monuments of both parts of the city, and that one of the members of the commission eventually disapproved of the limitation of its mandate to East Berlin. In 1992, in the context of the 'Preservation of Monuments and Sites' session of the International Congress of the History of Art held in Berlin, the curator of monuments Christine Hoh-Slodczik also regretted that the public debate on the rash transformation of the city, which involved the disappearance of 'City-West, celebrated for decades as a "shop-window of the Free West" and symbol of the city's will to survive', remained concentrated on the Eastern part, 'as if the competing construction of two city centres as mirrors of two political systems had not taken place'.[1] As for monuments in a more restricted sense, Eberhard Elfert stressed the same historical, political and aesthetic relationship when he concluded his summing up of the Friedrichshain Lenin affair by affirming that 'the political monuments of the DDR represent, together with the monuments of the Cold War era in the Western part of the city, a unique net of historical witnesses, which documents the meeting of two different political systems in one city', and that the historical value of many post-War monuments in Berlin depended on that confrontation.[2]

Political monuments in West Berlin

In effect, political monuments had been erected in West Berlin too. The first was the semi-abstract Airlift memorial inaugurated in 1951, which had been commissioned by the city Senate to commemorate the 77 victims of the blockade of 1948–9.[3] Among the last examples was an abstract representation of the division of Berlin by means of two gigantic intertwined broken loops, erected in 1987 for the 750-Year-Anniversary-Festival of the city in the context of the 'Sculpture Boulevard' exhibition set out between Gedächtniskirche and Wittemberg Square.[4] In 1989 a figurative work by Gerhard Marcks, *The Caller*, which had been created in 1967 for a site in Bremen, was installed in

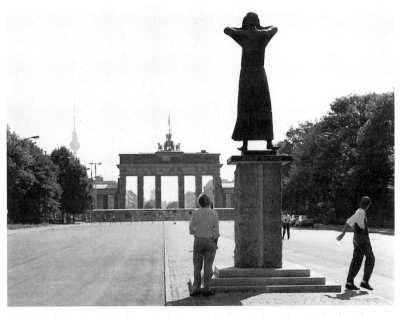

58 Gerhard Marcks, *The Caller*, 1967, in front of the Brandenburg Gate, Berlin, in 1989.

front of the Brandenburg Gate to transmit its appeal to freedom across the Wall (illus. 58). In 1952–3, an international competition for a 'Monument to the Unknown Political Prisoner' had been organized by the Institute of Contemporary Arts, and West Berliners had planned to erect it on an elevated site near the border. No artist from the 'Soviet bloc' participated in the competition, and most prizes were attributed to 'symbolical' and non-objective works, in particular to that of the English sculptor Reg Butler, who received first prize. The exhibition of the submitted projects, held in London at the Tate Gallery, provoked violent controversies about 'the question of contemporary art as a means of communication', among others a debate between John Berger, who reproached it with being inconclusive, abstract, sentimental and too generalizing, and Herbert Read, who accused Berger of defending a kind of Socialist Realism. A Hungarian refugee artist, László Szilvassy, even destroyed Butler's maquette, claiming to have escaped as a political prisoner of the Communists and accusing the English artist of reducing 'the memory of the dead and the suffering of the living . . . into scrap metal'.[5]

As this last (unrealized) example shows, aesthetics were involved in the Cold War too. Artists had to choose, as they had after the Reformation. In Berlin, for example, the sculptor Gustav Seitz, born in 1906, lost his professorship at the Hochschule für Bildende Künste in West Berlin after he became a member of the Deutsche Akademie der Künste in East Berlin; after years of living in the Eastern part and working in the Western one, he moved to Hamburg in

1958, but kept being attacked for his attachment to figuration, while Eastern critics reproached him with 'bourgeois formalism'.[6] As late as 1988, the reviewer of a conference bringing together (exceptionally) sculptors from both sides ascertained that 'the artistic positions in East and West were too loaded with ideology and too fearfully closed to one another' for the meeting to allow more than 'an exchange of information, hardly of ideas'.[7] The theme chosen, 'Image of Man and Abstraction', made only manifest that 'the parts were distributed beforehand: non-objective art hither, figurative art thither; there a fight around the figure, here its banishment from the work'. For the one, abstraction was 'a devaluation of man and a symptom of a deep break between artist and public'; for the other, it was part of the autonomy of polysemic works to be construed by a free receiver, and derived from the best idealist tradition in that it made of man the aim instead of the object of representation.

Modern art and the Cold War

This association, or even equation, of the values and characteristics of modern or contemporary art with those of the political system that allowed – or tolerated – its blossoming, permitted autonomous art, by virtue of its very independence, to symbolize and thus to serve the Western democracies in their ideological confrontation with 'existing socialism'. Needless to say, matters were more complicated, and the triumph of the New York School after the War also helped establish a much-disputed American hegemony in the 'Western camp'. The government of the United States was suspected of financing the competition for the 'Monument to the Unknown Political Prisoner', because of its direct political content and as an artistic manifestation that could exhibit the Western democratic ideals of individualism and freedom of expression.[8] Denouncing the 'objective' collusion linking 'decadent modernism' and 'bourgeois imperialism' was a leitmotif of Soviet artistic propaganda.[9] But it has been shown that avant-garde art, particularly Abstract Expressionism, was indeed utilized to represent American liberal values, first in the USA, then in Europe, and as a means of anti-Soviet propaganda in Berlin.[10]

This may have been not only a question of instrumentalization. Evoking the late 1930s in New York, Clement Greenberg later wrote that ' "anti-Stalinism", which started out more or less as "Trotskysm", turned into art for art's sake, and thereby cleared the way, heroically, for what was to come'.[11] The defence of modern art against Fascism and Stalinism thus contributed to its promotion in the West; in 1942, the collection of the Museum of Modern Art in New York was understood to be a 'symbol of one of the four freedoms for which we are fighting – the freedom of expression. . . . It is art that Hitler hates because it is modern – progressive – challenging. Because it is international, because it is free.'[12] After the War, this political and moral reading

and the institutionalization it justified, tended to delegitimize not only the Socialist Realism of the Soviet Union and its intermediate forms in the 'popular democracies', but the Western 'new realisms' as well, linked or not to Communist parties – even if the USA also tried to counter-attack by presenting Ben Shahn's 'social realism' at the 1954 Venice Biennale.[13]

In West Germany, this politically justified promotion of modern art obviously possessed a special import, as it had to contribute to de-Nazification and to the construction of democracy. Here more than anywhere, the defamation and persecution by the Nazis of autonomous art on the basis of form and style had given it a prominent political significance. The rehabilitation of German modern art and its publicly supported social diffusion by art associations and museums thus participated in the reconstruction and 're-education' of the new Federal Republic, with a sense of mission on the part of its promoters and characteristics of 'cultural politics of bad conscience'.[14] Walter Grasskamp has interpreted the first Documenta exhibition in 1955 as a direct and indirect answer to the trauma represented by Nazi iconoclasm, and more specifically by the 1937 exhibition 'Entartete Kunst'. A central position in the staircase of the Fridericianum in Kassel was thus given to Wilhelm Lehmbruck's *Kniende* ('Kneeling Woman'), a work that, after its creation in 1911 and its acclaim as an outstanding representative of German Expressionist sculpture in the main international exhibitions of modern art before the First World War, had been verbally attacked, pulled down and damaged when exhibited as a bronze in the open air in Duisburg in 1927, and included in the defamatory Munich exhibition ten years later.[15] At the entrance, a wall of photographs showing 'archaic, early Christian and exotic-primitive art objects' was to legitimize the primitivism of modern art by evoking a continuity of the primitive opposed to the Nazi-sponsored continuity of the classic.[16] Another legitimizing use of photography principally served abstraction and was proposed by the magazine *Magnum* to accompany the second Documenta in 1959: it consisted of the juxtaposition of reproductions of modern works and views of real contemporary objects or events, with comments pointing out the alleged indirect realism of the former. One of these ambiguously enhancing comparisons unmistakably paralleled Schulze-Naumburg's devaluing assimilations of 1928 (illus. 18): a gouache by Wols was paired with the photograph of a wrecked person, and the caption affirmed that the art of today, far from destroying the image of man – as was frequently said – was a cautionary representation of man's self-destruction (illus. 59).[17]

According to Grasskamp, modern art was thus enthroned rather than actually rehabilitated, and amounted to modernism rather than modernity. In particular, support was granted to formal, not political, progressiveness, and the socially engaged art of the Weimar Republic tended to be excluded from relevant genealogy, just as the equation of Stalinism with Nazism as 'totalitar-

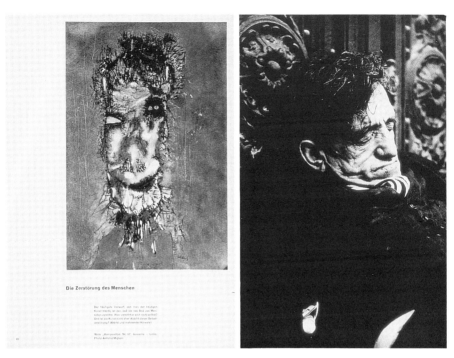

59 A double-page spread from 'Documenta der Kunst – Documenta des Lebens' in *Magnum* (June 1959); on the right a photograph by Antonio Migliori, on the left a gouache by Wols, *Composition no. 10*.

ian' regimes discredited Socialist – especially East German – art. This depoliticization of art was denounced as political in the 1960s, when the student movement also attacked cultural institutions. In between, the 'need to catch up' (*Nachholbedarf*) of the immediate post-War period had been replaced by a connection to what was regarded as the international avant-garde, so that the local and regional ties of cultural institutions were loosened to the benefit of orientations and stakes on a larger scale.[18] With the crisis of modernism and of its pretension to represent the whole of contemporary culture, modern – or rather 'contemporary' – art lost much of its symbolizing value for Western democracies. Justification for public funding tended to be submitted to the logic of the free market and to depend on the number of entries and sales, promoting the development of publicity and spectacularization, in a context marked by 'cultural industry' and the organization of leisure.

Institutionalization and aggression

This does not mean that modern art has ceased to meet with opposition. We shall have to return to this question apropos of contemporary 'vandalism', but

some elements are needed at this point. It has been mentioned that in 1952–3 the projects for a 'Monument to the Unknown Political Prisoner' selected by the international jury had been dismissed by the public. Rejection came from above as well as from below, as Sir Winston Churchill had thought it necessary to mock Butler's model during a banquet speech to the Royal Academy, believing that the realized work was to stand on the cliffs of Dover (where six years earlier it had been proposed to erect, along with bulldogs five metres high, an effigy of Churchill giving the famous V for Victory sign while smoking an ever-burning cigar that would serve as a beacon for shipping).[19] To some extent, the difficulties modern art encountered 'as a means of communication' were already present in the principles of the autonomous aesthetic elaborated in the eighteenth century in Germany. In it, as Martin Warnke has formulated, 'the bourgeoisie, economically powerful but politically under tutelage, articulates its utopia of a undetermined art, free from domination. From then on, works of art no longer primarily support symbols of power, they do not only represent particular interests any more, but they make human, moral, national norms appear to the senses.'[20] This enlightened universalism, powerfully supported by the French Revolution, was to bear not only on the definition of the role of art, but on that of its addressees. Art was for every human being to enjoy, and a human being was one who enjoyed art. This concealment of the social conditions of aesthetic communication – of great value for 'particular interests' in conflicts of social hierarchy – was never stronger than in the definition and promotion of modern art after the Second World War. In the manifesto published in *The New York Times* on 13 June 1943 by Adolf Gottlieb and Mark Rothko, Surrealist insistence on the relationship beween art and social life appeared reduced to a will and need to communicate freely with a public enlarged to include the whole of mankind, by means of an art emancipated from time thanks to a 'spiritual kinship with primitive and archaic art'.[21]

After the War, however, the utopian character of this supposedly unproblematic and socially undetermined communication progressively became more manifest, as a result of a number of linked factors. The evolution of autonomous art, based on the principles and logic of perpetual innovation and transgression, demanded from the perceiver an ever greater knowledge of its own history, and remained linked to the mental equipment of the non-specialized public – or 'non-public' – only insofar as the latter served it as negative set-off. The institutionalization of avant-gardism, on the other hand, permitted this art to be suspected and accused of arising from a collusion between pseudo-artists and self-elected experts and of provoking a waste of public funds. Finally, the spectacularization of artistic institutional life by means of highly publicized exhibitions and museum acquisitions literally exposed art, especially contemporary art, to a greater degree. The provisional or

permanent installation in public spaces of works (often not conceived for them and thus becoming generically criticized as 'drop sculpture'), a step generally justified by a will to 'democratize' art and to inform the public at large but also encouraged by reasons of administrative financing, urban design and local or supra-local politics, particularly brought the resulting conflicts to light. Such works – mostly sculptures – were rejected (and often assaulted) as invaders, instruments of an authoritarian occupation of public space and expressions of the cultural domination of social elites.[22] The more prescriptive than descriptive idea that art was there for all became untenable, and the relationship between contemporary creation and democracy visibly problematic. Cultural actors and institutions were generally content with dismissing negative reactions – not to speak of violent ones – as expressions of ignorance, intolerance, or resurgences of the Fascist dislike of modernism (an easy recourse to the post-War taboo that was sometimes facilitated by Rightist attempts at instrumentalizing public opposition).

'Sculpture Boulevard'

But if the causes remained unrecognized, the effects were apparent, and it is remarkable that in the debates about the fate of Communist statues, particularly in Germany, parallels with this other class of 'undesired monuments' – to use Grasskamp's phrase – were so rarely drawn. I personally know of only two exceptions: a passage in Hans-Ernst Mittig's introduction to the exhibition catalogue *Preserve – Destroy – Modify?*, in which the author argues that the replacement of the DDR's political monuments with irrelevant sculptures of the kind provoking indifference or 'vandalism' in the West would hardly be progress; and a widely diffused letter addressed by Alfred Hrdlicka on 31 October 1991 – immediately before the beginning of the demolition of Tomsky's Lenin – to East Berlin's Akademie der Künste, in which the Austrian artist accused the West Germans of dictating to their new fellow-citizens a 'capitulation without conditions' and provocatively proposed to submit the art of East and West to the rules of Western economy:

If the free Western art believes itself to be so superior, then it must enter into free competition with Socialist Realism. My proposition: in place of the demolished statue of Lenin, let us carry [Richard] Serra's iron stele from Bochum – a comparable order of magnitude – and erect Lenin in Bochum. Marx and Engels [on the Marx-Engels-Forum] exchange their site with [Max] Bill's sculpture before a West German bank, etc. We will see what is more attractive. I only fear that the free Western art will not fare particularly well, because of its irrelevance.[23]

The reference to Richard Serra is in accordance with the particularly controversial reception of his interventions in public space, of which we shall see more in the next chapter.[24] In Berlin, a work of his, *Berlin Junction*, had been

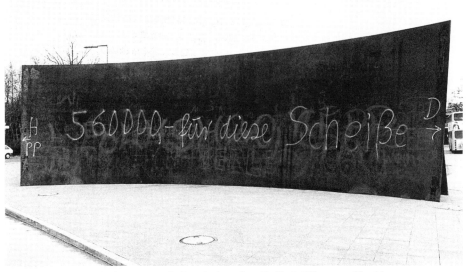

60 Richard Serra's *Berlin Junction* near the Brandenburg Gate, Berlin, in February 1988, with a sprayed inscription '560,000 [DM] for this shit'.

installed in the neighbourhood of the Wall and the Brandenburg Gate; one of the numerous inscriptions written or drawn on its surface read, in February 1988, '560,000 [DM] for this shit' (illus. 60). As for the general reception of art in public space, what could later be called a 'sociological experience' or 'maybe the biggest public discussion of modern art since 1945' had actually taken place in West Berlin in the years 1987–8, with the exhibition 'Sculpture Boulevard' (*Skulpturenboulevard*) on Kurfürstendamm and Tauentzien Street.[25]

The project had been conceived and commissioned to crown the 750-Year-Anniversary-Festival by Volker Hassemer, then Senator in charge of culture. It was to be a kind of 'art mile' in the commercial and leisure centre of the city, as well as a 'provisional museum'.[26] A special commission directly chose the artists, all living in West Berlin, who belonged to different generations and represented diverse stylistic positions. No particular attention seems to have been paid to the problems thematized or handled simultaneously by two major artistic events in West Germany: the 'return of the artist to the social context', at the eighth Documenta in Kassel, and site-specificity at the art-in-public-space exhibition *Skulpturprojekte in Münster* (Westphalia). Accordingly, the Berlin manifestation was criticized by some for its centralized and elite conception, and by as many for a large budget that appeared out of proportion in relation to the project's ephemeral character.

Controversies flamed up long before the exhibition officially opened, and a

61 Olaf Metzel's sculpture *13 April 1981* in Joachimstaler Square, during the 1987 *Skulpturenboulevard* exhibition Berlin as part of the Berlin 750-Year-Anniversary-Festival; the incription on the poster reads: 'Tendency: chaotic / Costs: shameless ...'.

negative opinion publicly expressed by Mayor Eberhard Diepgen did much to authorize them; in fact, the evaluation of the exhibition led within the CDU (to which both Hassemer and Diepgen belonged) to a polarization between a favorable Left wing and a dismissive Right wing. The 'occupation' of the Kurfürstendamm by the eight sculptures (among which were the intertwined broken loops entitled *Berlin* by Brigitte and Martin Matschinsky-Denninghof) provoked a flood of reactions, mostly negative and often violent. Two works in particular attracted aggression, Olaf Metzel's *13 April 1981* in Joachimstaler Square (illus. 61) and Wolf Vostell's *2 Concrete Cadillacs in the Form of the Naked Maja* in Rathenau Square (illus. 63). Characteristically, both included contemporary ready-made elements. Metzel referred to a demonstration that had taken place six years earlier on the boulevard by elaborating a construction of road barriers and trolleys from a detail seen in a view of the event. Vostell related his Goya-inspired arrangement of luxury cars to the erotic foundation of the 'myth automobile' and his regard for the car as 'the greatest sculpture of the twentieth century'; it was to enlarge the notion of sculpture by integrating the 'enormous craftsmanlike production of cars by industrial society' and would visualize, in the middle of real traffic on the square, 'the 24-hours "dance" of the car-drivers around the Golden Calf'.[27]

Apparently, these allusions and intentions escaped most of the involuntary

62 *Summit*, an anonymous 'Trabant sculpture' erected in the Rathenauplatz in July 1987 as a comment on Vostell's *2 Concrete Cadillacs*. The text reads: 'Unity and the right to artistic freedom!'; the number-plate 1A-B750 refers ironically to the quality of products displayed for the Berlin 750-Year-Anniversary-Festival.

63 Wolf Vostell, *2 Concrete Cadillacs in the Form of the Naked Maja*, in the Rathenauplatz, during the 1987 Berlin *Skulpturenboulevard* exhibition.

spectators. It must be added that neither the organizers nor the artists had expected such a wave of indignation, and that the money and effort devoted to both dispensing information and mediation proved totally insufficient. Opposition to Vostell's sculpture was particularly well organized and enduring, with a 'Bürgerinitiative Rathenauplatz' (Rathenau Square Citizens' Initiative), launched by an 'academic' painter and spontaneously joined by hundreds of upper-middle-class inhabitants of the neighbourhood coordinating the action. While an effect of gradual acceptance was noticeable regarding the other works, eventually allowing the Senator to prolong the exhibition in 1988, 'European year of culture', it did not abate in this case – though to no avail, since the sculpture was finally bought with private and public funds and maintained on the site. The means of protestation employed included human chains, happenings, tracts, banners, petitions, advertisement campaigns and TV debates. The most imaginative one consisted of three-dimensional comments to the works, which were granted the generic label 'Trabantskulpturen' (Trabant sculptures) because of their most famous example, an East German car placed within a concrete pyramid near Volstell's *2 Cadillacs* (illus. 62, 63).

Violence was not lacking. There were physical assaults, calls for 'Nacht-und-Nebel-Aktionen' (nocturnal actions), as well as anonymous letters and menaces. Phrases like 'degenerate art' and 'art of lunatics' appeared on the street and in readers' letters to the Press. This finally led the Berlin Academy of Arts to denounce publicly a degeneration of the debate into irrationality and defamation of artists that was doing unpredictable harm to the 'image of cultural openness' of the city and awoke 'the memory of the darkest age of art vandalism fifty years ago'.[28] Further protests against intolerance, 'opportunism' and 'populism' were expressed, but generally the artistic institutions observed the events from a safe distance. The mass media, on the contrary, accompanied or fuelled the controversy from the start. On 29 March 1987, one month before the opening, the *Berliner Morgenpost* published a photograph of Vostell's sculpture under construction and asked its readers: 'Kurfürstendamm – art or junk?' A few days later, a local TV station dedicated an evening show to the question 'leave in place or remove?'; the result was that 76 per cent of those who voted were in favour of its removal.[29]

In retrospect, comparisons with what was done and said only two years later with regard to the political monuments of East Berlin seem inevitable, and one cannot but marvel at the fact that the same Senator who, in charge of culture, had imposed and maintained the 'boulevard sculptures' through a storm of protests later promoted, as the person in charge of city development and environment, the removal of Tomsky's *Lenin* on the grounds that 'popular wrath' was a 'respectable emotion' and could provoke 'problematic developments'.[30] It is even more remarkable that such comparisons do not appear to have been

made at the time. It seems as if the objects in contention, 'undesired monuments' of the 'free Western art' on the one hand, obsolete symbols of a fallen regime on the other, belonged to such diverse categories as not to enable the public to judge their treatment by the same standards. The official view, according to which attempts at removing the former amounted to 'vandalism', while removing the latter corresponded to the legitimate interests of the city, could thus remain essentially unchallenged.

8 Legal Abuse

Moral right and freedom of speech

Constitutional states give a legal frame to the handling of art and to conflicts on which it is predicated. We have already met with two cases where a judicial appreciation was involved: in Berlin, the court judged that the owner's – i.e. the City of Berlin's – right to dispose of a 'scandalous' monument took precedence over its author's right to the respect of his work; in Berne, where the action had already, and illegally, taken place, the question was of its interpretation as 'political'. These cases confront us with the main issues at stake. Considered as the personal expression of an individual and a spiritual enrichment for all, yet remaining (often) a tangible and (almost always) an exchangeable good, the work of art induces conflicts between the 'traditional right of the owner ... to use or abuse his property as he pleases' and the rights of the artist over his or her work on the one hand, and the interest of the public in preserving the integrity of cultural property as well as the state's guarantee of intellectual freedom on the other.[1]

Of particular relevance to the artists' rights is the so-called moral right, as distinguished from patrimonial or property rights. It is a composite right, comprehending the right of integrity of the work of art (also called right to respect of the work), the 'right of paternity' (i.e. the right of the artist to insist that his or her work be associated with his or her name), the right to withhold the work (sometimes referred to as right of divulgation), and may also include the 'right to repent or to retake' and the 'right of modification'. As the name indicates, moral right is based on the assumption, already formulated by Kant in his *Doctrine of Law* apropos of books, that a work is not only a material product of art, liable to real right, but a discourse of the author with the public, to which a personal right must apply.[2] In Europe, particularly in France, jurisprudence and the law have adopted this conception of the work of the spirit as an attribute of personality, from which derives an analogous status of creation and person.[3] Its application has been disseminated and enforced by international conventions, especially the Berne Convention for the Protection of Literary and Artistic Works, distantly inspired by Victor Hugo, which was first signed on 9 September 1886 in Berne and revised for the last time in Paris on 24 July 1971.[4] As of 1991, it has been signed by 78 countries, including the

USA, although with reservations to which we shall return.[5] Clause 6 *bis* of the Convention states that 'independently of the author's economic rights, and even after the transfer of the said rights, the author shall have the right to claim authorship of the work and to object to any distortion, mutilation or other modification of, or other derogatory action in relation to, the said work, which would be prejudicial to his honour or reputation', while leaving the definition of the duration of these rights, of the persons or institutions authorized to exercise them, and of the means of redress for safeguarding them, to the legislation of the country where protection is claimed.[6]

That the author of a work is thus entitled to oppose a modification that he or she considers as a degradation is clear. That he or she may object to a destruction, however, depends on interpretation. A commentator on the Berne Convention as revised in Rome in 1928 considered, for instance, that destruction does not offend 'the need of the creator for protection of his honor and reputation. To deform his work is to present him to the public as the creator of a work not his own, and thus make him subject to criticism for work he has not done; the destruction of his work does not have this result.'[7] In West Germany, most commentators of the 1965 copyright law have equally regarded annihilation as admissible, unless its sole purpose is to harm the author.[8] It must also be recalled that even if the artist is legally granted an interest in the preservation of his or her work, the judges' decision depends on a weighing of interests that may favour those of the owner, as was the case with Tomsky's statue of Lenin. Concern for an artist's 'honour or reputation', finally, can lead to a demand for, as well as an opposition to, destruction. This is what the French painter Charles Camoin successfully did in 1925 with canvases he had torn and thrown away in 1914, and which had been recovered by a rag-gatherer, restored and put on sale by a Paris art dealer.[9] In 1990 Donald Judd required the destruction of a metal wall presented under his name in an exhibition of minimal art from the collection of the Italian Count Giuseppe Panza di Biumo in the Musée d'Art Moderne de la Ville de Paris, which the collector had arranged, without authorization, to be 'copied' from the one installed in 1974 in Varese by the artist.[10]

The concept of complete artistic freedom is a correlative of that of the work as an attribute of the person, and obviously derives from the emancipation of artists and the autonomization of art that began essentially at the end of the eighteenth century. The limitation of this freedom 'by those legally empowered to alter, suppress, or destroy works of art and to prohibit artists from making certain kinds of art' has been increasingly attacked as 'censorship', and use was made of the constitutional guarantee of freedom of speech to prevent or denounce such actions.[11] This implied a recognition that 'speech', as an aspect of liberty, may be non-verbal, with problems arising from the distinction between content (whose regulation is excluded, for instance, by the

first amendment to the U.S. Constitution) and form or manner of speech (whose regulation is allowed by the same). As John Henry Merryman and Albert Elsen have stressed, time–place–manner regulations thus often permit a 'diluted version of censorship', to which art in public places is particularly exposed. Matters of dissent have also been distinctions between 'public speech' and 'private speech' or 'political' and 'non-political' (especially 'commercial') speech as a basis for establishing degrees in the public interest to protect, and thus in the right to protection. State interests such as avoiding 'offensive' art, 'obscene' art, or provocative art 'inciting violence', have been continuously put forward to justify demand or imposition of restrictions on artistic speech, with special regard for 'captive audiences' – more likely again to be involved in public places. Finally, while freedom of speech was historically meant to protect individuals from state intervention, private agents such as national or multinational corporations have obtained such a financial, economic and political power as to make them even more of a menace, particularly when they resorted to the prestige of art patronage and to (autonomous) art as a means of self-representation. What a commentator wrote about state patronage can apply to corporate sponsorship as well, i.e. that money 'is the form censorship takes in a free, democratic, capitalistic society'.[12]

Lenin in New York

We have seen that in the case of the Berlin monument to Lenin, the court had attributed to Nicolai Tomsky a responsibility in the subject-matter and function of his work by concluding that because he had 'placed his art in the service of a propagandistic hero cult', his moral right was diminished. This conception of the work of art as a political statement of the artist rather than as the execution of a commission expressing the point of view and aspirations of the patron, appeared around 1800 as a (quantitatively) minor phenomenon with artists like Goya and the German Romantics. It enabled Jan Białostocki to distinguish, for that period, between 'politics in art as seen from above' and 'politics in art as seen from below'.[13] Needless to say, such personal involvement made works even more liable to objection and abuse, as it was generally easier to attack artists than powerful private or public patrons. Artistic institutions could intervene to defend them in the name of the autonomy of art, but this was by far not always the case, as there were conflicting notions of art and autonomy, some of which excluded precisely the works that most needed protection from extraneous impeachments. To make the symmetry more revealing, it is fitting to find a work destroyed by order of its patron because the artist, Diego Rivera (1886–1957), had on his own initiative included at the time of its making a figure of Lenin in 'the most accessible viewing site of a monument to capitalism', the Rockefeller Center in New York.[14]

In the 1920s Rivera had created his foremost Mexican murals, and his work, based on the study of Cubism as well as of Italian Early Christian, Byzantine and Renaissance wall painting, had been internationally recognized as a major contribution to the creation of a modern yet socially committed art that was striven for on both sides of the Atlantic between the Wars and particularly during the Great Depression. He was widely acclaimed on arrival in the United States in 1930, and his one-man exhibition at New York's Museum of Modern Art in 1931 attracted a record attendance, almost twice as large as the one for the Matisse show of the same year. He enjoyed the patronage of the Rockefellers, who were the main support of the Museum, as well as their political sympathy: Abby Aldrich Rockefeller purchased in September 1931, for a very high sum, Rivera's series of 45 watercolours done in Moscow on 1 May 1927.[15] After meeting Nelson Rockefeller, Rivera received a commission to paint murals in the Rockefeller Center from Todd-Robertson-Todd Engineering Corporation, the development agents of the buildings. His work would occupy the choicest location, the ground-floor elevator bank in the RCA 'Great Hall', and be viewed by all incoming workers and visitors. In accordance with the general 'New Frontiers' theme of the decoration, Rivera elaborated a complex programme for his three walls: *The Frontier of Ethical Evolution* on the left, *Man at the Crossroads* (illus. 64) in the centre, and *The Frontier of Material Development* on the right. Interestingly, the central extremities of the side murals resorted to the iconoclasm motif: 'human intelligence in possession of the forces of Nature' was expressed by lightning breaking the hands of a statue of Jupiter, and 'the Workers arriving at a true understanding of their rights regarding the means of production' gathered under a headless and equally handless statue of Caesar.[16]

Already in the original study submitted for approval, the main part evoked a contrast between the opposing political systems, capitalism and Socialism. At the centre, a 'New Generation' of human society was represented by the alliance of peasant, factory worker and soldier. However, during the work, which began in late March 1933, a radicalization occurred, turning the panel into 'a Socialist onslaught against capitalism in a citadel of capitalism'.[17] Man – a worker – stood in the middle, at the intersection of two huge ellipses referring to the macrocosm and microcosm, as well as between two conflicting worlds. On the right (as seen from the mural), capitalist society was depicted as repressive, corrupt and decadent. On the left appeared, as planned, a joyous May Day celebration, but Rivera's commitment to Communism was made more explicit by the addition of the hammer and sickle symbols (half-hidden in the telescopic section) and, above all, of the figure of Lenin joining the hands of a soldier and those of a white and a black worker. This unmistakable tribute was complemented by an arcane criticism of Stalin's contemporary position of leadership in the Soviet Union, in the guise of cancerous cells in the lower

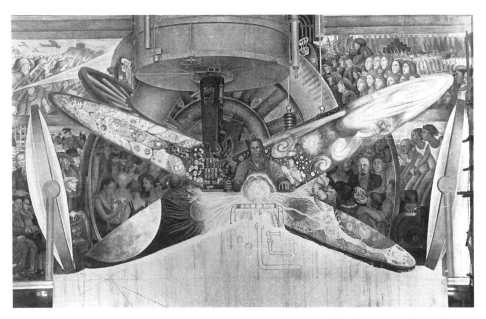

64 Diego Rivera's 1933 *Man at the Crossroads* in the Rockefeller Center, New York, in its uncompleted state after Rivera was dismissed.

microscopic segment, paralleling the 'capitalist' microbes of syphilis, gonorrhoea, gangrene and tetanus. This transformation was probably prompted both by the Rockefellers' active encouragement of Rivera's Marxist subject-matter, and by his wish to exonerate himself from the accusation of 'opportunism' launched upon him by the Communist Party of the United States of America (CPUSA).

The resulting political paradox was exposed in late April by the *World-Telegram* with the headline 'Rivera Perpetrates Scenes of Communist Activity for RCA Walls – and Rockefeller, Jr., Foots the Bill'. Nelson Rockefeller asked Rivera to 'substitute the face of some unknown man' for the portrait of Lenin, which 'might very easily seriously offend a great many people'. Rivera replied that he had simply painted his 'conception of leadership' and proposed instead to place opposite Lenin, in the section denouncing capitalist society, a great figure from American history such as Lincoln. Caught between his patron and his CPUSA detractors, he further added that 'rather than mutilate the conception', he would 'prefer the physical destruction in its entirety, but preserving, at least, its integrity'.[18] From then on, the Rockefellers evaded any responsibility in the matter, which was solely handled by Todd-Robertson-Todd. The firm completed the payment of Rivera's fee and ordered him to cease work. It appears that the architects had opposed his painting from the start, asking for a monochrome decoration executed on canvas – and thus

easily removable – instead of the brightly-coloured frescoes for which the artist was famous. They were also probably irritated by the delay that the realization of the mural was causing to the general construction work, and certainly anxious about the fact that, as the *Nation* put it, 'most businessmen object to renting space in a building where they and their customers must look at Lenin'.[19] Despite a protest campaign mobilized by Rivera's assistants and an all-but-concluded arrangement to transfer the murals to the Museum of Modern Art, they had the walls covered and eventually destroyed on the weekend of 10–11 February 1934. There were protest marches and demonstrations, the New York press charged the Rockefellers and the Center with artistic 'vandalism' and 'barbarism', but the 'Battle of the Rockefeller Center', as it was called, provoked the sudden and irreversible loss of Rivera's North American capitalist patronage. He returned 'morally exhausted' to Mexico City and found little comfort in painting a smaller version of the RCA mural on a wall of the Palace of Fine Arts, in which he introduced a portrait of John D. Rockefeller, Jr., in the nightclub scene close to the venereal microbes.[20]

Witch-hunt in the arts

Apparently, Rivera did not try to take a legal course against the patron and owner of his work. His position might have been weak, as a result of his carelessness in contractual matters and transformation of the initial project, and because moral right was not acknowledged in the United States at the time.[21] The political and cultural history of the young nation – comparable in many respects to that of an older, mainly Protestant, republic like Switzerland – explains why it greeted notions of art for art's sake with particular resistance, and remained essentially wary of granting Government support to such 'frivolous' matters. It can consequently boast of a rich history of censorship. We have seen that after the Second World War, American modernism tended simultaneously to reject political commitment and to be equated with liberal ideals of individual freedom and democracy. This can be verified in the fall from critical favour of the Mexicans – not only Rivera, but José Clemente Orozco and David Alfaro Siqueiros as well, who had also worked in the United States in the 1930s. The example of French modernism, praised for its 'spirit of democratic freedom of individual action', the dominant anti-collectivism and the equation of Communism with totalitarianism, all veered away from the Mexicans' figural and socially oriented art.[22] Some of their works, which were part of public buildings, were aggressively objected to. This was the case in 1952 of Rivera's paintings in the Detroit Institute of Art, which, however, were efficiently defended by the local Art Commission.[23] A year before, teachers and students of the New School for Social Research in New York had begun to

harass their authorities over the Russian portion of Orozco's 1930 murals depicting 'social revolutions astir in the world'. As would be tried again 40 years later in Berlin, a plaque was placed beneath the panel, asserting that the view it expressed was not that of the School, but the protests did not abate and called in 1953 for the destruction of the work. Instead, a curtain covered the offensive section, and could eventually be removed.[24]

But modern art in general, including its non- or anti-political versions, became involved in the anti-Communist witch-hunt of the McCarthy era, and political arguments were also used to oppose cultural autonomy and weaken artistic antagonists. Attacks on art and artists were not launched by Joseph McCarthy himself, but mainly by his colleague in Congress, George A. Dondero, a Republican representative from Michigan, trained as a lawyer and with no background in art or art criticism. One might believe that he had no background in history or politics either, for his approach to art, as summed up in an interview, could not be closer to those of the totalitarian regimes that he claimed to be fighting: 'Modern art is Communistic because it is distorted and ugly, because it does not glorify our beautiful country, our cheerful and smiling people, and our material progress. Art which does not glorify our beautiful country in plain, simple terms that everyone can understand breeds dissatisfaction. It is therefore opposed to our government, and those who create and promote it are our enemies.'[25] His anti-Communism was tinged by nationalism, and he considered the 'isms' of art un-American since they originated in Europe.

Between 1946 and 1956 Dondero managed to exert a considerable influence on the criticism of art museums and associations, the censorship and attempted destruction of large-scale mural decoration in prominent buildings, and the condemnation and suppression of art exhibitions that displayed modern art or art by suspected Communists. Among the latter were the State Department-sponsored travelling exhibition 'Advancing American Art' in 1946, the 'American Sculpture 1951' retrospective organized by the Metropolitan Museum of Art in New York, or another travelling exhibition of 1956, '100 American Artists of the Twentieth Century'. Dondero's ideas were shared by prominent members of the Federal government – of a painting by Kuniyoshi, President Truman declared in 1947: 'If that's art, I'm a Hottentot' – which established an official policy of censorship, excluding from support, in 1953, 'examples of our creative energy which are non-representational' and works by artists suspected of 'connection with the Communist movement'.[26] Another congenial and powerful layman was William Randolph Hearst, whose newspapers and magazines continuously reproduced works from the 'Advancing American Art' show with vilifying captions, evoking the methods employed by the Nazis nine years earlier (illus. 18–20, 142). Allies inside the art world or at its margins were con-

servative associations such as the National Sculpture Society and professional societies primarily composed of illustrators and commercial artists.

While politicians were generally reluctant to express public dissent with such strictures, many artists, art editors and museum officials protested vigorously and exposed the hypocrisy and political contradictions of this campaign. Lloyd Goodrich defended the Metropolitan Museum of Art against charges of 'aesthetic leftism' by denouncing the 'injection of false political issues into artistic controversy', and Alfred Frankfurter optimistically summed up in *Art News*: 'Only a great, generous, muddling democracy like ours could afford the simultaneous paradox of a congressman who tries to attack Communism by demanding the very rules which Communists enforce wherever they are in power, and a handful of artists who enroll idealistically in movements sympathetic to Soviet Russia while they go on painting pictures that would land them in jail under a Communist government'.[27] Dondero's attacks had debilitating effects on official cultural policy – the works acquired for 'Advancing American Art' were sold at auction with a 95 per cent loss on the original investment, and the United States Information Agency announced after the cancelling of '100 American Artists of the Twentieth Century' that it would henceforth ban from such exhibits 'American oil paintings dated after 1917' – but by and large, resistance proved stronger. As we have seen, murals from the 1930s were temporarily concealed, not destroyed. The same happened to panels begun in 1941 and completed in 1949 by the Russian-born Anton Refregier for the Rincon Annex Post Office in San Francisco. As a result of a national competition for a mural depicting the history of California, they were criticized as 'artistically offensive and historically inaccurate', and pickets were organized around the section showing the waterfront strike of 1934 to physically prevent its completion. Richard Nixon, then a California Congressman, concluded that there was a need to investigate 'objectionable art' in 'governmental buildings with the view to obtaining removal of all that is found to be inconsistent with American ideals and principles'.[28] On 5 March 1953, another representative for California, Hubert Scudder, introduced into Congress a bill directing 'the Administrator of General Services to remove the mural paintings', an action that would have ensured their destruction. But it was opposed by an exceptionally large number of artists, historians, representatives of museums, universities, cultural groups and professional institutions, including the three major San Francisco museums. The resolution was passed to the Committee on Public Works for hearings and, after a review of the entire history on 1 May 1953, it was shelved and the work was saved.

It may seem strange that the owner of a work should want to destroy or degrade what he or she possesses. There are, however, many circumstances that can lead to this apparent contradiction. The Rivera case has already presented us with a few of them: disagreement between several patrons (the Rockefellers as surrogate sponsors and the development agency as true patron), differences between model and final work, (predicted) negative reactions from sections of the public (the potential lessees). During the McCarthy decade, politicians and pressure groups tried to compel the official owners or keepers of works – schools, museums, and administrative authorities – to have them modified, removed or destroyed. Acting, at least in theory, in the name of the people, state officials are perforce especially exposed to the influence of electors, taxpayers and representatives. With institutional owners, changes in responsibilities may also deprive a commissioned work of its initial support. This was the case when, in 1975, a new president of Renault interrupted the construction of a 2,000-sq. yard environmental sculpture commissioned two years earlier from Jean Dubuffet, had the half-completed work junked and the site covered with a new lawn. Dubuffet sued the giant state-owned car company and eventually won after eight years of litigation. He declared himself content with the point he had made and renounced the reconstruction ordered by the Supreme Court of Cassation, explaining that he did not want to force Renault's people to build something that they did not want.[29]

Obviously, one may become the owner of a work one has neither wished for nor chosen, for instance by inheritance or in the context of a larger acquisition; or one may change one's taste and opinion in the course of time or according to an altered situation. The unhappy relationship thus created, however, is more likely to be solved by renouncing ownership than by eliminating property. But this cannot always be easily done, and the difference between movable and immovable objects is especially crucial. It is not by chance that the works so far mentioned were mostly monuments and murals, the physical nature of which resists an easy adaptation of site to circumstances. Moreover, this lesser adaptability is often involved in their very conception, which implies a precise destination in architectural, functional and social terms. The arts 'applied to architecture' thus share spiritually as well as materially the status of architecture itself, which – although legally entitled to the protection of historical monuments and of copyright – remains bound to imperatives of function and exposed to its changes. The Italian moral right law of 22 April 1941 thus typically sets apart 'the case of works of architecture', in which 'the author may not oppose modifications found necessary in the course of construction' or 'which may be necessary in any such completed work', and only requires that the author be 'entrusted with the study and execution of such modifications' if

'the work is recognized by the appropriate state authority as having an important artistic character'.[30] Architectural modification often jeopardizes 'decoration' or *Kunst am Bau* together with the original building, and tends to treat them with the same utilitarian lack of respect. Among countless examples can be cited the fate of Otto Herbert Hajek's contribution to the Munich headquarters of the German Automobile Club (ADAC), which was partially eliminated in 1977 when the building was enlarged five years after its construction. The sculptor sued his patron and won, but while ordering the ADAC to 'put an end to the deformation of the work', the court let it choose between restoring the original form or destroying the remaining fragments; the ADAC expressed its opinion of the matter by taking the latter course and putting the large painted concrete exterior staircases at the disposal of the Federal Army as material for testing explosives.[31]

Owners may also consider as aesthetic improvement modifications of a work that, for its author, amount to degradation or even destruction. The American sculptor David Smith, who resorted to colour after becoming famous for 'the use of direct, unembellished metal craft for expressive purposes', thus denounced in 1960 as 'a wilful act of vandalism' the unauthorized stripping of the coat of red paint from *17 h's*, a sculpture created ten years earlier, during the process of sale and resale. He wrote letters to the magazines *Arts* and *Art News* to publicize the misdeed, renounce *17 h's* as his 'original work and brand it a ruin', and declared 'its value to be only its weight of 60 lbs. of crap steel'.[32] Artists' influence on the determination of value is notoriously limited, however, and it turned out that after Smith's death in 1965, the executors of his estate, and especially the art critic Clement Greenberg, ordered the removal of white paint from a number of Smith's open-air works so that the painted surfaces would be eroded by the effect of the weather, thus imposing – in Hilton Kramer's words – 'a critical judgment that significantly alters our experience of the work'.[33] Dissent about the quality of Smith's late works derived from an evolution of his art that had driven it away from the version on which its reputation had been established. It must be recalled that in cases where such an evolution is more drastic, artists themselves often revise and sometimes destroy parts of their production that do not correspond to their or to others' current conception of their art, thus doing moral right no harm – indeed, it sometimes includes a right of the artist to withdraw the work from its owner on payment of an indemnity and a right of modification – but potentially offending the public interest in the preservation of their (historically) original work. Moreover, works may be acquired in order to be annihilated by others than their authors, in which case the apparent contradiction between ownership and destruction turns out to be a relation between means and purpose. It seems for instance that in 1872 John Ruskin and his bookseller Ellis burnt, 'with all due ceremony', a fine set of Goya's *Caprichos*,

thus accomplishing – as Francis Klingender noted – 'what the Inquisition had been foiled in doing'.[34] Maybe Ruskin took into account the fact that since the set he burnt was just one of many, his iconoclastic action was not enough to ensure the total disappearance of *Caprichos* – or maybe not. In any case, unique works have been submitted to a similar treatment, a major example being Courbet's anticlerical picture *The Return from the Conference*, which was bought and destroyed by an 'exalted Catholic' at the beginning of the twentieth century.[35] Painted in 1863 to probe – according to the artist – 'the degree of liberty that our time grants us', this depiction of drunken priests was not only refused entry to the official Salon, but excluded as well from the exhibition of rejected works organized that year by order of the Emperor.[36] It was also censured as political caricature by most defenders of Courbet's art, notably Champfleury, and Shigemi Inaga has argued that the oblivion into which the picture and its loss have fallen betrays the anti-narrative bias of modernist art history, which stylized instead the more or less mythic scandal of Manet's *Déjeuner sur l'herbe* at the 1863 Salon des Refusés into a foundation date of 'pure painting'.[37] The Socialist theoretician Pierre-Joseph Proudhon, on the contrary, interpreted the painting as a serious criticism proving the emancipation of art from the slavery of 'dogmatic idealism', and considered that in a society that had placed reason and the law above religion, it had 'civil rights in the Exhibition and a right to the Academy and the Museum'.[38]

Prudery and propriety

Courbet boasted of having painted *The Return from the Conference* 'so that it would be refused', and its eventual destruction did correspond, to some extent, to its provocative intent.[39] Such intention is generally taken for granted by those objecting to a work they consider 'offensive', although 'the flaws in invoking offensiveness', as Merryman and Elsen point out, 'are its subjectivity ... and generality'.[40] Together with politics, religion and sexual morals loom large in the arguments raised against certain works of art and used to explain why such works should be obliterated. Réau accordingly made a category of 'prudish vandalism', and Freedberg stressed the role of eroticism in the power of images and of repression in the definition of aesthetic pleasure. Given the importance of sexual control for Christianity (among other religions), it comes as no surprise that both motives should often be combined. When the large fresco painted in 1938 by Alfred D. Crimi on the rear chancel wall of the Rutgers Presbyterian Church in Manhattan was painted over eight years later, the reason seemed to be that which the former pastor of the church had given him, that is to say that 'some parishioners objected to the mural, feeling that a portrayal of Christ with so much of His chest bare placed more emphasis on His physical attributes than on His spiritual qualities'.[41] It is

worth noting that the court of appeals nonsuited Crimi on the ground that in the absence of moral right in U.S. law, the relation between artist and patron was 'essentially a service contract', and that rather than harming his artistic reputation, the destruction merely showed 'that those representing the 1938 congregation of this church thought highly of the fresco mural, while those representing the 1946 congregation did not like it'.

If churches are places where works keep on being displayed to people who do not primarily seek aesthetic experience, this is even more true of the street. Among modern artists who first faced the general public there, Jacob Epstein (1880–1959) deserves a special mention, for he was an early adept of 'uninhibited sexual expression in art and life' as well as of a 'Pagan or Archaic formula'.[42] In 1907, two years after arriving penniless in London, the American-born sculptor received his first major commission from the architect Charles Holden, to adorn exterior niches on the second floor of the new building for the British Medical Association's headquarters in the Strand.[43] The BMA wanted statues of their famous men, but Epstein 'was determined to do a series of nude figures' and carved eighteen statues symbolizing the relationship of Man to Universe and the development of Man's self-awareness.[44] The sculptures, on the Agar Street frontage, were over 40 feet above street level but, by an extraordinary coincidence, directly opposite offices belonging to the National Vigilance Association, whose members considered them – in particular the sensuous figure of a pregnant woman – as an affront to public decency (illus. 65).[45] They immediately notified the Press, and on 19 June 1908 the *Evening Standard*'s headline read 'Bold Sculpture. Amazing Figures on a Strand Building. Is it Art?', and the journalist affirmed that 'the difference between a nude figure in sculpture in a gallery, and one exposed to the public gaze in a busy thoroughfare is too obvious to need emphasizing'.[46] Thus vilified on the front page of a mass-circulation newspaper, Epstein's statues quickly found themselves the object of intense scrutiny and controversy, with opposing parties collecting support for their respective causes. Father Vaughan condemned the figures in the name of the Church and accused Epstein of trying to 'convert London into a Fiji Island, where there may be some excuse for want of drapery', while artists, museums directors, art historians and critics almost unanimously defended them. Most interestingly, the *Evening Standard* appealed in a leading article 'to the British Medical Association not to be misled by talk of art, which is a side issue, but to use their judgment as men of the world', and Epstein's friends enrolled 'recognized moral experts' such as Dr Cosmo Gordon Lang, then Bishop of Stepney and subsequently Archbishop of Canterbury, who made a close inspection of the figures and declared that 'he saw nothing indecent or shocking about them'.[47] Help also came from the representative of *The Times*, who 'first examined the figures from the street', and from the *British Medical Journal*, which

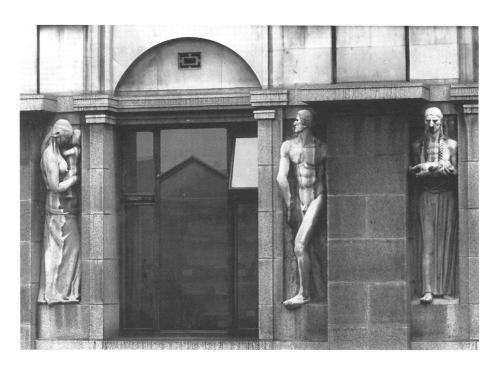

65 Jacob Epstein's
1907-8 *Maternity*,
Man and *The New-
born* at the then
headquarters of the
British Medical
Association, Strand,
London, in January
1914.

66 Jacob Epstein's
BMA figures after
their mutilation in
1937.

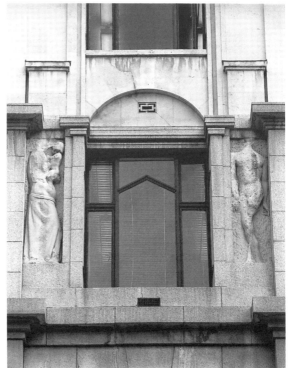

compared their censors to an elderly virgin complaining of men bathing while observing them with a spyglass – indeed, it turned out that the National Vigilance Association was charging a fee to those who wanted to look at the statues from its windows. The London County Council and the House of Commons turned down requests for intervention, and the Home Secretary 'replied that he was not officially the arbiter either of taste or morals, and he had no control over the decoration of private buildings unless they violated the law'. Finally, the BMA council followed the advice of *The Times* to discard 'this appeal to the philistinism and hypocrisy of a portion of our middle class' and allowed Epstein to complete the statues.

After Epstein had finished his work, no one seems to have been offended by the statues until 1935, when the Southern Rhodesian Government purchased the building and immediately announced that the carvings were to be removed because they were 'not perhaps within the austerity usually appertaining to Government buildings'.[48] Epstein replied that his statues 'were intended to have a universal appeal' and were built into the fabric, but the new owner insisted that they were not 'appropriate' because they did not 'indicate the produce of Southern Rhodesia'. A letter of protest published in *The Times* by an impressive number of influential art historians, museum directors and architects – including Kenneth Clark, then director of the National Gallery, the directors of the Tate Gallery and of the Victoria and Albert Museum, and H.S. Goodhart-Rendel, President of the Royal Institute of British Architects – nevertheless prevented the Government of Southern Rhodesia from accomplishing the planned destruction, but it found a pretext when, two years later, as decorations were being attached to the statues for George VI's coronation, a section from an Epstein figure crashed to the pavement. The Rhodesian High Commissioner ensured that the London County Council issued an injunction commanding the building's owners to render it safe, and despite a new Press campaign (or was it further incensed by it?) chose the most brutal method conceivable. One day Holden, accompanied by the President of the Royal Academy (who had not signed the 1935 letter), Rhodesian Government officials and the police, inspected, with a hammer and chisel to hand, every carving and condemned anything he considered to be hollow or eroded. The designated areas were cut away and the statues left in a state evoking more a revolutionary 'iconoclasm from below' than any allegedly authorized action (illus. 66). The reason why Epstein did not sue the Southern Rhodesian Government is not known to me. Why Holden participated in their mutilation is another intriguing question. Richard Cork suggests that he may have thought he would 'be able to save more of the carvings than would have been preserved in his absence'.[49] But his later assumption that 'the general decorative character of the band of figures was not seriously destroyed' in the process and that the statues had 'not lost their decorative value' points to another element fre-

quently present in conflicts of this kind, namely the ambivalent relation of interdependence and rivalry between representatives of architecture and of the fine arts 'applied to' it. Cork explains that Holden, who tended to approach the shaping of his buildings like a sculptor, had opted for narrow niches for the sculptures because he was unwilling 'to let the carvings compete too assertively with his own architecture', whereas Epstein, who denounced elsewhere 'the humiliating subservience of the sculptor to the architect', proudly remarked of the Strand scheme that 'perhaps this was the first time in London that a decoration was not purely "decorative"' but had 'some fundamentally human meaning'.[50]

If one may be tempted to attribute Epstein's trials to 'the combined forces of [a survival of] late Victorian puritanism, philistinism and hypocrisy', these cannot not be located exclusively in early twentieth-century England. The history of the sculptor's next important work, the tomb for Oscar Wilde in the Père Lachaise cemetery in Paris, attests this more than does the Strand episode.[51] Epstein received the commission at the end of 1908, at the time of the Strand scandal, probably at the suggestion of his protector William Rothenstein. He first imagined figures of young mourners, then a Narcissus, and finally carved in a huge monolith a flying demonic angel inspired by Assyrian, Egyptian and Indian sculpture. The angel's elaborate head-dress alluded to the sins, Christ, and Wilde's martyrdom, further stressed in the inscription that included a verse from *The Ballad of Reading Gaol* implying that, like homosexuals, artists and writers are 'outcast men'. Holden had to design a base for the sculpture, a difficult task that led to a disagreement between him and Epstein; they were not to collaborate again for many years. When finished in 1912 (illus 67), the tomb was exhibited in the sculptor's studio and greeted with enthusiasm, even the *Evening Standard* praising it as a 'dignified sculpture'. But the installation in Paris proved to be more frustrating. The French customs demanded that an import levy be paid on the commercial value of the stone, and the keeper of the Père Lachaise considered that the tomb was indecent because of the unusual size of the angel's testicles. He first had them swaddled in plaster, then the Prefect of the Seine and the keeper of the Ecole des Beaux-Arts decided that Epstein must either castrate the angel or supply a fig leaf for it, and a Comité d'Esthétique had the tomb covered with an enormous tarpaulin. Robert Ross, literary executor of the Wilde estate and patron of the memorial, wittily declared that he regarded 'the arrest of the monument by the French authorities simply as a graceful outcome of the Entente Cordiale and a symptom on the part of our allies to prove themselves worthy of political union with our great nation, which, rightly or wrongly, they think has always put Propriety before everything'.[52] He also had a bronze plaque provisionally affixed to the censored portion, so that the tomb could eventually be unveiled in early August 1914. It remained in relative peace until 1961, when the

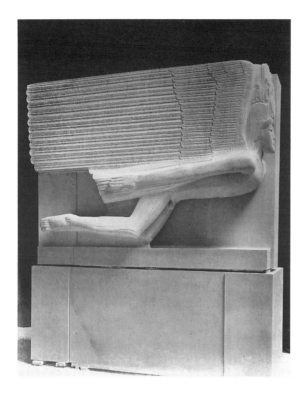

67 Jacob Epstein, *Tomb of Oscar Wilde*, 1911-12, in the studio in 1912, with the plinth fitted but as yet without the inscription.

testicles were anonymously hacked from the angel. According to a French author, this was done by two indignant English ladies, and the broken parts were brought by guardians to the keeper, who for some time used them as paperweights. Before this took place, another visitor to the tomb had noted the amount of graffiti it was attracting, as well as the shiny quality of the pendulous testicles, both attesting to the increasing notoriety of the memorial since the end of the First World War as a place of pilgrimage for the homosexual community.[53] Michael Pennington thus supposes that, by 1961, the testicular part of the sculpture must have been quite eye-catching, and may have been considered offensive by some. If this was the reason for the assault, it was another case of the close correspondence between use and abuse, and a reminder of the ambivalent fate of cult objects in the Middle Ages and the Reformation.

Ross's remark on the precedence of propriety seems to me particularly relevant, not only because the notion of the autonomy of art has always tended to conflict with extrinsic standards of morality, but because in many cases that we have examined, and particularly with the works of Rivera, Crimi and Epstein, the classic rule of decorum reappears under one guise or another. Taken in a broad sense, propriety can be understood as fitness to the architectural, functional, ideological or social context. The more a work depends on context to exist and be perceived, the more it is liable to appear as inappropriate at one

time or from one point of view. A crude but revealing statement, as far as the logic of propriety is concerned, was made in 1991 by Jacques Peyrat, an extreme Right-wing politician in Nice – who was to become mayor four years later – when he defamed works of the American sculptor Mark Di Suvero by saying: 'This heap of red metal planks on the beautiful Italianate square of the Court of Justice – it's like wearing a dinner-jacket with jeans.'[54]

'Tilted Arc'

The state promotion of modern art after the Second World War was also accomplished by means of temporary exhibitions and permanent installations in public places. Understandably, the latter came relatively late and remained particularly controversial, as they implied the daily confrontation of works by people who were neither primarily interested in, nor equipped for, their appreciation. In the United States, important steps were taken during and immediately after the Kennedy era. In 1963 the General Services Administration (GSA), the agency responsible for the construction of Federal buildings, initiated an Art-in-Architecture programme with a fine arts allowance of 0.5 per cent of the estimated cost of its realizations. Two years later the National Foundation of the Arts and the Humanities was created, including the National Endowment for the Arts (NEA) which devised an Art-in-Public-Places programme.[55] The recurrent problem of legitimacy prompted the NEA to intervene as a partner in artistic initiatives developed on a local level and to renounce both total sponsorship and ownership of the works. The GSA remained by contrast fully responsible for commissioning, acquiring and preserving the works associated with Federal buildings. Its administratively determined existence and funding also made its politically appointed administrators less resilient to politically inspired criticism.[56]

It comes then as no surprise that the GSA was also responsible for the most important crisis in American 'public art' of the last few decades, the removal of Richard Serra's *Tilted Arc* from Federal Plaza in lower Manhattan (illus. 68). The exemplary character of this controversy, which provoked a torrent of debate, was immediately recognized and went well beyond the limits of the United States, where its outcome marked a turning-point.[57] It was nevertheless dependent on the specificity of place, time, proceedings, artist, work, reception and a long chain of subsequent interactions, which must be examined in some detail.

The Jacob Javits Building was erected in 1968, at a time when the Art-in-Architecture programme had been suspended following a controversy over one earlier commission, the Boston *New England Elegy* mural by Robert Motherwell. The Javits Building was at the time the second largest Federal office building after the Pentagon, and housed among other agencies the re-

68 Richard Serra, *Tilted Arc*, installed 1981, photographed in February 1987, Federal Plaza, New York.

gional offices of the GSA and the U.S. Court of International Trade. When the Art-in-Architecture programme, re-established in 1972, planned an addition to the building, it decided to commission a work to be installed in the 160-foot-square Plaza in front of its entrance. In 1979 an NEA-appointed advisory panel composed of three art-world professionals recommended that Richard Serra be awarded the commission to create a work for this site, a recommendation subsequently approved by the GSA administrator. Serra, born in 1939, had moved in the 1970s from ephemeral interventions in lofts and remote no-man's-lands to permanent installations in exposed urban sites. In opposition to the sitelessness of modern sculpture and the abstract definition of site by Minimalist artists, he had developed a notion of 'site specificity', implying that a work be predicated on the characteristics of the place for which it was created. He did not understand this relation, however, as one of integration but as one of criticism and transformation, on a social and political as well as physical and aesthetic plane. Regarding locations in which a sculpture might be instrumentalized, he declared that 'it is necessary to work in opposition to the constraints of the context, so that the work cannot be read as an affirmation of questionable ideologies and political power'.[58]

Serra felt honoured by the commission and was – like all artists working for the GSA – particularly interested in the permanence associated with Govern-

ment patronage, even if the ownership clause of the contract stated that 'the work produced under this Agreement . . . may be conveyed by the Contracting Officer to the National Collection of Fine Arts—Smithsonian Institution for exhibiting purposes and permanent safekeeping'.[59] He made no mystery of his opinion of Federal Plaza, which he regarded as 'unarticulated in terms of its functions in relation to the surrounding buildings', or of his intention to 'dislocate or alter [its] decorative function', affirming that 'after the piece is created, the space will be understood primarily as a function of the sculpture', an attitude defined by Douglas Crimp as the use of 'sculpture to hold its site hostage'.[60] His project, a section of tilted cylinder crossing the Plaza, was examined by the GSA and accepted after a study had been made of the effect that the sculpture would have in relation to its setting. *Tilted Arc*, installed in 1981, was a 78-ton, 3-inch-thick, 12-feet-high and 120-feet-long curved sheet of Cor-ten steel tilting one foot off its vertical axis. Involving a self-protective rusting process, Cor-ten steel had been used by many modern sculptors. Serra associated it with his social origin, his early employment in steel-mills, and a distinctly American industrial aesthetic. *Tilted Arc* presented different aspects according to the perspective – indeed, Serra explained that it was intended to make the viewer 'aware of himself and of his movement through the plaza'.[61] Seen from the buildings or from the ends, it appeared as a gentle curve or almost disappeared; seen from the doors of the Javits building, it acted as a visual barrier cutting off the rest of the Plaza.

In contradiction to the guidelines for the installation of public sculpture under the Art-in-Architecture programme, no measures were taken to prepare and facilitate the local reception of *Tilted Arc*.[62] The work met with immediate opposition, expressed by letters to the GSA and 1300 signatures on petitions for its removal. A particularly powerful and vehement detractor was Edward D. Re, Chief Judge at the U.S. Court of International Trade. The reactions of the New York art world and media were mixed, but included downright condemnations, for instance in *The New York Times*, which labelled the sculpture 'an awkward, bullying piece that may conceivably be the ugliest outdoor work of art in the city'.[63] With the passing of time, however, overt hostility subsided, and might have died away had not a newly appointed regional administrator of the GSA, William Diamond, lent a sympathetic ear to Judge Re and endeavoured to get rid of the disputed object. Since the time of the commission, the political conditions, public personnel and presumed popular mandate had changed, as had the commissioning and installation procedures of the GSA, which had instituted more extensive community involvement but could not be employed retroactively. The decision regarding *Tilted Arc* had been taken on the Federal level, and Diamond's initiative in promoting a recall drive could be seen as consistent with the general policy of Reagan's administration, that of enhancing state and local control.[64] The re-

69 Richard Serra's *Tilted Arc* being disassembled during the night of 15 March 1989.

gional administrator's personal hostility to Serra's work was also interpreted as serving a personal political ambition.[65] In any case, Diamond encouraged the expression of disapproval with *Tilted Arc*, and organized an *ad hoc* three-day hearing to determine whether it should be preserved *in situ* or removed. He appointed himself head of the panel leading the debate, which included two other GSA collaborators but no specialist in public art. The controversy attracted considerable attention in the media, which further contributed to the polarization of opinion. The quantitative results of the hearing were clearly against the removal, but Diamond nevertheless proposed to relocate it, a decision confirmed by the GSA Federal administration and which Serra's subsequent legal efforts could not reverse. During the night of 15 March 1989, *Tilted Arc* was dismantled (illus. 69) and carted off to Brooklyn, where its three parts were packaged and stacked behind barbed wire.[66]

As soon as Diamond had begun to question the work's location, Serra had made his own position clear: '*Tilted Arc* was commissioned and designed for one particular site: Federal Plaza. It is a site-specific work and as such not to be relocated. To remove the work is to destroy the work.'[67] He maintained this stance consistently throughout the proceedings, and asserted that the removal impinged on his right to free expression, his right to due process, and his right to the respect of his work. These charges were all rejected by the District Court

and Courts of Appeals.[68] The judges considered that the 'speech' represented by *Tilted Arc* had become the property of the Government, which 'may advance or restrict its own speech in a manner that would clearly be forbidden were it regulating the speech of a private citizen', that the removal of the sculpture represented in any case 'a permissible time, place, and manner restriction ... without reference to the content of the regulated speech', and that 'the First Amendment protects the freedom to express one's views, not the freedom to continue speaking forever'.[69] The abstract character of his work undermined Serra's First Amendment claim: while he referred to a precedent of 1982 of books removed from high school libraries because of their 'anti-American content' and argued that the removal of *Tilted Arc* would represent a 'conduct akin to book-burning', the court stated that there was 'no assertion of facts to indicate that GSA officials understood the sculpture to be expressing any particular idea' and that their decision, insofar as it had been 'motivated by the sculpture's lack of aesthetic appeal', was permissible since 'consideration of aesthetics is a legitimate government function'.[70] The artist's attempt at resorting to copyright and trademark rights as substitutes for moral rights was counteracted by the insistence of the Copyright Office on 'a certain minimum amount of original artistic material', its rejection of 'familiar shapes and symbols' as copyrightable, and the court's opinion that no trademark rights could be claimed 'in the surroundings of the plaza'.[71] Finally, Serra's hope that the incorporation of the Berne Convention for the Protection of Literary and Artistic Works into U.S. copyright law – which became effective on 1 March 1989 – might allow him to block the impending removal was delusory, as it turned out that the U.S. Congress had specifically rejected the section of the Convention applying to moral rights. When the Congress finally adopted the Visual Artists Rights Act of 1990, a bill that took effect on 1 June 1991, it provided very limited protection for works of art incorporated into buildings or that would be damaged or destroyed by removal; Serra declared that the destruction of *Tilted Arc* had not influenced its drafting and continued to rely on his newly developed contracts, which specified that the buyer would 'permit no negligent, reckless or intentional modification, damage or destruction of any kind to the Work for any reason or need whatsoever', including 'any change or placement of the Work'.[72]

The partly published statements made during the hearing are of great interest. Advocating the removal was a socially and professionally heterogeneous group with a majority of office workers – the presence of judges and security officials may be worth pointing out because, as Harriet Senie has noted, their frequent negative reception of modern public works may be related to professional capacities that 'demand an approach based on the known past or one that, of necessity, views the new with suspicion and distrust'.[73] Their arguments were varied, with some recurring themes. The effect of *Tilted Arc* on

its site was regarded as destructive in terms of the latter's beauty and use. Judge Re had referred to symbolism and propriety by denouncing the transformation of the 'once beautiful plaza' by the 'rusted steel barrier' as running counter to efforts made 'to provide proper identification for the courthouse, and to generate respect for its symbol of justice'.[74] The wife of one of the architects of the building returned to the 'site specificity' argument by affirming that the Plaza was 'a site-specific work of art incorporating a geometric pavement design, now disrupted'. A physical security representative considered the sculpture to be 'a security hazard or disadvantage' because it could be used for pro-terrorist graffiti, conceal drugs dealings or provide a blast wall effect to 'explosions on federal property'. Less-specialized speakers also perceived the work as menacing, intimidating, as something 'forced on them from on high' or 'an arrogant, nose-thumbing gesture at the government and at those who serve the government'. It was repeatedly compared with the Berlin Wall and once labelled 'a rusty reminder of totalitarianism'. A Congressman correctly remarked that the 'shock effect' of *Tilted Arc* was augmented by the oxide coating that gave it 'the appearance of a rusted metal wall' and made people believe at first that it was 'an abandoned piece of construction material, a relic perhaps too large and cumbersome to move'. Indeed, the sculpture tended to be denied not only its aesthetic quality and value, but its artistic status as well. Several speakers made it plain that the removal they called for did equal destruction: 'a metal salvage yard' and the Hudson River were mentioned as 'better sites' for the work, and it was proposed to 'sell it to a scrap metal farm for maybe fifty dollars' or to reduce it 'to the scrap iron from which it seems to have been born'. Finally, some denounced an imposition of taste on the public and a defaming of the latter's refusal to acquiesce; an attorney thus commented: 'The public is saying, we don't like it, and we are not stupid, and we are not philistines, and we don't need some art historians and some curators to tell us that we will like it.'[75]

On the other side, Serra's cause had managed to gather what a commentator described as 'a virtual roll call of art-world personalities' encompassing the full range of its 'social and ideological extremes'.[76] This 'unexpected alliance' could be explained by the stakes made explicit in some of the statements: a removal of *Tilted Arc* would represent a breach not only of contract, but of trust between the administration, the art community and the public, resulting in further pressure, self-censorship, or a retreat of the best artists from the arena of 'public art'. Whatever their merits and relevance, the defenders' arguments need not detain us here. It must only be noted that they tended to put the blame for the conflict on the urban and social context of the work, seeing the value of *Tilted Arc* in its very 'subversiveness', considering that to ask for its removal amounted to 'shooting the messenger for the news it brings', or admitting a private 'right to detest contemporary art – especially art like that of

Richard Serra that addresses the conditions of alienation that make people detest art in the first place'.[77] Another important point is that many speakers explicitly endorsed the 'site specificity' theory, arguing that a removal would in effect represent a destruction of the work. After the hearing and the GSA decision, Serra's contention that he would deny his authorship to a relocated *Tilted Arc* and regard it as 'derivative work' discouraged the two organizations that had indicated preliminary interest in receiving it, and the NEA 'site review advisory panel' called for by the GSA reached the conclusion that 'both sites were inappropriate', so that the relocation project had to be dropped.[78] The sculptor thus managed to delegitimize the removal culturally, if not politically and legally.

The relevance of the political context has already been mentioned, but it was not limited to the GSA. The end of the *Tilted Arc* affair coincided with a political campaign against 'offensive art' strongly reminiscent of the McCarthy decade. The main heir to George Dondero was the Republican Jesse Helms of North Carolina, who promoted an amendment to the fiscal law – passed by the Senate in a supposedly more moderate form as the 'Yates amendment' – that would deny Federal funding to art deemed obscene.[79] At the beginning of 1989, a national controversy had inflamed around three 'scandals': an installation with an American flag spread on the floor in the Art Institute of Chicago (this was after the Supreme Court had rejected an attempt at prohibiting the burning of the national flag), a photograph by Andres Serrano of a crucifix in a glass vessel filled with urine, and a retrospective exhibition of the late Robert Mapplethorpe's photographs that included representations of homosexual and sado-masochistic practices.[80] As a sequel, NEA funding was cut and linked to an 'anti-obscenity' clause, while certain museums were financially punished or threatened for having supported 'indecent art'. In 1995, the 'conservative revolution' of the Republican Newt Gingrich took further political aim at what it called the liberal 'counterculture', denouncing state-sponsored art and media as – in Congress Speaker Gingrich's terms – 'playthings for the cultural elite', and proposing to let the private market decide 'what values are good currency'.[81] Richard Serra understood the destructive removal of *Tilted Arc* as part of this broader phenomenon, as the titles of the eight drawings he exhibited in October 1989 at Leo Castelli's Gallery made clear (illus. 70).

As had been foreseen, the *Tilted Arc* controversy and its outcome developed important sequels for Serra's career and for art in public spaces in the United States. A chain effect could rapidly be noticed, with a referendum organized in 1987 in St Louis to remove *Twain*, another disputed work installed five years earlier. Soon after the controversial installation of *Tilted Arc*, twenty-five projects of the Art-in-Architecture programme were halted pending the formulation of new procedures, which increased the participation of local communities and architects in the selection of the artist and the work of art,

1. The American Flag is not an object of worship.

2. The New York Times manufactures censorship.

3. The United States Senate dictates censorship.

4. The United States courts are partial to Government.

5. The United States Government destroys art.

6. The United States Government deprives artists of moral rights.

7. Support indecent and uncivil art!

8. No mandatory patriotism.

Richard Serra 8 Drawings: Weights and Measures 23 September-14 October 1989 Leo Castelli 420 West Broadway New York

70 Richard Serra, *8 Drawings: Weights and Measures* at the Leo Castelli Gallery, New York, 1989.

and included an agreement between the GSA and the NEA 'to deal with conservation and de-accession, as well as installation, of public art' – i.e. guaranteed the possibility of relocation.[82] Although Ronald Reagan bestowed a Presidential Award for Design Excellence on the GSA programme in 1985, praising its courage and vitality, cautiousness now commanded avoiding polemic.[83] The changed situation decidedly favoured what some termed a 'viewer-friendly public art' or a shift of emphasis, in 'public art', from 'the art component' to 'the public'.[84] This evolution, however, did not only result from external pressure, and its appreciation, like the conclusions drawn in retrospect from the *Tilted Arc* affair, varied considerably. Serra and his closest supporters tended to see this 'precedent for the priority of property rights over free expression and the moral rights of artists' as deriving from the very nature of state sponsorship, particularly in the United States. During the hearings, Clara Weyergraf-Serra had seen the process as a confirmation that she was right in being 'against artists accepting government commissions' because 'art was being used as a sign to advertise liberalism – a sign which would be ripped down when liberalism went out of political fashion'.[85] They were largely followed in their criticism of the GSA administration, which was condemned for its inconsistent policy, pseudo-democratic manipulation of public opinion, and partiality. The acknowledgement by the art world that the removal of *Tilted Arc* amounted to an act of destruction made it in effect just that, as far as the impossibility of a legitimate re-erection was concerned. It

71 Alison Seiffer, cartoon on the removal of *Tilted Arc* in *The New York Times* (30 April 1989).

also expressed the perception that in this as in many cases, the relocation proposal represented a legal and euphemized form of elimination.[86] Benjamin Buchloh labelled the action a case of 'vandalism from above', and an effective cartoon in *The New York Times* visualized the same interpretation (illus. 71).[87]

Nevertheless, commentators who could not be suspected of sympathizing with assaults on the independence of art also tended to attribute to Serra and his unconditional defenders a share of responsibility in this 'dangerous precedent'.[88] Some remarked that although the artist theoretically admitted the possibility of indifferent or negative reactions to his work, the very form and position of *Tilted Arc* excluded 'the option to ignore it or avoid participation', thus sacrificing to the artist's autonomy 'public freedom in the face of art', and that unappreciative perceptions of the work had been contemptuously discarded as expressing ignorance or reactionary narrow-mindedness.[89] Indeed, Serra's 'aesthetics of refusal', his will to prevent all 'instrumental' appropriation of his work and primary rejection of 'art as affirmation' ran counter to the semantic openness he also postulated, restricting legitimate reception to the one corresponding to his intentions.[90] To Robert Storr, Serra's 'failure to deal directly . . . with his least articulate but most important adversaries' made *Tilted Arc* stand 'as a monument to the convergence of formalist art and "formalist" politics – a politics, that is, of theory without praxis', and left unanswered 'the question of what if any are the appropriate forms such collective dissatisfaction should take'; Garry Apgar observed that if 'public art need not enhance its site in order to survive . . . failure to do so may well lead to popular or official rejection', and opposed the negative reception of *Tilted Arc* to the way in which Maya Lin's *Vietnam Veterans Memorial* of 1982 in Washington, DC, had 'won over those initially opposed to it' and become 'a permanent statement of affliction whose visual direction and therapeutic power truly

163

enhance ... the site and Mall as a whole'.[91] This dissent was also perceptible in the interpretation of Serra's artistic and historical position. Whereas the sculptor and a like-minded critic such as Douglas Crimp regarded his art – in the latter's terms – as a 'materialist critique of Modernist idealism', others, including Benjamin Buchloh, came to conclude from the *Tilted Arc* affair that Serra rather stood for the end of modernism and revealed the contradictions and shortcomings of its notions of social and political relevance.[92] Quoting a 1976 interview in which Serra denounced what he regarded as a current 'return of a kind of '30s reactionary value system ... in effect a revamped social realism' and insisted that art did not need 'any justification outside itself', Storr remarked that he assigned to himself 'the same privileges that were claimed for the Abstract Expressionists by their liberal apologists' and remained the prisoner of a conception of the artist 'as a uniquely free individual whose work is by definition beyond ideology'.[93] One might be further tempted to interpret this dissent in generational terms, on the basis of Serra's recurrent condemnation of 'post-modernist confusion' and of several assaults perpetrated by younger artists on his work. In 1981, for example, David Hammons had submitted the sculpture *TWU* to two 'iconoclastic' performances: *Shoetree*, consisting in the throwing of twenty-five pairs of shoes, laced together, on its top, and *Pissed Off*, by urinating on it; in 1992 David Antin criticized Serra's insistence on permanence as 'a form of tyranny' and pleaded for the public destruction of 'works like Serra's work ... after some specifically limited time ... in an honorable fashion'.[94] But differences in generation do not explain everything, as the work and trials of Hans Haacke, born three years before Serra, can attest.

The industry of consciousness

During the *Tilted Arc* hearing, Douglas Crimp rightly complained that he felt 'forced to argue for art as against some other social function' and that the debate, rather than attempting 'to build a communality of interest in art in the public realm', was 'convened by an administrator who seems to believe that art and social function are antithetical'.[95] From the end of the 1960s on, the political character of the depoliticization of modern art has been often recognized. The historical emancipation of art from function turned into a prescription as it became central to the definition of what art is or is not, became increasingly resented as a confinement in a ghetto, and the freedom of art as a *Narrenfreiheit*, the freedom to do anything because nothing counts. Attempts at re-socializing art followed various paths, one of which may be represented by the formal radicalism and 'site specificity' of Serra's work. Others turned rather to the precedent of early Soviet agit-prop and Productivism, and made use of a more social and pragmatic definition of 'site' and reception. The explicitly subversive intent and content of such self-mandated 'political art'

made it a permanent trial of the limits set to the 'freedom of art' and a target for legal or authority abuse. The justification of censorship generally implied, as was predictable, a negation of the artistic status of objects and attitudes.

This was the case with the destruction in 1976, by German conservative representatives of the CDU/CSU parliamentary group, of Klaus Staeck's political posters exhibited on the walls of the Parliamentary Society in Bonn.[96] Staeck, a lawyer, gallery owner and refugee from East Germany, had voluntarily left what he called the 'aesthetic ghetto' to deal only with social and political themes, appropriating and commenting on means of commercial and electioneering publicity – for instance in a 1974 poster of King Kong with the inscription 'CDU has the best exorcists. No one knows better how to do business with fear.'[97] His political antagonists accused him of misusing the freedom of art, of wanting to 'destroy liberty in a democratic way', or of promoting a 'cultural decadence'.[98] His works had been included, none the less, in a London exhibition of recent political art from Germany entitled 'Art into Society', before a Socialist (SPD) politician organized the controversial show in the Bonn Parliamentary premises. Interestingly, the incensed representatives waited until the TV cameras were on to perform their iconoclastic action, and a young man referred to their unpunished intervention when he was arrested a week later after throwing a stone through the window of Staeck's studio in Heidelberg. The fact that the posters torn apart were multiple images certainly contributed to this impunity, and the manager of the Parliamentary group, who had led the assault, declared that they had 'absolutely nothing to do with art anymore'.[99]

A comparable fate happened in 1981 to an open-air exhibition of Ernst Volland's posters organized around the Berlin Gedächtniskirche by the Neue Gesellschaft für Bildende Kunst.[100] The Berlin artist also practised the alienation of advertising methods to create an 'anti-publicity'. After twelve days of discussions with passers-by, the police came unannounced, ripped down some posters and later had the whole surfaces painted white. The exhibition was reconstructed and reopened, but a second assault was perpetrated by Right-wing demonstrators in the presence of the police. Eventually, the advertisement company that rented the surfaces, having received complaints from other clients, disregarded the contract and had the posters covered. The police intervention had been illegal and was not accompanied by any official statement, but one of the images furnished the authorities with a legal pretext for the destruction. It showed the President of the Federal Republic with helmet, imperial eagle and half-concealed swastika, which was identified as a prohibited 'use of symbols of anti-constitutional organizations' – an obvious misinterpretation – and a means of 'defaming the President of the Federal Republic', a democratic version of *lèse-majesté*.[101]

The expulsion from the public realm and from the aesthetic sphere of such

72 Hans Haacke, *Germania*, installation for the central room of the German pavilion in the Venice Biennale, 1993.

attempts at disputing current public and private monopolies is most revealing. The places, works and events can arguably be regarded, however, as relatively marginal. But one cannot dismiss so easily Hans Haacke, who was awarded, together with Nam June Paik, the National Prize of the 45th Venice Biennale in 1993, with an installation that recalled – with both literally and metaphorically iconoclastic means – the original propagandistic function of the German pavilion, built by the Nazi regime in 1938 (illus. 72). This is partly due to his insistence on the inseparableness of 'form' and 'content' and on the reflexive inclusion of art and the art world in the objects of his critical enquiry. Haacke, born in Cologne and the son of a Social Democrat civil servant dismissed by the Nazis, chose in 1965 to live in the United States, and began in the early 1970s to dedicate his conceptual art to socio-political and art-sociological issues. He questioned the autonomy of art in a less prescriptive than descriptive way: to him, the world of art is not a separate reality, as the attention and investments it receives from political and economic powers attest, but participates in the 'industry of consciousness' and influences the social

'climate'. He thus conceives of his works as 'fruitful provocations' that need to be amplified by the mass media, and regards neither the Press nor the public for art as monolithic, going so far as to consider that being 'recuperated' – a fate so deeply feared by most avant-gardists – may be the most efficient way to attain one's objectives.[102]

The censorship or iconoclasm to which he was also subjected took accordingly site-specific and modernized forms. In 1971 the Guggenheim Museum in New York cancelled his one-man exhibition one month before the opening because the director, Thomas Messer, objected to three works dealing with specific social situations as examples of 'real-time systems', in particular to presentations of large Manhattan real estate holdings, among which were slum-located properties, with photographs of the facades and documentary information about ownership collected from the public records of the County Clerk's office.[103] Haacke accused Messer of infringing 'the artist's right to free expression within the walls of the Guggenheim Museum' and argued that he was wrong in confusing 'the political stand which an artist's work may assert with a political stand taken by the museum that shows his work', as well as in assuming that the pieces advocated a political cause.[104] The director, on the other hand, considered the real estate documentation a 'muckraking venture' and expressed the fear that a libel suit might be directed against the Guggenheim Foundation. More fundamentally, he objected to what he regarded as a 'reduction of the work of art from its potential metaphoric level to a form of photojournalism concerned with topical statements rather than with symbolic expression', and affirmed that 'to the degree to which an artist deliberately pursues aims that lie beyond art, his very concentration upon ulterior ends stands in conflict with the intrinsic nature of the work as an end in itself', resulting in 'inappropriateness' and compelling the institution to choose 'between the acceptance of or the rejection of an alien substance that had entered the art museum organism'.[105] Editorialists, alluding to other recent cases of conflict between 'the inherent conservatism of museums, and the inherent radicalism of many artists', remarked that 'cultural boundaries' had 'actually replaced censorship by taking away the effective power of art', and that the numerous artists sharing 'a need to reach beyond traditional forms of art' and implicitly rejecting 'the art establishment and its institutions' had at the same time 'a greater need of these institutions than ever before, to validate and define their work as art, since the work's own boundaries are, in many cases, dematerialized or nearly dissolved'.[106] Haacke's *Shapolsky et al. Manhattan Real Estate Holdings, a Real Time Social System, as of May 1, 1971* was shown at the New York Cultural Center in October 1972 – with no legal action taken against the institution – and the cancellation of the Guggenheim exhibition benefited the artist's fame, but its curator, who had criticized the 'censorship', had to leave the Museum.[107]

One of the editorialists mentioned also pointed out, among the causes for 'certain inherent contradictions to the aims of artists and museums', the fact that in the United States, 'the very existence of museums depends on the voluntary support and good will of often conservative individuals'.[108] This dependency increased and spread to Europe during the 1970s and 1980s, as state institutions were encouraged or forced to resort to private funding and corporations discovered the virtues of art sponsorship as an instrument of communication and a 'tool for seducing opinion'.[109] 'Art as an end in itself' was essential to this indirect re-instrumentalization, and Haacke deliberately directed the self-mandated re-functionalizing of his art towards exposing this mechanism. Three years after the Guggenheim affair, his proposed contribution to the 'Projekt '74' exhibition commemorating the 150th anniversary of the Wallraf-Richartz-Museum in Cologne consisted of Manet's *Bunch of Asparagus* of 1880 – a work belonging to the Museum – surrounded by panels presenting 'the social and economic position of the persons who have owned the painting over the years and the prices that were paid for it'.[110] This ownership pedigree not only shed light on the appreciation of the canvas, but evoked at several points the spectre of Nazism, particularly when it stated that the financier Hermann J. Abs, president of the Kuratorium (a sort of Board of Trustees) of the Wallraf-Richartz-Museum who had helped buy the picture in 1968, had been an officer of the Reichsbank during the Nazi era and of continuing importance during the post-War period. The project was rejected by the director of the museum, Dr Horst Keller, who explained that devoting an entire panel to Abs gave the unfounded impression that he had been one of the owners of the work and, more importantly, that the work seemed to call into question his idealistic motives in implementing its acquisition, whereas 'a grateful museum . . . must protect initiatives of such an extraordinary character from any other interpretation which might later throw even the slightest shadow on them'.[111] While Haacke arranged to show *Manet Projekt '74* in a private gallery, Carl Andre, Robert Filiou and Sol LeWitt withdrew from the exhibition in protest against what they took to be the censorship of his work, and Daniel Buren attached to his own work in the show a small-scale photocopy of the panels with the comment 'Art remains politics' – a revised version of the official watchword of 'Projekt '74': 'Art remains art'. This modification, however, was in its turn covered over with sheets of white paper on order of Professor von der Osten, director of Cologne's municipal museums – an action that might have evoked the removal in 1914, from the exhibition rooms of the same Museum, of a picture by Ferdinand Hodler and its replacement with a panel denouncing the Swiss painter's signing of the 'Geneva Protest' against the German bombing of Rheims cathedral.[112]

In 1987 Haacke projected leaving the enclosed spaces of museums and galleries for the open air 'public realm' on the occasion of the already mentioned

'Skulptur Projekte' exhibition in Münster, but his proposition was again blocked by legal and administrative means. A few buses of the local public transport system were to have been painted in camouflage colours and carry the inscriptions: 'What do HIPPOS and this bus have in common? / They ride with MERCEDES motors across residential areas. / HIPPO = South African military vehicle, ironclad. In police operations against black inhabitants.' The city authorities objected that 'publicity with political content' was not allowed and that the camouflage would affect traffic safety.[113] A year later, however, the artist was invited to participate in an exhibition in Graz commemorating the 50th anniversary of the Nazi annexation of Austria to Germany. In this more congenial context he could realize his project, which consisted of the reconstruction of a temporary triumphal monument erected by the Nazis around the seventeenth-century 'Mariensäule' (Column of the Virgin Mary) in the centre of the town. The red obelisk had carried Nazi symbols and the inscription 'And yet you have won', to which Haacke added an indication of the number of victims of Nazi repression and the war in Styria.[114] This retrospective alienation of an ephemeral monument made a deep impression and also provoked some opposition, as an attempt to burn it made clear. The instigator (a 67-year-old former Nazi) and the executor (a 36-year-old unemployed neo-Nazi) of the assault were arrested and jailed. In his discussion in 1991 with the artist, the French sociologist Pierre Bourdieu remarked that the destruction of the work by its enemies had unleashed a discursive chain enabling the critical intention to unfold, so that it could appear as part of this very intention. Haacke, on the other hand, stressed that by stepping out in the street, one acted simultaneously in two different social spheres: passers-by had regarded the work and the burning as political actions, while only the Graz art world had seen in the latter also an assault on art.[115]

9 The Degradation of Art in Public Places

'Vandalism', justification and meaning

The burning of the Graz monument brings us back to illegal assaults perpetrated in public places by people who are not owners of their targets and can claim no authority regarding them. Works of art, and particularly modern works, without appearing to carry a specific political message, have very frequently been – and still are – subjected to such aggression, which has mostly been anonymous and unexplained. As we have seen, the term 'vandalism', generally used to designate these actions, postulates that they cannot be explained, and has come to deny all specificity to the degradation of works of art, as compared with that of public telephones, for example. Of course, this specificity cannot be taken for granted, but its denial, which excludes all too easily the critical relevance that attacks may have for art and the art world, must be questioned at the very least.

'Vandalism' in the broad sense, however, has been studied by sociologists, psychologists and criminologists, and art history has something to gain from their methods and conclusions.[1] As already mentioned, a major contribution to this study was made from the late 1960s on in Britain by adepts of the 'labelling theory of deviance'. Instead of asking 'why do people do these bad things', they asked 'why are these things defined as bad, deviant or socially problematic in the first place?', and later centred on the question of motivation 'precisely because the dominant societal stereotype of vandalism was (and is) that vandalism is the archetypal instance of "motiveless" action: senseless, wanton, random, meaningless'.[2] The second step required not only an examination of the form and context of actions labelled as 'vandalism', but attention to the meaning implicitly given by the actors or groups concerned, as well as to the specific vocabularies that could grant them legitimacy and credibility. This was all the more necessary because such vocabularies turn out to be socially unequally distributed. As a criminologist wrote: 'some groups are largely prepared to justify their behaviour from a spectrum of "reasons", while others have to negotiate the authorization to have reasons and others must accept that no suitable reason is given for their behaviour'[3] – a fact that should be borne in mind by anyone attempting to classify attacks against art according to the presence or absence of explicit motives and to the nature of these.

Physical aggression is by itself mute, or extremely polysemic, and the clandestine nature and anonymity of most illegal iconoclastic actions performed in public places make their interpretation especially difficult. Particular circumstances, however, can enable us to overcome these difficulties. This was the case with the 8th Swiss Sculpture Exhibition (SSE), which took place in Bienne in 1980. The number of degradations, which concerned almost half of the works presented in the open air; the quantity and richness of written and oral statements, testimonies and comments provoked by this controversial event; and the quality of its photographic documentation allow us to retrace the general reception of the exhibition and to detect and exploit a correlation between verbal and physical abuse of the works.[4]

The 'Swiss open air sculpture exhibition' had been created by a school director in 1954, with the intention of regularly presenting the various current tendencies of sculpture in Switzerland and of bringing this 'pre-eminently social art' into contact with a wide public.[5] Bienne (Biel in German) is a small bilingual industrial town (55,000 inhabitants in 1980) that owed its development and prosperity to watchmaking, precision machinery, car-making and metallurgy. Its social composition (mainly working class and lower middle class) and absence of purpose-built premises also explained the choice of 'open air' for the exhibition. When its creator, who had turned publisher and left the town, abandoned its organization in 1972, it was entrusted to a Foundation, which decided to mount it every five years and nominated Maurice Ziegler, who ran a gallery in Zurich, as art director. Shortly after this redefinition, the world economic crisis hit Bienne with a special violence and duration, a dramatic change that strained the relations between all publicly sponsored cultural activities, local authorities and the population. In 1975 an attempt at extending the sites of the exhibition beyond its previously enclosed spaces into the streets and squares of the old part of the town met with some verbal protests and physical aggression. Five years later, the organizers tried again to relate to a certain extent the works with the daily life of the inhabitants, but instead chose a peripheral area situated near the lake, a new-built school and a main road. The effects of the economic crisis could still be felt, a fact that certainly prompted them to 'increase the people's involvement' while affirming the status of Bienne as 'capital city of Swiss sculpture' against a growing competition in the realms of art, culture and tourism.[6] A 'didactic part' of the event was conceived to prepare and facilitate its local reception, consisting in an audio-visual introduction to contemporary sculpture (a project that eventually had to be dropped, however), small accompanying exhibitions (projects by artists participating in the show, documentation on art in public places, pupils' comments on their town), guided tours and 'open-air studios'.

The Press was invited to collaborate, and published presentation articles, interviews, a competition dealing with sculptures and a survey about which works readers liked best.

Despite these promotional and pedagogical efforts, the exhibition met with a large amount of negative local reaction, even before its opening on 31 May, which continued until its closing on 24 August 1980. In particular, 44 of the 177 sculptures – of which 107 were presented in the open air – were wilfully and anonymously injured or destroyed.[7] The sheer amount of damage obviously called into question the *raison d'être* of the institution and threatened the political and social position of its organizers and supporters. They answered with silence and denial, renouncing any legal action against the aggressors, trying to prevent journalists from publicizing the assaults, cancelling a conference planned on 'Art and Vandalism', and affirming that the problem was irrelevant to the exhibition. A retrospective assessment of the SSE 1980 summarized this official interpretation in the following manner: 'Many wondered what the secret motivation for these attacks could have been. The nature of the works affected invites one to conclude that there was no systematic anti-art campaign behind the actions, since provocative works were spared while inoffensive ones were senselessly destroyed. It seems rather that public property, belonging to no obvious owner, must bear the brunt of various cravings for destruction, without any particular or well-founded intention being associated with this mischievousness.'[8] The enlarged meaning of 'vandalism' was thus literally required to deprive the abuse of art-works of any specificity. One could easily check, however, that no simultaneous increase in wilful damage was caused to other objects, and no serial vandalism had been observed in Bienne during the exhibition.[9] Moreover, the apparent heterogeneity of the targets, called for to prove the meaninglessness of the iconoclastic actions, was based on the organizers' notion of the 'provocative' and 'inoffensive' sculptures, which they tended to equate respectively with the most 'modern' and with the most 'traditional' ones. This notion was far removed from the uninformed inhabitants' perception of the works, as the mediators involved in the guided tours of the exhibition noticed with some surprise. The 'traditional' (i.e. figurative) works assaulted were mainly female nudes, the erotic dimension of which was more strongly experienced, and sometimes resented, than they could have expected.

The organizers declared themselves surprised that fragile works had been left untouched, while very heavy ones were pulled down, and that the sculptures exhibited within rooms – because of their small size and more delicate components – had generally been respected, although there was little supervision and often few visitors.[10] Such remarks were also based on the assumption that the 'vandals' had not been reacting to specific works, but rather had been looking for the most convenient objects and the least risky circumstances in

which to vent their instinctive violence. In the absence of 'reasons', various factors weakening inhibitions, such as youth, idleness and alcohol, were invoked. Obviously, this view was unable to account for what had happened. But if one admitted that physical assaults were part of the reception of the exhibition, their almost exclusive concentration in the open air was easy to explain, since it was there that the confrontation with 'involuntary visitors' – a phrase used in the exhibition catalogue – took place, rather than in rooms that one only entered if one wanted to see the sculptures.[11] The spatial distribution of damaged works was clearly related to the proximity of daily non-cultural activities. In addition, the image of the town and its inhabitants could be involved. A large work made of standardized elements, installed in front of the railway station, was thus decried in letters to the Press and the authorities as 'a shame for our beautiful town of Bienne'; a newspaper published a reply from a local cultural personality suggesting that travellers arriving by train, far from being shocked by this sight, could deduce from it that 'here, one is not provincially minded'.[12] This work, however, was not attacked, perhaps because its rejection had found a largely public verbal expression. One might also be tempted to attribute this reserve to the massive presence of onlookers, but an assault might have been perpetrated during the night, and in a park integrated into the exhibition a particularly ponderous iron sculpture was pulled down on a Sunday afternoon without anyone intervening or reporting the misdeed – a fact attesting the approbation that iconoclasts enjoyed.

By examining systematically which works had been damaged and which had not, recurrent features can be discovered, which had been overlooked by organizers and journalists alike. They derive mainly from the materials used for the sculptures, and from the ways in which they had been employed. Works made of materials traditionally associated with fine arts, such as marble and bronze, or with handicraft, such as wood, had generally been spared (illus. 73), whereas attacks had concentrated on works made of concrete, plastics, aluminium, steel, unusual combinations and ready-made elements. The specific appearance of the materials could modify this general distribution, as when the treatment and display of bronze plates rather evoked sheet-iron pieces (illus. 74). In this case, the sculptor supposed that the mode of destruction had been suggested by the form of his work and that the absence of a pediment, by suppressing an 'emotional threshold', had developed a provocative effect and contributed to expose it to what he called the 'lower instincts of man'.[13] On the other hand, carefully executed works of polished or painted metal had not been damaged, and a large steel sculpture had won an unusual amount of respect, thanks to the technical expertise represented by its installation and balance (illus. 75). It thus becomes clear that works tended to be abused when their visual appearance, to an eye not versed in the history of modern art, did not make them exemplify 'sculpture' (but

73 *above left* René Küng's *Large Moon Scale* (1979–80) and *Ash-Tree Wind Wheel* (1979), both ash-wood, on show in the 8th Swiss Sculpture Exhibition in Bienne, 1980.

74 *above right* Part of Anton Egloff's *Profile of a Flight* (1976–77), as damaged during the 8th Swiss Sculpture Exhibition, Bienne.

75 Jürg Altherr's *Steel Construction XIIX* (1979–80) being installed in the 8th Swiss Sculpture Exhibition, Bienne.

rather 'industry', for example) and did not manifest the specific technical competence of their author.

This interpretation is corroborated by the comments made on specific works or the exhibition as a whole, and by numerous instances of verbal iconoclasm. The art director remembered that when the first sculpture was erected on a street corner, a passer-by said: 'Why don't you put this rubbish directly into the lake? The problem would be resolved!'[14] The most revealing statement was made by a porter of the new-built school, on the premises of which many sculptures were installed, in answer to a newspaper inquiry:

There are some things that are good, but, if you ask me, there are also many things included that have nothing to do with art. For example these iron sculptures [illus. 76], anyone who can weld can make them. On the other hand, I don't find the wooden sculptures over there by the lake bad, not everyone can make them. I heard many passers-by say this is not art. They find it a great pity that a rust heap was put on the new paving, so that one discovers rust spots on one's clothes afterwards, which cannot be removed. My colleagues and I have already considered leaving our jobs as porters and taking up art. One of them is a locksmith and I'm a plumber – weld such things together, we can do that too.[15]

The rejection of the 'rust heap' reminds one of objections made to the Cor-Ten steel *Tilted Arc* and countless other modern sculptures involving a rusty appearance – it is indeed a stereotype of the abuse of art in public places. A journalist observed in Bienne that, for many, such materials were 'ugly, unaesthetic, cold, dirty, to such an extent that the work itself was completely forgotten', and added that even if the rust eventually stabilized, the ground on which the sculpture stood remained soiled.[16] Clearly, artistically uneducated viewers encountering works in their daily environment had every reason to interpret and evaluate them according to extrinsic codes, in which – for example – rust denotes an object degraded as a result of neglect, disuse or dereliction, and must be avoided because it stains and may cause tetanus. Of course, knowing of the exhibition, they could not mistake them for rubbish, but the fact that works of art, statutorily associated with worth and preservation, assumed the appearance of rubbish could only strike them as a contradiction, a paradox, or a fraud. To the uninitiate – as well as to most legislators and insurers, as we shall see later – the value of an aesthetic object must result from the work added to the material. The porter's judgement shows that artistic competence was measured by comparison with the beholder's own technical capability. This is another, even more famous, *locus communis* of popular art criticism, as attested by the title chosen for an exhibition of cartoons about modern art, 'A Child of Six Could Do It!'[17] But if one wants to understand the conditions of the reception (including iconoclasm) of art in public places, as well as sometimes in museums, one has to take this criticism seriously. To many viewers in Bienne, sculptures appeared to be useless ob-

76 Bernhard Luginbühl, *Cardinal*, 1979, in the 8th Swiss Sculpture Exhibition, Bienne.

77 Max Bill in front of his *Pavilion Sculpture Made of 6 Round Timbers* (1969/76/80) at the 8th Swiss Sculpture Exhibition in Bienne.

78 Hans Aeschbacher, *Figure II*, 1962, with graffito inscription *R.I.P. Biel* ('Biel' is the German name for Bienne), in the 8th Swiss Sculpture Exhibition, Bienne.

jects, arbitrarily endowed with a high financial value, to the realization of which artists owed considerable social prestige, without having manifested in them professional abilities comparable to those daily demanded from the same viewers for a much lower material and symbolic gain. This was far from specific for the town, but local and historical circumstances help explain why the ensuing rejection took such unusual dimensions. The town's social composition gave a special weight to this kind of perception: its inhabitants included workers engaged in material processes that did not aim at technical perfection, and the economic crisis made professional skills a vital desideratum, but skills that were insufficient to guarantee continuing employment. In this context, the exemption from common norms and necessities that art and artists apparently enjoyed must have the effect of a provocation, and the collective acknowledgement of their value that the exhibition in the open air implied was resented as a symbolic redoubling of social domination.

It comes as no surprise that works mainly made of pre-existent elements or whose execution was not performed by the artist himself were also favourite targets of criticism. Spectators thus objected to a log sculpture by Max Bill ('one learns how to do that during military service'), and one cannot help interpreting the ironic expression of a local worker (illus. 77) participating in its installation – the sculptor faces the camera with a catalogue in his hand – as a comment on the process in which he is involved. As for the work standing closest to a Readymade, Gérald Minkoff's *Video Blind Piece* (illus. 126, 127), it was literally treated as rubbish. The case will be presented in more detail in chapter Fourteen, but it must straightaway be noted that the person who attacked it – the only identified 'vandal' in Bienne – far from corresponding to the stereotype of the drunken idle youth, was a sober middle-aged owner of a gardening business, a fact that underlines the conclusion of a conference on vandalism organized in 1979 in Messina: 'the vandal' is essentially 'a common individual, a normal person acting in particular conditions'.[18]

Another confirmation of interpretation was provided by the intermediary type of graffiti, which combines physical intervention and verbal comment. The sculpture derided as a 'rust heap' by the school porter was inscribed with 'Art-shit, idiocy', a violent symbolic reversal turning the tables of social value on the artwork and returning the judgement of imbecility to its legitimate users. (The first defaming reference was literally expressed when excrement was deposited on a sculpture in the form of chairs and inside another one entitled *Trojan Horse*.) Another graphic appropriation transformed an abstract work by Hans Aeschbacher, a recently deceased artist to which the SSE 1980 dedicated a small retrospective, into a gravestone for the town (illus. 78). Besides its visual effectiveness, this interpretation derived a particular relevance from the funeral connotations of the slab, the use of similar forms in modern graveyard sculpture, and the tension existing between the exhibition and the

79 'Fritzli', *The Thing*, added pseudonymously to the 8th Swiss Sculpture Exhibition in Bienne.

economic situation of Bienne, as remarked by the mayor in his opening speech, when he commented on the monumental dimensions of a number of works as 'a ditch in relation to the events that have marked our town during those same last years'.[19] Yet other means were employed to annotate the exhibition, in particular an equivalent to the later Berlin 'Trabant sculptures' (illus. 63), objects spontaneously and anonymously introduced among the official works. In accordance with the porter–plumber's own aim of changing his occupation, they were generally made of welded metal and seemed less intended to prove their authors' capacities than to mock those of professional sculptors. The most explicit was technically the simplest, supplied with name and title: 'Fritzli' (Little Fritz, probably a pseudonym), *The Thing* (illus. 79).

Criticism could also be found in the local Press, which was not content with serving as a connecting belt for the organizers. One journalist, who regularly commented on the exhibition, tended to express the negative reactions of her readers while pretending to invite them to tolerance and curiosity.[20] Another interviewed aggressively the art director and the sculptor Jean Tinguely, giving voice to the confusion, questioning and criticism of a part of the population.[21] The *Berner Zeitung* justified the inquiry which collected, among

others, the school porter's statement by declaring that 'besides the art viewers' and consumers' thoughts, the opinion of those persons confronted daily and directly with the sculptures also belong to the discussion about the exhibition'.[22] But newspapers only issued their own attacks under the euphemizing guise of humour, mostly by means of cartoons. These developed the theme of an alleged impossibility of distinguishing between art and non-art and will be discussed in chapter Fourteen. Already five weeks before the opening of the exhibition, the *Journal du Jura* published under the hyperbolic title 'A Sculptor of Genius' a photograph showing a mechanical detail of Tinguely's work in progress; whereas the document might have represented a corner of many workshops in town, the caption ironically described it as 'evidence that the great Tinguely is really at work in Bienne'.[23]

But logically, the Press primarily voiced manifestations of cultural goodwill. The author of the aforementioned inquiry stressed that those questioned wanted to understand the works, and regretted that one had to buy the catalogue to glean information; the manager of a coffee-house situated near the exhibition summed up his clients' complaints by declaring that even the catalogue mentioned only 'the authors and materials of the sculptures, whereas the artists' ideas and reflections were not expressed'.[24] Such remarks pointed to important shortcomings and contradictions in the organizers' intentions, which also became apparent in the interview with Tinguely and Maurice Ziegler. When the journalist stated that the 'ordinary citizen' asked himself how and whether he or she was 'capable of grasping these things', the art director answered that art dealt with emotions rather than intellect and that people should be told that 'there is nothing to understand'; and when he mentioned that Tinguely's funny and informal titles helped 'the people' to appreciate his works, Ziegler commented that titles should be suppressed. Needless to say, this conception of an innate disposition to enjoy art stifled by words and 'intellectuality' (what Nelson Goodman calls the 'Tingle-Immersion theory') could only undermine efforts made at 'going to meet the public'.[25] The interviewer correctly noted that 'the passer-by who is not engaged in art ... sees that certain persons, the artists, exhibit something that other people find pretty good ... but feels himself excluded from this enterprise'.[26] In fact, the negative – including the iconoclastic – reactions to the exhibition show that its extension into the site of daily activities was perceived as an invasion and generated a feeling of double exclusion, from the cultural practices that gave the sculptures their meaning, and from the public places temporarily dedicated to these practices. It follows that far from diminishing the distinction between the initiate and the layman, the suppression of architectural and spatial barriers revealed and dramatized it, by making it appear as situated solely within the person.

The official interpretation of the assaults as wanton, senseless and motive-

less actions has already been mentioned. It was part of a condemnation that stigmatized the 'vandals' as cowardly blockheads. While acknowledging the 'incomprehension of the public', the journalist who specialized in double (and confused) language affirmed that 'to go beyond and destroy or set fire to a work, that is a senseless – because anonymous – gesture'.[27] The same author defined the unknown destroyers as 'those who, in life, will never be able to "sign" their works'. 'Vandalism' was thus revealingly defined as the infamous reverse of artistic creation, with a symmetrical correspondence linking its anonymity to the celebrated signature, its 'purposelessness' to aesthetic 'disinterestedness'. (Stanley Cohen also remarked that 'vandalism is seen as an inversion of the Puritan ethic that demands that actions should be carried out for a recognizable, utilitarian reason'.)[28] Yet other commentators, more discerning and less involved in local interests, proposed perceptive interpretations. The writer Peter Bichsel declared that although the 'vandals from Bienne' had neither his comprehension nor his sympathy, he nevertheless understood that 'sculpture has to do with gigantism, strength, power and domination' and may provoke aggression 'because one still supposes a prince behind it, one who ordered and paid for this'.[29] A similar perception of the issue of domination was expressed by the art critic Peter Killer, who weakened his point, however, by restricting the role of art to that of a scapegoat. For him, whereas Erich Fromm had explained the vandalization of art as a pathological hateful reaction to objects valued by many,

the opposite must generally be true today: art provokes hate because it is loved by a minority and brought before the public because it corresponds to the notions of taste of an elite. Learning that decisions that determine life and modify the environment are increasingly taken without regard for the interests of the majority brings about a feeling of powerlessness that can lead to resignation or to aggressive discharge. One takes revenge on 'those up there', for instance by pulling down, degrading or daubing officially sponsored works of art that stand in one's way in public places. One says one thing and means another.[30]

Others, especially artists, were not satisfied with explanations that made out of the degraded works the indifferent targets of senseless actions. They often sought solace in the idea that a negative reaction is better than no reaction, and that aggression attested the power of the sculptures. Some went so far as to consider the violence done to the works as a reply to another violence contained within them, but they valued the latter as a 'subversive' dimension while seeing 'Nazi recollections' or symptoms of a Fascist-like atmosphere in the increasing rejection of art.[31] Such indirectly positive interpretation of the meaning of 'vandalism' was brought one step further by a commentator who, exceptionally relating the Bienne events to the history of iconoclasm, proposed to draw from them the following syllogism: free art has always been attacked; modern art is attacked; therefore it is free. He wrote that those to whom the

liberty conceded to art by the public and the state appeared as that of a fool had reasons to rejoice over the recent assaults: 'They remember that iconoclasts at least – from Abraham smashing the idols to the youths rioting against the opera-house – never denied their respect to art as their enemy number one. Despots of all times have kept and keep a panically watchful eye on the art that cannot be defeated even with censorship and sanctions. You must recognize it by its enemies.'[32] A precise relationship between artistic 'provocation' and public expectations had been described in his interview by Jean Tinguely, who recalled that he had 'a Bienne tradition':

I once exhibited an 'aquatic sculpture' that I wittingly considered as provisional. I forged some more tools and badly fixed the pipes, so that water spouted out on the sides as well. My conduct was doubly vicious because I knew that it was unskilfully done ... and yet it had a certain charm. When the sun was shining, a rainbow appeared. On the one hand, it was charming and enchanting; on the other, it was bad and wicked, so that the person who must daily supply a work of precision first gets angry and then, maybe, becomes thoughtful. ...[33]

Obviously, in 1980, most persons had stopped short of becoming pensive in the sense hoped by the artist. The fate of a naïve attempt at turning the 'aggression of the public' into an alleged participation in artistic creation illustrates even better the 'vicious' relations established between anticipated and actual reception: the four hammers attached with ropes to the base of Roland Lüchinger's *Action Sculpture* (illus. 80), which should have been used by spectators to fold the exterior sheet-iron parallelepipedon onto the interior steel cylinder, were stolen and probably employed on other works that did not demand any physical intervention. In an analogous way, the instruments of cultural integration proposed by the whole exhibition had been refused and turned against their legitimate holders.

'Barbarous taste' and symbolic violence

The extent to which specific factors of time and place must be considered when interpreting the 1980 iconoclastic outburst in Bienne has already been discussed. One may add to the structural and conjunctural elements mentioned the conjoined effects of a continuously bad weather, of some undesired technical deficiencies in some of the sculptures, and of the organizers' slow reaction to the degradations, which confronted the 'involuntary spectators' with objects whose poor appearance might be far removed from the artists' original intentions and which could lower the psychological threshold opposed to physical aggression.[34] All of this, however, accounts for the dimensions taken by the phenomenon rather than for the phenomenon itself, and the other factors identified possess a general relevance.

The sociological analyses of taste and domination elaborated from the

80 Roland Lüchinger, *Action Sculpture*, 1980, in its damaged state.

second half of the 1960s on by Pierre Bourdieu are of particular interest in the illumination of these broader issues. The study of the non-professional uses of photography and of the visiting of museums in Europe enabled him to define the instruments of perception and appraisement applied to aesthetic objects by the popular classes and by those fractions of the middle class least endowed with 'cultural capital', in reference to what Kant had negatively labelled as 'barbarous taste'. Such instruments equate aesthetic with social norms, thus submitting works to the demands of propriety, morals and pleasantness; they equate 'what pleases' with 'what brings pleasure', as well as the interest and value of representation with those of what is represented; they require from a work that it fulfil a function – be it only that of sign – and look to it for the unambiguous expression of a signified transcending the signifier.[35] In short, they refuse the very separation of the aesthetic realm from common norms and criteria on which 'pure taste' and autonomous art have been and keep on being predicated. It follows that their interpretation of the properties of modern works of art (e.g. the rusty surface of Cor-Ten steel), even if they amount to misunderstandings as far as artistic intentions are concerned, nevertheless possess a certain relevance and heuristic value

because 'barbaric taste' serves as a set-off to all more or less legitimate and competing tastes.

Formed through family, background and school education, tastes express views of, and relationships to, the world. The disinterested enjoyment of functionless objects, which constitutes the authorized model of aesthetic perception, implies a fundamental distance from economic necessity and to those who are bound to it, as the Bienne case made clear. Despite their ambitions of emancipation, culture and cultural practices thus also contribute to the modes of domination that – at the political opposite from totalitarian or authoritarian regimes – 'expect the symbolic integration of the dominated classes from the imposition of needs rather than from the inculcation of norms'.[36] Democratically motivated or justified attempts at widening the circle of those participating in 'culture' may, as we have seen, reinforce rather than weaken this phenomenon, all the more so as the logics of artistic innovation and social distinction tend to equate divulgation with vulgarization and to perpetuate the discrepancy between works and expectations. Bourdieu calls 'symbolic violence' a violence that implies its not being perceived as such for exerting its effects. In Bienne, verbal and physical violence can be understood as a reply to a violence of this kind, made more perceptible than usual by the nature and scale of the attempt and by adverse circumstances. Another interpretation of the rejection of non-traditional materials, proposed by Colin Ward, can be reconciled with the same overall explanation: during a meeting organized between London's Docklands tenants 'who were outraged by the piece of abstract sculpture bestowed on their estate by the Council' and the architect and sculptor concerned, it turned out that the former 'felt they had been fobbed off with a load of old driftwood and *objets trouvés* while other estates had fully-certificated minerals like stone and bronze. The signal sent out as "art" was received as "second-class citizen" '.[37]

Like 'vandalism' in general, assaults on art in public places may then be defined a form of 'social protest', and both may share characteristics of their targets (such as being publicly rather than privately owned, or of being already in an degraded state), context and offenders.[38] Both can also be seen as illegitimate ways of appropriating the 'public realm' or of resisting and denouncing an authoritarian occupation or management of it.[39] To some extent, such common elements derive from the fact that aesthetic and non-aesthetic objects can be perceived and resented as symbolizing the same elements such as power, wealth, the state, etc. However, this semantically unspecific community can only account for a small part of the abuse of works of art in public places, both in quantitative and qualitative terms. As we have seen, the social and aesthetic dynamics of art and culture are directly at stake in the actions that take their tokens as targets. Numerous cases attest that this is not a fact limited to a given time and place.

If the reception of the SSE 1980 was exceptional in degree, attacks and degradations have become a normal feature of temporary and permanent exhibitions in public places. Despite this pervasiveness, no systematic inquiry provides or makes possible statistically based comparisons of places and actions. But a broad overview shows that no types of area or work are primarily excluded. The social and spatial context need not be that of an industrial town, as the burning of a sculpture made of synthetic material in the grounds of the University of Konstanz witnesses.[40] It need not even be a town, and rural art can be assaulted as well. In 1985, four of the eleven works created near the dam of Cuxhaven in Germany for the second 'North Sea Coast Symposium' were wilfully destroyed; the organizer was an artist from Cuxhaven, Wulf Kirschner, whose metal coast sculptures entitled *Wind Caps* had been pulled down four times, the first one by means of a construction-site vehicle.[41] North of Hälsingborg in Sweden, Lars Vilk had to go through several lawsuits to maintain his driftwood sculpture *Nimis*, built over a period of four and a half years, against the local population. Joseph Beuys came to his help and bought the work, thinking that a famous name would act as a warrant, but this did not prevent it from being burned one night in January 1985.[42] In March 1995, the heads of Henry Moore's bronze *King and Queen* were sawn off on a remote hillside near a minor road in Scotland (illus. 81). Bought in 1954 by a director of Jardine Matheson, the work had been installed on an outcrop of rock on the family estate near Dumfries, and Moore, who had visited the place, was said to be delighted that a royal couple would be keeping an eye on the border separating Scotland from England. Together with five other sculptures by Moore, Epstein and Rodin, it had become a major tourist attraction in the area, but the owners had also received abusive letters asking how they dared desecrate the countryside with 'hideous bits of metal and the like', so that enemies of modern art as well as political activists can be considered as possibly responsible for the misdeed.[43] But neither is only modern art concerned, as a report in *The Burlington Magazine* in 1976 on the damage done to Florentine sculpture by tourists and inhabitants amply testifies. Tourists were not always content with picking up fallen fragments, such as those of the right arm of Christ from the marble group by Sansovino above the *Paradise* door of the Baptistery, which might have been set – as one local newspaper put it – 'beside the statuettes of the *David* on mantelpieces in Milwaukee', but seemed to choose their prey as well, for instance a marble pine-cone from the base of Cellini's *Perseus* in the Loggia dei Lanzi. Moreover, 'souvenir hunting' could hardly explain the beheading of the figure of *Truth Unveiling herself to Art* from Lorenzo Bartolini's monument of Nicholas Demidoff, and *The Burlington Magazine*'s

81 Henry Moore, *King and Queen*, 1953, in the Glenkill Estate, Dumfries, as beheaded in March 1995.

82 Erwin Rehmann, *Maternity*, 1950, photographed in September 1982. *This sculpture was bought in 1955 by the town of Bienne and placed in the courtyard of the Ecole des Prés Ritter.*

editor decried the wilful neglect of neo-classical sculpture by the authorities in charge of the preservation of the city's cultural heritage.[44]

This quasi-ubiquitous voluntary degradation even increases if one turns from spectacular assaults and damage towards minor, sometimes not easily discernible, interventions. For the sake of contextualization, I had visited most sculptures permanently displayed in the public places of Bienne while researching the ESS 1980, and found few that did not bear some scratch or inscription, or whose concavities had not been turned into a dustbin. Random examination in other places so far tend to confirm that this is again no specific trait of a particular town. The 'dustbin appropriation' is especially interesting, since it easily, harmlessly but none the less effectively expresses the desecration of a given work or of its kind as 'rubbish' (illus. 82). Such low-grade assaults understandably escape the attention of almost everyone but their authors, but they can be all the more revealing as part of the common-place reception of works of art accessible to everyone, and as symptoms of, in Freud's sense, a 'psychopathology of everyday life'.

Another ordinary type of unauthorized appropriation is the addition to works of architecture, sculpture, or more rarely paintings, of signatures, which can be accompanied by references to time and origin. It is particularly frequent in tourist areas, and may be related to so-called souvenir hunting, although it adds rather than subtracts. One may find it difficult to consider this time-honoured use of graffiti as aggression or criticism, but Louis Réau, defending as always cultural order against every infringement, gives us an-other clue in this respect: 'Innumerable are the simpletons who, armed with a chalk stick or a penknife, aim at perpetuating their foolishness by in-scribing their obscure names on the fronts of churches, the faces of tomb figures, or the looking-glasses of national palaces'.[45] A century before, Ro-dolphe Töpffer had shown more sympathy for the simple folk when commenting on the discovery of a name 'grossly carved in uncial letters' into a rock in the Alps. To him, the 'foolish vanity' commonly attributed to the authors of such signatures was 'as legitimate, more excusable perhaps than the one of those monarchs who have monuments, triumphal arches, bronze and marble inscribed with their names and virtues, favours and vic-tories'.[46] Réau and Töpffer both contrast worth, fame and eternity with obscurity, foolishness and transience; the former takes sides and tolerates no passing of the line, the latter concludes from the ideal of equality that all men are worthy to be – to some extent – known and remembered. This opposition may help explain the unauthorized signing of cultural objects (of 'monuments, triumphal arches, bronze and marble' themselves) as repre-senting not only an attempt at escaping death and oblivion, but a kind of puncturing of celebrity and value, or even a protest against the – socially de-termined – unequal distribution of visibility, regard and duration. The next

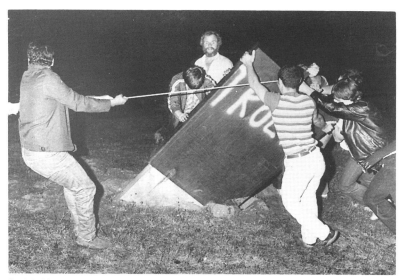

83 Inhabitants of Apeldoorn in The Netherlands pulling out from the ground a slab from a work by Evert Strobos on the night of 1-2 September 1983. *Another slab, not shown, is sprayed with the words* Alles moet plat *('Everything must [go] flat').*

chapter will show that such motives are central to the destruction of art within cultural institutions.

But attacks on art in public places are not restricted to minor incidents or even to individual and clandestine actions. In 1965 in Heilbronn (south-west Germany), someone used a taxi to try and pull down a controversial fountain statue by Dieter Läpple symbolizing the town.[47] On the night of 1 to 2 September 1983, about 100 local inhabitants of the Zevenhuizen district in the residential and garrison town of Apeldoorn in The Netherlands (148,745 inhabitants in 1995), not far from the celebrated Kröller–Müller Museum, dragged out from the ground 49 rectangular slabs belonging to a work by Evert Strobos, which had been bought by the city for 180,000 *gulden* and was in the process of being installed (illus. 83). Journalists and policemen were present, the former taking pictures of the event, the latter refraining from intervening because, as one speaker declared, 'a repressive action could only lead to an escalation by this massive manifestation of hostility'.[48] In The Netherlands, wilful destructions of works of art in public places have repeatedly taken serial or overtly collective dimensions in the last decades, for instance in 1961, 1973 and 1993, and commentators recently had the impression that the number of cases was increasing. The word 'iconoclasm' (*beeldenstorm*) was used concurrently with 'vandalism', and 'a new iconoclasm' was even evoked in relation to the sixteenth-century antecedent.[49] In 1993, an artists' organization in The Hague decided to create a documentation centre

on the subject as well as a telephone line dedicated to the collection of current information.[50] This exceptional development and interest implied attempts at understanding the causes of the phenomenon rather than the simple denunciation of it, as a 1985 cartoon on the topic – in itself an extraordinary occurrence – witnesses. The man and wife visiting an open-air exhibition, confronted with damaged works, state that 'vandalism was always a specifically Dutch problem' and relate it to national traits such as 'individualism' and an independent attitude towards authority. 'The Dutch will not be dictated to in what they must experience as art', they say, and may well protest for political reasons (against apartheid if the exhibition is sponsored by Shell) or because 'incomprehensible art' is being publicly funded rather than art by street kids or popular entertainments. Finally, the man adds that artists should keep up with their time and make self-defensive works of art.[51] One cannot fail to notice that this standard couple finds everyone to blame, except the 'vandals'.

There remains the question of the relationship between verbal and physical iconoclasm, even if the answer must remain conjectural. Obviously, the fact that similar factors and arguments can be found to bear on both types of aggression does not imply that the same persons resort to them, either simultaneously or at different times. Indeed, it is tempting to consider that being able or allowed to express one's hostility might make it unnecessary for one to act it out. But this need not always be the case either, and must certainly depend to some extent on the degree to which protests are acknowledged and followed up with actions. Robert Storr found that the defenders of *Tilted Arc* left unanswered 'the question of what if any are the appropriate forms . . . collective dissatisfaction should take', and we have seen that the destruction of *Nimis* near Hälsingborg followed several unsuccessful attempts at legal removal on the part of the local population.[52] The intervention of Beuys in the latter case and his resorting to both the right of property and the aura of artistic fame in order to maintain the rejected work are of particular interest here, since they exemplify the intimidation employed in most comparable instances. Instead of being seriously discussed in a spirit of emancipation corresponding to the promulgated artistic intentions, objections to modern works are generally discarded as expressions of prejudice, narrow-mindedness and a reactionary traditionalism disqualifying their authors. A polemic around the 'gift' of a sculpture by Dennis Oppenheim to the town of Geneva and its installation in a park, for example, was stylized into a heroic fight of 'the art that disturbs against the art that tranquillizes' – an inquiry opportunistically organized by a Right-wing marginal party also allowed its defenders to evoke the ghost of Nazi anti-modernism – until an independent commentator criticized the spatial and social irrelevance of the project.[53]

The exclusion from public debate, the denial of legal means of action and the resulting frustration may well lead to mute but effective interventions

that, however, tend to entrench rather than really challenge the balance of power to which they react, since their authors can be denounced as enemies of culture and society. The illegality, but even more the illegitimacy of 'vandalism', thus make it a dominated reply that reinforces domination, a counter-violence that hands weapons to symbolic violence.

10 Museums and Pathology

Thresholds

Who visits art museums? Cultural institutions, although 'public', really address only a select fraction of the population, even if it varies according to time, place and the kind of permanent or temporary exhibition concerned.[1] Moreover, entering a museum implies a will to see at least part of what it contains, and a knowledge that such objects, generally a public property, are valuable and consequently watched over. It follows that, in principle, within museums, works of art should not or should only exceptionally confront the 'involuntary', culturally inadequate or adversely equipped spectators who tend to be a majority in open-air and non-cultural public places.

And yet, attacks do take place in museums too. Indeed, they are very numerous, even if the absence of reliable figures discourages any comparison. Should they be related for that reason to altogether different factors, or to complementary ones? Before we embark on this search, the preceding remarks must be nuanced. First, the 'will' to visit a museum or perform another cultural activity is certainly in itself a complicated matter, engaging multiple and possibly conflictual combinations of interests, desires, anticipated pleasures, representations, and duties. Second, in the last few decades, deep social, cultural, political and economic transformations have contributed to a widening of the museums' public, so that even 25 years ago, an American specialist could attribute 'the increase in museum vandalism in recent years' not only to 'the heightening of human tension in modern society', but also to the fact that 'museums are faced with vastly increased and diversified audiences which include a segment of the public not previously conditioned to restraint in viewing'.[2] Third, the development of modern and contemporary art and its equally widening inclusion in museum presentations (in 'general' as well as in specialized institutions) account for a much augmented possibility that even voluntary and cultivated visitors encounter works that escape or defy their aesthetic expectations. All of this has tended to attenuate the difference between museum and non-museum contexts, or even – particularly with modern and contemporary art – to make it almost irrelevant. Nevertheless, and generally speaking, museums may be said to raise the threshold restraining the enacting of physical aggression, or to effect a selection among potential aggressors invol-

ving a greater 'interest' or involvement in the work and in the deed, a greater degree of premeditation, and a greater willingness to be recognized as the author of one's action and to suffer sequels that follow from it.

The last element is generally regarded as of special importance. It corresponds to a paradigm of the iconoclast, that of Herostratos, the obscure inhabitant of Ephesos who, according to the Greek historian Theopompos, set fire to the world famous temple of Artemis in 356 BC 'in order to preserve his name for posterity', and was condemned not only to death but – unsuccessfully – to oblivion by means of a prohibition against mentioning his name.[3] If the desire for publicity, for oneself or for a cause that one advocates, is unlikely to account fully for any iconoclastic action, it seems to play a part in not a few of those occurring in museums, conceived as temples of fame as well as of art. The man who in 1975 slashed Rembrandt's *Nightwatch*, for example, besides previously having received psychiatric treatment, was reported to having said to a couple of worshippers in the Amsterdam Westerkerk – Rembrandt's burial place – that he would make front-page news the next day.[4] Such parasitical puncturing of visibility derives not only from the value publicly attributed to works of art, and especially to very famous ones, but also from the 'quite extraordinary attention paid to the minutest details of each attack' in the Press, as David Freedberg remarked.[5] Indeed, a French psychiatrist and psychoanalyst considers that in a serial case such as the one that took place in Germany in 1977, the media campaign that accompanied the assaults had narcissistic and even therapeutic effects on the aggressor.[6] On the other hand, the iconoclastic actions of the Suffrage movement have shown that the very value and interest associated with works of art could be the target of a critical intention. They also showed that the relatively minor punishments incurred by destroyers of art could be taken into account by rational evaluations, even if ambivalent links existed between such deeds and 'bloodshedding militancy'. Due to the raising of the threshold, the respective importance and mutual relationships of overt and covert (not to speak of conscious and inconscious), collective and individual factors and motives tend to be particularly complex and difficult to probe. Defining 'tactical vandalism' as 'a conscious tactic used to advance some other end than acquiring money or property', Stanley Cohen added that when 'directed towards attracting attention', it 'might result from personal troubles rather than ideological convictions'.[7]

Techniques of and against aggression

Modes of degradation vary greatly as far as gravity and methods are concerned. A vast amount of damage, which generally escapes publicity, is of the 'petty' type caused by 'the blob of gum, the smear of lipstick, the smudge of

ink'; it should, according to the museum specialist already mentioned, stem 'from little more than the exercise of a visitor's ability to deface' and 'be applied with an indifference to selection paralleled only by the lift of a dog's hind leg', but may be better accounted for in relation to the low-grade assaults in public places (illus. 82).[8] With modern art, in particular non-varnished and especially monochrome paintings, however, very minor interventions such as touching or spitting (a traditional expression of contempt) can result in a destruction of the work, without the author of the gesture – who may even be primarily curious of material and construction – being necessarily conscious of it.[9] Technically, a distinction can be drawn between adding and subtracting interventions. Lipstick may be used as a kind of pencil, but in one case at least, it was deposited by the very lips of its owner, a 43-year-old woman named Ruth van Herpen, on a white monochrome canvas by the American painter Jo Baer, at the Oxford Museum of Modern Art; the author of the deed, who was put on trial, explained that she had found the painting cold and wanted to 'cheer it up'.[10] In 1912 a young woman had added red colour to the forehead, eyes and nose of a portrait by François Boucher in the Louvre; she had wanted to draw attention to herself and show that there were other sinners on earth whose faces should become 'red with shame' like hers.[11] Inscriptions can also be drawn, painted or sprayed over the surface of a work, as was the case with the puzzling 'KILL LIES ALL' written on 28 February 1974 on Picasso's *Guernica* in the Museum of Modern Art in New York by Tony Shafrazi, an Iranian living in New York, who considered himself to be an artist and described his 'Guernica action' as innovative art.[12]

Subtracting interventions are more frequently reported, and seem to embody better the aggressive dimension implied by any transgression of the prohibition of physical contact fundamental to accepted behaviour in museums. It has been pointed out that a simple direct touch may detach substance from some works, particularly modern ones, but reports generally mention the use of instruments. Some need not have been brought for that purpose, like the nail-file (comparable in this respect to the lipstick) used in 1966 by a woman to damage a picture by Hobbema in the National Gallery of Art in Washington.[13] Others, such as knives, are both more dangerous and revealing of a premeditated destructive intention. Scratches may be closer to a kind of appropriation, and have sometimes been related to artists' signatures, whereas cuts clearly aim at amputation or annihilation, and have rather been compared with murder – e.g. in the case of 'the Ripper', Mary Richardson – or, on the level of the unconscious, with sexual penetration. Yet other techniques allow for a greater distance between aggressor and victim. Any object (brought or found on the spot) can be thus re-functionalized, like the bronze statue thrown on 11 January 1976 at a painting of 1886 by Bouguereau, *The Spring*, in Omaha's Joslyn Art Museum, by a 37-year-old former window-

cleaner who found it 'filthy'.[14] A special mention must be made of acid, of which the author of the 1959 assault against Rubens's *Fall of the Damned* in Munich's Alte Pinakothek (illus. 84) said that when one threw it on a picture, it was as if one did not destroy it oneself: 'The liquid relieves one from the work of destruction'.[15]

Protective measures taken by museum staffs are generally of a technical and organizational nature, and derive from an analysis of the methods of aggression rather than of its motives. They need not be examined here. A reaction that bears on the conditions of the study of iconoclasm within museums is the silence pointed out by Peter Moritz Pickshaus: curators tend to avoid giving out information, and even to renounce legal actions and claim for damages.[16] This behaviour is generally justified by a belief in the contagious nature of aggression, already noted on a contextual level – Caroline Keck considers, for example, that 'one punctured eye in a portrait of George Washington suggests the puncturing of both eyes in a portrait of Thomas Jefferson'.[17] Such a fear is not altogether ungrounded. The 'attention-seeking' component of many acts does rely on publicity, and several serial degradations in public places, although anonymous, seem to have implied an analogous phenomenon.[18] In the case of modern art, approving reactions from a part of the general public may also encourage an aggressor to go on, or elicit imitators.[19] However, Pickshaus is certainly right in seeing other reasons for this silence: the fact that iconoclasm brutally exposes the contradiction between the conservation and mediation that is inherent in the functions of museums, its negative impact on the image of the institution, the careers of curators and their future collecting and exhibiting activities, and perhaps a kind of 'revenge' evoking Herostratos' punishment.[20] One may add to this, at least in some cases, a wish to deny the existence of reactions that, if considered meaningful, must imply some kind of criticism of the museum and of the art or culture it stands for. In this respect, the purely technical character of most answers to iconoclastic actions cannot be regarded as deriving solely from the difficulties of probing into heterogeneous and disputed causes. Three years after the much publicized assault on a painting by Barnett Newman that will be discussed later, the West Berlin Nationalgalerie did not provide its visitors with the information on modern art that this affair had shown to be so badly needed, but submitted them to security measures that made them feel harassed and suspected of malevolent intentions. Ironically, however, the instrument used to damage Newman's *Who's Afraid of Red, Yellow and Blue IV* (illus. 89) had been one of the plastic bars indicating the distance from the painting that visitors were required to respect. Another perverse relation between security and degradation (or law and transgression) may be illustrated by a case in which it was found out that the person responsible for the scratching of an x-shape on nine pictures in the Louvre was one of the guardians on

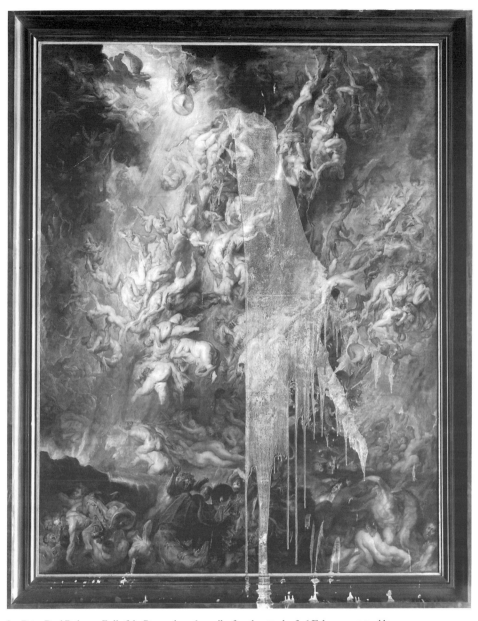

84 Peter Paul Rubens, *Fall of the Damned*, *c*. 1619, oil, after the attack of 26 February 1959. Alte Pinakothek, Munich.

night duty, and that the hard instrument employed was probably his bunch of keys.[21]

Psychopathological and psychological explanations

Following the attack on Rembrandt's *Nightwatch* on 14 September 1975, the director of public relations at the Rijksmuseum in Amsterdam was reported to have declared: 'The assailant and his motives are wholly uninteresting to us; for one cannot apply normal criteria to the motivations of someone who is mentally disturbed.'[22] This statement is typical of the way in which judgements of psychic abnormality are frequently used to deny relevance and meaning to aggression directed at works of art perpetrated within cultural institutions. The analogy with the function of the 'vandalism' concept is readily apparent, and Martin Warnke could point it out in the condemnations passed on the Münster Anabaptists, whose iconoclastic actions belonged to the 'charges which, because they contain a moment of truth, were represented as an outburst of madness'.[23] The distinction between normal and abnormal behaviour is pre-eminently a question of labelling, predicated on the conventional conditions under which, for example, the form and content of a protest are considered to be legitimate and admissible.[24]

The sociologist Luc Boltanski, who made a ground-breaking study of such conditions in the case of letters sent to the Press, defined as obstacles to understanding the usual distinction between individual action and collective action as well as the rejection of the former to other disciplines, such as historical psychoanalysis or social psychiatry; he proposed, instead, examining 'normal' and 'abnormal' cases from the same standpoint and questioning the reasons for their perception as 'individual' or 'collective' acts.[25] This is a fundamental methodological issue, and Boltanski's attitude seems to me to be the right one. In order to examine what iconoclasm can yield about the general effect of images, David Freedberg recommended on the contrary 'to turn to the individual act, sometimes a part of a larger movement, but preferably where it is indeed isolated from any kind of socially acceptable behaviour'.[26] Among the motivational types of iconoclasm that he proposed provisionally to distinguish (attention-seeking acts, attempts at depriving an image of its power, attempts at diminishing a power by damaging the symbols of this power), the first two ones seemed to him to stand closer to 'the psychologically more fundamental levels of motivation', i.e. 'the desire present in all of us, to rupture the identity of image and prototype'.[27] He found particular evidence of this transhistorical phenomenon of 'fusion' and rejection in the frequent concentration of attacks, in the sixteenth or in the twentieth century, on the representation in an image of 'those organs which give us most sense of its liveliness', the eyes, or in the 'fear of the senses' manifested by assaults on more or less erotic pictures.[28]

In a very original way, Freedberg valorized – on a heuristic level – elements and modes of 'response' to images that had generally been neglected, repressed or condemned. In 1915 Julius von Végh had drawn from his study of iconoclasts the conclusion that 'man wants time and again to revenge himself like a child on lifeless objects for his pains and breaks over and over again toys of which he has become tired, because he has endowed them with properties which they in reality do not and cannot possess'.[29] An analogous – phylogenetic or ontogenetic – interpretation of iconoclasm as archaism is also implied by remarks to the effect that iconoclasts are as much idolaters as their adversaries, and can be associated with an opposition between pre- and post-Enlightenment attitudes towards images and beliefs.[30] However, conscious, rational and historically determined motives are not excluded by the (supposed or demonstrated) presence of factors such as fear of the senses, for example. Mary Richardson's assault on the *Rokeby Venus* has already shown this. The case of the first attack on Bouguereau's *The Spring*, which had taken place in Omaha in 1891, also connects public notions of propriety with private experience. The painting was on view in a touring exhibition organized by its owner when a fervently religious young man named Carey Judson Warbington threw a chair at it. He was arrested, and explained that he had seen similar pictures in 'a house of ill-fame', knew why they were to be found there, and would not have liked his mother or his sister to see such a painting; he had therefore decided to destroy the one which 'was not at the place which must be natural to it'. Warbington was declared insane at his trial and acquitted; he committed suicide shortly afterwards. A remarkable proof of the public interest generated by this affair is the fact that the owner of *The Spring* bought the chair used by the assailant and exhibited it together with the damaged painting before sending the latter to Bouguereau for repair. Supposing that the confusion between museum and brothel, evoked for this viewer by Bouguereau's voluptuous nude, had induced an unbearable confusion between persons (his mother and sister on the one hand, prostitutes on the other), Didier Chartier convincingly proposed interpreting the aggressive gesture as an attempt at dividing those feminine images and at reordering psychic spaces.[31] The moral convictions and emotional situation of the iconoclast contributed to making him pass a judgement on this allegory which, after all, stood close to the opinion of cultivated critics of late academic art. In more recent cases, comparable rejections could even correspond to a quantatively 'normal' perception of the work deemed 'offensive'. In 1985, for instance, a retired craftsman and painter who had sprayed shellac on three paintings by Salomé depicting homosexual practices found sympathetic ears in the judge and public of the Düsseldorf County Court, even if he was condemned for 'damage to an object of public utility'.[32]

The evolution of art and of the theory of art in our century has made Von

Végh's restrictive definition of the properties that a work can possess 'in reality' appear just as untenable. The attribution of a signified to an object may indeed follow very idiosyncrasic paths, and is probably more liable to do it when this attribution provokes an act of aggression and when this aggression is necessarily stigmatized. But the relation between more and less idiosyncrasic interpretations can be better understood as a continuum than by means of a sharp distinction between 'normal' and 'abnormal' perception. All serious attempts at analysing iconoclastic actions agree that a multiplicity of factors are involved, the decision to privilege one or another resulting from theoretical and methodological affiliations and premises. The trouble with explanations that consider some factors – for instance 'individual' and 'psychological' ones – as being primarily more 'fundamental' than others is that they are bound to make the latter appear as 'pretexts'. The effects of such a bias are further aggravated when the opposition between 'individual' and 'collective' is conceived as one between transhistorical phenomena on the one hand, historical and social 'context' on the other. Fortunately, the few authors who have dealt at some length with the destruction of art within museums, such as Pickshaus and Chartier, reveal a broad spectrum of causes and influences – at times broader than they acknowledge. (Chartier praised, for instance, iconoclasts for restoring our 'capacity to feel [the image] in the plurality of its dimensions'.)[33] But the isolation of particularly spectacular cases associated with very high thresholds of transgression tends to marginalize larger issues, in particular those pertaining to the specifically artistic and cultural dimension of the targets. This is a limit of Freedberg's theory of the fusion between image and prototype, since it does not account for a possible influence of the artistic status of certain artefacts and situations. It is also a shortcoming of most psychoanalytic approaches, which derive from Freud's conception of the work of art as an expression of unconscious contents whose indirectness permits acceptance and enjoyment. Guy Rosolato, for instance, considers that 'a certain paranoid sensitivity realizes a short-circuit that makes the phantasm too immediately accessible' and suppresses a 'symbolical distance'; in front of a picture of Caesar's death, 'the fanatical spectator flies to Caesar's help'.[34] The canvas, painting, the museum have disappeared: in such a view, abuse of art can hardly be relevant for art since it springs from an elision of it.

Statements, rationalizations, attention-seeking

In order to identify, weigh and articulate the various factors involved in an iconoclastic action, one has to make use of every token. Aggressors acting in museums more often provide warning, accompanying and subsequent statements, since they tend to desire and enjoy publicity and are more often identified than is the case in public places. By reason of the illegal and highly

stigmatized character of their deeds, these self-explanations primarily appear as suspect, and are generally dismissed as justifications, 'pseudo-grounds' and deceptive 'rationalizations'.[35] Such dismissals, however, typically derive from the socially determined distribution of the right to a credible explanation of one's behaviour, and the labelling theory of deviance has stressed the necessity of taking the actors' viewpoints and explanations seriously – which does not mean at face value. Statements, like the physical actions themselves, can be better understood and utilized when they are considered as communication rather than expression. Referring to C. W. Mills's 'motivational accounts theory', Stanley Cohen defined the interactions following acts of vandalism as 'definitional contests' and 'reality negotiations', and proposed a typology of situations according to whether the actor offers a political or a non-political account and whether the audience accepts or discounts it.[36] Iconoclasts' explanations often vary in time, a phenomenon interpreted by Chartier as 'identity questioning', which may be linked to the evolution of a 'pathological process', but also to changing relations to different interlocutors and contexts.[37] Interactions may be complex, and Pickshaus noticed for example that the German 1977 serial iconoclast's explanation that he was obliged 'to destroy what others worshipped', which made headlines in the newspapers, had been found by him in a criminologist's comment on his activity published before his arrest.[38]

Among the reasons for qualifying actors' statements are inner contradictions, 'abnormal' accompanying manifestations such as nervous breakdowns or attempted suicides, and discrepancies between the aims expressed and the means employed. In many cases, the scarcity of available data does not allow any cross-examination. In 1962, for example, the nature of the symbol daubed on a painting at the Vanguard American exhibition at the American Embassy suggested – together with the institutional and political context – that it was a Ban-the-Bomb supporter who was responsible.[39] In 1969, ten Old Master paintings in the Metropolitan Museum in New York had the letter H anonymously scratched on their surface, a degradation connected to the ongoing controversial exhibition 'Harlem on My Mind'.[40] In 1985, Rembrandt's *Danaë* at the Hermitage in St Petersburg was assaulted by a man who, it was reported, was a Lithuanian and intended to protest against the Soviet occupation of his homeland.[41] A much better documented case, the destruction in 1959 of Rubens's *Fall of the Damned into Hell* at the Alte Pinakothek in Munich, allows one to examine more closely the questions of semi-rational explanations, relations between means and ends, and motives for attention-seeking behaviour.[42]

After throwing enough acid on this large picture to ruin it almost completely (illus. 84), the assailant, to whom Pickshaus gave the pseudonym 'Walmen', managed to leave the building. But he had already sent letters confessing his deed to Press agencies and newspapers, and gave himself up to the

police the next day. He was arrested, brought to trial, found criminally responsible by the court, and condemned for 'damage to an object of public utility'. His letters stated that he was not insane but had an extremely important message to deliver for the future of mankind. When the judge asked him why he had destroyed a picture, he answered that he needed to startle the world, which was only interested in television, and that it was an action that could be performed with a minimum of means and would never be forgotten: 'A forest fire is a sensation too, but how long does one talk about it'.[43] He later added that he had envisaged other means of attracting attention to his ideas, such as committing suicide or colouring the Bodensee, before he had arrived at the idea of destroying 'some famous picture' and verified that it could not cost him more than three years of jail. 'Walmen' was 52 years old at the time of the assault. His father was a mining machinist who had decided that his son would 'climb to a higher social class'. At seventeen, after an interrupted training as a surveyor and the death of his mother, he had embarked for Brazil. In lieu of professional and emotive stability, he had experienced in the midst of the Amazon forest a 'philosophical' illumination and discovered what he called the 'law of the scale', according to which 'variety continuously produces variety' and there are no two identical things in the world. Back in his own country, he was disqualified as 'megalomaniac' by a Nazi agency for the promotion of German literature, and in 1936 returned to Latin America, where he stayed for almost twenty years. After the failure of several endeavours, he finally returned to Germany and settled in a small provincial town, where he was soon the victim of mistrust and various civil actions. This was the time, in 1958, when he planned to sacrifice a famous work of art to his 'mission'. For fear of being regarded and confined as insane, he postponed the deed at first and brought the acid to the General Director of Bavaria's state collection of paintings, who arranged for him a discussion with a professor of philosophy which turned out to be overwhelming. 'Walmen' wrote and sent to a literary agent a 500-page autobiography and returned to his iconoclastic project.

Pickshaus diagnosed in this man a fear of being rejected and a chronic lack of self-confidence, further proposing to see his craving for immortality as a reaction to his mother's early death. Of particular interest are elements from the traditional image of the artist, which he pointed out in the failed globetrotter's fantastic self-stylizations: 'Walmen' was inspired, expected to be valued only after his death, and defined himself as a 'misunderstood genius'. Indeed, his doomed attempts at self-aggrandizement might be regarded as typical for impotent or unfortunate would-be creators.[44] But the self-appointed philosopher's unexpected vocation came at a time when professionally more accessible plans had already failed, so that it should probably be understood as a compensatory rationalization, a way of escaping into fiction rather than confronting reality and mourning his father's ambitions and his own hopes.

The romantic notion of the *artiste maudit*, with its valorization of failure, marginality and incomprehension, is perfectly suited to fulfil such functions and give illusory solutions to unbearable discrepancies between inner feelings and strivings on the one hand, and objective situations and possibilities on the other. It further enabled 'Walmen' to deny his responsibility in the name of a medium-like inspiration and to justify in his own eyes his resorting to any means for the sake of his 'message'.

Whatever the psychopathological label that might be best applied to him, 'Walmen' obviously suffered from a defective sense of reality. The combination of uprootedness, wounded narcissism and craving for recognition evokes a number of fallen emigrants who turned iconoclasts, among them the author of the assault on Michelangelo's *Pietà*, whose case will be discussed later. In one interesting instance, the aggressor's relation to his target was not simply one of obscurity to fame: the man who threw a stone at Leonardo's *Mona Lisa* on 30 December 1956 had been forced to leave Bolivia after being persecuted because of his name, since his father and a cousin were major figures of the political opposition there.[45] An identity crisis is involved in all these cases, as it was – on a collective plane and in a less acute form – in the Bienne iconoclastic wave. Boltansky also found 'identity deficits', provoked by various combinations of individual trajectories and broader social transformations, at the heart of the public denunciations that he studied.[46] The storming of fame, which attention-seeking assaults on celebrated works of art represent, further belongs to the questioning of social hierarchies already evoked, although rarely in the revolutionary sense that it could have when, by ripping out the names of the dead who had enjoyed the privilege of being buried within the cathedral cloister, the Münster Anabaptists had restored the equality before death stressed in late medieval morals.[47]

Of course, identity crises and a desire for publicity may lead to many kinds of actions, some of them destructive, but not necessarily directed against art. Among recent examples, one may quote the man who, after trying to kill Klaus Barbie and resorting to unauthorized appearances on television or at political meetings to attract notice for his books, finally in 1993 killed the former Minister of Police of the Vichy Government, René Bousquet; or the American serial killer nicknamed 'Unabomber', who promised in June 1995 to stop sending explosive parcels to members of the 'industrial and scientific elite' if *The New York Times* and *The Washington Post* published his 35,000-word 'manifesto'.[48] A remarkable case of a harmless and humorous attention-seeker is currently provided by a retired clerk of the French Paris Mutuel Urbain (a state betting-office) who, regretting the 'democratic side' of his former work and declaring that 'one's life is never successful until one has become President of the Republic', makes use of his good looks to 'pass through social borders' by slipping into the best-guarded international polit-

ical summits and appearing in their official photographic records.[49] Traumatic displacements, failed ambitions and social frustrations also abound in the more sinister context of the biographies of despots and war criminals. Again, current affairs supply us with numerous examples, and it should be enough to mention the leader of the Bosnian Serbs, Radovan Karadzic, the son of a nationalist imprisoned by the Communists, who left his modest rural society for Sarajevo, became a psychiatrist, published poems praising destruction and perverted Freud's theories to justify the Serbs' claims to domination by referring to them as the only 'Oedipian' people, freed from paternal authority.[50] Hitler's case is of particular interest to us since he began his career as a poor commercial artist and came to enjoy both the planning and the destruction of numerous towns and cities. According to Erich Fromm, 'his idea of becoming an artist was essentially a rationalization for his incapacity for any kind of disciplined work and effort' – a common enough effect of the image of the artist as a person free from all social and material determinations – and his 'necrophilia' (in the enlarged sense of a passion 'to destroy for the sake of destruction') was nurtured by personal defeat and humiliation. [51]

Should works of art damaged within museums be considered then as indifferent tools of 'blind' attention-seekers, as the rational explanation given by the aggressor of Rubens's *Fall of the Damned into Hell* would lead us to believe? Pickshaus rightly stressed that 'celebrity rarely shows itself less protected than in museums'.[52] But even here, one cannot help noticing that the 'misunderstood genius' selected a masterpiece, and one in which he could easily see a frightening metaphor of his own social and psychic history. Not only does the symbolic function of works of art predispose them for all kinds of mental appropriation, but their double character, at the same time material and fictional, makes of them privileged instruments to fill up menacing gaps between the inner and the outer world. Intending to justify the destruction of the canvas, 'Walmen' revealingly explained: 'a square metre of painted surface stood between me and mankind'.[53] Of course, works are simultaneously abused because they exemplify fame, value and domination, with changing proportions and combinations of properties according to individual cases. Specificity of art destruction may also be gained progressively: the German serial iconoclast already mentioned, who had first attacked non-artistic objects, seemed to learn from the relation between the value attributed to the paintings and the public reactions to his deeds, and showed a growing discrimination in the selection of his targets.[54]

Christ, artists and would-be creators

The medium-like denial of responsibility sometimes takes the form of visions or voices ordering the iconoclast to strike, and spectacular expressions of iden-

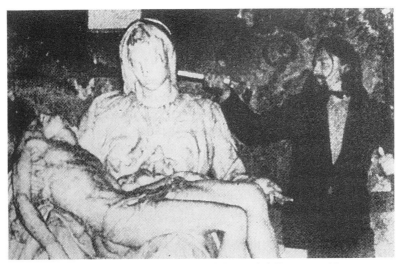

85 László Toth attacking Michelangelo's *Pietà* in Saint Peter's in Rome on 21 May 1972.

tity crises are identifications with authority figures, in particular with Christ. The authors of assaults on two famous works, Michelangelo's *Pietà* in 1972 and Rembrandt's *Nightwatch* in 1975, both declared themselves to be the son of God. There are many analogies between those cases, but the first one presents especially illuminating links to the modern definition of the artist.[55]

On Whit Sunday, 21 May 1972, shortly before noon, while a crowd of people who had attended Mass in St Peter's in Rome were leaving the cathedral, a man jumped into the aisle Capella della Pietà and battered with a hammer Michelangelo's sculpture of the Virgin holding her dead son in her lap, shouting: 'I am Jesus Christ, Christ is risen from the dead'. The action was seen by many, and was even photographed (illus. 85). A fireman overcame the assailant, a 33-year-old Hungarian-born émigré to Australia named László Toth, who had to be protected from the congregation and was carried away. The Pope had roses brought, knelt and prayed himself before the statue, and awarded the Knight's Cross of the Gregorian order to the fireman because he had preserved more than a work of art, 'the very symbol of the mother of God'.[56] After his arrest, Toth repeated that he was Christ and stood ready for crucifixion, but also pretended to be Michelangelo. God had commanded him to destroy the statue of the Madonna, because, being eternal, He could have no mother. Toth obviously enjoyed publicity, and further explained the strokes that had damaged the eye, nose, folded veil and left arm of the figure of the Virgin as aiming at falsely assumed virtues of the Church. Before the court, he charged the judges with pride because they wanted to declare Christ insane, and warned them that they would be condemned by him at Doomsday.[57] He was deported back

to Australia, where psychiatrists did not consider him dangerous, and has not been heard of since.

Predictably, this act attracted much comment. Two American literary critics, John Teunissen and Evelyn Hinz, proposed an 'archetypal analysis' according to which it could be seen as 'the violent reaction of a male and son figure to that of a female and mother figure' which embodied a 'life-denying' religion, and 'as an attestation, first, of the power of the archetype embodied in the statue, second, to Michelangelo's skill in evoking the archetype, and third, to Toth's extreme sensitivity to that particular archetype'.[58] Chartier also interpreted the concentration of the attack on the mother figure as resulting from a will to expel her from representation and perception, and pointed out her unusually youthful appearance, already discussed in the sixteenth century. But he enlarged the frame of analysis by stating that Toth had simultaneously attacked a sacred object, an element of heritage, a work of art, and a symbol of the Roman Catholic Church, and observed that the hammer Toth had used for his action was a sculptor's tool, establishing a symmetrical relation between the destructive and the creative 'touch'.[59] Pickshaus added psychopathological labels (the Italian psychiatrists had diagnosed a *delirio profetico*), in particular autism, paranoia and schizophrenia, as well as biographical data that allow us to recognize the influence of factors that we have already encountered.

László Toth, born on 1 July 1938 in Pilisvörösyar into a Catholic family, had moved in 1965 to Sydney, without almost any knowledge of English. His diploma in geology was not recognized, and he had to work in a soap factory. He tried without success to compensate for this failure by 'organizing' fellow emigrants, and in 1967, after suffering a fracture of the skull in a fight with other Hungarians, he disappeared for some time. When he turned up, he wore a Christ-like beard and spoke of going to Europe.[60] He arrived in Rome in June 1971, not knowing a word of Italian, with the intention, as he later explained to his lawyer, of being recognized as Christ. He sent letters to Pope Paul VI and tried to meet him in Castelgandolfo (the Pope's summer residence), to no avail. The Church, he concluded, could only accept a dead Christ, and he resolved to attack the *Pietà* as a symbol of this 'incredible' practice. It may be noticed, in relation to Toth's linguistic isolation, that the moment he chose to deliver his 'message' not only guaranteed the greatest possible publicity, but was also the feast of Pentecost. Ten days later, he would have turned 34, a serious drawback for his identification with Christ.[61] Apparently, he objected to Mary more as the figure of the Church (a traditional iconographic interpretation) than as the instrument of the incarnation of God. Toth also declared to his lawyer that in the personal union of Michelangelo Buonarroti and Jesus Christ, he had formerly ordered a 'spotless boy', unsullied by the Catholic Church, to create the *Pietà* without finishing it, because he was to realize this completion on Whit Sunday.

This 'condensation' – to use a Freudian term – of Michelangelo and Christ is highly significant when related to the history of the formation of modern artistic identity. As Philippe Junod showed, identification with Christ, generally in the guise of self-portraits, accompanied the progressive autonomization of art and appeared particularly during the Renaissance and, increasingly, from the nineteenth century on.[62] Expressing at first the divine origin and liberal status claimed for the visual arts, it later contributed to sacralizing the aesthetic field and to glorifying or rationalizing, thanks to the ambivalence of the motif of martyrdom, a marginality defined as the ransom of authentic and innovative creation. It is not by chance that Michelangelo was a favourite model of this image of the tormented and lonely genius, for instance in Eugène Delacroix's *Michelangelo in his Studio* of 1849–52 (Montpellier, Musée Fabre). By identifying with him as well as with Jesus, the uprooted Hungarian not only usurped the right to modify or even destroy his work, but made clear that his idiosyncratic and desperate attempt at self-realization followed paths that singular artists and collective definitions of artistic activity had also trodden and helped to lay down to some extent.

This aspect of Toth's motives brings it into contact with cases where works have been attacked – or 'completed' – by artists or by would-be artists. A curious example is provided by the young man who stole Watteau's painting *L'Indifférent* in the Louvre in order to suppress what he imagined to be disrespectful restorations.[63] More brutally, a 47-year-old unsuccessful Italian painter named Piero Cannata used a hammer on 14 September 1991 to break off the tip of one toe of Michelangelo's *David* at the Galleria dell'Accademia in Florence (illus. 86).[64] The man, a former heroin addict who had also been in receipt of psychiatric treatment, explained that he was 'jealous of Michelangelo'. The reason appears almost too simple, but it may contain an element of truth in terms of identity conflict. Indeed, the case seems a parody of Henry Fuseli's famous drawing depicting the artist in despair over the greatness of Antique fragments (illus. 87), the hand and foot of a colossal statue of Constantine, which has been related to the literal meaning of Fuseli's original name, Füssli (little foot).[65] It also evokes a series of cartoons published in the 1960s by Ronald Searle, which show disabled men threatening gigantic sculptural representations of the part of the body that they lack (illus. 88). Indeed, 'jealousy' and frustration were often mentioned to explain the wilful destruction of works of art, not without reason, but too often predicated on absolute notions of values and hierarchies. Réau's affirmation that 'beauty offends inferior beings who are conscious of their inferiority' has been quoted.[66] In his *Report on Vandalism* of 1794, Grégoire had already written that 'fools denounce genius to console themselves for being deprived of it'.[67] Gogol imagined in 1841–2 a painter who, having abandoned the cultivation of his faculties for the pursuit of fame and money, became obsessed with a 'horrible

86 The left foot of Michelangelo's *David*, 1501-4, in the Galleria dell'Accademia, Florence, damaged after the attack of 14 September 1991.

87 John Henry Fuseli, *The Artist in Despair over the Greatness of Antique Fragments*, 1778-80, chalk with wash. Kunsthaus, Zürich.

88 Ronald Searle, *The Philistines: 1 & 2* (detail), a cartoon from his *L'Œuf cube et le cercle vicieux* (Paris, 1968).

envy', bordering 'on madness', of true talent. He thus 'began buying up all the best works of art that came into the market. Having spent a fortune on a picture, he took it up carefully into his studio and there flung himself on it with the fury of a tiger, slashing it, tearing it, cutting it to pieces, stamping on it, and roaring with delighted laughter as he did so.'[68] When the Japanese writer Yukio Mishima, a politically reactionary worshipper of physical and artistic perfection, based a novel on the burning in 1950, by a novice *bonze*, of the celebrated Golden Pavilion of the Rokuon Temple in Kyoto, he characteristically developed the statement according to which the 21-year-old monk, hating the ugliness of his own soul and disabled body, had felt insulted by the beauty of the construction, and rejected the later explanation that he had lost all hope of succeeding the prior and had destroyed the Pavilion because the revenue it brought gave the prior his power.[69]

Who's afraid of modern art?

I have already indicated that in the case of aggression against modern and contemporary art, the difference between museum and non-museum contexts diminishes and may even vanish. A conference on 'vandalism in modern art' concluded in 1993 that in such cases, limits were fluid between play, intention, participation and destructive rage. Among the factors mentioned were the physical fragility of modern works, their deviation from, or transgression of, traditional aesthetic norms, their incomprehension by large sections of the population (and the ensuing frequent approval of their being attacked), as well as the presence of destruction and degradation in the materials and genesis of many objects.[70] A commentator interpreted recent iconoclastic actions in British institutions as 'the public expression of an internal quarrel between modernists (or post-modernists) and traditionalists', denouncing the fact that the news media and the 'philistine power structure' had taken sides against artistic innovation, and affirmed: 'Those who attack Old Masters often have a history of mental illness; but destroyers of the new tend to be critics who

89 Barnett Newman, *Who's Afraid of Red, Yellow and Blue IV*, 1969–70, acrylic on canvas, as displayed in the Nationalgalerie, Berlin, before the attack of 13 April 1982.

prefer actions to words.'[71] Things can be more complicated, however, and the 'threshold effect' has to be questioned in relation to the exact circumstances of each intervention. The particularly publicized and well documented assault on Barnett Newman's *Who's Afraid of Red, Yellow and Blue IV* in West Berlin is a case in point.[72]

On 13 April 1982, a 29-year-old student of veterinary medicine named Josef Nikolaus Kleer, carrying a building helmet and a leather bag of the Federal postal office, entered the Nationalgalerie (then closed because an exhibition was being dismantled) by means of a rear entrance, and went into the unlit room where Newman's large canvas (2.74 x 6.03 metres) hung. There, he took one of the plastic bars that were arranged in a semi-circle on the ground to limit the viewing distance (illus. 89) and violently struck the painting (after the interrogation, he told journalists that he had also struck it with his fist and his foot, and finally spat at its middle).[73] He then placed several documents on and around the damaged work: on its blue part, a slip of paper inscribed 'Whoever does not yet understand it must pay for it! A small contribution to cleanness. Author: Josef Nikolaus Kleer. Price: on arrangement' and 'Action artist'; on the ground in front of it, a copy of the last issue of the magazine

Der Spiegel, with a caricature of the then British Prime Minister Margaret Thatcher on the cover, appearing as a holy knight on a dark-blue background in a reference to the Falklands War; in front of the red part, a copy of the 'Red List', an official catalogue of remedies published by the German pharmaceutical industry; in front of the yellow part, a yellow housekeeping book with a second slip of paper carrying the inscription 'Title: Housekeeping book. A work of art of the commune Tietzenweg, attic on the right. Not to be sold'; finally, lying somewhere on the ground, a red cheque-book.[74] These items enabled the police to find the culprit quickly. Kleer confessed that he was the assailant, and gave several reasons for his action, which can be summed up as follows: he had been afraid of the painting; Newman's work was a 'perversion of the German flag' (which is horizontally divided into black, red and gold), it ought to 'frighten the Germans' and did not belong to the Nationalgalerie; the purchase of such a work with public funds was irresponsible and artists earned too much money.

Who's Afraid of Red, Yellow and Blue IV, painted by Newman in the year of his death, had just been bought from his widow for 2.7 million marks. To collect this enormous sum, the Director of the Nationalgalerie, Dieter Honisch, had resorted to unusual and spectacular means, among others the realization (by 26 German artists) and sale of 'Homages to Barnett Newman'. A catalogue of these works was published, in which Günther Uecker, one of the artists particularly involved in the fundraising campaign, praised its object in revealing terms. It was an icon of a tradition of painting that overcame 'provincial narrowness' and founded an international culture, an 'unlimited spiritual communication', and Uecker wished it to be in Berlin and in the Nationalgalerie 'as a signal for the freedom of art – a manifesto of the spirit in painting, a great work of this century', concluding: 'I am not afraid of Red, Yellow and Blue!'[75] Needless to say, this opinion was not shared by all, so that Dieter Honisch could later blame for the assault 'the over-publicity which the picture and above all its price have found in the media', as if it had not been provoked by the campaign that he had himself launched.[76] Criticism of the work and of its purchase found new opportunities for expression in comments made on the damage, especially in readers' letters published by the Berlin tabloid *B.Z.* under the heading 'Any apprentice could have painted this' (illus. 90). Seen in this context, Kleer's declared 'fear' of Newman's work, his desecration of it, even his provincial origin – he was born in Ensdorf near Saarlouis and the French border, and had arrived in Berlin in 1978 – seem to respond to the promotion of the painting by cultural authorities and to materialize widespread opinions and attitudes towards it. But of course, no other disapproving taxpayer had taken the same violent, and illegal, course of action, so that Kleer's personal motives must be further questioned.

Pickshaus's interviews with him provide useful information to that effect.

Briefe an die BZ

DIE STIMME
DER BERLINER
— jeden Tag
in der BZ
Kochstraße 50, 1000 Berlin 61

BZ-LESER ZUM ANSCHLAG AUF GEMÄLDE IN DER NATIONALGALERIE

13. April 1982 um 15 Uhr 25: Der Student Josef Kleer (links) zerstört in der Nationalgalerie das drei Millionen Mark teure Newman-Gemälde „Wer hat Angst vor Rot, Gelb und Blau" (rechts). Als Kleer festgenommen wird, erzählt er in seinem Geständnis: Ich habe vor dem Gemälde Angst bekommen.

Das hätte jeder Lehrling malen können

Haftbefehl

Gegen den Beschuldigten

den Studenten
Josef K l e e r ,
geboren am 12.10.1952
wohnhaft ▮▮▮▮▮▮▮▮▮▮▮▮,

wird die Untersuchungshaft angeordnet.

Er wird beschuldigt
in Berlin
am 13.April 1982
rechtswidrig einen Gegenstand der Kunst, welcher in öffentlichen Sammlungen aufbewahrt wurde, beschädigt zu haben,
indem er
am Tattage gegen 15.25 Uhr in der Nationalgalerie in der Potsdamer Straße in 1000 Berlin 30, das dort befindliche Bild des Malers Brannet Neumann „Wer hat Angst vor Rot, Gelb und Blau" mit der Faust und mit einer Absperrschnüre erheblich beschädigte.

Vergehen strafbar nach § 304 StGB.

Der dringende Tatverdacht ergibt sich aus dem Geständnis des Beschuldigten. Es besteht der Haftgrund des § 112 Abs. 2 Nr. 2 StPO. Der Beschuldigte, der in leicht löslichen Wohnverhältnissen lebt, hat bei einer Verurteilung mit einer fluchtanreizbietenden Strafe zu rechnen.

Richter am Amtsgericht

Ausgefertigt

Justizangestellte

14. April 1982: Ein Tag nach dem Attentat wird der Haftbefehl ausgestellt. Josef Kleer wird verhört. Ein Tag später wird der 30jährige wieder freigelassen. Ihm wird Paß und Ausweis abgenommen. Kleer darf die Stadt nicht ohne weiteres verlassen.

Zum Attentat auf das 3-Millionen-Mark-Gemälde:
Dieses Werk hätte jeder Anstreicherlehrling ebensogut anfertigen können. Nur dann hätte es lediglich das Material und die paar Arbeitsstunden gekostet.
Hans T., Clayallee, Zehlendorf

Man sollte sich mal in den ersten Grundschulklassen erkundigen!
Vielleicht haben wir in unserer Stadt einige Talente, die das Gemälde auch für eine Million Mark malen könnten.
Fragen wir doch einmal in den ersten und zweiten Klassen einer Grundschule nach!
Peter P., Zadekstr., Buckow

Mein Werk ist schwarz-rot-gold
Dem Nationalgalerie-Direktor biete ich Trost und Ersatz ein eigenes Werk an: sechs Meter lang, drei Meter hoch, breiter schwarzer Streifen, schmaler roter

Streifen, breiter goldener Streifen, Titel: „Wer ist hier der Irre?"
Ich habe meine ganze Lebenserfahrung darin verewigt.
Der Preis von 2,7 Millionen Mark geht in die Stiftung „Frauenhäuser" (Jahreskosten für ein Frauenhaus: eine Million Mark).
Dr. Cillie R., Bürkerstr., Neukölln

Was für mich Kunst bedeutet
Für mich heißt Kunst Rubens, Rembrandt, Tizian.
E. U., Trauenbrietzener Str., Wittenau

Ich muß die Kopien für den Schulunterricht aus der eigenen Tasche bezahlen
Ich bin der Meinung, daß man eher diejenigen als „irre" bezeichnen sollte, die für drei aneinanderhängende Farbflächen einen Betrag von 3 000 000 Mark bezahlen, während ich z. B. die Kopien, die ich für meinen Schulun-

terricht (Physik und Mathematik) benötige, selbst bezahlen muß, da hierfür in unserem „bildungsbewußten" Staat kein Geld zur Verfügung steht. Ich bin Studienrat.
Michael B., Wiesrader Pfad, Lichterfelde

Renovierung statt Restaurierung
Vielleicht ist es möglich, im Hinblick auf die notwendige Instandsetzung des Gemäldes nicht mehr von einer Restaurierung, sondern von einer Renovierung zu sprechen. Sollte diese aber nicht zu lohnend sein, dann liefere ich kostenlos und kurzfristig eine nicht unterscheidungsfähige Nachbildung.
Martin V., Mühlenfeldstr., Hermsdorf

Solche Sachen malte ich als Malerlehrling
Als Malerlehrling (1927) mußte ich öfter solche und ähnliche Sachen malen. Es wurde meist mit Leimfarben gemalt.
Hans N., Mariendorfer Damm, Mariendorf

BZ-LESER ZUM MORDFALL ELIN UND CARMEN

Wenn es doch etwas gäbe, was das

90 'Any Apprentice Could Have Painted This' with photo and papers of Josef Kleer, perpetrator of the attack on Newman's *Who's Afraid of Red, Yellow and Blue IV*, as well as readers' letters, from the *Berliner Zeitung* (22 April 1982).

Kleer was born the first of five children into a working-class family, and had been the only one to attain matriculation standard. He had been bound to fulfil his parents' social ambitions and had begun to study medicine, but had failed. According to Pickshaus, the first signs of an affective 'manic–depressive' psychosis had coincided with this failure. Kleer had also refused to serve in the army, and moved to Berlin for that reason. He lived in a commune, where his alternating periods of euphoria and depression were a source of difficulty. Two months before the assault, he had 'more or less accidentally come into the Nationalgalerie', where the semi-circular arrangement of plastic bars on the ground had drawn his attention to *Who's Afraid of Red, Yellow and Blue IV*. He had asked a museum keeper about the huge canvas and received the following answer: 'If it cost three millions DM, then it must be art indeed!'; he had then looked directly at the painting and shortly experienced 'a very strange feeling' that he defined as fear. The other visitors' attitude towards Newman's work reminded him of the dance around the Golden Calf – a classic reference of iconoclastic doctrine – and struck him in retrospect as 'a kind of symbol for the whole dance around money, which prevents people from living naturally or living their own decisions'. He thought that money was responsible for the 'order of values being somehow downright topsy-turvy', and now saw an 'embodiment of this whole chaos' in the painting.[77] Kleer lived on a small scholarly grant, and at the time of his deed, the Tuesday after Easter, he was alone, short of money and almost starving. He defined his intervention as an artistic 'happening' and a way of 'completing' the painting, as his written messages and the chromatic correspondences between his additions and the canvas likewise attested. He thought that he was 'capable of making a comparable picture for a fraction of the acquisition price' of *Who's Afraid of Red, Yellow and Blue IV*, and opposed to it the housekeeping book of his commune as a 'symbol of companionship'. By contrast, he rejected his own allusions to the German flag and stated that they had been encouraged by the interrogating officers.[78]

The combination of identity crisis, social criticism and idiosyncratic interpretation that emerges from these data is consistent with much that we have seen. The 'pathological' features therein appear to act as reinforcing and facilitating factors rather than as motivations *sui generis*. In a letter to the Nationalgalerie written after his deed, Kleer defined Newman's painting as a 'physio-psychological masterpiece', and Pickshaus suggested that the imageless void in it might provoke the feelings without an objective cause that is typical of 'affective psychoses'. But he also noticed that defenders of the painting had praised it by saying that it made them aggressive or generated primeval anxieties, and that the evocation of fear was essential to the aesthetic experience of the 'sublime' that Newman had explicitly aimed at creating in modern terms.[79] To some extent, Newman's two-dimensional experiments

91 Barnett Newman, *Who's Afraid of Red, Yellow and Blue III*, 1967-8, acrylic on canvas, after the attack of 21 March, 1986. Stedelijk Museum, Amsterdam.

with colour and perception may be compared with Richard Serra's later three-dimensional ones in Cor-Ten steel, as far as undesired reception – respectively within museums and in public places – is concerned. In any case, another of his last canvases, *Who's Afraid of Red, Yellow and Blue III*, was slashed from side to side with a Stanley knife (illus. 91) four years later in the Stedelijk Museum in Amsterdam by a 33-year-old man named Gerard Jan van Bladeren, who wanted his act to be understood as an 'ode to Carel Willink', a Dutch exponent of 'Magic Realism' whose anti-modernist book *Painting in a Critical Phase* (1950) he quoted before the court.[80] Of course, the role played by the market price of Newman's works and their compositional simplicity must not be underrated. In 1989, the acquisition by the National Gallery of Canada in Ottawa of his *Voice of Fire* (1967) for 1.76 million dollars had prompted two painters, one specialized in buildings and the other in pictures, to execute 'copies' of its three colour stripes, the first one entitled *Voice of the Tax-Payer* and the second one accompanied by a poster inscribed 'This is a copy of the National Gallery's 1,800,000 dollar rip-off of the Canadian artiste [sic]'. As Thierry de Duve commented, however, the two works were rather different in intent. The painter of buildings – whose wife had said when seeing *Voice of Fire* on television 'Hey, anybody could paint this, even a painter' – manifested 'the respect that he had for the craft that was his', whereas the painter of pictures expressed his 'contempt for the absence of craft of which he accused Barnett Newman'.[81] Claiming to be an artist, the latter had, of course, deeper reasons to resent the model of artistic accomplishment represented by Newman, and his gesture of indirect defacement was thus closer to the gestures of those for whom physical attack plays the role of a kind of practical criticism.

11 'Embellishing Vandalism'

Anonymous and individual assaults on works of art in public places and in museums occupy the highest position on the scale of illegitimacy in destruction. At the other extreme, one finds eliminations and transformations that their authors and supporters justify, often in aesthetic terms, as necessary means for positive ends, and which – if they are successful – may simply not be considered and labelled as destruction. Martin Warnke pointed to the social and political basis for this distinction when he wrote that iconoclasm from above could be celebrated among the great dates of the history of art, while iconoclasm from below was denounced as blind vandalism, and so did Colin Ward by recalling that the activities of 'vandals' 'are far less devastating, lethal and expensive than the destruction and attrition of the urban environment by other forces in society'.[1] Examining the factors promoting the 'embellishing' assaults and the arguments used for and against them, however, is not only a matter of social criticism. Nor does it necessarily partake of an approach that neglects the difference in motives because of the similarity of results. In fact, overt reasons such as proposed by rational explanations can also serve as pretexts for covert ones, and analogous mechanisms of disqualification can be shown to be at work in the 'creative' eliminations undertaken by 'embellishers' and in the aggressive ones by 'vandals'.[2]

Beauty, salubriousness, and the tabula rasa

In the course of time, and particularly after major historical transformations, the preservation of artefacts has always implied some kind of redefinition of use and modification of form. A good example is Trajan's Column: the senators of the township of Rome distinguished in 1162 between its material and spiritual ownership by decreeing that it belonged to the abbess of St Cyriac's, together with the small church of St Nicholas, provided that 'the honour of the city of Rome be safeguarded', i.e. the Column be neither damaged nor destroyed; but the church had been built at the foot of the Column, which served as its bell-tower, and the inscribed Roman dedication had been

92 Benito Mussolini starting demolition work for the construction of the Via dell'Impero (now the Via dei Fori Imperiali) in Rome, 1932.

mutilated to build its roof.[3] Paradoxes of the policy of preservation are particularly visible in Rome, from the popes of the Quattrocento to Mussolini. Raphael could affirm that the new Rome with its palaces and churches was entirely built with lime made from antique marble, and that 'Hannibal and the other enemies of Rome could not have acted more cruelly', although he himself made use of such materials for the construction of St Peter's.[4] As for Mussolini, whose urban intervention was described as a *sventramento* (disembowelling) of the city, he concluded on 22 October 1934 a speech outlining his project of framing the Mausoleum of Augustus with a huge rectangular piazza by seizing a pickaxe and crying 'And now let the pickaxe speak!' Tim Benton, who recently recalled the event, remarked that 'the image (in film, photograph and painting) of Mussolini energetically wielding a pickaxe proved an effective means of projecting the demolition of the old Rome as a "revolutionary" Fascist act' (illus. 92).[5]

Since the Renaissance, the aesthetic disqualification of mediaeval architecture allowed among other things what Louis Réau termed 'the embellishing vandalism of canons'.[6] In 1739, Voltaire denounced the fact that 'buildings of Goths and Vandals' concealed the front of the Louvre, and proposed embellishing Paris by 'enlarging the narrow and infectious streets, uncovering the monuments that one does not see, and erecting ones that can be seen'.[7] This idea of *embellissement*, developed in Pierre Patte's projects for Paris,

became a central topic in the middle of the eighteenth century, and could be seen in connection with the debate over the public exhibition of works of art. It served the self-representation of absolutist state power, but was also understood in the greater social framework of 'progress in the arts and sciences'.[8]

The deep changes following the French Revolution have already been alluded to. They were by far not only political, and combined with the influence of the Industrial Revolution on means of production, modes of life and spatial organization to make the whole urban texture of European towns appear obsolete.[9] The pre-Revolutionary objects that were not deemed worthy of being part of the national 'heritage' – a vast majority – were increasingly regarded as exemplifying archaism rather than feudalism. In 1846 Léon de Laborde protested that whereas politically motivated destructions could at least be denounced, 'today, our mouths are being shut by the big words of modernism, material improvements, and we may be happy if one does not compel us to applaud the blind execution of orders to set houses in a straight line, of laws of dispossession for public purposes, and the brutal direction of railways, these marvels of civilization'.[10] An important aspect of 'material improvements' concerned sanitary conditions, particularly in working-class neighbourhoods. Insalubrity was associated with marginality, and together with the adaptation of the city to the new means of transportation and 'embellishment' proper, hygiene was called on to justify the elimination of whole parts of European towns until late in the twentieth century, in the name of *assainissement* in French or of *Stadtsanierung* ('cleaning of the town') in German. As for the elements of 'heritage' to be retained, they were mostly conceived as 'monuments', which had to be extricated from their surroundings and extensively restored in order to be viewed and valued. Among the most influential and active restorers of medieval architecture, James Wyatt and Sir George Gilbert Scott in Britain, Eugène Viollet-le-Duc and Paul Abadie in France, all conceived their interventions as a remodelling intended to revive 'the original appearance ... lost by decay, accident or ill-judged alteration' or even – in Viollet-le-Duc's terms – 'a complete state that may never have existed at a given moment'.[11]

In fact, the architectural objects positively appropriated as exemplifying symbols of the past were part of the overall process of modernization. This was obviously true in Eugène Haussmann's global restructuring of Paris under the Second Empire, which implied the singling out, cleansing of their surroundings and restoration of historical landmarks as well as the massive destruction of the old urban texture. When elected in 1867 a free member of the Académie, Haussmann declared to his friends that he had been chosen as 'artiste démolisseur'.[12] But it was true as well in Le Corbu-

sier's project for a Contemporary City for Three Million Inhabitants in 1922 and of his Plan Voisin for Paris in 1925.[13] The dream of wiping the slate clean that underlay these urban utopias celebrating – as Stanislaus von Moos puts it – 'the apotheosis of the automobile, of corporate business administration and middle-class housing at the expense of virtually all of the other functions that make up city life' did not prevent the Ville Contemporaine from being organized around evocations of historic monuments and sites, or the Plan Voisin from incorporating real monuments cut out of the city to represent the essence of its history.[14] As was mentioned in chapter Two, the mechanized warfare of the two World Wars enabled the 'embellishing' ideal of the *tabula rasa* to become a reality, through destruction and later through reconstruction. Von Moos considers that it was '*the* historic agent that helped the Plan Voisin to become a paradigm'. He comments on the tragedy of Rotterdam (illus. 93) that 'in the rudimentary and radical urbanism that is implied in the massive bombing of cities, preservation of historic monuments ranks higher than that of the housing stock for the urban poor', while its reconstruction 'began with a radical clearing of the damaged buildings that surrounded the public buildings and churches spared by the bombs and chosen for restoration' and ended 'as a prototypical example of CIAM urbanism'.[15] The current fate of Beirut, where the damage caused by the war has been followed by an almost total destruction of the ancient centre – with the dubious compensation of an unheard-of archaeological campaign – shows that this tradition is not ended.[16] The needs of propagandistic self-representation and the suppression of opposition in authoritarian and totalitarian regimes of the twentieth century has also provoked radical remodelling on a grand scale.[17] At the end of the 1980s, Ceaucescu's interrupted 'Programme for territory systemization', which consisted of razing to the ground more than 7,000 Romanian villages and replacing them with socialist uniform 'agrotowns', gave a new example, in a rural context, of a destructive attempt at imposing 'a new society'.[18]

Restoration as destruction

Official measures against undesired modernizations and for the preservation of architectural heritage began to appear at the end of the eighteenth century, not only as a sequel to politically motivated destruction – in 1794, for instance, a provision of Prussian common law was directed against the 'gross disfigurement of streets and squares'.[19] Opposition to 'embellishing' restorations seems to have been expressed particularly early in Britain, a fact that may be related to the comparative chronology of iconoclasms, of the Industrial Revolution, and of the Gothic Revival.[20] The *Gentleman's Magazine* commented in 1793 on Wyatt's cathedral restoration at Hereford that 'such is the

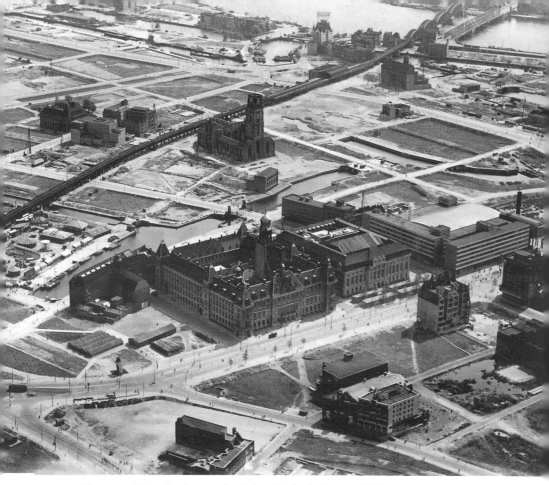

93 The centre of Rotterdam in 1941 after the bombing by the German Air Force.

rage for renewing this ancient structure, that it seems doubtful, if the whole may be able to resist the experiments intended to be practised on it', and four years later, the Revd John Milner published a *Dissertation of the modern style of altering antient Cathedrals.*[21]

But voices became loud in France too. After a youth poem denouncing the activities of the so-called 'black bands', companies of speculators who, during the first French Revolution, had bought up the estates of the nobles to sell them in small lots, as well as houses and churches to pull them down and sell the materials, Victor Hugo wrote in 1832 a manifesto entitled 'War on the Demolishers'.[22] In this text he listed and rejected the current political, economic and aesthetic ways of justifying destruction. He ridiculed the stereotyped allusions to the 'feudal past', affirmed that 'these monuments are a capital' and that the 'cause of medieval architecture' had been won by the Romantic movement. He further objected to the claims of property by distinguishing between use, which belongs to the owner, and beauty, which

216

belongs 'to everyone, to you, to me, to all of us'. And he personified 'vandalism', describing its triumph as architect, entrepreneur, professor or representative; in this guise, it tended to embody not only a disrespectful attitude towards the past, but any present manifestation of bad taste. A year later, his call was repeated and developed by Charles de Montalembert, whose typology has already been quoted. To Montalembert, a militant Catholic, 'modern vandalism' was not only 'a brutality and a foolishness', it was moreover 'a sacrilege', and the 'crusade' against it required nothing short of 'fanaticism'.[23] He was also new in coining the phrase 'restorative vandalism' (*vandalisme restaurateur*), and considered that while it sprang from different motives, its results were as disastrous as those of 'destructive vandalism'. In 1834 Prosper Mérimée, newly appointed 'general inspector of historical monuments', observed that clumsy restorers proved to be more dangerous enemies of ancient monuments than the Protestants and the *sans-culottes* who had previously visited them.[24]

The most radical criticism of restoration, however, was formulated in England by John Ruskin in *The Seven Lamps of Architecture* of 1849. In his view, 'restorative vandalism' was a pleonasm: 'Neither by the public nor by those who have the care of public monuments, is the true meaning of the word *restoration* understood. It means the most total destruction which a building can suffer: a destruction out of which no remnants can be gathered: a destruction accompanied with false descriptions of the thing destroyed.'[25] The importance of this interpretation for the history of the notions of 'heritage' and 'vandalism' cannot be overrated. It rested on an early conviction of the primacy of what Riegl would half a century later term 'antiquity value': 'The greatest glory of a building is not in its stones nor in its gold. Its glory is in its age.'[26] Since 'the whole finish of the work, was in the half inch that is gone', no authentic 'restoration' was possible and one must be content with 'keeping out wind and weather', as William Morris, the most influential disciple of Ruskin, put it when founding in 1877 the Society for the Protection of Ancient Buildings, best known as 'The Anti-Scrape'.[27]

The debate on restoration extended to painting, where current doctrine and practice implied de-glazing and completing.[28] Nor were sculptures spared by modernization, particularly in public places. In Berne, to take one example, the Christoffelturm (Tower of St Christopher), the main element of the late medieval fortification of the town, was sacrificed in 1865 to the construction of the railway station. This was not merely a technical decision, since the tower and the station were clearly understood as symbolizing respectively the identity of the ancient Berne and the 'needs of progress'. The fight between their supporters lasted six years and concentrated on the large wooden figure of St Christopher which had been placed in 1498 in a recess of the tower on the side of the town and had survived, as

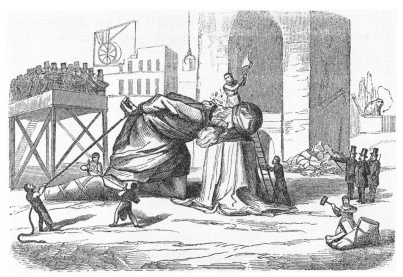

94 An anonymous woodcut, *How the Biggest Man of Berne is Being Sacrificed and Beheaded on the Order of the Little Gods of Materialism*, in *Die Schweiz* (March 1865).

a kind of gate-keeper, the iconoclasm of the Reformation. After the township had chosen the destruction with 415 votes against 411, the statue was cut into pieces that were distributed – with the exception of the head, the feet and one hand – as firewood to the poor, just as in the Reformation. Defenders of Christopher made relics out of the surviving fragments, and a cartoonist interpreted the elimination as the beheading of 'the biggest man of Berne ... on the order of the little gods of materialism' (illus. 94).[29] As for the fountains with statues (illus. 44), which lost their function when water was brought directly into the houses and became obstacles to the new means of transportation, they were saved by a German-born shoemaker who in 1896 bequeathed his fortune to the town for their maintenance and restoration.[30]

The faith in progress and the utilitarian and aesthetic justifications of many interventions, however, impeded a widespread consciousness of the extent of such destructions, so that comparisons with earlier iconoclasms remained relatively rare. Martin Warnke quoted a German thesis of 1905 evoking the Münster Anabaptists.[31] George Bernard Shaw, in his *Common Sense about the War* of 1914, recommended being

careful how we boast of our love of medieval art to people who well know, from the protests of Ruskin and Morris, that in time of peace we have done things no less mischievous and irreparable for no better reason than that the Mayor's brother or the Dean's uncle-in-law was a builder in search of a 'restoration' job. If Rheims cathedral were taken from the Church tomorrow and given to an English or French joint stock

company, everything transportable in it would presently be sold to American collectors, and the site cleaned and let out in building sites.

Indeed, Hugo had pointed out that, in 1825, for the coronation of Charles X, the overhanging sculptures of Rheims cathedral had been systematically broken off for fear of one falling on the King.[32] Moreover, even enemies of 'embellishing' destructions tended to take sides against some other period or type of objects. Montalembert, for instance, refused to examine the case of the 'bad churches of the seventeenth and eighteenth centuries', and hoped that an archbishop of discerning taste would remove the marblings, wainscot screens and the 'hideous' high altar from St Andrew's cathedral in Bordeaux.[33] As Nikolaus Pevsner remarked, Morris did not want to confine protection to one style or one period, and defended, for example, Wren's churches in London, but his tolerance could hardly extend to the Victorian architects and restorers who were his enemies.[34]

Enlarged heritage and selective preservation

A new understanding of the roots of such difficulties and contradictions was made possible when Alois Riegl, in order to provide theoretical guidelines for the conservation of Austrian monuments, wrote his essay on 'the modern cult of monuments: its essence and its development'.[35] Riegl, who had been responsible for the fabrics department at the Austrian Museum of Applied Arts, discarded the distinction between 'artistic' and 'historical' monuments as irrelevant and affirmed that 'according to today's conceptions, there is no absolute artistic value, but only a relative, modern one'. He further observed that the majority of monuments were 'unintentional', since 'the works do not find in themselves, by virtue of their original determination, their meaning and significance as monuments, but receive them from us, [i.e.] modern subjects'.[36] He analyzed the partly antithetical values involved in what he called their modern cult, and found them consisting in 'memory values' (*Erinnerungswerte*) on the one hand, including the 'antiquity value' (*Alterswert*), the 'historical value' and the 'intentional memory value', and 'present values' (*Gegenwartswerte*) on the other hand, comprising the 'use value' (*Gebrauchswert*) and the 'artistic value' (*Kunstwert*). The latter had two aspects, a 'novelty value' (*Neuheitswert*) possessed by any newly created work, and a 'relative artistic value' that it could claim insofar as it corresponded to the current demands of the modern 'artistic intention' (*Kunstwollen*). Riegl concluded from an examination of the historical development of these values that the 'antiquity value', which proceeded from the cult of the historical value typical of the nineteenth century, would ultimately get the upper hand. It was logically opposed to restoration,

because it cherished monuments as tokens of the passing of time.

A friend of Riegl, the Viennese architect and historian Camillo Sitte, proposed a comparable enlargement and relativization of monumental values in his *Town-Planning According to its Artistic Principles* of 1889.[37] Ruskin and Morris had already contributed to the defence of domestic architecture and to the international promotion of preservation at a European level.[38] The idea of the historical town as monument, consisting in topography and site, streets, squares and 'minor' as well as in major buildings, was further developed in Italy, particularly by Gustavo Giovannoni, who coined the phrase 'urban heritage'.[39] It tended to be marginalized, however, by the modernist ideal of the blank canvas, with or without selected symbols from the past. But when economic growth and the world expansion of technological progress added their destructive power to those of the Second World War and of the reconstruction period, the inadequacy of preservation policies based on traditional notions of the isolated monument became obvious, and measures were taken at national and international level. In France, which long resisted such a revision, André Malraux had a law passed in 1962 that allowed the global protection of ancient areas. In 1968, after the controversies provoked by the operations at the High Dam on the Nile in Egypt, the General Conference of UNESCO adopted a recommendation to protect 'structures having artistic, historic or scientific importance ... threatened by public and private works resulting from industrial development and urbanization'. It pointed out that measures to that effect 'should extend to the whole territory of the state and should not be confined to certain monuments and sites', and mentioned among the dangers 'urban expansion and renewal projects, although they may retain scheduled monuments while sometimes removing less important structures, with the result that historical relations and the setting of historic quarters are destroyed', as well as 'similar projects in areas where groups of traditional structures having cultural value as a whole risk being destroyed for the lack of a scheduled individual monument'.[40] Four years later, another recommendation dedicated to protection at national level defined 'cultural heritage' as including monuments, groups of buildings and sites, and required that it 'be considered in its entirety as a homogeneous whole, comprising not only works of great intrinsic value, but also more modest items that have, with the passage of time, acquired cultural ... value'.[41]

This generalization accomplished to some extent Riegl's prophecy. During the last decades, the Western definition of 'heritage' was affected by a typological, chronological and geographic extension that made it include elements of minor, vernacular and industrial architecture, urban textures, whole towns or systems of towns, modern and even recent buildings, as well as artefacts from countries or cultures in which their physical

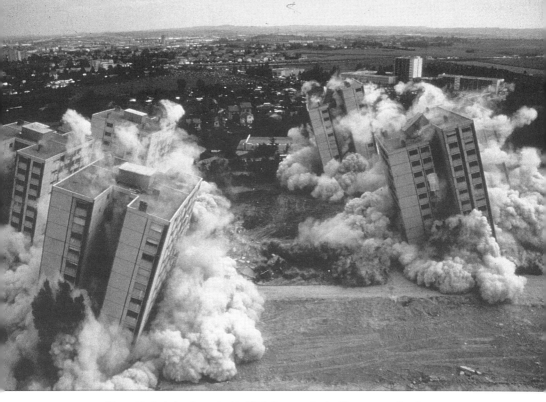

95 Tower blocks being dynamited in Vénissieux, a suburb of Lyon, on 11 October 1994.

conservation had not hitherto played a comparable role.[42] The triumph of 'heritage' implied a rejection of the modernist condemnation of historicism. Protection was thus slowly granted to the 'embellishing' interventions of the nineteenth century, whereas the tokens of more recent, and sometimes more radical, attempts at remodelling the environment had more difficulties in being regarded as 'heritage'. Haussmann's Paris, for example, appeared as a model of urbanity compared with the effects of 'adaptation to the motor-car' of the second half of the twentieth century. Indeed, the current elimination in France of large housing areas constructed (more or less hastily) in the 1960s and 1970s and renovated (unsuccessfully) in the 1980s gives striking evidence of the utter disqualification of the standard architecture and town-planning of that period and of the actuality of 'embellishing' and expiatory destruction. The example of the district named 'Démocratie', in Vénissieux near Lyon, calls for many parallels with the removal of monuments erected during the Communist era in Central and Eastern Europe. The *préfet* declared that 'one had to let the walls fall', and the mayor of the town even planned to make of the 'thunder-striking' (demolition) of the quarter a musical show for the 200th anniversary of the Revolution, on 14 July 1989.[43] Finally, as French suburbs increasingly became places and symbols of social revolt, a more modest staging was chosen, and on 11 October 1994

the ten tower-blocks of the quarter were dynamited (illus. 95). Although the majority of the 640 flats had been deserted and the 'towers' had been walled up since 1985, former inhabitants deplored the operation as an elimination of their own memories and identities. Ambitious projects conceived to reanimate the quarter had all failed, and they doubted that the destruction would be compensated by a creation – a doubt that so far has proved to be well-founded.[44] Most revealingly, no one dared oppose the elimination in the name of monumental values, despite the fact that the architect was alive and that neither he nor the politicians, town-planners, administrators and undertakers also responsible for the construction had been personally accused. An exception was the architect Paul Chemetov, born in 1928, whose own interventions in suburbs of the 1970s had tended to keep extant streets and buildings in order to 'preserve for the quarter an image of the past'.[45] Commenting on the simultaneous presentation in the news media of a further 'implosion' of housing blocks near Paris and of the killing by the police of a young inhabitant of the Lyon suburbs suspected of Islamic Fundamentalist terrorism, he defined this double elimination as an 'aesthetic and ethnic purification' and denounced the destruction of buildings as staging the 'instantaneous devalorization' of a past that, not so long ago, had been praised and claimed by the promoters and the users of the same architecture.[46]

At the level of historical centres, the post-War development of Brussels gave birth to the neologism 'bruxellization', used by town-planners to designate the ruthless destruction of a town. It started with the 'ripping up' of quarters to connect the North and South railway stations and was fostered by the installation of international organizations, the possibilities for property speculation that it offered, and the peculiar position of the capital city in the complex linguistic, social and political system of Belgium.[47] The rich Art Nouveau heritage of Brussels was thus largely sacrificed to 'modernization'. Paris was subjected to gigantic operations of urban 'renovation' in the 1960s. The transfer of the Halles, the central market, to Rungis in 1969 was followed by the destruction of whole streets and of the famous iron, glass and brick pavilions constructed in 1852–9 by Victor Baltard (illus. 96).[48] They had been part of Haussmann's Paris, but André Chastel and Jean-Pierre Babelon could none the less write that their elimination 'conformed to the Haussmannian tradition, which never ceased to rule in the offices of the capital city'.[49]

This destruction, however, was widely condemned, and it indirectly contributed to the extension of 'heritage'. In 1965 the Marais quarter had been declared 'secteur sauveguardé'. The delimitation of protected urban areas was an answer to the shortcomings of the notion of 'monument' as isolated architectural object, but it transformed rather than eliminated the practice of

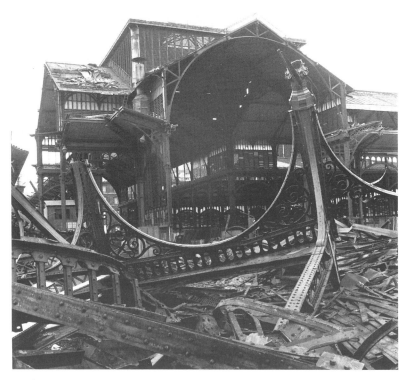

96 Victor Baltard's Pavillons des Halles of 1852-9 in the course of demolition, September, 1971, Paris.

selective preservation. On the one hand, it maintained within its confines typological and chronological distinctions – in Rennes, for instance, the area defined in 1966, whose architectural substance dated mainly from the eighteenth century, did not provide systematic protection to its nineteenth-century and minor constructions;[50] on the other hand, it happened that it was obtained at the cost of other destructions, and the existence of areas symbolizing heritage tended to create an implicit 'zoning' at the global urban level and to expose even more the less prestigious parts of towns to the destructive effects of building speculation and modernization.[51]

Aesthetic and functional obsolescence naturally continued to provoke transformations and eliminations, particularly in the realm of domestic and minor realizations. Neo-medieval castles of the Anjou, for instance, were generally destroyed by the offspring of those who had built them, and most French Art Nouveau and Art Deco shop-fronts were destroyed during the 1960s in the name of taste.[52] When the Gothic Revival had been rediscovered, as well as other historicist styles, the label 'neo-Byzantine' continued to 'carry along the condemnation without appeal' of the standard church architecture of the 1920s.[53]

The consensus created around the notion and values of 'heritage', however, obliged recourse to roundabout methods and definitions of destruction. An age-old technique consists in letting wind, weather and 'vandals' act, even on a theoretically protected work: as Emmanuel de Roux recently wrote about a scheduled Art Deco swimming-pool owned by the City of Paris, 'an abandoned building is a condemned building'.[54] A more recent one (variously named *curetage*, *façadisme*, *Entkernung*) consists of gutting the buildings while keeping or reconstructing their fronts or that of whole streets. It can be observed everywhere – the 'Schiller-Haus' in Weimar, 'renovated' in this manner in 1988–9, was a late example in the history of the DDR – but the treatment of Haussmann's boulevards in Paris may be mentioned for the sake of continuity.[55] This more or less cynical preservation of outward appearance contributes to a confusion of old and new, fake and authentic, and relates to a last modern type of destruction caused by the very development of 'heritage'. Françoise Choay in particular has pointed to the 'perverse effects' of this new industry, showing that the adjustment of 'cultural objects' to the needs of 'cultural consumption' as well as this consumption itself could amount to a 'cultural destruction' in physical and intellectual terms. She called for a redefined protection of the monuments and of the public, which could mean helping the former 'to live and to die'.[56]

'Statuomanie'

We have seen that radical preservationists had their contradictions. They are made particularly apparent by Louis Réau, who dedicated an important part of his *History of Vandalism* to the 'embellishing' type. He rejected in principle all types of degradation and destruction, but readily excused those who had 'compensated' for them by valuable creations. Moreover, he approved of elimination or called for it in the case of ecclesiastical art and public sculpture of the second half of the nineteenth and of the beginning of the twentieth century, for which he used the defaming labels of 'Saint-Sulpicerie' and 'statuomanie'. The authors of the revised and augmented edition of his book, Michel Fleury and Guy-Michel Leproux, proposed distinguishing even more clearly between 'illegitimate destructions' and 'beneficial' or neutral ones, 'necessitated by the creation of new and magnificent works', although they tended to stigmatize all recent constructions which implied an attempt on ancient heritage.[57] Returning to Réau, this blind spot is all the more striking, for Réau was very much aware of the historically determined character of aesthetic criteria: 'Taste changes from one generation to the next: this is why it is always rash to destroy the work of the past.'[58] I shall deal with the 'Saint-Sulpicerie' in the next chapter. On Parisian public statues, Réau wrote the following condemnation:

The German occupation, between 1940 and 1944, has rid us of a certain number of bronze effigies that did little honour to the capital city of modern art. It is the only service that, without intending it, the invaders have rendered Paris . . . The demands of motor-car traffic, which transforms streets and squares into garages, will soon have suppressed the cumbersome statues that will have to seek a refuge in parks and gardens. But there are yet too many left, and one wishes for a severe purification of the Republican effigies that spoil – rather than embellish – the flower-beds of the Tuileries, of the Jardin du Luxembourg or of the Parc Monceau.[59]

Réau found that 'a swarm of nymphs or of Diana's companions' would better suit these gardens, and the political connotations of his preferences are clear enough. In France at least, the Revolution contributed both to the development of public sculpture and to its criticism. For the latter, the long-term disqualification of instrumental art has been sufficiently mentioned in the preceding chapters. As for the former, Maurice Agulhon has shown how the enlightened cult of the *grands hommes*, promoted – if not invented – by the Revolutionaries against that of the King and the saints, had progressively extended the privilege of being 'monumentalized' to ever greater circles of living, dead and fictional characters. At first perceived as an anti-clerical and radical initiative, the propagandist use of statues in public places was soon appropriated by all sides and greatly benefited from the deeply conflictual nature of French nineteenth-century politics.[60] As was everywhere the case in Europe, monuments also participated in the modernization and *embellissement* of towns, in relation with the removal of walls, the creation of boulevards and squares, and the supplying of water; they were also touched, especially their most widespread and modest versions, by industrial techniques of production and multiplication.[61]

According to Jean Adhémar, there were only 11 statues of 'great men' in Paris by 1870, but 34 were erected in the decade 1870–1880, 23 in 1880–90, 34 in 1890–1900, 51 in 1900–1910, and 13 between 1910 and 1914. The First World War, which provoked a wave of monuments to the dead soldiers, marked the end of this one.[62] The Third Republic, which lived much longer than the two previous ones and could thus resort to lasting monuments, did so in order to affirm its legitimacy against that of the authoritarian and clerical regimes of the Second Empire and the *Ordre Moral*, to commemorate the French Revolution, the prematurely deceased Gambetta and Carnot, and the victims of the Franco–Prussian war, as well as to proclaim its democratic and meritocratic message.[63] Moreover, the easier access to monumentalization also enabled 'groups alienated from the ideological mainstream' to appropriate its rituals and efficacy for means of partisan militancy.[64] This increasingly apparent instrumentality, together with the inflation of monuments, their repetitive aesthetics and the appearance of new conceptions such as Rodin's *Balzac*, provoked a devalorization

that spread from an elite to common opinion and from certain specimens to the whole class of public monuments. The judgement of invisibility passed by Robert Musil in 1927 has already been mentioned. It was preceded by many less all-inclusive rejections. As early as 1879, a newspaper article entitled 'La Statuomanie' denounced an overabundance of effigies in public places.[65] In the entry 'Statues' written for his dictionary in the 1880s, Pierre Larousse found that his time deserved 'to some extent the reproach of *statuomanie*', but he pointed to the questionable greatness of the prototypes rather than to the artistic quality of the works.[66] Much more radically, Degas equated statues with excrement when he affirmed that 'one puts iron wire around the lawns of public gardens to prevent sculptors from depositing their works therein'.[67] After anti-statuomanie press campaigns in 1901 and 1905, a debate launched by the newspaper *La Quinzaine* allowed in 1911 one Frédéric Masson to call for a massive beheading and, in case other measures would not suffice, the creation of a 'small, nice iconoclastic sect'.[68] Between the two Wars, the aesthetic statue had so far deserted Parisian monuments that the Surrealists could use it as a kind of poetic raw material, following Pierre Reverdy's judgement that 'it is not the image which is great, but the emotion that it calls forth'.[69] The political manifestations that certain statues still attracted appeared to them as magic revivals, and in 1933 the verbal appropriations of their already mentioned inquiry 'on some possibilities of irrational embellishment of a town' proposed many forms of metaphorical iconoclasm.[70]

The wilful destruction of many French monuments and parts of monuments (more than 100 in Paris alone) during the Second World War may be regarded as expressing the regressive character of the regime that ordered it.[71] But their aesthetic indignity, which was by then well established, made it at least easier to accomplish, so that comparisons with the removals following 1989 in Central and Eastern Europe – under inverted political circumstances – are not altogether out of place. The very reason officially given by the government of Vichy (for, in this case as in others, the invaders mentioned by Réau were far from alone) reduced the statues to their material dimension: the needs of national agriculture and industry required the recovering of non-ferrous metal like bronze. It was said that some of it also served to make copies of famous French works for the Nazis, was put at the disposal of Arno Breker's Paris studio, or contributed to German weapons production.[72] In any case, a law of 11 October 1941 'referring to the removal of metal statues and monuments for the purpose of remelting' ordered all those situated in public places and in official buildings to be taken away, unless commissions created in each *département* consider them to possess an 'artistic or historic interest'.[73] These commissions tried to save time and monuments, but the Minister of National Education, Abel Bonnard, im-

97 Pierre Jahan, *Alligators*, from Jean Cocteau's *La mort et les statues* (Paris, 1946). *The bronze alligators belong to Jules Dalou's* Triumph of the Republic *(1879–99), and are shown in storage in December 1941 before being melted down.*

posed further eliminations and made plain the political objectives of the de-struction. As an official circular of 22 March 1943 repeated, the removal gave the occasion of a 'true revision of our glories' and could be used 'not only to take away the honour of a statue or of a bust from people who had evidently usurped it, but to award this honour to others who deserve and had not obtained it'.[74] The main target of this concealed iconoclasm was thus the Third Republic, with its pantheon and its values. Thanks to many protests, Jules Dalou's *Triumph of the Republic* (1879–99) on the Place de la Nation was only provisionally dismantled, but the menacing alligators that surrounded it, traditionally considered as symbols of the enemies of democ-racy, never found their way back (illus. 97).[75] Aesthetic elements were present from the start. A violent press campaign required the 'disappearing of the ugly' and radical circles, which saw in Fascism and the Occupation the means of modernizing France, pleaded for the elimination of all statues, including those of stone and marble, proposing to 'unleash an iconoclastic wave'.[76] For less enthusiastic commentators, aesthetic indignity allowed the

destruction to be accepted; the mayor of Lyon, Edouard Herriot, thus explained to members of his town council: 'one must admit that our statues do not have a very great artistic value. They mostly date from the unhappy time for sculpture that extends from 1880 to 1900.'[77] As for the Surrealists' interest in monuments and iconoclasm, it was further documented in a book entitled *Death and the Statues*, combining Jean Cocteau's comments with the remarkable photographs of some of the monuments taken clandestinely by Pierre Jahan in a warehouse before they were melted down (illus. 97).[78]

After the War, the lost statues were not replaced until the 1980s – even then, in very few cases, and for reasons that have more to do with the persons represented than with the sculptures.[79] To the continuing indignity of nineteenth- and early twentieth-century monuments contributed the triumph of the modernist condemnation of instrumentality and 'academism' as well as, perhaps, a more specific identification of the 'pedagogical' monuments of the turn of the century with the monumental propaganda of authoritarian and totalitarian regimes.[80] Striking evidence of this illegitimacy can be found in the fact that although no political revolution estranged the Third from the Fifth Republic, monuments erected during the former were further eliminated during the latter, mostly in favour of modernizations and 'embellishments'. In Lyon, for instance, the construction of a subway in the first half of the 1970s occasioned the total or partial removal of several major works. Of the complex monument to Sadi Carnot, erected in 1902 on a square near the spot where the President of the Republic had been assassinated in 1894, only his effigy was preserved: it was transferred to the gardens of the Préfecture.[81] The monument to the Republic completed in 1894 (illus. 98), which greeted the people coming from the station and acted symbolically as a riposte to the equestrian statue of Louis XIV on Place Bellecour, was dismantled. The higher part of the pedestal with the figure of the Republic was removed to one side of the square, the allegory of Lyon was placed on the opposite side, the three groups symbolizing the Republican virtues of Liberty, Equality and Fraternity were relegated to a small park in a suburban working-class quarter (illus. 99), and the personifications of rivers were destroyed.[82]

Apparently, the monument had to be relocated because its weight would have endangered the subway tunnel. A sculptor consulted by Louis Pradel, the Mayor, had proposed eliminating it entirely, and replacing it with a new statue of the Republic of his own creation; his project was judged too expensive, however, and the Mayor's own cheaper dispersal scheme was chosen.[83] This Mayor became famous for the particularly brutal 'modernization' of the town he unflinchingly promoted, and an idea of his good conscience in doing so can be gained from the photograph of a ceremony published in the local Press in 1964: the creation of a *secteur sauveguardé*

98 The Place Carnot, Lyon, with the 1887–94 monument to the Republic, before 1975.

99 The Georges-Bazin square in Montchat, Lyon, showing the current placement of the three allegorical groups *Liberty*, *Equality* and *Fraternity* by Peynot from the lower part of the monument to the Republic formerly in the Place Carnot, Lyon.

100 The bas-relief of *Progress* by Maspoli from the 1913 monument to Antoine Gailleton, Lyon.

on one side of the Saône was being 'compensated' for by the destruction of a whole row of ancient houses on the other side of the river, and Louis Pradel was shown 'symbolically breaking the first tile' of the first building, an inversion of the more traditional laying of the first stone that recalled not only Mussolini's self-staging as a revolutionary demolisher (illus. 92) but also the symbolic blow given in 1793 by the representative of the First Republic to the front of the Place Bellecour in Lyon (illus. 6).[84] Despite this ambiguous ancestry, the gesture was renewed by Louis Pradel's successors Francisque Collomb and Michel Noir, who were shown giving 'the first blow with a pickaxe' of demolitions or 'rehabilitations' as late as 1984 and 1994.[85] An element of local tradition may thus explain the presence in Lyon of a rare example of an allegory of 'embellishing vandalism' (illus. 100), on the monument erected in 1913 to honour the memory of Antoine Gailleton, Mayor of the town from 1881 to 1900. Politically a radical Republican and by profession a physician, Gailleton had among other works helped establish the university and reconstructed the central Grôlée quarter, considered insalubrious. The main part of the monument shows a personification of Lyon examining projects of *embellissement* for the city, under a bust of the Mayor – replaced in stone after it was melted down during the War. On the sides, bas-reliefs symbolize respectively Science (a meditative woman with the university buildings in the background) and Progress. The latter is represented by another woman, with bare breast, holding a torch in the right hand above building tools, next to a picturesque view of the Grôlée quarter. The torch is no attribute

of Liberty giving light to the world, and the old street does not embody heritage, as today's spectators might believe: Progress is about to set fire to the place.[86]

12 Reformations of Church Art

Louis Réau found *statuomanie* even worse than the ecclesiastical art to which he objected and which he denigrated as 'St-Sulpicerie' because one is condemned to see the works installed in public places, whereas one is free not to enter churches. But he found that the latter were 'dishonoured' by objects – in particular mass-produced plaster figures – 'partaking no more of art, but of industry', and called for a 'purging'. To him, the causes of this disgrace were that the clergy lacked an artistic education and its origin was the 'vandalism' of the French Revolution, which had emptied the churches and provoked an 'invasion'.[1] The extent of this 'emptying' ought to be relativized and differentiated.[2] But the autonomization of art fostered in the long run by the Revolutionary transformations had a double impact on the further evolution of religious and especially of church art: on the one hand, it made it difficult for artists to accept the conditions of ecclesiastical commission and liturgical use, and for images produced under such conditions to be recognized as works of art; on the other hand, these very difficulties made of church art a privileged field for attempts at re-instrumentalizing or at re-socializing art.

Art, religion and autonomy

Of course, this phenomenon did not appear suddenly after the Revolution. Olivier Christin has shown that already at the end of the seventeenth century, the traditional annual donation of votive pictures to Notre-Dame of Paris by the Parisian goldsmiths' guild was governed more by aesthetic than by religious criteria. The paintings, exhibited for a day in front of the cathedral before being installed in site, were commissioned from members of the Académie Royale de Peinture or from painters who were about to become members, and played a role in their artistic career; the representation of the donors was progressively banished from them. In the second half of the eighteenth century, printed descriptions of the pictures hardly mentioned their subject-matter any more, but praised instead their stylistic qualities and the reputations of their authors.[3] Neither were these transformations restricted to France: the early attempt at reuniting art and religion proposed from 1809 on

by the German members of the *Lukasbund*, established in an abandoned convent in Rome and nicknamed *Nazarener*, had a deep influence on all subsequent kindred movements in France, England and Italy.

In France, however, the relation to the Revolution and its sequels was direct. Under the Restoration, the need for a redecoration of the churches gave Quatremère de Quincy, who was by then life secretary of the Académie des Beaux-Arts and member of the Paris city council, an opportunity to put into practice his conception of art. To him, works of art could and should not be judged 'by reason of an abstract perfection, independent from places and circumstances', but only 'where works intended for public use are publicly submitted to the criticism of feeling'. He regarded the freedom proposed by many artistic competitions as 'much too close to the one granted by indifference' and condemned museums as pernicious gatherings of uprooted objects, comparable to 'tombs' or 'demolition workshops', the development of which was 'disinheriting' the arts by 'banishing them from all political, religious and moral uses'.[4] Accordingly, the Comte de Chabrol, who was responsible for the redecoration of Paris churches, decided not to buy any ready-made works by recognized painters and sculptors but to systematically commission young artists to realize *ad hoc* decorations, thus creating a kind of artistic 'microclimate' protected from the influence of the market.[5] This reactionary – with regard to the general cultural as well as political evolution – dimension remained essential to most actors and promoters of the renewal of church art until the end of the nineteenth century, at least in France. It also helps explain the rebirth of fresco painting and the general preference given to murals, since the mobility of easel pictures, implying a freedom from *destination* as well as from location, was essential both to the autonomy of art and to its commodification.

A programmatic picture painted in 1840 by the main exponent of Nazarene art, Friedrich Overbeck, depicted *The Triumph of Religion in the Arts* (Frankfurt-am-Main, Städelsches Kunstinstitut). In 1839 Lacordaire prepared the re-establishment of the Dominican order in France, where it had been suppressed in 1792, with the creation in Rome of a group of French artists, the Confrérie de Saint-Jean-l'Evangéliste, the objective of which was 'the sanctification of art and of artists by the Catholic faith and the propagation of the Catholic faith by art and by artists'.[6] Theoreticians of Christian art proposed apologetical interpretations of the Platonic tradition and annexed the academic doctrine of ideal beauty. Abbé Esprit-Gustave Jouve could thus affirm in 1856 that 'art is by itself essentially moral and religious'.[7] French Catholics like Montalembert and Alexis-François Rio considered that the Renaissance, because of its 'paganism' and the emancipation of artists from the Church, had marked the beginning of a decadence. The return to pre-modern aesthetic and social models inspired the foundation of several artistic communities, such as

the English Pre-Raphaelite Brotherhood in 1848 or the project of an 'art monastery' (*Kunstkonvent*) written down in 1864 by Peter Lenz in Rome.[8] The fifteenth-century monk-painter Fra Angelico became a cult figure, the model of a personal and institutional accomplishment conjoining faith and art. Among the French painters dedicated to church art were pupils of Ingres, in particular Hippolyte Flandrin.[9] Romantic artists – not to speak of the Realists – did not receive many church commissions, the main exception being the decoration of the Chapelle des Saint-Anges in the church of Saint-Sulpice, which Delacroix painted from 1849 to 1861. Religious subjects were relatively frequent in Delacroix's easel paintings, but he typically interpreted them in a free and personal way, realizing by means of colour and interior feeling what Klaus Herding terms a 'dissolution (*Aufhebung*) of religion into art'.[10]

Further developments of modern art could be anticipated by the Primitivist leanings of nineteenth-century religious revivalists, who rejected illusionism in the search for transcendence. This is particularly striking in the case of the syncretist and geometrizing experiments of the art school founded by Lenz in the Benedictine abbey of Beuron in southern Germany.[11] But despite some relations to Socialist and Utopian thought, the movement as a whole was mainly connected with conservative politics and considered anti-modernist.[12] Only at the end of the century, at a time of neo-spiritualism and religious 'renaissance', could its 'hieratic', anti-naturalistic aesthetics become associated with the artistic 'avant-garde'. The second generation of 'independent' artists, who really depended on what Harrison and Cynthia White have called the 'dealer–critic system', not only criticized the shortcomings of mimetic art, but tended to resent the individualism and social marginality that were to some extent forced upon them.[13] In 1891 Albert Aurier concluded the article in which he crowned Gauguin the representative of 'Symbolism' in painting by claiming that public 'walls' be intrusted to him for decoration.[14] At about the same time, the Nabi Jan Verkade rejected easel painting and declared that 'the painter's task begins where the architect considers his own as finished'.[15] Born in The Netherlands and educated in the Protestant faith, Verkade converted to Catholicism, went to Beuron and became a monk in 1894. True to the Hebrew meaning of the name they had chosen, the other Nabis followed by contrast the model of the 'prophet' rather than of the priest, and participated in the sacralization of the artistic field characteristic of the nineteenth century.[16] A notable exception was Maurice Denis, who in his teens already had ambitions to become a new Fra Angelico and to 'bring Art back to its great Master who is God'.[17] In 1901, the priest of his childhood parish commissioned him to decorate a chapel in the new church of Ste-Marguerite in Le Vésinet near Paris. An approving commentator praised the finished work as a refuge in which 'Christian souls enamoured of beauty' could come 'to pray without closing their eyes'.[18]

This critic implied that in most other churches open eyes were 'offended' – to use a phrase we have often encountered – by the sight of what surrounded them. Why was it so? By the turn of the century, the normal conditions of commission, creation and reception of church decoration and liturgical objects had long been in contradiction with the very definition of artistic activity. This may be illustrated by a telling anecdote from the life of Raphael Ritz, an artist from the Valais, then an essentially rural and Catholic part of Switzerland. In 1863 Ritz returned after studying at the Academy of Fine Arts in Düsseldorf, and attempted to collaborate again with his father, a craftsman-painter of altarpieces and portraits. This proved to be impossible, and he expressed on one occasion the distance separating his newly acquired conception of art and what was required of him by omitting to sign an altar painting on which the peasant who paid for it had obliged him to add wings with kneeling children; in 1865 he went back to Düsseldorf.[19] Of course, in less remote places and especially in cities, control was rather exercised by ecclesiastical authorities and may have been more subtle, but the problem was not essentially different. This situation provoked a selection and a specialization of artists who either had personal (religious, moral or political) reasons to choose this undervalued field of activity and in some cases try to revalue it, or who failed in more prestigious enterprises and fell back to a relatively secure source of income. Melchior Paul von Deschwanden for instance, another nineteenth-century painter from a rural and Catholic part of Switzerland, returned to his native Stans after meeting Overbeck in Rome. He worked essentially for the Church, executed with his pupils many hundreds of altarpieces and devotional pictures inspired by Raphael and the Nazarenes, and replied to those who objected to the traditionalism and sentimentality of his production that he 'painted for pious souls and not for critics'.[20]

The Gothic Revival, the construction and restoration of churches, transformations in religious practices and a resultant growing demand for decoration, liturgical objects and domestic religious images, also promoted the creation and development of semi-industrial and industrial workshops, which employed old and new means of reproduction to provide more products at lower prices. The sequels to these technical and commercial transformations were denounced in general terms as a 'substitution of industry to art', together with photography, photosculpture, or casting.[21] In 1853 a French priest regretted that pious images and objects were 'abandoned to inferior industries that make a traffic of ignorance and simplicity, render piety spiritless and sometimes even insult Christian dogmas and feelings'.[22] This was the time when, in Paris, many shops selling *articles de piété* settled in the quarter around the church of St-Sulpice. Not all the Paris shops that

sold *articles de piété* were located there, and Paris was not alone in providing France – not to speak of other countries – with such articles. But 'St-Sulpice' progressively became a nickname for them as well as for church art considered in bad taste, in phrases like *Saint-Sulpicerie*, *art de Saint-Sulpice* or even *style de Saint-Sulpice*. Claude Savart has proposed identifying what was initially labelled 'St-Sulpice' with a third phase of church art beginning in the 1860s, after an infatuation with neo-medievalism (which had replaced, to some extent, the 'folk art' produced until then) had declined. It was characterized on the iconographic level by the predominance of recently canonized saints and new objects of devotion; on the level of expression by a kind of 'euphoric censorship' banishing the presence of evil, sin, asceticism or human concreteness; and it found its symbol in the countless plaster figures placed in churches, particularly when they were painted in bright hues for rural audiences.[23]

The stigmatization of 'St-Sulpice' runs more or less parallel to that of 'statue-mania'. This connexion, still visible in Réau's double condemnation, is hardly astonishing, for the two may be considered as the secular and religious sides of the same phenomenon, namely the devaluation and degradation of instrumental or commissioned art. Statues erected in public places, however, tended to be (verbally) attacked in the name of art at least as often as in the name of politics, because they presented themselves to the gaze of strolling aesthetes who refused to let them 'escape their senses'. But in order to be hurt by church art or articles of devotion, one had to enter churches or look into the shop-windows of specialized stores in the first place. Since the current religious production was obviously adapted to the taste, needs and convictions of the majority of churchgoers, this required the intervention of people who visited churches like museums or of believers who had different, more refined and more 'modern' aesthetic and religious expectations. The latter group was much more important and the condemnation implied wide-ranging social and cultural transformations, since it meant the rejection not only of certain religious images but of religious practices and of an image of religion.

The ecclesiastical hierarchy intervened in some cases, as when the Belgian bishops decided in 1886 to re-establish censorship in order to eliminate 'frivolous and dangerous' images and to favour a better quality of artistic expression.[24] But intellectuals and artists – among them many converts – played a major role in this evolution, and so did the intellectually respectable Dominican order. In France, the most influential taste-maker who participated in the disqualification of 'St-Sulpice' was the writer and art critic Joris-Karl Huysmans, who converted to Catholicism in 1892. In his widely-read *Les foules de Lourdes* (Crowds of Lourdes) of 1906, he opposed to the interior beauty of religion and to the reality of miracles the unworthiness of the vessels

101 Emmanuel Barcot's cartoon in *L'Assiette au Beurre* (December 1907): 'THE BEADLE: It is the Holy Virgin. JESUS: Poor mother! She used to be so pretty!'

LE BEDEAU. — C'est la Sainte Vierge...
JESUS. — Pauvre maman ! Elle qui était si jolie !

built to receive them during the nineteenth century. He attributed the responsibility for this discrepancy to no less than the Devil, whom he made address the Virgin in the following way: 'but art, which is the only clean thing on earth after sanctity, not only will you not have it, but I shall arrange things in such a way that you will be insulted without respite by the continuous blasphemy of Ugliness'. Huysmans based his theological interpretation of the judgement of taste on Catholic idealist aesthetics, as he made clear with reference to Lamennais: if beauty came from God, then 'ugliness, a-technia, un-art, as soon as they apply to Jesus, fatally become, for the one who commits them, a sacrilege'.[25] By then, the indignity of religious art was well established and could also be used to make fun of the Church, as a 1907 Christmas issue of the anti-clerical *L'Assiette au Beurre* witnesses (illus. 101). As in the case of public sculpture, the meaning of 'St-Sulpice' and the target of attacks against it widened in the process, until they covered almost the whole of nineteenth-century church art. In particular, the original plaster statues that had been part of the first post-Revolutionary phase of redecoration were assimilated to the cast figures of the second half of the century, and were often destroyed by the same movement.[26] This lack of differentiation resulted from the devaluation itself, and helped the concept to function as a set-off to all subsequent efforts at renewal.

Two main stages can be distinguished in the modernization of church art during the twentieth century, the first one developing between the Wars and the second one beginning immediately after 1945. In France they can be associated with two labels, 'modern religious art' (*l'art religieux moderne*) and 'sacred art' (*l'art sacré*), as well as with two men, Maurice Denis and Pierre Couturier. A pupil of Denis, the latter became a Dominican – under the first name 'Marie-Alain' – in 1925 and progressively renounced painting for the sake of defining, promoting and defending modern art in general and 'sacred art' in particular.[27] Their personal relationships went from filiation to surpassing and eventually rejection, an evolution that characterized the process as a whole.

With the exception of some Art Nouveau realizations, particularly in stained glass, modern artistic interventions in churches remained rare until the First World War. Appeals to a renewal were then published, such as *La décadence de l'art sacré* (the decadence of sacred art) by the Swiss painter Alexandre Cingria, and the philosopher Jacques Maritain proposed a Thomist theory of art open to innovation in his *Art et pensée scolastique* (art and scholastic thought).[28] New conditions favoured a coincidence between ecclesiastic and artistic interests. On the one hand, there were needs to reconstruct and redecorate the devastated churches, to build new ones for the growing suburbs, and to bring religion nearer to the modern world; on the other, ambitions to moralize art, to oppose the self-sufficiency and alleged 'anarchy' of the avant-gardes, and to make of church art a 'bridge' reuniting 'art and the people'.[29] Many groups, schools and associations endeavoured to create a 'modern religious art' – a phrase that positively asserted what could be regarded as a contradiction in terms – and competed against specialized craftsmen and industries to receive commissions.[30] The most famous one, the 'Ateliers d'art sacré' (church art studios), was founded by Denis together with Georges Desvallières in 1919, and proposed to the clergy the means of providing churches with 'religious works that are at the same time works of art'.[31] The movement was international and achieved a remarkable visibility, thanks to special exhibitions and inclusions in universal exhibitions as well as to numerous realizations.[32] In the 1930s, however, opposition to 'modern religious art' tended to grow, and political polarizations bore on the kind of aesthetic compromise pursued by most advocates of this renewal. Denis, for instance, who had criticised the attachment of the clergy and the faithful to the styles of the past, especially Gothic, also denounced as idolatry the 'cult of the artist' and 'the cult of an object that is an end in and of itself, that is not the sign of an idea'.[33] In 1939 he retrospectively defined the effort of which he had been a part as an attempt to 'baptize modern art', in the same way as

Catholic painters of the beginning of the nineteenth century had wanted to 'baptize Greek art'.[34]

Couturier, by contrast, rejected all such attempts and proposed asking the greatest artists, even 'geniuses without faith', to work for the Church because, as he explained, one had to 'reintroduce *living* art, the life of art in the church', and could 'always hope to baptize the living, while one cannot baptize the dead'.[35] After turning progressively away from the political and aesthetic conservatism of his former master, Denis, Couturier had spent the War years in North America, where he had become a supporter of modern art, including abstraction. On returning to France he joined another Dominican, Pie-Raymond Régamey, to edit the journal *L'Art Sacré*, which became the most influential organ of the new movement concerned with modernizing church art.[36] Couturier abandoned the requirement of faith, which artists had been asked to meet by all renewal movements since the beginning of the nineteenth century, and discarded the productions of specialized artists and groups. Radicalizing the link between art and transcendance, he found in aesthetic quality itself the justification for liturgical use, elaborating a notion of 'sacred art' that widened, and in a way abolished, those of 'church art' and of 'religious art'. Aesthetic criteria thus took precedence over religious ones in the evaluation and legitimation of art associated with the Church, a reversal of priorities explicitly stated by Couturier when he affirmed that in order to be 'representative of our time', Christian art had '(1) to be simply art, (2) to be *Catholic*'.[37] Artists had to be granted 'absolute liberty', and the symbolizing relation connecting art with the Church could be reduced to the type encountered in other cases of sponsorship of modern art.

Characteristically, the first major work based on these principles, the decoration of the church of Assy in Haute-Savoie, was said to have begun with the purchase of a stained glass by Georges Roualt in a Paris exhibition; it eventually comprised contributions by Bazaine, Bonnard, Braque, Léger, Lipchitz, Lurçat, Matisse, Richier and Rouault, and was consecrated in 1950.[38] A major representative of the previous movement, the painter Gino Severini, criticized it in the name of 'the requirement of the "function" and "destination" of the work', and declared that 'the Church is not a private collector'.[39] Other realizations, such as the parish church of Audincourt in the Doubs, built (like Assy) by Maurice Novarina and ornated with mosaics and stained glass by Bazaine, Léger and Le Moal, aimed at a better integration of all contributions. But the best-known examples of this second stage are typically one-man works and what could be termed artists' churches. This is the case of the chapel of the Dominican convent in Vence, designed from 1948 to 1951 entirely by Matisse, who declared to the bishop of Nice that he considered it as his 'masterpiece'.[40] It can also be said of the Dominican friary La Tourette in Eveux–sur–l'Arbresle near Lyon and of the pilgrimage church of

Notre-Dame du Haut in Ronchamp, built by Le Corbusier – a notorious atheist – respectively in 1950–55 (illus. 111) and in 1953–61.[41] When Couturier, who had acted as a mediator and adviser in Assy, Audincourt, Vence and Ronchamp, died in 1954, the violent opposition met by some realizations had led him to a more modest, pessimistic and aniconic attitude – Régamey resigned for his part from *L'Art Sacré*. But the diffusion of modernist values and forms that they accomplished, participated in a way that has been underestimated with regard to the post-War institutionalization of modern art. Moreover, their redefinition of 'sacred art' and of the relationship between aesthetics and religion had a lasting effect on the further evolution of church art, made manifest in the domination of abstraction and in the frequent practice of commissioning artists primarily renowned for non-religious works.

'Visual blasphemies'

Church art of the nineteenth and twentieth centuries has been confronted with attacks and elimination in two main ways. The first – external – one resulted from negative reactions to unusual forms and images. The second derived from the renewal process itself, which repeatedly involved a rejection of its previous stages.

Negative reactions are better documented in the twentieth century and may well have been more frequent, as the distance grew between autonomous art and the public at large. In the church as in the street, works could be seen by people who would never enter a museum, not to speak of a private gallery. Moreover, the specific values attributed to religious representations and to their prototypes gave a particular weight to requirements of conformity and propriety, and tended to make deviations from traditional models appear sacrilegious. Of course, such deviations were prone to be refused by patrons in the first place, so that conflicts arose only when differences existed between projects and final realizations, or between various levels of decision and ecclesiastical authority, or between the conceptions of the patrons as a whole and those of sections of the public. Encouragement of innovation was rather a matter of local or regional initiative, as in the case of Le Vésinet or in the support granted to Cingria's Groupe de Saint-Luc et Saint-Maurice by Marius Besson, bishop of Lausanne, Geneva and Fribourg from 1920 to 1945.[42] The 1917 Code of Canon Law had reaffirmed the condemnation of unprecedented images passed in 1563 by the Council of Trent, and emphasized the fact that bishops could only authorize images if these conformed to 'the practice approved of by the Church'.[43] During the 1920s, the Holy Office intervened at least twice against examples of 'modern religious art'. In 1921 it had Stations of the Cross by the Flemish expressionist Albert Servaes removed.[44] In 1928, it used the opportunity of Gino Severini's recent apsis mural painting in the

Swiss church of Semsales to prohibit the depiction of the Trinity as three identical persons already mocked by Calvin; the work, however, was not destroyed but only – and temporarily – concealed.[45]

The latter case was a matter of dogmatic and iconographical control. Churchgoers tended to be less concerned with theology and more with style, although the two could be tightly connected, at least on the level of argument. We have seen that, in 1938, the reproach addressed by the pastor of the Rutgers Presbyterian church in the name of his parishioners to Alfred Crimi's depiction of Christ was that its bare chest 'placed more emphasis on His physical attributes than on His spiritual qualities'.[46] The figure of Christ remained a privileged object of dispute, because of its dual nature and of its association with beauty and eternity on the one hand, with suffering and death on the other hand. After the First World War it was often chosen by artists to symbolize the tortures endured by humanity, and some of these works found their way into churches. In Lübeck, an Expressionist crucifix of painted wood, realized by the sculptor Ludwig Gies in the context of an ecclesiastical competition for a war memorial, was proposed in 1921 to the congregation of the cathedral by the young museum director Georg Heise.[47] Installed on trial (illus. 102), the work provoked violent controversies within the parish and in the Press, and was denounced as an instance of 'artistic Bolshevism'. As a result, the parishioners refused to buy it, but Heise envisaged that it could be given to the church by art-lovers. This was prevented by an assault perpetrated on it on 3 March 1922: the head of the sculpture was taken away and thrown into a mill-pond, where it was found 24 hours later. Heise noted that the mutilation had been executed in a workmanlike way, and suspected it to have been ordered and paid for by extreme Right-wingers. The authors of the act remained unknown, but the following events confirmed his interpretation. Nazis objected to another presentation of the repaired crucifix in 1922 and confiscated it in 1937 from the Stettin Museum, to which it had been loaned by the artist. It was placed at the top of the stairs leading to the first room of the exhibition 'Entartete Kunst', in which religious pictures were stigmatized as an 'impudent derision of the experience of God'.[48] Gies lost his teaching position and was excluded from the Prussian Academy of Arts, while Heise had already been dismissed in 1933 because of his championship of Expressionism.

This case may appear as a political exploitation of aesthetically and religiously motivated objections to modernism. But the three domains became increasingly intermingled between the Wars, and not only in Germany. The conservative accusation of cultural 'Bolshevism' was addressed to Functionalist architecture – derided as 'nudist' – as well as to Expressionist 'deformations'. It was used, for instance, in October 1932 against the small mountain church of Lourtier, in Valais, which was built by Alberto Sartoris

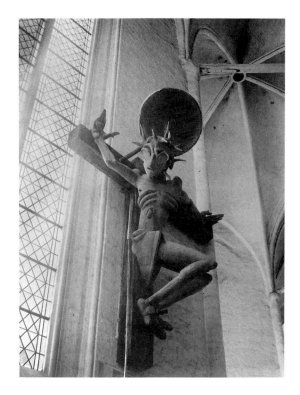

102 Ludwig Gies, *Crucifix*, 1921, wood, as displayed in Lübeck cathedral, 1921-2.

with the support of progressive canons of the St-Maurice abbey.[49] This 'scandal' followed widely heard admonitions. In June, Bishop Besson had warned artists and 'those who entrust them with the construction or decoration of holy places against certain eccentricities that bear too visibly the mark of the contemporary lack of balance', and reminded them that 'a church is a church, and not a garage or a cinema, nor a pattern-counter'.[50] In July, while opening the new rooms of the Pinacoteca Vaticana, Pius XI had officially taken a stand against the introduction of the new art in churches and condemned its use in their construction, transformation and decoration; at the same time, a greater freedom from Western visual traditions was granted to church art in the missions, in order to facilitate the propagation of faith and to 'uproot ... the prejudice that sees in the missionary an iconoclast, someone who destroys for the pleasure of destroying'.[51] In Europe, the hardening of the ecclesiastical hierarchy encouraged the enemies of 'modern religious art'. From 1933 on, for instance, a certain Charles Du Mont, a painter and polemicist converted to Catholicism, published a journal entitled *L'Observateur de Genève* to campaign against the production of the Groupe de Saint-Luc et Saint-Maurice. In a publication of 1944, he recapitulated his arguments by opposing reproductions (among which was a sculpture by Epstein) exemplifying what he termed 'the bantering conceit of deformist religious art' to others attesting

what he praised as 'a modern effort at recovery worthy of attention' (illus. 103, 104).

After the Second World War, the new 'sacred art' was immediately confronted with similar controversies. The most famous one was the so-called 'Querelle d'Assy', which concerned the whole church of Assy, and indeed the whole movement, but concentrated on the crucifix created by Germaine Richier.[52] After the journal *L'Art Sacré* had published a striking photograph of this pathetic sculpture, taken on a neutral background before its installation (illus. 105), a traditionalist group from Angers reproduced it in January 1951 on a pamphlet, contrasted with a Spanish 'venerated image of Christ' (illus. 106). It cited a 1949 condemnation of 'visual blasphemies' by Cardinal Celso Costantini, Secretary of the Congregation for the Propagation of Faith (and brother of Giovanni Costantini, President of the Central Pontifical Commission for Sacred Art in Italy), and stigmatized Assy as 'an insult to the majesty of God and a scandal for Christian piety'.[53] The polemic became a general 'quarrel of sacred art', and by April 1951 the same bishop of Annecy who had consecrated the church ordered Richier's Christ to be removed. On 30 June 1952 there appeared an *Instruction of the Holy Office on Sacred Art* that required a strict observance of the norms of canon law and prohibited both 'these representations recently introduced by some, which seem a deformation and depravation of healthy art', and the 'numerous statues and worthless images, generally stereotyped, exhibited without order or taste to the veneration of the faithful'.[54]

Doctrinal arguments were employed against the crucifix of Assy, in particular the idea that its emphasis on suffering made one forget either the divinity of Christ or his 'admirable humanity'.[55] But phrases like 'healthy art' make clear that such arguments implied the attribution of dogmatic authority to aesthetic norms and conventions. The authoritarian organization of the Church also accounts for the fact that even when they originated with laymen, condemnations of church art were pronounced and executed 'from above' and took the form of removals rather than destruction. Exceptions may be explained by special circumstances, like those of the beheading of Gies's crucifix, or by special dispositions, as when a 46-year-old woman subject to nervous breakdowns, who had worked in the fine arts department of the British Council, inscribed in 1963 her signature on Graham Sutherland's painting *The Risen Christ* in Chichester Cathedral and explained that the picture was obscene and filled her with loathing.[56] We are here nearer to the attack on Michelangelo's *Pietà*, and may conclude from the rarity of such acts that churches operate an even stricter selection among potential assailants than museums. The Rocamadour case, which took place out of doors, was an instrumental appropriation of disqualified art to criticize the Church as an institution.[57] As Etienne Fouilloux remarked, the term 'iconoclasm' cannot be

Les quatres Évangélistes
(Église St-Charles, Lucerne 1936)
Die vier Evangelisten.
(St. Karlskirche. Luzern)

Où en arrive la fantaisie persiflante de l'art religieux déformiste

Wohin die spöttelnde Phantasie der deformistischen religiösen Kunst gelangt.

Ste-Geneviève
(Tiré de la revue «Art, Vie et Cités», 2. 39.)
René Auberjonois, pinx.
Die hl. Genovefa.

St-Christophe P. Boesch, del.
(Extrait du «Portefeuille d'images religieuses», publié en 1934, par l'administration des postes fédérales).

Figure biblique Epstein, sc.
Eine biblische Figur.

103, 104 Double-page spread from Charles Du Mont, *Où en est notre Art religieux? Wie steht es mit unserer religiösen Kunst ?* (Geneva, 1944).

Un effort moderne de ressaisissement digne d'attention

Eine moderne Bestrebung des Wiederaufbaus, die der Beachtung würdig ist.

Mgr. Besson l'a dit dans sa causerie à la radio déjà citée : Faisons confiance à ces artistes, dignes et probes, qui cherchent patiemment une formule adéquate, répondant à notre besoin de quelque chose d'entraînant et d'équilibré à la fois, fatigués que nous sommes par tant de bluff ou de véhémences brutales et désordonnées.

In seiner Ansprache per Radio (10. Okt. 1940) sagte Mgr. Besson : Setzen wir unser Vertrauen in die würdigen und redlichen Künstler, welche geduldig eine adequate Formel suchen, die unserem Verlangen nach etwas Begeisterndem und Harmonischem entspricht, wir sind ermüdet von dem vielen Bluff und der brutalen Heftigkeit.

St-Marc
Der hl. Markus.
Louis Rivier, pinx.
(Fragment de la décoration du temple d'Auteuil)

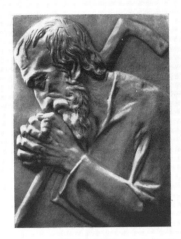

Nicolas de Flüe
(Éd., imp. St-Paul, Fribourg) A. Reindl, sc.
Bruder Klaus

Sainte - Barbe
Die hl. Barbara.
Leandro Ferraro, pinx. (Tiré de "Arte Cristiana")

— 47 —

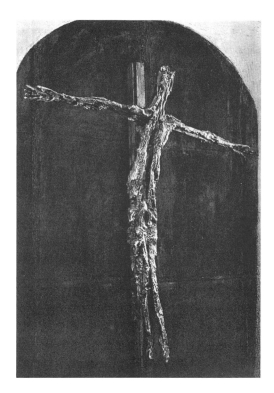

105 Germaine Richier, *The Christ of Assy*, bronze crucifix for the main altar of the church of Assy, 1950, photograph by Rogi reproduced in *L'Art Sacré* (September-October 1950).

used in its original sense in the contemporary religious context, since all men-tioned objections were directed against the manner of depiction and not its principle. Destruction of religious representations as such seems indeed to have become exotic, as witnessed by the most recent case that I know of. In 1995 on 12 October, the feast-day of Nossa Senhora Aparecida, Brazil's patron saint, a pastor of the Protestant sect called the Universal Church of the Reign of God appeared on television and beat with his fists and feet a statue of the black Virgin, shouting that it was but a piece of plaster and that God could not be compared to such an ugly and horrible puppet.[58] The use of modern media – a television network belonging to the sect – recalls the ambi-guities surrounding the 'archaism' of political destructions in Central and Eastern Europe, and calls for a closer questioning of this spectacle. But as far as the West is concerned, we shall see that the evolution of modern church art involved a large amount of aniconism, and that elimination tended to take the prudent and efficient form familiar to us from 'embellishing vandalism'.

Purifications

The religious values attached to churches did not prevent them from being transformed or replaced according to changes in liturgy, attendance and

taste. They only demanded that sufficient legitimization be provided, as when Abbot Suger justified – with Bernard de Clairvaux among other critics in mind – his having 'renewed from its very foundations' the venerable abbey church of St-Denis by relating the 'grave inconveniences' caused by its smallness and the miracles that, between 1122 and 1144, had allowed an epoch-making 'enlargement'.[59] During and after the French Revolution, however, the increasing destruction of Gothic church architecture and decoration was denounced in the context of the defence of heritage. Hugo, for instance, castigated a priest from Fécamp who had arranged for the fifteenth-century rood-screen of his church to be demolished because it prevented the parishioners from seeing him at the altar.[60] Montalembert generalized this criticism and envisaged the contribution of the clergy not only to 'destructive' and 'restorative vandalism', but to what he termed 'constructive vandalism' as well. He considered that since the Renaissance, a 'false, ridiculous, pagan taste' had introduced itself into ecclesiastical constructions and restorations, and defined as 'depredations' the interventions of itinerant painters from Italy in rural churches of the South of France; we have seen that he suggested that St-Andrew's cathedral in Bordeaux be purified by an 'archbishop of good taste'.[61] In his *Du vandalisme et du catholicisme dans l'art*, he visualized this opposition by contrasting two pairs of engravings after medieval or neo-medieval and classical or neo-classical works respectively: a drawing by a pupil of Overbeck showing the Virgin 'according to the regenerated art of the nineteenth century in Germany' against an eighteenth-century statue of the Virgin by Edme Bouchardon as example of the 'art claimed as religious in France since Louis XIV' (illus. 107); and the thirteenth-century Ste-Chapelle as 'Christian architecture' against the church of Notre-Dame de Lorette (by Hippolyte Lebas, 1823–36), which he derided as 'a kind of mouse-trap' in which 'all the profanations of modern art seem to have found an appointed place'.[62]

From then on, all movements of 'renewal' in part based the legitimacy of their proposals on the disqualification of earlier versions of church art, including the last attempt at renovation that, according to a logic typical of the reform process, appeared as an obstacle on the way to perfection. By the very nature of the works involved, which were tied to place and function, the success of each stage thus involved the removal, mutilation or destruction of realizations of the previous stage. In the course of the nineteenth century, the destruction of medieval works became rarer. In 1892 the Spanish painter Dario de Regoyos exhibited in Brussels a drawing entitled *Bois à brûler* (firewood), which depicted a Gothic wooden statue of Christ cut into pieces because it was 'too ugly for the parish, too long for the fireplace'; he explained that Spanish priests, who were often very ignorant, rejected the old images of saints and replaced them by 'modern banal' ones.[63] But the nineteenth-century historicist creations and restorations soon began to be rejected together

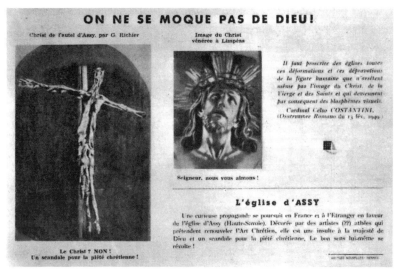

106 *One doesn't mock God!*, pamphlet issued in Angers, 1951, showing Richier's *Christ of Assy*, reproduced in *L'Art Sacré* (May-June 1952).

107 *The Holy Virgin According to the Regenerated Art of the Nineteenth Century in Germany* and *The Holy Virgin According to the Art Claimed as Religious in France since Louis XIV*, engravings by A. Boblet after a drawing by Eduard von Steinle and a lost statue by Edme Bouchardon, in Charles de Montalembert's *Du vandalisme et du catholicisme dans l'art* (Paris, 1839).

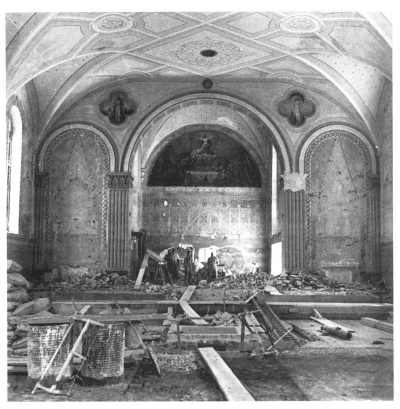

108 Parish church of Henau, St–Gallen, Switzerland, during the 1938 renovation, after the destruction of the altars and before the removal of the 1888 decoration.

with the industrial productions stigmatized as 'St-Sulpice'. They tended to be eliminated during the major part of the twentieth century, as until recently, restorations of church decorations generally obeyed the purist research of the 'original', most valued or most desired state (illus. 108).[64]

Maurice Denis was exceptionally conscious of his filiation to earlier nineteenth-century renewal movements, and explicitly stated in 1919 that 'by claiming room for modern art, I do not wish any destruction'.[65] But this respect and reserve were not shared by all and, except in new buildings, 'room' was needed anyhow. After the Second World War, nineteenth-century and early twentieth-century decorations immediately became the target of more direct, violent and systematic appeals to elimination. It could be exceptionally obtained through changes in the power of decision, as when a representative of the victorious French army in Germany had mural paintings by Jan Verkade whitewashed because the Frenchman found them ugly, but it normally depended on the clergy.[66] Pie-Raymond Régamey therefore launched in *L'Art Sacré* a pedagogical campaign that aimed at making priests and churchgoers

'conscious of the evil' represented in churches by the ugliness, obstruction, in-congruity and pretentiousness of many nineteenth- and twentieth-century realizations, and called for their 'purification' (*épuration*) – a word then em-ployed for the elimination of those who had collaborated with the Germans during the Occupation.[67] Images were essential to his strategy, and he used what he called 'the method of differences', a juxtaposition of good and bad ex-amples that had already been employed by Montalembert (illus. 106, 107), but had more recent antecedents in anti-modernist publications such as those by Schulze-Naumburg (illus. 18) and by Du Mont (illus. 103, 104).[68] His pur-pose was to educate the eye of his reader so that it perceived some images as 'offending', either by contrast (illus. 109) or by analogy (illus. 110). Some of his visual comparisons directly invited intervention by showing two states of a given church interior, one before and one after a 'purifying' renovation.[69] Moreover, he explicitly denounced as a continuation of 'St-Sulpice' the 'pseudo-modern' works of artists who had worked in churches between the Wars, such as Réal del Sarte, Sarrabezolles and Landowsky.[70]

Couturier consciously privileged the 'reformation of "taste" ' over the 're-formation of ideas' and considered that it necessitated a 'reformation of senses' and especially sight that could be obtained without mediation by the 'beauty of forms'.[71] In consequence, the issues of *L'Art Sacré* that he edited relied on uncommented images (reproductions of modern or ancient works and monuments, industrial and natural objects) in a way that primarily ad-dressed intuition and tended to make of them works of art in their own right.[72] But if he discarded Régamey's use of negative examples, the reactive side of his involvement was just as visceral. According to family memory, he was even found breaking 'St-Sulpician' statues in churches, an attitude recal-ling that of Maxime Claremoris, an Irish-born aesthete and art critic in a 1913 novel by Valéry Larbaud, whose 'cult of beauty' led him to attack 'national idols' such as effigies of Garibaldi and to 'suppress a little ugliness' by buying porcelain statues of saints, breaking them with a hammer and throwing the pieces down the lavatory.[73] Obviously, as in the case of Huysmans, champions of the new 'sacred art' felt personally assaulted by images that obstructed their identification with religion and the Church, in a way that may evoke – even though they did not question the legitimacy of religious representation as such – earlier 'iconoclastic' reformers. Régamey, for instance, wrote that 'the face presented by the Church to the world' was at stake, and that poor church art 'gave to the Church a horrible mask'.[74]

Some ten years later, the resolutions of the Second Vatican Council even-tually favoured the reformations called for by the Dominicans of *L'Art Sacré* and other modernizers of church art, at least as far as 'purification' was con-cerned. The *Constitution on Sacred Liturgy* adopted in 1963 maintained 'firmly the practice of proposing in churches images for the veneration of the

109 Visual comparison by Pie-Raymond Régamey between (*left*) a contemporary *Sainte Anne and the Virgin* mass-produced by Serraz and (*right*) a casting of a fifteenth-century French statue on the same theme sold by *L'Art Catholique* (*L'Art Sacré*, May-June 1951).

110 Visual comparison by Pie-Raymond Régamey between profane and religious mass-produced images (*L'Art Sacré*, January-February 1951).

faithful', but specified that they should be exhibited in 'limited number' and 'appropriately arranged'. It required from bishops that they remove from all sacred places works 'irreconcilable with faith and morals as well as with Christian piety, which offend truly religious sensibility either by the depravity of form or by the insufficiency, mediocrity or falsehood of their art', while prohibiting the alienation or destruction of 'sacred furniture and works of value'.[75] In May 1964 Paul VI proposed to 're-establish the friendship between the Church and the artists' and recognized that if the latter had offended the former by resorting to 'a language of Babel, of confusion', the former had offended the latter by imposing imitation on them and by resorting to 'fake, reproduction, and cheap art'.[76]

Opinions on the effects of the resolutions of the Second Vatican Council in the realm of church art have tended to vary together with opinions on the Council and the correlated transformations of the Catholic church, in a way reminiscent of the historiography of the French Revolution. Indeed, the authors of the augmented edition of Réau's *Histoire du vandalisme* consider that the 'disastrous application' of its prescriptions by part of the French clergy contributed to a 'wave of vandalism unprecedented since the Revolution'.[77] The more moderate conclusions of two case studies show that eliminations were restricted to works of the nineteenth century and the first half of the twentieth, while earlier elements were defended and became fossilized as 'heritage'.[78] Another commentator, visibly favourable to 'Vatican II', recognized that the modifications in the liturgy had necessarily affected buildings and furniture, and that the abandonment of churches for other meeting places had endangered their preservation, but felt that the liturgical reform and its praise of evangelical poverty had also been used as pretexts for a 'great cleansing' intended to express a 'break with the images that the Church had given of itself until then'.[79] In any case, the 'purification' of churches had begun long before the Council. It resulted from complex religious, social and aesthetic transformations prepared between the Wars, and probably found in the *Constitution on Sacred Liturgy* an official authorization rather than a decisive impulse.

As always, accusations of 'vandalism' and – given the religious context – 'iconoclasm' were used as weapons in this battle. However, one cannot be content with noting the official approbation of the use of religious images to reject totally the historical associations evoked by the latter term. One difference between the post-War renewal and previous ones was that it vehemently rejected – on religious and aesthetic grounds – the accumulation and heterogeneity that had tended until then to allow some degree of stylistic cohabitation. Moreover, the introduction of abstract art helped avoid the controversies provoked by 'unusual images', and the monopolistic claims of modern architecture tended to reduce decoration to non-objective stained glass that could satisfy Protes-

111 View of a cell in 1959 in Le Corbusier's Dominican friary of La Tourette (1950–55), Eveux-sur-l'Arbresle.

tant as well as Catholic churches and audiences. Nor were the references made by advocates of the new 'sacred art' to Protestant works and the striking resemblances between later realizations in both confessions merely a matter of form. In fact, this stage of the reformation of church art tacitly resumed the tradition of iconomachy and aniconism that had played a role in many episodes of religious reform. Aesthetics, morals and religion were inseparably involved in this phenomenon, as Marie Alamir-Paillard has shown apropos the rediscovery of Cistercian architecture after the Second World War.[80] Whereas all nineteenth-century revivalists had excluded from their admiration of St Bernard his condemnation of images, twentieth-century formalists began to praise the monuments of his order for their simplicity, bareness, functionalism and authenticity. These properties corresponded to the reductionist criteria of the architectural and pictural avant-garde of the 1920s then spread and imposed by the International Style. Le Corbusier, who was of Calvinist origin and had in 1925 made an apology for the aesthetic, hygienic and moral virtues of whitewashing, visited the Cistercian abbey of Le Thoronet in 1952, on the advice of Couturier, who had entrusted him with the commission of La Tourette (illus. 111).[81] Echoes of this visit can be found in the Dominican friary, and Le Corbusier outdid Couturier's request of a 'strict poverty' by declaring on the building site, in terms reminiscent of St Bernard's *Apologia ad Willelmum Abbatem Sancti Theodori*, that there would be 'no possible distraction by images'

and that 'every gift concerning stained glass, images and statues' should be refused.[82] In the case of the canvases painted by Mark Rothko from 1964 to 1967 for the Rothko Chapel in Houston, relations also exist between abstraction, spirituality, aniconism, and Couturier's involvement in the cause of modern art.[83]

In the course of the two last decades, the rejection of modernist purism has also affected the evaluation and treatment of church art. Nineteenth-century historicism became part of heritage, soon to be followed by 'modern religious art', so that the 'post-Vatican II rural priest' could appear – at least to a professional preservationist – as a 'vandal by nature'.[84] These rediscoveries, however, rather enforced than lifted the abstention from modernized representation, already perceptible in the recourse to photography for small images of devotion and to oriental icons for private and collective veneration.[85] In France, state commissions have favoured the introduction of 'contemporary art' in churches, for instance with Pierre Soulages's abstract stained glass in the Conques abbey (Aveyron).[86] The 1983 Code of Canon Law renounced the control of new works by the hierarchy, but the joint declarations of John-Paul II and of the Patriarch of Constantinople Dimitrios I on the occasion of the twelth centenary of the Council of Nicaea II attested in 1987 a renewed will to subordinate church art to faith as its 'necessary inspiration'. The Pope praised the 'rediscovery of the Christian icon' as a means to react against 'the depersonalizing and at times degrading effects of those multiple images that condition our lives in publicity and the media', and while the head of the Orthodox Church condemned the profane use of icons by worldly people 'who appreciate them only as works of art', he affirmed that 'art for art's sake which only refers to its author, without establishing a relation to the divine, has no place in the Christian conception of the icon'.[87] The tension between tradition and modernism, religious and aesthetic function is thus far from resolved, and the degree of artistic autonomy that liturgical use and ecclesiastical authority can admit of remains a central issue in this as in other domains.

13 Modern Art and Iconoclasm

Modernism and anti-traditionalism

According to dictionaries, the figurative use of 'iconoclast' as 'one who assails or attacks cherished beliefs or venerated institutions on the ground that they are erroneous or pernicious' appeared around the middle of the nineteenth century.[1] It has tended since to be replaced in English by 'radical', but has maintained itself in most other European languages, *Bilderstürmer* being the German equivalent.[2] The *Trésor de la langue française* specifies that the tradition opposed by an 'iconoclast' may be literary, artistic, political or of yet another kind, and quotes Henri Frédéric Amiel, who in 1866 sceptically referred to 'the vainglorious deliveries of our iconoclastic radicalism'.[3] Indeed, aesthetic 'iconoclasm' implied a radicalization of the idea of artistic progress, according to which tradition was not only insufficient to bring it forth but really stood in its way. Rebellious pupils of David, the *Barbus* whom George Levitine has situated 'at the dawn of Bohemianism', had already come to this conclusion in the first years of the nineteenth century, and their leader Maurice Quai declared that the Louvre had to be burned down because museums only served to corrupt taste.[4] 'Progress' connected artistic with political as well as scientific ideals, particularly in France, where the state continued to play a central role in the arts through all regimes. Therefore, the aesthetic radicalism of necessity had social connotations – the transfer on the cultural plane of the military concept of 'avant-garde' is generally dated to a 1845 pamphlet by the Fourierist Gabriel-Désiré Laverdan, and Klaus Herding noticed its presence in an acknowledgement of writers as precursors of the Revolution made in 1794 by Abbé Grégoire.[5]

It comes, then, as no surprise that by the 1850s and 1860s, Realists at war with the artistic and political establishment indulged in iconoclastic fantasies and were branded as iconoclasts. In 1856, the writer and art critic Louis Edmond Duranty concluded in his journal *Réalisme* from a visit to the Louvre: 'If I had had some matches, I would have set fire to that catacomb, with the intimate conviction that I was serving the art of the future.'[6] Although many innovative artists found in the Louvre aesthetic models rejected by the Academy and the Ecole des Beaux-Arts, others saw it – in Theodore Reff's terms – as 'a symbol of that absolute domination of the past which blinded

artists and public alike to the demands of the present', and Camille Pissarro reportedly declared that 'we must bring down the necropolises of art'.[7] On the other side, Thomas Couture painted in 1865 a caricature of *The Realist*, whom he showed sitting on the head of an Antique god while drawing that of a pig.[8] Courbet was accused of pursuing ugliness for ugliness's sake, and the subversive artistic efforts of his 'school' were explicitly denounced as equating a renewed form of 'revolutionary vandalism':

> Their rough hands lay waste to every flower,
> Insult every Grace,
> Sully every Virtue,
> Demolish every altar
> On which the sacred flame burns,
> Iconoclasts of Art.
> Their heavy clogs trample
> The mutilated statues of all the virgin goddesses,
> And in rags they dance the Carmagnole
> Around a Venus in the gutter
> That the hammer of a stonebreaker
> Has chipped into a curbstone.[9]

The use of 'iconoclast' rather than 'vandal', however, signalled the metaphorical character of the destruction. Indeed, when the radical Commune took over Paris in 1871, Courbet suggested that an elected assembly of artists 'might name the directors and curators of museums, suppress the Ecole de Rome and the Ecole des Beaux-Arts, and abolish all decorations and medals for artists', and proposed to *déboulonner* the Vendôme column (illus. 12), but he simultaneously did his best to protect all museum treasures from damage of every kind.[10] The architectural ruins left by the Communards were immediately admired as the work of unconscious artists by an Englishman, Sir William Erskine.[11] Those of the Palais d'Orsay, which had been built in 1810 and had housed the Conseil d'Etat and the Cour des Comptes, were still exposed to wind and weather fifteen years later, when they prompted Huysmans to another exercise in figurative iconoclasm. While the Press demanded that they be demolished and a Museum of Decorative Arts built instead, he declared that what had been a 'hideous barracks' looked now like an etching by Piranesi, and proposed embellishing Paris by burning down 'the Bourse, the Madeleine, the Ministère de la Guerre, the church of St-Xavier, the Opéra and the Odéon, the best of an infamous art', hoping that one would then realize that 'Fire is the essential artist of our time and that the architecture of the [nineteenth] century, so pitiful when it is raw, becomes imposing, almost splendid, when it is baked.'[12]

This provocatively disqualifying *projet d'embellissement* was typical of a writer and aesthete actively involved in the new 'dealer–critic system'.[13] By

that time, independent artists defined themselves and their works against both 'official' and 'commercial' art and artists by emphasizing their freedom from inherited norms and from pre-existing expectations. The competition to which they were submitted contributed to making innovation a central element of aesthetic value, thus encouraging the collective strategies of groups and '-isms' and inaugurating what would be termed a 'tradition of the new'.[14] The element of social distinction and of financial speculation inherent in the nascent market of modern art further enforced the tendency to see a proof of quality and value in the extent to which a work broke with extant criteria and was rejected by the public at large (in 1866, Zola had prophesied that the derided Manet would become admired just as Courbet had been before him, and that in ten years' time, his canvases would sell for 'fifteen and twenty times more', whereas 'some pictures at forty thousand francs would not be worth forty francs').[15] Originating in Romantic and *l'art pour l'art* conceptions, the idea of *l'artiste maudit* and the negative reference to the philistine taste of the *bourgeois* – a 'term of studio slang' meaning 'the unexercised man' for Théophile Gautier – thus became institutionalized with modernist avant-gardism.[16] Combined with increasing efforts at disseminating and 'democratizing' modern art, this logic resulted in what the conductors of a large-scale study commissioned by UNESCO's International Council of Museums described (somewhat simplistically) in 1969 as 'a generally stable gap of two generations or a minimum of half a century between important creative innovation and its general acceptance by the ordinary public'.[17] 'Postmodernism' doesn't seem to have fundamentally changed this, judging from the testimonies and observations gathered in the late 1980s and early 1990s by the French sociologist Raymonde Moulin. Asked about their criteria of choice, collectors of contemporary art insisted that they required from a work that it 'disturb', 'shock' and even 'assault' them, or that it 'displease most people'; a new fact concerning public art was that the towns and regions resorting to it for their competing 'images' were no longer arrested by the fear of hostile reactions from the local population.[18]

At the turn of the century, modernity was thus inevitably linked to 'iconoclasm'. The writer Marcel Schwob explained in 1894 that 'to imagine a new art, one must break the ancient art. And so the new art appears as a kind of iconoclasticism.'[19] There are many tokens that innovative works could indeed be experienced as aggressive, and elicit aggression in return. A major case in point is Ruskin's response to Whistler's canvases, especially *Nocturne in Black and Gold: The Falling Rocket*, exhibited in 1877 at the new Grosvenor Gallery in London. In one of a series of published letters entitled *Fors Clavigera*, Ruskin condemned the admittance of works 'in which the ill-educated conceit of the artist so nearly approached the aspect of wilful imposture' and declared that he had 'seen, and heard, much of Cockney impudence before

112 Henry Gray, detail from a poster for the 1883 third *Exposition des Arts incohérents*.

now; but never expected to hear a coxcomb ask two hundred guineas for fling-ing a pot of paint in the public's face'.[20] The reasons for this unmeasured outburst, which prompted Whistler to sue him for libel (and obtain a ruinous victory), are complex and exemplary. As summed up by Linda Merrill, they may have comprised a personal dislike of the painter, a moral criticism of the relation between labour and wealth, an idiosyncratic sensitivity due to Rus-kin's pathological belief that the natural world was darkening, a notion of Whistler's nocturnes as travesties of Turner's paintings – which the critic had passionately defended – and, above all, a perception of them as 'ill-con-ceived, poorly crafted, overpriced parodies of paintings' because they exhibited 'neither noble subject matter nor truthful beauty, neither sincerity nor invention'.[21]

Thematizations of this iconoclastic dimension probably began with the long-forgotten because not seriously-minded group of the 'Incohérents', active in Paris between 1882 and 1896.[22] On the poster of their third exhibition in 1883, one could see at the feet of the muse of 'incoherent art' (with a fool's cap) a diminutive man thrusting his foot into a canvas, and busts being pushed away with a broom (illus. 112); among the works reproduced in the catalogue of the 1886 exhibition was a figurative assault on a canonical masterpiece en-titled *The Husband of the Venus of Milo*, showing the statue with a bearded face.[23]

More memorable and infinitely more serious were the radical appeals to reject the past in the name of an art and a world to come made before the

First World War by the Italian Futurists and after the Soviet Revolution by the Russian Constructivists, Productivists and Suprematists. In 1909, Marinetti's first manifesto of Futurism affirmed that 'a racing car ... is more beautiful than the *Victory of Samothrace*', and proposed to free Italy from its 'cancer of professors, archaeologists, tourist guides and antiquaries' by demolishing museums and libraries; he logically foresaw that ten years later, younger creators would rise to attack him and his fellow Futurists, but predicted that they would find them burning their own books and would have to kill them, 'for art can only be violence, cruelty and injustice'.[24] In 1913 Prampolini specified the target and modernized the weapons by appeals to bomb the academies – after which he was expelled from the Roman Accademia di Belle Arti – and Boccioni manifested a revealing ambivalence by declaring publicly that Beethoven, Michelangelo and Dante disgusted him, while asking himself privately how he could 'hope to be something before such giants' as Leonardo, Michelangelo and Bramante.[25] This inferiority complex, reminiscent of Fuseli's despair over the greatness of Antique ruins (illus. 87), certainly had a specifically Italian component, but the relation between a relatively late industrialization on the one hand, vehement and optimistic appeals to modernization on the other, also existed in the new Soviet Russia. Kasimir Malevich, for instance, wrote in 1919 that an aircraft pilot did not need 'Rubens or the pyramid of Cheops, the lascivious Venus, on the summits of our new knowledge', and that the only concession to be made to preservationists was 'to let all periods burn, as one dead body', and put the resulting powder on one medicine shelf.[26] Like the calls for cultural elimination by Duranty, Pissarro, Huysmans, Marinetti and Prampolini, however, this one remained metaphorical iconoclasm, as did the positive answers made to the inquiry organized *c.* 1920 by the editors of *L'Esprit Nouveau* (among whom was Le Corbusier) on the question of whether one ought to burn down the Louvre, even if several of them were – directly or indirectly, on the side of perpetrators or of victims – associated with real destructions.[27]

Reciprocal Readymades

With the ideal of the blank canvas was associated a notion of the 'end' or of the 'death' of art. With Dada, the rejection of past art was radicalized into an overall condemnation of art as part of the values and civilization that the First World War revealed to be false and destructive, thus requiring above all desecration and 'iconoclasm'. Although he rarely participated in Dadaist collective endeavours, Marcel Duchamp became the most influential representative of this tendency and an unsurpassed master of 'anti-art' as art. According to the point of view, he could thus be praised as the main 'father' of contemporary art, or denounced as a 'grave-digger' by those who deplored its 'confusion'

and paraphrased with a 'c'est la faute à Duchamp' the attribution to Rousseau and Voltaire of the disasters of the Revolution.[28] In 1915 he gave several interviews to American newspapers and magazines that broadly publicized his 'iconoclastic opinions'. To *Arts and Decoration* he praised the harmonious growth of New York City, which he deemed 'a complete work of art', and declared: 'And I believe that your idea of demolishing old buildings, old souvenirs, is fine. It is in line with that so much misunderstood manifesto issued by the Italian Futurists which demanded, in symbol only however, though it was taken literally, the destruction of the museums and libraries. The dead should not be permitted to be so much stronger than the living. We must learn to forget the past, to live our own lives in our own times.'[29]

At the end of his life Duchamp manifested a will to expose art as such. To Otto Hahn in 1964, he explained that his Readymades had aimed at drawing 'the attention of people to the fact that art is a mirage', even if a 'solid' one, and concluded from the vagaries of taste that art history was to be doubted: 'The critics talk about the "truth of art" as one says "the truth of religion". People follow like sheep. I reject that, it does not exist. These are invented veils. It does not exist any more than in religion. Moreover, I do not believe in anything, because believing gives rise to a mirage.'[30] Twelve years earlier, the problems of value and recognition had also prompted him to connect art with religion, when answering a question by his brother-in-law, the painter Jean Crotti, about his opinion of the latter's work: 'It's a lengthy thing to say in just a few words – and especially from me who has no faith at all – of the religious sort – in artistic activity as a social value.' This specification may help us to understand Duchamp's enduring refusal to exhibit, for he had replied in 1921 to a request to participate in the Paris Salon Dada transmitted by his sister Suzanne and by Crotti: 'You know very well that I have nothing to show – and that to me the word show sounds like the word marriage.'[31]

When the Neo-Dadaist George Maciunas delineated in 1973 a genealogical tree of Fluxus and other avant-gardist movements, he included 'Byzantine Iconoclasm' among the roots.[32] Art historians have also drawn relations between twentieth-century radical artistic developments and elements from the intellectual history of iconoclasm and iconomachy. Horst Bredekamp saw a filiation between the fifteenth-century artists who threw their own works into Savonarola's pyres and 'anti-art', while Werner Hofmann compared the Reformers' criticism of relics with the 'art of artlessness' *(Kunst der Kunstlosigkeit)* and especially Duchamp's 'nominalist' Readymades.[33] Hofmann likewise remarked, however, that 'this playful way of considering our commonplace repertory won back to materiality the fascination that it had lost when the worship of relics had been put on trial'. This ambiguity of the Readymade made Octavio Paz define it as 'a two-edged weapon: if it is trans-

formed into a work of art, it spoils the gesture by desecrating it; if it preserves its neutrality, it converts the gesture into a work'.[34]

'Iconoclasm' does not by far tell the whole story about Readymades, but it is nevertheless an essential aspect of them, which Duchamp emphasized on many occasions. One was the celebrated *L.H.O.O.Q.* (illus. 113) he realized in 1919 when he was in close contact with the Dada group in Paris; he would define it in 1964 as 'a combination Readymade and iconoclastic Dadaism'. In our context, it deserves to be brought together with the *Husband of the Venus of Milo* of 1886, as well as with one of the postcards on which around 1941–2 Willy Baumeister, then branded a 'degenerate artist' and prohibited from exhibiting, mocked the official art of Nazi Germany (illus. 114).[35] In the same way, the anonymous defender of Duchamp's *Fountain* – the urinal submitted in 1917 for exhibition under the pseudonym 'R. Mutt' (illus. 57) and rejected by the Society of Independent Artists – who replied to the accusation of its being 'plagiarism, a plain piece of plumbing' that 'the only works of art America has given are her plumbing and her bridges', stood in a line with Marinetti's and Malevich's Futurist comparisons between modern machines and Antique sculpture on one side, with Richard Serra's choice of Cor-Ten steel on the other.[36] But the most explicit statement about the 'iconoclasm' of all Readymades is one of the notes written between 1911 and 1915 included by Duchamp in his 'Green Box' of 1934: 'RECIPROCAL READYMADE / Use a Rembrandt as an ironing-board'.[37] Four years later, he appended this definition to that of the Readymade ('Everyday commodity promoted to the dignity of a work of art by the mere choice of the artist') in the *Dictionnaire abrégé du surréalisme*, a section of the catalogue of the Paris 'Exposition Internationale du Surréalisme'; and in 1961, in a talk delivered at the conference organized by the Museum of Modern Art in New York for the exhibition 'The Art of Assemblage', he mentioned it as resulting from a desire 'to expose the basic antinomy between art and readymades'.[38] Again, this imagined degradation of a work of art to the indignity of everyday commodity, implying the replacement of symbolic enjoyment at a distance by practical use, physical contact and material wear and tear, finds revealing parallels in fantasies of metaphorical and literal iconoclasm. We have seen that in the 1860s, a rhyming enemy of the Realists had depicted them dancing around a Venus 'chipped into a curbstone'. In 1920, the art critic and dealer Félix Fénéon, who might have known of the 'Richard Mutt case' through Guillaume Apollinaire, affirmed in a discussion with the Russian collector Ivan Morosov that the Soviet People's Commissar to Public Education and Fine Arts, Lunacharski, had 'not prevented in Petrograd muzhiks from cutting themselves boots out of the Rembrandts of the Hermitage'– to which Morosov, who had become assistant curator of his own nationalized collection, replied that muzhiks were 'not so impractical' and that nothing of the sort had happened . . .[39]

113 Marcel Duchamp, *Replica of L.H.O.O.Q.*, 1919, from the *Boîte-en-Valise*, 1941-2.
Philadephia Museum of Art.

114 Willi Baumeister, *Simultaneous Picture 'Man With Pointed Beard'*, c.1941, pencil, gouache
and watercolour on postcard of Adolf Ziegler's *Terpsichore*. Archiv Baumeister, Stuttgart.
Ziegler, as President of the Reichskammer der Bildenden Künste, *had organized the 1937*
Entartete Kunst *exhibition, in which some of Baumeister's works were vilified, and his* Terpsichore
had been shown in the simultaneous 'Große Deutsche Kunstausstellung'.

Characteristically, the paradigm of the 'reciprocal Readymade' found a free
interpreter in Daniel Spoerri, a 43-year-old younger member of the Nouveaux
Réalistes and occasional collaborator of Fluxus who would contribute in 1973
to a 'collective portrait' of Duchamp by hailing him as his 'grand Father'.[40]
Spoerri's *Use a Rembrandt as an Ironing Board (Marcel Duchamp)* of 1964
(illus. 115) was in reality a combination of *L.H.O.O.Q.* and the note from the
'Green Box', since the 'Rembrandt' was a reproduction of Leonardo's *Mona
Lisa* (the *Gioconda*) on cloth.[41] It was meant to protrude horizontally from the
wall, like all 'trap-pictures' by its author. In a sense, this position made it
reciprocal to Duchamp's *Trébuchet* (trap) of 1917, a coat-hanger that had

115 Daniel Spoerri, *Use a Rembrandt as an Ironing Board (Marcel Duchamp)*, 1964, assemblage. Arturo Schwarz Collection, Milan.

been left lying on the floor of the artist's New York studio (illus. 132) to play the role of a 'scandal' in the etymological sense of stumbling-block. Instead of putting it out of the way, like so many 'offending' objects whose fates we have been studying, Duchamp had done exactly the reverse, as he explained in 1953 to Harriet Janis: 'I got crazy about it and I said the Hell with it, if it wants to stay there and bore me, I'll nail it down...'.[42] But the idea of 'reciprocal Readymade' also had a broader and less literal offspring with two distinct

phenomena: the aesthetic utilization of extant works of art, and the abuse of modern works – in particular Readymades – supposedly not recognized as such.

The destruction of art as art

The author of a report on the 1993 Ostende conference on 'vandalism in modern art' mentioned among specific factors the fact that 'modern artists destroy their works themselves . . ., brutally paint them over . . ., or make use of deterioration from the start as artistic means'.[43] Indeed, the essential link that modern psychologists have tended to establish between destructiveness and creativity has gained in modern art an unprecedented visibility and importance, in direct relation to its 'iconoclasm'.[44] In the 1930s Picasso emphasized this dramatic change to Christian Zervos on the level of the *modus operandum*: 'Previously, pictures advanced to their end by progression. Each day brought something new. A picture was a sum of additions. With me, a picture is a sum of destructions.'[45] Carel Blotkamp has recently shown that destruction was even more central to Mondrian's evolution and conception of art. To him, 'the destruction of old forms was the condition for the creation of new, higher forms', and he applied it first to representation, by discarding 'the incidental, outward image of reality', then to the means of expression themselves, by removing the vestiges of spatiality, destroying the colour planes as form, and eventually breaking up the lines altogether. Mondrian regarded this process as a model for transcending 'the limitations of matter and the closed forms imposed by conventions and institutions' that was taking place 'in the arts, in society and in life itself', and in a letter written at the end of his life, he expressed his conviction that 'the destructive element is too much neglected in art'.[46]

Mondrian had turned away from the Calvinist faith of his parents towards Theosophy around 1900, but his upbringing in an aniconic tradition (as far as religion is concerned) may have played a role in his artistic evolution.[47] Several proposals to relate more generally the development of abstraction to a Protestant or Jewish background have been made.[48] A particular case in point, Barnett Newman, declared that 'like God, the artist must start from chaos, from emptiness: with the white colour, without forms, textures nor details', thus reminding us, according to Thierry de Duve, that 'the appeal of the blank canvas had been haunted from the start by the apocalyptic perspective of the end of painting'.[49] But it was the more or less utopian component of social and political criticism that took the lead in the Neo-Dadaist experiments in self-destruction that multiplied in the 1960s and 1970s.

In September 1966 an international 'Destruction in Art Symposium' (DIAS) took place in London, principally organized by the German-born

Gustav Metzger, who was experimenting a form of Action-painting that involved applying acid with brushes to nylon sheets laid on glass, and had written in 1959 a manifesto entitled *Auto-Destructive Art*. Metzger conceived this art as 'a desperate, last minute subversive political weapon . . . an attack on the capitalist system . . . committed to nuclear disarmament [. . . and] an attack also on art dealers and collectors who manipulate modern art for profit'.[50] The Destruction in Art Symposium intended to 'isolate the element of destruction in new art forms, and to discover any links with destruction in society'; Metzger insisted that 'destruction *in* art did not mean the destruction *of* art'.[51] Among the participants were Ivor Davies, Kenneth Kemble (an Argentinian artist who had organized in 1961 an exhibition entitled 'Arte Destructivo' at the Galeria Lirolay in Buenos Aires), John Latham, Hermann Nitsch, Yoko Ono, Ralph Ortiz, Werner Schreib, and the future author of *2 Concrete Cadillacs in the Form of the Naked Maja*, Wolf Vostell (illus. 63).[52] Ivor Davies, who liked to work with explosives, mentioned the three kinds of obsolescence defined by Vance Packard in *Waste Makers* (functional, psychological, and planned obsolescence) and declared: 'I believe these techniques have been used in art since the war. Functional obsolescence occurs when a new aesthetic supersedes . . . Since 1945, a series of short-lived movements have replaced one another. All date quickly – have become psychologically obsolete. The physical break-down is clearly seen in the use of impermanent material. Auto-destructive art represents all three kinds of obsolescence.'[53] The Viennese Actionists were then showing their work for the first time to a large public, and after the presentation of Hermann Nitsch's 21st action of his Orgies Mystery Theatre on the night of 16 September 1966, the police charged the organizers of DIAS with presenting an 'indecent exhibition contrary to the common law'. Metzger was eventually fined £100 the following year.[54]

A telling token of both the affinities and the distance between avant-gardist radicalism and real attacks on recognized masterpieces was given in 1972 when László Toth committed his assault on Michelangelo's *Pietà* (illus. 85). Whereas the 64-year-old Italian sculptor Giacomo Manzù, who had dedicated to John XXIII his *Gate of Death* for St Peter's in 1964, called for the death penalty for Toth, young artists in residence at the Swiss Institute in Rome sent to the directors of the Venice Biennale a telegram proposing that it present Toth its award. Their gesture was predictably perceived as 'iconoclastic', even more so than they had intended: the Swiss cultural administration required that the telegram, which had been reproduced in the catalogue of the yearly exhibition of the Institute, be cut away from each copy of it – a *damnatio memoriæ* more rigorous than the one imposed on Herostratos, since 23 years later no trace of the litigious document was to be found.[55] The entrenched illegitimacy of the destruction of art excluded that actual attacks on great works be acknowledged as valid artistic interventions, for instance in the case of Tony

Shafrazi's 'Guernica action' of 1974.[56] In consequence, avant-gardist 'icono-clastic' manifestations either remained on a metaphorical plane, or abused objects considered to be of little intrinsic aesthetic value, or secured themselves the agreement and sometimes the collaboration of the authors of the works concerned.

To stay with *Guernica*, the Spanish painter Antonio Saura published in 1981 a 'pamphlet' consisting of a litany of declarations of hate for the picture, alluding among other things to the exceptional security measures bestowed on it in Madrid, to various cases and methods of real museum 'vandalism', and to Duchamp's indirect iconoclasm: 'I despise *Guernica* in its glass nightwatch . . . I hate the glass that prevents my knife from opening vaginas in the damned canvas . . . I hate the Gioconda moustache of *Guernica* . . .'.[57] One may note in passing that the numerous works with holes or slits realized by Lucio Fon-tana, in particular his *Tagli* (incisions) of the 1950s, necessarily evoked acts of violence to canvases – and vice versa thereafter, as in the case of the 1986 spec-tacular 'ripping' of Barnett Newman's *Who's Afraid of Red, Yellow and Blue III* in Amsterdam (illus. 91).[58] The destruction of objects became a frequent ingredient of 'Happenings' and works of art in the 1960s, especially within movements and groups such as Fluxus and Nouveau Réalisme. Outstanding examples are Nam June Paik's *One for Violin* executed in 1964 by George Maciunas, which included breaking the violin, and the *Coupes* (cuts), *Colères* (rages) and *Combustions* performed from 1961 on by Arman. Among the countless commodities broken, cut, sliced, burned and compressed by or for the latter were some objects associated with high culture, notably musical in-struments, but none were works of art in their own right, and Arman occasionally insisted that he did not destroy valuable ones. Typical of this choice of aesthetically unqualified or disqualified material was his happening entitled *Conscious Vandalism*, which took place in 1975 at the Gibson Gallery in New York and consisted of the destruction by the artist, with a club and an axe, of a 'lower middle class interior'.[59] One is tempted to conclude from the selection of this sociological specification that the criticism of the 'consumer society' associated with Arman's eliminations rested on a firm ideological con-sensus within the public he addressed, and that the reproduction of Dalí's crucifixion scene entitled *Corpus Hypercubus* (New York, Metropolitan Museum of Art), which figured above the matrimonial bed and received a direct blow (illus. 116), was considered by him to be a modern 'St-Sulpice'. As for the title of the performance, it made an unquestioned use of the notion of 'vandalism' as 'unconscious', and cautiously emphasized the difference be-tween this stigmatized behaviour and the cultural status that it claimed for itself.

In the 1950s and 1960s, European artists like Raymond Hains and Mimmo Rotella tore down commercial and political posters, or had them torn down.

116 Arman (Armand Fernandez), *Conscious Vandalism*, 1975, 'happening' at the John Gibson Gallery, New York.

They not only discovered the aesthetic potentialities of street palimpsests but, as Werner Hofmann commented, attacked the 'idol of the material satisfaction of desire', an object that was at once valueless – it would be torn down to be replaced anyway – and powerful: it could be attacked by people who found it provocative. Their works proved to be 'negations of negations', for the destroyed image changed into 'an anti-image, the themes of which were determined by the wanton destruction'.[60] In 1953 Robert Rauschenberg took a very different step by asking the (21-years-older) Willem de Kooning, whom he regarded as 'the most important artist of his time', to let him erase one of his drawings. He explained in 1976 that he had been trying both to 'purge' himself of teaching and to exercise the possibility of 'doing a monochrome non-image', and still later that he was 'trying to make art and so therefore . . . had to erase art'.[61] By this date, Rauschenberg had already begun his 'White Paintings'; he considered that they would have to be remade when the paint had yellowed, but not necessarily by him, and wrote in 1951: 'It is completely irrelevant that I am making them – today is their creator'.[62] In 1953, after the closure of an exhibition of 'contemplative boxes and personal fetishes' in the Galleria d'Arte Contemporanea in Florence, he had followed the (malevolent?) advice of a local critic and thrown the small objects in the Arno. In order to use the eraser 'as a drawing tool', however, he renounced resorting to one of his own drawings because the erased work 'would return to nothing', and decided that he needed a drawing already recognized as art. De Kooning gave him a drawing 'important enough for him to miss, and one that was difficult to erase'. Rauschenberg in effect needed four weeks of hard work to remove all but a few traces. He hand-lettered the title *Erased de Kooning Drawing, 1953* on a passe-partout, added his name and the date, and placed the sheet in a gold-leaf frame bought for the purpose (illus. 117). The destroyed work thus survived not only in minor original markings that had been absorbed by the paper, but in the title of the new work, which made it adhere to its negative genesis. The insistance on the dating and the museum-like labelling and framing further turned it into a monument to the appropriation and outdoing of a stage of art – not of a despised and obsolete stage, though, but of a respected and still powerful one.

Around the same time, the Austrian Arnulf Rainer began to paint over extant pictures by himself or by other artists, a method that would remain central to his work thereafter. Duchamp had already imagined he himself might 'buy or take known / unknown paintings / and sign them with the name of a known or unknown painter', in order to make an inimitable 'authentic work' of the '*difference* between the "style" and / the unexpected name for the / "experts" '. On one occasion at least, in 1916, he had actually signed 'a huge old fashioned painting' at the Café des Artistes in New York.[63] But this was an essentially conceptual, disinterested and impersonal 'appropriation', which

117 Robert Rauschenberg, *Erased de Kooning Drawing, 1953*, traces of ink and crayon on paper. Collection of the artist.

proposed another way of creating art without almost any intervention of the hand, and thus did not imply that the picture would disappear. With Rainer, on the contrary, the hand was very much present, and the aesthetic interaction between the work employed and its *Übermalung* (overpainting) rather recalled the unconscious destruction of a masterpiece by its deranged author evoked in Balzac's *Le chef-d'œuvre inconnu* of 1831. In 1961 Rainer was arrested because he had painted over a prized print in Wolfsburg made by the young graphic artist Helga Pape. The author of the print, however, later sold it at a good price to the town's Städtische Galerie as a work by the Austrian.[64] Ambiguities of this material and valorizing appropriation became farcically apparent when, in 1994, Rainer's manager discovered that 25 of his pictures and photographs had been anonymously painted over in black in his studio at the Vienna Academy of Fine Arts. The '*übermalter Übermaler*', as one commentator wrote, mentioned a number of possible suspects, among them students, renowned artists, and the rector of the Academy of Applied Arts, but the police came to the conclusion that Rainer and his manager might have organized and staged the whole thing themselves in order to stimulate a stagnant market, while the local Press accused Right-wingers of trying to defame contemporary art.[65] In the autumn of 1995, however, several professors of the Academy received a

very long and intricate confession whose anonymous author boasted of this 'secret iconoclastic shock actionism' and explained it as a form of criticism of the contemporary 'non-art', meant to expose the contradictions and imposture of an 'art cabaret' situated 'at the vermiform appendix of art history'. According to Rainer, who decided to retire from the Academy, the author of the deed and of the pamphlet taught the history of art at the same institution.

The destruction of objects of little value or of those obtained from their authors was further practised by younger artists in the 1970s and 1980s. For example, under the general title of 'Campagne prophylactique', Hervé Fischer presented the remains of works lent to him between 1971 and 1974 in plastic bags carrying the inscription 'Hygiène de l'art / La déchirure' (hygiene of art / the rent) and his name; Christian Jaccard, to give another example, burned anonymous paintings of the nineteenth and twentieth centuries that he called 'abductions' and 'restitutions'.[66] François Morellet had participated in the early 1960s in the denunciation, by the 'Groupe de Recherche d'Art Visuel', of the 'myths' and values on which were based the relations between artists and society, works of art and spectators, and encouraged the last-named to make the true 'revolution in art' by following the instructions 'No not participating / No not touching / No not breaking.'[67] In 1971 he inaugurated 'architectural disintegrations', which consisted of 'opposing the rhythms and materials of [his] intervention to the rhythms and materials of a building', in a 'true combat whose winner is not the best of the two, but the fight itself'.[68] Ten years later, he defined these confrontations of extant, formally complex works with an 'all-over' grid as 'iconoclastic geometry' and the 'absurd encounter of two logical systems'.[69] The intervention planned for Bordeaux Cathedral – which would have looked, in accordance with its patron saint, like a giant St Andrew's Cross – was rejected by the clergy, but Morellet tended to work on the invitation of curators and willy-nilly contributed to the animation and popularization of museums and collections. From 1972 he extended his patterns over paintings and sculptures, submitting ancient works to an apparently regardless geometry that was in fact related to their composition and iconography and became reciprocally 'destroyed' by them as soon as one departed from a frontal point of view (illus. 118). The grid was created by means of adhesive tape, stuck onto protective glass in the case of paintings, and Morellet remarked that 'in a work made to last one day, one month at the most, a certain amount of aggressiveness is possible'.[70] He once applied the tape directly to a canvas by the (23-years younger) Bertrand Lavier, who had covered up one of his works with paint and a stroke 'à la Van Gogh'. In the 1980s, Lavier proposed another restatement of Duchamp's Readymade by exhibiting pairs of industrially produced objects, such as a refrigerator and a safe, one on top of the other, thus evoking the relation between statue and pedestal. In one case at least,

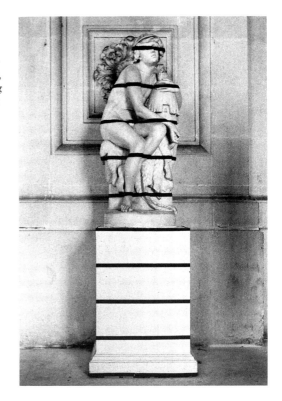

118 François Morellet, *Parallèles o°*, 1973, adhesive tape on marble statue (J. M. Caillé's 1866 *Aristaeus Weeping over the Death of his Bees*), temporary installation during Morellet's 1973 exhibition at the Musée des Beaux-Arts, Nantes.

his *Peinture moderne* of 1984, one of the artefacts employed was a sculpture; it was painted over in black and placed on a pedestal painted in white, both with the same broad visible stroke.[71] The result seems to be an academic exercise in the paradoxes of Readymades and reciprocal Readymades. According to the status that it may have possessed prior to its incorporation in Lavier's work, the anonymous abstract sculpture can be considered as having been degraded to the rank of raw material, or promoted to the one of an acknowledged work of art. More arguments speak in favour of the first interpretation, especially the coat of paint that transformed its visual qualities and the title that made the whole a 'painting' and not a sculpture.

Kirk Varnedoe has proposed seeing a symbol of the innovation essential to modern art in the 'fine disregard for the rules of football' – as expressed on the stone commemorating the exploit at Rugby College of William Webb Ellis, when, in 1823, he 'first took the ball in his arms and ran with it, thus originating the distinctive feature of the rugby game'.[72] The 'iconoclastic' impulse that we have examined indeed made of this disregard a necessity and eventually a rule. One of the most fundamental norms traditionally applying to works of art was duration, or rather the capacity to obtain a material longevity that both expressed and served the values ('purely' aesthetic or otherwise) associated

with it. This claim tended to determine to a large extent the artists' choice of materials, their handling and combination, as well as the way finished works were treated by their owners and, in the case of public property, by the professionals mandated to take care of them. Particularly since the beginning of the twentieth century, a number of artists transgressed this implicit 'rule' in so many ways that only cases in which this rejection of duration took the extreme form of outright self-destruction will be mentioned here. It must be noted in passing, however, that in a way unexpectedly paralleled by the recent pulling down of monuments in Europe's former Communist states, the development of techniques of recording and transmission has contributed to this evolution by enabling an event or an ephemeral object to gain a multiple existence and to recover duration indirectly.[73] As for the contradictions faced by conservationists when confronted with objects devised to disappear, they cannot simply be considered as resulting from the inadaptability of conservative institutions, or from their will to absorb and thus eliminate contestation, since the very fragility of contemporary art has made it even more dependent on museums for its production and reception.

The destruction by a modern artist of his or her own work need of course not always have corresponded to 'iconoclastic' intentions, but we may leave aside here such cases where it resulted, for example, from negative judgements passed by the author or by other critics. As with most transgressions, Duchamp had already given a model of artistic auto-destruction. While in Buenos Aires in 1919, he had sent his present to the newly-wed Suzanne and Jean Crotti in the form of written instructions for the execution of an *Unhappy Readymade*, consisting of 'a geometry book, which [Crotti] had to hang by strings on the balcony of his apartment in the Rue La Condamine; the wind had to go through the book, choose its own problems, turn and tear out the pages'. While the original – though executed by proxy – Readymade was destroyed by wind and weather in accordance with the will of its creator, its appearance was preserved and commemorated by a photograph (illus. 119) and a painting based on it by Suzanne Duchamp, dated 1920 and entitled *Le Ready-made malheureux de Marcel*.[74] Auto-destructive works and happenings multiplied in the late 1950s and early 1960s, at a time when Duchamp's work was rediscovered by a younger generation of artists who could find in this 'grand-father' an ally against the dominating middle-aged heroes of abstraction. Pontus Hultén has borne witness to Jean Tinguely's gratitude towards Dada, and especially to Duchamp:

He relates that he was obsessed by the idea of throwing a grenade at the Gioconda. He had even drawn up a detailed plan of the assault. The virtual punishment – confinement and condemnation to an almost absolute inertia – made him hesitate. He then noticed that Marcel Duchamp had already carried out this assault by dressing up the Gioconda with a moustache and a goatee – a more witty gesture than the one he

119 Photograph (possibly by
Suzanne Duchamp and Jean
Crotti) of Marcel Duchamp's 1919
Unhappy Readymade.
Philadelphia Museum of Art.

planned. The assault having become pointless, Tinguely could dedicate himself to more useful tasks.[75]

'Spirituel' means both spiritual and witty, two senses that well indicate the distance instituted between the metaphorical plane on which Duchamp had situated his 'iconoclasm' and the literal one momentarily envisaged by Tinguely, as well as the reasons for the superiority that he recognized. Among the 'more useful tasks' was the construction of machines that, around 1960, led to kinetic stagings of the destruction and auto-destruction of art. The *Machine for Breaking Sculpture* (illus. 120), which has since disappeared, was a somewhat illustrative example of the former. *Homage to New York*, his first auto-destructive 'machine-happening', executed on 17 March 1960 in the garden of the Museum of Modern Art (illus. 121), significantly became more famous, and – because of photographic documents, recollections, mentions and comments – kept its place in the collective art-historical memory.[76] Duchamp had composed for the invitation card a poem in French that punned on Tinguely's nationality and made of artistic self-destruction a metaphor of suicide: 'Si la scie scie la scie / Et si la scie qui scie la scie / Est la scie que scie la scie / Il y a Suissscide métallique' (If the saw saws the saw/ And if the saw sawing the saw / Is the saw sawed by the saw / What results is a metallic Swiss-icide).[77]

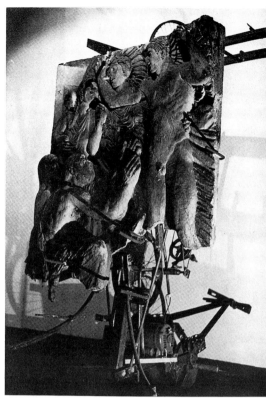

120 Jean Tinguely, *Machine for Breaking Sculpture*, 1960 (original destroyed).

121 Jean Tinguely, *Homage to New York*, event in the garden of the Museum of Modern Art, New York, 17 March 1960.

The transformation of destruction into creation was so successful that when, at a critical moment of *Homage to New York*, the Museum's fireman intervened at the request of the artist (illus. 121), spectators tried to prevent him from doing what they obviously considered was an iconoclastic or vandalistic act.

The systematic promotion of auto-destructive art by the DIAS movement has already been mentioned. William Turnbull devised 'vandalizable sculpture', and we have encountered a later – and hardly convincing – example of the appeal to public aggression with Roland Lüchinger's *Action Sculpture* of 1980 (illus. 80).[78] Actionism and Body Art also tended to imply suggested or actual violence against persons and even risks to human life, as with the 'edge pieces' performed in the 1970s by the American Chris Burden, who defined them as 'going right to the edge of disaster'. One of these 'pieces', entitled *Doomed*, applied to self-destruction the transfer from object to artist that was one of the results of the invention of the Readymade, and implicitly proposed suicide as a work of art; it also pushed to the extreme the perverse relationships that the logic of transgression could establish between artists and institutions. As related by a commentator, *Doomed* was supposed to consist of Chris Burden lying in a museum without food or water for 45 hours. On being informed by the medical authorities that the artist could be facing serious deprivation or death, the museum broke this rule and had food taken to him. Burden then revealed that he had privately decided ahead of time that the responsibility for his life was in the hands of the museum, and that he would make no attempt to save himself.[79] Whereas the explicit contract – a typical double bind – faced the remarkably improvident institution with the alternative of having to destroy the art or the artist, the secret provisions (if one may say so) rather made art of whatever would happen: another form of the artistic use of chance.

A last example shows a recent way of reconciling self-destruction with a relic-like preservation of materiality. The French artist Jean-Pierre Raynaud, after producing in the 1960s *Psycho-Objects* congenial to Nouveau Réalisme, had turned to the systematic use of white tiles and covered his own house at La Celle-Saint-Cloud with them. Open to the public from 1971 to 1988, the house had received many visitors and become a kind of monument. The hygienic and purist connotations of the material were enriched by Raynaud's realization of stained glass for the Cistercian abbey of Noirlac in 1975–6. In the late 1980s, a project that he cover with tiles one of the abandoned buildings in Vénissieux (see illus. 95) was envisaged but finally dropped.[80] In 1993 the artist had his house demolished, and presented the debris, in 976 surgical containers, in a visually powerful exhibition evoking a military graveyard at the CAPC, a centre for contemporary art in Bordeaux. The containers entitled 'This is the House of Raynaud' were on sale for 10,000 francs each, and Raynaud explained that he wished them to be dispersed all over the world.[81] He

also related the decision to destroy his *Gesamtkunstwerk* to his fear of degradation, his lack of confidence in society for taking care of it after his death, and his feeling that it had reached a state of perfection beyond which every gesture would represent a profanation.[82] It was further reported that he had replied to a question from the architect Jean Nouvel that one had a right to destroy a work of art if it resulted in creating another one.[83] Judgements varied, but generally there was praise for the 'coherence' and 'radicalism' of an attitude that, as one commentator put it,'wiped the slate clean so as to charge our memories for a long time with this immaterial mausoleum'.[84]

'Iconoclasm' as criticism and protest

The critical dimension of physical attacks on modern art has already been discussed in the context of public places and museums. The existence of historical and logical connections between such literal destructions and avant-gardist 'iconoclasm' need not be emphasized further. The aesthetic criteria of a John Ruskin durably retained – and probably still do – some degree of currency, and if Ruskin was outraged by what he perceived to be Whistler's 'flinging a pot of paint in the public's face', how would he have reacted to no paint at all? What I want to examine here are cases of (mostly indirect) abuse of modern art by artists or would-be artists, in which the aggression can be unequivocally understood as 'the public expression of an internal quarrel' within the artistic field.[85]

'Anti-modernism' is as complex and heterogeneous a phenomenon as 'modernism' itself, all the more so as few artists could afford to renounce the claim of being 'modern'. The fight was rather between competing definitions of modernity and legitimacy, so that anti-modernism may not be simply equated with 'traditionalism'. An interesting case in point is provided by the German-born painter George Grosz, who increasingly attacked paradigmatic artists like Picasso and Pollock, although he had participated in the Berlin Dada movement and integrated in his work elements from all the '-isms' of the first quarter of the century, posing in 1920 for the opening of the 'First International Dada-Fair' with a poster inscribed 'Art is dead – long live Tatlin's new machine art'.[86] This evolution was probably influenced in part by the professional frustration he experienced after his emigration to the United States in 1933, but it did not spring from it. Already in 1925, he had published with Wieland Herzfelde an essay significantly entitled *Kunst ist in Gefahr. Ein Orientierungsversuch* (Art is in danger: an attempt at orientation), and his dislike of Cubism developed quickly into a rejection of French modern art and of abstraction, which he regarded as an escape from social responsibility. In 1950 he read with approval *Verlust der Mitte* (Loss of the centre), a classic of anti-modernism published two years before by the art historian Hans Sedlmayr,

276

although his own early drawings were mentioned in it as intimately 'degenerate'. Grosz only expressed within a small circle his overt spite for Abstract Expressionism, but with means that are related in several ways to the methods of abuse we have encountered. His most hated target was Jackson Pollock, whose use of automatism he derided by calling him a 'Rorschach-Test-Rembrandt'. Grosz's friend and former student Marshall Glasier reported a double indirect assault that the artist made, executing first a painted parody and then treating it as a 'reciprocal Readymade': 'One day I came back from the League and George said: "Look, I just made a Pollock". "Oh yeah", I said, "where is it?" – "Right here", he said, getting off a stool. There it was, black, white and gray. He said: "All you need is a stick and you stir it round until there are no images." '

As I mentioned already, Duchamp was recently much attacked in the context of a French campaign against 'official contemporary art'.[87] In an interview in 1992, the Chilean-born French painter Roberto Matta also declared that the idea of the Readymade had progressively become 'ready-thought and *prêt-à-porter*', and considered that Duchamp had made something 'between Herostratos and Samson, with the blindness that it supposes. He demolished the temple and the whole story.'[88] An earlier condemnation, passed in the name of social and political implication, had been visualized in 1965 as a kind of execution *in effigie* by three members of the movement known as Nouvelle Figuration, 'figuration narrative' or 'figuration critique'. The eight canvases entitled *Vivre et laisser mourir ou la fin tragique de Marcel Duchamp* (Live and let die, or the tragic end of Marcel Duchamp) were collectively painted and exhibited in the Galerie Creuze in Paris by Gilles Aillaud, Eduardo Arroyo and Antonio Recalcati. They integrated in chronological order the representation of three major works by Duchamp (the *Nude Descending a Staircase* of 1912, *Fountain* of 1917, and *The Bride Stripped Bare by Her Bachelors, Even* of 1915–23) into a story showing him climbing up stairs, being hit by the three painters, sitting prostrated in an armchair, being thrown naked down the stairs, and finally carried to his grave by Rauschenberg, Oldenburg, Martial Raysse, Warhol, Restany and Arman dressed as U.S. Marines. The work, which contradicted the simultaneous homages paid by other young enemies of abstraction, was taken to be a manifesto, and contributed to its authors being enduringly labelled as 'political artists', as Arroyo somewhat regretfully noted in 1992.[89] In 1986 Hans Haacke also swiped at Duchamp for his criticism of the functioning of art as part of the 'industry of consciousness' (illus. 122). He restated two Readymades standing chronologically wide apart, *In Advance of the Broken Arm* of 1915, the first one to have been called by that name, and *Eau & gaz à tous les étages* (water & gas on every floor), a facsimile of plaques affixed to apartment houses in France produced in 1958 by Duchamp for the lids of boxes containing a special edition of Robert Lebel's monograph on him. This

122 Hans Haacke, *Broken R.M. . . .*, 1986, enamel plaque, gilded snowshovel with broken handle. Philadelphia Museum of Art.

revision submitted them to two different 'iconoclastic' treatments: the snow-shovel was literally broken, its superior part left hanging to cast a typical shadow on the wall, while *Eau & gaz* was replaced by *Art & argent* (art & money), a designation of the two 'fluids' essential to the 'real-time-system' under scrutiny. One is tempted to compare this manipulation with Edward Fry's statement, published in 1972, that Haacke 'may be even more subversive than Duchamp, since he handles his Readymades in such a way that they remain systems that represent themselves and thus do not let themselves assimilate with art'.[90] But Haacke explicitly praised Duchamp's *Fountain* as

an antecedent of his own work, which had 'unveiled the rules of the game, the symbolical power of context', so that his *Broken R.M. . . .* may rather be interpreted as designating the historical transformation of the 'iconoclastic' gesture of 1917 into a kind of 'relic', with or without Duchamp's participation.[91]

David Hammons's 1981 performances entitled *Shoetree* and *Pissed Off* can be considered as 'iconoclastic' criticism of modernism by a member of the younger generation.[92] They did imply a physical contact with Richard Serra's sculpture but no actual damage, and were declared to be art by their author. Both characteristics distinguish them from real destructions committed by artists or would-be artists who did not claim an artistic status for their actions. In 1978, for instance, a Dutch painter attacked with a Stanley knife Van Gogh's painting *La Berçeuse* in Amsterdam's Stedelijk Museum, and explained that he had wanted to protest against the fact that his own works were regarded as not corresponding to the norms of an artists' association, the Beeldende Kunstenaars Regeling.[93] In 1980, an artist named Kanama Yamashita damaged 38 pictures of modern Japanese art at the National Museum in Tokyo, declaring that he could 'no longer see them'.[94] In 1975, a large and complex work entitled *L'Imangue* was destroyed in a storeroom in Berlin by a group of eight art students who named themselves 'Rote Zelle HdK' (Red Cell Hochschule der Künste, i.e. College of Fine Arts), and reproached the author, the German artist and art historian Ekkehard Kaemmerling, with producing art that was 'hermetic, bourgeois' and not 'in the service of the proletariat'. Kaemmerling, who interrupted his work as an artist after this event, considered that the political motivation had been a pretext for an expression of jealousy, as his work had been discovered and launched in a short time with great success by a gallery owner, while he worked at the university and was not part of the art world.[95]

But artistic notions and genres like 'Happening' and 'Performance' could also be used as pretexts or excuses, so that the interpretation of recent 'iconoclastic' acts cannot avoid examining in a critical way – and thus passing a judgement on – their claim to artistic status. A final case will show some of the problems involved. In 1993 the new Carré d'Art in Nîmes opened with a programmatic exhibition on 'the object in the art of the twentieth century' entitled 'L'ivresse du réel' (The exhilaration of the real), which comprised one of the copies of Duchamp's 1917 *Fountain* edited in 1964.[96] On 24 August, a few days before the exhibition closed, a man sprinkled the urinal with liquid (his urine or, according to the director of the museum, tea brought in a bottle), hit it with a hammer and escaped.[97] A legal action against an 'act of vandalism and destruction of a work of art' was brought by the Carré d'Art, the town of Nîmes and the owner, the Centre Georges Pompidou. The author of the deed was immediately identified, put on trial, and received a suspended sentence of one month's imprisonment for 'voluntary degradation of a monument

or an object of public utility'.[98] During the trial, the 64-year-old Pierre Pinoncelli stated that he had committed an artistic gesture that Marcel Duchamp 'would have understood', by first giving back to *Fountain* its 'original function' and then hitting the 'simple object' that it had become again.[99] In a fax dated 30 August sent to various art-world personalities, he claimed his authorship of the 'urinal-happening' and declared that the news agency A.F.P. had refused to cover it when hearing that he intended to break the Readymade, thus depriving the event of publicity and photographic preservation.[100] These explanations were further developed in a long text dated 1 September 1993, published in a volume in 1994. Pinoncelli situated his 'behaviour art' in the wake of Duchamp and defined his 'iconoclastic gesture' as a way of giving life again to what had become 'a public monument'. Urinating on *Fountain*, which he called 'the most mythic work (with the *Mona Lisa*) of modern art', had reversed the process of the Readymade, and destruction was supposed to dispatch it and 'kill the father' in a 'charitable' way. As for the verdict, far from attesting mildness, it had aimed at 'minimizing' his action and made it appear 'derisive'.[101] In addition to much self-praise, numerous contradictions and a great deal of verbiage, this declaration showed a poor knowledge of its supposed model: Pinoncelli believed that the creation and attempted exhibition of *Fountain* had taken place in 1913 (probably confusing the date of the first exhibition of the American Society of Independent Artists with that of the Armory Show), and he had obviously never heard of the 'reciprocal Readymade', not to mention the less well-known fact that in a 1950 collective exhibition entitled 'Challenge and Defy' held at the Sidney Janis Gallery in New York, Duchamp had arranged for *Fountain* to be mounted right-side up and low on the wall so that 'little boys could use it' (illus. 123).[102]

While Pinoncelli's action and statements were abundantly publicized in the local Press they failed to attract much notice at the national level, and were either ignored or condemned by the specialized world of contemporary art. A revealing comment was made by the artist Ben (Benjamin Vautier), who said that he had first admired the risk taken by Pinoncelli and his attack on 'consecrated art', but later regretted that he had only 'broken off' *Fountain* and had immediately contacted the Press. He further related that when he had wanted to take Pinoncelli's side and said that the magazine *Art Press* would have to acknowledge the assault as artistic, he had received the following reply: 'but Ben don't you see he has done all that only for the Press and not for art, he would have done anything to be talked about, one cannot inscribe his name in the history of art while removing every meaning except that of whimpering for publicity'.[103] Pinoncelli's artistic biography, as complacently narrated in the volume already mentioned, tends to confirm this disqualifying interpretation. Born in 1929, he 'abandoned painting' and his native industrial town of Saint-Etienne for 'Happenings' and Nice after obtaining in 1966 an ambigu-

123 Installation view of the 1950 exhibition *Challenge and Defy* at the Sidney Janis Gallery, New York, with Marcel Duchamp's *Fountain* in the far-right lower corner.

ous status as a 'celebrity' by appearing at the opening of an Yves Klein exhibition at the Jewish Museum in New York with his face painted blue. In 1969 he threw red paint over André Malraux, who, as Minister of Culture, was inaugurating the construction of the memorial destined to receive Chagall's *Message biblique*. From 1971 Pinoncelli worked as a manager for a seed company while occasionally turning to painting (self-portraits in various disguises), artistically or politically justified 'Happenings' (a false hold-up in 1975 to protest against the links between Nice and South Africa), or writing (a rejected novel).[104]

In fact, the importance of the attention-seeking element and of previous failures in the assault on *Fountain*, as well as its lack of coherence and relevance from an 'artistic' point of view, bring it exceptionally close to the 'pathological' cases that we studied in the chapter on attacks within museums. This does not mean that Pierre Pinoncelli was deranged, or that the search for public acknowledgment does not belong to artistic pursuits, or that 'jealousy' is necessarily absent from all 'iconoclasm' in the metaphorical sense – but certainly that categories are more fluid than one might think. In this case, the fact that Pinoncelli could not give a convincing internal explanation of his resorting not only to 'urine' but to a hammer – which, if the tale of the refusal by the A.F.P. is true, was detrimental to the desired publicity – is particularly illuminating. The only real clue given in his text dated 1 September 1993 is the statement according to which breaking was meant to prevent 'the Happening from being only "funny" ' and the 'artist' from appearing to be a clown.[105] Rather than the result of a will to cope with, surpass or annul artistic ante-

cedents, the transgression of the taboo of iconoclasm thus seems to have sprung from an anxiety about being taken seriously. As for the choice of Duchamp's *Fountain* as target, it did not follow any pondering over the example of the arch-'iconoclast', which would probably have led Pinoncelli, like Tinguely, to renounce physical violence, but derived from the celebrity of a work that he naïvely equated with the *Mona Lisa*. Of course, Pinoncelli distinguished himself from other parasitic fame-seekers by claiming artistic status for himself and for his action, but this very claim, even if it structured his whole vital search for social recognition, might represent a kind of rationalization made possible by the institutionalization and vulgarization of avant-gardism.

'Object to be Destroyed' – 'Indestructible Object'

Artists' reactions to the degradation or destruction of their work are of particular interest in the case of 'iconoclastic' art, because they tend to demonstrate whether they give precedence – under the circumstances involved – to its 'anti-artistic' character or to the acknowledgement of it as a work of art. We shall see more of this in the next chapter, but we must begin to tackle the question here. An almost emblematic case is provided by an 'aided Readymade' assembled in 1923 by Man Ray in Paris and entitled *Object to be Destroyed* (illus. 124). A drawing of it, dated 1932, carries on the back an inscription specifying this injunction: 'Cut out the eye from a photograph of one who has been loved but is not seen anymore. Attach the eye to the pendulum of a metronome and regulate the weight to suit the tempo desired. Keep going to the limit of endurance. With a hammer well aimed, try to destroy the whole with a single blow.'[106] In his autobiography published in 1963, Man Ray related that six years before, *Object to be Destroyed* was included together with a 1917 assemblage called *Boardwalk* (illus. 125) in a retrospective exhibition of early Dada works shown in a Paris gallery.[107] While he was in the room with Tristan Tzara, students from the nearby Ecole des Beaux-Arts rushed into it, threw handbills denigrating all Dadaists and Surrealists in the name of French tradition, took down the pictures from the walls and then went away, carrying off with them *Object to be Destroyed* and *Boardwalk*. Man Ray ran after them and saw one of them shoot at the latter work. He recovered it when the police arrived, but *Object to be Destroyed* had disappeared.

This is an interesting case of anti-modernist metaphorical and literal iconoclasm, but the most remarkable part of the relation concerns Man Ray's ensuing discussion with the man from the insurance company. The works on show had been insured by the gallery, and *Boardwalk* borrowed from its owner. For the loss of *Object to be Destroyed*, which still belonged to the artist, the insurance expert proposed to reimburse the price of a metronome. Man

124 Man Ray, *Indestructible Object*, 1958 replica of the 1923 *Object to Be Destroyed*. Arturo Schwarz Collection, Milan.

125 Man Ray, *Boardwalk*, 1917, assemblage (with damage from gunshots in lower left quarter). Staatsgalerie, Stuttgart.

Ray replied that one did not replace 'a work of art, a painting, with brushes, paints and canvas'. The expert admitted the objection and agreed, since the artist was a famous one, to pay the entire amount insured, while hinting at the fact that the sum would enable him to buy 'a whole stock of metronomes'. Man Ray said that he intended to do so, but also assured him that he would change the title into *Indestructible Object* – which he did in 1958. For *Board-walk*, the expert offered to fill up the holes and clean it. The artist protested that, as a Dada object, it had become even more precious and should not be restored. When the expert asked why, then, had he made an insurance claim, Man Ray made reference to the owner and proposed that the insurance company pay the amount and keep the work, as specified in the contract. The insurer objected that the company did not collect works of art and agreed to pay half of the sum. Man Ray concluded this narration by stating that he was very satisfied because he had 'succeeded in making what was not considered a work of art as valid as any legitimate painting or sculpture'.[108]

The fate of *Object to be Destroyed* shows that Man Ray's typically 'iconoclastic' appeal to destruction was not addressed to the public, or had ceased to be so by 1957. It is interesting to confront this fact with the artist's introductory words to his great 1971 retrospective exhibition held in Rotterdam, which stated that the show was 'not addressed to the great public nor even to the few', but was 'presented by one person to only one other person, to you who are here'.[109] In his autobiography, Man Ray specified that he had 'really intended to destroy [the *Object to be Destroyed*] one day, but before witnesses, or an audience in the course of a lecture'.[110] Its replacement was in accordance with Duchamp's practice and theory of the 'lack of uniqueness' of the Ready-made, but the insurance claim and the modification of the title were not.[111] Indeed, the passage from *Object to be Destroyed* to *Indestructible Object* recalls Martin Warnke's observation that 'Every party, even if it has fought and won with the means of iconoclasm, immediately lays a taboo on those means, because there are new signs and symbols to protect'.[112] With Man Ray and other authors of early 'Dadaist objects', the 'taboo' was not immediately laid or at least demonstrated. But in the 35 years separating the creation of *Object to be Destroyed* from that of *Indestructible Object*, those initially more or less private experiments had become objects of collection, commerce and study – a part of 'heritage'. In this particular case, the discussion with the insurer makes clear that there were two conditions to the latter's agreement, namely the contract signed by the gallery and the author's acknowledged status as an artist, so that Man Ray owed to the collaboration of the whole art field the capacity to 'give a value of work of art to objects that were not considered as such'.[113]

This is not to minimize Man Ray's qualities as artist and negotiator. Indeed, he succeeded in winning twice with *Boardwalk* by distinguishing its symbolic

dimension (that of the 'Dada object', conceived as event or process, for which the 'Happening'-like aggressive intervention represented an increase in value and which called for an 'anti-scrape' attitude towards preservation) from its commercial and patrimonial dimension (that of the object of collection, for which degradation meant a decrease in value). The role played by financial factors in this evolution can remind us of Octavio Paz's observation that 'the practice of "ready-made" demands an absolute disinterest' and the remark made by Duchamp in 1967 that he had done 'as few things as possible, which isn't like the current attitude of making as many as you can, in order to make as much money as possible'.[114] Man Ray was of the same generation as Duchamp, and was a friend of his, but Man Ray's assemblages had, from the start, stood nearer to 'Surrealist objects' than to the 'pure' Readymades that – it must be emphasized – were inimitable or rather irrepeatable as gestures. By the 1960s, however, they had come somewhat closer, as the edition of *Fountain* by the Galleria Schwarz in Milan (in 1964) and that of *Indestructible Object* by the Galerie Der Spiegel in Cologne (in 1963) attested.

In the same long interview of 1967, Duchamp declared that he did not visit museums because he doubted the value of the judgements on which the selection of works had been based, so that Pierre Cabanne asked him why he had accepted that all his works should be in a museum – he had, in fact, actively collaborated on their gathering in the Philadelphia Museum of Art and was at the time organizing the addition of his secret last work, *Etant donnés: 1° la chute d'eau, 2° le gaz d'éclairage* (Given: 1. The Waterfall, 2. The Illuminating Gas). Duchamp answered that there were 'practical things in life that one can't stop', and that he could have 'torn them up or broken them; that would have been an idiotic gesture'.[115] He thus mentioned the possibility of a physical destruction of his own works as a means of opposing their institutional homologization, but only to reject it as lacking intelligence – a judgement in accordance with the habitual condemnation of 'vandalism' and with Tinguely's appraisal of *L.H.O.O.Q.* as more *spirituel*. The reference to 'practical things in life' corroborates the art-historical interest of situations – like the one following the attack on Man Ray's unusual works – in which the conceptions of avant-garde art are confronted with extrinsic authorities. The contradictions that they make appear between theory and practice are often due to a denial of economic interest that has long been essential to the definition of culture, especially in the 'independent' tradition opposed to 'official' and 'commercial' art.[116]

There is an obvious paradox, or at the least difficulties, for people without a private fortune involved in the professional pursuit of disinterest, and Duchamp had explicitly renounced living from the proceeds of his art in 1913. When they were not accompanied by new means of financing, 'radical' innovations directed against the materiality and saleability of the work of art tended

to favour disguised returns of the work's repressed commodity status, for instance by means of the reimbursement of amounts insured. In extreme cases, one can even suspect that a destruction was committed or provoked to that purpose, so that in a perverse way, attacks contributed to the recognition – in Man Ray's sense – of objects as works of art.[117] Such equivocations and ambiguities were further facilitated by the fact that the suppression of aesthetic norms possessing a general validity made the evaluation of the state of preservation of a work of art particularly arbitrary. One could without difficulty apply to the visual arts the first stanza of a poem by D.J. Enright entitled *Vandalism*: 'Since the object in question is a modern poem, / A police spokesman stated yesterday, / It is hard to tell whether it has been damaged / Or not or how badly.'[118] Planned destructions must admittedly be exceptional, but they point to the broader conclusion that the anti-modernist 'vandalism' may not only be a logical but also a necessary counterpart to the modernist anti-traditional 'iconoclasm'.

14 Mistaking Art for Refuse

The scarcity and poverty of reasons given for attacks against art (particularly modern art) is less due to an absence of motives than to their illegitimacy. This problem is generally solved by anonymity and silence. Another solution, however, proves to be even more economical in that it enforces the attack while exonerating the assailant: it is the explanation according to which a work was not damaged deliberately but by mistake, because it was taken to be something else. As we shall see, this kind of story generally comes close to a stereotyped narrative and partakes of the aggressive logic of jokes. While the possibility of such an event really taking place cannot be discarded altogether, it also bears significant resemblances to major motifs of art theory and techniques of social criticism.

'Video Blind Piece'

During the local 'iconoclastic crisis' occasioned by the 1980 Swiss Sculpture Exhibition in Bienne, the anonymity of the destructive interventions was broken once, and I have mentioned that the identity revealed differed strikingly from the stereotype of the 'vandal'.[1] This contradiction, however, did not lead to an overt questioning of the current interpretation of the events because, in this case, the destruction was considered to have resulted from a mistake and not from a malicious intention. As we shall discover, this explanation was itself part of the overall criticism of the works on show, but the fact that, despite its weaknesses, it was maintained by all the parties involved is another token of the taboo bearing on iconoclasm and of the potential danger represented by a recognition of its true nature.[2]

The object of the 'mistake' was a work entitled *Video Blind Piece* by Gérald Minkoff, an artist born in 1937 who lives in Geneva. It was represented in the catalogue of the exhibition by a drawing (illus. 126) and explained as follows by the author: 'For an improbable reader. This piece consists of fourteen exhausted television tubes buried in the ground with the screens facing up. VIDEO means "I see" in Latin and is translated here in braille, the alphabet for the blind, by fourteen dots.'[3] *Video Blind Piece* measured four metres by

126 Gérald Minkoff, 1978 sketch of his 1980 *Video Blind Piece*, reproduced in the catalogue of the 1980 Swiss Sculpture Exhibition in Bienne.

127 Minkoff's *Video Blind Piece*, detail of television screens buried in the ground, in a news-paper photograph of 5 June 1980.

288

fourteen, and one can deduce from its semiotic characteristics that its 'improbable reader' should have been a blind giant, some nine hundred metres high, possessing a considerable tactile sensitivity – the screens were barely protruding – and informed of the presence of a message in this unexpected place. To the average-size visitor of the exhibition, one blessed with sight and a copy of the catalogue, it proposed a complex and amusing array of paradoxes about visual communication. The 'involuntary spectator', by contrast, was not likely to perceive much of these, since the label placed nearby only carried the name of the artist, the title of the work and the catalogue number. However, failures and accidents of communication were theoretically greeted by Minkoff, who concluded a short presentation of his activity by affirming that 'the most favourable perspective' for the series to which the work belonged was that of anamorphosis, and that 'misunderstanding' was 'also welcome'.[4]

In order to allow views of it that were other than 'anamorphotic', *Video Blind Piece* was placed near a overhanging path and the new-built school. Construction had suffered delays, so that the surrounding ground had yet to be levelled and sown with grass when Minkoff installed the television tubes a week before the opening, which took place on 31 May 1980. On 5 June a competition about the exhibition published in a local newspaper mentioned *Video Blind Piece* and reproduced a partial view from above (illus. 127). On 19 June the artist returned to take photographs. He found the ground in a finished state, but no trace of his work. In a letter written the following day, the organizers of the exhibition explained that on 16 June, 'by a concatenation of unhappy circumstances', the television tubes had been removed and destroyed on order of the gardener responsible for the grounds, Oskar Fischer, and that they had requested the perpetrator of this 'mistake' to find other screens so that Minkoff's work might 'recover its place as soon as possible'. The artist replied that he could neither redo his work nor 'tolerate any duplicate', since *Video Blind Piece* had been installed by him 'specially on the ground indicated to this effect' and was 'original and unique'; he asked for the payment of the insurance value (14,000 Swiss francs), the reimbursement of his travel expenses and an indemnity of 5,000 francs.[5] On the same day, however, the gardener placed the following advertisement in the *Bieler Tagblatt*, along with his name and address: 'Urgently wanted: 14 old television tubes (uniform format 59 x 29) to restore a sculpture of the sculpture exhibition not recognized as such and for this reason removed to the refuse-dump.'[6] His advert caught the attention of the media, and between 27 June and 2 July the affair was related in three newspapers with a national circulation, the popular tabloid *Blick*, the Geneva-based *La Suisse* and the *Tages-Anzeiger* in Zurich.[7] The first one, an article entitled 'Work of Art Looked Like Refuse: Away With It!', reproduced the advert and quoted a declaration by the gardener: 'I am no philistine, on the contrary, even provocative art appeals to me. It was all a mis-

take. As the television screens had been soiled and partly broken by the stormy weather, I assumed that they were waste from the new grammar school nearby – or creations by the pupils, who had made fun of the exhibition with works of their own.'[8]

The advertisement also produced many offers of old television tubes. On 7 July, after some exchange of letters and phone calls, the artist wrote to the organizers – whom he regarded as his 'only interlocutor in this affair' – that he was 'ready, not to reconstitute a duplicate (a question of ethics), but to execute an analogous piece, "Video Blind Piece no. 2" ', on condition that half his previous requirements be paid and that the new installation be announced in the local press, *La Suisse* and the *Tages-Anzeiger*.[9] But the gardener wanted to settle the financial question with his insurance, so that Minkoff was asked to proceed before being indemnified, a proposition that he refused 'to prevent any later contestation and misunderstanding'.[10] While the organizers notified Fischer that they were transferring to him the responsibility 'for all the consequences arising from the regrettable incident', the gardener rejected any such responsibility for a 'mishap' which, he explained, could have happened to any other contractor because 'the work of art was not indicated as such, the raw material was not processed, the location was a building site, and more building refuse (pardon the expression) lay around more or less at random'.[11] The artist hired a lawyer, who understood from the organizers that they did not really believe in the 'mistake'. The gardener's insurer maintained this explanation, contested the value of the work and the impossibility of reconstituting it, but nevertheless offered a sum of 4,000 francs to 'dispose of the affair'. The artist refused, against the advice of his lawyer. There were no further developments beyond that point.

If the gardener's account is correct, this is a case in which a conjunction of form, place and circumstances made it possible for a work of art to be mistaken not only for something else, but specifically for refuse, so that it was destroyed by error. If not, the removal of *Video Blind Piece* was an early and special contribution to the destruction of works from the ESS 1980, one in which violence was performed by proxy and under the guise of misunderstanding. In fact, a majority of clues speak for a conscious elimination. Even if the label had already disappeared at the time of the gardener's intervention, if the bad weather had degraded the appearance of the work, and if there had been other objects lying about, fourteen television screens arranged according to a geometrical pattern could hardly be taken for 'building refuse', all the more so as the gardener knew of the exhibition and had been informed – according to the organizers – that this part of the ground would have to be sown by hand because of Minkoff's work. Rather than giving further plausibility to the mistake, his hint at artefacts spontaneously added to 'make fun of the exhibition' (illus. 79) strengthens this suspicion, as does his ironical 'pardon the expres-

sion' or the argument that he had refused to collaborate with journalists because Minkoff would have been likely to be treated 'as a half-artist, a quarter-of-an-artist, or a nothing-at-all'.[12] According to Minkoff, the gardener had really taken revenge on *Video Blind Piece* for the damage caused by the installation of the sculptures to his own work – the preparation of the ground surrounding the new school.[13] If this is the case, the conflict provoked by the accidental simultaneousness of two uses of the same site gave but an acute form to the opposition between artistic and mechanical activity and to the revolt against the inequality of their evaluation that we have observed in the overall reception of the exhibition.[14] Minkoff thought his work represented a perfect scapegoat because it was relatively easy to remove, seemed less precious than other sculptures, could countenance the idea of a 'mistake', and was particularly 'disturbing'. It must be added that in the context of the ESS 1980, the character of the 'unprocessed raw material' of *Video Blind Piece* made it the most accomplished example of what people like the school-porter denounced as not being art. If it was destroyed on purpose, then, the explanation according to which it was eliminated by error could not simply be an excuse invented to evade responsibility but must have been a particularly efficient way of exposing what was regarded as a fraud. By treating a supposed work of art like refuse and pretending that he had done it in good faith, the gardener 'proved' that such a work could be mistaken for refuse and thus 'deserved' in some way to be treated as such, condensing in one gesture judgement, condemnation and execution. Seen in this light, the advertisement that publicized the affair and imposed his version was a masterpiece of pseudo-naïveté and provocation, and the very proposal to reconstitute the work possessed its 'iconoclastic' dimension, since it implied that nothing was easier and that 'a gardener could do it'.

The artist's refusal attested this violence, as did his request that the newspapers that had related the 'mishap' announce its replacement. Of course, there were other reasons for his reactions, and the occultation of financial interest played in his statements and behaviour a role symmetrical to that of iconoclasm for the gardener. Minkoff's insistence on the irreplaceability of *Video Blind Piece* recalls both Man Ray's and Richard Serra's arguments. It was undermined by an allusion to the interest of buyers in the work (which would have implied a re-installation) and, to some extent, by the very project of an 'analogous' *Video Blind Piece no. 2*. Moreover, several chronological and mathematical ambiguities in the estimation of the value and of the idemnities show that the artist also saw in the 'incident' a possibility of converting his disappeared work into unhoped-for money.

As for the organizers, they obviously feared nothing more than publicity, never questioned openly the hypothetical 'mistake', and did all they could to promote a reconstitution – i.e. the suppression of what had happened – even before consulting Minkoff. The silence observed on this affair by the local

Press, apart from Fischer's statement-as-advertisement, speaks volumes for the pressures they must have exerted. Their defence of the artist was also far from unconditional. The secretary of the exhibition, in particular, declared that 'one cannot have a grudge against workers who know nothing about art', and that 'this had to happen, given what certain artists make today'.[15] Such an attitude is typical of the half-hearted support of 'avant-gardist' art by a part of those professionally (or semi-professionally) bound to express solidarity with it, an ambivalence that can amount to a latent iconoclasm and extend to the covert approval – if not actual encouragement – of degradations. The accent of *Schadenfreude* was unmistakable in the Press, which insisted on the naïveté of the 'honest gardener' to better emphasize the inevitability of his 'mistake'. This could be done implicitly, as in *La Suisse*, which made fun of the 'uncultivated gardener' but compared the photograph of a large wooden box belonging to a work by Fritz Ruenzi with that of a closed ice-cream shop, with the comment 'Art and chance . . .' (illus. 128).[16] Without mentioning the 'incident', the local Press also confirmed its relevance for the reception of the ESS 1980. We have seen that already five weeks before the opening, the *Journal du Jura* had tackled the theme of the lack of distinction between modern art and non-art apropos Tinguely.[17] This motif was repeatedly exploited thereafter, always under the guise of humour and generally by cartoons. On 16 June, the very day of the destruction of *Video Blind Piece*, the same newspaper showed two 'normal' inhabitants of Bienne standing beside a telephone-booth with an open catalogue of the exhibition and saying '... there are three things like that along the Pasquart and one doesn't find them in the catalogue ... and yet ... *they* represent something!!!' (illus. 129).[18] On 8 August it reproduced a work by Edouard Delieutraz consisting of a painted oil-barrel and asked 'dustbin or sculpture?' – as could be expected, the barrel was indeed filled with refuse. And on 27 August 1980, three days after the closure of the exhibition, the *Bieler Tagblatt* published under the title 'A strange sculpture' a photograph of the connecting-piece of a pipe for spreading liquid animal waste on the fields (illus. 130).

Reciprocated Readymades

It seems that only in the twentieth century were the conditions given for stories of works of art mistaken for something else to be believed or true. These conditions all derived to a high degree from the autonomy of art, which permitted the development of great differences in knowledge of and opinion about what was or should be considered as art, as well as a systematic questioning of the line between art and non-art. Efforts at reducing these differences and the institutionalization of the avant-garde further contributed to bringing into contact objects requiring a rare competence to be regarded as works of art and people devoid of – and generally uninterested in – that competence.

128 *An . . . unculti-vated gardener*, article in the Geneva newspaper *La Suisse* (28 June 1980).

129 *Horlopotin at the Swiss Sculpture Exhibition*, unsigned cartoon in the *Journal du Jura* (16 June 1980).

EXPOSITION SUISSE DE SCULPTURE A BIENNE

Un jardinier... inculte

À gauche l'étal (fermé) du marchand de glaces, à droite l'une des œuvres due au Zurichois Fritz Ruenzi. L'art et le hasard... (Photo « La Suisse »)

BIENNE — Le sculpteur genevois Gérald Minkoff est navré, les organisateurs de la 7e Exposition suisse de sculpture de Bienne sont ennuyés, et le jardinier Oscar Fischer est tout penaud: en nettoyant consciencieusement la pelouse du Standboden, au bord du lac, il a tout aussi consciencieusement déterré quatorze tubes-images de télévision, pour les jeter aux ordures. Déchets provenant de la construction du nouveau gymnase, pensait le jardinier... qui venait de détruire en fait une œuvre d'art de Gérald Minkoff.

Cette œuvre, «Video blind piece», s'adressait à un «lecteur improbable», et ses quatorze écrans TV enfoncés au ras du sol et tournés vers le ciel transcrivaient en alphabet braille le mot «video» («je vois» en latin). Le jardinier, qui n'a rien vu du tout, sinon des «détritus» maculés de boue et endommagés par les intempéries, s'est empressé de faire place nette. Si nette que l'artiste, revenu le 20 juin pour photographier son œuvre en prévision d'un projet semblable à réaliser à l'étranger (dans un désert, où les écrans TV seraient remplacés par des tumuli visibles d'avion) s'en est allé signaler la mystérieuse disparition aux responsables de l'exposition. Voui, avouèrent-ils, il y a eu comme un petit problème! En fait de petit problème, le jardinier biennois, pressentant la grosse gaffe, tentait de la rattraper en cherchant, par la voie de petites annonces dans le journal local, quatorze tubes-images de télévision pour bricoler une sculpture d'occasion...

La mésaventure est cocasse autant que surprenante. «Invraisemblable, et d'autant plus piquante que l'œuvre, écrite pour les aveugles, ait été si peu remarquée par les gens qui voient!» ajoute Gérald Minkoff. Il a reçu, par lettre, les excuses embarrassées des organisateurs, qui déplorent l'erreur, commise en dépit des ordres donnés aux jardiniers de la ville et aux personnes chargées de s'occuper du terrain. L'œuvre était dûment cataloguée et inscrite sur le plan de situation depuis quinze jours lorsqu'elle a été si cavalièrement délogée.

Les outrages de l'art ne font, après tout, que refléter les outrances de l'époque. Mais parmi les «sculptures» vraies ou fortuites qui affluent sur le gazon du Strandboden ou qui émergent du bitume de la ville, le passant pressé, ce visiteur malgré lui, n'est pas tenu de séparer le bon grain de l'ivraie, alors que l'organisateur de l'exposition, celui qui a sélectionné l'art et le hasard, est tenu de prendre soin de ce qui lui est confié. La leçon coûtera 14 000 francs, valeur déclarée de «Video blind piece», donc de la bévue du jardinier biennois...

HORLOPOTIN à l'Exposition suisse de sculpture

...il y a trois machins comme ça le long du Pasquart et on ne les trouve pas dans le catalogue... et pourtant ça... ça représente quelque chose!!!

130 *A Strange Sculpture...*, from the *Bieler Tagblatt* (27 August 1980).

Eine seltsame Plastik ...
... die allerdings nicht von der soeben zu Ende gegangenen Schweizerischen Plastikausstellung stammt, entdeckte unser Fotograf an der Strasse zwischen Lyss und Frienisberg, in der Nähe von Wiler. Bei dem eigenartigen Gebilde handelt es sich in Wirklichkeit um den Stutzen einer Jaucheleitung, mit der die «Bschütti» unter der Strasse hindurch auf das Land verteilt wird. (WB)

Understandably, architecture, painting and the graphic arts (as far as such traditional genres remained valid) were generally spared by this accessory symptom of modern art. One may quote the special case of a postmodern building designed by the New York architect James Wines for a department store company in Houston, Texas, whose ruined aspect a state inspector would not believe to have been intentionally produced and officially recorded – so the story goes – as due to 'hurricane damage'.[19] Another remarkable case is related by Igor Stravinsky in his autobiography: during the First World War he had been prevented from taking a portrait of himself by Picasso into Switzerland by the customs officers in Chiasso, who declared that the drawing was 'not a portrait, but a plan'; it finally reached Paris by the diplomatic post.[20] This mistake, which must have been genuine, was based on a conjunction of Picasso's transgression of mimetic conventions and the professional tendency of security officials to view 'the new with suspicion and distrust', aggravated by current fear of spies and secret writings.[21]

Conversely, the history of sculpture, 'object art' and especially Readymades abounds in such anecdotes. This is perfectly logical, since the revolution of the Readymade consisted in transferring art from object to beholder – the artist on the one hand, the spectator on the other. This was only a radical conclusion

drawn from the fact, exemplified by the customs officers, that one finds what one is looking for, but it greatly increased the dependence on context for interpretation of works created after this principle. To some extent, the very lack of distinction between art and non-art featured among the liberating aims of avant-gardist 'iconoclasm', as expressed in the remark of *The Blind Man* on 'plumbing and bridges' or in Fernand Léger's article on 'The Aesthetic of the Machine' of 1924: 'Many individuals would be sensitive to the beauty of common objects, *without artistic intention*, if the preconceived notion of the *objet d'art* were not a bandage over their eyes. . . . Beauty is everywhere, in the arrangement of your pots and pans, on the white wall of your kitchen, more perhaps than in your eighteenth-century salon or in the official museum.'[22] Forty years later, the Fluxus artist George Brecht organized minimal 'events' of which participants might have remained unconscious and selected his objects 'because they existed and could be easily overlooked'.[23]

Dieter Daniels has convincingly argued that Readymades were primarily – in Duchamp's own terms – 'a wholly private experiment' and that their place was the private environment of flat or studio where no one except the artist could tell which objects were Readymades and which were not (illus. 131).[24] This was true of their 'iconoclastic' dimension as well, as Duchamp made clear during a public discussion in 1961 when, to Robert Rauschenberg's question 'So you want to destroy art for all mankind?', he answered 'No, only for myself'.[25] When first exhibited, Readymades proved to be 'impregnated against attention' in the manner of traditional monuments – although for different reasons. In 1916 a few of them figured in two group shows in New York. In the 'Exhibition of Modern Art' of the Bourgeois Galleries, Duchamp had hung them on a hall-stand in the entrance, and he observed with amusement that no one noticed them because visitors thought that they were things that had been forgotten.[26] As for *Pharmacy*, a cheap print to which he had added two small red and green marks in 1914 and which he presented in the exhibition 'Jean Crotti, Marcel Duchamp, Albert Gleizes and Jean Metzinger' by the Montross Gallery, it was praised by a critic as a 'delicate and well recognizable landscape'.[27] One year later, *Fountain* (illus. 57) was denied inclusion in the first exhibition of the Society of Independent Artists. Duchamp was one of the founder-members, and had submitted the urinal under the pseudonym of 'R. Mutt' as a test of its proclaimed principle that whatever 'artists of all schools. . .send will be hung'.[28] *Fountain* provoked a battle within the board of directors, ending up in its rejection on the grounds that it was not art and was indecent. Concern for the nascent reputation of the Independents and a suspicion that the whole thing was a joke surely played a role in this decision, and Beatrice Wood recalled the following exchange between George Bellows and Walter Arensberg: 'It is gross, offensive! There is such a thing as decency. – Only in the eye of the beholder. You forget our bylaws.'[29] Duchamp

In advance of the broken arm
(Ready made; haut. 1ᵐ)
New-York, 1915

131 Photograph from the *Boîte-en-Valise* of 1941-2, showing Marcel Duchamp's *In Advance of the Broken Arm* of 1915. Philadelphia Museum of Art.

132 Photograph from the *Boîte-en-Valise* of 1941-2, showing Marcel Duchamp's studio at 33 West 67th Street, New York, *c.* 1917-18, with two Readymades, *Bicycle Wheel* (copy of 1916) and *Trap* (1917). Philadelphia Museum of Art.

33 West 67 th.
New-York
(1917-18)

resigned from the Society and renounced exhibiting for many years. *Fountain* was first concealed behind a partition, then removed by Duchamp from the hall and supposedly purchased by Walter and Louise Arensberg, who do not seem to have displayed it in their apartment and eventually lost it.[30]

Duchamp's friend and near contemporary Hans Richter considered in 1964 that once they had delivered their initial shocking statement, the 'artistic or anti-artistic content' of the Readymades was 'reduced to nothing' and that 'they could be thrown away, put in some store or returned to their normal functions'.[31] This was the year of the Galleria Schwarz edition, but Richter's recommendation agreed with the original fate of most Readymades. Neither Duchamp nor his devoted collectors had considered them as works that ought to be preserved, and as Daniels remarked, the 'originals' of nine out of the sixteen objects listed in the *Boîte-en-Valise* of 1941 had disappeared, including all 'pure' Readymades with the only exception of the 1916 *Comb*. According to Duchamp, the *Bicycle Wheel* of 1913 and the *Bottle Dryer* of 1914 were thrown away by his sister and his sister-in-law when they cleaned out his Paris studio after he left for New York, although he asked Suzanne to write an inscription on the bottle rack to 'make it a "*Readymade*" from a distance'. Maybe the letter arrived too late.[32] As already indicated, these lost 'originals' were replaced when needed, by similar but not necessarily identical items. This was, for instance, the case with *In Advance of the Broken Arm* of 1915 (illus. 131), which reincarnated 30 years later for a retrospective exhibition of the work of the three Duchamp brothers at Yale, where it was shown dangling from the ceiling as in its reproduction in the *Boîte-en-Valise*. George Heard Hamilton, who had collaborated on the organization, later related that when the 'little exhibition went on a tour, a janitor at a Museum in Minnesota the next winter mistook it for a shovel, as well he might, and went to work on a snowdrift, doing Duchamp's inscription no good'.[33]

Provided that *In Advance of the Broken Arm* was not dangling from the ceiling when it was transformed into a reciprocal Readymade, this may be a plausible case of misunderstanding. For once publicized, even Readymades require special conditions in order to be taken for commonplace objects. Favourite potential doers are professionals dealing with the physical context of preservation and exhibition but not with cultural functions. Gardeners and policemen out of doors, doorkeepers and cleaners within buildings come to the forefront because their tasks imply the identification and removal of degraded or displaced things. Needless to say, they may for the same reasons be irritated by objects with which they are unvoluntarily confronted and possess ready-made excuses for eliminating them. The places best suited to real or feigned mistakes are marginal or ambiguous ones like parks, store-rooms, improvised or provisional locations and means of transportation. The conflict between school ground and exhibition ground in the *Video Blind Piece* affair

133 Meret Oppenheim, *My Nurse*, 1936, shoes with paper ruffles tied with string on an oval metal dish. Moderna Museet, Stockholm.

was obviously perfect, but public places are generally good. *Tilted Arc* was too solidly anchored into the substructure of Federal Plaza to be removed by someone pretending to have mistaken it for something else, but one representative of a local community board declared during the 1985 hearings: 'Many people are even bewildered when they are told that this large metal structure is not a piece of leftover construction material, but is, in fact, a piece of art.'[34] Weight alone might not have been enough, as two instances of sculptures stolen to be cut out and reused as metal demonstrate, one in The Netherlands in 1979, the other – a ten-ton heavy work by the American Richard Nonas, worth 300,000 dollars and sold for 4,350 dollars to a dealer in scrap metal – in the neighbourhood of Lodz in 1994.[35]

When Meret Oppenheim's Surrealist object *My Nurse* of 1936 (illus. 133) was received for an exhibition, the string tying up its two women's shoes like a chicken was believed to be a part of the packaging and accordingly removed.[36] During the preparation of another show in Bayonne, in 1989, a piece of striped white and red cloth belonging to a work by Daniel Buren was thrown into a dustbin by an employee of the Musée Bonnat and recovered from it at the last moment by the curator.[37] Here again, published information does not allow a critical examination of the 'mistake' argument. By contrast, a malicious intention was clearly involved in a case that brings together destruction as art and the destruction of art. On arriving in Paris in 1959, the Swedish artist Erik

298

Dietman had begun to carry up to his room at the Hôtel Carcassone 'refuse of all kinds' and to arrange it according to the principle 'assemble, drink a beer, break, collect more materials, assemble, drink a beer, break everything, etc.' In June 1962, the manager of the hotel, Mrs Bénèche, took advantage of his temporary absence to remove all that he had accumulated; Dietman later declared that his first impression had been of having his work stolen, but that he later felt 'freed from all those things'.[38]

'Mistakes' concerning Joseph Beuys are of particular interest in relation to the problem of the status of his works. In an interview with Bernard La-marche-Vadel, Beuys clearly defined his objects in 1979 as 'documents left by [his] actions' and 'tools that allow the reconstitution of these actions'. Asked about the 'fetishism' surrounding them, he answered: 'People apprehend these objects in very different ways according to their being collectors, curators or dealers, for example. Everyone may do what he wants. Once they have left my hands, they are free...'[39] A few years before, however, an 'incident' had shown that the 'traces' had become works of art in their own right and that their availability was restricted to the valorizing interventions of members of the art world. The Von der Heydt-Museum in Wuppertal (West Germany) had organized an exhibition entitled *Reality – Realism – Reality*, which toured from October 1972 to December 1973. It was dedicated to 'the history of the unmanipulated, unadjusted piece of reality in art' and aimed at showing on the basis of works by Duchamp, Warhol and Beuys 'the change of this radical reality-relatedness into magic-emotional incantation rites and a relic-like object-art'.[40] It must be remembered in passing that, in 1964, Beuys had entitled *Das Schweigen von Marcel Duchamp wird überwertet* (Marcel Duchamp's Silence is Overvalued) an action that he meant as a 'condemnation of Duchamp's notion of anti-art' because for him, 'the anti' could only refer to 'the traditional notion of art'.[41] Among Beuys's works in the exhibition were three objects lent by Lothar Schirmer, a Munich private collector: *Badewanne*, a child's bath-tub (illus. 134); *Ofen* (illus. 135); and an untitled assemblage comprising a plastic basin partially filled with linseed-oil, a knife, a ladle and a painted cardboard cover (illus. 136). The corresponding catalogue passages pointed to Beuys's notion of a 'trans-substantiation of matter' analogous to that of the Christian Eucharist and emphasized the autobiographical dimension of his objects, contrasting, for instance, the artist's relation to *Badewanne*, in which he had been bathed as a child, with Duchamp's 'indifference' towards *Bottle Dryer* (plumbing might have made *Fountain* a better point of comparison). The bath-tub had become the object *Badewanne* in 1960, when Beuys had 'prepared' it with some sticking plasters and gauze bands impregnated with fat; as for his former studio stove, it had received in 1970 the addition of felt and 'magical signs', such as an axe and a fish.[42]

At the end of 1973, when Schirmer received his collection items back, the

299

134 *top left* Joseph Beuys's 1960 *Bath–Tub*, before being used as a wine cooler and cleaned by German politicians in 1973, a child's bath-tub with sticking plasters and gauze bands.

135 *top right* Joseph Beuys, *Stove*, 1970, stove with paint.

136 *below* Joseph Beuys, *Untitled*, 1962, plastic basin with linseed-oil, knife, ladle and painted cardboard cover.

bath-tub had been cleared of its plasters and bands (he compared it to a 'shaven cactus'), the basin was empty, its cover greasy, and the fish painted on *Ofen* had received bones. It is not clear from published accounts whether a plate inscribed 'In dieser Wanne wurde Joseph Beuys gebadet' (Joseph Beuys was bathed in this tub), to which had been anonymously added 'Offenbar zu heiß' (obviously too hot), figured on *Badewanne* or had accompanied it in one or several of the museums.[43] It turned out that before the opening of the last stage of the exhibition, on 3 November 1973, the ground floor of Morsbroich Castle – in which the town museum of Leverkusen was housed – had been rented by the local section of the SPD (including town-councillors) for a celebration. Looking for seats, the guests had 'through oversight of a temporary assistant' entered the storeroom that contained Beuys's *Badewanne*, which they used to cool bottles of beer and wash glasses after having cleaned it. No explanation was given for the comments added to the plate and to *Ofen*, or for what had happened to the untitled basin. The owner sued the town of Leverkusen, and a hearing took place in 1976. Independent experts considered the three objects to be so badly damaged that they could not be restored, and set their market value at 165,000 marks, about twice the amount insured. The Wuppertal Regional Court admitted that nothing was left of Beuys's 'non-recurring creative act' and sentenced the town to reimburse the estimated sum plus 15,000 marks interest.[44]

The most absorbing aspect of this story may well be that, despite the oddities, obscurities and tokens of deliberate abuse manifest even in its published accounts, the idea that the destruction of *Badewanne* and its companions had resulted from a 'mistake' was not openly questioned. It permitted commentators to indulge in irony, for instance by contrasting Beuys's thesis that 'everyone is an artist' with the statement that not everyone can recognize what art is.[45] The controversial quality of Beuys's fame was also perceptible in a 'mistake' that concluded posthumously the history of his conflictual relations with the Düsseldorf Kunstakademie. After the cancellation in 1972 of his professorship had been declared invalid in 1978, Beuys obtained the right of using his studio in the art school until the completion of his 65th year on 12 May 1986.[46] In 1980 he turned it into the office of the new-founded 'Forschungsinstitut Erweiterter Kunstbegriff' (research institute [for an] enlarged notion of art), the manager of which was his former assistant Johannes Stüttgen. Beuys died on 23 January 1986, and after some hesitation the room was assigned to Klaus Staeck, invited as a visiting professor. On 9 October Stüttgen came to collect Beuys's furniture and discovered in a waste-paper basket (illus. 137) the remains of a *Fettecke*, a 'fat corner' consisting in some five pounds of butter that the artist had applied five metres high in a corner of the room in 1982, at the request of, and as a gift to, his collaborator. The crystalline, geometric and compact form of 'fat corners' symbolized for Beuys a 'cold', intellectual pole opposed to the 'warm' affective

137 Joseph Beuys's former assistant Johannes Stüttgen holding the remains of Beuys's 1982 *Fettecke* ('Fat Corner') in the Kunstakademie, Düsseldorf, with another person showing its original location in the background, 9 October 1986.

one represented by liquid and shapeless fat.[47] Stüttgen immediately informed the Press of the event. The Kunstakademie's administrators explained that after it had organized a cautious cleaning of the room limited to the floor level, the janitor of the school had turned to the walls and corners. He and his workers had 'not recognized Beuys's work as an art object' and had touched it with a broom while sweeping off cobwebs, thus causing it to fall. Stüttgen affirmed on the contrary that it had been 'quite purposefully and consciously thrown down', that this 'highly sensitive and so individual work of art' could not be restored, and sued the Land Nordrhein-Westfalen for 50,000 marks damages. There was a dispute over the ownership of the work because of its relation to the building, but in 1989 Stüttgen won.[48] By contrast, some journalists and most authors of readers' letters tended to sympathize with the cleaners. The director of the Kunstakademie received a letter asking her to congratulate the janitor for having 'done, consciously or unconsciously, the only right thing to do with this Beuysian trash, namely to put it where it belongs, on the rubbish heap'.[49]

138 Pablo Picasso, *Bull's Head*, 1943, bronze, comprising a bicycle seat and handle-bars. Musée Picasso, Paris.

Zeuxis against the grain

Gaps in documentation and the very nature of such events do not allow one to propose definitive interpretations, but it is by now clear that in some of them at least, the fact of not recognizing an object as a work of art indicated a refusal to acknowledge this status. When, of all things, works of art were 'mistaken' for refuse, this scenario represented the most efficient way of coping with the taboo of iconoclasm by both transgressing it – art was damaged or destroyed – and obeying it: art was not overtly criticized, and one could at most speak of a 'unintentional "iconoclasm"'.[50] The interest of the media in these stories, public reactions to them, and the sticking to the 'oversight' hypothesis in the face of all contrary evidence indicate that they also responded to pre-existing needs and expectations.

Further tokens of this can be found in fictional 'mistakes'. A friend of Picasso related that when his *Bull's Head* of 1943, a bronze sculpture made from a bicycle seat and handle-bars (illus. 138), was exhibited after the Liberation, he considered it with amusement and said: 'A metamorphosis has taken place . . . but I should like another metamorphosis to happen in an opposite direction. Suppose my bull's head should be thrown aside as waste and a man come and say: Here is something that I could use as handle-bars for my bicycle. A double metamorphosis would have thus been achieved . . .'[51] This fantasy of an innocent re-functionalization, made possible by the unexplained intermediate stage of the 'waste', has nothing of the 'iconoclastic' dimension of the 'reciprocal Readymade' – a fact that may be related to the difference between Picasso's

303

Bull's Head and Duchamp's Readymades. By contrast, an implicit criticism is obvious in all cartoons imagining comparable situations. George Melly's and J. R. Glaves-Smith's anthology of 'cartoons about modern art' includes three dating – like Picasso's statement – from the decade following the Second World War. In a time of popularization of modern art, they visibly aim at exposing the ignorance, credulity and snobbishness of its new devotees (artists and curators being involved by implication), and rather than people mistaking art for something else, they show people taking for art instruments of its preservation and presentation: a ventilator in R. Taylor's cartoon of 1947 (illus. 139) as well as in another drawing by William Scully published in *Sketch* (7 May 1952), a pedestal – inspired by Brancusi – in a contribution to the *New Yorker* (23 July 1955) by O. Soglow.[52] In 1969 a draughtsman imagined a refunctionalization of a typical 'trap-picture' by Spoerri, performed by a museum guardian who re-erected it in order to take his lunch.[53] The comic strip did not make it clear whether the spectator was confronted with a commodity presented as a work of art or with a work of art abused by the guardian, but the difference was obviously deemed by the author to be irrelevant. These cartoons, like others dealing with the same topic, not only corresponded to the artistic notions and expectations of their public, but also expressed the conflictual relations of commercial artists with autonomous art and 'pure' artists.[54]

All of this calls for the conclusion that the stories in which works of art are mistaken for something else, and especially refuse, represent a fully fledged *topos* of the reception of modern art, sharing features with the jokes analyzed by Freud and with the stereotyped anecdotes of the life of artists studied by Kris and Kurz. In fact, this *topos* is an actualization of one of the major commonplaces of ancient writings on art, that of the work so effectively illusionistic that it is mistaken for the reality it represents.[55] The stock version can be found in Pliny the Elder's *Historia Naturalis* (xxv, 65) with the anecdote of the Greek artists Zeuxis and Parrhasios. After swallows had picked grapes on a painting by Zeuxis, the latter was invited to his studio by Parrhasios. There, he asked his guest to lift from a work a curtain that turned out to be painted. Zeuxis acknowledged Parrhasios's superiority by saying: 'I have deceived swallows, but you have managed to deceive me.' This hyperbolic compliment was based on the notion of art as *mimesis*, as an imitation of reality, a notion that remained effective, even if increasingly challenged, until late in the nineteenth century. It could still be heard, in a paradoxical way, in Balzac's *Le chef-d'œuvre inconnu* of 1831, when the deranged Frenhofer praised his portrait of a nude woman to Pourbus and Poussin, both bewildered by the 'wall of paint' that would later appear as a prefiguration of Abstract Expressionism: 'Ha ha! You're looking for a painting, but you should be looking for a woman! ... Where is the art? Lost! Disappeared! You have never found yourself before so much perfection.'[56]

139 R. Taylor, '*I'm not going to be the one to tell 'em it's a ventilator*', cartoon from the *New Yorker* reprinted in George Melly and J. R. Glaves-Smith, *A Child of Six Could Do It! Cartoons about Modern Art* (London, 1973).

140 Caricature by 'Cham' (Amédée de Noë), '*The Spinner*, by M. Courbet', in *Le Charivari* (29 May 1853). *The caption reads: 'The fresh complexion of this village woman tends to prove that dirtiness is not as prejudicial to health as the world generally believes'.*

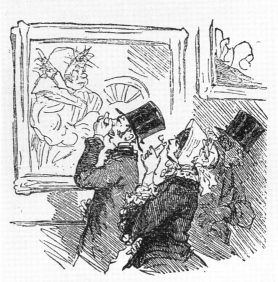

LA FILEUSE, PAR M. COURBET.

La fraîcheur de cette villageoise tend à nous prouver que la malpropreté n'est pas aussi nuisible à la santé qu'on le croit généralement en société.

305

In the classical and academic doctrine, however, what had to be 'imitated' was the *belle nature*, idealized reality, so that Realists were denounced as worshippers of ugliness and destroyers of art. Resemblance with motifs deemed unworthy of representation was not to be pursued, and the old paradigm of Zeuxis' grapes was inverted apropos Courbet, whose depictions of female farmworkers were caricatured as 'stinking' pictures (illus. 140).[57] We have seen that Realists were also symbolized as chipping a Venus into a curbstone.[58] After modern art had radically challenged or rejected representation itself, the 'mistake' *topos* could only reappear in the same negative sense, provided that works seem closer to non-artistic reality than to artistic conventions, or that pieces of reality be introduced into art with little or no modification. In this new version of the ancient anecdote, being mistaken for reality is not called on to attest aesthetic accomplishment but a failure to be perceived and enjoyed as art. The fact that, in some cases, such a judgement can correspond to an artistic intention not to go beyond the quiddity and 'tautology' of objects further illustrates the complex relations between artistic 'iconoclasm' and attacks on its products.

The world turned upside-down

The 'mistake' *topos* is both related to a long history of art theory and to recurrent forms and motives of iconomachy and iconoclasm. By refusing to recognize objects as works of art, and especially by treating them as refuse, one demonstrably reduces them to their material dimension. Now this is precisely what many critics of images have tended to do from the Reformation onwards. The French Reformer Guillaume Farel, for instance, appealed to Christian princes for calling 'all crosses, and other such idols trash, stones, wooden trunks, or dead wood'.[59] Iconoclastic actions aimed at exposing an imposture by proving that images were only matter processed by man and owed what power they had to him, not to any immanent or superior virtue.[60] 'Ritual desacralizations' reduced religious objects 'to being once more mere material objects' in two stages: objects were challenged to display their power, and when they could not do so their materiality was demonstrated by smashing them.[61] Even if the theme of a possible reaction of the image generally disappeared afterwards, attesting the effectiveness of the process, this phenomenon was not limited to religious use and abuse. In 1794, Grégoire explained to the Convention in the following terms the educational side of the fight against Revolutionary 'vandalism': 'In this statue, which is a work of art, the ignorant see only a piece of crafted stone; let us show them that this piece of marble breathes, that this canvas is alive, and that this book is an arsenal with which to defend their rights.'[62] Balzac wrote in 1844 that 'for industry, monuments are quarries of rough stones, saltpetre mines or storehouses for cotton'.[63]

Advocates of works had thus to defend, restore or create valorizing associations that their enemies strove to dissolve. Exceptionally, an artist could himself resort to a dissolving strategy when disclaiming an abused work as an expression of his personality, as when David Smith publicly declared that the value of his sculpture *17 h's*, stripped of its original paint, was 'only its weight of 60 lbs of crap steel'.[64] On the level of the study of art, Antoine Hennion and Bruno Latour have recently characterized as akin to iconoclasm the traditionally 'anti-fetishistic' approach of sociology and proposed to renounce this bias by admitting that 'the social is constructed by the objects' and cannot be projected upon them, and that 'we share the social bond with non-humans'.[65]

Another element of resemblance with earlier iconoclastic instances is the inversion of values. We have seen that 'mistaking' art for refuse could constitute an answer to the paradox of works of art, statutorily associated with worth and preservation, exploiting waste materials or assuming the appearance of refuse.[66] It always meant equating art with its opposite on the scale of the social valorization of objects, bringing to the bottom what was or was supposed to be at the top. This is also a common trait of many attacks on images, particularly during the Reformation. Olivier Christin notes that in Rouen by 1560, Huguenots were hanging pictures upside-down – a position remindful of executions *in effigie* – on gibbets, and that contemporaries called 'derision' actions taken against sacred objects that tended to reduce them to a socially devalorized status and often resorted to the scatological and obscene repertory.[67] Natalie Zemon Davis has also pointed to the 'desecration of religious objects by filthy and disgusting means'.[68] The Huguenots of Le Puy called images on paper of the famous Black Virgin of the town 'torche-cul' (arse-rag); the Münster Anabaptists were said to turn pictures of the Virgin into latrine-lids; and high altars were repeatedly used as latrines.[69] Louis Réau has emphasized the recurrence of what he calls 'stercoraceous' or 'excremential vandalism', from the Byzantine iconoclastic emperor Constantine V, nicknamed 'Copronymos' (filthy) by his enemies, to the anticlerical French Republicans who, after the 1905 law of separation between the Church and the State, transformed the church of St-Martin in Vendôme into public latrines. One can add the earlier example of the emperor Nero having images of the singers and actors with whom he competed thrown into the latrines.[70] During the French Revolution, the statues of the kings of Judah from Notre-Dame de Paris – pulled down because mistaken for effigies of French monarchs – were submitted to a similar abuse, according to Sébastien Mercier, who nevertheless thought that 'chance. . .more than malicious intention, had presided over their grotesque and humiliating degradation'.[71]

These phenomena evoke the traditions of carnival, of the world turned upside-down, and more generally of the popular culture studied by Mikhail Bakhtin apropos Rabelais. Bob Scribner has compared Bakhtin's notion of

'grotesque realism', involving 'the lowering of all that is high, spiritual, ideal or abstract to a material level, to the sphere of the earth and the body' and especially basic bodily functions, with the Reformation in Germany as manifestation of collective mentalities.[72] In the incidents linking carnival and Reformation that he studied – most of them dating from the initial period during which the latter could be called a spontaneous and popular movement – the 'mockery, mimicry and parody of official life, culture and ceremonies' also sought 'to overturn the official world by exposing it to ridicule'.[73] This inversion took a particularly radical dimension in Münster, where money was abolished and the Anabaptists declared to hold gold and silver 'als Dreck und Steine' (as filth and stones), reminding Martin Warnke of Thomas More's Utopians who made their chamber-pots of gold.[74] The idea that iconoclasts made use of one 'traditional repertory of punishments and destructions' borrowed from carnival rituals, judicial procedures and parodies of liturgy has been criticized by Christin, who emphasized the historical constitution of the 'rites of violence' of the Reformation and doubted the existence of a universal 'grammar of insult and humiliation'.[75] Keeping in mind this reservation, one must nevertheless notice the persistence of techniques of subversion of values corresponding to relatively stable hierarchies and modes of valorization. The cases that we examined have presented us with a few instances of metaphorical or literal 'excremental vandalism': the inscription 'W.C.' on the head of Stalin's statue in Budapest (illus. 25), 'Kunst-Scheisse' on Luginbühl's sculpture in Bienne, where two other works were used as latrines. As for reversals in general, they were clearly omnipresent: one need only think of George Grosz's use of his parody of Jackson Pollock.[76]

Similar methods, including the scatological and obscene ingredients, have been repeatedly used by independent and avant-garde artists in their assaults on official and traditional culture. In 1899 Alfred Jarry provided an indirect criticism of contemporary aesthetic manifestations by narrating the fictional voyage 'from Paris to Paris by sea' of the 'pataphysician' Dr Faustroll. At some point, Faustroll sent his servant, a monkey called Bosse-de-Nage, to buy canvas at the 'Magasin national, dit *au Luxe Bourgeois*' – a parody of the Musée du Luxembourg, where the French state exhibited the works by living artists in its possession, as a warehouse. Bosse-de-Nage was to pay with gold the *chefs de rayon*, who carried names of famous late academic painters like Bouguereau and Bonnat, and to cleanse his mouth of commercial words by worshipping in a small room the 'icons of the Saints' Puvis de Chavannes, Monet, Degas, Whistler, Cézanne, Renoir and Manet. As the narrator asked if the canvas might not rather be stolen, Faustroll explained that whereas the alchemist Van Gogh called the gold into which he turned everything 'yellow', the sellers' pockets would turn his gold into excrement. As for their canvases, he turned against them a painting machine managed by the Douanier Rous-

141 Adolphe Willette, *Jean Paul Great Pontiff*, caricature of Jean-Paul Laurens in *L'Assiette au Beurre* (9 May 1901).

seau, who carefully covered 'with the calm uniform of chaos the impotent diversity of the grimaces from the national Warehouse'.[77] Two years later, Adolphe Willette caricatured the painter Jean-Paul Laurens, a member of the Académie and *commandeur* of the Légion d'honneur, with a pope's tiara, a latrine-broom instead of a brush and with excrement on his palette (illus. 141). I have mentioned Degas's *bon mot* against the sculptors who 'deposit their works' on the lawns of public gardens. For political rather than aesthetic reasons, a Communard compared in 1871 the 'filthy bronze' of the Vendôme Column to the 'bed of filth' that had deadened its fall, and called it a 'gigantic urinal'.[78] As for Maxime Claremoris, the worshipper of beauty imagined by Larbaud in 1913, who broke Sulpician statues and threw them down the lavatory, he spent two months in a Prussian jail for having put a signboard inscribed 'Pissoir' (public convenience) on a statue of Bismarck.[79]

Such disqualifying equations further emphasize the relevance of Duchamp's choice of *Fountain* (illus. 57) in 1917 as a way of testing the Independents' principle of the freedom of art and of challenging the very notion of taste. It was objected to as 'obscene', although the term would have better suited the 1919 *L.H.O.O.Q.* (illus. 113), the inscribed title of which – as the author later explained to his American audience – 'pronounced like initials in French, made a very risqué joke on the Gioconda'.[80] Among later 'iconoclastic' reversals, the one closest to this theme, and especially to Jarry's parody, was realized in 1961 when Piero Manzoni saved his own excrement, had it canned every day in little tins that he signed, numbered, dated and labelled *Merda d'artista* and offered for sale at the current price of gold. On 25 October 1960,

Arman filled with refuse the Galerie Iris Clert in Paris, keeping the public invited to the opening outside. In fact, the use of 'base' materials was essential to a great number of artistic 'transgressions' and renewals in the twentieth century, with typical oscillations or ambiguities between a subversion of existing hierarchies, a questioning of the notion of hierarchy, and the relic-like 'trans-substantiation' of the commonplace.

Redrawing the line

There has been much discussion about the ultimately revolutionary or conservative character of carnival and carnival-like overturnings of social order. With all due cautiousness, a comparison between the iconoclasm of the Reformation and twentieth-century attacks against modern art seems to me to be potentially illuminating. Natalie Zemon Davis remarked that in sixteenth-century France, many acts of violence reacted against what their perpetrators regarded as 'pollution'. Consequently, they had 'the character either of rites of purification or of a paradoxical desecration, intended to cut down on uncleanness by placing profane things, like chrism, back in the profane world where they belonged'. In other words, the objects considered as offensive – to use a broader concept with which we have become familiar – were first denied their sacredness, so that desecrating them really meant redrawing 'the line between the sacred and the profane'.[81] Bob Scribner reached a comparable conclusion, observing that although carnival could be seen as acting out a desire to overthrow the existing social hierarchy, it generally remained at the level of acting, Münster being the only case where an attempt was made to accompany social degradation in carnival with a broader social change. He considered the ritual character of the actions as a characteristic feature because of the general function of ritual in creating within the social order the harmony and structure menaced by ambiguity or anomaly.[82] In a similar way, Olivier Christin interpreted the iconoclasm of the Huguenots as part of a 'recomposition of sacrality' provoked by transformations in the production of images that endowed them with an unheard-of multiplicity and illusionism.[83]

Again, analogies with events we have studied are striking. Denis Crouzet has explained that churches were destroyed by Protestants because they had to be cleaned of the 'filth which filled them and desecrated divine glory'.[84] For Huysmans, the shops of the quartier Saint-Sulpice were places of 'divine prostitution' and the Devil organized with their help 'the carnival of the heavenly Jerusalem'.[85] For Pie-Raymond Régamey too, ugly and sentimental images represented a profanation of religion (illus. 110), from which churches had to be purified. As Sergiusz Michalski has remarked, the inflation of statues denounced as 'statue-mania' was perceived as a 'profanation of the cult of monuments', because the 'border became blurred between the eternity con-

gealed in marble or bronze on the one hand and daily life on the other hand'.[86] Josef Kleer saw in *Who's Afraid of Red, Yellow and Blue IV* a symbol of a world in which values were turned upside-down, and defined his deed as a 'small contribution to cleanness'.[87] The author of the letter approving of the destruction of Beuys's *Fettecke* thought that it had been forwarded 'where it belonged', and by asking the rhetorical question 'art-scrap or scrap-art?', the poster of an opponent to Olaf Metzel's assemblage of road barriers and trolley (illus. 61) clearly appealed to reinverting the artist's 'iconoclastic' inversion of material values.

These examples are enough to remind us that the critics of art whose actions we have studied also intended to redraw a line, generally the one separating the artistic from the non-artistic. Such attempts tended to react to a displacement or to a blurring of limits that could derive from redefinitions or de-definitions of art.[88] Cases in which art was 'mistaken' for something else most clearly represented – to adapt Natalie Zemon Davis's formula – a 'placing non-artistic things, like refuse, back in the non-artistic world where they belonged'. The motivations and purposes of these actions are thus by necessity conservative, at least as far as cultural order is concerned. With social order, things are more complicated, since the revolutionary claims of avant-gardes and avant-gardism have too often revealed themselves to be limited to internal use. We have seen how 'objects to destroy', once attacked, could turn into 'indestructible objects'. In order to define the 'radical' experiments of the 1960s, Pierre Bourdieu resorted to a phrase that Bob Scribner would use for the Reformation, that of 'ritual desacralizations', and commented indirectly on Duchamp's critique of the belief in the 'truth of art' by affirming that 'art cannot deliver the truth on art without stealing it away by making of this unveiling an artistic manifestation'.[89] This may be a too global and pessimistic view, however, akin to Duchamp's own 'anti-fetishistic' stance. We have seen that Hans Haacke could include art and the art world in the objects of his critical enquiry without renouncing making art. He also insisted on the importance of the historical and cultural context of reception, on the heterogeneity of publics, and on the fruitful possibilities of both the autonomy of art and its limits.[90]

15 Disqualification and Heritage

'De-arting'

Mistaking art for refuse also represents an outcome of the 'aesthetics of the beholder', a foundation of which was laid – according to Werner Hofmann – by Luther when he declared that images are 'neither good nor bad' in themselves but depend, like the Sacrament of the Communion, on the word and on interpretation: 'if you take away the word or see it without the word, then you have nothing but mere bread and wine'.[1] As Hofmann remarked, Readymades proceed from the same nominalist attitude, and it is not surprising to find that Duchamp adhered to this aesthetic. His conviction, expressed on several occasions, that 'it is the BEHOLDER who makes the pictures', may seem to contradict the definition of the Readymade as an object 'promoted to the dignity of work of art by the mere choice of the artist', but it really attests to his awareness of the collective character of this 'trans-substantiation' as well as his preoccupation with posterity.[2] A particularly radical and pessimistic formulation of this tenet appears in the letter of 1952 to Jean Crotti from which I have already quoted:

A picture is *not* made by the painter but by those who look at it and grant it their favours; in other words, there does not exist a painter who knows himself or knows what he is doing – there is no exterior sign that explains why a Fra Angelico and a Leonardo are equally 'recognized'.

Everything happens through pure luck. Artists who during their lifetime have known how to make their shoddy goods appreciated are excellent travelling salesmen, but nothing guarantees the immortality of their work. And even posterity is a real bitch who cheats some, reinstates others (El Greco), and is also free to change its mind every 50 years.[3]

Duchamp gave a more balanced view of the same process in the public talk given in April 1957 at the meeting of the American Federation of the Arts in Houston. While emphasizing that 'the artist may shout from all the rooftops that he is a genius; he will have to wait for the verdict of the spectator in order that his declarations take a social value and that, finally, posterity includes him in the primers of Art History', he spoke of 'the two poles of the creation of art: the artist on one hand, and on the other the spectator who later becomes posterity'. A further passage probably alluded to the special case of Readymades:

'The creative act takes another aspect when the spectator experiences the phenomenon of transmutation; through the change from inert matter into a work of art, an actual trans-substantiation has taken place, and the role of the spectator is to determine the weight of the work on the aesthetic scale.'[4]

In his contribution to the 1972 'collective portrait of Marcel Duchamp', Allan Kaprow, chief theorist of the 'Happening' in the late 1950s, considered that whereas the Readymades were 'radically useful contributions to the current scene', the 'reciprocal Readymade' had produced few progeny: 'Conversely, since any non-art can be art after making the appropriate ceremonial announcement, any art, theoretically, can be de-arted. . . . This, it turns out, is a bit difficult. Duchamp's gesture in this direction, his *L.H.O.O.Q.*, didn't alter the *Mona Lisa*, it simply added one more painting to the museums. Replacing the meaning and function of the history of the arts with some other criteria seems to interest us much less than discovering art where art wasn't.'[5] To some extent, this remark points to the difference between metaphorical and literal 'iconoclasm', and to the limitations of 'ritual desecrations'. On the other hand, it is based on the assumption – contradicted by Duchamp, as we have seen – that an artist is able to promote an object to the dignity of work of art or to degrade it from this dignity *alone*, without any 'weighing' by 'the spectator'. In fact, 'de-arting' is an extremely widespread and common phenomenon if one understands by the term not an instantaneous and individually operated transformation of art into non-art, but the collectively and historically produced devaluation and disqualification of works of art. By reason of its essentially theoretical nature, the 'reciprocal Readymade' may be better entitled to symbolize this process than Readymades are to illumine the social construction of art. The physical degradations and destructions on which our enquiry has been centred can be regarded as extreme and crude forms of this much more pervasive phenomenon, while more subtle methods appeared in the verbal and metaphorical attacks or in the legal proceedings of 'embellishing vandalism'. The continuity and coherence of these varied actions and statements can be observed and further explored on the linguistic level by means of the recurrence of prefixes denoting deprivation, such as 'de-' (deface, defame, deform, degrade, delegitimize, denounce, deride, destroy, devalue, as well as debase, debunk, declaim, declassify, decry, delete, denigrate, deprecate, despise or detract) and 'ab-' (abase, abate, abhor, abjure, abolish, abominate, abridge, abuse).

Techniques of defamation and collective objects

In this broader context, openly conflictual situations involving physical or verbal attacks and resistances are especially interesting because they force antagonists to make explicit and justify their objections. The battles fought

around the removal of Serra's *Tilted Arc* and of Tomsky's statue of Lenin are obvious cases in point. Equally remarkable among techniques of defamation are the denigrating comparisons (by assimilation or dissimilation) of which we have met many instances: with Montalembert in 1839 (illus. 107), Schulze-Naumburg in 1928 (illus. 18), the exhibitions 'Deutsche Kunst' and 'Entartete Kunst' in 1937 (illus. 19), Charles Du Mont in 1944 (illus. 103), the 'Angers pamphlet' (illus. 106) and Régamey's issues of *L'Art Sacré* in the years following the Second World War (illus. 109, 110) . . . A purely verbal variation on this theme was proposed by the editor of the French journal *Esprit* in a contribution to the recent French campaign against 'official' contemporary art. Without providing reproductions of the paintings mentioned, Jean-Philippe Domecq asked his reader to evoke mentally 'diptychs of interrogation' opposing Mondrian to Vieira da Silva, Klee to the Czech Mikulas Medek, Miró to the seventeenth-century model of one of his *Netherlandish Interiors*, and Picasso to Velázquez; in each case, the superiority of the second work was supposed to be manifested by its retaining 'the gaze longer than the other one'.[6]

We have seen that real destructions tended to correspond to these symbolic assaults – directly or indirectly. In October 1930, Schulze-Naumburg, a member of Alfred Rosenberg's 'Kampfbund für Deutsche Kultur' (combat league for German civilization), was personally responsible for the whitewashing of Oskar Schlemmer's wall paintings in the Weimar Bauhaus building. However, as Marcel Struwe has remarked, this remained a relatively rare example of literal iconoclasm, and what it led to was rather a 'systematic disposal' of works that 'eliminated their artistic character' by depriving them of 'their claimed autonomy and of the corresponding reception', while 'preserving in them what had lost its autonomy, namely their mere materiality'.[7] In this case, works were not only devalued but disqualified as art, a fact emphasized by the quotation marks surrounding the word 'Kunst' on the cover of the publication that accompanied the 1937 defaming exhibition (illus. 142).

In fact, acts of devaluation and disqualification are all the more efficient as well as unobtrusive when they are based on a long tradition and a broad consensus, and need not resort to spectacular means. The defaming of groups of works – gathered according to stylistic, iconographic or functional criteria – often begins with arbiters distinguished by the originality of their opinions. If they are successful, it becomes common and institutionalized, and tends to apply to works initially distinct or even opposed to the relevant group, as we have seen with the partial assimilation of 'modern religious art' to 'St-Sulpice'. Eventually, the negative dogma may be questioned by new prophets who launch a 'rediscovery' of the kind studied by Francis Haskell. Haskell has thus quoted a typical statement made in 1845 by the young Ruskin writing from Bologna: 'So much the worse for Raffaele. I have been a long time hesi-

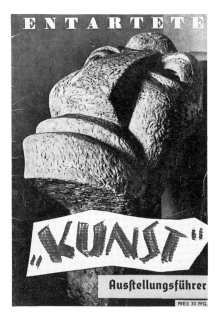

142 Cover of a pamphlet *Degenerate 'Art' Exhibition Guide* published in Berlin in 1937, shortly before or after the closure of the first showing of the *Entartete 'Kunst'* exhibition in Munich.

tating, but I have given him up to-day, before the St Cecilia. I shall knock him down, and put up Perugino in his niche.' He could even mention an early case of a 'reciprocal Readymade', described by the French art dealer Jean-Baptiste-Pierre Le Brun when he evoked in 1783 'one who, summoned to a house filled with pictures by the greatest masters, by chance went into a room somewhat apart and found that the main table in it was made up of one of Annibale Carracci's masterpieces that had been attached to a base solid enough to resist the ravages of time for a few years more'.[8] But in the meantime, during what is often termed a 'purgatory', works may disappear without notice – precisely because they have become invisible or non-existent as works. The fate of Simone Martini's altarpieces during the seventeenth and eighteenth centuries thus prompted Andrew Martindale to emphasize the role of indifference, apathy or 'iconameleia' – a pseudo-Greek word coined to designate this attitude – in the disappearance of the past. He proposed to situate it 'somewhere between iconoclasm and iconodulism', but noted its structural kinship with the former by adding to the statement that 'doing nothing is, both philosophically and practically, no less positive than doing something' the reminder that 'the results of doing nothing can indeed be dramatic, especially in architecture' – as we saw with the example of the Molitor swimming-pool.[9]

'Rediscoveries in art' are thus preceded and made possible by negative judgements and anti-conservational measures, which have generally been less researched than have rehabilitations, perhaps because historians of art are primarily heirs and contributors to the latter. One could examine more systematically, from this point of view, the aesthetic devaluation or disqualifi-

315

cation of medieval, Renaissance, Baroque, Rococo, Neoclassical, historicist and even modernist – to use some period and stylistic labels as simple categories – art and architecture. Voltaire's opinion on the 'buildings of Goths and Vandals' obstructing the view of the Louvre has already been mentioned. In his unfinished *Introduction à l'histoire de l'art français*, André Chastel considered that of all Western countries, France is the one where even famous works of the past have been most easily destroyed as a result of 'either indifference and lack of interest, or the conviction that an outdated work deserves to be eliminated'.[10] Among the examples that he gave are another remarkable condemnation of medieval art by Jean-Jacques Rousseau – 'the portals of Gothic cathedrals subsist only for the shame of those who had the patience to make them' – and a telling anecdote about the rejection of eighteenth-century art after the French Revolution: when Jean-Honoré Fragonard found his son, Alexandre-Evariste, born in 1780 and also a painter, burning his collection of prints, and asked him what the hell he was doing, the latter replied: 'I offer a holocaust to good taste'.[11] According to another story, Watteau's painting *Pierrot* (long known as *Gilles*) was bought prior to 1820 for 100 francs from a merchant who had chalked out on the canvas two lines of a popular song: 'Que Pierrot serait content / s'il avait l'art de vous plaire' (Pierrot would rejoice so much / had he the art of pleasing you).[12] An interesting formulation, close to Balzac's remark of 1844, was written down in 1825 by Charles Nodier when relating his intervention in Le Grand Andeli. The Grande Maison was being demolished by workers who, he said, 'hammered walls dumb for a degraded generation that sees only building stones behind all this'.[13]

'Statuomanie' and 'St-Sulpice' have already provided us with sufficient examples of the later disqualification of nineteenth-century art. Statues, and especially plastercasts and models (a technical and material category rather than a stylistic one), are of outstanding relevance in this context, because the particularly profound and lasting indignity that was, and to a large extent still is, inflicted on them owes much to their real, apparent or supposed disregard for the modern requirement of uniqueness, as well as to the greater attachment of sculpture to *destination*. In 1986 Jacques de Caso emphasized the interest of the history of 'the abandonment, the destruction, the stealing of objects and works of art from knowledge' for historians and historians of sculpture. He mentioned a case of 'gradual abandonment stretched out in time' with the disappearance in the 1930s of eight colossal statues by David d'Angers and Ramey that had decorated the Porte d'Aix in Marseille, probably after they had been neglected and degraded beyond repair. A later example that he related combined 'radical' politics and aesthetics. In 1968 the director of the Ecole des Beaux-Arts in Paris, who was an artist, authorized his students to organize a ball in an underground room in which a part of the collection of sculpture was stored, as well as to remove themselves the works to a nearby

room. The statues were placed in a heap, the 50 'modelled sketches' of the collection devastated, and the keeper prevented from intervening. The director later explained that this elimination had represented a 'desired' sign of 'new' modes of thinking and making art.[14] In 1994 Anne Pingeot came to the conclusion that 'abandoned collections' remained numerous, and that the most important one, that of the Ecole des Beaux-Arts, was then being submitted to a 'deliberate decay' (illus. 143) involving the suppression of the position of keeper.[15]

Examples of similar destructions or degradations could be multiplied endlessly. To mention only two involving works that had not yet entered, or were in the process of entering, public collections, the plaster models of the Swiss sculptor Richard Kissling, author of many important official monuments, were thrown into Lake Zurich after his death in 1919, and the museum of Rheims preserved only the heads of those of René de Saint-Marceaux, bequeathed in 1922 by his widow.[16] Like the abuse of monuments of the French Third Republic in the context of post-War 'embellishing' modernization, these cases show that the elimination of 'Communist monuments' can also be regarded as an extension of a much broader phenomenon. A last token of this fact can be found in the proposition of a 'cemetery for sculptures and monuments' launched in 1991 in Zurich (illus. 144). The author of this project, an architect who had organized the 1986 'Swiss Sculpture Exhibition' in Bienne, argued that many monuments and sculptures in the city, representing 'the rising middle class of the nineteenth and of the first half of the twentieth century', must leave room for today's generation as well as for works by younger artists, that the transformation of their environment had often made them inappropriate, and that 'no sculpture is primarily entitled to eternal life'. Published reactions to this idea introduced distinctions between political monuments and modern 'drop sculptures', reservations about a sacrifice of memory on the altar of renewal, and the observation that it was ambiguous, 'neither iconoclasm nor statue-worship'.[17]

Museums and movements

In the Ecole des Beaux-Arts, the degradation and neglect of plaster models that had fulfilled pedagogical functions in the past can be interpreted as an expression of the modern conflict between heritage and creation. The Rheims case of beheading as admission fee in a public collection rather indicates that the institutions devoted to the preservation of works of art or other cultural goods are also involved in elimination. This too rarely mentioned fact does not merely result from faults, oversights or shortcomings, but is primarily an effect of their mission of selection – which was performed in an admittingly crude way with Saint-Marceaux's models. What David Lowenthal wrote

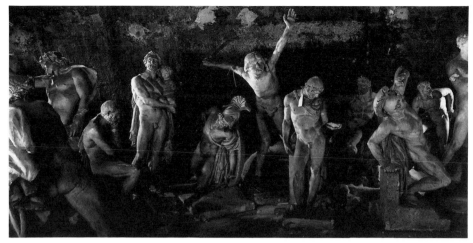

143 Plaster models of sculptures by winners of the Grand Prix de Rome between 1815 and 1900, in store in a cellar of the Ecole des Beaux-Arts, Paris, in 1994.

144 Niklaus Morgenthaler, seen in his proposed 'cemetery for sculptures and monuments', in a photomontage by Uri Werner Urech published in *Die WochenZeitung*, Zurich (4 October 1991). On the left in the background, the monument to Alfred Escher by Richard Kissling (1883-9), actually in front of Zurich's main railway station.

about museums of history, that 'inclusion in a museum signals moral endorsement no matter what display labels may say', is even more valid for art museums – 'moral' being read as 'aesthetic' – where labels tend to refrain from making qualifying comments.[18] Selection first and foremost operates at the entrance, where objects potentially or actually proposed as acquisitions, gifts, bequests, loans or deposits either become part of the collection and are thus granted a theoretically unlimited protection, or remain exterior to it and are abandoned to whatever use and abuse may be their lot. This sorting is more important with modern than with ancient art, since it participates in the 'production of rarity' and has not been preceded by a history of eliminations. The first director of the Museum of Modern Art in New York, Alfred H. Barr, thus lucidly defined his task as 'the continuous, conscientious, resolute distinction of quality from mediocrity - the discovery and proclamation of excellence'.[19]

Selection and elimination, however, are not restricted to the threshold. For obvious reasons pertaining to their conservational purpose and to the law of heritage and public property, destructions are normally not documented within museums. A non-artistic example may therefore be mentioned. In the inventory of the Bernisches Historisches Museum, one finds under the entry 19643 the mention 'destroyed!', dated 1957. The period concerned was that of the first extensive reshaping of the Museum, during which the overfilled rooms were emptied and the presentation was concentrated on the aesthetically most valuable items of the collection. Number 19643 was an object far removed from such criteria, namely a mummified calf that had been used in the 1860s as an animal amulet during an epidemic in an Alpine region and had entered the collection in 1928 as a testimony regarding rural folklore.[20] Like the vigorous handwriting and the use of an exclamation mark, the very recording of this elimination probably attests the especially offensive quality of the object for the eye of the responsible curator, made possible by the heterogeneous character of the collections and by changes in the conceptions and priorities of the institution. Under less exceptional circumstances and with a less conscientious selector, the amulet would have disappeared 'without leaving a trace', as the usual formula goes.[21]

By contrast, an official and legal – in some countries and types of museums – way of getting rid of collection items is 'de-accessioning', which means suppressing from the inventory and generally offering for sale. This obviously implies that some economic value is at least recognized in the works disposed of, but also that they are deemed less precious for the collection than the ones their sale may help acquire. We have seen that one sequel of the *Tilted Arc* affair was a revision of the agreement between concerned American Federal agencies 'to deal with conservation and de-accession, as well as installation, of public art', and that Tomsky's statue of Lenin was cancelled from the list of protected monuments prior to its removal – similar measures were taken in

other *Länder* of the former East Germany.[22] The theoretical and practical stakes involved in de-accession were made clear when, in 1987, the British Government endeavoured to allow and encourage the Trustees of the Tate Gallery, the National Gallery and the National Portrait Gallery to put on the market 'duplicates' and paintings either irretrievably ruined or considered as 'unsuited for the collection and devoid of interest for the public and for research'.[23] A suspicion that the intended result was an excuse for further reducing acquisition budgets contributed to the opposition with which this suggestion met, but there were less tactical arguments against it: the chilling effect on potential donors, the problematic character of the notion of 'duplicate', and the awareness that historical transformations of value judgements and criteria would inevitably turn some of the apparently most sensible de-accessions into gross mistakes – an apprehension justified by famous American examples, which had led one art dealer to cite Max Friedländer's maxim 'one always sells what one doesn't understand'.[24]

Without leaving collections and museums, works are generally submitted to movements within exhibition rooms and from there to storerooms (and vice-versa) that are practical expressions of interpretation and judgement. On this level, devaluation is mediated by the management of presentation and preservation resources, and takes the normally reversible form of relegation – a capital difference with destruction and (most of the time) with de-accession. In 1909 and 1912, the French art historian Louis Dimier complained about the absence of the Italian seventeenth-century paintings that had been removed from the walls of the Louvre some twenty years earlier and listed the pictures of what he called 'the invisible Louvre'. Two paintings from a series of 1992 entitled *Paintings with Veils and False Tails*, presented by Jenny Watson in the Australian Pavilion of the 1993 Venice Biennale, alluded to the same phenomenon and suggested iconographic explanations for the differential fate of related works: no. 3, *Pleasure*, depicted a woman, lying naked, being approached by a horse, and was accompanied by a large label inscribed 'This painting is in the process of becoming important', while no. 10, *Domestication*, showed a woman cleaning a floor on her knees and was commented on thus: 'This painting is in the process of being relegated to a back room'.[25] It must be remembered, however, that according to conditions of transportation and of storage, relegation can exert a negative influence on preservation, and may even represent – directly or indirectly, immediately or in the long term – a euphemized mode of elimination.

This is even more true in public spaces, where the relevance of Richard Serra's affirmation that 'to remove the piece is to destroy the piece' is not only a matter of art theory. We have seen that among the recent tokens of a growing awareness of this mutual determination of work and context was the 1987 'Skulptur Projekte' exhibition in Münster, which aimed at the creation of

sculptures that would be 'one with their place of origin' and 'lose their meaning if removed'.[26] A contributor, the Swiss Rémy Zaugg, discarded the idea of adding another object to the town and attempted instead to recreate an already existing but relegated work by Karl H. Bernewitz. The two bronze groups, representing cattle-breeding by means of a maid with an ox and agriculture by a farm-labourer and a horse, had been set up in 1912 on either side of the main street as a sign of welcome for the Westphalian farmers coming to town, transferred onto a low common pedestal close to the new-built second town hall in the 1960s as a result of changes in traffic and taste, and were half-concealed by building materials when Zaugg accidentally discovered them (illus. 145). He denounced the removal and abasement of these statues as an 'administrative vandalism' – a kind of reciprocal Readymade – that remained unnoticed because it destroyed 'not the objects, but the relations between them'. He proposed either to let the remaining 'skeleton of monument' wholly disappear, as an 'act of public cleanliness and intellectual hygiene', or to remake a sculpture out of it – a kind of Readymade – by removing it to the place where 'the phenomenal and functional expression of the sculpture would possess the greatest analogy with the supposed original expression'.[27] The latter proposal was realized (illus. 146), and although it impressively demonstrated the irrevocability of the transformation of an urban context, it met with such a popular approval that the town decided to make it permanent. Appreciation was based on a subtle kind of mistake, however, as was proven by the scandal that Zaugg's request for additional fees provoked. Authors of readers' letters and some journalists considered that he had done nothing worth remunerating, while the artist insisted that he had 'made a monument again out of the scrap of this destroyed sculpture' and criticized the 'primitive fetishism' that ignored the fact that 'one can leave the material forms of a sculpture untouched and yet inflict substantial damage on it'.[28] Another recent work can be understood as a lighthearted comment on the particular dependence of 'public art' on context and on the continuous care needed to be given to every work of art in order to retard its disappearence: the snowman created in 1990 by Peter Fischli and David Weiss, together with an ice landscape, for the thermic power station Römerbrücke in Saarbrücken (illus. 147): installed in a showcase near the porter's office, it is preserved by the same energy as the heat produced by the station and was defined by its authors as the 'soul of the whole machine'.[29]

Manipulations and transformations of status

The 1960s had already produced interesting experiments in the relation between work and context. In 1966, David Bainbridge, a member of the British Art & Language group, used a commission from Camden Borough Council in

145 Karl H. Bernewitz's *Maid with Ox* and *Farm-Labourer with Horse*, both 1912, bronze, behind a building fence in Münster, Westphalia, in 1986.

146 Rémy Zaugg's re-installation of Karl H. Bernewitz's *Maid with Ox* and *Farm-Labourer with Horse* on the circular plot of Ludgeriplatz, June 1987.

147 Peter Fischli and David Weiss, *Snowman*, 1990, snow, metal and glass. Heizkraftwerk Römerbrücke Thermic Power Station, Saarbrücken.

north London to build a 'plaything' as a pretext for investigating the changes of status possible within one object, which was supposed to be 'sometimes a member of the class "art-object" and sometimes a functional crane, depending on the location and attributed function'.[30] The weak point of this demonstration, which looks like an exercise in Goodmanian aesthetics, is of course that status can be proposed, not determined, by the artist alone and forever. The same may be said of a variation on the idea of a 'reciprocal Readymade' devised in 1963 by Robert Morris. This two-part work consisted of *Litanies* (illus. 148), a relief bearing a bunch of keys inscribed with words from Duchamp's 'litanies of the chariot' in the *Green Box* notes for the 'Great Glass', and *Document* (illus. 149), a typed and notarized affidavit by which the artist claims to withdraw from 'the metal construction. . .all aesthetic quality and content and declares that from the date hereof said construction has no such quality and content'.[31] The incorporation of *Litanies* and *Document* into the collection of the Museum of Modern Art in New York, by a gift of Philip Johnson, and the public display of both parts in its rooms may show that the aesthetic disqualification of one's own work is difficult to effect beyond a statement, but they certainly prove that it can be acknowledged and intended – like auto-destruction – as art.

An analogous 'aesthetic withdrawal' was really performed, however, by Man Ray on his arrival in France in 1921; its intention was probably more

148 Robert Morris, *Litanies*, 1963, lead over wood with steel ring, keys and a brass lock. The Museum of Modern Art, New York.

149 Robert Morris, *Document*, 1963, typed and notarized statement on paper and sheet of lead over wood mounted in imitation leather mat. The Museum of Modern Art, New York.

* *the text reads:* The Undersigned, ROBERT MORRIS, being the maker of the metal construction entitled LITANIES described in the annexe Exhibit A, hereby withdraws from said construction all esthetic quality and content and declares that from the date hereof said construction has no such quality and content.

Dated: November 15, 1963 Robert Morris

STATE OF NEW YORK
COUNTY OF NEW YORK

On the 15th day of November 1963, before me personally came ROBERT MORRIS, to me known, and known to me to be the individual described in, and who executed the foregoing instrument, and duly acknowledged to me that he executed the same.

[signature]
Notary Public

serious, less profound, and more provisional. According to his autobiography, published in 1963, he managed to have his works exempted from taxation by explaining that the paintings were 'in no way intended for duplication or commercial exploitation' and – as he was 'not wishing to enter into an exposé of what constituted a Dada object' – by letting the customs officer mistake his assemblages for a 'guide' for colour combinations, a 'decoration' or a 'primitive idol made by the American Indians'.[32] The contradiction with Man Ray's attitude towards the insurer in 1957 need not be emphasized, and obviously derives from the opposite financial consequences of an acknowledgement of artistic status. This story may well stand for the kind of most frequent unpublicized 'self-disqualifications', since customs law tends to associate the apparently theoretical question of aesthetic categories with very practical and sometimes weighty issues. It has been particularly the case in the United States after the Supreme Court held in 1892 that not all art would be admitted duty free into the country but only fine art, i.e. that 'intended solely for ornamental purposes, and including paintings in oil and water, upon canvas, plaster, or other material, and original statuary of marble, stone or bronze'.[33] In 1916 the Customs Court had introduced a 'representational test' that further limitated the duty-free category to 'the free fine arts imitative of natural objects as the artist sees them, and appealing to the emotions through the eye alone'. This remarkably conservative requirement was abandoned in 1928 as a result of one of the most famed cases involving art and the law, *Brancusi v United States*.

The affair is well-known and will only be briefly recounted here.[34] At its centre was *Bird in Flight* (illus. 150), a bronze sculpture bought from Brancusi by the American photographer and gallery owner Edward Steichen, which had been taxed at 40 per cent *ad valorem* – 240 dollars – as a 'manufacture of metal'. After hearing expert testimony from both sides (among others Jacob Epstein for Brancusi) as well as witnesses, the Customs Court overruled customs officers and held that *Bird in Flight* was a work of art and as such entitled to free entry. It characteristically relied on the opinion of intrinsic authorities, admitted that the work was an 'original production by a professional sculptor', and concluded from the development of 'a so-called new school of art whose exponents attempt to portray abstract ideas rather than to imitate natural objects': 'Whether or not we are in sympathy with these newer ideas and the schools which represent them, we think that the fact of their existence and their influence upon the art world as recognized by the courts must be considered.' Despite its intrinsic interest, the debate itself need not detain us, while its circumstances are highly revealing.

The increasing abstraction of Brancusi's works and their polished surfaces could evoke an industrial processing – if not use – and the presentation of several versions of *Bird in Flight* in New York had been liable to enforce the

150 Constantin Brancusi, *Bird in Flight*, 1926, bronze on stone and wood bases. Collection Hesther Diamond.

impression of a serial production. In any case, according to Thomas Munro, the collector of customs had not acted alone but 'had been advised by certain artists, members of the National Academy and National Sculpture Society, that it was not art and not sculpture'.[35] If so, the officer's 'mistake' expressed primarily a disqualification of Brancusi's work – and, by extension, of modern sculpture – by unlike-minded competitors. Moreover, its protectionist dimension was geographic as well as stylistic. In 1909 the American Congress had imposed a 15 per cent duty on the importation of all works of art less than twenty years old, the increased cost being borne by the collector. This measure was obviously directed against modern European art, which was occasionally labelled 'Ellis Island art'. In 1913 this tariff regulation was successfully denounced by the Association of American Painters and Sculptors, which organized the 'Armory Show', and especially by the attorney, collector and dedicated advocate of modernism John Quinn.[36] Brancusi's contribution to the Armory Show was highly appreciated, but it was also greeted by defamatory interpretations, such as the description of it as 'a hard egg on a piece of sugar'.[37] Margit Rowell relates that, in 1914, the artistic status of works

shipped for his first personal show was already being questioned, and that he had to swear at the American consulate in Paris that they were by his own hand. Over the next ten years Quinn helped to prevent such incidents, even advising in 1922 Henri-Pierre Roché, the artist's agent in New York, to declare Brancusi's wooden pedestals as 'sculptures' so that they be exempted. But in 1924 Quinn died (prematurely) of cancer, which of course meant that Brancusi's works no longer enjoyed his protection. They were none the less further promoted by Roché and Duchamp, who occasionally made a living from his sales. It was Duchamp who arranged the Brancusi exhibition at the Brummer Gallery and who accompanied the works. In 1927 he bought with Roché and Mrs Charles Rumsey, at the artist's request, Quinn's Brancusi sculptures at the public auction of the late attorney's collection. It is thus not surprising to find that Duchamp was also the one who decided to appeal against the customs decision and mobilized the New York art world for financial and legal help in the name of the free circulation of works of art. Ten years after *Fountain* had been rejected by the American Society of Independent Artists as a 'piece of plumbing', there were indeed for him commercial and artistic as well as theoretical reasons for attempting to disqualify the disqualifiers.

 A spectacular example of transformation and contradictions of status is provided by the case of graffiti after the Second World War. Graffiti are generally defined as unofficial drawings or inscriptions made on surfaces the main function of which is not usually related to that purpose.[38] Transgression is thus to some degree essential to this kind of unauthorized expression, which tends to be illegal and illegitimate. However, as Stanley Cohen noted, 'the writing of graffiti . . . is a form of behaviour with a long history of institutionalisation'.[39] I have cited Rodolphe Töpffer's defence of the people's right to self-perpetuation. One could also mention the stones of the north tower of Strasburg Cathedral, on which visitors have had their names incised, together with their quality, provenance, and the date of their visit, from the second half of the sixteenth century until 1836, at which time no more room was available. All these inscriptions could be seen as a way 'to appropriate architectural heritage', but some of them – Goethe's in particular – soon became monuments in their own right.[40] To a certain extent, the legitimization of graffiti was part of the 'discovery' and utilization of 'popular culture' by elite culture, together with that of the art of children, of the insane, of rural and 'primitive' societies.[41] But its practice continued to represent an appropriation of the public realm, and it is no chance that the writer Restif de La Bretonne began to inscribe his private diary on the walls of the Ile Saint-Louis in 1779, at the time when 'public place' was taking its modern form in Paris.[42] In the twentieth century, it was especially associated with the 1968 revolt, and with the Berlin Wall as seen and commented on from the Western side.[43]

 Together with the development of 'underground' or 'alternative' cultural

movements, the technical facilities of sprays and felt-tip pens contributed to the expansion and transformation of graffiti in Western urban societies from the 1970s on. These often provocative graphic and verbal inventions were denounced and repressed as 'vandalism' on the one hand, praised and encouraged as 'art' on the other. Condemnations were based on the fact that while expressive – a property generally denied to other forms of 'vandalism' – graffiti nevertheless instrumentalized and degraded property and heritage. The fact that public buildings and sometimes sculptures or even paintings happened to be chosen as surfaces does indicate that official culture could figure among the targets; graffiti can also belong, as we have seen, to critical abuse of art at large.[44] By contrast, positive judgements tended to emphasize aesthetic qualities and to modify the forms of graffiti as well as their conditions of production and reception, with the appearance of recognizable individualities and reproductions, of careers and movable works. The simultaneity and contradiction of the two statuses is particularly striking in the case of a 'pioneer' like the 'sprayer of Zurich', Harald Nägeli, who could at the same time be pursued, arrested, convicted and jailed, and be sponsored, collected and defended by artists (among others Beuys in Germany, Tinguely and Luginbühl in Switzerland) and by art institutions; as for his graphic interventions, they were officially removed in Switzerland, officially preserved and even restored – after being 'vandalized' – in Germany.[45] In 1987 the Swiss news agency ATS announced that a town employee of Heidelberg entrusted with cleaning the fronts of buildings had destroyed 'by mistake' two of Nägeli's sprayed drawings because he 'had not noticed that they were works of art'.[46]

The climax of this schizophrenia of values may have been reached in Paris when, in 1983, the Fondation Nationale des Arts Plastiques et Graphiques sued, for having sprayed heads on the wall surrounding its premises, the artist Gérard Zlotykamien, from whom it had bought six years earlier a graffito executed on a window-blind.[47] Paradoxes of the official cultural sponsorship of illegal 'degrading' practices were further emphasized when, during a controversial exhibition entitled 'Graffiti Art' organized by the Direction des Musées de France at the Palais de Chaillot, anonymous sprayers 'tagged' five Métro stations, in particular those of the Louvre (which features copies of Antique statues) and of the Assemblée Nationale, decorated by the French painter Jean-Charles Blais.[48] By reducing their content to a kind of territory-claiming signature and their explicit addressees to insiders and competitors, 'tags' enforced the anti-social dimension of graffiti. New York and its subway system became the centre and paradigm of a truceless war of images between 'taggers' and cleaners, and between 'taggers' themselves. The 'arting' process was also particularly advanced, however, and the New York City Transit Authority had to advertise with posters that 'defacing subway cars with spray paint is vandalism and it's a crime'. Gallerists like Tony Shafrazi (the author of

the 1974 graffiti assault on Picasso's *Guernica*) and the well-established Sidney Janis (who had exhibited Duchamp, and organized in 1983 a successful show entitled 'Post-Graffiti') paved a way into the international art world for selected *enfants prodiges* from the street like Jean-Michel Basquiat.[49] The latter's early contributions to the team inscriptions signed 'SAMO ©', sprayed on the walls of Manhattan from 1978 on, paralleled the ambiguous status of graffiti with that of 'anti-art', and occasionally exposed the self-indulgent 'radicalism' of the Bohemians who had appropriated Soho: SAMO ©/ AS A / NEO ART / FORM', 'SAMO © AS AN END 2 / CONFINING ART / TERMS', 'SAMO ©: ANTI- / ART! / # XXXX', 'SAMO © AS AN / ALTERNATIVE 2 / 'LAYING ART' / WITH THE 'RADICAL?' / CHIC' SECT ON / DADDY$ FUNDS ... 4-U.[50] It need hardly be emphasized that the legitimation that Basquiat's later collaboration with Andy Warhol further attested concerns but the smallest fraction of all graffiti daily executed in Western cities, not to speak of other parts of the world like Pakistan, where two members of the Christian minority were condemned to death for having supposedly painted anti-Islamic graffiti on a mosque in Gujranwalla.[51]

Two sides of the same coin

The current view of the way 'heritage' is being constituted sees it involved in a process of unlimited expansion, from which some elements remain excluded only by reason of accidents, failures or resistance. But we have seen that true to the logic of 'knocking down and putting up', all promoters of preservation, from the 'Anti-Scrape' over Montalembert to Réau and his followers, simultaneously admitted of, or even called for, the elimination of works that they did not value or considered to be 'degrading'.[52] In fact, we are now able to recognize that preservation and elimination are fundamentally interdependent. David Lowenthal has almost reached the same conclusion when he writes that 'to expunge the obsolete and restore it as heritage are, like disease and its treatment, conjoined processes less discordant than symbiotic'.[53] But I do not mean here what has been destroyed and what is being restored as one and the same thing. Rather, I want to make clear that qualifying something – as art, as 'cultural property', as worth being taken care of – necessarily implies disqualifying something else, something that might have been qualified and is being ignored or something against which the qualities of the elected object are being set off. The 'defaming comparisons' that we have identified as a technique of disqualification often really serve this double purpose. The polemical dimension of this phenomenon further implies that what is qualified by someone may be – and often is – disqualified by someone else, and vice-versa. 'Wars of images' and of interpretations come to mind. (This is nothing specific to the world of art, and jurists regard 'the dialectics of qualification–disqualification'

as 'inherent to every act of nomination').[54] The mutual determination of 're-discoveries' and collective devaluations also prompted Philippe Junod to compare the history of aesthetic judgements to the ancient wheel of Fortune, 'where falls compensate for ascents'.[55] Seen in this perspective, appraisal and rejection, conservation and destruction represent two sides of the same coin, and 'selective preservation', however varied in its modes and effects, turns out to be less a contradiction than a pleonasm.[56]

Criteria of disqualification may then be studied in systematic relation to criteria of qualification, for example with reference to the typology of values established by Riegl in *The Modern Cult of Monuments*.[57] One can turn his analysis inside out and show how the absence, loss or denial of each of these values justifies the neglect or the destruction of former and potential 'monuments'. Among 'present values', a deficiency of 'use value' primarily depreciates architecture, but it may indirectly affect the arts applied to it and public art, as in the case of *Tilted Arc*, which was accused of hindering a normal use of Federal Plaza. Decrease in 'novelty value' is all the more general and rapid in that innovation has since Riegl's days become stylized into an indispensable ingredient of artistic quality and status. Because museums have been touched by the 'fever of immediacy' and assume functions of 'discovery' and promotion, their storerooms are less immune than ever from the 'purgatory' period.[58] Works are then bound to decay or perish unless they succeed – like the bough in the Salzburg salt mine in Stendhal's theory of love – in crystallizing 'memory values'.[59] As for a lack of the 'relative artistic value' (which depends on the accord between the work and 'modern artistic intention'), one can recall the recent fate of the official monuments of Communist regimes, which had been conceived, realized and employed against the requirements of autonomy and non-instrumentality essential to the Western definition of the modern work of art. Logically unable to meet these requirements, they remained dependent on an 'intentional memory value' that had become obsolete or 'scandalous' as a result of the fall of their commissioners and ideological prototypes. The same example shows that to be obtained, 'historical value' needs a temporal and emotional distance that often goes together – by means of elimination – with the rarifying of candidates for preservation. Finally, it may seem difficult to deny 'antiquity value' to any material evidence of the past, and Riegl accordingly prophesied the triumph of this value over all others. However, one cannot fail to notice that, even today, objects can be valued as 'ancient' *or* denigrated as 'old' and that there are no fixed chronological boundaries beyond which they would automatically cease to be 'old' and be recognized as 'ancient'. In a remarkable example of the rhetorics of 'destructive preservation', the former Mayor of Lyon thus defined the relationship between the Lyon opera-house as 'renovated' by Jean Nouvel – a providential pun – and the neo-classical building that had provided it with a part of its

materials: 'A truly original work of note in contemporary architecture, the Opéra Nouvel magnifies the past by having wiped out the old.'[60]

When objects are simply found to lack the virtues that would have ensured their preservation, elimination is likely to take the form of 'doing nothing' – to use Martindale's phrase – or to be justified by some 'embellishing' purpose and occasion. But they may also be perceived as exhibiting vices (anti-values rather than non-values) calling for their destruction, a process that assumes in this case a more obviously active and – if there is no broad negative consensus – controversial appearance. This is the situation expressed by the *topos* of the object 'offending' the eye and 'scandalizing' the spectator. It can be retraced from the Reformation down to our own time, and we have seen many examples of it, including this fine piece of dialogue apropos Duchamp's *Fountain*: 'It is gross, offensive! There is such a thing as decency. – Only in the eye of the beholder . . .' – to which must only be added a reminder that the artist is a beholder too, and that production and reception are interrelated.

But if elimination and preservation are two sides of the same coin, then elimination is the dark side, not only in the sense that it may be found depressing, but in the sense that it is concealed. In fact, the two meanings go together: it is hidden because it is repressed. I have already suggested that the consensus obtained by 'heritage' obliged using roundabout methods and definitions of destruction, and the taboo of iconoclasm has been sufficiently highlighted in this book. Since every work of art, whatever its individual qualities and defects, is supposed to incorporate universal and eternal values concerning the whole of present and future mankind, neglecting it – let alone destroying it – offends humanity and the public interest. Something analogous can be said of all material relics of the past, and we have already seen that for Riegl, the distinction between 'artistic' and 'historical' monuments had become irrelevant. On the other hand, since the number of objects laying a claim to artistic or historical status is increasing exponentially while the amount of resources at disposal for their preservation is not, since the specific interest found in each of the claimants varies greatly (according to object, beholder, place, time and circumstance), and many of them get in the way of other interests of all kinds, elimination is bound to take place – and it does. But it does either in aggressive and illegal ways, or in obscure and disguised ones, united in what may well be the paradigm of modern iconoclasm, namely mistaking art for refuse. Born out, to some extent, of the 'Revolutionary vandalism', modern art has been predicated on the universalization of its values and has progressively replaced the question 'is it good art?' by the question 'is it art?'[61] Submitted to these conditions, iconoclasm has tended to assume the form of the answer: 'I have not noticed that it was'.

According to Françoise Choay, this logic began with the popes of the Renaissance and their counsellors, who 'by binding the notion of antiquities to

that of preservation and thus excluding the concept of destruction ... establish an ideal protection the purely verbal nature of which allows masking and authorizes the real destruction ... of the same antiquities'.[62] Dominique Poulot has shown that the anti-vandalistic discourse of the French Revolution must be understood not only as a reaction against the 'Revolutionary vandalism', but as 'the legacy of a rationalization of the politics of iconoclasm'. After the Terror, although one could still find some praising 'the modest expenditure of the purifiers of good taste', many 'preferred to await the natural consequences of indifference and neglect rather than implement a policy of immediate and reasoned selection'. In 1806, the director of the Musée Napoléon, Vivant-Denon, expressed the revealing wish that man might be relieved from the decision and responsibility of elimination: 'It would be ideal if some event caused each century to destroy all the bad paintings that had helped to create good artists'.[63] In Andrew Martindale's words, 'two world wars in the twentieth century have completed a rather different revolution whereby what was once regarded as "maintenance" and an unwelcome drain on one's resources has become in our time "conservation" and a quasi-sacred duty to civilisation'.[64] Modernization must be added to the Wars – they are in fact deeply connected, as we have seen. For David Lowenthal, 'heritage thrives as the felt opposite of obsolescence', and by 'salvaging ever more from erosion and discard, we seek to redress the balance between the ephemeral and the enduring'.[65] Lowenthal considers that such efforts imply a refusal of history, which is 'by definition irrevocable', and are related to a general repression of oblivion, the relation of which to memory parallels that of destruction to conservation.[66] As evidence of the cultic aspect of preservation, he cites the comment made by an American museum curator on her experience of a symposium organized in 1989 on the fate of the ritual and cultural objects that would be restored to tribal groups under the Native American Graves and Repatriation Act of 1991 and then – at least about half of them – be reburied, exposed to the elements, or destroyed for purposes of purification: 'The thought of deliberately letting knowledge perish was as sacrilegious to me as the thought of keeping one's ancestors on a museum shelf was sacrilegious to the Indians in the audience.'[67]

The shortcomings of this conception have tended to become manifest in recent times. Françoise Choay has called for exposing 'the false discourse on the preservation of heritage, which was born during the Renaissance and aims at concealing the real destructions and disfigurements'.[68] Not only does it not prevent eliminations – in fact, quite the contrary – but the occultation of destruction precludes the possibility of a 'reasoned selection' and of a public debate on its criteria and choices. Pleas against the 'worship of the past' may be re-examined in this light, since one may not infer from the fact that destruction needed pretexts that they were all pretexts for destruction. Nathaniel

Hawthorne, for instance, does not seem to have had a particular style, period or place in mind when he wrote in 1859 that 'all towns should be made capable of purification by fire, or of decay within each half-century. Otherwise, they become the hereditary haunts of vermin and noisomeness, besides standing apart from the possibility of ... improvements.'[69] After a day spent at the British Museum in 1855, Hawthorne also formulated a conclusion that strikes unexpected chords among the objects of our investigations, from Bateman's 1916 *Criticism of Life* (illus. 43) to recent denials of artistic status: 'We do not recognize for rubbish what is really rubbish' – a reminder perhaps that if one is consistently relativistic, there is no primary reason to disqualify disqualification rather than qualification, and vice-versa.[70]

Questioning material preservation

I have already mentioned another criticism addressed by Choay to modern preservation practices, namely that 'cultural consumption' eventually means 'cultural destruction'.[71] More fundamentally, Lowenthal considers that 'material preservation is ... at bottom an illusion' because things are identified and cherished 'for their form or genetic continuity' rather than for their 'original substance'.[72] Like other critical commentators of the Western notion of heritage, he points to the existence of 'alternative modes of coming to terms with a legacy' in other societies, even if our own mode has been expanding worldwide in the last decades. The examples of China and Japan have been most frequently cited, although many others could be mentioned – in ancient Assyria for instance, the fact that all buildings, including palaces, were made of brick led the kings to resort to documenting their foundation for the perpetuation of their names and deeds.[73] The Japanese notoriously 'preserve not materials but processes of manufacture' by replicating rather than saving relics and by sponsoring (since 1955) as 'Living National Treasures' traditionally trained craftsmen who are expected to transmit their experience.[74] Regardless of their state of conservation, the great Shinto sanctuaries are regularly dismantled and rebuilt with identical but new materials, and for the famed temples in Ise, this occurs every twenty years.[75]

There is also an implicit criticism of current Western theory and practice in Pierre Ryckmans's essay on 'The Chinese Attitude Toward the Past'.[76] Ryckmans emphasizes what must appear to us as a paradox or a contradiction in Chinese civilization between its 'unique cultural continuity', its 'extraordinary sense of history' and the Confucian praise of the values of the past, and its 'curious neglect or indifference (even at times downright iconoclasm) toward the *material* heritage of the past'. Antiquarianism, while not altogether ignored, appeared very late in its history and was limited to a very narrow category of objects. Moreover, the quasi-monopolistic concentration of ancient calli-

graphic masterpieces in the imperial collections, combined with their inaccessibility and with the looting and burning of the imperial palace following the fall of every dynasty, made it 'practically impossible for most artists, aesthetes, connoisseurs, and critics to acquire a full, first-hand knowledge of ancient art'. Indeed, it is now suspected that the fourth-century *Preface to the Orchid Pavilion* by Wang Xizhi, which was considered as the absolute masterpiece of the art of calligraphy and continuously referred to as its ultimate model, may in fact never have existed. Commenting on these observations, Ryckmans proposes to replace contradiction with coherence and causality. Placed in this broad historical perspective, he suggests, the 'Cultural Revolution' may 'cease to appear as an accidental aberration' and be seen 'as the latest expression of a very ancient phenomenon of massive iconoclasm recurring through Chinese history'; and there may be 'some relation between the inexhaustible creativity of Chinese culture and the periodic *tabula rasa* that prevented this culture from becoming ... paralyzed by the weight of the treasures accumulated in earlier ages'. The moral of this interpretation is that, for the Chinese, 'continuity is not ensured by the immobilism of inanimate objects; it is achieved through the fluidity of successive generations'.

Whatever subtext may have informed Ryckmans's study, it is not my intention to reconcile Confucians and Futurists. But one cannot fail to notice that the 'alternative ways of coming to terms with a legacy' – the saving of fragments rather than wholes, processes rather than materials, representations rather than 'real' things – commended by Lowenthal have been extensively experimented with, in our world and our century, by modern artists of the 'iconoclastic' tradition, who questioned among other 'fetishes' materiality and commodification (illus. 151). The disposal and replication of Duchamp's Readymades may be compared with the rebuilding of Japanese temples, and the 'transfer of rarity' from work to artist with the Chinese conviction that 'man only survives in man'.[77] Differences and difficulties abound, notably around the contradiction between the modern insistence on individualism and innovation on the one hand, and the very ideas of 'tradition' and 'legacy' on the other – Lowenthal concedes that his alternatives are 'not options freely open to modern Western culture' since they are 'patterns that derive from habit, not from deliberate adoption'.[78] But as in the case of Hawthorne's plea for transience, one cannot infer from the fact that the 'representations' of Happenings, performances and ephemeral works have tended to be treated like material relics, or from the fact that the use of perishable materials and unstable combinations has spurred the ingenuities of conservators and curators rather than modified their attitudes and missions, that these experiments were null or disingenuous, and much may still be learnt from them.

The French physician, sinologist, and poet Victor Segalen, who had gathered and preserved Gauguin's last works after arriving on the Marquesas

151 Photograph from the *Boîte-en-Valise* of 1941–2, showing Duchamp's Unhappy Readymade of 1919 (see illus. 119). Philadelphia Museum of Art.

Islands shortly after the artist's death in 1903, first contrasted Chinese and Western attitudes toward the relation between art, time and matter in a prose poem in his collection *Stèles* (1914).[79] He availed himself of the historical priority of the Chinese civilization to invert the usual perspective and make his narrator mock as tokens of 'barbarism' and 'ignorance' the Westerners' use of stone to 'build for eternity', their worship of 'tombs the glory of which is to be still extant, of bridges renowned for their being old'. He affirmed that 'if time does not attack the work, it eats the worker', commended 'building on sand', defined the work as a sacrifice whose material disappearance indicates that it has been accepted, and concluded: 'No revolt: let us honour the ages in their successive falls and time in its voracity.'

When, in 1983, I published the results of my inquiry into the assaults carried out at Bienne and the *Video Blind Piece* affair, I was careful to point out that I

was dealing only with 'violence deliberately exerted by individual or feebly organized actors, devoid of explicit theoretical or strategic support, against objects officially enjoying the status of works of art'. Against the usual labelling of such violence as 'vandalism', I had proposed to call it 'iconoclasm', in order to give it a right to attain intelligibility or even intelligence. An overall study of attacks directed against works of art in modern times would have, I thought, exhausted its author long before its subject. Moreover, a unified approach to the heterogeneous phenomena involved seemed to me bound to serve polemical rather than scientific aims, as had been the case with Réau's *Histoire du vandalisme*.

For better or for worse, I have discarded my own warning. The subject is anything if exhausted, the author is not quite. By doing so, I have broadened the topic even more than I imagined and discovered links between exceptional assaults and unconspicuous instances of daily degradation. In the end, 'iconoclasm' and 'vandalism' appear to me as being but the most visible form of disqualification of art, and elimination as the other side of preservation in a Janus-like process of building 'heritage'. I hope to have thus taken advantage of what I deemed the heuristic value of these apparently abnormal phenomena, which throw an unusual light on 'normal' attitudes and thus teach us about the place of works of art and material culture in society – or rather, taking into account geographical, political and cultural differences, societies. Indeed, this indirect lighting can amount to a return of the repressed, as was the case with jokes in Freud's analysis. I have proposed to consider that this repression results from the stigmatization of 'vandalism' and the universalization of artistic and cultural values, and is further enforced by the constant enlarging and loosening of the notions of heritage – as predicted by Riegl – and of art. According to Françoise Choay, the exclusion of the concept of destruction began in the Renaissance with the binding of the notion of antiquities to that of preservation, so that an ideal protection masked and authorized the real elimination. This is historically close to the role of the Reformation, as noted by Werner Hofmann, in the birth of the modern theory of art. In fact, the major iconoclastic episodes, the French Revolution in particular, being predicated on non-aesthetic functions of images, proved instrumental in establishing for art a primacy of the aesthetic function that would progressively claim the exclusion of all others. But autonomy can never be absolute, as art remains a part of the social fabric, and it implies an increased openness towards the multiplicity of interpretations, uses and attitudes, including adverse and violent ones. The history of iconoclasm thus continues to accompany that of art like a shadow, bearing witness to its substance and weight.

References

Introduction

1 Ernst Kris and Otto Kurz, *Legend, Myth and Magic in the Image of the Artist* (New Haven and London, 1979).

2 D. Gamboni, *Un iconoclasme moderne. Théories et pratiques contemporaines du vandalisme artistique* (Zurich and Lausanne, 1983; Jahrbuch 1982–83 of the Swiss Institute for Art Research).

3 M. Warnke, 'Bilderstürme', in *Bildersturm: Die Zerstörung des Kunstwerks*, ed. M. Warnke (Frankfurt, 1977, 1st edn Munich, 1973), p. 8.

4 P. Valéry, 'Préambule' to the Exposition d'Art Italien à Paris, 1935, reprinted in *Pièces sur l'art*, revised and augmented edn (Paris, 1936, 43rd edn 1948), p. 211.

5 See Werner Busch, ed., *Funkkolleg Kunst: Eine Geschichte der Kunst im Wandel ihrer Funktionen* (Munich and Zurich, 1987).

Chapter 1

1 L. Réau, *Histoire du vandalisme. Les monuments détruits de l'art français* (Paris, 1959), 1, p. 7 (augmented edn, ed. Michel Fleury and Guy-Michel Leproux, Paris, 1994, p. 1); P. M. Pickshaus, *Kunstzerstörer: Fallstudien: Tatmotive und Psychogramme* (Reinbeck bei Hamburg, 1988), p. 10; D. Freedberg, *The Power of Images: Studies in the History and Theory of Response* (Chicago and London, 1989), p. 421; D. Freedberg, *Iconoclasts and their Motives* (Maarssen, 1985), p. 7.

2 Martin Warnke, 'Von der Gewalt gegen Kunst zur Gewalt der Kunst. Die Stellungnahmen von Schiller und Kleist zum Bildersturm', in *Bildersturm: Die Zerstörung des Kunstwerks*, ed. M. Warnke (Frankfurt, 1977), pp. 99–107; M. Warnke, 'Ansichten über Bilderstürmer: zur Wertbestimmung des Bildersturms in der Neuzeit', in *Bilder und Bildersturm im Spätmittelalter und in der frühen Neuzeit*, ed. Bob Scribner (Wiesbaden, 1990; Wolfenbütteler Forschungen, XLVI), pp. 299–325.

3 *La peinture dans la peinture*, exhibition catalogue by Pierre Georgel and Anne-Marie Lecoq: Musée des Beaux-Arts, Dijon (1983), pp. 209–10; Victor I. Stoichita, ' "Cabinets d'amateurs" et scénario iconoclaste dans la peinture anversoise du XVIIe siècle', in *Les iconoclasmes*, ed. Sergiusz Michalski (Strasbourg, Société Alsacienne pour le Développement de l'Histoire de l'Art, 1992; XXVIIe congrès international d'histoire de l'art du CIHA, *L'art et les révolutions*, Actes, Section 4), pp. 171–92; V. I. Stoichita, *L'instauration du tableau. Métapeinture à l'aube des Temps modernes* (Paris, 1993), pp. 131–43; Gary Schwartz, 'Love in the Kunstkamer: Additions to the Work of Guillam van Haecht (1593–1637)', *Tableau* (Summer 1996), pp. 43–52.

4 *Goya and the Spirit of Enlightenment*, exhibition catalogue by Alfonso E. Pérez Sánchez and Eleanor A. Sayre: Museum of Fine Arts, Boston; Museo del Prado, Madrid; Metropolitan Museum of Art, New York (Boston, 1989), pp.278–80.

5 Warnke, 'Von der Gewalt gegen Kunst zur Gewalt der Kunst'.

6 Réau, *Histoire du vandalisme*, 1, p. 242 (1994 edn, p. 310).

7 Henri Grégoire, *Second rapport sur le vandalisme* (Paris, 8 brumaire an III, 1794), p. 2; Charles de Montalembert, 'Du vandalisme en France. Lettre à M. Victor Hugo', *Revue des Deux Mondes*, n.s. I (1833), pp. 477–524 (p. 494).

8 M. Warnke, 'Bilderstürme', in *Bildersturm*, p. 7.

9 H. Bredekamp, *Kunst als Medium sozialer Konflikte: Bilderkämpfe von der Spätantike bis zur Hussitenrevolution* (Frankfurt, 1975), pp. 12–13.

10 Reiner Haussherr, review of *Bildersturm*, in *Kunstchronik*, XXVII (1974), pp. 359–69; M. Warnke, 'Rückruf', *Kritische Berichte*, IV/4 (1976), pp. 55–8; Peter Schreiner, review of *Kunst als Medium sozialer Konflikte*, in *Zeitschrift für Kunstgeschichte*, XXXIX (1976), pp. 239–44; Wolfgang Grape, 'Anmerkungen zu H. Bredekamp [. . .] und zu der Rezension des Buches von Peter Schreiner [. . .]', *Kritische Berichte*, V/I (1977), pp. 20–34.

11 J. von Végh, *Die Bilderstürmer: Eine kulturgeschichtliche Studie* (Strassburg, 1915), pp. 2–3. Végh's book, of which a Hungarian edition also appeared in Budapest in 1915, was ready for publication as the First World War broke out.

12 *Ibid.*, pp. 105–15, 134–40.

13 M. Baxandall, *The Limewood Sculptors of Renaissance Germany* (New Haven and London, 1980), p. 69.

14 Freedberg, *Iconoclasts and their Motives*, p. 8.

15 O. Christin, *Une révolution symbolique. L'iconoclasme huguenot et la reconstruction catholique* (Paris, 1991); O. Christin, 'L'iconoclasme huguenot. "Praxis pietatis" et geste révolutionnaire', *Ethnologie française*, XXIV/2 (1994), pp. 216–25.

16 Réau, *Histoire du vandalisme*, I, p. 14 (1994 edn, p. 11).

17 H. Grégoire, *Mémoires*, ed. M. Carnot (Paris, 1837), I, p. 345; see Réau, *Histoire du vandalisme*, I, p. 13 (1994 edn, p. 10); Pierre Marot, 'L'abbé Grégoire et le vandalisme révolutionnaire', *Revue de l'art*, no. 49 (1980), pp. 36–9; *The Oxford English Dictionary*, ed. J. A. Simpson and E.S.C. Weiner, 2nd edn (Oxford, 1989), XIX, p. 425; *Encyclopédie générale Hachette* (Paris, 1974).

18 *The Oxford English Dictionary*, VII, p. 609.

19 *Ibid.*, XIX, p. 425.

20 Végh, *Bilderstürmer*, pp. 6–7.

21 Guy Houchon, 'Criminologie du vandalisme', unpublished paper presented to the International Conference on Vandalism in Paris (27–29 October 1982).

22 J. Phillips, *The Reformation of Images: Destruction of Art in England, 1535–1660* (Berkeley, Los Angeles and London, 1973), p. x.

23 Réau, *Histoire du vandalisme*, I, p. 16 (1994 edn, p. 13).

24 Nelson Goodman, *Ways of Worldmaking* (Indianapolis, 1978), pp. 57–70.

25 See Margaret Aston, *England's Iconoclasts*, I: *Laws against Images* (Oxford, 1988); Freedberg, *The Power of Images*; Sergiusz Michalski, *The Reformation and the Visual Arts: The Protestant Image Question in Western and Eastern Europe* (London and New York, 1993).

26 Colin Ward, ed., *Vandalism* (London, 1973). See chapter Nine.

27 Friedrich Geerds, 'Kunstvandalismus. Kriminologische und kriminalistische Gedanken über ein bisher vernachlässigtes Phänomen im Bereich von Kunst und Kriminalität', *Archiv für Kriminologie*, CLXIII/5 (1979), pp. 129–44.

28 See chapter Ten.

29 Wolfgang Kemp, 'Kunstwissenschaft und Rezeptionsästhetik', in *Der Betrachter ist im Bild: Kunstwissenschaft und Rezeptionsästhetik*, ed. W. Kemp, augmented edn (Berlin, 1992), pp. 7–27.

30 Hans Robert Jauß, *Literaturgeschichte als Provokation* (Frankfurt, 1970); Wolfgang Iser, *Der implizite Leser* (Munich, 1972); Joseph Jurt, 'Für eine Rezeptionssoziologie', *Romanistische Zeitschrift für Literaturgeschichte*, I–2 (1979), pp. 214–230; *The Reader in the Text: Essays on Audience and Interpretation*, ed. Jane P. Tompkins (Baltimore and London, 1980).

31 P. Veyne, 'Conduites sans croyance et œuvres d'art sans spectateurs', *Diogène*, no. 143 (July–September 1988), pp. 3–22.

32 S. Settis, 'La colonne Trajane: l'empereur et son public', *Revue archéologique* n.s.,1 (1991), pp. 186–98; see chapter Two.

33 See for example Christin, *Une révolution symbolique*, p. 135.

34 C. Ward, 'Introduction', *Vandalism*, ed. Ward, pp. 13–22 (p. 19); Stanley Cohen, 'Property Destruction: Motives and Meanings', in *ibid.*, pp. 23–53 (p. 41).

35 Cohen, 'Property Destruction', pp. 34–51; S. Cohen, 'Sociological Approaches to Vandalism', in *Vandalism: Behaviour and Motivations*, ed. Claude Lévy-Leboyer (Amsterdam, New York and Oxford, 1984), pp. 51–61.

36 Geerds, 'Kunstvandalismus', pp. 137–8.

37 Réau, *Histoire du vandalisme*, I, pp. 16–25 (1994 edn, pp. 13–26).

38 Warnke, 'Bilderstürme', p. 11.

39 André Chagny, 'Histoires de statues sous la Seconde République', *Echo Liberté* [Lyon] (29 September 1959); Gilbert Gardes, *Lyon l'art et la ville. Architecture – décor* (Paris, 1988), II, pp. 189–90 (with reproduction of an engraving of J.-B. Lépind's statue).

40 Réau, *Histoire du vandalisme*, pp. 46, 103, 139–40, above all 378 (1994 edn, pp. 52, 128, 180, 498). Compare Végh, *Bilderstürmer*, p. 122; Végh excludes in principle 'embellishing vandalism' from his study but is not always consistent (pp. 5, 131).

41 Montalembert, 'Du vandalisme en France', pp. 484–5; Françoise Choay, *L'allégorie du patrimoine* (Paris, 1992), pp. 22–3.

42 O. Christin, 'Les iconoclastes savent-ils ce qu'ils font? Rouen, 1562–1793', in *Révolution française et 'vandalisme révolutionnaire'*, ed. Simone Bernard-Griffiths, Marie-Claude Chemin and Jean Erhard (Paris, 1992), pp. 353–65 (pp. 355–7).

43 Pierre Bourdieu, 'La production de la croyance. Contribution à une économie des biens symboliques', *Actes de la recherche en sciences sociales*, no. 13 (February 1977), pp. 3–43; P. Bourdieu, *Les règles de l'art. Genèse et structure du champ littéraire* (Paris, 1992).

44 Alain Schnapp, 'Vandalisme', in *Encyclopædia Universalis, Thesaurus* (Paris, 1990), p. 3593. In the introduction to his study of 'the destruction myth in the art of the early 1960s' Justin Hoffmann has recently proposed to distinguish between the collective and ideologically motivated *Ikonoklasmus* and the individual *Kunstattentat* (assault on art) on the one hand and the representation of destruction, the integration of destroyed objects into works of art, and *Destruktionskunst* (destruction art) proper on the other (*Destruktionskunst. Der Mythos der Zerstörung in der Kunst der frühen sechziger Jahre*, Munich, 1995, pp. 11–16). His emphasis lies almost exclusively on the intentions of the persons concerned, in particular the artists. We shall see, however, that dividing lines can be fluid or even misleading, for example between collective and individual actions (chapters Nine and Ten) and between destructive and creative intention (chapter Thirteen).

Chapter 2

1 G. Kubler, *The Shape of Time: Remarks on the History of Things* (New Haven, 1962).

2 L. Vitet, 'De l'architecture du Moyen Age en Angleterre' (1836), quoted in Françoise Choay, *L'allégorie du patrimoine* (Paris, 1992), p. 124. In 1903 Alois Riegl logically considered 'use value' as a positive ally to 'antiquity value' and considered the performance of religious rituals in churches as a 'living decoration' of sorts (A. Riegl, *Der moderne Denkmalkultus, sein Wesen und seine Entstehung*, Vienna, 1903, reprinted after Georg Dehio and A. Riegl, *Konservieren, nicht restaurieren: Streitschriften zur Denkmalpflege um 1900*, ed. Marion Wohlleben, Braunschweig, 1988, p. 71).

3 Smita J. Baxi, 'Problèmes de sécurité dans les musées indiens', *Museum*, XXVI/1 (1974), pp. 48–52 (p. 52).

4 On relegation, see Enrico Castelnuovo and Carlo Ginzburg, 'Centro e periferia', in *Storia dell'arte italiana*, I: *Questioni e metodi* (Turin, 1979), pp. 285–352 (pp. 308–9, 340–42).

5 See Nelson Goodman's notion of 'exemplification', particularly in *Languages of Art: An*

Approach to a Theory of Symbols (Indianapolis and Cambridge, 1976), pp. 52–6, and *Ways of Worldmaking* (Indianapolis, 1978), pp. 23–40.

6 See, for example, Martin S. Briggs, *Goths and Vandals: A Study of the Destruction, Neglect and Preservation of Historical Buildings in England* (London, 1952), p. 10; L. Réau, *Histoire du vandalisme. Les monuments détruits de l'art français* (Paris, 1959), I, p. 48 (Paris, 1994, pp. 54–5); Choay, *L'allégorie du patrimoine*, pp. 12–13, 22–3.

7 Louis Marin, *Le portrait du roi* (Paris, 1981); Peter Burke, *The Fabrication of Louis XIV* (New Haven and London, 1992).

8 Klaus Herding, 'Kunst und Revolution', in *Die Französische Revolution*, ed. Rolf Reichardt (Würzburg, 1988), pp. 200–40 (p. 230); James A. Leith, *The Idea of Art as Propaganda in France, 1750–1799* (Toronto, 1965); see further chapter Three.

9 A. Chastel, *Introduction à l'histoire de l'art français* (Paris, 1993), pp. 110–11. The connection between iconoclasm and competition within a system has been noted by Berthold Hinz in 'Säkularisation als verwerteter "Bildersturm". Zum Prozeß der Aneignung der Kunst durch die Bürgerliche Gesellschaft', in *Bildersturm: Die Zerstörung des Kunstwerks*, ed. M. Warnke (Frankfurt, 1977), pp. 108–20, 170–76 (p. 175, n. 45).

10 On (and against) the 'animist' explanation, see D. Freedberg, *The Power of Images: Studies in the History and Theory of Response* (Chicago and London, 1989); on images as substitutes for persons, see Wolfgang Brückner, *Bildnis und Brauch: Studien zur Bildfunktion der Effigies* (Berlin, 1966); Adolf Reinle, *Das stellvertretende Bildnis: Plastiken und Gemälde von der Antike bis ins 19. Jahrhundert* (Zurich and Munich, 1984).

11 See Bazon Brock, 'Der byzantinische Bilderstreit', in *Bildersturm*, ed. Warnke, pp. 30–40; Horst Bredekamp, *Kunst als Medium sozialer Konflikte: Bilderkämpfe von der Spätantike bis zur Hussitenrevolution* (Frankfurt, 1975); Anthony Bryer and Judith Herrin, eds, *Iconoclasm* (Birmingham, 1977); Johannes Irmscher, ed., *Der byzantinische Bilderstreit; sozialökonomische Voraussetzungen, ideologischen Grundlagen, geschichtliche Wirkungen: Eine Sammlung von Forschungsbeiträgen* (Leipzig, 1980); Robin Cormack, *Writing in Gold: Byzantine Society and its Icons* (London, 1985), pp. 95–140; Daniel J. Sahas, *Icons and Logos: Sources in Eighth-century Iconoclasm* (Toronto and London, 1986); François Boespflug and Nicolas Lossky, eds, *Nicée II 787–1987. Douze siècles d'images religieuses* (Paris, 1987); Hans Belting, *Bild und Kult: Eine Geschichte des Bildes vor dem Zeitalter der Kunst* [trans. as *Likeness and Presence: A History of the Image before the Era of Art*, Chicago and London, 1994] (Munich, 1990), pp. 166–84.

12 H. Bredekamp, 'Renaissancekultur als "Hölle": Savonarolas Verbrennungen der Eitelkeiten', in *Bildersturm*, ed. Warnke, pp. 41–64.

13 Marie-Claude Decamps, 'Le pape a prononcé un discours de "réconciliation" au Mexique', *Le Monde* (13 August 1993), p. 6.

14 Serge Gruzinski, *La colonisation de l'imaginaire. Sociétés indigènes et occidentalisation dans le Mexique espagnol XVIe–XVIIIe siècles* (Paris, 1988); S. Gruzinski, *Painting the Conquest: The Mexican Indians and the European Renaissance* (Paris, 1992); S. Gruzinski and Gilles Mermet, *L'aigle et la sibylle, fresques indiennes du Mexique* (Paris, 1994).

15 Alain Schnapp, 'Vandalisme', in *Encyclopædia Universalis, Thesaurus* (Paris, 1990), p. 3593.

16 D. Freedberg, 'The Structure of Byzantine and European Iconoclasm', in *Iconoclasm*, ed. Bryer and Herrin, pp. 165–77 (p. 166); Jean Wirth, 'L'immagine', in Gherardo Ortalli, ed., *Storia d'Europa*, III, *Il Medioevo. Secoli V–XV* (Torino, 1994), pp. 1103–41 (pp. 1122–4); among the numerous recent studies of the Reformation and iconoclasm, see in particular J. Phillips, *The Reformation of Images: Destruction of Art in England, 1535–1660* (Berkeley, Los Angeles and London, 1973); Natalie Zemon Davis, 'The Rites of Violence: Religious Riot in Sixteenth-Century France', *Past and Present*, no. 59 (May 1973), pp. 51–91; Bob Scribner, 'Reformation, Carnival and the World Turned Upside-Down', in *Städtische Gesellschaft und Reformation*, ed. Ingrid Bátori (Stuttgart, 1980), pp. 234–64; Solange Deyon and Alain Lottin, *Les 'casseurs' de l'été 1566. L'iconoclasme dans le nord de la France* (Paris, 1981); Werner Hofmann, ed., *Luther und die Folgen für die Kunst*, exhibition

catalogue: Hamburger Kunsthalle, Hamburg (Munich, 1983); D. Freedberg, *Iconoclasm and Painting in the Revolt of the Netherlands 1566–1609* (New York and London, 1988); M. Aston, *England's Iconoclasts*, I: *Laws against Images* (Oxford, 1988); Belting, *Bild und Kult*; Bob Scribner, ed., *Bilder und Bildersturm im Spätmittelalter und in der frühen Neuzeit* (Wiesbaden, 1990); O. Christin, *Une révolution symbolique. L'iconoclasme huguenot et la reconstruction catholique* (Paris, 1991); S. Michalski, *The Reformation and the Visual Arts: The Protestant Image Question in Western and Eastern Europe* (London and New York, 1993).

17 See chapter Fourteen, pp. 310–11.

18 Christin, *Une révolution symbolique*, pp. 355–7; see also M. Warnke, 'Durchbrochene Geschichte? Die Bilderstürme der Wiedertäufer in Münster 1534/1535', in *Bildersturm*, ed. Warnke, pp. 71–2; Peter Jezler, 'Etappen des Zürcher Bildersturms. Ein Beitrag zur soziologischen Differenzierung ikonoklastischer Vorgänge in der Reformation', in *Bilder und Bildersturm*, ed. Scribner, pp. 143–74; O. Christin, 'L'iconoclasme huguenot. "Praxis pietatis" et geste révolutionnaire', *Ethnologie française*, XXIV/2 (1994), pp. 216–25 (p. 216).

19 W. Hofmann, 'Die Geburt der Moderne aus dem Geist der Religion', in *Luther und die Folgen für die Kunst*, ed. Hofmann, pp. 46–51.

20 Phillips, *The Reformation of Images*, p. 209.

21 K.-A. Knappe, 'Bilderstürmerei. Byzanz – Reformation – Französische Revolution', *Kunstspiegel*, III (1981), pp. 265–85 (pp. 281–5).

22 Chastel, *Introduction à l'histoire de l'art français*, p. 114.

23 The main recent works on the iconoclasm of the French Revolution are Gabriele Sprigath, 'Sur le vandalisme révolutionnaire (1792–1794)', *Annales historiques de la Révolution française*, no. 242 (October–December 1980), pp. 510–35; Daniel Hermant, 'Le vandalisme révolutionnaire', *Annales ESC*, XXXIII (1978), pp. 703–19; Claude Langlois, 'Les vandales de la Révolution', *L'histoire*, no. 99 (April 1987), pp. 8–14; Bronislaw Baczko, *Comment sortir de la Terreur. Thermidor et la Révolution* (Paris, 1989), pp. 255–304; Klaus Herding, 'Denkmalsturz und Denkmalkult – Revolution und Ancien Régime', *Neue Zürcher Zeitung* (30–31 January 1993), pp. 63–4; Edouard Pommier, *L'art de la liberté. Doctrines et débats de la Révolution française* (Paris, 1991), pp. 93–166; Simone Bernard-Griffiths, Marie-Claude Chemin and Jean Erhard, eds, *Révolution française et 'vandalisme révolutionnaire'* (Paris, 1992); Dominique Poulot, 'Le sens du patrimoine: hier et aujourd'hui (note critique)', *Annales ESC*, XLVIII (1993), pp. 1601–13; Roger Bourderon, ed., *Saint-Denis ou le jugement dernier des rois* (Saint-Denis, 1993); Richard Wrigley, 'Breaking the Code: Interpreting French Revolutionary Iconoclasm', in *Reflections of Revolution*, ed. Alison Yarington and Kelvin Everest (London, 1993), pp. 182–95; D. Poulot, 'Revolutionary "Vandalism" and the Birth of the Museum: The Effects of a Representation of Modern Cultural Terror', in *Art in Museums*, ed. S. Pearce, New Research in Museum Studies, 5 (London and Atlantic Highlands, NJ, 1995), pp. 192–214.

24 Annie Duprat, *Le roi décapité. Essai sur les imaginaires politiques* (Paris, 1992).

25 *Procès-verbaux des séances des Corps Municipaux de la ville de Lyon* (Lyon, 1899–1907), Conseil général, 9 September 1792, quoted in Paul Feuga, 'De la destruction des signes de féodalité sur les monuments publics de Lyon', *Actes de l'Union des Sociétés d'Histoire du Rhône* (1980), pp. 81–100 (p. 88).

26 Quoted in A. Kleinclausz, *Histoire de Lyon* (Lyon, 1939–52; reprint Marseille, 1978), II, p. 349.

27 On the rhetoric of the 'offended eye', see E. Pommier, 'La théorie des arts', in *Aux armes et aux arts ! Les arts de la Révolution 1789–1799*, ed. Philippe Bordes and Régis Michel (Paris, 1988), pp. 168–99 (pp. 178–80), as well as Poulot, 'Revolutionary "Vandalism" and the Birth of the Museum', p. 207. For an example of print showing Time as iconoclast, see the etching entitled *La Révolution française arrivée sous le règne de Louis XVI* by Duplessis, reproduced (and commented on) in *La Révolution française et l'Europe*, exhibition catalogue: Galeries nationales du Grand Palais, Paris (Paris, 1989), II, pp. 404–45, and – in

a revised version – in K. Herding and R. Reichardt, *Die Bildpublizistik der Französischen Revolution* (Frankfurt, 1989), pp. 91–4.

28 Hans-Jürgen Lüsebrink, 'Votivbilder der Freiheit – der "Patriote Palloy" und die populäre Bildmagie der Bastille', in *Die Bastille – Symbolik und Mythos in der Revolutionsgraphik*, exhibition catalogue: Landesmuseum Mainz und Universitätsbibliothek Mainz (Mainz, 1989), pp. 71–80.

29 Wrigley, 'Breaking the Code', p. 185.

30 See for instance the projects for a monument to be erected on the site of the Bastille in *La Révolution française et l'Europe*, pp. 409–11.

31 Inscription on a 1793 medal commemorating the melting down of a medieval bell from the Rouen cathedral, cited in Réau, *Histoire du vandalisme*, I, p. 367 (1994, p. 483).

32 *Le Moniteur*, no. 237 (4 August 1792), quoted in Choay, *L'allégorie du patrimoine*, p. 87; Rapport Poirier, 13 Brumaire an II, 'concernant la démolition des monuments de l'église paroissiale de Franciade – ci-devant Saint-Denis – en France', in *Procès Verbal de la Commission des Monuments*, II, 211, published in *Nouvelles Archives de l'Art Français*, 3rd series, XVIII (1902), quoted after E. Castelnuono, 'Arti e rivoluzione. Ideologie e politiche artistiche nella Francia rivoluzionaria', *Ricerche di Storia dell'arte*, no. 13–14 (1981), pp. 5–20 (pp. 12, 18 n. 59); *Archives parlementaires*, 79, p. 100, quoted in Sprigath, 'Sur le vandalisme révolutionnaire', p. 521.

33 Castelnuovo, 'Arti e rivoluzione'; D. Poulot, 'La naissance du musée', in *Aux armes et aux arts!*, pp. 201–31.

34 P. Marot, 'L'abbé Grégoire et le vandalisme révolutionnaire', *Revue de l'art*, no. 49 (1980), pp. 36–9; Poulot, 'La naissance du musée'; Anthony Vidler, 'Grégoire, Lenoir et les "monuments parlants" ', in *La Carmagnole des Muses. L'homme de lettres et l'artiste dans la Révolution*, ed. Jean-Claude Bonnet (Paris, 1988), pp. 131–54; Pommier, *L'art de la liberté*; Francis Haskell, *History and its Images: Art and the Interpretation of the Past* (New Haven and London, 1993), pp. 236–52.

35 *Wilhelm Tell. Schauspiel von Schiller* (Tübingen, 1804), pp. 212–13; see M. Warnke, 'Von der Gewalt gegen Kunst zur Gewalt der Kunst. Die Stellungnahmen von Schiller und Kleist zum Bildersturm', in *Bildersturm*, ed. Warnke, pp. 99–107; D. Gamboni, ' "Instrument de la tyrannie, signe de la liberté": la fin de l'Ancien Régime en Suisse et la conservation des emblèmes politiques', in *Les iconoclasmes*, ed. S. Michalski (*L'Art et les révolutions. XXVIIe congrès international d'histoire de l'art. Strasbourg 1–7 septembre 1989*, IV) (Strasbourg, 1992), pp. 213–28.

36 Quatremère de Quincy, *Lettres à Miranda sur le déplacement des monuments de l'art de l'Italie* (1796), ed. E. Pommier (Paris, 1989); Quatremère de Quincy, *Considérations morales sur la destination des ouvrages de l'art* (1815; Paris, 1989); René Schneider, *Quatremère de Quincy et son intervention dans les arts (1788–1830)* (Paris, 1910); Pommier, *L'art de la liberté*, pp. 414–43.

37 For more on this subject, see Thomas Crow, *Painters and Public Life in Eighteenth-century Paris* (New Haven and London, 1985); R. Wrigley, *The Origins of French Art Criticism from the Ancien Régime to the Restoration* (Oxford, 1993); P. Bourdieu, *Les règles de l'art. Genèse et structure du champ littéraire* (Paris, 1992).

38 K. Herding, 'Utopie concrète à l'échelle mondiale: l'art de la Révolution', in *La Révolution française et l'Europe*, I, pp. xxi–l.

39 Maurice Agulhon, *Marianne au combat. L'imagerie et la symbolique républicaine de 1789 à 1880* (Paris, 1979), pp. 85–128; Marie-Claude Chaudonneret, *La figure de la République. Le concours de 1848* (Paris, 1987); M.-Cl. Chaudonneret, '1848 "La République des Arts" ', *Oxford Art Journal*, no. 1 (1987), pp. 59–70; M. Warnke, 'Die Demokratie zwischen Vorbildern und Zerrbildern', in *Zeichen der Freiheit: Das Bild der Republik in der Kunst des 16. bis 20. Jahrhunderts*, exhibition catalogue ed. D. Gamboni and Georg Germann: Bernisches Historisches Museum and Kunstmuseum Bern (Berne, 1991), pp. 75–97.

40 *Le triomphe des mairies. Grands décors républicains à Paris 1870–1914*, exhibition catalogue: Musée du Petit Palais, Paris (1986); Miriam R. Levin, *Republican Art and Ideology in Late*

Nineteenth-century France (Ann Arbor, 1986); M. Agulhon, *Marianne au pouvoir.*
L'imagerie et la symbolique républicaines de 1880 à 1914 (Paris, 1989); *Quand Paris dansait
avec Marianne 1879–1889,* exhibition catalogue: Musée du Petit Palais, Paris (1989); Pierre
Vaisse, *La Troisième République et les peintres* (Paris, 1995).

41 M. Warnke, 'Bilderstürme', in *Bildersturm,* ed. Warnke, p. 9.

42 Hinz, 'Säkularisation als verwerteter "Bildersturm" ', in *Bildersturm,* ed. Warnke, pp. 108–
 20.

43 See chapters Eleven and Fifteen.

44 Charles de Montalembert, 'Du vandalisme en France. Lettre à M. Victor Hugo', *Revue des
 Deux Mondes,* n.s. 1 (1833), pp. 477–524 (pp. 482, 490); Ch. de Montalembert, *Du
 vandalisme et du catholicisme dans l'art* (Paris, 1839).

45 Montalembert, 'Du vandalisme en France', p. 485; see chapter Eleven, pp. 215–19.

46 See, for example, I. Rose, ' "La celebrada caída de nuestro coloso". Destrucciones
 espontáneas de retratos de Manuel Godoy por el populacho', *Academia,* XLVII (1978), pp.
 197–226; Edward Lilley, 'Consular Portraits of Napoleon Bonaparte', *Gazette des Beaux-
 Arts,* n.s. 6, CVI (1985), pp. 147–56; Nicole Hubert, 'A propos des portraits consulaires de
 Napoléon Bonaparte. Remarques complémentaires', *Gazette des Beaux-Arts,* n.s. 6, CVIII
 (1986), pp. 23–30.

47 Mona Ozouf, 'Le Panthéon', in *Les lieux de mémoire* I: *La République,* ed. Pierre Nora
 (Paris, 1984), pp. 139–66; *Le Panthéon. Symbole des révolutions. De l'Eglise de la Nation au
 Temple des grands hommes* exhibition catalogue: Panthéon, Paris (1989).

48 See in particular Maxime du Camp, *Les convulsions de Paris* (Paris, 1878); Julius v. Végh,
 Die Bilderstürmer. Eine kulturgeschichtliche Studie (Strasburg, 1915), pp. 96–104; L. Réau,
 Histoire du vandalisme: les monuments détruits de l'art français (Paris, 1959), II, pp. 192–205
 (1994, pp. 790–808).

49 V. Hugo, *L'année terrible,* 'Juin. VIII: A qui la faute?' (Paris, 1874), p. 499; Pierre Joseph
 Proudhon had prophesied that if 'the law of ideal and of capital' were subordinated to the
 workers' rights, there would be no iconoclasts or vandals any more (*Du principe de l'art et de
 sa destination sociale,* Paris, 1865, p. 63).

50 P. Veyne, 'Conduites sans croyance et œuvres d'art sans spectateurs', *Diogène,* no. 143
 (July–September 1988), pp. 3–22 (pp. 6–7).

51 See in particular Bernard Gagnebin, 'Courbet et la colonne Vendôme. De l'utilisation du
 témoignage en histoire', in *Mélanges d'histoire économique et sociale en hommage au professeur
 Antony Babel à l'occasion de son soixante-quinzième anniversaire* (Geneva, 1963), II, pp.
 251–71; Rodolphe Walter, 'Un dossier délicat: Courbet et la colonne Vendôme', *Gazette
 des Beaux-Arts,* LXXXI/1 (1973), pp. 173–84; Linda Nochlin, 'Courbet, die Commune und
 die bildenden Künste', in *Realismus als Widerspruch. Die Wirklichkeit in Courbets Malerei,*
 ed. K. Herding (Frankfurt, 1978), pp. 248–61, 316–18.

52 Gagnebin, 'Courbet et la colonne Vendôme', p. 252; Charles Léger, *Courbet selon les
 caricatures et les images* (Paris, 1920); K. Herding, *Courbet: To Venture Independence* (New
 Haven and London, 1991), pp. 1–9 ('Redeemer and Charlatan, Subversive and Martyr:
 Remarks on Courbet's Roles'), 156–87 ('Courbet's Modernity as Reflected in Caricature').

53 Wilhelm Treue, *Kunstraub: Über die Schicksale von Kunstwerken in Krieg, Revolution und
 Frieden* (Düsseldorf, 1957); David Roxan and Ken Wanstall, *The Jackdaw of Linz*
 (London, 1964); Charles de Jaeger, *The Linz File: Hitler's Plunder of Europe's Art* (Exeter,
 1981); Lynn H. Nicholas, *The Rape of Europa: The Fate of Europe's Treasures in the Third
 Reich and the Second World War* (New York, 1994); Hector Feliciano, *Le musée disparu.
 Enquête sur le pillage des œuvres d'art en France par les nazis* (Paris, 1995).

54 Albert Dalimier, 'Nos richesses d'art sauvées de la destruction', *Lectures pour tous,* 1915, pp.
 140–43; *Louvain-Reims II. Documents* (Lausanne, Cahiers Vaudois, 1915); Wolfgang
 Schivelbuch, *Die Bibliothek von Löwen: Eine Episode aus der Zeit der Weltkriege* (Munich
 and Vienna, 1988); François Cochet, *Rémois en guerre (1914–1918). L'héroïsation au
 quotidien* (Nancy, 1994).

55 G. B. Shaw, 'Common Sense about the War', *The New Statesman*, Special War
 Supplement (14 November 1914); see also Végh, *Bilderstürmer*, pp. x–xv.
56 See the special issue 'L'art assassiné' of the journal *L'art et les artistes* (1917); for an example
 of German propaganda, see *La destruction des monuments artistiques sur le front occidental par
 les Anglais et les Français* (Weimar, Gustav Kiepenheuer Verlag, 1917; Zentralbibliothek,
 Zurich, LK 2001a731).
57 *A Protest against Fascist Vandalism. Report of Anti-Fascist Meeting of Soviet Workers in Art
 and Literature, Moscow, November 29, 1942* (Moscow, Foreign Language Publishing
 House, [1942]; British Library 8028.a.54).
58 Nicholas, *The Rape of Europa*, pp. 215, 275; *La guerra contro l'arte* (Milan, 1944; British
 Library 7813.b.3).
59 *Conventions and Recommendations of Unesco concerning the protection of the cultural heritage*
 (Paris, 1985, 1st edn 1983), pp. 15–56; John Henry Merryman and Albert E. Elsen, *Law,
 Ethics, and the Visual Arts* (Philadelphia, 1987), I, pp. 28–39.
60 Henry La Farge, *Lost Treasures of Europe* (New York, 1946); Walter Hancock,
 'Experiences of a Monuments Officer in Germany', *College Art Journal*, V/4 (May 1946);
 Faustino Asagliano, ed., *Il bombardamento di Montecassino, diario di guerra, di E. Grossetti,
 M. Matronola, con altre testimonianze e documenti* (Montecassino, 1980); David Hapgood
 and David Richardson, *Montecassino* (London, 1985); John Taylor, 'London's Latest
 "Immortal" – the Statue to Sir Arthur Harris of Bomber Command', *Kritische Berichte*,
 XX/3 (1992), pp. 96–102; Ch. M., 'Lenin geht – Kaiser Wilhelm kehrt zurück. Sturz und
 Auferstehung deutscher Denkmäler', *Neue Zürcher Zeitung* (30–31 May 1992), p. 7;
 Lucien Delattre, 'L'Allemagne commémore la nuit tragique du bombardement de
 Dresde', *Le Monde* (15 February 1995); Wolfgang Hauptmann, 'Dresden als
 "geschäftstüchtige Schöne". 50 Jahre nach den verheerenden Luftangriffen', *Neue Zürcher
 Zeitung* (11–12 February 1995); Kai Bird, 'Fallait-il lancer la bombe sur Hiroshima?', *Le
 Monde diplomatique* (August 1995), p. 5.
61 See for instance, on the case of Saint-Malo, Régis Guyotat, 'Saint-Malo détruite, Saint-
 Malo reconstruite', *Le Monde* (9 July 1994), pp. iv–v.
62 On the persecution of modern art by the Nazis, see Paul Ortwin Rave, *Kunstdiktatur im
 Dritten Reich* (Hamburg, 1949); Hildegard Brenner, *Die Kunstpolitik des
 Nationalsozialismus* (Reinbek bei Hamburg, 1963); Günter Busch, *Entartete Kunst –
 Geschichte und Moral* (Frankfurt, 1969); Marcel Struwe, ' "Nationalsozialistischer
 Bildersturm". Funktion eines Begriffs', in *Bildersturm*, ed. Warnke, pp. 121–40; Peter-
 Klaus Schuster, ed., *Die 'Kunststadt' München 1937: Nationalsozialismus und 'Entartete
 Kunst'* (Munich, 1987); Jean-Michel Palmier, ed., *L'art dégénéré. Une exposition sous le IIIe
 Reich* (Paris, 1992); *Degenerate Art: The Fate of the Avant-Garde in Nazi Germany*,
 exhibition catalogue ed. Stephanie Barron: County Museum of Art, Los Angeles (Los
 Angeles and New York, 1992).
63 See Yvon Bizardel, 'Les statues parisiennes fondues sous l'occupation (1940–1944)',
 Gazette des Beaux-Arts, n.s. 6, LXXXIII (March 1974), pp. 129–52, and chapter Eleven, pp.
 226–8. On Vichy and the arts, see Laurence Bertrand Dorléac, *Histoire de l'art. Paris,
 1940–1944* (Paris, 1986); Michèle C. Cone, *Artists under Vichy: A Case of Prejudice and
 Persecution* (Princeton, 1992); L. Bertrand Dorléac, *L'art de la défaite (1940–1944)* (Paris,
 1994).
64 M. Nordau, *Degeneration* (New York, 1895); P. Schultze-Naumburg, *Kunst und Rasse*
 (Munich), 1928.
65 Edouard Conte and Cornelia Essner, *La quête de la race: Une anthropologie du nazisme*
 (Paris, 1995).
66 On this concept and its further use against modern art, see *Im Namen des Volkes: Das
 'gesunde Volksempfinden' als Kunstmaßstab*, exhibition catalogue: Wilhelm-Lehmbruck-
 Museum der Stadt Duisburg (1979).
67 Mario-Andreas von Lüttichau, ' "Deutsche Kunst" und "Entartete Kunst": Die

Münchner Ausstellungen 1937', in *Die 'Kunststadt' München 1937*, ed. Schuster, pp. 83–118.

68 P.-K. Schuster, 'München – das Verhängnis einer Kunststadt', in *Die 'Kunststadt' München 1937*, ed. Schuster, pp. 12–36 (pp. 30–31).

69 On the official art of authoritarian and totalitarian regimes (with due caution regarding simplifying unifications), see Berthold Hinz, Hans-Ernst Mittig, Wolfgang Schäche and Angela Schönberger, eds, *Die Dekoration der Gewalt: Kunst und Medien im Faschismus* (Gießen, 1976); Igor Golomstock, *Totalitarian Art in the Soviet Union, the Third Reich, Fascist Italy and the People's Republic of China* (London, 1990); Christine Lindey, *Art in the Cold War: From Vladivostock to Kalamazoo, 1945–1962* (London, 1990); *Kunst und Diktatur. Architektur, Bildhauerei und Malerei in Österreich, Deutschland, Italien und der Sowjetunion 1922–1956*, exhibition catalogue ed. Jan Tabor: Künstlerhaus, Vienna (Baden, 1994); *Art and Power: Europe under the Dictators, 1930–45*, exhibition catalogue: Hayward Gallery, London (London, 1995). For Socialist Realism, see further chapter Three.

70 Warnke, 'Bilderstürme', pp. 8–9.

71 See Paul Ricoeur, 'Ideology and Utopia as Cultural Imagination', *Philosophical Exchange*, no. 2 (1976), pp. 17–28; see also Claude Reichler, 'La réserve du symbolique', *Les Temps Modernes*, XLVIII, no. 550 (May 1992), pp. 85–93.

72 Ivan Straus, *Sarajevo, l'architectes et les barbares* (Paris, 1994), p. 11, with reference to the Serbian architect and former mayor of Belgrade Bogdan Bogdanovic; *ARH Magazine for Architecture, Town Planning and Design*, no. 24 (June 1993): 'Sarajevo'; Florence Hartmann and Yves Heller, 'Le patrimoine perdu de l'ex-Yougoslavie. Prolongement de la "purification" ethnique, la "purification" culturelle détruit les derniers symboles identitaires', *Le Monde* (20 October 1993), p. 13; *Urbicide Sarajevo. Dossier* (Association of Architects DAS–SABIH Sarajevo), 2nd edn (Paris, 1995).

73 Jean-Baptiste Naudet, 'La destruction du pont de Mostar est un sacrilège irréparable pour les Musulmans de Bosnie', *Le Monde* (16 November 1993).

74 Nedim Gürsel, 'Le cafetan des poètes', *Le Monde* (13 August 1993), p. 12.

Chapter 3

1 See Georg Kreis, 'Denkmäler und Denkmalnutzungen in unserer Zeit', *Schweizerische Zeitschrift für Soziologie*, III (1987), pp. 411–26.

2 R. Musil, 'Denkmale' (1927), in R. Musil, *Gesammelte Werke*, ed. Adolf Frisé, VII (Reinbek bei Hamburg, 1981), pp. 506–9. On changes of visibility and invisibility, see Albert Boime, 'Perestroika and the Destabilization of the Soviet Monuments', *ARS: Journal of the Institute for History of Art of Slovak Academy of Sciences*, 2–3 (1993); 'Totalitarianisms and Traditions' (1994), pp. 211–26 (p. 222).

3 Quoted in Y. Bizardel, 'Les statues parisiennes fondues sous l'occupation (1940-1944)', *Gazette des Beaux-Arts*, n.s. 6, LXXXIII (March 1974), p. 132; Wierd Duk, 'Land van lege sokkels. Russische beeldenstorm haalt rode verheerlijking onderuit', *Elsevier* (6 November 1993), pp. 58–62.

4 D. Buren, 'On statuary', in *Daniel Buren: around 'Ponctuations'* (Lyon, Le Nouveau Musée, 1980); see *Le cadre & le socle dans l'art du 20e siècle*, exhibition catalogue: Université de Bourgogne, Dijon; Centre Georges-Pompidou, Paris (Dijon and Paris, 1987).

5 At the present date, the main publications on the subject are, to my knowledge, *Kritische Berichte*, XX/3 (1992), issue entitled 'Der Fall der Denkmäler'; Bernd Kramer, ed., *Demontage . . . revolutionärer oder restaurativer Bildersturm? Texte & Bilder* (Berlin, 1992); *Bildersturm in Osteuropa: Die Denkmäler der kommunistischen Ära im Umbruch* (Munich, 1994: *ICOMOS – Journals of the German National Committee* XIII); Boime, 'Perestroika'.

6 Peter Funken, 'Ihr mit euren Denkmälern', in *Demontage*, pp. 37–8. On the simplifying and unifying use of the topic and especially its images in the Western media, see Annette

Tietenberg, 'Marmor, Stein und Eisen bricht', in *Demontage*, pp. 111–17 (p. 111); Boime, 'Perestroika', p. 213.

7 M. Baxandall, *The Limewood Sculptors of Renaissance Germany* (New Haven, 1980), p. 74.

8 Quoted after the German translation in *Demontage*, p. 13 (Mikhail Gorbachev, 'Über die Unterbindung einer Schändung von Denkmälern, die mit der Geschichte des Staates und seinen Symbolen verbunden sind').

9 A.P., 'Zehn Tonnen schwere Lenin-Statue gestohlen', *Neue Zürcher Zeitung* (21–22 August 1993); José-Alain Fralon, 'Les "nostalgiques" ont été privés de la célébration de l'anniversaire de la Révolution d'Octobre', *Le Monde* (9 November 1993), p. 8. In Tiflis, the capital city of Georgia, a monument to Lenin had been pulled down on 28 August 1990, in the presence of authorities and to the sound of the Georgian national hymn (Reuter, 'Leninstatue in Tiflis zerstört', *Neue Zürcher Zeitung*, 29 August 1990).

10 See for instance Gheorge Vida, 'Die Situation in Rumänien – eine Analyse der Mutationen', in *Bildersturm in Osteuropa*, pp. 63–5 (p. 63); Marek Konopka, ' "Habent sua fata . . . monumenta". Denkmäler in Polen nach 1989', in *Bildersturm in Osteuropa*, pp. 66–8 (p. 67). An iconographic and chronological survey of the 'monuments of the Communist era' has been sketched by Andrzej Tomaszewski in 'Zwischen Ideologie, Politik und Kunst: Denkmäler der kommunistischen Ära', in *Bildersturm in Osteuropa*, pp. 29–33. It must be noted that although public monuments represented the official ideal of sculpture for the doctrine of Realist Socialism, occasions for their realization remained relatively scarce and were mainly replaced by the commission of simple busts (Antoine Baudin, 'Le réalisme socialiste soviétique de la période jdanovienne (1947-1953): les arts plastiques et leurs institutions, étude descriptive', unpublished PhD dissertation, University of Lausanne, 1995, pp. 171–6).

11 See the papers collected in *Bildersturm in Osteuropa* and the review of the conference by A. Tietenberg, ' "Bildersturm in Osteuropa" – Tagung des Deutschen Nationalkomitees von ICOMOS und des Institutes für Auslandsbeziehungen (18.-20.2.1993)', *Kritische Berichte*, XXII/2 (1994), pp. 74–7.

12 See, for example, Bogdan Tscherkes, 'Denkmäler von Führern des sowjetischen Kommunismus in der Ukraine', in *Bildersturm in Osteuropa*, pp. 39–45 (p. 39); Katalin Sinkó, 'Political Rituals: The Raising and Demolition of Monuments', in *Art and Society in the Age of Stalin*, ed. Péter György and Hedvig Turai (Budapest, Corvina, 1992), pp. 73–86.

13 Tscherkes, 'Denkmäler von Führern des sowjetischen Kommunismus in der Ukraine' (with map on p. 45).

14 Snjeska Knezevic, 'Die Denkmäler der sozialistischen Ära in Kroatien' in *Bildersturm in Osteuropa*, pp. 49–53; Gojko Zupan, 'Les monuments et l'espace public slovène de 1945 à 1991', in *Bildersturm in Osteuropa*, pp. 54–5.

15 Boime, 'Perestroika', p. 214; Bruno Adrian, 'Punta-Arenas, le nouvel "attrape-gringos" ', *Le Monde* (20–21 February 1994).

16 See C. Arvidsson and L. E. Blomquist, eds, *Symbols of Power: The Aesthetics of Political Legitimation in the Soviet Union and Eastern Europe* (Stockholm, 1987); Boris Groys, *Gesamtkunstwerk Stalin: Die gespaltene Kultur in der Sowjetunion* (Munich and Vienna, 1988); Matthew Cullerne Bown, *Art under Stalin* (Oxford, 1991); *Soviet Socialist Realist Painting 1930s–1960s*, exhibition catalogue by M. C. Bown and David Elliott: The Museum of Modern Art, Oxford (Oxford, 1992); Irène Semenoff-Tian-Chansky, *Le pinceau, la faucille et le marteau. Les peintres et le pouvoir en Union soviétique de 1953 à 1989* (Paris, IMSECO, 1993); György and Turai, eds, *Art and Society in the Age of Stalin*; *Agitation zum Glück: Sowjetische Kunst der Stalinzeit*, exhibition catalogue: Staatliches Russisches Museum, St. Petersburg; Kulturdezernat der Stadt Kassel-documenta Archiv (Bremen, 1993–4); Monika Flacke, ed., *Auftragskunst der DDR 1949–1990* (Munich and Berlin, 1995).

17 See W. Treue, *Kunstraub: Über die Schicksale von Kunstwerken in Krieg, Revolution und Frieden* (Düsseldorf, 1957), pp. 336–8; *Revolution und Literatur: Zum Verhältnis von Erbe*

(Leipzig, 1971); Walter Fähnders and Martin Rector, *Literatur im Klassenkampf* (Munich, 1971), pp. 43 ff.; *Razrushennye i oskvernennye khramy* [Destroyed and Desecrated Churches] (Frankfurt, Poev-Verlag, 1980); F. Choay, *L'allégorie du patrimoine* (Paris, 1992), p. 89.

18 See Lenin, *Sur l'art et la littérature*, ed. Jean-Michel Palmier, III (Paris, 1975), pp. 245–65.

19 Lenin, *Sur l'art et la littérature*, pp. 256–7 (German translation in *Demontage*, p. 11).

20 Lenin, *Sur l'art et la littérature*, pp. 248–9, 299; Baudin, 'Le réalisme socialiste soviétique de la période jdanovienne', pp. 167–8. On the differentiated attitudes to monuments in Moscow and Petrograd and the conservation of Falconet's statue, see Heinz-Werner Lawo, 'Krzysztof Wodiczko, Leninplatz-Projektion', in *Die Endlichkeit der Freiheit Berlin 1990. Ein Ausstellungsprojekt in Ost und West* (Berlin, Edition Hentrich, 1990), p. 207–8. Lawo considers that it was the destruction of the tsarist monuments in Russia that allowed the continued use of a baroque and monarchic formal language.

21 Lenin, *Sur l'art et la littérature*, pp. 261–4.

22 Ants Hein, 'Denkmäler der sowjetischen Ära in Estland', in *Bildersturm in Osteuropa*, pp. 69–75 (p. 69).

23 Boime, 'Perestroika', p. 218. See Hubertus Gaßner, 'Sowjetische Denkmäler im Aufbau', in *Mo(nu)mente: Formen und Funktionen ephemerer Denkmäler*, ed. Michael Diers (Berlin, 1993), pp. 153–78.

24 Alain Brossat, 'Le culte de Lénine: le mausolée et les statues', in *A l'Est la mémoire retrouvée*, ed. A. Brossat (Paris, 1990), pp. 165–97 (p. 172).

25 See Nina Tumarkin, *Lenin lives! The Lenin Cult in Soviet Russia* (Cambridge, Mass., 1983).

26 Brossat, 'Le culte de Lénine', pp. 187–8; Sinkó, 'Political Rituals', p. 81.

27 Christiane Stachau, 'Peruns Sandbank', in *Demontage*, pp. 15–19 (p. 16).

28 The historian Dmitri Volkogonov quoted in Marie Jégo, 'Les rangs clairsemés des enfants de Lénine', *Le Monde* (9 November 1994).

29 This synthetic view relies heavily on A. Baudin, 'Socrealizm. Le réalisme socialiste soviétique et les arts plastiques vers 1950: quelques données du problème', *Ligeia*, no. 1 (April–June 1988), pp. 65–88. I owe special thanks to Antoine Baudin for his reading of this chapter.

30 Baudin, 'Socrealizm', p. 79, with reference to V. Papernyj, *Kult'ura 'dva'* (Ann Arbor, 1985).

31 Baudin, 'Le réalisme socialiste soviétique de la période jdanovienne', pp. 171–3.

32 Radko Pytlík, 'Eine politisch indifferente Stimme aus Prag', in *Demontage*, pp. 127–30 (p. 127).

33 Brossat, 'Le culte de Lénine', p. 190; see also Gabi Dolff-Bonekämper, 'Kunstgeschichte als Zeitgeschichte. Der Streit um das Thälmann-Denkmal in Berlin', in Ruth Reiher and Rüdiger Läzer, eds, *Von Busch-Zulage und Ossi-Nachweis: Ost-Westdeutsch in der Diskussion* (Berlin, in preparation). According to Boime, however, this reinterpretation was integrated into the message and function of the monuments that became 'constant reminders of the guilt of accommodation', thus giving to their later destruction a dimension of 'self-detestation' and 'self-flagellation' (Boime, 'Perestroika', pp. 218, 221).

34 Anna Sianko, 'Pologne: quels monuments reconstruire après la destruction de Varsovie', in *A l'Est la mémoire retrouvée*, pp. 246–68 (p. 255); on 'humour culture', see Jacques Poumet, *La satire en R.D.A.: cabarets et presse satirique* (Lyon, 1990); Peter Pfrunder, 'Wie sozialkritisch können Witze sein? Witzkultur unter der Ceaucescu-Diktatur', in *Neue Zürcher Zeitung* (23 April 1990), no. 93, pp. 23–4.

35 See unspecified allusions in Jerzy Korejwo, 'Dserschinski in Stücke gehauen', in *Demontage*, pp. 151–4 (p. 151), and in Boime, 'Perstroika and the Destabilization of the Soviet Monuments'.

36 Tomaszewski, 'Zwischen Ideologie, Politik und Kunst', p. 32; Hein, 'Denkmäler der sowjetischen Ära in Estland', pp. 71–2 (on the 1954 all-Union conference of architects and the 1955 decree on the 'elimination of exaggerations in projecting and building').

347

37 If not mentioned otherwise, this summary relies on László Beke, 'The Demolition of Stalin's Statue in Budapest', in *Les iconoclasmes*, ed. S. Michalski (Strasburg, 1992), pp. 275–84, where reference to the sources can be found.

38 Sinkó, 'Political Rituals', p. 84; Beke, 'The Demolition of Stalin's Statue', p. 278.

39 The models are reproduced in János Pótó, *Emlékmüvek, politika, közgondolkodás: Budapest köztéri emlékmüvei, 1945–1949 így épült a Sztálin-szobor, 1949–1953* (Budapest, MTA Történettudományi Intézet, 1989).

40 László Prohászka, *Szóbórsórsók* (Budapest, Kornétás Kiadó, 1994), pp. 169–71; on the statue park, see below in the same chapter.

41 Peter Möbius and Helmut Trotnow, *Mauer sind nicht für ewig gebaut: Zur Geschichte der Berliner Mauer* (Berlin, 1990); Wolfgang Georg Fischer and Fritz von der Schulenburg, *Die Mauer: Monument des Jahrhunderts – Monument of the Century* (Berlin, 1990); M. Diers, 'Die Mauer. Notizen zur Kunst- und Kulturgeschichte eines deutschen Symbol(l)werks' in *Der Fall der Denkmäler*, pp. 58–74; Margaret Manale, *Le mur de Berlin* (Paris, 1993).

42 Robert Darnton, *Berlin Journal: 1989–1990* (New York and London, 1991), pp. 74–86; Nicolas Weill, 'Un entretien avec Robert Darnton', *Le Monde* (12–13 February 1995), p. 12.

43 Darnton, *Berlin Journal*, p. 75.

44 Darnton, *Berlin Journal*, p. 77; Diers, 'Die Mauer', pp. 62–3.

45 Diers, 'Die Mauer', pp. 58–9; 'Berlijn via Straatsburg naar Paris', *Haagse Courant* (6 April 1990); this piece had first been provisionally exhibited in front of the European Parliament in Strasburg.

46 Diers, 'Die Mauer', p. 61; for example, 'Verblassende Erinnerung an die Berliner Mauer. Kontroverse um eine angemessene Gedenkstätte', *Neue Zürcher Zeitung* (14 August 1992); G. Dolff-Bonekämper, 'Im Niemandsland', *Frankfurter Allgemeine Zeitung* (25 May 1994); G. Dolff-Bonekämper, 'Denkmalschutz – Denkmalsetzung – Grenzmarkierung' (forthcoming).

47 Harry Pross, 'Kann man Geschichte sehen?', in *Demontage*, pp. 107–9 (p. 108).

48 See elements of thought in Maurice Agulhon, 'Débats actuels sur la Révolution en France', *Annales historiques de la Révolution française*, no. 279 (January–March 1990), pp. 1–13.

49 Kirill Razlogov and Anna Vasilieva, ' "Damnatio memoriae": Neue Namen – neue Denkmäler in Rußland (1917–1991)' in *Bildersturm in Osteuropa*, pp. 29–33 (p. 36). For A. Brossat, the rejection of the Communist cult and idols may lead either to a secularization of public life or – as in Poland or Serbia – to a new topology of the sacred that will repress the former one ('Le culte de Lénine', p. 196); see also V. Soulé, 'Nouveaux rituels, nouveaux symboles', in A. Brossat and Jean-Yves Potel, eds, *L'Est: les mythes et les restes* (*Communications*, no. 55, 1992), pp. 11–22.

50 Untitled (and wordless) film by Evgeny Asse, Dmitri Gutoff, Vadim Fishkin and Viktor Misiano, part of the Russian Pavilion at the 1995 Biennale of Venice. In 1997 will be celebrated the 850th anniversary of the creation of Moscow (see Bernard Cohen, 'Le Christ-Sauveur ressuscite à Moscou', *Libération*, 6 October 1994, p. 11). A comparable criticism was expressed by Vitaly Komar: 'Bolsheviks topple czar monuments, Stalin erases old Bolsheviks, Krushchev tears down Stalin, Brezhnev tears down Krushchev ... No difference ... This is old Moscow technique: either worship or destroy ... Each time it is history, the country's true past, which is conveniently being obliterated. And usually by the same people!' (quoted in Lawrence Wechsler, 'Slight Modifications', *The New Yorker*, 12 July 1993, pp. 59–65).

51 Ch. M., 'Lenin geht – Kaiser Wilhelm kehrt zurück. Sturz und Auferstehung deutscher Denkmäler', *Neue Zürcher Zeitung* (30–31 May 1992), no. 124, p. 7; AFP, 'Une statue controversée de Guillaume Ier érigée à Coblence', *Le Monde* (4 September 1993); Yves Leblanc, 'Le "Deutsches Eck" de Coblence, un monument aux unités allemandes 1888–1894' (unpublished D.E.A. dissertation, E.H.E.S.S., Paris, 1994).

52 See chapter Five, p. 111–13.

53 P. Roettig, 'Sprechende Denkmäler. Von der Inschrift zum Graffito – Formen des Denkmalkommentars', in *Der Fall der Denkmäler*, pp. 75–82. Schön's woodcut is reproduced in this essay (p. 78), as well as in M. Warnke, 'Ansichten über Bilderstürmer: zur Wertbestimmung des Bildersturms in der Neuzeit', in *Bilder und Bildersturm im Spätmittelalter und in der frühen Neuzeit*, ed. Bob Scribner (Wiesbaden, 1990; Wolfenbütteler Forschungen, XLVI), p. 311 (comment on p. 301).

54 D.P.A.,, 'Stalin-Büste auf dem Roten Platz demoliert', *Neue Zürcher Zeitung* (19 March 1991).

55 C. Sr., 'Grossdemonstration in Tirana. Das Denkmal Enver Hodschas vom Sockel gestürzt', *Neue Zürcher Zeitung* (21 February 1991), p. 1; D.P.A./A.F.P., 'Ankündigung einer Präsidialregierung in Albanien', *Neue Zürcher Zeitung* (22 February 1991), no. 44, p. 3.

56 A.F.P., 'Lenin-Statue in Bukarest entfernt', *Neue Zürcher Zeitung* (6 March 1990), no. 54, p. 3; Gheorghe Vida, 'Zur Situation in Rumänien', pp. 63–5.

57 Reuter, 'C'est notre Mur de Berlin', *Gazette de Lausanne* (24–25 August 1991); witness by Michel Melot, Paris. Pieces of the statue were also taken away as tokens, and a young collector is reported to have said: 'This is our Berlin wall'. The next day (Friday), the Communist Party was prohibited by Boris Yeltsin, who announced the names of the new ministers in front of the Lubyanka; during the weekend, the monuments to Sverdlov and to Kalinin were demolished, reportedly by demonstrators (Ulrich Schmid, 'Jelzin betimmt die sowjetische Politik. Ein Schlag gegen die russische Kommunistische Partei', *Neue Zürcher Zeitung*, 24-25 August 1991; U. Schmid, 'Rücktritt Gorbatschews als Parteichef. Rapider Zerfall der Sowjetunion und der KPdSU', *Neue Zürcher Zeitung*, 26 August 1991, p. 1).

58 Boime, 'Perestroika and the Destabilization of the Soviet Monuments', p. 211.

59 Viktor Misiano, interviewed in the film by Mark Lewis and Laura Mulvey, *Disgraced Monuments* (A Monumental Pictures Production for Channel Four), 1993.

60 Dieter E. Zimmer, 'Was tun mit Lenin?', *Die Zeit* (18 October 1991), p. 102.

61 Sianko, 'Pologne', pp. 246–7.

62 See M. Warnke, 'Durchbrochene Geschichte? Die Bilderstürme der Wiedertäufer in Münster 1534/1535', in *Bildersturm: Die Zerstörung des Kunstwerks*, ed. M. Warnke (Frankfurt, 1977), p. 92.

63 Reuter, 'Kommunistische Symbole in Bulgarien entfernt', *Neue Zürcher Zeitung* (25 August 1990).

64 Yves-Michel Riols, 'Le Parlement interdit l'utilisation des symboles nazis et communistes', *Le Monde* (16 April 1993).

65 A.P., 'Die Stephanskrone wieder in Ungarns Staatswappen', *Neue Zürcher Zeitung* (5 July 1990), p. 2; see Véronique Soulé, 'Hongrie: la guerre des blasons', in *A l'Est la mémoire retrouvée*, pp. 150–61; Csaba G. Kiss, 'La guerre des blasons dans l'Europe centrale', *Les Temps Modernes*, XLVIII, no. 550 (May 1992), pp. 117–24.

66 Annette Leo, 'Spuren der DDR', in *Demontage*, pp. 59–66.

67 Antoni Czubinski, 'Die Zerstörung von Denkmälern – zum vierten Mal in Polen', in *Demontage*, pp. 157–62; Marion Van Renterghem, 'Budapest brade ses fantômes', *Le Monde* (20 November 1993), pp. vi–vii.

68 Leo, 'Spuren der DDR', p. 61 (the author adds that the Leninalle has been renamed Landsberger Allee in between, as this inhabitant wished, but doubts that he has ceased to be recognizable for that); Christoph Dieckmann, 'Hindenburg zu Dimitroff?', *Die Zeit* (10 November 1995).

69 W. Hauptmann, 'Berlin unterwegs zur wirklichen Hauptstadt', *Neue Zürcher Zeitung* (6–7 August 1994), p. 7; see Michael Klonovsky, 'Berlin. Verhaßte Symbole', *Frankfurter Allgemeine Zeitung* (25 Oktober 1991), p. 23.

70 Czubinski, 'Die Zerstörung von Denkmälern', p. 162.

71 Siegfried Stadler, 'Im Café Trabi. Deutsche Szene: Agricola statt Marx in Chemnitz', *Frankfurter Allgemeine Zeitung* (8 March 1994).

72 See M. Flacke, ed., *Auf der Suche nach dem verlorenen Staat: Die Kunst der Parteien und Massenorganisationen der DDR* (Berlin, 1994); Andreas Hüneke, 'Auferstehung des Fleischers. Die Integration der "DDR–Kunst" in der veränderten Hängung der Neuen Nationalgalerie', *Kritische Berichte*, XXII/3 (1994), pp. 34–8; Flacke, ed., *Auftragskunst der DDR 1949–1990*. Wall paintings, however, may share the fate of buildings, and museumization is not always a guarantee against disappearance: see Ernst-Michael Brandt, 'Nuttenbrosche? Keine Chance!', *Die Zeit* (7 August 1992), p. 12; Peter H. Feist, 'Geschichtsräume. Störbilder. Die Wandbilder im Berliner Palast der Republik', in *Städtebau und Staatsbau im 20. Jahrhundert: Auf der Suche nach der Neuen Stadt. Parallelen und Kontraste im deutschen Städtebau*, ed. G. Dolff-Bonekämper and Hiltrud Kier (Munich, forthcoming); and chapter Fifteen.

73 On the elimination of 'Traditionskabinette' in East Germany, see Leo, 'Spuren der DDR', p. 66; A. Leo, 'RDA: traces, vestiges, stigmates', in Brossat and Potel, eds, *L'Est: les mythes et les restes*, pp.43–54; see also Berthold Unfried, ' "Gedächtnisorte" und Musealisierung des "Realsozialismus" (am Beispiel Tschekoslowakei)', in *Der Fall der Denkmäler*, pp. 83–9; B. Unfried, 'La muséification du "socialisme réel" ', in *L'Est: les mythes et les restes*, pp. 23–42.

74 Henri de Bresson, 'Les Berlinois au château', *Le Monde* (2 July 1993); Frédéric Edelmann and Emmanuel de Roux, 'Berlin et ses fantômes', *Le Monde* (16 February 1994), p. 19; H. de Bresson, 'Un architecte pour le cœur de Berlin', *Le Monde* (24 May 1994), p. 11.

75 See the issue of *Kritische Berichte* on this topic ('Inmitten Berlins – das Schloß?', 1994, no. 1), in particular the contributions by K. Herding (pp. 26—30), H.-E. Mittig (pp. 75–6) and Bruno Flierl (pp. 77–8).

76 Roman Hollenstein, 'Jahrmarkt der architektonischen Eitelkeiten. Berlin im November', *Neue Zürcher Zeitung* (18–19 November 1995), p. 33; G. Dolff-Bonekämper, 'Der "Palast der Republik" in Berlin', unpublished paper delivered before the German Parliament in June 1994.

77 A. Brossat, Sonia Combe, J.-Y. Potel and Jean-Charles Szurek, 'Introduction', in *A l'Est la mémoire retrouvée*, pp. 11–35 (p. 11).

78 Unfried, 'Gedächtnisorte', p. 87; E. J. Hobsbawm and T. Ranger, *The Invention of Tradition* (Oxford and London, 1982).

79 Brossat et al., 'Introduction', pp. 33–4.

80 See Joseph Jurt, 'L'identité allemande et ses symboles', *Les Temps Modernes*, XLVIII, no. 550 (May 1992), pp. 125–53; Andreas Bärnreuther, 'NS–Architektur und Stadtplanung als Herausforderung für die Kunstgeschichte', *Kritische Berichte*, XXII/3 (1994), pp. 47–54.

81 For comparisons, see the case of the Panthéon / Sainte-Geneviève mentioned in chapter Two, p. 39; Czubinski, 'Die Zerstörung von Denkmälern'; G. Dolff-Bonekämper, 'Schinkels Neue Wache Unter den Linden. Ein Denkmal in Deutschland', in *Streit um die Neue Wache: Zur Gestaltung einer zentralen Gedenkstätte* (Berlin, 1993), pp. 35–44.

82 Wolf Biermann, 'Et à la frontière? ou Que vont devenir les chiens?', *Libération* (14 November 1989); an East German, Biermann had been denied access to his country since 1975.

83 Boime, 'Perestroika', pp. 212, 218.

84 See for example Lawo, 'Krzysztof Wodiczko', pp. 207–9; Wladimir Miljutenko, 'Wir dürfen nicht geschichtslos werden', in *Demontage*, pp. 23–30; H.-E. Mittig, 'Rekonstruieren gegen Erinnern?', *Kritische Berichte*, XXII/1 (1994), pp. 75–6.

85 Friedrich Dieckmann, 'Friedrich und Iljitsch – Zwei Berliner Monumente', in *Demontage*, pp. 47–8.

86 Already in 1988, an organization called 'Palais-Jalta' was founded in Frankfurt, in relation to the Deutsches Architekturmuseum, in order to preserve the monumental heritage of Communism.

87 Thomas Flierl, 'Denkmalstürze zu Berlin. Vom Umgang mit einem prekären Erbe', in *Der Fall der Denkmäler*, pp. 45–57 (p. 49).

88 H.-E. Mittig, 'Zur Eröffnung der Ausstellung' in *Erhalten – zerstören – verändern?*

Denkmäler der DDR in Ost-Berlin. Eine dokumentarische Ausstellung, exhibition catalogue: Neue Gesellschaft für Bildende Kunst (Berlin, Schriftenreihe des Aktiven Museums Faschismus und Widerstand in Berlin e.V., 1, 1990), pp. 8–15 (p. 11); Hans Haacke, 'Die Freiheit wird jetzt einfach gesponsert – aus der Portokasse', in *Die Endlichkeit der Freiheit*, pp. 87–104 (Haacke's contribution to this exhibition consisted of a Berlin watch-tower combined with a Mercedes star and the inscriptions 'Bereit sein is alles' – to be ready is everything, and 'Kunst bleibt Kunst' – art remains art). For examples of monuments to the victims of Communist regimes, see Christine Stachau, 'Peruns Sandbank', in *Demontage*, pp. 15–19 (p. 18, on the monument erected in the autumn of 1989 in Lubyanka Square, with reproduction); 'Den Opfern. Kulturausschuß für DDR-Mahnmale', *Frankfurter Allgemeine Zeitung* (17 March 1994), p. 33.

89 'Bericht. Kommission zum Umgang mit den politischen Denkmälern der Nachkriegszeit im ehemaligen Ost-Berlin. Berlin, den 15. Februar 1993', unpublished report (Berlin, 1993), pp. 82–5. In his essay (Boime, 'Perestroika', pp. 213–14), A. Boime proposed to distinguish between monument inversion ('collective crowd action in overturning monuments during times of drastic political change'), monument subversion ('official overthrow of the history of the recent past'), and monument conversion ('salvaging of the monument or its fragments by recoding and recycling them in a different interplay between the past, present and future').

90 Ekkehard Schwerk, 'Nachdenkliche Annäherung an Standbilder im Stadtbild. Die Denkmäler des SED-Regimes', *Der Tagesspiegel / Berlin* (9 February 1991), p. 15; 'Bericht', p. 9.

91 W.S., 'Mehrheit für Marx und Engels, auch wenn sie nicht gefallen', *Frankfurter Allgemeine Zeitung* (29 November 1990); 'Bericht', pp. 26–8.

92 Ulrich Schmid, 'Etikettenschwindel in der russischen Provinz. Altkommunistische "Reformer" in Woronesch', *Neue Zürcher Zeitung* (17–18 September 1994); U. Schmid, 'In Moskau bleibt Lenin allgegenwärtig. Weit über 100 Denkmäler und Büsten allein in der Innenstadt', *Neue Zürcher Zeitung* (9 June 1995), p. 48. The recent removal of the national emblems – which had replaced the Soviet ones – from official buildings in Bielorussia may go in the same direction (Jan Krauze, 'Histoire de la conquête russe, 12. "L'empire se venge" ', *Le Monde*, 27–28 August 1995, p. 8).

93 Hein, 'Denkmäler der Sowjetischen Ära in Estland', p. 73; Korejwo, 'Dserschinski in Stücke gehauen', p. 154.

94 Tomás V. Novák, 'Der rosarote Panzer – Made in Czechoslovakia', in *Demontage*, pp. 133–40; Unfried, 'Gedächtnisorte', p. 83. The tank was later transferred to the Museum of Military History.

95 Razgolov and Vasilieva, 'Damnatio memoriae', p. 37 (with another photograph showing the Moscow Sverdlov monument inscribed 'hangman').

96 P. Roettig, ' "Proletarier der Welt, vergebt mir!" Von der Inschrift zu den Graffiti – Formen der Denkmalkommentare', *Neue Zürcher Zeitung* (12–13 September 1992), p. 69-70; Roettig, 'Sprechende Denkmäler'. The preservation of the graffiti has been envisaged (see the opinion of Christine Hoh-Slodczik mentioned in Schwerk, 'Nachdenkliche Annäherung an Standbilder im Stadtbild'; on graffiti, see further chapter Fifteen.

97 Dieter E. Zimmer made a revealing allusion to this necessity when he mentioned the fact that 'one identifies willy-nilly the state with the monuments that stand on its streets' ('Was tun mit Lenin?').

98 Dirk Schumann, 'Betriebskampfgruppendenkmal' in *Erhalten – Zerstören – Verändern?*, pp. 77–9; Torsten Harmsen, ' "Darmverschlingung" gegen Marx-Engels-Forum? "Sozialistische" Monumente in Visier', *Berliner Zeitung* (5 October 1990); Ralf Neukirch, ' "Am liebsten würde ich den Kerl einfach umhauen". An den Denkmälern des SED-Staates scheiden sich die Geister', *Bonner Rundschau* (1 November 1990); Andrea Scheuring, 'Denkmäler fallen für teures Geld. Abriß des Kampfgruppen-Monuments steht bevor', *Berliner Zeitung* (29 January 1992); Thomas Flierl, 'Gegen den Abriß eines

Baudenkmals. Eine Rede aus dem Jahr 1984', in *Der Fall der Denkmäler*, pp. 53–7 (pp. 51–2).

99 For an example of an 'anti-monument' see Dietrich Schubert, 'Alfred Hrdlickas antifaschistisches Mahnmal in Hamburg' in *Denkmal – Zeichen – Monument: Skulptur und öffentlicher Raum heute*, ed. Ekkehard Mai and Gisela Schmirber (Munich, 1989), pp. 134–43; D. Schubert, ' "Hamburger Feuersturm" und "Fluchtgruppe Cap Arcona". Zu Alfred Hrdlickas "Gegendenkmal" ' in *Kunst im öffentlichen Raum. Anstöße der 80er Jahre*, ed. Volker Plagemann (Cologne, 1989), pp. 150–70; Jürgen Hohmeyer, 'Das Hakenkreuz als statische Krücke. Zu Alfred Hrdlickas "Gegendenkmal" ', in *Kunst im öffentlichen Raum*, pp. 171–6.

100 Rudolf Herz, *Lenins Lager. Entwurf für eine Skulptur in Dresden* (Berlin, 1992).

101 *Demontage*, p. 171; Komar and Melamid, 'What is to Be Done with Monumental Propaganda?', *Artforum* (May 1992); Wechsler, 'Slight Modifications'; *Monumental Propaganda*, travelling exhibition ed. Dore Ashton (New York: Independent Curators Inc., 1994).

102 Oral communication by Pierre Vaisse; see *Pierre Puvis de Chavannes*, exhibition catalogue by Aimée Brown Price: Van Gogh Museum, Amsterdam (Zwolle, 1994), p. 200.

103 Mentioned in W. Hofmann, 'Die Geburt der Moderne aus dem Geist der Religion', in *Luther und die Folgen für die Kunst*, exhibition catalogue: Hamburger Kunsthalle, Hamburg (Munich, 1983), p. 68.

104 'Sur certaines possibilités d'embellissement irrationnel d'une ville (12 mars 1933)', enquiry E of the 'Recherches expérimentales', *Le surréalisme au service de la révolution*, no. 6 (May 1933), pp. 18–20; see Thierry Dufrêne, 'Les "places" de Giacometti ou le "monumental à rebours" ', *Histoire de l'art*, no. 27 (October 1994), pp. 81–92 (pp. 82–4).

105 E. Marosi, 'Sturz alter und Errichtung neuer Denkmäler in Ungarn 1989-1992', in *Bildersturm in Osteuropa*, pp. 58–62 (p. 59).

106 Korejwo, 'Dserschinski in Stücke gehauen', p. 151; *Demontage*, p. 141.

107 L. Beke, 'Das Schicksal der Denkmäler des Sozialismus in Ungarn' in *Bildersturm in Osteuropa*, pp. 56–7.

108 W.S., 'Mehrheit für Marx und Engels'; Schwerk, 'Nachdenkliche Annäherung an Standbilder im Stadtbild'.

109 Unfried, 'Gedächtnisorte', p. 88.

110 W. Dormidontow, 'Idole hier – Idole dort' in *Demontage*, p. 164.

111 Unfried, 'Gedächtnisorte', p. 88; for a failed project of 'anti-memorial' in Estonia see Hein, 'Denkmäler der sowjetischen Ära in Estland', pp. 73–4.

112 Marosi, 'Sturz alter und Errichtung neuer Denkmäler', p. 58; V. Soulé, 'Les statues communistes vont s'exposer à Budapest', *Libération* (17 February 1993); Van Renterghem, 'Budapest brade ses fantômes'; Prohászka, *Szóbórsórsók*, pp. 172–7; V. Soulé, 'A Budapest, le gardien des héros du peuple', *Libération* (18 January 1995).

113 Kerstin Holm, 'Alte Dämonen als neue Teufelchen. Ästhetik der Antikunst und Phantasiepreise: In Rußland wird der Realismus der Stalin-Zeit wiederentdeckt', *Frankfurter Allgemeine Zeitung* (23 November 1993), p. 37; see, for instance, the catalogue of the exhibition *Kunst und Diktatur*, which also mentions, under the name 'Premjera', a Moscow 'experimental-commercial cultural centre of the association The World of Culture'.

114 'Podiumsdiskussion: Wohin mit der Kunst?', in *Auf der Suche nach dem verlorenen Staat*, ed. Flacke, p. 163 (intervention of Klaus-Peter Wild).

115 M. Diers, 'Von dem, was der Fall (der Denkmäler) ist', in *Der Fall der Denkmäler*, pp. 4–6 (p. 5); *Spuren suchen* (Körber-Stiftung, Hamburg), VI (1992): 'Denkmal: Erinnerung – Mahnung – Ärgernis', p. 45.

116 The following relation is based in particular on Eberhard Elfert, 'Die politischen Denkmäler der DDR im ehemaligen Ost-Berlin und unser Lenin' in *Demontage*, pp. 53–8; Hubertus Adam, 'Erinnerungsrituale – Erinnerungsdiskurse – Erinnerungstabus. Politische Denkmäler der DDR zwischen Verhinderung, Veränderung und Realisierung',

in *Der Fall der Denkmäler*, pp. 10–35; Maria Rüger, 'Das Berliner Lenin-Denkmal', in *Der Fall der Denkmäler*, pp. 36–44; *Bürgerinitiative Lenindenkmal = Demokratie in Aktion* (Berlin, 'Bürgerinitiative Lenindenkmal Berlin-Friedrichshain', 1992); M. Flacke, Jörn Schütrumpf, 'Nikolai Tomski, Lenindenkmal. Auftraggeber: Zentralkomitee der SED', in *Auftragskunst*, ed. Flacke, pp. 201–5; Elisabeth von Hagenow, 'Ikonographische Anmerkung', in *ibid*, pp. 205–7; as well as on interviews with E. Elfert and A. Tietenberg conducted in Berlin in July 1992.

117 Adam, 'Erinnerungsrituale', pp. 26–8; on monuments and urbanism in the DDR, see further Bruno Flierl, 'Politische Wandbilder und Denkmäler im Stadtraum' in *Auf der Suche nach dem verlorenen Staat*, pp. 47–60.

118 Flacke and Schütrumpf, 'Nikolai Tomski', pp. 204–5.

119 Peter Jochen Winters, 'Der steinerne Gast geht. Das Lenin-Denkmal in Berlin-Friedrichshain soll entfernt werden', *Frankfurter Allgemeine Zeitung* (17 October 1991).

120 Elfert, 'Die politischen Denkmäler', p. 53; G. Dolff-Bonekämper, 'Das Spanienkämpfer-Denkmal von Fritz Cremer', in *Bildersturm in Osteuropa*, pp. 89–90 (p. 89); *Erhalten – zerstören – verändern?*, p. 16.

121 *Erhalten – Zerstören – Verändern?*; Walter Grasskamp, *Die unbewältigte Moderne. Kunst und Öffentlichkeit* (Munich, 1989), p. 130.

122 Winters, 'Der steinerne Gast geht'; Zimmer, 'Was tun mit Lenin?'.

123 Lawo, 'Krzysztof Wodiczko'; see also *Public Address. Krzysztof Wodiczko*, exhibition catalogue: Walker Art Center, Minneapolis (Minneapolis, 1993), p. 158; K. Wodiczko, *Art public, art critique. Textes, propos et documents* (Paris, 1995), p. 161. On Wodiczko's projections, see in particular his 'Public Projection', *Canadian Journal of Political and Social Theory*, VII/1–2 (1983).

124 Winters, 'Der steinerne Gast geht'; Zimmer, 'Was tun mit Lenin?'

125 Winters, 'Der steinerne Gast geht'; see also H.-E. Mittig, 'Gegen den Abriß des Berliner Lenin-Denkmals' in *Demontage*, pp. 41–6.

126 Zimmer, 'Was tun mit Lenin?'.

127 Matthias Matussek, 'Lenins Stirn, fünfter Stock', *Der Spiegel*, no. 46 (1991), pp. 341–2.

128 Flacke and Schütrumpf, 'Nikolai Tomski', p. 205.

129 'Wann brennen die Bücher?', reproduced in *Bürgerinitiative Lenindenkmal*, p. 6. The inscription 'Keine Gewalt' should not be interpreted as meaning 'no power' (see Boime, 'Perestroika', p. 219) but 'no violence'; it alluded to the peaceful 1989 revolution, where this formula had been used as slogan.

130 *Bürgerinitiative Lenindenkmal*, pp. 18–19. The argument according to which the statue was a scandal for the public was put forward by the Superior court on 5 November.

131 See 'Bericht', p. 82. The commission observed that the pieces were partially damaged, as a sequel of the dismantling and because of souvenir hunters, and excluded a reconstruction unless a private buyer would purchase them for this purpose.

132 It is a curious coincidence that after the pulling down of the Vendôme Column as a 'necessary victim to the United States of Europe', the Parisian Commune renamed the Vendôme Square 'place Internationale' (B. Gagnebin, 'Courbet et la colonne Vendôme' in *Mélanges d'histoire économique et sociale en hommage au professeur Antony Babel* (Geneva, 1963), II, p. 257, with quotation from Félix Pyat, *Le Vengeur*, 17 May 1871). According to a recent testimony (Dieckmann, 'Hindenburg zu Dimitroff?'), an East Berlin bus driver is renowned for calling 'Nächste Station: Leninplatz der Vereinten Nationen!' (next stop: Lenin Square of the United Nations).

133 Dieter Stäcker, 'Selbstreinigung oder primitive Bilderstürmerei? "Was kann 'ne tote Figur dafür, daß sich die Zeiten ändern"', *Badische Zeitung* (11 October 1991).

134 Hubert Staroste, 'Politische Denkmäler in Ost-Berlin im Spannungsfeld von Kulturpolitik und Denkmalpflege' in *Bildersturm in Osteuropa*, pp. 84–6 (p. 84).

135 Staroste, 'Politische Denkmäler in Ost-Berlin', p. 85; Elfert, 'Die politischen Denkmäler der DDR', p. 58; 'Bericht', pp. 2–3.

136 'Bericht', pp. 6–8, 12.

137 See Vida, 'Zur Situation in Rumänien', p. 65, on the removal of a statue of Petru Groza by the important Rumanian sculptor Romul Ladea.

138 The Berlin commission proposed, for instance, to preserve the monuments to anti-Fascists and to remove the ones to the 'border soldiers' ('Bericht', pp. 72, 83–4).

139 Dolff-Bonekämper, 'Das Spanienkämpfer-Denkmal'; letter of G. Dolff-Bonekämper to the author, 31 October 1995.

140 Paul Stoop, 'Die lästigen Zeugnisse. Kontroverse Debatte um die Denkmäler im Osten Berlins', *Der Tagesspiegel* (27 October 1990); the author of the phrase quoted is an East Berlin art historian called Joachim Scheel; names of like-minded artists are Reinhard Zabka and Eva Kowalski.

141 Thomas Rietzschel, 'Marx und Engels dösen in die Zukunft', *Frankfurter Allgemeine Zeitung* (29 October 1990).

142 Martin Schönfeld and A. Tietenberg, 'Vorwort' in *Erhalten – Zerstören – Verändern?*, p. 7 ; Stoop, 'Die lästigen Zeugnisse'.

143 See in particular H.-E. Mittig and V. Plagemann, eds, *Denkmäler im 19. Jahrhundert: Deutung und Kritik* (Munich, 1972); B. Hinz and H.-E. Mittig, eds, *Die Dekoration der Gewalt: Kunst und Medien im Faschismus* (Gießen, 1979); H.-E. Mittig, 'Das Denkmal' in *Funkkolleg Kunst: Eine Geschichte der Kunst im Wandel ihrer Funktionen*, ed. Werner Busch (Munich and Zurich, 1987), II, pp. 532–58.

144 Mittig, 'Gegen den Abriß'.

145 Mittig, 'Zur Eröffnung der Ausstellung', p. 10.

146 'Podiumsdiskussion: Wohin mit der Kunst?', pp. 161–2, 167–8 (interventions of M. Warnke and P. Feist); see also the intervention of Heinz Dieter Kittsteiner, p. 169; on the modern conception of the work of art as a political statement of the artist rather than of the patron, see chapter Eight, p. 141.

147 Quoted in Brandt, ' Nuttenbrosche? Keine Chance', p. 12.

148 Werner Schmidt, quoted in 'Jens Uwe Sommerschuch', *Art*, no. 4 (1992), reproduced in Herz, *Lenins Lager*, p. 29.

149 *Bürgerinitiative Lenindenkmal*, p. 9.

150 W.S., 'Mehrheit für Marx und Engels'.

151 Sinkó, 'Political Rituals', p. 81; see also Marosi, 'Sturz alter und Errichtung neuer Denkmäler', p. 60.

152 Baudin, 'Socrealizm', p. 66. A. Brossat notices that in the Soviet Union, Lenin statues were rarely mentioned as worth seeing in tourist information for Western visitors (Brossat, 'Le culte de Lénine', pp. 188–9).

153 Marosi, 'Sturz alter und Errichtung neuer Denkmäler', p. 60; see also Unfried, 'Gedächtnisorte', pp. 84–5, 88, with reference to Pierre Nora's concept of 'lieux de mémoire'.

Chapter 4

1 Christian Caujolle, 'Prologue explosif: "Arrêt Curés" s'en prend à Ponce Pilate', *Libération* (13–15 August 1983), p. 2. Saint Bernadette Soubirous (1844–79) was the young peasant whose visions of the Virgin initiated the Lourdes pilgrimage.

2 'A Rocamadour. Quatre statues décapitées pour protester contre "les pantalonnades révolutionnaires" ', *Le Monde* (29 August 1989).

3 See Neil McWilliam, 'Monuments, Martyrdom, and the Politics of Religion in the French Third Republic', *Art Bulletin*, LVII/2 (June 1995), pp. 186–206 (in particular pp. 189, 192ff).

4 'Représentation' is a fascinatingly polysemic word. It was certainly meant here in the sense of symbolic representation, with reference to what others have denounced as the 'politique-spectacle', i.e. politics made as and by means of (particularly television) shows, but probably also in the politological sense of 'representative' democracies; see Carlo Ginzburg, 'Représentation: le mot, l'idée, la chose', *Annales ESC*, XLVI (1991), pp. 1219–34. In the

Lourdes case, it must be added that a few days before the 'assault', the 'association La libre pensée' had written a protest against the 'intolerable offensive of the mass media (notably radio and television)' on the occasion of the Pope's visit, stating that this event concerned only Catholics and that the Government was not observing 'the 1905 law on the separation of Church and State' ('Les libre-penseurs protestent', *Libération*, 13–15 August 1983, p. 2). This announcement, however, was published in *Libération* only as an appendix to the article relating the later 'assault', the greater efficiency of which in obtaining access to the media is thus clearly apparent.

5 Julius von Végh, *Die Bilderstürmer: Eine kulturgeschichtliche Studie* (Strasburg, 1915) p. 135.

6 'National Gallery outrage', *The Times* (11 March 1914). My brief account is based on this very lengthy article, from which the quotations are excerpted. Lynda Nead adds that 10 March was a Tuesday, one of the days on which admission to the Gallery was free of charge (L. Nead, *The Female Nude: Art, Obscenity and Sexuality*, London and New York, 1992, p. 34).

7 *The Times* (11 March 1914): 'Miss Richardson's statement'.

8 Emmeline Pankhurst, *My own Story* (London, 1914), p. 344, reprinted in Marie Mulvey Roberts and Tamae Mizuta, eds, *The Suffragettes: Towards Emancipation* (London, 1993).

9 *The Star* (22 February 1952); D. Freedberg, *The Power of Images: Studies in the History and Theory of Response* (Chicago and London, 1989), p. 410.

10 Nead, *The Female Nude*, p. 36. For a case of 'destruction art' possessing an important feminist dimension, see the *Tirs* (shots, i.e. plaster reliefs containing colour that the spectator or artist could shoot at) created between 1961 and 1963 by Niki de Saint-Phalle (Justin Hoffmann, *Destruktionskunst. Der Mythos der Zerstörung in der Kunst der frühen sechziger Jahre*, Munich, 1995, pp. 64–71).

11 Barbara Caine, *Victorian Feminists* (Oxford, 1992), p. 262.

12 Roberts and Mizuta, *The Suffragettes*, p. x; Lisa Tickner, *The Spectacle of Women: Imagery of the Suffrage Campaign 1907–14* (London, 1987), p. 135.

13 E. Sylvia Pankhurst, *The Suffragette Movement: An Intimate Account of Persons and Ideals* (London, 1977, 1st edn, 1931), p. 544. Sylvia Pankhurst mentions the number of 261 'more serious acts of destruction attributed by the Press to the Suffragettes in the years 1913 and 1914' (*op. cit.*). She also mentions the damaging by May Spencer of Clausen's *Primavera* at the Royal Academy, five pictures slashed at the National Gallery, Lavery's portrait of the King damaged in the Royal Scottish Academy (p. 554), the explosion of (presumably another) bomb in Westminster Abbey damaging the Coronation chair and stone and the wall of Edward the Confessor's chapel (p. 569), as well as the sentencing of Gertrude Ansell and of Mary (presumably the same as May) Spencer to six months imprisonment for injuring pictures at the Royal Academy (p. 578). Other destructions of art are mentioned in passing in Pankhurst, *My Own Story* (pp. 282–3, 306), in particular an attack on 'another famous painting, the Sargent portrait of Henry James' a few weeks after the *Rokeby Venus* case (p. 345).

14 Pankhurst, *My Own Story*, pp. 213–4, 268, 265.

15 Freedberg, *The Power of Images*, p. 412; Pankhurst, *My Own Story*, p. 345. Sylvia Pankhurst's later account of the campaign is marked by a similar obsession with figures.

16 *The Times* (11 March 1913): 'Police court proceedings. An expert's account of the damages'; Nead, *The Female Nude*, pp. 38–9. Kathrin Hoffmann-Curtius has contrasted this depreciative designation with the positive – though provocative – use of the same nicknames for themselves by artists like Walter Sickert and George Grosz (K. Hoffmann-Curtius, *George Grosz, 'John, der Frauenmörder'*, Stuttgart, 1993, p. 42).

17 Pankhurst, *My Own Story*, p. 345.

18 On the establishment of the referential relationship necessary to exemplification, see N. Goodman, *Languages of Art: An Approach to a Theory of Symbols* (Indianapolis and Cambridge, 1976), p. 88.

19 See Nathalie Heinich, 'Les objets-personnes. Fétiches, reliques et œuvres d'art', *Sociologie de l'art*, no. 6 (1993), pp. 25–55.

20 The story was later included in *A Book of Drawings* (London, 1921) and reprinted as an independent volume in 1976 (London: Henry Pordes). Nothing in it alludes directly to the Suffragettes' attacks in museums, but one can notice that they smashed many glasses (the ones of thirteen paintings in the Manchester Art Gallery, for instance, mentioned in Pankhurst, *My Own Story*, p. 306) and, at least on one occasion, a mummy case at the British Museum (Pankhurst, *The Suffragette Movement*, p. 554). Because of the glass protecting the *Rokeby Venus*, Lynda Nead sees Mary Richardson's action as well as the suffragists' attacks on the windows of famous London department stores as expressions of their 'rejection of patriarchal culture both on the street and in the art gallery' (Nead, *The Female Nude*, p. 39).

21 See Georg Germann, 'Brunnenfigur der Gerechtigkeit', in *Zeichen der Freiheit: Das Bild der Republik in der Kunst des 16. bis 20. Jahrhunderts*, ed. D. Gamboni and G. Germann (Berne, 1991), p. 169–70. The very severely damaged statue could nevertheless be restored and intrusted to the Bernisches Historiches Museum. After some debate on how to commemorate the destruction and replace the sculpture, a copy was realized.

22 'Mitteilung des Pressedienstes der Stadt Bern. Stellungnahme der Stadtberner Exekutive zum Vandalenakt am Gerechtigkeitsbrunnen' (13 October 1986). As with most documents quoted hereafter, this one was consulted in the files of the Denkmalpflege der Stadt Bern, Berne, which were kindly made available to me by Bernhard Furrer.

23 'La "Justice" de Berne à terre', undated ('Tavannes, date du timbre postal'), signed 'Au nom du Groupe Bélier / L'animateur principal / D. Carnazzi'.

24 'Le gouvernement jurassien condamne le coup des Béliers à Berne' (16 October 1986).

25 See *Nouvelle histoire de la Suisse et des Suisses* (Lausanne, 1983), III, pp. 273–6; Fritz-René Alleman, *Vingt-six fois la Suisse* (Lausanne, 1985), pp. 369–85; *BGE (Bundesgerichtsentscheidungen)* (Berne, 1992), CXVIII, part IV, pp. 376–7.

26 *BGE*, p. 372; the Supreme Court of the canton of Berne has obligingly allowed me access to the unpublished judgment of the Berne court.

27 *BGE*, p. 377.

28 *BGE*, p. 378–93.

29 Ivan Vecchi, 'La "Sentinelle" abattue', *Le Matin* (2 June 1984), p. 3; G. Kreis, 'Geschichte eines Denkmals', *Basler Magazin* (25 August 1984); S.D.-A., 'Soldatendenkmal in Les Rangiers erneut Ziel eines Anschlags', *Neue Zürcher Zeitung* (11 August 1989), p. 17; V. G., 'Nouvel attentat contre le "Fritz" des Rangiers', *Le Matin* (27 February 1990), p. 12.

30 Jorg Kiefer, 'Brandanschlag auf die Aarebrücke von Büren. Rache für den Berner Justitia-Prozess?', *Neue Zürcher Zeitung* (6 April 1989). The same bridge (built in 1821 to replace bridges going back to 1284) had already been set on fire in 1987, another group (the 'Nouveau Front de libération du Jura') claiming the action as its 'tenth assault' (A.T.S., 'Sur le compte du "nouveau FLJ". "Dixième attentat" revendiqué', *24 Heures*, 19 November 1987).

31 Ivan Vecchi, 'Histoire de fortes têtes', *Le Matin* (9 June 1984), p. 3; G. Kreis, 'Denkmäler und Denkmalnutzung in unserer Zeit', *Schweizerische Zeitschrift für Soziologie*, III (1987), pp. 420–21.

32 Ivan Vecchi, 'Un "accident" prévisible', *Tribune de Lausanne* (2 June 1984), p. 3.

33 Raul Riesen, 'Les Béliers au front bas', *La Suisse* (15 October 1986); Bertil Galland, 'La bêtise au front de bélier', *24 Heures* (21 October 1986).

34 Bernhard Furrer, 'Die Zerstörung des Gerechtigkeitsbrunnens in Bern', *Unsere Kunstdenkmäler*, XXXVIII (1987), pp. 192–5.

35 Germann, 'Brunnenfigur der Gerechtigkeit', p. 170.

36 Franz Bächtiger, presentation sheet of the fountain statues in the Bernisches Historisches Museum, 1988. On the handling of political symbols in Berne in 1798, see D. Gamboni, ' "Instrument de la tyrannie, signe de la liberté": la fin de l'Ancien Régime en Suisse et la

conservation des emblèmes politiques', in *Les iconoclasmes*, ed. S. Michalski (Strasburg, 1992), pp. 213–28.

37 Kreis, 'Denkmäler und Denkmalnutzung', p. 421. For Kreis, the *Sentinel* was by contrast resented as a 'remnant of the Bernese domination, a foreign body that had to be removed from the sovereign territory of the young canton'); see further Furrer, 'Die Zerstörung', p. 81, as well as the popular reactions to the destruction, comparable – according to the defender of Pascal Hêche – to the ones provoked by a murder (W., 'Ich habe an diesem Vandalenakt nicht teilgenommen', *Der Bund*, 16 March 1989, p. 27).

38 Plb, 'Justizia-Prozess. "Eine unentschulbare und ruchlose Tat" ', *Der Bund* (17 March 1989), p. 25. It is significant, even though obvious, that this action had failed to attract notice.

39 See Alleman, *Vingt-six fois la Suisse*, p. 385.

40 Jean-Philippe Ceppi, 'Effondré, le groupe Bélier pleure son disparu. Et s'en distancie', *Le Nouveau Quotidien* (9 January 1993), p. 8.

41 Telephone interview with the author, 5 July 1995.

42 See Luc Boltanski and Laurent Thévenot, *De la justification: Les économies de la grandeur* (Paris, 1991).

43 W., 'Ich habe an diesem Vandalenakt nicht teilgenommen'.

44 Hélène Guéné and François Loyer, *L'Eglise, l'Etat et les architectes: Rennes, 1870–1940* (Paris, 1995), pp. 263–4. The statue had filled the gap created by the elimination, during the French Revolution, of a monument to Louis xv by Jean-Baptiste Lemoyne bearing the same title (idem, and L. Réau, *Histoire du vandalisme. Les monuments détruits de l'art français* (Paris, 1959), II, p. 262 (1994, pp. 881–2).

45 A.P., 'Beeld vernield in Wenen', *Algemeen Dagblad* (2 October 1961).

46 A.F.P., 'Après le vol de tableaux en Eire. Double exigence et menace' (4 May 1974).

47 Bader, *Das politische Verbrechen* (Zurich, 1900), p. 187, quoted in *BGE*, p. 389.

48 See François Thual, *Les conflits identitaires* (Paris, 1995), as well as Bertrand Badie, *La fin des territoires. Essai sur le désordre international et sur l'utilité sociale du respect* (Paris, 1995). Some separatist militants have not refrained from simplifying the complex history and geography of the Jura problem into clearcut oppositions of 'ethnic' identity (*Nouvelle Histoire de la Suisse*, p. 276; Alleman, *Vingt-six fois la Suisse*, pp. 371–3).

49 Furrer, 'Die Zerstörung', pp. 193–4.

50 Josette Rey-Debove and Alain Rey, eds, *Le nouveau Petit Robert. Dictionnaire alphabétique et analogique de la langue française* (Paris, 1993), p. 2238; A.F.P., ' "Weinende Frau". Neue Botschaft der "Kulturterroristen" ', *Frankfurter Allgemeine Zeitung* (18 August 1986); Anon., 'Daders van aanslagen zijn cultuurterroristen', *Nieuwe Rotterdamsche Courant* (29 July 1993).

51 Marie-Claude Descamps, 'Après les attentats meurtriers de Milan et de Rome. Le gouvernement et les syndicats italiens appellent à combattre le terrorisme', *Le Monde* (29 July 1993), pp. 1, 6. In Milan, the bomb exploded near to the Civico Museo d'Arte Contemporanea and Piazza Cavour. The Mafia leader Giovanni Brusca, arrested by the Italian police in May 1996, was accused of having organized the car-bombs, which the prosecutors said 'came in retaliation to the arrest of Riina [the former 'Boss of Bosses'] and to the Pope's condemnation of Cosa Nostra' in 1993 (Reuters, 'Italian Police Arrest the Mafia's "Boss of Bosses" ', *The Independ*ent, 21 May 1996, p. 9).

52 'L'Italie s'interroge', *Le Monde* (30 July 1993), p. 1; A. Krauze, *The Guardian* (29 July 1993).

53 Végh, *Die Bilderstürmer*, p. 135.

Chapter 5

1 M. Warnke, 'Bilderstürme', in *Bildersturm. Die Zerstörung des Kunstwerks*, ed. M. Warnke (Frankfurt, 1977), pp. 13, 8.

2 H. Bredekamp, *Kunst als Medium sozialer Konflikte. Bilderkämpfe von der Spätantike bis zur Hussitenrevolution* (Frankfurt, 1975), p. 11.

3 Igor Golomstock, *Totalitarian Art in the Soviet Union, the Third Reich, Fascist Italy and the People's Republic of China* (London, 1990), pp. 121–30; see further, Arnold Chang, *Painting in the People's Republic of China: The Politics of Style* (Boulder, 1980); Ellen Johnston Laing, *The Winking Owl: Art in the People's Republic of China* (Berkeley, 1988); Julia Andrews, *Painters and Politics in the People's Republic of China, 1949–1979* (Berkeley, Los Angeles and London, 1994).

4 Marc Blecher, *China Politics, Economics and Society: Iconoclasm and Innovation in a Revolutionary Socialist Country* (London, 1986), pp. 80–90. Blecher uses 'iconoclasm' in the figurative sense.

5 Blecher, *China Politics*, p. 83.

6 Blecher, *China Politics*, pp. 87–8.

7 Jean-Claude Buhrer, 'Lhassa, dernier carré', *Le Monde* (3 December 1994), pp. i, iv–v.

8 Philippe Pons, 'Kim Jong-il asseoit son pouvoir en Corée du Nord', *Le Monde* (17 February 1995).

9 Reuter, 'Portrait de Mao souillé: lourdes peines', *Gazette de Lausanne* (13 August 1989).

10 See for example 'L'écrasement du "printemps de Pékin" ', *Le Monde* (10 January 1990), p. 7.

11 Urs Morf, 'Aufwendiger Personenkult um Deng Yiaoping', *Neue Zürcher Zeitung* (6–7 November 1993).

12 *I Don't Want to Play Cards with Cézanne and Other Works: Selections from the Chinese New Wave and Avant-garde Art of the Eighties*, exhibition catalogue ed. Richard E. Strassberg: Pacific Asia Museum, Pasadena (1991); Philippe Dagen, 'Liu Wei, peintre, chinois et blasphémateur', *Le Monde* (3 February 1994), p. xii; Francis Deron, 'Le difficile retour des libertés en Chine', *Le Monde* (26 August 1995), pp. 1, 9.

13 Francis Deron, 'Chromos maoïstes et spéculation', *Le Monde* (22–23 October 1995), p. 20.

14 F. Deron, 'Hongkong casse-tête chinois', *Le Monde* (26 December 1992), p. 7.

15 Deron, 'Hongkong'.

16 Yves Leonard, 'La fin de l'empire portugais', *L'Histoire*, no. 192 (October 1995), pp. 17–18.

17 Martine Jacot, 'Haïti: l'héritage de l'esclavage', *Le Monde* (14–15 November 1993), p. 3.

18 Marie-Pierre Subtil, 'A Durban, un musée pour toutes les races', *Le Monde* (16 May 1994).

19 *Tribune-Le Matin* [Lausanne] (4 April 1984).

20 Anne Proenza, 'Ministre colombien de la défense, le fils du sculpteur Fernando Botero a été indirectement visé par les tueurs de Medellin', *Le Monde* (16 June 1995).

21 Reuter A.P., 'Protesters Wreck Japanese Exhibit in Seoul Museum', *International Herald Tribune* (3–4 September 1994).

22 Emmanuel de Roux, 'Cérémonies secrètes', *Le Monde* (12 May 1993).

23 *Universalia 1993* (Paris, 1993), p. 86.

24 Marc Kravetz, 'Un coup de force diplomatique', *Libération* (16 August 1990), p. 3, and see Samir al-Khalil, *The Monument: Art, Vulgarity and Reponsibility in Iraq* (London, 1991), p. 13; M. Kravetz, 'Le palais de Baaba, résidence-bunker du général Aoun', *Libération* (2 January 1990), pp. 16–17; O. I. Bamako, 'Malis Mächtige gegen den "Multipartisme" ', *Neue Zürcher Zeitung* (9 May 1990), p. 7. On state art in the 'Third World', see Jutta Ströter-Bender, *Zeitgenössische Kunst der 'Dritten Welt'* (Cologne, 1991), pp. 19–26.

25 David Freedberg, *The Power of Images: Studies in the History and Theory of Response* (Chicago and London, 1989), p. 258; Bernard Imhasly, 'Der Subkontinent im Spannungsfeld des Kriegs', *Neue Zürcher Zeitung* (23 January 1991), p. 5.

26 See Freedberg, *The Power of Images*, pp. 246–82, as well as Wolfgang Brückner, *Bildnis und Brauch: Studien zur Bildfunktion der Effigies* (Berlin, 1966); Gherardo Ortalli, '... Pingatur in Palatio ... La pittura infamante nei secoli XIII–XVI* (Rome, 1979); Samuel Y. Edgerton, *Pictures and Punishment: Art and Criminal Prosecution during the Florentine Renaissance* (Ithaca and London, 1985); chapter Three, pp. 57, 76–7.

27 D.P.A., 'Umdenken bei Clinton und Busch', *Berliner Zeitung* (18–19 July 1992); Robert Sikkes, 'Studeren is te vanzelfsprekend', *de Volkskrant* (3 November 1994); Reuter, 'Edith perd la tête', *Libération* (15 July 1991).

28 Charles E. Ritterband, 'Frieden in Nordirland – innert einer Woche?', *Neue Zürcher Zeitung* (6–7 November 1993), p. 3; see Bill Rolston, *Politics and Painting: Murals and Conflict in Northern Ireland* (London and Toronto, 1991).

29 Eduardo Galeano, 'Die Erinnerung ist eine Brandstifterin', *WochenZeitung*, no. 51–2 (21 December 1990), pp. 25–6; 'Crónica de un muralicidio anunciado', *Nuevo Amanecer Cultural* [Managua] (29 February 1992), pp. 4–5; see David Kunzle, *The Murals of Revolutionary Nicaragua, 1979–1992* (Berkeley, Los Angeles and London, 1995), especially pp. 12–23.

30 See 'A La Havane sous embargo, les artistes défendent leur "cubanité" ', *Le Monde* (9 June 1995), p. 26.

31 Thomas Gutierrez and Juan Carlos Tabio, *Fresa y Chocolate* (Cuba, 1994).

32 Al-Khalil, *The Monument*, pp. 1–4.

33 *Ibid.*, pp. 8–9.

34 Saddam Husain, *Al-Dimuqratiyya Masdar Quwwah lil-fard wa al-Mujtama'* (Baghdad, 1977), pp. 19–21, quoted in Al-Khalil, *The Monument*, p. 36.

35 Al-Khalil, *The Monument*, pp. 31, 2–3.

36 *Ibid.*, pp. 68–100.

37 *Ibid.*, pp. 46, 111.

38 *Ibid.*, pp. 60–67.

39 *Ibid.*, pp. 66, 110.

40 A.F.P., 'Le retour de Coca-Cola', *Le Monde* (19 May 1993); Martine Jacot, 'Désinformation high-tech', *Le Monde* (10 March 1995).

Chapter 6

1 M. Warnke, 'Bilderstürme', in *Bildersturm: Die Zerstörung des Kunstwerks*, ed. M. Warnke (Frankfurt, 1977), p. 9. See further M. Warnke, 'Kunst unter Verweigerungspflicht', in *Kunst im öffentlichen Raum. Anstöße der 80er Jahre*, ed. V. Plagemann (Cologne, 1989), pp. 223–6.

2 The cartoon accompanied the following recension of a *reportage* by Hugues Le Paige and Jean-François Bastin entitled *Portrait en surimpressions* and produced by Arte: Alain Rollat, 'François Mitterand en clair-obscur', *Le Monde* (3 May 1995).

3 Photograph by Dukas reproduced in 'Les enjeux de demain', *Construire*, no. 2 (10 January 1990), p. 16; photo Reuter, in Rudolf Stamm, 'Ruhe nach dem Sturm auf die Stasi-Zentrale', *Neue Zürcher Zeitung* (17 January 1990), p. 2 (the remark on touching-up is taken from the caption).

4 David Freedberg, *The Power of Images: Studies in the History and Theory of Response* (Chicago and London, 1989), p. 413. The portraits seems to be a photograph rather than a 'photographic' painting, but it obviously makes no difference.

5 M. Agulhon, *Marianne au combat. L'imagerie et la symbolique républicaine de 1789 à 1880* (Paris, 1979); M. Agulhon, *Marianne au pouvoir. L'imagerie et la symbolique républicaine de 1880 à 1914* (Paris, 1989); E. Kantorowicz, *The King's Two Bodies: A Study in Mediaeval Political Theology* (Princeton, 1957).

6 Albert Boime, 'Perestroika and the Destabilization of the Soviet Monuments', *ARS: Journal of the Institute for History of Art of Slovak Academy of Sciences*, no. 2/3 (1993): 'Totalitarianisms and Traditions' (1994), p. 213.

7 See, for example, the documents reproduced on the covers of the following publications: Gosztony, ed., *Histoire du soulèvement hongrois 1956* (Lyon, 1966); *Actes de la recherche en science sociale*, no. 85 (November 1990: 'La crise du léninisme'); A. Brossat, ed., *A l'Est la mémoire retrouvée* (Paris, 1990); A. Brossat and J.-Y. Potel, eds, *L'Est: les mythes et les restes* (*Communications*, no. 55, Paris, 1992).

8 Cartoon by Honoré in *Le Monde* (19 May 1993); cartoon by A. Chabanov in *Izvestia*, reproduced in *Courrier international* (August 1992), p. 15.

9 Reproduced in Boime, 'Perestroïka', p. 217.

10 Cartoon by Plantu in *Le Monde*, reproduced in *Courrier international* (18 April 1991), p. 10; cartoon by F. Behrendt in *Frankfurter Allgemeine Zeitung* (27 April 1993).

11 Cartoon by Willem on the cover of *Libération* (30 September 1993).

12 Jean-Pierre Rioux, 'La désunion soviétique', *Le Monde* (21 September 1990), p. 24; H. Carrère d'Encausse, *La gloire des nations. La fin de l'empire soviétique* (Paris, 1990).

13 See, for example, the episode related in Pierre Georges, 'Barbes virtuelles', *Le Monde* (23 November 1994), p. 26, and Ar. Ch., 'Un graphiste est à l'origine de l'"erreur" commise dans "La Marche du siècle"', *Le Monde* (24 November 1994); Yoshio Murakami, editor-in-chief of a Tokyo newspaper, interviewed in Annick Cojean, 'L'univers sans repos de l'"Asahi Shimbun"', *Le Monde* (11–12 December 1994).

14 See, for example, Annette Tietenberg, 'Marmor, Stein und Eisen bricht' in Bernd Kramer, ed., *Demontage . . . revolutionärer oder restaurativer Bildersturm? Texte & Bilder* (Berlin, 1992), p. 111.

15 Ulrich Schmid, 'In Moskau bleibt Lenin allgegenwärtig', *Neue Zürcher Zeitung* (9 June 1995), p. 48.

16 Michael Diers, 'Von dem, was der Fall (der Denkmäler) ist', *Kritische Berichte*, XX/3 (1992: *Der Fall der Denkmäler*), p. 7.

17 See Bogdan S. Tscherkes, 'Denkmäler von Führern des Sowjetischen Kommunismus in der Ukraine', in *Bildersturm in Osteuropa: Die Denkmäler der kommunistischen Ära im Umbruch* (Munich, 1994), p. 43.

18 Walter Benjamin, 'The Work of Art in the Age of Mechanical Reproduction' (1936), in W. Benjamin, *Illuminations* (New York, 1968), pp. 217–51.

19 N. Heinich, 'L'aura de Walter Benjamin. Note sur "l'œuvre d'art à l'ère de sa reproductibilité technique"', *Actes de la recherche en sciences sociales*, no. 49 (September 1983), pp. 107–9.

20 Raymonde Moulin, 'La genèse de la rareté artistique', *Ethnologie française*, VIII (1978), pp. 241–58.

21 Moulin, 'La genèse de la rareté artistique', pp. 242, 245, 247.

22 Michel Melot, 'La notion d'originalité et son importance dans la définition des œuvres d'art', in *Sociologie de l'art. Colloque international Marseille 13–14 juin 1985*, ed. R. Moulin (Paris, 1986), pp. 192–4.

23 The arguments summarized here were mentioned by Maxime Préaud in an interview of 14 October 1994; for the 'anti-scrape' campaigns, see chapter Eleven.

24 Letter of Jean-François Millet to Alfred Sensier, 24 January 1869, quoted in M. Melot, *L'œuvre gravé de Boudin, Corot, Daubigny, Dupré, Jongkind, Millet, Théodore Rousseau* (Paris, 1978), p. 15. See also M. Melot, *L'estampe impressionniste* (Paris, 1994), pp. 160–64.

25 Moulin, 'La genèse de la rareté', pp. 250–54. The 'problem' of posthumous prints, for example Man Ray's photographs, is typical of this evolution (see recently M. G., 'Des tirages déclassés au Centre Pompidou,', *Le Monde*, 15 February 1995).

26 Moulin, 'La genèse de la rareté artistique', p. 249.

27 M. Duchamp, 'Apropos of "Readymades"', in *Salt Seller: The Writings of Marcel Duchamp (Marchand du Sel)*, ed. M. Sanouillet and E. Peterson (New York, 1973), p. 142; quoted in Calvin Tomkins, *The Bride and the Bachelors: The Heretical Courtship in Modern Art* (New York, 1965), p. 40. See also *Multiples: The First Decade*, exhibition catalogue by John L. Tancock: Philadelphia Museum of Art (1971).

28 'The Green Box', in *Salt Seller*, p. 33; 'Apropos of Readymades', in *Salt Seller*, p. 142.

29 Otto Hahn, 'Entretien. Marcel Duchamp', *L'Express* (23 July 1964), p. 22.

30 M. Duchamp, *Notes*, ed. Paul Matisse (Paris, 1980), nos. 1–46, in particular nos. 1, 7, 18, and 35 (quotation).

31 Anonymous, 'The Richard Mutt Case', *The Blind Man*, no. 2 (May 1917). On the context

and origin of this text, which was inspired and approved of – if not actually written – by Duchamp, see William A. Camfield, *Marcel Duchamp / Fountain* (Houston, 1989), p. 37.

32 See in particular chapter Thirteen on the 'iconoclastic' character of Readymades and chapter Fourteen on their destruction or survival.

Chapter 7

1 C. Hoh-Slodczik, 'Die "Mitte" Berlins – Zeugnis und Ort deutscher Geschichte', in *Künstlerischer Austausch. Artistic Exchange. Akten des XXVIII. Internationalen Kongresses für Kunstgeschichte Berlin, 15.–20. Juli 1992*, ed. Thomas W. Gaehtgens (Berlin, 1993), III, pp. 353–64 (pp. 353–4).

2 Eberhard Elfert, 'Die politischen Denkmäler der DDR im ehemaligen Ost-Berlin und unser Lenin' in *Demontage . . . revolutionärer oder restaurativer Bildersturm? Texte & Bilder* (Berlin, 1992), p. 58.

3 For this and the other political monuments in West Berlin, see *Erhalten – Zerstören – Verändern? Denkmäler der DDR in Ost-Berlin*, exhibition catalogue: Neue Gesellschaft für Bildende Kunst (Berlin, 1990), pp. 22–4.

4 Brigitte and Martin Matschinsky-Denninghof, *Berlin*, 1985–7; see *Kunst im öffentlichen Raum: Skulpturenboulevard Kurfürstendamm Tauentzien*, exhibition catalogue (Berlin, 1987), pp. 122–45; the authors declared that they had 'tried to deliver in a symbolic way something of the situation in Berlin' (p. 122).

5 Richard Calvocoressi, 'Public Sculpture in the 1950s', in *British Sculpture in the Twentieth Century*, ed. Sandy Nairne and Nicholas Serota (London, 1981) pp. 134–53 (pp. 136–9). The phrase about 'the question of contemporary art' comes from a letter of Sir John Rothenstein to Alfred J. Barr of 29 April 1953 (p. 139); see also Robert Burstow, 'Butler's Competition Project for a Monument to "The Unknown Political Prisoner": Allegory, Abstraction and Cold War Politics', *Art History*, XII/4 (December 1989), pp. 472–96; *The Times* (17 March 1953), quoted in Burstow, 'Butler's Competition Project', p. 473.

6 *Erhalten – Zerstören – Verändern?*, p. 92.

7 Martina Wehlte-Höschele, 'Harte Fronten, zarte Bande. Ein deutsch-deutsches Bildhauersymposium in der Mannheimer Kunsthalle', *Frankfurter Allgemeine Zeitung* (26 March 1988), p. 29.

8 Calvocoressi, 'Public Sculpture', p. 57.

9 A. Baudin, ' "Socrealizm". Le réalisme socialiste soviétique et les arts platiques vers 1950: quelques données du problème', *Ligeia*, no. 1 (April–June 1988), pp. 65–110 (p. 83).

10 See David and Cecile Shapiro, 'Abstract Expressionism: The Politics of Apolitical Painting', *Prospects*, III (1976), pp. 175–214, reprinted in *Pollock and After: The Critical Debate*, ed. Francis Frascina (London and New York, 1985), pp. 135–52; Annette Cox, *Art as Politics: The Abstract Expressionist Avant-garde and Society* (Ann Arbor, 1982); Serge Guilbaut, *How New York Stole the Idea of Modern Art: Abstract Expressionism, Freedom and the Cold War* (Chicago, 1983).

11 Clement Greeenberg, 'The Late '30s in New York' [1957/1960], *Art and Culture* (Boston, 1961), p. 230, quoted in S. Guilbaut, *Comment New York a volé l'idée d'art moderne* (Nîmes, 1989), p. 250.

12 *Museum of Modern Art Bulletin*, 1942, quoted in Guilbaut, *How New York*, p. 88.

13 Baudin, 'Socrealizm', p. 66; Frances K. Pohl, 'An American in Venice: Ben Shahn and United States Foreign Policy at the 1954 Venice Biennale', *Art History*, IV/1 (1981), pp. 80–114; see Jeannine Verdès Leroux, 'L'art de parti. Le parti communiste français et ses peintres 1947–1954', *Actes de la recherche en sciences sociales*, no. 28 (June 1979), pp. 33–55.

14 Walter Grasskamp, *Die unbewältigte Moderne: Kunst und Öffentlichkeit* (Munich, 1989), p. 122. This passage relies heavily on two chapters of Grasskamp's book: ' "Entartete Kunst" und documenta I. Verfemung und Entschärfung der Moderne' (pp. 76–119) and 'Rekonstruktion und Revision. Die Kunstvereine nach 1945' (pp. 120–32).

15 Grasskamp, *Die unbewältigte Moderne*, pp. 99–100. See Siegfried Salzmann, *'Hinweg mit der "Knienden"': Ein Beitrag zur Geschichte des Kunstskandals* (Duisburg, 1981).

16 Grasskamp, *Die unbewältigte Moderne*, pp. 83–7. Grasskamp rightly remarks that both are false generalizations.

17 *Ibid.*, pp. 101–19.

18 *Ibid.*, pp. 91, 96, 126–32.

19 Calvocoressi, 'Public Sculpture', p. 153.

20 M. Warnke, 'Bilderstürme', in *Bildersturm. Die Zerstörung des Kunstwerks*, ed. M. Warnke (Frankfurt, 1977), p. 12.

21 Letter quoted in Edward Alden Jewell, ' "Globalism" Pops into View', *The New York Times* (13 June 1943), p. X9, commented on in Guilbaut, *How New York*, pp. 76–7.

22 See chapter Nine, as well as my previous study of this aspect (*Un iconoclasme moderne. Théorie et pratiques contemporaines du vandalisme artistique* (Zurich and Lausanne, 1983) and the following publications by W. Grasskamp: 'Warum wird Kunst im Aussenraum zerstört?', *Kunst-Bulletin* (April 1984), pp. 2–7; 'Kunst als Störfall. Demokratie im öffentlichen Raum', *Frankfurter Allgemeine Zeitung* (15 August 1987); 'Wieviel Kunst verträgt die Demokratie?', in *Nazi-Kunst ins Museum?*, ed. K. Staeck (Göttingen, 1988); 'Invasion aus dem Atelier', in *Unerwünschte Monumente. Moderne Kunst im Stadtraum*, ed. W. Grasskamp (Munich, 1989), pp. 141–68.

23 Reproduced in *Demontage . . . revolutionärer oder restaurativer Bildersturm? Texte & Bilder* (Berlin, 1992), p. 171.

24 On Serra's work in Bochum, see *Terminal von Richard Serra: Eine Dokumentation in 7 Kapiteln* (Bochum, 1980).

25 See *Kunst im öffentlichen Raum. Skulpturenboulevard*, as well as Barbara Straka, 'Die Berliner Mobilmachung. Eine kritische Nachlese zum "Skulpturenboulevard" als "Museum auf Zeit" ', in *Kunst im öffentlichen Raum. Anstöße der 80er Jahre*, ed. V. Plagemann (Cologne, 1989), pp. 97–115. The following summary of the events is essentially based on this article. The definition of the exhibition's reception as 'sociological experiment' was proposed by B. Straka, its evaluation as 'maybe the largest public debate about post-War modern art' by Bazon Brock (Straka, 'Die Berliner Mobilmachung', p. 97).

26 Straka, 'Die Berliner Mobilmachung', p. 99.

27 *Kunst im öffentlichen Raum. Skulpturenboulevard*, 1, pp. 150–51, 220. On an earlier work by Vostell involving the destruction of an automobile, *Neun Nein Décollagen* of 1963, see Justin Hoffmann, *Destruktionskunst. Der Mythos der Zerstörung in der Kunst der frühen sechziger Jahre* (Munich, 1995), pp. 116–18.

28 Press declaration of the 'Berliner Akademie der Künste' (March 1987), quoted in Straka, 'Die Berliner Mobilmachung', p. 109.

29 Straka, 'Die Berliner Mobilmachung', p. 104.

30 'Zorn ist eine ehrenhafte Emotion', *Volksblatt Berlin* (17 October 1991), quoted in Elfert, 'Die politischen Denkmäler der DDR', p. 55.

Chapter 8

1 John Henry Merryman and Albert Elsen, *Law, Ethics, and the Visual Arts* (Philadelphia, 1987), 1, p. 145.

2 §31, 11. Quoted in Bernard Edelman, *La propriété littéraire et artistique* (Paris, 1989), p. 39.

3 Edelman, *La propriété littéraire*, p. 19.

4 *Ibid.*, p. 105.

5 Clara Weyergraf-Serra and Martha Buskirk, *The Destruction of 'Tilted Arc': Documents* (Cambridge, Mass., and London, 1991), p. 261.

6 Merryman and Elsen, *Law*, p. 145; Weyergraf-Serra and Buskirk, eds, *The Destruction*, p. 266.

7 Martin A. Roeder, 'The Doctrine of Moral Right: A Study in the Law of Artists and

Creators', *Harvard Law Review*, LIII (1939), p. 569, quoted in Merryman and Elsen, *Law*, p. 152.

8 Rudolf Gerhardt, 'Ware oder Wert? Rechtsstreit des Bildhauers Hajek mit dem ADAC', *Frankfurter Allgemeine Zeitung* (9 August 1982).

9 Edelman, *La propriété littéraire*, p. 40.

10 Dagmar Sinz, 'Minimal Art aus der Sammlung Panza. Fragen anlässlich der Pariser Ausstellung', *Neue Zürcher Zeitung* (9 August 1990).

11 Merryman and Elsen, *Law*, p. 243, pp. 276–8.

12 Nicols Fox, 'Helms ups the ante', *New Art Examiner* (October 1989), pp. 20–23 (p. 22).

13 Jan Białostocki, 'Art and Politics: 1770–1830', in J. Białostocki, *The Message of Images: Studies in the History of Art* (Vienna, 1988), pp. 186–210.

14 Laurance P. Hurlburt, *The Mexican Muralists in the United States* (Albuquerque, 1989), p. 172. This passage is essentially based on L. P. Hurlburt's account of Rivera's stay and works in the U.S. (pp. 89–193).

15 *Ibid.*, p. 123.

16 *Ibid.*, p. 159 (studies and sketches reproduced on pp. 160–67).

17 *Ibid.*, p. 162.

18 Rivera's reply of 6 May to Nelson Rockefeller's letter of 4 May 1933, quoted in Hurlburt, *The Mexican Muralists*, p. 169.

19 Hurlburt, *The Mexican Muralists*, p. 172.

20 *Ibid.*, p. 174, 247.

21 Rivera did sue his patron Alberto Pani a few years later for having had portraits of Mexican political, religious and business leaders that the artist had included in the decoration of his Hotel Reforma painted out. Rivera won damages and was allowed to restore the work, but the panels were consigned to storage and he did not receive another public commission until 1942 (Hurlburt, *The Mexican Muralists*, p. 248).

22 Hurlburt, *The Mexican Muralists*, p. 250.

23 *Ibid.*, p. 251; William Hauptman, 'Suppression of Art in the McCarthy Decade', *Art-forum 12*, no. 2 (October 1973), p. 48ff., reprinted in Merryman and Elsen, *Law*, p. 273.

24 Hauptman, 'Suppression of Art', p. 273.

25 Interview with Emily Genauer, *New York World Telegram*, quoted in Hauptman, 'Suppression of Art', p. 268.

26 Speech of 1953 by A. H. Berding, spokesman for the U.S. Information Agency, before the American Federation of Arts, quoted in Hauptman, 'Suppression of Art', p. 272.

27 Hauptman, 'Suppression of Art', p. 271, 269.

28 Letter of 18 July 1949 to C. E. Plant, quoted in Hauptman, 'Suppression of Art', p. 275.

29 Merryman and Elsen, *Law*, pp. 160–61.

30 *Ibid.*, p. 146.

31 Gerhardt, 'Ware oder Wert?'; D.P.A., 'Hajeks ADAC-Plastik. Bundeswehr-Sprengung', *Frankfurter Allgemeine Zeitung* (16 July 1982).

32 *Art News* (Summer 1960), cited in Merryman and Elsen, *Law*, p. 172; the quotation concerning Smith's earlier production is from Hilton Kramer, 'Questions Raised by Art Alterations', *New York Times* (14 September 1974), cited in Merryman and Law, *Law*, pp. 172–3.

33 Kramer, 'Questions Raised by Art Alterations'; the alteration had been first noticed and condemned by Rosalind Krauss in 'Changing the Work of David Smith', *Art in America*, XXX (September–October 1974), p. 31, quoted in Merryman and Elsen, *Law*, pp. 171–2.

34 Francis D. Klingender, *Goya in the Democratic Tradition* (London, 1948), p. 86, with reference to H. Stokes, *Goya* (London, 1914).

35 L. Réau, *Histoire du vandalisme. Les monuments détruits de l'art français* (Paris, 1959), I, pp. 20–21 (Paris, 1994, p. 20).

36 Letter of 23 April 1863 to La Fizelière, quoted in Marie-Thérèse de Forges, 'Biographie' in *Gustave Courbet (1819–1877)*, exhibition catalogue: Grand Palais, Paris (1977), p. 38.

37 Shigemi Inaga, ' "Retour de la Conférence": une œuvre perdue de Gustave Courbet et sa

position (manquée) dans l'histoire de l'art', *Bulletin de la Société franco-japonaise d'art et d'archéologie*, no. 9 (1989), pp. 21–31; L. Nochlin, 'The Depoliticisation of Gustave Courbet: Transformation and Rehabilitation under the Third Republic', in *Art Criticism and its Institutions in Nineteenth-century France*, ed. Michael R. Orwicz (Manchester and New York, 1994), pp. 109–21.

38 Pierre Joseph Proudhon, *Du principe de l'art et de sa destination sociale* (Paris, 1865), chapter XVII, pp. 266, 278.

39 Letter of 23 April 1863 to La Fizelière, quoted in de Forges, 'Biographie', p. 38.

40 Merryman and Elsen, *Law*, p. 277.

41 *Ibid.*, pp. 149–53.

42 Evelyn Silber, *The Sculpture of Epstein* (London, 1986), p. 20; 'A Sculptor in Revolt', *Pall Mall Gazette* (6 June 1908); both quoted in Michael Pennington, *An Angel for a Martyr: Jacob Epstein's Tomb for Oscar Wilde* (Reading,1987), pp. 26, 45.

43 Pennington, *An Angel for a Martyr*, p. 11. On the history of the Strand statues, see Richard Cork, 'Jacob Epstein and Charles Holden: A Whitmanesque Collaboration in the Strand', *AA Files*, no. 8 (January 1985), pp. 64–98, and R. Cork, *Art Beyond the Gallery in Early 20th Century England* (New Haven and London, 1985), pp. 9–60.

44 Pennington, *An Angel for a Martyr*, p. 11 (quotation from Jacob Epstein, *An Autobiography*, London, 1955, p. 22).

45 Cork, *Art Beyond the Gallery*, p. 24.

46 *The Evening Standard and St James's Gazette* (19 June 1908), quoted in Pennington, *An Angel for a Martyr*, p. 12.

47 For the sources of these and following quotations, see Cork, *Art Beyond the Gallery*, pp. 27–9.

48 For this later episode, see Cork, *Art Beyond the Gallery*, pp. 54–9.

49 *Ibid.*, p. 59.

50 *Ibid.*, pp. 32, 54; quoted in Dennis Farr, 'The Patronage and Support of Sculptors', in *British Sculpture in the Twentieth Century*, ed. S. Nairne and N. Serota (London, 1981), p. 15. It may be worth noticing that in Richard Cork's relation of the affair, the only public opponent to Epstein's figures within the art world in 1908 is the *Architectural Review's* editor, Mervyn Macartney (p. 27).

51 For a detailed account and the sources of the following passage, see Pennington, *An Angel for a Martyr*; the quotation is from Simon Wilson, 'A Newly Discovered Sketch by Jacob Epstein for the Tomb of Oscar Wilde', *The Burlington Magazine* (November 1975), pp. 726–9.

52 *Pall Mall Gazette* (28 September 1912), quoted in Pennington, *An Angel for a Martyr*, p. 52.

53 Michel Dansel, *Au Père Lachaise, son histoire, ses secrets, ses promenades* (Paris, 1973), p. 65, and recollections of Professor Giles Robertson, quoted in Pennington, *An Angel for a Martyr*, p. 61.

54 Stéphane Davet, Dominique Frétard and Michel Guerrin, 'Les milieux culturels réagissent aux victoires du Front national', *Le Monde* (21 June 1995). A year later, another French mayor belonging to the extreme Right-wing 'Front national' had a fountain of 1993 by the artist René Guiffrey destroyed in Toulon (Geneviève Breerette, 'Une fontaine rasée au bulldozer à Toulon', *Le Monde*, 7–8 July 1996, p. 15).

55 Merryman and Elsen, *Law*, pp. 335–74.

56 Judith H. Balfe and Margaret J. Wyszomirski, 'Public Art and Public Policy', *The Journal of Arts Management and Law*, XV/44 (Winter 1986), reprinted in *Going Public*, ed. Jeffrey L. Cruikshank and Pam Korza (Amherst, Mass., 1988), pp. 268–79 (pp. 272–5).

57 See Clara Weyergraf-Serra and Martha Buskirk, *The Destruction of 'Tilted Arc': Documents* (Cambridge, Mass., and London, 1991), and Merryman and Elsen, *Law*, pp. 358–66, with bibliographic references.

58 Richard Serra, 'Introduction', in Weyergraf-Serra and Buskirk, *The Destruction*, p. 13.

59 Merryman and Elsen, *Law*, p. 358.

60 Paper presented by Richard Serra to *Tilted Arc* Site Review Advisory Panel, 15 December 1987, reproduced in Weyergraf-Serra and Buskirk, *The Destruction*, p. 184; *Richard Serra: Interviews Etc., 1970–1980*, written and compiled in collaboration with C. Weyergraf (Yonkers, 1980), p. 168, quoted in Robert Storr, ' "Tilted Arc": Enemy of the People?', *Art in America* (September 1985), pp. 90–97 (p. 96); Douglas Crimp, 'Serra's Public Sculpture: Redefining Site Specificity' in *Richard Serra / Sculpture*, ed. Rosalind E. Krauss (New York, 1986), pp. 41–57 (p. 53).

61 Richard Serra's statement at the 1985 hearing, in Weyergraf-Serra and Buskirk, *The Destruction*, p. 65.

62 Balfe and Wyszomirski, 'Public Art', p. 269.

63 Grace Glueck, 'An Outdoor-Sculpture Safari around New York', *The New York Times* (7 August 1981), p. C20; see also Peter Schjeldahl, 'Artistic Control', *The Village Voice* (14–20 October 1981), pp. 100–01.

64 Balfe and Wyszomirski, 'Public Art', pp. 269, 272.

65 Harriet Senie, 'Richard Serra's "Tilted Arc": Art and Non-Art Issues', *Art Journal*, XLVIII/44 (Winter 1989), pp. 298–302 (p. 302).

66 Michael Brenson, 'The Messy Saga of "Tilted Arc" ', *The New York Times* (2 April 1989).

67 Letter of 1 January 1985 from Richard Serra to Donald Thalacker, director of the Art-in-Architecture programme, reproduced in Weyergraf-Serra and Buskirk, *The Destruction*, p. 38. This argument was criticized as untenable by William Diamond on the grounds that 'if the sculpture is specific to the site, and the sculpture is permanent and can not be removed, then there must not be any changes to the site either, else the change of the environment would also cause the destruction of the sculpture' (letter of 1 May 1985 to Dwight Ink, Acting Administrator of GSA, p. 147).

68 See Weyergraf-Serra and Buskirk, *The Destruction*, pp. 197–253.

69 Decision by Judge Jon O. Newman, U.S. Court of Appeals for the Second Circuit, 27 May 1988, reproduced in Weyergraf-Serra and Buskirk, *The Destruction*, pp. 249–50.

70 Appeal filed by Richard Serra in the U.S. Court of Appeals for the Second Circuit, 15 December 1987, reproduced in Weyergraf-Serra and Buskirk, *The Destruction*, p. 235; decision by Judge Jon O. Newman, pp. 251–2.

71 Form letter from Copyright Office to Gustave Harrow in response to Richard Serra's application for a copyright for *Tilted Arc*, 20 June 1986, and decision by Judge Milton Pollack, U.S. District Court, Southern District of New York, 31 August 1987, reproduced in Weyergraf-Serra and Buskirk, *The Destruction*, pp. 175, 210.

72 Weyergraf-Serra and Buskirk, *The Destruction*, pp. 261–8; M. Buskirk, 'Moral Rights: First Step or False Start?', *Art in America* (July 1991), pp. 37–45. The almost simultaneous case of the Berlin Lenin reminds one, however, that even if the American law had recognized moral rights, the weighing of interests which would have ensued might have allowed the 'significant interest [of the GSA] in keeping the plaza unobstructed' (as recognized by the Court of Appeals) to take precedence over the artist's interest in the respect of his site-specific work; in France, land of moral rights *par excellence*, artists normally cannot oppose the relocation of their works and local authorities are allowed to destroy them if safety or salubrity requires (Gilles Lamarque, *Droit et fiscalité du marché de l'art*, Paris, 1992, pp. 41–56).

73 H. F. Senie, 'Baboons, Pet Rocks, and Bomb Threats. Public Art and Public Perception' in *Critical Issues in Public Art. Content, Context, and Controversy*, ed. H. F. Senie and Sally Webster (New York, 1992), pp. 237–46 (p. 243).

74 Letter of 5 November 1984 from Edward D. Re to Ray Kline, Acting Administrator of GSA, reproduced in Weyergraf-Serra and Buskirk, *The Destruction*, p. 27.

75 Statements at the 1985 hearing by Margo Jacobs, Vickie O'Dougherty, Norman Steinlauf, Shirley Paris, Representative Theodore Weiss, William Toby, Harry Watson, and Peter Hirsch, reproduced in Weyergraf-Serra and Buskirk, *The Destruction*, pp. 124, 117, 112, 126, 114, 119, 120, 123.

76 Storr, 'Tilted Arc', p. 93.

77 Statements at the 1985 hearing by Joel Kove, Roberta Smith, and Benjamin Buchloh, reproduced in Weyergraf-Serra and Buskirk, *The Destruction*, pp. 94, 104, 91.

78 Letter of 5 January 1988 from Frank Hodsoll, NEA Chairman, to Terence C. Golden, GSA Administrator, reproduced in Weyergraf-Serra and Buskirk, *The Destruction*, p. 189.

79 Fox, 'Helm ups the ante', p. 20; R. Serra, 'Art and Censorship' in *Art and the Public Sphere*, ed. W.J.T. Mitchell (Chicago and London, 1992), pp. 226–33 (p. 231).

80 Marlena G. Corcoran, 'Anstössiges erkenne ich auf Anhieb', *Die Weltwoche* (3 August 1989).

81 Sieglinde Geisel, 'Die Moral des Steuerdollars', *Neue Zürcher Zeitung* (18 January 1995), p. 43; Henri Béhar, 'Les républicains américains s'attaquent aux subventions pour les arts', *Le Monde* (28 January 1995), p. 29.

82 Don Hawthorne, 'Does the Public Want Public Sculpture?', *ARTnews* (May 1982), p. 59; Dwight Ink, 'Decision on "Tilted Arc"' (1985), in Weyergraf-Serra and Buskirk, *The Destruction*, p. 159; Serra, 'Art and Censorship', p. 233.

83 Moorman, 'Arc Enemies', p. 156.

84 Merryman and Elsen, *Law*, p. 364; Senie, 'Baboons', p. 245.

85 Statement at the 1985 hearing by Clara Weyergraf-Serra, reproduced in Weyergraf-Serra and Buskirk, *The Destruction*, p. 89.

86 See François Grundbacher, 'Wenn die Kunst fehl am Platz ist', *Kunst-Bulletin*, no. 2 (1987), pp. 2–5.

87 Benjamin H. D. Buchloh, 'Vandalismus von oben. Richard Serras "Tilted Arc" in New York', in *Unerwünschte Monumente. Moderne Kunst im Stadtraum*, ed. W. Grasskamp (Munich, 1989), pp. 103–19 (p. 104).

88 The phrase is drawn from the title of a book by H. F. Senie announced on the subject (*Dangerous Precedent: Richard Serra's 'Tilted Arc' in Context*). This chapter has shown, however, that if the removal of *Tilted Arc* can be regarded as a 'precedent' for the 1980s, it was anteceded by many comparable cases in the history of American and European art in public places.

89 Patricia C. Phillips, 'Forum: Something There Is That Doesn't Love a Wall', *Artforum* (June 1985), p. 101; Balfe and Wyszomirski, 'Public Art', p. 269; Storr, 'Tilted Arc', p. 94.

90 Richard Serra, 'My sculpture shares the logic of towers, dams, silos, bridges, skyscrapers and tunnels', *The Art Newspaper*, no. 23 (December 1992), p. 23; the phrase 'aesthetics of refusal' is from Buchloh, 'Vandalismus von oben', p. 115.

91 Storr, 'Tilted Arc', pp. 96, 94; G. Apgar, 'Redrawing the Boundaries of Public Art', *Sculpture*, XI/3 (May–June 1992), pp. 24–9 (pp. 27–8). It must be added, however, that the contrast in the public reception of *Tilted Arc* and the *Vietnam Veterans Memorial* is also predicated on major differences in location and function: contrary to Federal Plaza in New York, the Constitution Gardens in Washington are no place of daily work and traffic, and the commemorative and quasi-funeral dimension officially attributed to the *Memorial* enabled the public to invest Maya Lin's abstract wall form – covered with the 58,191 names of the dead and missing – with meaning in a way utterly closed to Serra's 'autonomous' sculpture.

92 Buchloh, 'Vandalismus von oben', pp. 115–18. See also this comment by W.J.T. Mitchell: 'Richard Serra's "Tilted Arc" can be seen as a classic instance of the high modernist transformation of a utilitarian public space into an aesthetic form (with predictable reactions from the philistines), or as a signal that modernism can no longer mediate public and private spheres on its own terms, but must submit itself to social negotiation, and anticipate reactions ranging from violence to indifference' ('Introduction: Utopia and Critique' in Mitchell, ed., *Art and the Public Sphere*, p. 3).

93 *Richard Serra: Interviews*, p. 63, quoted in Storr, 'Tilted Arc', p. 95.

94 Russel Ferguson, 'Un effet de levier', *Cahier 4 Institut pour l'Art et la Ville* (1993), p. 8, and see *David Hammon: Rousing the Rubble* (New York and Cambridge, Mass., 1991), pp. 52, 84–5, 88; David Antin, 'Fine Furs' in Mitchell, ed., *Art and the Public Sphere*, pp. 249–61 (p. 260).

95 Statement at the 1985 hearing by Douglas Crimp, reproduced in Weyergraf-Serra and Buskirk, *The Destruction*, p. 73.

96 The relation of this case is based on Peter Moritz Pickshaus, *Kunstzerstörer. Fallstudien: Tatmotive und Psychogrammen* (Reinbek bei Hamburg, 1988), pp. 375–95. See Klaus Staeck, 'Kunst und Öffentlichkeit', in *Grenzen politischer Kunst*, ed. H.-O. Mühleisen (Munich and Zurich, 1982), pp. 77–113.

97 K. Staeck, *Die CDU hat die besten Teufelsaustreiber* (1974), reproduced in Pickshaus, *Kunstzerstörer*, p. 386, and in Staeck, 'Kunst und Öffentlichkeit', pp. 125–7, with visual comparisons from the history of political propaganda.

98 Philipp Jenninger, and Franz Josef Strauß, quoted in Pickshaus, *Kunstzerstörer*, pp. 380, 388. See *Im Namen des Volkes. Das 'gesunde Volksempfinden' als Kunstmaßstab*, exhibition catalogue: Wilhelm-Lehmbruck-Museum der Stadt Duisburg (1979), pp. 137–46 ('Klaus Staeck, 50 Ausstellungsverbote – Deutschland 1976 bis heute').

99 Philipp Jenninger, quoted in Pickshaus, *Kunstzerstörer*, p. 377.

100 See Barbara Straka, 'Polizei-Zensur. Bericht über die Zerstörung der Ernst Volland-Ausstellung der Neuen Gesellschaft für Bildende Kunst Berlin', *Kritische Berichte*, X/1 (1982), pp. 45–50; *Polizei zerstört Kunst – Der Fall Volland. Ein soziologisches Experiment*, ed. Realismusstudio der NGBK (Berlin, 1981).

101 Straka, 'Polizei-Zensur', p. 49.

102 P. Bourdieu and H. Haacke, *Libre-échange* (Paris, 1994), pp. 30–31, 92, 115.

103 See Merryman and Elsen, *Law*, pp. 305–15.

104 Letter of 3 April 1971 from H. Haacke to all interested parties, reproduced in Merryman and Elsen, *Law*, p. 305.

105 Thomas E. Messor, 'Editorial', *Arts*, XLV/8 (Summer 1971), p. 4, reprinted in Merryman and Elsen, *Law*, pp. 309–10.

106 Joseph James Akston, 'Editorial', *Arts*, XLV/8 (Summer 1971), p. 4, and E.C.B., 'Editorial: Artists vs. Museums', *ARTnews* LXX/3 (May 1971), p. 25, reprinted in Merryman and Elsen, *Law*, pp. 308, 311. The other cases mentioned were a Carl Andre travelling exhibition in Canada and Sol LeWitt's cancelled show at the New York Cultural Center.

107 Inès Champey, 'Hans Haacke: jeu de l'art et enjeux de pouvoir', *Liber*, no. 8 (December 1991), pp. 1–4.

108 E.C.B., 'Editorial: Artists vs. Museums', *ARTnews* LXX/3 (May 1971), p. 25, reprinted in Merryman and Elsen, *Law*, p. 312.

109 Alain-Dominique Perrin, 'Le mécénat français: la fin d'un préjugé', interview by Sandra d'Aboville, *Galeries Magazine*, no. 15 (October–November 1986), p. 74, quoted in Bourdieu and Haacke, *Libre-échange*, p. 145.

110 Carl Baldwin, 'Haacke: Refusé in Cologne', *Art in America* (November–December 1974), pp. 36–7, reprinted in Merryman and Elsen, *Law*, pp. 264–7. One may note in relation to this that Haacke has been a consistent advocate of resale royalties as a part of artists' moral rights (see Buskirk, 'Moral Rights: First Step or False Start?', p. 41).

111 Letter from Horst Keller to H. Haacke, quoted without mention of date in Baldwin, 'Haacke', p. 266.

112 See 'Krieg und Kunst', *Kunstchronik*, no. 3 (16 October 1914), p. 40, and Julius von Végh, *Die Bilderstürmer: Eine kulturgeschichtliche Studie* (Strasburg, 1915), p. xiv.

113 H. Haacke, 'Projekt: Hippokratie', in *Skulpturprojekte in Münster 1987*, ed. K. Bußmann and Kasper König (Cologne, 1987), pp. 113–16.

114 Bourdieu and Haacke, *Libre-échange*, pp. 82–5.

115 *Ibid.*, pp. 29, 100, 101.

Chapter 9

1 For general views, see Claude Lévy-Leboyer, ed., *Vandalism: Behaviour and Motivations* (Amsterdam, New York and Oxford, 1984); Penny Mitchell, *Vandalism, a State of the Art Review and Guide to the Information* (Stanford: Capital Planning Information, 1987).

2 Stanley Cohen, 'Sociological Approaches to Vandalism', in *Vandalism*, ed. Cl. Lévy-Leboyer, p. 51. See also S. Cohen, ed., *Images of Deviance* (Harmondsworth, 1971); Colin Ward, ed., *Vandalism* (London, 1973).

3 Guy Houchon, 'Criminologie du vandalisme', a paper presented to the International Conference on Vandalism in Paris (27–29 October 1982) but not printed in its acts (*Vandalism*, ed. Cl. Lévy-Leboyer), with reference to L. Taylor, 'Vocabularies, Rethorics and Grammar: Problems in the Sociology of Motivation', in *Deviant Interpretation*, ed. D. Downes and P. Rock (New York, 1979), pp. 145–61.

4 For a more detailed presentation of this case study and its sources, see D. Gamboni, *Un iconoclasme moderne. Théories et pratiques contemporaines du vandalisme artistique* (Zurich and Lausanne, 1983), pp. 22–68.

5 Marcel Joray, 'Aspects de la sculpture contemporaine', *Exposition suisse de sculpture en plein air*, exhibition catalogue (Bienne, 1954).

6 Text of the exhibition press conference of 11 May 1979, Archives of the SSE, Bienne.

7 See a complete list of the works concerned with the description of the damages in Gamboni, *Un iconoclasme moderne*, pp. 107–08.

8 Rudolph Hadorn, 'Die 7. schweizerische Plastikausstellung 1980 in Biel', *Neues Bieler Jahrbuch* (1980), pp. 86–107 (p. 103).

9 Letter of 2 December 1981 from Captain E. Schweizer, of the Bernese Cantonal Police, to the author.

10 Only four of the damaged works were presented indoors. The information for which no source is given were gathered between 1981 and 1983 in the archives of the SSE and in numerous interviews with the persons involved.

11 *7e Exposition Suisse de Sculpture Bienne. 7. Schweizer Plastikausstellung Biel 1980*, exhibition catalogue (Bienne, 1980), p. 23.

12 Heinrich Spinner, *Bieler Tagblatt* (8 July 1980).

13 Letter of 23 August 1982 from Anton Egloff to the author.

14 Pierre Rothenbühler, 'Jean Tinguely, êtes-vous un charlatan?', *Biel/Bienne* (12 June 1980).

15 Ernst Rieben, 'Alltags-Stimmen zur Schweizerischen Plastikausstellug in Biel: "Respektable Dinge, die einem zusagen können" ', *Berner Zeitung* (30 July 1980).

16 Isabelle van Beek, 'La sculpture en fer', *Journal du Jura* (27 June 1980).

17 George Melly and J. R. Glaves-Smith, *A Child of Six Could Do It!*, exhibition catalogue: The Tate Gallery, London (1973).

18 Ch. Nilsson, in *Il vandalismo dei giovani, aspetti sociologici, psicologici e giuridici* (Milan, 1981), p. 580. As for the stereotype of the vandal, Colin Ward stated that it 'is that of a working-class male adolescent' (*Vandalism*, p. 13).

19 Archives of the SSE.

20 See above the judgement on rusty metal.

21 Rothenbühler, 'Jean Tinguely'.

22 Rieben, 'Alltags-Stimmen'.

23 Mtj, 'Un sculpteur de génie', *Journal du Jura* (22 April 1980).

24 Rieben, 'Alltags-Stimmen'.

25 Nelson Goodman, *Languages of Art: An Approach to a Theory of Symbols* (2nd edn, Indianapolis, 1976), p. 112.

26 Rothenbühler, 'Jean Tinguely'.

27 I. van Beek, 'Erica Pedretti, la sculpture-objet', *Journal du Jura* (11 July 1980).

28 S. Cohen, 'Campaigning against vandalism' in *Vandalism*, ed. Ward, pp. 215–58 (p. 217).

29 P. Bichsel, 'Das Reiterstandbild und die Muschel', *Die Weltwoche*, 1980, reproduced in Willy Rotzler, Hans Baumann and P. Bichsel, *Raffael Benazzi* (Zurich, 1981), pp. 197–201.

30 P. Killer, 'Bieler Plastikausstellung: fast ein Drittel aller Ausstellungsstücke versehrt', *Tages-Anzeiger* (29 August 1980).

31 Interview with the architect Alain Tschumi, co-director of the SSE, 13 August 1982; J. Tinguely in Rothenbühler, 'Jean Tinguely'.

32 Henri Paucker, 'Kunstvandalen in Biel. Der Feind Nummer Eins', *Wir Brückenbauer* (5 September 1980). The mention of 'youths rioting against the opera-house' alluded to the grave social disturbances that had marked the summer of 1980 in several towns (but not in Bienne) in Switzerland; in Zurich, the first 'youth demonstration' had been organized to protest against the grant of 61 millions francs for the repair of the opera-house, as compared with the means put at the disposal of less traditional cultural activities.

33 Rothenbühler, 'Jean Tinguely'. The work described by the sculptor was *Fountain No. 4*, exhibited in the SSE 1962.

34 It is well known that 'derelict, incomplete or badly kept' property is more prone to being damaged; see for example Stanley Cohen, 'Property destruction: motives and meanings', in Ward, *Vandalism*, pp. 23–53 (p. 50).

35 See in particular P. Bourdieu *et al.*, *Un art moyen. Essai sur les usages sociaux de la photographie* (Paris, 1965), pp. 113–33; P. Bourdieu and Alain Darbel, *L'amour de l'art. Les musées d'art européens et leur public* (2nd edn, Paris, 1969), pp. 73–4; P. Bourdieu, *La Distinction. Critique sociale du jugement* (Paris, 1979), pp. 33–67.

36 P. Bourdieu, *La distinction*, p. 172.

37 Ward, *Vandalism*, pp. 15–16.

38 *Ibid.*, p. 19, 50–51.

39 On 'the public realm' as a polysemic notion implying dimensions of spatial context and social interactions, see André Ducret, *L'art dans l'espace public. Une analyse sociologique* (Zurich: Seismo, 1994), pp. 143–44, with reference to Jürgen Habermas and Richard Sennett.

40 Friedrich Gräsel, *Röhrenplastik* (photographs of the burning and burned sculpture in W. Grasskamp, 'Warum wird Kunst im Aussenraum zerstört? Künstlerischer und kultureller Raum', in *Kunst-Bulletin* (April 1984), pp. 2–7, p. 5, without mention of date).

41 Jörg-Uwe Albig, 'Vandalen zerstören Kunst in der Natur. Volkszorn auf "Windmützen" und "Wetterfenster" ', *Art*, no. 5 (1985), p. 8.

42 Albig, 'Vandalen zerstören Kunst in der Natur'.

43 'Moore's King and Queen beheaded by vandals', *The Herald* (21 March 1995); Alison Daniels, 'Vandals behead £1m Moore bronze', *The Scotsman* (21 March 1995).

44 Editorial, 'Deterioration of Florentine Sculpture', *The Burlington Magazine*, CXVIII, no. 874 (January 1976), pp. 3–4.

45 L. Réau, *Histoire du vandalisme. Les monuments détruits de l'art français* (Paris, 1959), I, p. 19 (1994, p. 17).

46 R. Töpffer, *Nouveaux voyages en zigzag à la Grande-Chartreuse, autour du Mont-Blanc, dans les vallées d'Hérens, de Zermatt, au Grimsel, à Gênes et à la Corniche* (Paris, [1854]), pp. 193–4.

47 Rolf Kroseberg, 'Das "Käthchen" ist sehr standfest. Versuchter Anschlag auf die umstrittene Heilbronner Plastik', *Die Welt* (3 August 1965).

48 'Kunstwerk in Apeldoorn moet het ongelden', *Gelders Overijsselse Courant* (2 September 1983); see also 'Kunstenaar reageert op vernielen kunstwerk', *Gelders Overijsselse Courant* (3 September 1983); Rob Hirdes, 'Vanuit een helikopter zag 't er toch heel aardig uit . . .', *Arnhemse Courant* (6 September 1983); Willem Ellenbroek, 'Kunst meer dan ooit vogelvrij verklaard', *de Volkskrant* (8 September 1983).

49 See for example 'Beeldenstorm van vandalen te Groningen', *De Telegraaf* (25 September 1961); 'Beeldenstorm', *Elseviers Weekblad* (7 October 1961); L. P. J. Braat, 'Goedvaderlandse kunstvernieling', *Nieuwe Rotterdamse Courant* (11 October 1961); Walter Barten, 'De kunst wordt in elkaar getrapt', *Gorene Amsterdammer* (25 July 1970); Jouke Mulder, 'Een nieuwe beeldenstorm', *Elseviers Magazine* (5 May 1973); Monique van de Ven, 'Steeds meer kunstwerken worden vernield', *Fries Dagblad* (27 March 1993); Monique Brandt, 'Beeldenstorm in Nederland', *Nieuwsblad van het Noorden* (9 April 1993).

50 A.N.P., 'Haags meldpunt voor vernielde kunst', *de Volkskrant* (19 March 1993).

51 Jaap Vegter, 'Raad kunst', *Vrij Nederland* (12 July 1986).

52 Robert Storr, ' "Tilted Arc": Enemy of the People?', *Art in America* (September 1985), p. 94.

53 Lorette Coen, 'L'affaire Oppenheim', *L'Hebdo*, no. 14 (11 December 1981), pp. 36–8; François Albera, 'Y a-t-il une "Affaire Oppenheim"?', *Voix ouvrière hebdomadaire* (29 April–5 May 1982).

Chapter 10

1 See, in particular, P. Bourdieu and A. Darbel, *L'amour de l'art. Les musées d'art européens et leur public* (2nd edn, Paris, 1969).

2 Caroline Keck, 'On Conservation', *Museum News. The Journal of the American Association of Museums*, L (May 1972), p. 9.

3 Wilhelm Anzinger, *Die Ruinen von Ephesos* (Berlin and Vienna, 1972), p. 140, quoted in Peter Moritz Pickshaus, *Kunstzerstörer: Fallstudien: Tatmotive und Psychogramme* (Reinbek bei Hamburg, 1988), pp. 36–9. The question of Herostratos' motives remains disputed. Pickshaus proposes to see the traditional explanation as a rationalization deduced from the mode of punishment itself, while Dieter Metzler mentions the possibility of a political motivation ('Bilderstürme und Bilderfeindlichkeit in der Antike', in *Bildersturm. Die Zerstörung des Kunstwerks*, ed. M. Warnke, Frankfurt, 1977, p. 24).

4 *De Telegraaf* (16 September 1975), and *Het Parool* (15 and 16 September 1975), quoted in David Freedberg, *Iconoclasts and their Motives* (Maarssen, 1985), p. 13.

5 Freedberg, *Iconoclasts*, p. 24.

6 Didier A. Chartier, *Les créateurs d'invisible. De la destruction des œuvres d'art* ([?Paris]: Synapse, 1989), p. 269.

7 S. Cohen, 'Property destruction: motives and meanings', *Vandalism*, ed. C. Ward (London, 1973), p. 43.

8 Keck, 'On Conservation', p. 9.

9 Heinz Althöfer, 'Besucher als Täter. Über Vandalismus gegen die moderne Kunst', *Frankfurter Allgemeine Zeitung* (2 November 1993).

10 A.P., 'Un baiser intempestif lui coûte 2870 francs', *Tribune de Lausanne-Le Matin* (23 November 1977); see Pickshaus, *Kunstzerstörer*, p. 17.

11 Joseph Bonnet, 'Un acte de vandalisme au Louvre. Etat mental de son auteur', *Annales médico-psychologiques*, x (1912), 11, quoted in Chartier, *Les créateurs d'invisible*, pp. 302–15.

12 Pickshaus, *Kunstzerstörer*, pp. 41–64. See also Justin Hoffmann, *Destruktionskunst. Der Mythos der Zerstörung in der Kunst der frühen sechziger Jahre* (Munich, 1995), p. 13.

13 A.P., 'Doek van Hobbema in Washington met vijl beschadigd', *Trouw* (5 November 1966).

14 Frank Santiago, *Omaha World Herald* (23 January 1976), quoted in Chartier, *Les créateurs d'invisible*, pp. 127–34; Mark Steven Walker, 'Le printemps', in *William Bouguereau, 1825–1905*, exhibition catalogue: Musée du Petit Palais, Paris; Musée des Beaux-Arts de Montréal; The Wadsworth Atheneum, Hartford (Paris, 1984), pp. 233–4.

15 Pickshaus, *Kunstzerstörer*, p. 154. On Gustav Metzger's use of acid as an instrument of 'destruction art', see Hoffmann, *Destruktionskunst*, pp. 48–51.

16 *Ibid.*, pp. 10–14.

17 Keck, 'On Conservation', p. 9.

18 See, for example, the 1961 Netherlandish 'wave of vandalism' starting with an exhibition in the Groningen town park ('Beeldenstorm van vandalen te Groningen', *De Telegraaf* (25 September 1961); 'Beeldenstorm', *Elseviers Weekblad* (7 October 1961); L.P.J. Braat, 'Goedvaderlandse kunstvernieling', *Nieuwe Rotterdamse Courant* (11 October 1961).

19 Althöfer, 'Besucher als Täter'.

20 Pickshaus, *Kunstzerstörer*, pp. 11–14. Pickshaus recently augmented his 1988 study with an 'Aktualisierung' comprising a methodological and terminological discussion, a list of cases and a bibliography, and presented it as a PhD dissertation in psychology at the Freie Universität in Berlin (1995).

21 'Louvre Paintings Damaged', *The Times* (12 October 1962); Darsie Gillie, 'Damage in the Louvre explained', *The Guardian* (13 October 1962).

22 *Neue Kronen Zeitung* (11 October 1975), quoted in Freedberg, Iconoclasts, p. 7, and in D. Freedberg, *The Power of Images. Studies in the History and Theory of Response* (Chicago and London, 1989), p. 407.

23 M. Warnke, 'Durchbrochene Geschichte? Die Bilderstürme der Wiedertäufer in Münster 1534/1535', in *Bildersturm. Die Zerstörung des Kunstwerks*, ed. Warnke, p. 69.

24 See Luc Boltanski, with Yann Darré and Marie-Ange Schiltz, 'La dénonciation', *Actes de la recherche en sciences sociales*, no. 51 (March 1984), pp. 3–40.

25 Boltanski, 'La dénonciation', p. 3. See also L. Boltanski and Laurent Thévenot, *De la justification. Les économies de la grandeur* (Paris, 1991).

26 Freedberg, *Iconoclasts*, pp. 9–10.

27 *Ibid.*, pp. 25–7, 35.

28 *Ibid.*, pp. 29–33; Freedberg, *The Power of Images*, pp. 410–12.

29 J. von Végh, *Die Bilderstürmer. Eine kulturgeschichtliche Studie* (Strasburg, 1915), p. 134.

30 See Louis Réau, *Histoire du vandalisme* (Paris, 1959), I, p. 18 (Paris, 1994, p. 17); Pickshaus, *Kunstzerstörer*, pp. 305–06, 315–16.

31 *Omaha Daily Bee* (16 December 1890), quoted in Chartier, *Les créateurs d'invisible*, pp. 109–18, 124–5; Walker, 'Le printemps', p. 234.

32 Hans Jürgensen, 'Auch gute Absicht rechtfertigt keinen Kunstvandalismus', *Frankfurter Allgemeine Zeitung* (18 March 1985).

33 Chartier, *Les créateurs d'invisible*, p. 380.

34 G. Rosolato, 'Notes psychanalytiques sur le vol et la dégradation des œuvres d'art', *Museum*, XXVI/1 (1974), pp. 21–5 (p. 24).

35 Pickshaus, *Kunstzerstörer*, pp. 22–3.

36 Stanley Cohen, 'Property destruction: motives and meanings' in *Vandalism*, ed. Ward, p. 55.

37 Chartier, *Les créateurs d'invisible*, p. 145.

38 Pickshaus, *Kunstzerstörer*, pp. 244–7; see for example D.W., 'Seelisch kranker Frührentner gestand Säure-Anschläge – Gemälde im Wert von mehr als 100 Millionen Mark zerstört. "Ich mußte zerstören, was andere verehrten" ', *Die Welt* (10 October 1977).

39 'Painting in London Daubed', *The New York Times* (20 March 1962).

40 'New York paintings defaced', *The Times* (18 January 1969); Mark R. Arnold, 'Over Exhibit on Harlem. Protesters Mar 10 Paintings in New York Metropolitan Museum', *The New York Herald Tribune* (19 January 1969).

41 Chartier, *Les créateurs d'invisible*, p. 34.

42 See, in particular, the chapter in Pickshaus, *Kunstzerstörer*, pp. 125–73, from which the following information is borrowed. As in the whole book, the relation and discussion of this case are organized in an extremely confused way, but are rich in firsthand information.

43 Pickshaus, *Kunstzerstörer*, p. 159.

44 *Ibid.*, pp. 165–6.

45 Chartier, *Les créateurs d'invisible*, pp. 140–44.

46 Boltanski, 'La dénonciation', pp. 35–8.

47 M. Warnke, 'Durchbrochene Geschichte?', p. 88.

48 'L'assassinat de René Bousquet', *Le Monde* (10 June 1993), p. 12; Sylvie Kauffmann, 'Le "Washington Post" publie le manifeste d'un assassin en série', *Le Monde* (21 September 1995).

49 Jean-Michel Dumay, 'Le passe-murailles qui déjeunait à l'Elysée inquiète les services de sécurité', *Le Monde* (23 September 1995), p. 12.

50 Florence Hartmann, 'Radovan Karadzic, le psychiatre psychopathe', *Le Monde* (23 June 1995).

51 E. Fromm, *The Anatomy of Destructiveness* (Harmondsworth, 1990; 1st edn 1973), pp. 490–574 (quotations on pp. 441, 506, 525).

52 Pickshaus, *Kunstzerstörer*, p. 130.

53 *Ibid.*, p. 159.

54 Chartier, *Les créateurs d'invisible*, pp. 259–60.

55 See Pickshaus, *Kunstzerstörer*, pp. 182–222, and Chartier, *Les créateurs d'invisible*, pp. 167–96, from which most of the following information is taken. In the case of Rembrandt's *Nightwatch*, see Pickshaus, *Kunstzerstörer*, pp. 176–222.

56 Pickshaus, *Kunstzerstörer*, pp. 208–10.

57 *Il Messagero* (30 January 1973), quoted in Pickshaus, *Kunstzerstörer*, p. 190.

58 John J. Teunissen and Evelyn J. Hinz, 'The Attack on the Pietà: An Archetypal Analysis', *Journal of Aesthetics*, XXXIII/1 (1974–5), pp. 42–50.

59 Chartier, *Les créateurs d'invisible*, pp. 177, 184, 180, 182.

60 *Sydney Daily Telegraph* and *Morning Herald* (24 May 1972), quoted in Pickshaus, *Kunstzerstörer*, p. 218.

61 This observation was kindly suggested to me by Ingrid Junillon.

62 Ph. Junod, '(Auto)portrait de l'artiste en Christ', *L'autoportrait à l'âge de la photographie. Peintres et photographes en dialogue avec leur propre image*, exhibition catalogue: Musée cantonal des Beaux-Arts de Lausanne (Berne, 1985), pp. 59–79. See also Rudolf and Margot Wittkower, *Born Under Saturn: The Character and Conduct of Artists: A Documented History from Antiquity to the French Revolution* (New York, 1969), and Ernst Kris and Otto Kurz, *Legend, Myth, and Magic in the Image of the Artist* (New Haven and London, 1979).

63 *Le Figaro* (15 August 1939), quoted in Chartier, *Les créateurs d'invisible*, pp. 317–21.

64 A.P., 'Anschlag auf Michelangelos "David" in Florenz', *Neue Zürcher Zeitung* (16 September 1991); Marc Leijendekker, 'Italiaanse schilder beschadigt beeld David met hamer', *NRC Handelsblad* (16 September 1991), p. 6; Pickshaus, 'Aktualisierung', p. 33.

65 Jean Starobinski, 'La vision de la dormeuse', *Nouvelle revue de psychanalyse*, no. 5 (Spring 1972), p. 14.

66 Réau, *Histoire du vandalisme*, p. 16 (1994, p. 14).

67 Quoted by Pierre Marot, 'L'abbé Grégoire et le vandalisme révolutionnaire', *Revue de l'art*, no. 49 (1980), p. 38.

68 Nicolaï V. Gogol, 'The Portrait', in *Tales of Good and Evil*, translated by David Magarshack (New York, 1957), pp. 134–5.

69 See the preface by Marc Mécréant to Y. Mishima, *Le Pavillon d'Or (Kinkakuji)* (Paris, 1961), and Chartier, *Les créateurs d'invisible*, pp. 275–98.

70 Althöfer, 'Besucher als Täter'. The conference was organized by the University of Ghent in the Media Center in Ostende.

71 Anthony Everitt, 'Painting modernism black', *The Guardian* (16 May 1994).

72 See Pickshaus, *Kunstzerstörer*, pp. 65–123, from which the following data are borrowed unless otherwise mentioned. Mrs Angela Schneider, of the Berlin Nationalgalerie, kindly put at my disposal important press documentation.

73 ' "Bilderstürmer" auf freiem Fuß, weil keine Fluchtgefahr besteht', *Berliner Morgenpost* (16 April 1982). According to Pickshaus, each blow was directed to a colour field (*Kunstzerstörer*, p. 95).

74 Pickshaus, *Kunstzerstörer*, pp. 93–4 (the two slips of paper are reproduced on p. 83, with the name and address concealed). This complex arrangement was immediately dismantled by the museum keeper who discovered it.

75 *Hommage à Barnett Newman* (Berlin, 1981).

76 Pickshaus, *Kunstzerstörer*, p. 86.

77 *Ibid.*, pp. 74, 78–9, 86, 100.

78 *Ibid.*, pp. 86, 84.

79 *Ibid.*, pp. 79–80, 74, 77, 68–73.

80 See 'Vernieler doek wil museum blijven bezoeken', *NRC Handelsblad* (3 April 1986); Jan Eilander, 'De Newman killer', *Haagse Post* (5 April 1986); 'Vernieler van schilderij ziet daad als kunstkritiek', *Reformatorisch Dagblad* (26 June 1986); 'Man vernielde schilderij "om de discussie" ', *Het Parool* (18 September 1986); A.N.P., 'Verbod voor vernieler

schilderij', *Het Parool* (2 October 1986). The restoration of this painting later caused a major scandal: Renée Steenbergen, 'Kritiek face-lift doek Newman', *NRC Handelsblad* (16 August 1991); Christian Chartier, 'L'honneur perdu d'un restaurateur', *Le Monde* (31 January 1992); Pickshaus, 'Aktualisierung', pp. 26–7.

81 Thierry de Duve, 'Vox Ignis Vox Populi', *Parachute*, no. 60 (October–December 1990), pp. 30–34, republished in T. de Duve, *Du nom au nous* (Paris, 1995), pp. 33–44.

Chapter 11

1 M. Warnke, 'Bilderstürme', in *Bildersturm. Die Zerstörung des Kunstwerks*, ed. M. Warnke (Frankfurt, 1977), pp. 10–11; C. Ward, 'Introduction', in *Vandalism*, ed. C. Ward (London, 1973), p. 18.

2 For the opposition between motivational and behaviourist approaches, see E. Fromm, *The Anatomy of Destructiveness* (Harmondsworth, 1990; 1st edn 1973), *passim*.

3 S. Settis, 'La Colonne Trajane: l'empereur et son public', *Revue archéologique*, n.s., no. 1 (1991), pp. 186–7.

4 Letter of disputed authorship, published in the *Works* of Baldassare Castiglione (1733), quoted after F. Choay, *L'allégorie du patrimoine* (Paris, 1992), p. 49.

5 T. Benton, 'Rome reclaims its Empire', in *Art and Power: Europe under the Dictators 1930–45*, exhibition catalogue: Hayward Gallery, London (1995), pp. 120–29 (p. 121). See, further, Ronald T. Ridley, 'Augusti Manes Volitant per Auras: The Archaeology of Rome under the Fascists', *Xenia*, 11 (1986), pp. 19–46.

6 Louis Réau, *Histoire du vandalisme. Les monuments détruits de l'art français* (Paris, 1959), I, pp. 109–41 (1994, pp. 135–82).

7 Voltaire, *Des embellissements de Paris* (1739), quoted in Réau, *Histoire du vandalisme*, II, p. 142 (1994, p. 725).

8 Werner Oechslin, 'Monument, Town and its Synthesis in the Theory of "Embellissement" ', *Daidalos*, no. 49 (September 1993), pp. 138–49.

9 Choay, *L'allégorie du patrimoine*, p. 111. On the economic effects of the Revolution, see the example of Cologne in B. Hinz, 'Säkularisation als verwerteter "Bildersturm". Zum Prozess der Aneignung der Kunst durch die Bürgerliche Gesellschaft', in *Bildersturm*, ed. Warnke, pp. 108–20.

10 L. de Laborde, *Les anciens monuments de Paris* (1846), quoted in Réau, *Histoire du vandalisme*, II, p. 123 (1994, p. 700).

11 Restoration principles of the Cambridge Camden Society, as put forth in *Ecclesiologist*, I (1842), p. 65; Eugène Viollet-le-Duc, *Dictionnaire raisonné de l'architecture* (Paris, 1854–8), VIII, article 'Restauration'; both quoted in Nikolaus Pevsner, 'Scrape and Anti-Scrape', in *The Future of the Past: Attitudes Towards Conservation*, ed. Janet Fawcett (London, 1976), pp. 41, 48.

12 Quoted in Réau, *Histoire du vandalisme*, II, p. 159 (1994, p. 746). See Pier Luigi Cervellati, ' "L'artiste démolisseur": G. E. Haussmann', in *La cultura della conservazione* (Milan, 1993), pp. 371–8.

13 Stanislaus von Moos, 'Le Corbusier, The Monument and the Metropolis', *Columbia Documents of Architecture and Theory*, III (1993), pp. 115–37.

14 *Ibid.*, 'Le Corbusier', pp. 124, 116, 126.

15 *Ibid.*, pp. 129–31.

16 See Frédéric Edelmann, 'Comment réconcilier les villes martyres et leur histoire', *Le Monde* (11 February 1995), p. 26; Emmanuel de Roux, 'La reconstruction de Beyrouth menace le patrimoine architectural de la ville', *Le Monde* (3 June 1995); Sawsan Awada Jalu, 'Patrimoine et reconstruction: le cas de Beyrouth', to be published in the papers of the International Conference *Le patrimoine et la cité* (Annecy, 28–30 September 1995).

17 See, for example, A. Bärnreuther, 'NS-Architektur und Stadtplanung als Herausforderung für die Kunstgeschichte', *Kritische Berichte*, XXII/3 (1994), pp. 47–54.

18 'Rettet Rumäniens Dörfer!', *Neue Zürcher Zeitung* (14 October 1988), p. 5; Christophe

Chatelot and Yves-Michel Riols, 'Snagov, ancien village "systématisé" ', *Le Monde* (22–23 May 1994).

19 See Albert Knoepfli, *Schweizerische Denkmalpflege: Geschichte und Doktrinen*, Jahrbuch 1970–71 of the Swiss Institute for Art Research (Zurich, 1972), pp. 13–15.

20 See Choay, *L'allégorie du patrimoine*, pp. 104–06, 118; Georg Germann, *The Gothic Revival in Europe and Britain: Sources, Influences and Ideas* (London, 1972).

21 *The Gentleman's Magazine*, XLIII (1793), p. 178, quoted in Pevsner, 'Scrape and Anti-Scrape', p. 38.

22 V. Hugo, 'La Bande noire', in *Odes et Ballades* (Paris, 1823); V. Hugo, 'Guerre aux démolisseurs', *Revue des Deux Mondes*, V (1832), pp. 607–22.

23 Ch. de Montalembert, 'Du vandalisme en France. Lettre à M. Victor Hugo', *Revue des Deux Mondes*, n.s. I (1833), pp. 477–524; see chapter Two.

24 Letter of 2 July 1834 to Arcisse de Caumont, quoted in Réau, *Histoire du vandalisme*, II, p. 127 (1994, p. 705).

25 *The Works of John Ruskin*, ed. E. T. Cook and A. Wedderburn (London, 1903), VIII, p. 242, quoted in Pevsner, 'Scrape and Anti-Scrape', p. 49.

26 J. Ruskin, *The Seven Lamps of Architecture*, quoted in Martin S. Briggs, *Goths and Vandals: A Study of the Destruction, Neglect and Preservation of Historical Buildings in England* (London, 1952), p. 10.

27 William Morris, letter of 5 March 1877 to the *Athenaeum*, quoted in Pevsner, 'Scrape and Anti-Scrape', p. 51. See also Briggs, *Goths and Vandals*, pp. 203–19. For the corresponding debate in the German-speaking countries, see Marion Wohlleben, *Konservieren oder restaurieren? Zur Diskussion über Aufgaben, Ziele und Probleme der Denkmalpflege um die Jahrhundertwende* (Zurich, 1989).

28 See, for example, the mid-century controversy over the cleaning of pictures at the National Gallery in London (Verax, 'The National Gallery – To the Editor of The Times', *The Times*, 29 October 1846; Morris Moore, *Revival of Vandalism at the National Gallery; a Reply to Messrs. Ruskin, ... Heaphy, and Wornum's Letters in 'The Times', 23rd, 27th, and 29th December, 1852 ... with Notes*, London, 1853), as well as A. Chastel and Jean-Pierre Babelon, 'La notion de patrimoine', *Revue de l'Art*, no. 49 (1980), pp. 23–4.

29 See Franz Bächtiger, *Zur Revision des Berner Christoffel* (Berne, 1980). The fragments are now preserved in the Bernisches Historisches Museum, and a copy of the head was placed in 1975 in the underground passage of the new railway station, close to the foundations of the tower.

30 Za, 'Gerechtigkeitsbrunnen Justitia', *Brunne Zytig*, no. 4 (2 December 1988), p. 2.

31 Friedrich Born, *Hendrik und Johann Beldensnyder* (Münster, 1905), p. 4, mentioned in M. Warnke, 'Durchbrochene Geschichte? Die Bilderstürme der Wiedertäufer in Münster 1534/1535', in *Bildersturm*, ed. M. Warnke, p. 160, n. 10, with a further reference to H. Deiters, *Restauration und Vandalismus* (Düsseldorf, 1882).

32 G. B. Shaw, 'Common Sense about the War', *The New Statesman*, Special War Supplement (14 November 1914), pp. 26–7; Hugo, 'Guerre aux démolisseurs', pp. 615–16.

33 Montalembert, 'Du vandalisme en France', pp. 520, 514.

34 Pevsner, 'Scrape and Anti-Scrape', pp. 51–4.

35 A. Riegl, *Der moderne Denkmalkultus. Sein Wesen und seine Entstehung* (Vienna, 1903), republished in Georg Dehio, A. Riegl, *Konservieren, nicht restaurieren. Streitschriften zur Denkmalpflege um 1900* (Braunschweig–Wiesbaden, 1988).

36 Riegl, *Der moderne Denkmalkultus*, pp. 46–7. On Riegl, see Michael Podro, *The Critical Historians of Art* (New Haven and London), 1982, pp. 71–97, and W. Kemp, 'Alois Riegl (1858–1905)', in *Altmeister moderner Kunstgeschichte*, ed. Heinrich Dilly (Berlin, 1990), pp. 37–60.

37 C. Sitte, *Der Städtebau nach seinen künstlerischen Grundsätzen* (Vienna, 1889).

38 Choay, *L'allégorie du patrimoine*, p. 109.

39 Gustavo Giovannoni, *Vecchie città ed edilizia nuova* (Turin, 1931), quoted in Choay, *L'allégorie du patrimoine*, p. 151.

40 'Recommendation concerning the Preservation of Cultural Property Endangered by Public or Private Works' (Paris, 19 November 1968), in *Conventions and Recommendations of Unesco concerning the protection of the cultural heritage* (Paris, 1985), pp. 147–61.

41 'Recommendation concerning the Protection, at National Level, of Cultural and Natural Heritage' (Paris, 16 November 1972), in *Conventions and Recommendations of Unesco*, pp. 167–79.

42 Choay, *L'allégorie du patrimoine*, pp. 10–12.

43 *Le Monde* [édition 'Rhône-Alpes'] (11 October 1994), pp. 18–19 (Bruno Caussé, 'Le double échec'; Acacio Pereira, 'Un-deux-trois-soleil'; Frédéric Edelmann, 'Oublier le vingtième siècle').

44 Pierre Le Hir, 'Démocratie couchée dans l'herbe', *Le Monde* [édition 'Rhône-Alpes'] (11 October 1995).

45 Pierre Joly, 'Chemetov, Paul', in *Dictionnaire encyclopédique de l'architecture moderne et contemporaine* (Paris, 1987), pp. 75–6.

46 P. Chemetov, 'Des bâtiments et des hommes', *Le Monde* (12 October 1995).

47 F. Edelmann and Emmanuel de Roux, 'Bruxelles, ou les vertiges de l'autodestruction', *Le Monde* (18 February 1994).

48 Réau, *Histoire du vandalisme* (1994), pp. 948–54; Claude de Montclos, *La mémoire des ruines. Anthologie des monuments disparus en France* (Paris 1992), pp. 271–99.

49 Chastel and Babelon, 'La notion de patrimoine', p. 27.

50 Thierry Goyet, 'Le secteur sauvegardé de Rennes', to be published in the papers of the International Conference *Le patrimoine et la cité* (Annecy, 28–30 September 1995).

51 Damien Voutay, *Démolitions et protection du patrimoine, état des lieux à Lyon, 1980–1995*, master dissertation, University of Lyon II, 1995, p. 15. See also F. Edelmann and E. de Roux, 'Les démolisseurs sont de retour', *Le Monde* (21 October 1993).

52 Anna Leicher, *Le château en Anjou entre 1840 et 1880*, D.E.A. dissertation, University of Lyon II, 1994, p. 23; Hélène Guéné, 'Devantures à consommer', *Monuments historiques*, no. 131 (February–March 1984), pp. 26–9 (p. 27).

53 François Chaslin, 'La démolition programmée de Notre-Dame-d'Espérance', *Le Monde* (25 January 1995).

54 E. de Roux, 'La piscine Molitor est toujours menacée de destruction', *Le Monde* (21 January 1995), p. 27.

55 E. de Roux, 'L'agonie des Grands Boulevards', *Le Monde* (4 March 1995).

56 Choay, *L'allégorie du patrimoine*, pp. 178, 182, 197.

57 Réau, *Histoire du vandalisme* (1994), pp. vii–viii, and for example pp. 995, 997, 999.

58 Réau, *Histoire du vandalisme*, I, p. 140 (1994, p. 180).

59 Réau, *Histoire du vandalisme*, II, pp. 258–9 (1994, pp. 875–6).

60 M. Agulhon, 'La "statuomanie" et l'histoire', *Ethnologie française*, VIII/1 (1978), reprinted in M. Agulhon, *Histoire vagabonde*, I (Paris, 1988), pp. 137–85.

61 M. Agulhon, 'Imagerie civique et décor urbain', *Ethnologie française*, V/1 (1975), reprinted in M. Agulhon, *Histoire vagabonde*, pp. 101–36.

62 Jean Adhémar, 'Les statues parisiennes de grands hommes', *Gazette des Beaux-Arts*, n.s. 6, LXXXIII (March 1974), pp. 149–52.

63 Agulhon, 'Imagerie civique et décor urbain', pp. 128–31.

64 N. McWilliam, 'Monuments, Martyrdom, and the Politics of Religion in the French Third Republic', *Art Bulletin*, LVII/2 (June 1995), pp. 186–206.

65 'La Statuomanie', *Le Voleur* (17 October 1879), quoted in Adhémar, 'Les statues parisiennes de grands hommes', p. 149.

66 P. Larousse, 'Statues', *Grand dictionnaire universel du XIXe siècle*, vol. XVII, 2nd supplement, quoted in Agulhon, 'La "statuomanie" et l'histoire', pp. 138, 148.

67 Quoted in Adhémar, 'Les statues parisiennes de grands hommes', p. 149.

68 Quoted in S. Michalski, 'Die Pariser Denkmäler der III. Republik und die Surrealisten',

Idea, VII (1988), pp. 91–107 (p. 93). See also Gustave Pessard, *Statuomanie parisienne. Etude critique sur l'abus des statues* (Paris, 1912).

69 Pierre Reverdy, 'L'image', *Nord-Sud*, no. 13 (March 1918), p. 2, quoted in Michalski, 'Die Pariser Denkmäler', p. 95.

70 'Sur certaines possibilités d'embellissement irrationnel d'une ville', *Le surréalisme au service de la révolution*, no. 6 (May 1933), pp. 18–20; see chapter Three, p. 76.

71 M. Agulhon, 'Les statues de "grands hommes" constituent-elles un patrimoine?', to be published in the papers of the International Conference *Le patrimoine et la cité* (Annecy, 28–30 September 1995).

72 Y. Bizardel, 'Les statues parisiennes fondues sous l'occupation (1940–1944)', *Gazette des Beaux-Arts*, n.s. 6, LXXXIII (March 1974), pp. 129–52 (p. 134); Michalski, 'Die Pariser Denkmäler', p. 102; Gilbert Gardes, *Le monument public français* (Paris, 1994), p. 44.

73 'Loi du 11 octobre 1941 relative à l'enlèvement des statues et monuments métalliques en vue de la refonte', *Journal officiel de l'Etat français* (15 October 1941).

74 'Une révision nécessaire de nos gloires nationales. Statues à abattre, statues à élever', document no. 260, 22 mars 1943 (Archives Municipales de Saint-Etienne, I M 199).

75 See John M. Hunisak, *The Sculptor Jules Dalou: Studies in his Style and Imagery* (New York and London, 1977), pp. 227–8 (without reference to Jahan's photographs); Ute Hüningen, *'Le triomphe de la République': Das Republikdenkmal von Jules-Aimé Dalou in Paris 1879–1899* (Munich, 1989).

76 Pierre Dominique, 'Les faux dieux', *Candide* (19 November 1942), p. 1, quoted in Michalski, 'Die Pariser Denkmäler', p. 103.

77 Conseil municipal de Lyon, séance du 12 janvier 1942 (Archives Municipales de Lyon).

78 P. Jahan, *La mort et les statues* (Paris, 1946; new edn Paris, 1977); see P. Jahan, 'La mort et les statues, décembre 1941', *Gazette des Beaux-Arts*, n.s. 6, LXXXIII (March 1974), pp. 153–6; Michalski, 'Die Pariser Denkmäler', pp. 96–100.

79 Anne Pingeot, 'La sculpture du XIXe siècle. La dernière décennie', *Revue de l'art*, no. 104 (1994), pp. 5–7 (p. 6).

80 Agulhon, 'Les statues de "grands hommes" constituent-elles un patrimoine?'.

81 See G. Gardes, *Lyon l'Art et la Ville* (Paris, 1988), II, p. 190, repr. on p. 192.

82 Gardes, *Lyon l'Art et la Ville*, II, pp. 189–91.

83 'Statue de la République française élevée place Carnot' (Archives Municipales de Lyon, série 3 M; *Bulletin municipal officiel*, séance du 3 décembre 1973 (Archives Municipales de Lyon).

84 *Echo Liberté* (8 July 1964).

85 'Le coup de pioche de M. le Maire. Inauguration de la démolition de l'îlot 24', *Le Journal* (17 November 1984); '32 logements sociaux rue Burdeau', *Le Progrès* (14 February 1994).

86 G. Gardes, 'La place Gailleton à Lyon et son décor 1773–1978', *Travaux de l'Institut d'Histoire de l'Art* (Lyon), no. 6 (1980), pp. 13–28; G. Gardes, 'Le monument public français. L'exemple de Lyon', unpublished PhD dissertation, University of Lyon II, 1985, IV, p. 506; Gardes, *Lyon l'Art et la Ville*, pp. 197–9.

Chapter 12

1 L. Réau, *Histoire du vandalisme. Les monuments détruits de l'art français* (Paris, 1959), I, p. 414, II, pp. 258, 292 (1994, pp. 549, 875, 921).

2 Marie-Hélène Froeschlé-Chopard, 'Le décor des églises, test du "vandalisme révolutionnaire" ', in *Révolution française et 'vandalisme révolutionnaire'*, ed. S. Bernard-Griffiths, M.-C. Chemin and J. Ehrard (Paris, 1992), p. 229–40.

3 O. Christin, 'Le May des orfèvres. Contribution à l'histoire de la genèse du sentiment esthétique', *Actes de la recherche en sciences sociales*, no. 105 (1994), pp. 75–90.

4 A. Quatremère de Quincy, *Considérations morales sur la destination des ouvrages de l'art* (1815) (Paris, 1989), pp. 37, 30, 47–8, 38.

5 Georges Brunel, 'La peinture religieuse: art officiel et art sacré', in *Les années romantiques.*

La peinture française de 1815 à 1850, exhibition catalogue: Musée des Beaux-Arts, Nantes; Galeries Nationales du Grand Palais, Paris; Palazzo Gotico, Piacenza (Paris, 1995), pp. 61–75.

6 Henri Lacordaire, *Règlement de la confrérie de Saint-Jean l'Evangéliste* (Paris, 1840), partially reproduced in Daniele Menozzi, *Les images. L'Eglise et les arts visuels* (Paris, 1991), p. 236.

7 Bruno Foucart, *Le renouveau de la peinture religieuse en France (1800–1860)* (Paris, 1987), pp. 15–16.

8 Menozzi, *Les images*, pp. 242–5.

9 *Hippolyte, Auguste et Paul Flandrin. Une fraternité picturale au XIXe siècle*, exhibition catalogue: Musée du Luxembourg, Paris; Musée des Beaux-Arts, Lyon (Paris, 1984).

10 K. Herding, 'Die fruchtbare Krise. Delacroix' religiöse Gemälde', *Neue Zürcher Zeitung* (24–25 June 1995), p. 49; K. Herding, 'Friedrich Schlegel und Eugène Delacroix: Krise und Erneuerung der religiösen Malerei am Beginn der Moderne', to be published in the acts of the International Conference *Crises de l'image religieuse – Krisen religiöser Kunst* (Göttingen, 18–20 March 1994).

11 Harald Siebenmorgen, *Die Anfänge der Beuroner Kunstschule* (Sigmaringen, 1983).

12 N. McWilliam, *Dreams of Happiness: Social Art and the French Left 1830–1850* (Princeton, 1993); Michael Paul Driskel, *Representing Belief: Religion, Art and Society in Nineteenth-century France* (University Park, Pa, 1992).

13 Harrison C. and Cynthia A. White, *Canvases and Careers: Institutional Change in the French Painting World* (New York, London and Sidney, 1965).

14 G.-Albert Aurier, 'Le symbolisme en peinture. Paul Gauguin', *Le Mercure de France* (March 1891), pp. 155–65 (p. 165).

15 Dom Willibord Verkade, *Le tourment de Dieu. Etapes d'un moine peintre* (Paris, 1926), p. 94.

16 R. Liebenwein-Krämer, *Säkularisierung und Sakralisierung: Studien zum Bedeutungswandel christlicher Bildformen in der Kunst des 19. Jahrhunderts*, PhD dissertation (Frankfurt-am-Main, 1977).

17 Maurice Denis, *Journal* (Paris, 1957), I, p. 64 (26 August 1885).

18 L. Rouart, 'Maurice Denis et la renaissance de l'art chrétien', *L'Occident*, no. 1 (December 1901), pp. 37–42 (p. 37). See Jean-Paul Bouillon, *Maurice Denis* (Geneva, 1993), pp. 9–13.

19 Walter Ruppen, *Raphael Ritz 1829–1894, Leben und Werk* (Vira, 1971), p. 86.

20 Mathilde Tobler, ' "Ich male für fromme Gemüter und nicht für Kritiker". Melchior Paul von Deschwanden als Kirchenmaler', in *'Ich male für fromme Gemüter'. Zur religiösen Schweizer Malerei im 19. Jahrhundert*, exhibition catalogue: Kunstmuseum, Lucerne (1985), pp. 53–118.

21 Abbé Hurel, *L'art religieux contemporain, étude critique* (Paris, 1868), pp. 337–8, quoted in Claude Savart, 'A la recherche de l'"art" dit de Saint-Sulpice', *Revue d'histoire de la spiritualité*, LII (1976), pp. 265–82 (p. 270).

22 Abbé Sagette, *Essai sur l'art chrétien, son principe, ses développements, sa renaissance* (Paris, 1853), p. 230, quoted in Savart, *'A la recherche'*, p. 270.

23 Savart, 'A la recherche', pp. 273–81.

24 Menozzi, *Les images*, p. 55.

25 J.-K. Huysmans, *Les foules de Lourdes* (Paris, 1906), pp. 107–09 (the original *atechnie* and *inart* are also neologisms in French).

26 Brunel, 'La peinture religieuse'.

27 M.-A. Couturier, *Se garder libre (Journal 1947–1954)* (Paris, 1962); *Dieu et l'art dans une vie – Le père Marie-Alain Couturier de 1897 à 1945* (Paris, 1965).

28 A. Cingria, *La décadence de l'art sacré* (Lausanne, 1917); J. Maritain, *Art et pensée scolastique* (Paris, 1920; first published in the journal *Les Lettres*, September and October 1919).

29 M. Wackernagel, 'Zum Problem der kirchlichen Kunst', *Ars sacra* (1927), pp. 13–22 (p. 22). See D. Gamboni *et al.*, *Louis Rivier (1885–1963) et la peinture religieuse en Suisse romande* (Lausanne, 1985), pp. 46–61; Kenneth E. Silver, *Esprit de Corps: The Art of the Parisian Avant-Garde and the First World War, 1914–1925* (Princeton, 1989).

30 Geneviève and Henri Taillefert, 'Les Sociétés d'Artistes et la fondation de l'Art catholique', in *L'Art Sacré au XXe siècle en France*, exhibition catalogue: Musée Municipal and Centre culturel, Boulogne-Billancourt (Thonon-les-Bains, 1993), pp. 15–25.

31 *Ateliers d'art sacré 8, rue de Furstemberg, Paris* (Paris, n.d.); see D. Gamboni, ' "The Baptism of Modern Art"? Maurice Denis and Religious Art', in *Maurice Denis 1870–1943*, exhibition catalogue: Musée des Beaux-Arts, Lyon; Wallraf-Richartz-Museum, Cologne; Walker Art Gallery, Liverpool; Van Gogh Museum, Amsterdam (Ghent, 1994), pp. 74–93.

32 See, for example, G. Arnaud d'Agnel, *L'art religieux moderne* (Grenoble, 1936); Emmanuel Bréon, 'L'Art Sacré s'expose', in *L'Art Sacré au XXe siècle en France*, pp. 81—8.

33 M. Denis, *Nouvelles théories sur l'art moderne, sur l'art sacré 1914–1921* (Paris, 1922), p. 256 (1920), 186–7 (1918).

34 M. Denis, *Histoire de l'art religieux* (Paris, 1939), p. 293.

35 M.-A. Couturier, 'L'appel aux maîtres de l'art moderne', reproduced in Marcel Billot, 'Le père Couturier et l'art sacré', in *Paris–Paris 1937–1957*, exhibition catalogue: Centre Georges Pompidou, Paris (1981), pp. 196–205 (p. 202). See also Gérard Monnier, 'Actualité de l'art sacré', in *L'art en Europe. Les années décisives 1945–1953*, exhibition catalogue: Musée d'art moderne, Saint-Etienne (Geneva, 1987), pp. 48–53.

36 Sabine de Lavergne, *Art sacré et modernité. Les grandes années de la revue 'l'Art Sacré'* (Namur, 1992).

37 M.-A. Couturier, 'Christian Art and Modern Art', paper delivered in 1941, quoted in Billot, 'Le père Couturier et l'art sacré', p. 200.

38 Joseph Pichard, *L'art sacré moderne* (Paris and Grenoble, 1953), p. 100; William Rubin, *Modern Sacred Art and the Church of Assy* (New York, 1960).

39 G. Severini, 'A propos du débat sur l'art sacré contemporain', *Art d'aujourd'hui*, III/6 (August 1952), p. 29; G. Severini, 'Problèmes de l'art sacré contemporain', *Témoignages* (1952), p. 147.

40 Pichard, *L'art sacré moderne*, p. 105; see H. Matisse, M.-A. Couturier, L.-B. Rayssiguier, *La chapelle de Vence. Journal d'une création* (Paris, 1993).

41 Jean Petit, *Un couvent de Le Corbusier* (Paris, 1961).

42 D. Gamboni and Marie Claude Morand, 'Le "renouveau de l'art sacré". Notes sur la peinture d'église en Suisse romande, de la fin du XIXe siècle à la seconde guerre mondiale', *Unsere Kunstdenkmäler / Nos monuments d'art et d'histoire*, XXXVI/1 (1985), pp. 75–86; Gamboni, *Louis Rivier*, pp. 50–56; M. Cl. Morand, 'L'art religieux moderne en terre catholique. Histoire d'un monopole', in *19–39. La Suisse romande entre les deux guerres*, exhibition catalogue: Musée Cantonal des Beaux-Arts, Musée des Arts Décoratifs, Musée de l'Elysée, Musée Historique de l'Ancien-Evêché, Lausanne (Lausanne, 1986), pp. 82–91.

43 Menozzi, *Les images*, p. 57.

44 Decree of the Holy Office of 30 May 1921; see a comment by the Jesuit Joseph Maréchal in *Nouvelle Revue théologique* (Louvain), July 1921, pp. 337–44.

45 François Boespflug, 'Dieux chrétiens d'Occident', in *Le grand atlas des religions* (Paris, Encyclopædia Universalis, 1988), pp. 188–91 (p. 191); Morand, 'L'art religieux moderne en terre catholique', p. 85.

46 Chapter Eight, pp. 149–50.

47 Jenns Eric Howoldt, 'Der Kruzifixus von Ludwig Gies. Ein Beispiel "entarteter Kunst" in Lübeck', *Der Waagen. Ein lübeckisches Jahrbuch* (1988), pp. 164–74.

48 M.-A. von Lüttichau, ' "Deutsche Kunst" und "Entartete Kunst": Die Münchner Ausstellungen 1937', in *Die 'Kunststadt' München 1937: Nationalsozialismus und 'Entartete Kunst'*, ed. P.-K. Schuster (Munich, 1987), p. 104.

49 Jacques Gubler, *Nationalisme et internationalisme dans l'architecture moderne de la Suisse* (Lausanne, 1975), pp. 119, 195, 213.

50 M. Besson, 'A propos d'art religieux', *La semaine catholique de la Suisse française*, no. 25 (23 June 1932), pp. 385–6.

51 Menozzi, *Les images*, pp. 58, 255 (quotation from P. Ryckmans, General Governor of the

Congo, in a letter of 14 December 1936 by Cardinal Fumasoni Biondi and Celso Costantini).

52 Paul-Louis Rinuy, 'La sculpture dans la "querelle de l'Art Sacré" (1950–1960)', *Histoire de l'art*, no. 28 (December 1994), pp. 3–16.

53 *On ne se moque pas de Dieu !*, reproduced in *L'Art Sacré*, nos. 9–10 (May–June 1952), p. 4; Lavergne, *Art sacré et modernité*, pp. 127, 151–54; Etienne Fouilloux, 'Autour de Vatican II: crise de l'image religieuse ou crises de l'art sacré?', to be published in the acts of the International Conference *Crises de l'image religieuse – Krisen religiöser Kunst* (Göttingen, 18–20 March 1994).

54 Menozzi, *Les images*, pp. 271–4.

55 Robert Rouquette, 'Le plateau d'Assy ou Saint-Sulpice?', *La Croix* (25 August 1951); Giovanni Costantini, *L'Osservatore romano* (10 June 1951); cited in Fouilloux, 'Autour de Vatican II'.

56 'Woman defaced painting', *The Times* (27 February 1963).

57 Chapter Four, pp. 91–3.

58 Dominique Dhombres, 'Iconoclastes brésiliens briseurs de Vierge noire', *Le Monde* (25 October 1995), p. 1.

59 Abbot Suger, *The Other Little Book on the Consecration of the Church of St.-Denis*, in *Abbot Suger on the Abbey church of St.-Denis and Its Art Treasures*, ed. Erwin Panofsky, 2nd edn (Princeton, 1979), pp. 14, 87–9.

60 V. Hugo, 'Guerre aux démolisseurs', *Revue des Deux Mondes*, V (1832), p. 613.

61 Ch. de Montalembert, 'Du vandalisme en France. Lettre à M. Victor Hugo', *Revue des Deux Mondes*, n.s., I (1833), pp. 501–02, 514.

62 Ch. de Montalembert, *Du vandalisme et du catholicisme dans l'art* (Paris, 1839), pp. vii–viii.

63 D. de Regoyos, letter of 10 December 1892 to Octave Maus, published in *Le Salon Emile Verhaeren. Donation du Président René Vandevoir au Musée Plantin-Moretus à Anvers* (Anvers, 1987), pp. 152–3. The present location of this drawing is unknown.

64 Albert Knoepfli, 'Abkehr vom und Rückkehr zum 19. Jahrhundert. Kirchenrenovation im 19. Jahrhundert – Restaurierung von Kirchen des 19. Jahrhunderts', *Unsere Kunstdenkmäler / Nos monuments d'art et d'histoire*, XXXVI/1 (1985), pp. 17–24.

65 M. Denis, 'Les nouvelles directions de l'art chrétien', lecture given in February 1919, published in M. Denis, *Nouvelles théories*, p. 217.

66 Reported to me by Pierre Georgel, Paris, 22 July 1993.

67 Pie-Raymond Régamey, 'Le zèle de la maison de Dieu', *L'Art Sacré* (March 1947), p. 57.

68 P.-R. Régamey, 'Education artistique du clergé', *L'Art Sacré*, no. 9 (November 1946), p. 21. See Lavergne, *Art sacré et modernité*, pp. 41–7.

69 See, for example, P.-R. Régamey, 'La réprobation de "Saint-Sulpice"', *L'Art Sacré*, nos. 9–10 (May–June 1952), pp. 12–13.

70 P.-R. Régamey, 'Discernement du mal', *L'Art Sacré*, nos. 9–10 (May–June 1951), pp. 3–5.

71 M.-A. Couturier, letter of 14 November 1953 to Abbé Joseph Brochet, published in Lavergne, *Art sacré et modernité*, pp. 251–2; see idem, pp. 122–9.

72 See M.-A. Couturier, *Art sacré* (Houston, 1983).

73 Information received from Hélène Lafont-Couturier, 1992; V. Larbaud, *A. O. Barnabooth, son journal intime* (Paris, 1913), pp. 20, 26–7, 210.

74 Régamey, 'Discernement du mal', p. 3; P.-R. Régamey, *Ni snobisme, ni démagogie*, *L'Art Sacré*, nos. 7–8 (March–April 1952), p. 5.

75 'Constitutio de sacra liturgia. Sacrosanctum concilium', in *Concilium œcumenicorum decreta [...]* (Rome, 1963), pp. 841–2, quoted after Menozzi, *Les images*, pp. 276–8.

76 Paul VI, 'La Chiesa e l'arte', *Insegnamenti di Paolo VI*, II (Rome, 1964), pp. 312–18, quoted after Menozzi, *Les images*, pp. 276–8.

77 M. Fleury and G.-M. Leproux, in Réau, *Histoire du vandalisme* (1994), p. 999. See also Franck Debié and Pierre Vérot, *Urbanisme et art sacré. Une aventure du XXe siècle* (Paris, 1991), p. 241.

78 M.-H. Froeschlé-Chopard, 'L'événement Vatican II: étude iconographique' in

L'événement (Aix-en-Provence and Marseille, 1986), pp. 7–23, reprinted in M.-H. Froeschlé-Chopard, *Espace et Sacré en Provence (XVIe-XXe siècle)* (Paris, 1994), pp. 383–94; Luc Perrin, 'Les paroisses parisiennes et le concile Vatican II (1959-1968)', unpublished PhD dissertation (Paris–Sorbonne, 1994), pp. 295–307.

79 Gilles Chazal, 'L'art dans l'Eglise après Vatican II', *Revue de l'art*, no. 24 (1974), pp. 73, 75.

80 Marie Alamir-Paillard, 'Amor vacui: de saint Bernard à Le Corbusier. Notes sur la réception de l'austérité cistercienne', *Etudes de Lettres* [Lausanne], no. 1 (January–March 1991), pp. 73–101.

81 Le Corbusier, *L'art décoratif d'aujourd'hui* (Paris, 1925), quoted in Alamir-Paillard, 'Amor vacui', p. 95.

82 François Biot and François Perrot, *Le Corbusier et l'architecture sacrée* (Lyon, 1985), p. 92, cited in Alamir-Paillard, 'Amor vacui', p. 98.

83 Susan J. Barnes, *The Rothko Chapel: An Act of Faith* (Houston, 1989).

84 Dominique Ponnau, 'L'héritage et la présence', *Histoire de l'art*, no. 28 (December 1994), pp. 93–5 (p. 94).

85 Fouilloux, 'Autour de Vatican II'.

86 *Conques. Les vitraux de Soulages* (Paris, 1994).

87 John-Paul II, 'Lettre apostolique "Duodecimum saeculum"', Dimitrios I, 'Encyclique sur la signification théologique de l'icône', in *La Documentation catholique*, LIIIV (1988), pp. 286–7, 323–8, quoted in Menozzi, *Les images*, pp. 288–92.

Chapter 13

1 J. A. Simpson and E. S. C. Weiner, *The Oxford English Dictionary*, 2nd edn (Oxford, 1989), VII, p. 609.

2 *Harper's Dictionary of Contemporary Usage* (London, 1985).

3 H. F. Amiel, *Journal*, quoted in Paul Imbs, ed., *Trésor de la langue française. Dictionnaire de la langue du XIXe et du XXe siècle (1789–1960)* (Paris, 1971), p. 1062.

4 Mentioned in E. H. Gombrich, *The Ideas of Progress and their Impact on Art* (New York, 1971), p. 38; G. Levitine, *The Dawn of Bohemianism: The Barbu Rebellion and Primitivism in Neo-Classical France* (University Park, Pa, and London, 1978).

5 Renato Poggiolo, *The Theory of the Avant-Garde* (Cambridge, Mass., 1968), p. 9; K. Herding, 'Décadence und Progrès als kunsttheoretische Begriffe bei Barrault, Baudelaire und Proudhon', *Wissenschaftliche Zeitschrift der Humboldt-Universität zu Berlin*, Gesellschaftsw. R. XXXIV/1-2 (1985), pp. 35–54 (p. 37). See also Linda Nochlin, 'The Invention of the Avant-Garde: France 1830–1880', *Art News Annual*, XXXIV (1968), pp. 11–18; Nicos Hadjinicolau, 'Sur l'idéologie de l'avant-gardisme', *Histoire et critique des arts*, no. 6 (1978), pp. 49–76; Donald Drew Egbert, *Social Radicalism and the Arts, Western Europe: A Cultural History from the French Revolution to 1968* (London, 1970).

6 Quoted in Linda Nochlin, 'Museums and Radicals: A History of Emergencies', *Art in America*, LIX/4 (1971), pp. 26–39 (p. 32).

7 Theodore Reff, 'Copyists in the Louvre, 1850–1870', *The Art Bulletin*, XLVI (1964), pp. 552–91 (p. 553).

8 Formerly Vanderbilt Collection, New York (reproduced in John Rewald, *The History of Impressionism*, 4th revd edn, New York, 1973, p. 24).

9 Quoted in Champfleury, 'Courbet en 1860', here after K. Herding, *Courbet: To Venture Independence* (New Haven and London, 1991), p. 6.

10 Cited in G. Darcel, 'Les musées, les arts et les artistes pendant la Commune', *Gazette des Beaux-Arts*, V (1872), p. 46, here after Nochlin, 'Museums and Radicals', p. 31; see chapter Two, p. 40.

11 Cited in L. Réau, *Histoire du vandalisme. Les monuments détruits de l'art français* (Paris, 1959), II, pp. 201–02 (1994, pp. 802–03).

12 J.-K. Huysmans, 'Fantaisie sur le Musée des arts décoratifs et sur l'architecture cuite',

Revue indépendante, n.s., no. 1 (November 1886), reprinted in J.-K. Huysmans, *Certains* [1889] (Paris, 1975), pp. 397–9.

13 Harrison C. and Cynthia A. White, *Canvases and Careers: Institutional Change in the French Painting World* (New York, London and Sidney, 1965). See D. Gamboni, *La plume et le pinceau. Odilon Redon et la littérature* (Paris, 1989), pp. 73–84.

14 Harold Rosenberg, *The Tradition of the New* (New York, 1959).

15 7 May 1866, in *Zola's Salons*, ed. F. W. Hemmings and R. Niess (Geneva, 1959), cited in Gombrich, *The Ideas of Progress*.

16 T. Gautier, 'De la composition en peinture', *La Presse* (22 November 1836), quoted in Francis Moulinat, 'Théophile Gautier, critique d'art, dans les années 1830', unpublished PhD dissertation (Paris–Sorbonne, 1994), p. 275. See Maurice Z. Shroder, *Icarus: The Image of the Artist in French Romanticism* (Cambridge, Mass., 1961); N. Heinich, *La gloire de Van Gogh. Essai d'anthropologie de l'admiration* (Paris, 1991).

17 T. A. Heinrich, in A. Zacks, D. F. Cameron, D. S. Abbey *et al.*, 'Public Attitudes toward Modern Art', *Museum*, XXII/3-4 (1969), p. 140, quoted after Nochlin, 'Museums and Radicals', p. 35.

18 R. Moulin, *L'artiste, l'institution et le marché* (Paris, 1992), pp. 222, 165 n. 2.

19 Marcel Schwob, *Le livre de Monelle* (Paris, 1894), p. 16, quoted in Imbs, ed., *Trésor de la langue française*, p. 1062.

20 John Ruskin, 'The Social Monster', *Fors Clavigera*, no. 79 (July 1877), quoted in Linda Merrill, *A Pot of Paint: Aesthetics on Trial in 'Whistler v Ruskin'* (Washington and London, 1992), p. 47.

21 Merrill, *A Pot of Paint*, pp. 44–56 (the passages quoted are by this author).

22 Daniel Grojnowski, 'Une avant-garde sans avancée. Les "arts incohérents" 1882–1889', *Actes de la recherche en sciences sociales*, no. 40 (November 1981), pp. 73–86; *Arts incohérents, académie du dérisoire*, exhibition catalogue by Luce Abélès and Catherine Charpin: Musée d'Orsay, Paris (1992).

23 'Alfred Ko-S'Inn-Hus', *Le mari de la Vénus de Milo*, in *Catalogue de l'Exposition des Arts Incohérents, 1866* (Paris, 1866), reproduced in Grojnowski, 'Une avant-garde sans avancée', p. 80.

24 Filippo Tommaso Marinetti, 'Manifeste technique de la littérature futuriste', *Le Figaro* (20 February 1909), republished in Giovanni Lista, *Futurisme. Manifestes, proclamations, documents* (Lausanne, 1973), p. 85–9.

25 Enrico Prampolini, published in *Noi*, series 1 (February 1918), translated in Lista, *Futurisme*, p. 125; Umberto Boccioni, *Lacerba*, September 1913, translated in U. Boccioni, *Dynamisme plastique. Peinture et sculpture futuriste* (Lausanne, 1975), p. 126; notebooks, cited in Z. Birolli, *Umberto Boccioni – Gli scritti editi e inediti* (Milan, 1971), p. 270.

26 Kasimir Malevich, 'O mouzee', *Iskousstvo Kommuny*, no. 12 (23 January 1919), translated in *Malevitch. Ecrits*, ed. Andrei B. Nakov (Paris, 1975), pp. 233–6.

27 'Faut-il brûler le Louvre ?', *L'Esprit Nouveau*, no. 6 (n.d.), after p. 718 (pp. 1–8) and no. 8 (n.d.), pp. 960–62 (mentioned in Nochlin, 'Museums and radicals', p. 38 n. 37).

28 See John Tancock, 'The Influence of Marcel Duchamp', in *Marcel Duchamp*, exhibition catalogue by A. d'Harnoncourt and K. McShine: Museum of Modern Art, New York; Museum of Art, Philadelphia (reprint Munich, 1989), pp. 159–78; Françoise Gaillard, 'Fais n'importe quoi', *Esprit*, no. 179 (February 1992), pp. 51–7.

29 Anon., 'A Complete Reversal of Art Opinions by Marcel Duchamp, Iconoclast', *Arts and Decoration*, V/11 (September 1915), pp. 427–8, 442 (p. 428).

30 Otto Hahn, 'Entretien. Marcel Duchamp', *L'Express* (23 July 1964), pp. 22–3.

31 Letter of 17 August 1952 to Jean Crotti and Suzanne Crotti-Duchamp, published in Francis M. Naumann, 'Affectueusement, Marcel. Ten Letters from Marcel Duchamp to Suzanne Duchamp and Jean Crotti', *Archives of American Art Journal*, XXII/4 (1982), pp. 2–19 (p. 16); letter of 19 May 1921 to J. Crotti and S. Crotti-Duchamp, published in Naumann, 'Affectueusement, Marcel', p. 15.

32 George Maciunas, *Diagram of Historical Development of Fluxus and Other 4 Dimensional,*

Aural, Optic, Olfactory, Epithelial and Tactile Art Forms, 1973, Gilbert and Lila Silverman Fluxus Collection, Detroit, reproduced in Jon Hendricks, *Fluxus Codex* (Detroit and New York, 1988), p. 329.

33 H. Bredekamp, 'Renaissancekultur als "Hölle": Savonarolas Verbrennungen der Eitelkeiten' in *Bildersturm. Die Zerstörung des Kunstwerks*, ed. M. Warnke (Frankfurt, 1977), p. 63; W. Hofmann, 'Die Geburt der Moderne aus dem Geist der Religion', in *Luther und die Folgen für die Kunst*, exhibition catalogue by W. Hofmann: Hamburger Kunsthalle, Hamburg (Munich, 1983), pp. 59, 67. See Thierry de Duve, *Pictorial Nominalism: Marcel Duchamp's Passage from Painting to the Readymade* (Minneapolis and Oxford, 1991, original edn Paris, 1984).

34 Octavio Paz, *Marcel Duchamp o el castillo de la pureza* (1968), translated by Donald Gardner (London, 1970), quoted after Joseph Masheck, ed., *Marcel Duchamp in Perspective* (Englewood Cliffs, N.J., 1975), pp. 87–8.

35 M. Duchamp, 'Apropos of Myself', slide lecture delivered at the City Art Museum of St Louis, Missouri, on 24 November 1964, quoted after d'Harnoncourt and McShine, eds, *Marcel Duchamp*, p. 289; Peter Chametzky, 'Marginal Comments, Oppositional Work: Willi Baumeister's Confrontation with Nazi Art', in *Willi Baumeister: Zeichnungen, Gouachen, Collagen*, exhibition catalogue: Staatsgalerie, Stuttgart; Museum Fridericianum, Kassel; Kunstmuseum, Bern (Stuttgart, 1989), pp. 251–72 (pp. 263–5).

36 Anonymous, 'The Richard Mutt Case', *The Blind Man*, no. 2 (May 1917); see chapter Six, pp. 125–6.

37 M. Duchamp, *La Mariée mise à nu par ses célibataires, même* (Paris, 1934); see *Salt Seller: The Writings of Marcel Duchamp (Marchand du Sel)*, ed. M. Sanouillet and E. Peterson (New York, 1973), p. 32.

38 *Dictionnaire abrégé du surréalisme* (Paris, 1938), p. 23; M. Duchamp, 'Apropos of "Readymades"', in *Salt Seller*, p. 142.

39 F. Fénéon, 'Les grands collectionneurs. III. M. Ivan Morosoff', *Bulletin de la Vie Artistique*, Editions de la Galerie Bernheim-Jeune (15 May 1920), reprinted in F. Fénéon, *œuvres plus que complètes*, ed. J. U. Halperin (Geneva, 1970), pp. 354–8 (p. 357); see anon. [Guillaume Apollinaire], 'Le cas de Richard Mutt', *Mercure de France*, CXXVII, no. 480 (16 June 1918), reprinted in Pierre Caizergues, 'Guillaume Apollinaire: Echos et anecdotes inédits', *Cahiers du Musée national d'art moderne*, no. 6 (1981), p. 15.

40 'A Collective Portrait of Marcel Duchamp', in d'Harnoncourt and McShine eds, *Marcel Duchamp*, p. 219.

41 See *Übrigens sterben immer die anderen: Marcel Duchamp und die Avantgarde seit 1950*, exhibition catalogue: Museum Ludwig, Cologne (Cologne, 1988), p. 71; *Copier / Créer*, exhibition catalogue: Musée du Louvre, Paris (1993), no. 312.

42 Cited in d'Harnoncourt and McShine, eds, *Marcel Duchamp*, p. 283.

43 Heinz Althöfer, 'Besucher als Täter. Über Vandalismus gegen die moderne Kunst', *Frankfurter Allgemeine Zeitung* (2 November 1993).

44 See V. L. Allen, 'Toward an understanding of the hedonic component of vandalism', in C. Lévy-Leboyer, ed., *Vandalism: Behaviour and Motivations* (Amsterdam, New York, and Oxford, 1984), pp. 77–89; Diane Le Jeune, 'Destructie in de kunst. Een situering en een onderzoek naar de betekenis van deze tendens in de twintigste eeuw', unpublished PhD dissertation (Catholic University of Louvain, 1989).

45 Pablo Picasso, 'Conversations avec Christian Zervos', *Cahiers d'art* (1935), pp. 173–8.

46 Letter of 24 May 1943 to James Johnson Sweeney, quoted after C. Blotkamp, *Mondrian: The Art of Destruction* (London, 1994), p. 240; the other quotations are from Blotkamp's text, pp. 15, 135–6. Compare Wolfgang Kersten, *Paul Klee – 'Zerstörung der Konstruktion zuliebe?'* (Marburg, 1987).

47 Blotkamp, *Mondrian*, p. 34. See Susanne Deicher, *Piet Mondrian: Protestantismus und Modernität* (Berlin, 1994).

48 See Robert Rosenblum, *Modern Painting and the Northern Romantic Tradition* (New York,

1975); Jean Clair, *Considérations sur l'état des beaux-arts. Critique de la modernité* (Paris, 1984), pp. 91–2 (with a polemical intent).

49 T. de Duve, *Résonances du readymade. Duchamp entre avant-garde et tradition* (Nîmes, 1989), p. 288 (B. Newman quoted in Thomas Hess, *Barnett Newman*, New York, 1971, p. 56).

50 G. Metzger, *Auto-Destructive Art* (1959), quoted in John A. Walker, 'Message from the Margin. John A. Walker tracks down Gustav Metzger', *Art Monthly*, no. 190 (October 1995), pp. 14–17 (p. 15). See further Adrian Henri, *Environments and Happenings* (London, 1974); Kristine Elaine Dolan Stiles, 'The Destruction in Art Symposium (DIAS). The Radical Project of Event-Structured Live Art', unpublished PhD dissertation (University of California, Berkeley, 1986). A very detailed account of Gustav Metzger's activities and of the DIAS can now be found in Justin Hoffmann, *Destruktionskunst: Der Mythos der Zerstörung in der Kunst der frühen sechziger Jahre* (Munich, 1995), pp. 43–54, 147–66. Rather than on the 'iconoclastic' element emphasized in this chapter, Hoffmann insists on the 'mythical' dimension of the idea of destruction as conceived by artists in the early Sixties, and considers that by the end of the decade it had already become 'almost a convention' and would play thereafter only a 'self-evident but peripheral role' (*ibid.*, pp. 182–7).

51 'Excerpts from selected papers presented at the 1966 Destruction in Art Symposium', *Studio International*, CLXXII (1966), no. 884, pp. 282–3; Walker, 'Message from the Margin', p. 17.

52 *Ibid.*, p. 15; K. Stiles, 'Introduction to the Destruction in Art Symposium: DIAS', *Link* (Cardiff), no. 52 (September–October 1986), pp. 4–8 (p. 7); see also the exhibition catalogue *Destruction Art: Destroy to Create*, with an introduction and acknowledgement by Elayne H. Varian: Finch College Museum of Art, New York (1968).

53 'Excerpts from selected papers', pp. 282–3.

54 Stiles, 'Introduction to the Destruction in Art Symposium', p. 5; Walker, 'Message from the Margin', p. 15; Hoffmann, *Destruktionskunst*, pp. 159–60.

55 These pieces of information were kindly transmitted to me by Christoph Eggenberger, Zurich, who was at the time a member of the Swiss Institute in Rome as an art historian. For Manzù's reaction, see Pickshaus, *Kunstzerstörer*, p. 210.

56 *Ibid.*, pp. 41–64.

57 Antonio Saura, *Contre Guernica* (Paris, 1981), pp. 8–11.

58 See Jacques Soulillou, *L'impunité de l'art* (Paris, 1995), p. 130.

59 Soulillou, *L'impunité de l'art*, pp. 132–3; *Arman o l'oggetto come alfabeto. Retrospettiva 1955–1984*, exhibition catalogue: Museo Civico di Belle Arti Villa Ciani, Lugano (1984), pp. 122–3.

60 W. Hofmann, 'Der neue Bilderstreit (Kat. 524–528)', in *Luther und die Folgen für die Kunst*, p. 638; see also Hoffmann, *Destruktionskunst*, pp. 96–105.

61 *Interview* (May 1976), cited in *Robert Rauschenberg*, p. 262; Barbara Rose, *Rauschenberg* (New York, 1987), p. 51.

62 R. Rauschenberg, letter of October 1951 to Betty Parsons, quoted in *Robert Rauschenberg. Werke 1950–1980*, exhibition catalogue: Staatliche Kunsthalle, Berlin; Kunsthalle Düsseldorf; Louisiana-Museum, Humlebæk/Kopenhagen; Städelsches Kunstinstitut, Frankfurt/Main; Lenbachhaus, Munich (Berlin, 1980), p. 259.

63 M. Duchamp, *Notes*, ed. P. Matisse (Paris, 1980), no. 169; Arturo Schwarz, *The Complete Works of Marcel Duchamp* (New York, 1969), p. 462, no. 239 (the painting signed by Duchamp has since been replaced).

64 *Arnulf Rainer*, exhibition catalogue: Museum des 20. Jahrhunderts, Vienna (1968), pp. 30–31; *Art* (May 1985), p. 44.

65 Djawid C. Borower, 'Übermalter Übermaler. Wiener Schlammschlacht: Der Fall Arnulf Rainer', *Frankfurter Allgemeine Zeitung* (17 February 1995); 'Admittenda tibi ioca sunt post jeria quaedam jed tamen et dignis ipsa gerenda modis', unsigned document obligingly transmitted to me by Arnulf Rainer; letter of 26 March 1996 from A. Rainer to the author.

66 *Pierre Restany. Le cœur et la raison*, exhibition catalogue: Musée de Morlaix (Morlaix, 1991), p. 129. See P. Restany, 'L'art sociologique d'Hervé Fischer', *Quotidien de Paris* (3 July 1974); see *Christian Jaccard. Anonymes calcinés des XIXe et XXe siècles*, exhibition catalogue: Direction des Musées de Nice (Nice, 1983).

67 'Transformer l'actuelle situation de l'art plastique' (25 October 1961), 'Assez de mystifications' (October 1963), in *3e Biennale de Paris*, exhibition catalogue: Musée d'art Moderne de la Ville de Paris (Paris, 1963), pp. 164–8.

68 F. Morellet interviewed by Daniel Soutif, 'Le système Morellet', *Libération* (6 March 1986). See S. Lemoine, *François Morellet* (Zurich, 1986).

69 F. Morellet, 'Géométrie iconoclaste, géométrie accidentée', *Bulletin de la Galerie Durand-Dessert*, no. 12

70 See the exhibition catalogues *Morellet – Cieslewicz* (Musée des Beaux-Arts, Grenoble, 1972) and *François Morellet* (Musée des Beaux-Arts, Nantes, 1973).

71 *Brandt / Haffner*, 1984 (Musée national d'art moderne, Paris); *Peinture moderne*, 1984 (Musée d'art moderne, Saint-Etienne). See *Catalogue raisonné des œuvres du F.R.A.C. Rhône-Alpes* (Lyon, 1986), p. 350; *Bertrand Lavier*, exhibition catalogue: Musée national d'art moderne, Paris (Paris, 1991).

72 Kirk Varnedoe, *A Fine Disregard: What Makes Modern Art Modern* (New York, 1990), pp. 9–10.

73 See Thomas Kellein, *Sputnick-Schock und Mondlandung. Künstlerische Großprojekte von Yves Klein zu Christo* (Stuttgart, 1989); M. Diers, ed., *Mo(nu)mente. Formen und Funktionen ephemerer Denkmäler* (Berlin, 1993).

74 Naumann, 'Affectueusement, Marcel', p. 13; the quotation is from Pierre Cabanne, *Dialogues with Marcel Duchamp* (New York, 1971; original edn Paris, 1967); Suzanne Duchamp's painting is in the collection of Professor Guido Rossi, Milan.

75 K. G. Pontus Hultén, *Jean Tinguely 'Méta'* (Paris, 1967), p. 35.

76 K. Stiles considers negatively 'the universal critical attention to Tinguely's use of destruction' as compared with the obscurity of DIAS and its participants. For her, this concentration 'has stripped their more radical social and political impact on changing values in the art world and reshaped it to fit an ideology and discourse related to studio, gallery, and museum art' ('Introduction to the Destruction in Art Symposium', pp. 6–7). Justin Hoffmann takes an analogous stance and suggests that Tinguely may have found part of the idea for his auto–destructive machine in a review of a Metzger exhibition published in *The Daily Express* on 12 November 1959, a day on which the Swiss artist happened to be in London to give a lecture (Hoffman, *Destruktionskunst*, pp. 45–6 and 56–64 on Tinguely's contributions to 'destructive art'). Hoffmann's book, however, also gives ample evidence of the fierce competition in which some of the 'destructive artists' were engaged, in the Sixties and in retrospect – a fact that makes of the history of the 'movement' a major stake for the actors themselves.

77 Duchamp, *Duchamp du signe*, p. 251; *Salt Seller*, p. 170.

78 S. Cohen, 'Property destruction: motives and meanings', in *Vandalism*, ed. C. Ward (London, 1973), p. 40.

79 Bruce E. Mitchell, 'Body Art: A Legal Policy Analysis', in J. H. Merryman and A. E. Elsen, *Law, Ethics and the Visual Arts: Cases and Materials* (1st edn, New York, 1979), I, pp. 3–168. See also J. H. Merryman and A. E. Elsen, *Law, Ethics, and the Visual Arts* (2nd edn, Philadelphia, 1987), I, p. 293, as well as Hoffmann, *Destruktionskunst*, pp. 131–46, on the works by Günter Brus and by Rudolf Schwarzkloger involving self-injuring and its representation.

80 Agnès Sinai, 'Ces quartiers défigurés par l'architecture du mépris', *Le Monde diplomatique* (April 1992).

81 Harry Bellet, 'La maison en pots', *Le Monde* (3 August 1993).

82 François Chaslin, 'Les mille chutes de la maison Raynaud', *Architecture d'Aujourd'hui*, no. 288 (1993), pp. 55–6.

83 Michel Nuridsany, 'Jean-Pierre Raynaud: la renaissance des décombres', *Le Figaro* (6 July 1993).

84 Chaslin, 'Les mille chutes de la maison Raynaud', p. 55.

85 See Anthony Everitt, 'Painting modernism black', *The Guardian* (16 May 1994).

86 For this and the following information, see Andres Lepik, 'Verlust der Mitte? George Grosz und die Moderne', *Neue Zürcher Zeitung* (21–22 January 1995), p. 66, and *George Grosz*, exhibition catalogue: Neue Nationalgalerie, Berlin (1995).

87 See 'Art contemporain. Peintres ou imposteurs', *Le Monde des débats* (February 1993), pp. 14–16, with bibliographical references.

88 'La conscience de Matta', interview by Henri-François Debailleux, *Libération* (29–30 August 1992, pp. 25–6.

89 *Figurations critiques. 11 artistes des figurations critiques 1965–1975*, exhibition catalogue: ELAC, Lyon (1992), p. 37. See Gérald Gassiot-Talabot, 'Procès-verbal d'un assassinat prémédité', *Aujourd'hui* (1965); idem, 'Les années scandaleuses d'Eduardo Arroyo', in *Arroyo*, exhibition catalogue: Musée national d'art moderne, Centre Georges Pompidou, Paris (1982), pp. 8–11; Werner Spies, 'Eduardo Arroyo: Artist of the Narrative Image', in *Eduardo Arroyo*, exhibition catalogue: Leonard Hutton Galleries, New York (1983), pp. 8–12.

90 Edwar F. Fry, 'Hans Haacke – Realzeitsysteme', in *Hans Haacke. Werkmonographie* (Cologne, 1972), p. 22.

91 P. Bourdieu and H. Haacke, *Libre-échange* (Paris, 1994), p. 101.

92 See chapter Eight, p. 164.

93 'Fronkeman vernielt "uit protest" doek van Vincent van Gogh', *NRC Handelsblad* (6 April 1978).

94 A.P., 'Schilderijen toegetakeld in Japans museum', *Nieuwe Rotterdamse Courant* (24 November 1980).

95 Letter to the author of 20 February 1985; interview with E. Kaemmerling of 16 April 1985.

96 *L'ivresse du réel. L'objet dans l'art du XXe siècle*, exhibition catalogue: Carré d'Art, Musée d'Art contemporain, Nîmes (Paris, 1993), p. 44.

97 'Une œuvre de Marcel Duchamp endommagée', *Le Monde* (26 August 1993); telephone interview with Joël Chouzenoux, 3 September 1993.

98 'Tribunal de Grande Instance de Nîmes, audience correctionnelle du 26 août 1993' (Extrait des Minutes du Secrétariat, Greffe du Tribunal de Grande Instance de Nîmes).

99 Gilles Lorillard, 'Un mois de prison avec sursis pour le "bourreau de l'urinoir" ', *Le Midi Libre* (28 August 1993).

100 N. Heinich, 'C'est la faute à Duchamp ! D'urinoir en pissotière, 1917–1993', *Giallu* [Ajaccio], no. 2 (1994), pp. 7–24 (p. 15).

101 P. Pinoncelli, 'J'irai pisser sur vos tombes', in *Bonjour Monsieur Pinoncelli (Cahiers de création, no. 1)* (Saint-Etienne, 1994), pp. 11–14.

102 William Camfield, *Marcel Duchamp / Fountain* (Houston, 1989), pp. 79–80, with reference to a letter of Sidney Janis to the author and a photograph of the installation.

103 Ben, 'La Violence dans l'avant-garde', *Arthèmes* [Nice], no. 76 (Autumn 1993), cited in Heinich, 'C'est la faute à Duchamp !', pp. 16–17.

104 *Bonjour Monsieur Pinoncelli*, pp. 87–92.

105 *Ibid.*, p. 12. One can compare in several respects Pinoncelli's assault on *Fountain* with Tony Shafrazi's one on Picasso's *Guernica*, which Justin Hoffmann justly considers to be a border case between 'assault on art' and 'destruction art' (*Destruktionskunst*, p. 13).

106 Roland Penrose, *Man Ray* (London, 1975), p. 109. The drawing belonged to Tristan Tzara and was exhibited in 1936 at the Museum of Modern Art in New York under the title *Object of Destruction*.

107 Man Ray, *Self Portrait* (Boston and Toronto, 1964), pp. 389–92.

108 *Ibid.*, p. 392. The owner was the painter William Copley.

109 Man Ray, 'Person to Person', in *Man Ray*, exhibition catalogue: Museum Boymans–van Beuningen, Rotterdam (Rotterdam, 1971), p. 14.

110 Ray, *Self Portrait*, p. 389.

111 See chapter Six, p. 125. In 1920 Man Ray had immediately replaced a paper spiral entitled *Lampshade*, which, created for the opening of the Société Anonyme galleries in New York, had been crumpled up and removed 'with the other rubbish' by the janitor, with a tin replica painted in white, later bought by Katherine Dreier. He commented on this in his autobiography: 'Other contraptions of mine have been destroyed by visitors; not always through ignorance nor by accident, but wilfully, as a protest. But I have managed to make them indestructible, that is, by making duplicates very easily.' (*Self Portrait*, pp. 96–7).

112 M. Warnke, 'Bilderstürme', in *Bildersturm. Die Zerstörung des Kunstwerks*, ed. M. Warnke (Frankfurt, 1977), p. 10.

113 See P. Bourdieu, 'La production de la croyance. Contribution à une économie des biens symboliques', *Actes de la recherche en sciences sociales*, no. 13 (February 1977), p. 9.

114 Paz, *Marcel Duchamp*, p. 88; Cabanne, *Dialogues with Marcel Duchamp*, p. 95.

115 Cabanne, *Dialogues with Marcel Duchamp*, p. 71.

116 See Bourdieu, 'La production de la croyance', pp. 4–5.

117 For a case of this kind, about which I was informed by Oskar Bätschmann, see D. Gamboni, *Un iconoclasme moderne. Théories et pratiques contemporaines du vandalisme artistique* (Zurich and Lausanne, 1983), pp. 103–04.

118 Published as one of 'Two Poems by D.J. Enright' in the *London Review of Books*, XIII/17 (12 September 1991), p. 7.

Chapter 14

1 See chapter Nine.

2 For a more detailed account and analysis of this case, as well as transcriptions of the correspondence pertaining to it, see D. Gamboni, *Un iconoclasme moderne. Théories et pratiques contemporaines du vandalisme artistique* (Zurich and Lausanne, 1983), pp. 69–84, 109–12.

3 *7e Exposition suisse de sculpture Bienne / 7. Schweizer Plastikausstellung Biel 1980*, exhibition catalogue (Bienne, 1980), p. 96.

4 *Ibid.*, p. 96.

5 Letter of 20 June 1980 from Pierre Benoit (ESS) to Gérald Minkoff; letter of 25 June from G. Minkoff to P. Benoit; published in Gamboni, *Un iconoclasme moderne*, p. 109.

6 *Bieler Tagblatt* (25 June 1980).

7 'Kunstwerk sah aus wie Kehricht: Weg damit!', *Blick* (27 June 1980); 'Un jardinier . . . inculte', *La Suisse* (28 June 1980); Marcel Schwander, 'Kunstmissverständnis eines Landschaftsgärtners. Blind für Blindenschrift', *Tages-Anzeiger* (2 July 1980); see also Jean-Claude Nicolet, 'Salut l'artiste!', *Coopération* (3 July 1980).

8 'Kunstwerk sah aus wie Kehricht'.

9 Letter of 7 July 1980 from G. Minkoff to P. Benoit, published in Gamboni, *Un iconoclasme moderne*, p. 111.

10 Letter of 11 July 1980 from P. Benoit to G. Minkoff; letter of 14 July 1980 from G. Minkoff to P. Benoit; published in *ibid.*, pp. 111–12.

11 Letter of 18 July 1980 from P. Benoit to O. Fischer; letter of 28 July 1980 from O. Fischer to P. Benoit; published in *ibid.*, p. 112.

12 Interview with the author, Bienne, 19 August 1981.

13 Interview with the author, Geneva, 25 August 1981.

14 See chapter Nine.

15 Interview with Erika Schwingruber, Bienne, 20 August 1981.

16 'Un jardinier . . . inculte'.

17 See chapter Nine, pp. 175–7.

18 'Horlopotin à l'Exposition suisse de sculpture', *Journal du Jura* (16 June 1980).

19 V. L. Allen, 'Toward an Understanding of the Hedonic Component of Vandalism', in

Claude Lévy-Leboyer, ed., *Vandalism: Behaviour and Motivations* (Amsterdam, New York and Oxford, 1984), pp. 77–89 (p. 82).

20 Igor Stravinsky, *Chroniques de ma vie* (Paris, 1935), pp. 147–8; *Igor Strawinski* (Rome, 1917, pencil), reproduced in Christian Zervos, *Pablo Picasso*, III (Paris, 1949), p. 10, no. 24.

21 See chapter Eight, p. 159..

22 F. Léger, 'L'esthétique de la machine', *Bulletin de l'Effort moderne*, I, nos. 1–2 (January–February 1924), p. 5, quoted from William A. Camfield, *Marcel Duchamp / Fountain* (Houston, 1989), p. 65.

23 John Tancock, 'The Influence of Marcel Duchamp', in *Marcel Duchamp*, exhibition catalogue by A. d'Harnoncourt and K. McShine: Museum of Modern Art, New York; Philadelphia Museum of Art, Philadelphia (reprint Munich, 1989), pp. 159–78 (p. 173).

24 Dieter Daniels, *Duchamp und die anderen: Der Modellfall einer künstlerischen Wirkungsgeschichte in der Moderne* (Cologne, 1992), pp. 170, 208; the quotation is from anon., 'Artist Marcel Duchamp visits U-Classes, exhibits at Walker', Minnesota Daily (22 October 1965).

25 Simon Watson Taylor, 'Ready-Made', in *Art and Artists*, I/4 (July 1966), p. 46, quoted from Daniels, *Duchamp und die anderen*, p. 216.

26 *Marcel Duchamp Letters to Marcel Jean* (Munich, 1987), p. 77; Serge Stauffer, *Marcel Duchamp, Ready-made!* (Zurich, 1973), p. 52; Camfield, *Marcel Duchamp*, p. 17; Daniels, *Duchamp und die anderen*, p. 175. The catalogue of the exhibition mentioned only 'Two Ready-mades'.

27 Anon., 'More Modernists at Montross', *American Art News*, XIV, no. 27 (8 April 1916), p. 5, quoted from Daniels, *Duchamp und die anderen*, p. 175.

28 Announcement entitled 'The Society of Independent Artists, Inc.', undated (1917), quoted in Camfield, *Marcel Duchamp*, p. 19.

29 Beatrice Wood, *I Shock Myself* (Ojai, Calif., 1985), p. 30, quoted from Camfield, *Marcel Duchamp*, p. 25.

30 Camfield, *Marcel Duchamp*, pp. 33, 60.

31 Hans Richter, *Dada: Art and Anti-Art* (New York, 1965; original edn Cologne, 1964), p. 208, quoted from Camfield, *Marcel Duchamp*, p. 100.

32 Letter from M. Duchamp to Suzanne Duchamp, dated 'around 15th of January [1916]', published in Francis M. Naumann, 'Affectueusement, Marcel: Ten Letters from Marcel Duchamp to Suzanne Duchamp and Jean Crotti', *Archives of American Art Journal*, XXII/4 (1982), p. 5; Pierre Cabanne, *Dialogues with Marcel Duchamp* (New York, 1971), p. 47.

33 G. H. Hamilton, 'In Advance of Whose Broken Arm?', in *Art and Artists*, I/4 (July 1966), pp. 29–31 (p. 29).

34 Paul Goldstein, cited in C. Weyergraf-Serra and M. Buskirk, *The Destruction of 'Tilted Arc': Documents* (Cambridge, Mass., and London, 1991), p. 128.

35 Anonymous, 'Kunstwerk van f. 50.000 op schroothoop', *Het Parool* (11 October 1979); A.F.P., 'Kunstwerk als schroot verkocht', *Nieuwe Rotterdamsche Courant* (30 May 1994).

36 Wilhelm Stebler, 'Technische Auskünfte von Künstlern', *Maltechnik 1. Restauro. Internationale Zeitschrift für Farb- und Maltechniken, Restaurierungen und Museumsfragen. Mitteilungen der IADA*, XCI (January 1985), pp. 19–34 (p. 22).

37 'Buren sauvé des poubelles', *Libération* (15–16 April 1989).

38 *Erik Dietman, Enstöring fiskar stör, entre lard et l'art*, exhibition catalogue by Olle Granath: Moderna Museet, Stockholm (Stockholm, 1937), pp. 27, 70–71.

39 Bernard Lamarche-Vadel, 'Entretien avec Joseph Beuys, 1er août 1979', *Artistes*, no. 3 (February–March 1980), pp. 14–19 (p. 17).

40 'Vorwort', *Realität – Realismus – Realität*, exhibition catalogue: Von der Heydt-Museum, Wuppertal; Haus am Waldsee, Berlin; Kunsthalle Kiel; Kunsthalle Bielefeld; Wilhelm-Lehmbruck-Museum, Duisburg; Westfälischer Kunstverein Münster; Städtisches Museum Leverkusen (Wuppertal, 1973), pp. 3–4 (p. 3).

41 'Krawall in Aachen Interview mit Joseph Beuys', *Kunst*, 4 (October–November 1964), p.

96, quoted from Götz Adriani, Winfried Konnertz and Karin Thomas, *Joseph Beuys. Leben und Werk* (Cologne, 1981), p. 139.

42 Karlheinz Nowald, 'Realität/Beuys/Realität', *Realität – Realismus – Realität*, pp. 118, 116.

43 Anon., 'Rasierter Kaktus', *Spiegel* (17 March 1975), pp. 162–4; Anon., '. . . diese Wanne ist im Eimer', *Stern*, no. 7 (1976).

44 '. . . diese Wanne ist im Eimer'; Fernando Wassner, 'Beuys, die Badewanne und das Bürgerliche Gesetzbuch', *Frankfurter Allgemeine Zeitung*, no. 36 (12 February 1976).

45 S.-F., 'Die Ur-Badewanne', *Frankfurter Allgemeine Zeitung*, no. 15 (19 January 1976).

46 Adriani, Konnertz and Thomas, *Joseph Beuys*, pp. 298, 343, 345.

47 Johannes Am Ende *et al.*, *Joseph Beuys und die Fettecke. Eine Dokumentation zur Zerstörung der Fettecke in der Kunstakademie Düsseldorf* (Heidelberg, 1987), pp. 17, 33–55.

48 D.P.A., 'Beuys-"Fettecke" beschäftigt Gericht', *Kölnische Rundschau* (22 May 1987); Am Ende, *Joseph Beuys und die Fettecke*, pp. 17–18; 'Schadevergoeding voor boterbeeldje van Beuys', *Haagsche Courant* (27 January 1989).

49 Letter of 21 October 1986 from Manfred Huppertz to Professor Irmin Kamp, reproduced in Am Ende, *Joseph Beuys und die Fettecke*, p. 13.

50 D.P.A., 'Hasenpfote', *Frankfurter Allgemeine Zeitung* (22 October 1986), reproduced in Am Ende, *Joseph Beuys und die Fettecke*, p. 22.

51 Antonina Vallentin, *Picasso* (Paris, 1957), p. 361.

52 George Melly and J. R. Glaves-Smith, *A Child of Six Could Do It! Cartoons about Modern Art*, exhibition catalogue: The Tate Gallery, London (London, 1973, 4th edn 1987), pp. 74, 66, 62.

53 Ploeg, untitled, *Tim*, 7 (1969), reproduced in Cuno Affolter, Urs Hangartner and Martin Heller, eds, *'Mit Pikasso macht man Kasso': Kunst und Kunstwelt im Comic*, exhibition catalogue: Museum für Gestaltung, Zurich (Zurich, 1990), p. 72.

54 See Sarah Burns, 'Dabble, Daubman, and Dauber: Cartoons and Artistic Identity in Turn-of-the-Century America', paper presented at the Conference of the Comité International d'Histoire de l'Art *Images de l'artiste* (University of Lausanne, 9–12 June 1994).

55 See E. Kris and O. Kurz, *Legend, Myth, and Magic in the Image of the Artist: A Historical Experiment* (New Haven and London, 1979 [1st edn 1929]), pp. 61–71.

56 *Honoré de Balzac's The Unknown Masterpiece*, translated and illustrated by Michael Neff (Berkeley, 1984), pp. 50–51.

57 See K. Herding, 'Courbet's Modernity as Reflected in Caricature', in K. Herding, *Courbet: To Venture Independence* (New Haven and London, 1991), pp. 177–9.

58 See chapter Thirteen, p. 256.

59 Guillaume Farel, *Du vray usage de la croix de Jésus-Christ et de l'abus et de l'idolâtrie commise autour d'icelle et de l'authorité de la parole de Dieu et des traditions humaines; avec un avertissement de Pierre Viret*, Geneva, 1560 (chapter LIV, 'De l'office des Princes Chrestiens touchant l'abolition de l'idolâtrie et des idoles, à l'imitation d'Ezéchias, et du vray usage, et de l'abus de la liberté Chrestienne').

60 O. Christin, *Une révolution symbolique. L'iconoclasme huguenot et la reconstruction catholique* (Paris, 1991), p. 145.

61 R. W. Scribner, 'Reformation, Carnival and the World Turned Upside-Down', in *Städtische Gesellschaft und Reformation*, ed. I. Batóri (Stuttgart, 1980), pp. 234–64 (p. 259).

62 H. Grégoire, *Second rapport sur le vandalisme* (Paris, 8 brumaire an III [1794]), p. 10; quoted from D. Poulot, 'Revolutionary "Vandalism" and the Birth of the Museum: The Effects of a Representation of Modern Cultural Terror', in *Art in Museums*, ed. S. Pearce (London and Atlantic Highlands, N. J., 1995), pp. 192–214 (p. 194).

63 H. de Balzac, *Scènes de la vie privée, Béatrix*, in *Œuvres complètes* (Paris, 1855), III, pp. 286–7, quoted from F. Choay, *L'allégorie du patrimoine* (Paris, 1992), p. 227 n. 29.

64 See chapter Eight, p. 148.

65 A. Hennion and B. Latour, 'Objet d'art, objet de science. Note sur les limites de l'anti-fétichisme', *Sociologie de l'art* [Bruxelles], no. 6 (1993), pp. 7, 18–19.

66 See chapter Nine.

67 Christin, *Une révolution symbolique*, pp. 132, 144, 142.

68 Natalie Zemon Davis, 'The Rites of Violence: Religious Riot in Sixteenth-Century France', *Past and Present*, no. 59 (May 1973), pp. 51–91 (p. 83).

69 Christin, *Une révolution symbolique*, p. 143; M. Warnke, 'Durchbrochene Geschichte? Die Bilderstürme der Wiedertäufer in Münster 1534/1535', in *Bildersturm*, ed. M. Warnke, pp. 65–98 (p. 83); L. Réau, *Histoire du vandalisme. Les monuments détruits de l'art français* (Paris, 1959), I, p. 91 (1994, p. 111).

70 Réau, *Histoire du vandalisme*, I, p. 230, II, p. 214 (1994, p. 295, 816); D. Metzler, 'Bilderstürme und Bilderfeindlichkeit in der Antike' in *Bildersturm*, ed. Warnke, p. 16.

71 L. S. Mercier, *Nouveau tableau de Paris* (1799–1800), quoted from Réau, *Histoire du vandalisme*, I, p. 230 (1994, p. 295).

72 Scribner, *Reformation*, p. 256. See M. Bakhtin, *Rabelais and his World* (Cambridge Mass., 1968).

73 Scribner, *Reformation*, pp. 234–5, 256.

74 Warnke, 'Durchbrochene Geschichte?', p. 75.

75 O. Christin, 'L'iconoclasme huguenot. "Praxis pietatis" et geste révolutionnaire', *Ethnologie française*, XXIV (1994), pp. 219–20. See Davis, 'The Rites of Violence'.

76 See chapter Three, p. 59; chapter Nine, p. 177; chapter Thirteen, p. 277.

77 A. Jarry, *Gestes et opinions du docteur Faustroll, pataphysicien. Roman néo-scientifique* (1899), in *Œuvres complètes*, I (Paris, 1972), pp. 710–12.

78 Anon., 'Un Empereur sur un fumier', *Le Salut public* (18 May 1871), quoted from B. Gagnebin, 'Courbet et la colonne Vendôme', in *Mélanges d'histoire économique et sociale en hommage au professeur Antony Babel à l'occasion de son soixante–quinzième anniversaire* (Geneva, 1963), II, p. 257.

79 V. Larbaud, *A. O. Barnabooth, son journal intime* (Paris, 1913), p. 210.

80 M. Duchamp, 'Apropos of Myself', slide lecture delivered at the City Art Museum of St Louis, Missouri, on 24 November 1964, quoted after d'Harnoncourt and McShine eds, *Marcel Duchamp*, p. 289.

81 Davis, 'The Rites of violence', pp. 5, 83.

82 Scribner, *Reformation*, p. 259.

83 Christin, *Une révolution symbolique*, pp. 171–4.

84 Denis Crouzet, *Les guerriers de Dieu. La violence au temps des troubles de religion (vers 1525–vers 1610)* (Paris, 1990), I, p. 539.

85 J.-K. Huysmans, *Les foules de Lourdes* (Paris, 1906), p. 97.

86 S. Michalski, 'Die Pariser Denkmäler der III. Republik und die Surrealisten', *Idea*, VII (1988), p. 91.

87 See chapter Ten, p. 207.

88 See Harold Rosenberg, *The De-definition of Art* (New York, 1972).

89 P. Bourdieu, 'La production de la croyance: contribution à une économie des biens symboliques', *Actes de la recherche en sciences sociales*, no. 13 (February 1977), p. 8; see Scribner, *Reformation*, p. 258.

90 P. Bourdieu and H. Haacke, *Libre-échange* (Paris, 1994), pp. 30–31, 92, 94–5, 102–03.

Chapter 15

1 Martin Luther, Sermons of Tuesday and Wednesday after Invocavit (11 and 12 March 1522), in *Luther Deutsch*, ed. K. Aland, IV, p. 73, quoted from W. Hofmann, 'Die Geburt der Moderne aus dem Geist der Religion', in *Luther und die Folgen für die Kunst*, exhibition catalogue by W. Hofmann: Hamburger Kunsthalle, Hamburg (Munich, 1983), pp. 46, 50.

2 Jean Schuster, 'Marcel Duchamp, vite', *Le Surréalisme, même*, no. 2 (Spring 1957), pp. 143–5, cited after M. Duchamp, *Duchamp du signe. Ecrits*, ed. M. Sanouillet with E. Peterson (Paris, 1975), pp. 247–8.

3 Letter of 17 August 1952 from M. Duchamp to J. Crotti and S. Crotti-Duchamp, published in Francis M. Naumann, 'Affectueusement, Marcel. Ten Letters from Marcel

Duchamp to Suzanne Duchamp and Jean Crotti', *Archives of American Art Journal*, XXII/4 (1982), pp. 16–17.

4 M. Duchamp, 'The Creative Act', *ARTnews*, LVI/4 (Summer 1957), quoted from *The Essential Writings of Marcel Duchamp*, ed. M. Sanouillet and E. Peterson (London, 1975), pp. 138–40.

5 A. Kaprow, 'Doctor MD', in *Marcel Duchamp*, exhibition catalogue by A. d'Harnoncourt and K. McShine: Museum of Modern Art, New York; Philadelphia Museum of Art, Philadelphia (reprint Munich, 1989), p. 205.

6 J.-Ph. Domecq, *Artistes sans art?* (Paris, 1994), pp. 237–42. See T. Dufrêne, 'La prétendue crise de l'art moderne n'est-elle pas une crise de la critique ?' in *Critiquer la critique? Culture et médias, l'impossible mariage de raison*, ed. Jean-Louis Roux (Grenoble, 1994), pp. 23–33.

7 M. Struwe, ' "Nationalsozialistischer Bildersturm". Funktion eines Begriffs', in *Bildersturm. Die Zerstörung des Kunstwerks*, ed. M. Warnke (Frankfurt, 1977), pp. 123–4.

8 Letter from 9 July 1845, in *Ruskin in Italy: Letters to his Parents*, ed. Harold I. Shapiro (Oxford, 1972), p. 140, and M. [Le Bœuf], *Catalogue raisonné... 8 Avril 1783*, quoted in F. Haskell, *Rediscoveries in Art: Some Aspects of Taste, Fashion and Collecting in England and France* (Oxford, 1980 [1st edn 1976]), pp. 20–21, 30.

9 See chapter Eleven, p. 224; A. Martindale, 'Iconoclasm or Apathy? The Vanishing Past', in *Les iconoclasmes*, ed. S. Michalski (Strasburg, 1992), pp. 229–36 (p. 234).

10 A. Chastel, *Introduction à l'histoire de l'art français* (Paris, 1993), p. 113.

11 *Ibid.*, pp. 112–13, 117, with reference to Louis Dimier, 'Fragonard', *Le Mois littéraire et pittoresque* (1907), pp. 25–38.

12 *Watteau 1684–1721*, exhibition catalogue: Galeries Nationales du Grand Palais, Paris (1984), p. 434. According to Francis Haskell, however, 'David's pupils may, as legend goes, have flicked pellets of bread at Watteau's *Embarquement pour Cythère*, but it was Le Brun and Restout who were fatally damaged' (*Rediscoveries in Art*, p. 108).

13 See chapter Fourteen, pp. 306–7; C. Nodier, *Voyages pittoresques et romantiques dans l'ancienne France. Normandie*, II (Paris, 1825), p. 27.

14 J. de Caso, 'Alors, on ne jette plus?', in *La sculpture du XIXe siècle, une mémoire retrouvée. Les fonds de sculpture* (Paris, 1986), pp. 18–21. See in the same volume Simone Besques, 'La collection de moulages de l'Ecole nationale supérieure des beaux-arts de Paris et le musée des Monuments antiques', pp. 51–9.

15 A. Pingeot, 'La sculpture du XIXe siècle. La dernière décennie', *Revue de l'art*, no. 104 (1994), p. 7.

16 Karl Iten, 'Zerstörung und Rekonstruktion eines Lebenwerkes', in *Richard Kissling 1848–1919*, exhibition catalogue: Danioth-Ring, Kunst- und Kulturverein, Altdorf (1988), pp. 7–14 (p. 9); Véronique Alemany-Dessaint, *Une famille d'artistes en 1900. Les Saint-Marceaux*, exhibition catalogue: Musée d'Orsay, Paris (1992), pp. 28, 43.

17 Niklaus Morgenthaler, 'Plädoyer für einen "Skulpturen- und Denkmalfriedhof" ', *WochenZeitung*, no. 40 (4 October 1991), pp. 28–9; 'Kunst wie Pickel im Gesicht?', *WochenZeitung*, no. 41 (11 October 1991), p. 31.

18 D. Lowenthal, 'Memory and Oblivion', *Museum Management and Curatorship*, XII (1993), pp. 171–82 (p. 178).

19 See chapter Six, p. 123; quoted by Philip L. Goodwin in the preface to *Built in USA 1932–1944*, exhibition catalogue: The Museum of Modern Art, New York (1944), p. 8.

20 Thomas Meier, 'Eintrag im Inventarbuch des Bernischen Historischen Museums, 1928', *Emotionen konserviert – katalogisiert – präsentiert*, exhibition catalogue: Bernisches Historisches Museum, Berne (1992), p. 228.

21 See de Caso, 'Alors, on ne jette plus?', pp. 18–19.

22 See chapter Eight, p. 162; chapter Three, p. 83.

23 Günter Kowa, 'Englische Museen im Streit mit der Regierung', *Neue Zürcher Zeitung* (2 December 1987), p. 27.

24 Richard Kingzett of Agnew & Son, quoted from Kowa, 'Englische Museen'; on de-

accession in the United States, see J. H. Merryman and A. Elsen, *Law, Ethics, and the Visual Arts* (Philadelphia, 1987), II, pp. 718–30.

25 Haskell, *Rediscoveries in Art*, pp. 155–6; *La Biennale di Venezia. XLV Esposizione Internazionale d'Arte. Punti cardinali dell'arte*, exhibition catalogue (Venice, 1993), I, pp. 88–9.

26 Klaus Bußmann, 'Zwei Skulpturen-Ausstellungen in Münster. Eine Bilanz', in *Unerwünschte Monumente. Moderne Kunst im Stadtraum*, ed. W. Grasskamp (Munich, 1989), p. 135; *Skulptur Projekte in Münster 1987*, exhibition catalogue by K. Bußmann und K. König: Westfälisches Landesmuseum für Kunst und Kulturgeschichte (Cologne, 1987).

27 Rémy Zaugg, *Vom Bild zur Welt*, ed. Eva Schmidt (Cologne, 1993), pp. 104–71 ('Eine Stadt, ein Monument').

28 Thomas Wulffen and R. Zaugg, 'Den persönlichen Ausdrucksakt neutralisieren', in Zaugg, *Vom Bild zur Welt*, pp. 150, 157.

29 *Kunstprojekt Heizkraftwerk Römerbrücke* (Saarbrücken, 1992), n.p.

30 J. Tancock, 'The Influence of Marcel Duchamp', in *Marcel Duchamp*, ed. d'Harnoncourt and McShine, p. 176.

31 Tancock, 'The Influence of Marcel Duchamp', p. 174.

32 Man Ray, *Self Portrait* (Boston and Toronto, 1964), pp. 109–10.

33 J. H. Merryman and A. E. Elsen, *Law, Ethics and the Visual Arts: Cases and Materials* (1st edn: New York, 1979), I, pp. 3/2–3/7.

34 See *ibid.*, pp. 3/3–3/5; J. H. Merryman and A. Elsen, *Law, Ethics, and the Visual Arts* (2nd edn, Philadelphia, 1987), I, pp. 317–20; Carola Giedion-Welcker, *Constantin Brancusi 1876–1957* (Neuchâtel, 1958), pp. 211–16; Laurie Adams, *Art on Trial: From Whistler to Rothko* (New York, 1976), pp. 35–58; T. de Duve, 'Réponse à côté de la question "Qu'est-ce que la sculpture moderne?" ', in *Qu'est-ce que la sculpture moderne?*, exhibition catalogue: Musée national d'art moderne, Centre Georges Pompidou, Paris (1986), pp. 277–91; *Brancusi contre Etats-Unis. Un procès historique, 1928*, préface de Margit Rowell, postface et fortune critique par André Paléologue (Paris, 1995).

35 T. Munro, *The Arts and their Interrelations*, revised and enlarged edn (Cleveland and London, 1969; 1st edn 1949), p. 8.

36 Judith Zilczer, *'The Noble Buyer': John Quinn, Patron of the Avant-Garde* (Washington, DC, 1978), pp. 28–31.

37 Margit Rowell, preface to *Brancusi contre Etats-Unis*, p. 6.

38 W. P. McLean, 'Graffiti', *Encyclopædia Universalis*, VII (Paris, 1970), pp. 849–54 (4th edn 1995, X, pp. 624–9, with revised bibliography).

39 S. Cohen, 'Property Destruction: Motives and Meanings', in *Vandalism*, ed. C. Ward (London, 1973), p. 29.

40 Roger Lehni, 'Les inscriptions de la tour nord à la cathédrale de Strasbourg', in Louis Grodecki, 'L'usure du Patrimoine', *Revue de l'art*, no. 49 (1980), pp. 93–5.

41 See, for example, P. Georgel, 'Enfance et génie en 1775. Sur un tableau du peintre écossais David Allan', *Interfaces* [Dijon], no. 4 (1993), pp. 241–72; *Mit dem Auge des Kindes: Kinderzeichnung und moderne Kunst*, exhibition catalogue by Jonathan Fineberg: Lenbachhaus, Munich; Kunstmuseum, Berne (Stuttgart, 1995); John M. MacGregor, *The Discovery of the Art of the Insane* (Princeton, N.J., 1989); *'Primitivism' in 20th Century Art*, exhibition catalogue ed. William Rubin: The Museum of Modern Art, New York (1984).

42 Restif de La Bretonne, *Mes inscripcions* (Paris, 1889); Thomas E. Crow, *Painters and Public Life in Eighteenth-century Paris* (New Haven and London, 1985).

43 *Les murs ont la parole* (Paris, 1968); Rainer Hildebrant, *The Wall Speaks* (Berlin, 1982); Hermann Waldenburg, *Berliner Mauerbilder* (Berlin, 1990); Terry Tillman, *The Writings on the Wall. Peace at the Berlin Wall* (Santa Monica, 1990).

44 See chapter Nine, p. 177; an example of a wall painting covered with graffiti: Henk Meier Jr., 'Rudi Martina, maker van vernielde muurschildering: "Dit is puur vandalisme" ', *Het Binnenhof* (26 May 1979).

45 Paolo Bianchi, ed., *Graffiti. Wandkunst und wilde Bilder* (Basel, Boston and Stuttgart, 1984), pp. 42–9.

46 ATS, 'Deux sprayages', *Gazette de Lausanne. Samedi littéraire* (18 April 1987).

47 Pierre Mangetout, 'Quand l'art passe de la rue au tribunal', *Libération* (21 September 1984).

48 Nidam Abdi and François Reynaert, 'Coups de tags dans le métro', *Libération* (13 January 1992), p. 27; see Réau, *Histoire du vandalisme* (1994), pp. 919, 1027, 1058.

49 Bianchi, ed., *Graffiti*, pp. 60–77. On subway graffiti, see Craig Castleman, *Getting Up: Subway Graffiti in New York* (Cambridge, Mass., 1982); Martha Cooper and Henry Chalfant, *Subway Art* (London, 1984).

50 Henry Flint, 'Regards sur SAMO 1978–1979', in *Et tous ils changent le monde*, exhibition catalogue: 2e Biennale d'art contemporain, Halle Tony Garnier, Lyon (Paris, 1993), pp. 255–9.

51 Bruno Philip, 'Benazir Bhutto et les graffitis de Lahore', *Le Monde* (19–20 February 1995).

52 See chapter Eleven, p. 219; Haskell, *Rediscoveries in Art*, p. 21.

53 D. Lowenthal, *Possessed by the Past: The Heritage Crusade and the Spoils of History* (New York and London, 1996), p. 26.

54 Olivier Cayla, 'Ouverture: La qualification, ou la vérité du droit', *Droits. Revue française de théorie juridique*, no. 18 (1993), pp. 3–18 (p. 11).

55 P. Junod, 'Comment une œuvre d'art devient un classique', in *La sélection*, Publications de l'Université de Lausanne, fascicule 88, cours général public 1994–1995 (Lausanne, 1995), pp. 95–108 (p. 101).

56 See chapter Eleven, pp. 219–24.

57 See chapter Eleven, p. 219.

58 R. Moulin, *L'artiste, l'institution et le marché* (Paris, 1992), p. 261; Junod, 'Comment une œuvre d'art devient un classique', p. 99.

59 Stendhal, *De l'amour* (Geneva, 1948; 1st edn Paris, 1822), pp. 11–21.

60 Michel Noir, leaflet presenting the refurbished opera-house, Lyon, May 1993.

61 See T. de Duve, *Au nom de l'art. Pour une archéologie de la modernité* (Paris, 1989). A striking testimony of this shift mentioned by Haskell is an attack against the display of French nineteenth-century late Academic painting by the Metropolitan Museum of Art, in which John Rewald stated that such 'paintings should be preserved [in the storerooms] as evidence of the bad taste of a bygone era and of the cynicism of our days which treats them as though they were works of art' (Rewald, 'Should Hoving be De-Accessioned?', *Art in America*, LXI/1, 1973, pp. 24–30, quoted in Haskell, *Rediscoveries in Art*, p. 180).

62 F. Choay, *L'allégorie du patrimoine* (Paris, 1992), p. 50.

63 Quoted in D. Poulot, 'Revolutionary "Vandalism" and the Birth of the Museum: The Effects of a Representation of Modern Cultural Terror', in *Art in Museums*, ed. S. Pearce (London and Atlantic Highlands, N.J., 1995), pp. 201–03.

64 Martindale, Iconoclasm or Apathy?', p. 234.

65 Lowenthal, *Possessed by the Past*.

66 Lowenthal, 'Memory and Oblivion', pp. 171–82.

67 Carolyn Gilman, cited in Lowenthal, *Possessed by the Past*, p. 30.

68 Choay, *L'allégorie du patrimoine*, p. 179.

69 N. Hawthorne, *The Marble Faun*, quoted from D. Lowenthal, 'Material Preservation and its Alternatives', *Perspecta. The Yale Architectural Journal*, XXV (1989), p. 70; the phrase 'worship of the past' is taken from an article of 1983 by Roy Strong, then director of the Victoria and Albert Museum, quoted from the same.

70 N. Hawthorne, *English Notebooks*, journal entry 29 September 1855, quoted in Lowenthal, *Possessed by the Past*.

71 See chapter Eleven, p. 224.

72 Lowenthal, 'Material Preservation', pp. 68–9.

73 Sylvie Lackenbacher, *Le palais sans rival. Le récit de construction en Assyrie* (Paris, 1990), in particular pp. 152–60.

74 Lowenthal, 'Material Preservation', p. 73; Laurence Benaïm, 'Un "trésor vivant" à Paris', *Le Monde* (29 December 1994).

75 A. Chastel and J.-P. Babelon, 'La notion de patrimoine', *Revue de l'Art*, no. 49 (1980), p. 25; Shikinen-Sengu of Jingu, *Renewal of the Grand Shrines of Ise at Fixed Intervals of 20 Years* (Ise, 1973).

76 P. Ryckmans, 'The Chinese Attitude Toward the Past', in *World Art: Themes of Unity in Diversity. Acts of the XXVIth International Congress of the History of Art*, ed. Irving Lavin (University Park, Pa, and London, 1989), III, pp. 809–12.

77 Lowenthal, 'Material Preservation', pp. 71–7; R. Moulin, 'La genèse de la rareté artistique', *Ethnologie française*, VIII (1978), pp. 241–58; Ryckmans, 'The Chinese Attitude', p. 811.

78 Lowenthal, 'Material Preservation', p. 77.

79 'Aux dix-mille années', in V. Segalen, *Stèles* (Paris, 1994; 1st edn Paris, 1914).

Bibliography

The following list presents a selection of the material given in the References. With a few exceptions, archival sources and newspaper articles have been excluded, and only studies dealing directly with attacks on art and heritage are given.

A. GENERAL STUDIES

Boespflug, François, and Nicolas Lossky, eds, *Nicée II 787–1987. Douze siècles d'images religieuses* (Paris, 1987)

Briggs, Martin S., *Goths and Vandals: A Study of the Destruction, Neglect and Preservation of Historical Buildings in England* (London, 1952)

Cohen, Stanley, ed., *Images of Deviance* (Harmondsworth, 1971)

Freedberg, David, *Iconoclasts and their Motives* (Maarsen, 1985)

——, *The Power of Images: Studies in the History and Theory of Response* (Chicago and London, 1989)

Gamboni, Dario, *Un iconoclasme moderne. Théorie et pratiques contemporaines du vandalisme artistique* (Zurich and Lausanne, 1983) [Jahrbuch 1982–83 of the Swiss Institute for Art Research]

Geerds, Friedrich, 'Kunstvandalismus. Kriminologische und kriminalistische Gedanken über ein bisher vernachlässigtes Phänomen im Bereich von Kunst und Kriminalität', *Archiv für Kriminologie*, CLXIII/5 (1979), pp. 129–44

Hofmann, Werner, ed., *Luther und die Folgen für die Kunst*, exhibition catalogue: Hamburger Kunsthalle, Hamburg (Munich, 1983)

Knappe, Karl-Adolf, 'Bilderstürmerei. Byzanz – Reformation – Französische Revolution', *Kunstspiegel*, 3 (1981), pp. 265–85

Les iconoclasmes, ed. S. Michalski (Strasburg, 1992) [*L'Art et les révolutions. XXVIIe congrès international d'histoire de l'art. Strasbourg 1–7 septembre 1989*, IV]

Lévy-Leboyer, Claude, ed., *Vandalism: Behaviour and Motivations* (Amsterdam, New York and Oxford, 1984)

Montclos, Claude de, *La mémoire des ruines. Anthologie des monuments disparus en France* (Paris, 1992)

Réau, Louis, *Histoire du vandalisme. Les monuments détruits de l'art français*, 2 vols (Paris, 1959); augmented edn, ed. Michel Fleury and Guy-Michel Leproux (Paris, 1994)

Schnapp, Alain, 'Vandalisme', in *Encyclopædia Universalis, Thesaurus* (Paris, 1990), p. 3593

Scribner, Bob, ed., *Bilder und Bildersturm im Spätmittelalter und in der frühen Neuzeit* (Wiesbaden, 1990) [Wolfenbütteler Forschungen, 46]

Treue, Wilhelm , *Kunstraub: Über die Schicksale von Kunstwerken in Krieg, Revolution und Frieden* (Düsseldorf, 1957)

Végh, Julius von, *Die Bilderstürmer: Eine kulturgeschichtliche Studie* (Strasburg, 1915)

Ward, Colin, ed., *Vandalism* (London, 1973)

Warnke, Martin, ed., *Bildersturm: Die Zerstörung des Kunstwerks* (Frankfurt, 1977) [1st edn Munich, 1973]

B. HISTORICAL PERIODS UP TO THE FRENCH REVOLUTION

i. From Byzantium to the Middle Ages

Belting, Hans, *Bild und Kult: Eine Geschichte des Bildes vor dem Zeitalter der Kunst* (Munich, 1990)
Bredekamp, Horst, *Kunst als Medium sozialer Konflikte: Bilderkämpfe von der Spätantike bis zur Hussitenrevolution* (Frankfurt, 1975)
Bryer, Anthony, and Judith Herrin, eds, *Iconoclasm* (Birmingham, 1977)
Cormak, Robin, *Writing in Gold: Byzantine Society and its Icons* (London, 1985)
André Grabar, *L'iconoclasme byzantin. Dossier archéologique* (Paris, 1957)
Lippold, Lutz, *Macht des Bildes – Bilder der Macht: Kunst zwischen Verehrung und Zerstörung bis zum ausgehenden Mittelalter* (Leipzig, 1993)
Sahas, Daniel J., *Icons and Logos: Sources in Eighth-Century Iconoclasm* (Toronto and London, 1986)

ii. Reformation and the Renaissance

Aston, Margaret, *England's Iconoclasts*, vol. I, *Laws against Images* (Oxford, 1988)
Christin, Olivier, *Une révolution symbolique. L'iconoclasme huguenot et la reconstruction catholique* (Paris, 1991)
——, 'L'iconoclasme huguenot. "Praxis pietatis" et geste révolutionnaire', *Ethnologie française*, XXIV/2 (1994), pp. 216–25
Crouzet, Denis, *Les guerriers de Dieu. La violence au temps des troubles de religion (vers 1525–vers 1610)* (Paris, 1990)
Davis, Natalie Zemon, 'The Rites of Violence: Religious Riot in Sixteenth-century France', *Past and Present*, no. 59 (May 1973), pp. 51–91
Deyon, Solange, and Alain Lottin, *Les 'casseurs' de l'été 1566. L'iconoclasme dans le nord de la France* (Paris, 1981)
Freedberg, David, *Iconoclasm and Painting in the Revolt of the Netherlands 1566–1609* (New York and London, 1988)
Gruzinski, Serge, *Painting the Conquest: The Mexican Indians and the European Renaissance* (Paris, 1992)
Michalski, Sergiusz, *The Reformation and the Visual Arts: The Protestant Image Question in Western and Eastern Europe* (London and New York, 1993)
Phillips, John, *The Reformation of Images: Destruction of Art in England, 1535–1660* (Berkeley, Los Angeles and London, 1973)
Scribner, Robert, 'Reformation, Carnival and the World Turned Upside-Down', in *Städtische Gesellschaft und Reformation*, ed. Ingrid Bátori (Stuttgart, 1980), pp. 234–64
Warnke, Martin, 'Durchbrochene Geschichte? Die Bilderstürme der Wiedertäufer in Münster 1534/1535', in *Bildersturm: Die Zerstörung des Kunstwerks*, ed. M. Warnke (Frankfurt, 1977), pp. 99–107

iii. The French Revolution

Bordes, Philippe, and Michel Régis, eds, *Aux armes et aux arts ! Les arts de la Révolution 1789–1799* (Paris, 1988)
Castelnuono, Enrico, 'Arti e rivoluzione. Ideologie e politiche artistiche nella Francia rivoluzionaria', *Ricerche di Storia dell'arte*, nos. 13–14 (1981), pp. 5–20; reprinted in E. Castelnuovo, *Arte, industria, rivoluzioni. Temi di storia sociale dell'arte* (Turin, 1985), pp. 125–58
Feuga, Paul, 'De la destruction des signes de féodalité sur les monuments publics de Lyon', *Actes de l'Union des Sociétés d'Histoire du Rhône* (1980), pp. 81–100
Gamboni, Dario, ' "Instrument de la tyrannie, signe de la liberté": la fin de l'Ancien Régime en Suisse et la conservation des emblèmes politiques', in *Les iconoclasmes*, ed. Sergiusz Michalski (Strasburg, 1992), pp. 213–28.

Herding, Klaus, 'Denkmalsturz und Denkmalkult – Revolution und Ancien Régime', *Neue Zürcher Zeitung* (30–31 January 1993), pp. 63–4

Hermant, Daniel, 'Le vandalisme révolutionnaire', *Annales ESC*, XXXIII (1978), pp. 703–19

Langlois, Claude, 'Les vandales de la Révolution', *L'histoire*, no. 99 (April 1987), pp. 8–14

Lüsebrink, Hans-Jürgen, 'Votivbilder der Freiheit – der "Patriote Palloy" und die populäre Bildmagie der Bastille', in *Die Bastille – Symbolik und Mythos in der Revolutionsgraphik*, exhibition catalogue: Landesmuseum Mainz und Universitätsbibliothek Mainz (Mainz, 1989), pp. 71–80

Marot, Pierre, 'L'abbé Grégoire et le vandalisme révolutionnaire', *Revue de l'art*, no. 49 (1980), pp. 36–9

Pommier, Edouard, *L'art de la liberté. Doctrines et débats de la Révolution française* (Paris, 1991)

Poulot, Dominique, 'Revolutionary "Vandalism" and the Birth of the Museum: The Effects of a Representation of Modern Cultural Terror', in *Art in Museums*, ed. Susan Pearce (London and Atlantic Highlands, N.J., 1995), pp. 192–214

Révolution française et 'vandalisme révolutionnaire', ed. Simone Bernard-Griffiths, Marie-Claude Chemin and Jean Erhard (Paris, 1992)

Sprigath, Gabriele, 'Sur le vandalisme révolutionnaire (1792–1794)', *Annales historiques de la Révolution française*, no. 242 (October–December 1980), pp. 510–35

Vidler, Anthony, 'Grégoire, Lenoir et les "monuments parlants"', in *La Carmagnole des Muses. L'homme de lettres et l'artiste dans la Révolution*, ed. Jean-Claude Bonnet (Paris, 1988), pp. 131–54

Wrigley, Richard, 'Breaking the Code: Interpreting French Revolutionary Iconoclasm', in *Reflections of Revolution*, ed. Alison Yarington and Kelvin Everest (London, 1993), pp. 182–95

C. POLITICS AND ICONOCLASM SINCE THE FRENCH REVOLUTION

i. Courbet and the Commune

Gagnebin, Bernard, 'Courbet et la colonne Vendôme. De l'utilisation du témoignage en histoire', in *Mélanges d'histoire économique et sociale en hommage au professeur Antony Babel à l'occasion de son soixante-quinzième anniversaire* (Geneva, 1963), II, pp. 251–71

Nochlin, Linda, 'Courbet, die Commune und die bildenden Künste', in *Realismus als Widerspruch: Die Wirklichkeit in Courbets Malerei*, ed. Klaus Herding (Frankfurt, 1978), pp. 248–61, 316–18

——, 'The Depoliticisation of Gustave Courbet: Transformation and Rehabilitation under the Third Republic', in *Art Criticism and its Institutions in Nineteenth-century France*, ed. Michael R. Orwicz (Manchester and New York, 1994), pp. 109–121

Walter, Rodolphe, 'Un dossier délicat: Courbet et la colonne Vendôme', *Gazette des Beaux-Arts*, LXXXI/1 (1973), pp. 173–84

ii. The Suffrage Movement

Hoffmann-Curtius, Kathrin, *George Grosz, 'John, der Frauenmörder'* (Stuttgart, 1993)

Nead, Lynda, *The Female Nude: Art, Obscenity and Sexuality* (London and New York, 1992)

Pankhurst, Emmeline, *My own Story* (London, 1914); reprinted in *The Suffragettes: Towards Emancipation*, ed. Marie Mulvey Roberts and Tamae Mizuta (London, 1993)

Pankhurst, E. Sylvia, *The Suffragette Movement: An Intimate Account of Persons and Ideals* (London, 1977) [1st edn 1931]

Tickner, Lisa, *The Spectacle of Women: Imagery of the Suffrage Campaign 1907–14* (London, 1987)

iii. The World Wars

Asagliano, Faustino, ed., *Il bombardamento di Montecassino, diario di guerra, di E. Grossetti, M. Matronola, con altre testimonianze e documenti* (Montecassino, 1980)

Cochet, François, *Rémois en guerre (1914–1918). L'héroïsation au quotidien* (Nancy, 1994)

Hancock, Walter, 'Experiences of a Monuments Officer in Germany', *College Art Journal*, V/4 (May 1946)

Hapgood, David, and David Richardson, *Montecassino* (London, 1985)

La Farge, Henry, *Lost Treasures of Europe* (New York, 1946)

Louvain–Reims II. Documents (Lausanne, 1915)

Nicholas, Lynn H., *The Rape of Europa: The Fate of Europe's Treasures in the Third Reich and the Second World War* (New York, 1994)

Schivelbuch, Wolfgang, *Die Bibliothek von Löwen: Eine Episode aus der Zeit der Weltkriege* (Munich and Vienna, 1988)

Shaw, George Bernard, 'Common Sense about the War', *The New Statesman*, Special War Supplement (14 November 1914)

iv. Fascism, Nazism and Vichy

Bizardel, Yvon, 'Les statues parisiennes fondues sous l'occupation (1940–1944)', *Gazette des Beaux-Arts*, n.s. 6, LXXXIII (March 1974), pp. 129–52

Busch, Günter, *Entartete Kunst – Geschichte und Moral* (Frankfurt, 1969)

Cone, Michèle C., *Artists under Vichy: A Case of Prejudice and Persecution* (Princeton, 1992)

Degenerate Art: The Fate of the Avant-Garde in Nazi Germany, exhibition catalogue ed. Stephanie Barron: County Museum of Art, Los Angeles (Los Angeles and New York, 1992)

Palmier, Jean-Michel, ed., *L'art dégénéré. Une exposition sous le IIIe Reich* (Paris, 1992)

Salzmann, Siegfried, *'Hinweg mit der "Knienden" ': Ein Beitrag zur Geschichte des Kunstskandals* (Duisburg, 1981)

Schuster, Peter-Klaus, ed., *Die 'Kunststadt' München 1937: Nationalsozialismus und 'Entartete Kunst'* (Munich, 1987)

Struwe, Marcel, ' "Nationalsozialistischer Bildersturm". Funktion eines Begriffs', in *Bildersturm: Die Zerstörung des Kunstwerks*, ed. Martin Warnke (Frankfurt, 1977), pp. 121–40

v. The Cold War

Burstow, Robert, 'Butler's Competition Project for a Monument to "The Unknown Political Prisoner": Allegory, Abstraction and Cold War Politics', *Art History*, XII/4 (December 1989), pp. 472–96

Hauptman, William, 'Suppression of Art in the McCarthy Decade', *Art-forum* 12, no. 2 (October 1973), p. 48ff.; reprinted in Merryman, John Henry and Albert Elsen, *Law, Ethics, and the Visual Arts* (Philadelphia, 1987), I, pp. 268–75

Hurlburt, Laurance P., *The Mexican Muralists in the United States* (Albuquerque, 1989)

vi. The Communist Regimes

Beke, László, 'The Demolition of Stalin's Statue in Budapest', in *Les iconoclasmes*, ed. Sergiusz Michalski (Strasburg, 1992), pp. 275–84

Bildersturm in Osteuropa: Die Denkmäler der kommunistischen Ära im Umbruch (Munich, 1994) [*ICOMOS – Journals of the German National Committee*, XIII]

Boime, Albert, 'Perestroika and the Destabilization of the Soviet Monuments', *ARS: Journal of the Institute for History of Art of Slovak Academy of Sciences*, 2–3 (1993), pp. 211–26

Darnton, Robert, *Berlin Journal: 1989–1990* (New York and London, 1991)

Dolff-Bonekämper, Gabi, 'Kunstgeschichte als Zeitgeschichte. Der Streit um das Thälmann-Denkmal in Berlin' in *Von Busch-Zulage und Ossi-Nachweis: Ost-Westdeutsch in der Diskussion*, ed. Ruth Reiher and Rüdiger Läzer (Berlin, forthcoming)

Erhalten – zerstören – verändern? Denkmäler der DDR in Ost-Berlin. Eine dokumentarische Ausstellung, exhibition catalogue: Neue Gesellschaft für Bildende Kunst (Berlin, 1990) [Schriftenreihe des Aktiven Museums Faschismus und Widerstand in Berlin e.V., 1]

Feist, Peter H., 'Geschichtsräume, Störbilder. Die Wandbilder im Berliner Palast der Republik', in *Städtebau und Staatsbau im 20. Jahrhundert: Auf der Suche nach der Neuen Stadt. Parallelen und Kontraste im deutschen Städtebau*, ed. Gabi Dolff-Bonekämper and Hiltrud Kier (Munich, forthcoming)

Hoh-Slodczik, Christine, 'Die "Mitte" Berlins – Zeugnis und Ort deutscher Geschichte', in *Künstlerischer Austausch. Artistic Exchange. Akten des XXVIII. Internationalen Kongresses für Kunstgeschichte Berlin, 15.–20. Juli 1992*, ed. Thomas W. Gaehtgens (Berlin, 1993), III, pp. 353–64

Kritische Berichte, XX/3 (1992): 'Der Fall der Denkmäler'

Kritische Berichte XXII/I (1994): 'Inmitten Berlins – das Schloß?'

Kramer, Bernd, ed., *Demontage. . .revolutionärer oder restaurativer Bildersturm? Texte & Bilder* (Berlin, 1992)

Möbius, Peter, and Helmut Trotnow, *Mauer sind nicht für ewig gebaut: Zur Geschichte der Berliner Mauer* (Berlin, 1990)

Monumental Propaganda, travelling exhibition catalogue, ed. Dore Ashton (New York, 1994)

Sinkó, Katalin, 'Political Rituals: The Raising and Demolition of Monuments', in *Art and Society in the Age of Stalin*, ed. Péter György and Hedvig Turai (Budapest, 1992), pp. 73–86

Wechsler, Lawrence, 'Slight Modifications', *The New Yorker* (12 July 1993), pp. 59–65

vii. Outside the West

Al-Khalil, Samir, *The Monument: Art, Vulgarity and Reponsibility in Iraq* (London, 1991)

Kunzle, David, *The Murals of Revolutionary Nicaragua, 1979–92* (Berkeley, Los Angeles and London, 1995)

D. THE LAW, PROPRIETY AND CENSORSHIP

i. Legislation and Trials

Adams, Laurie, *Art on Trial: From Whistler to Rothko* (New York, 1976)

Brancusi contre Etats-Unis. Un procès historique, 1928, ed. Margit Rowell and André Paléologue (Paris, 1995)

Buskirk, Martha, 'Moral Rights: First Step or False Start?', *Art in America* (July 1991), pp. 37–45

Edelman, Bernard, *La propriété littéraire et artistique* (Paris, 1989)

Merryman, John Henry, and Albert Elsen, *Law, Ethics, and the Visual Arts*, 2 vols (Philadelphia, 1987) [1st edn, New York, 1979]

ii. Jacob Epstein

Cork, Richard, *Art Beyond the Gallery in Early 20th-century England* (New Haven and London, 1985)

Epstein, Jacob, *An Autobiography* (London, 1955)

Pennington, Michael, *An Angel for a Martyr: Jacob Epstein's Tomb for Oscar Wilde* (Reading, 1987)

iii. Censorship

Gamboni, Dario, 'Skizze eines Hin und Zurück: Graffiti, Vandalismus, Zensur und Zerstörung', in *Graffiti: Wandkunst und wilde Bilder*, ed. Paolo Bianchi (Basel, Boston and Stuttgart, 1984), pp. 38–9

Im Namen des Volkes: Das 'gesunde Volksempfinden' als Kunstmaßstab, exhibition catalogue: Wilhelm-Lehmbruck-Museum der Stadt Duisburg (Duisburg, 1979)

Straka, Barbara, 'Polizei-Zensur. Bericht über die Zerstörung der Ernst Volland-Ausstellung der Neuen Gesellschaft für Bildende Kunst Berlin', *Kritische Berichte*, X/I (1982), pp. 45–50

Polizei zerstört Kunst – Der Fall Volland. Ein soziologisches Experiment (Berlin, 1981)

E. ART IN PUBLIC PLACES

i. Statues and Monuments

Adhémar, Jean, 'Les statues parisiennes de grands hommes', *Gazette des Beaux-Arts*, n.s. 6, LXXXIII (March 1974), pp. 149–52

Agulhon, Maurice, *Histoire vagabonde*, I (Paris, 1988)

——, 'Les statues de "grands hommes" constituent-elles un patrimoine?', papers of the
 international conference *Le patrimoine et la cité*, Annecy, 28–30 September 1995
 (forthcoming)
Gardes, Gilbert, *Le monument public français* (Paris, 1994)
Kreis, Georg, 'Denkmäler und Denkmalnutzung in unserer Zeit', *Schweizerische Zeitschrift für
 Soziologie*, III (1987), pp. 420–21
McWilliam, Neil, 'Monuments, Martyrdom, and the Politics of Religion in the French Third
 Republic', *Art Bulletin*, LVII/2 (June 1995), pp. 186–206
Michalski, Sergiusz, 'Die Pariser Denkmäler der III. Republik und die Surrealisten', *Idea.
 Jahrbuch der Hamburger Kunsthalle*, 7 (1988), pp. 91–107
Mittig, Hans-Ernst, and Volker Plagemann, eds, *Denkmäler im 19. Jahrhundert: Deutung und
 Kritik* (Munich, 1972)

ii. Public Art

Apgar, Garry, 'Redrawing the Boundaries of Public Art', *Sculpture*, XI/3 (May–June 1992), pp.
 24–9
Calvocoressi, Richard, 'Public Sculpture in the 1950s', in *British Sculpture in the Twentieth
 Century*, ed. Sandy Nairne and Nicholas Serota (London, 1981)
Gamboni, Dario, 'Méprises et mépris. Eléments pour une étude de l'iconoclasme
 contemporain', *Actes de la recherche en sciences sociales*, no. 49 (September 1983), pp. 2–28
Grasskamp, Walter, 'Warum wird Kunst im Aussenraum zerstört? Künstlerischer und
 kultureller Raum', *Kunst-Bulletin*, no. 4 (April 1984), pp. 2–7
——, ed., *Unerwünschte Monumente: Moderne Kunst im Stadtraum* (Munich, 1989; 2nd edn
 with augmented bibliography, 1993)
Grundbacher, François, 'Wenn die Kunst fehl am Platz ist', *Kunst-Bulletin*, no. 2 (1987),
 pp. 2–5
Mitchell, W.J.T., ed., *Art and the Public Sphere* (Chicago and London, 1990)
Senie, Harriet F., and Sally Webster, eds, *Critical Issues in Public Art. Content, Context, and
 Controversy* (New York, 1992)
Straka, Barbara, 'Die Berliner Mobilmachung. Eine kritische Nachlese zum
 "Skulpturenboulevard" als "Museum auf Zeit" ', in *Kunst im öffentlichen Raum. Anstöße der
 80er Jahre*, ed. Volker Plagemann (Cologne, 1989), pp. 97–115
Zaugg, Rémy, *Vom Bild zur Welt*, ed. Eva Schmidt (Cologne, 1993)

iii. Richard Serra's 'Tilted Arc'

Balfe, Judith H., and Margaret J.Wyszomirski, 'Public Art and Public Policy', *The Journal of
 Arts Management and Law*, XV/44 (Winter 1986); reprinted in *Going Public*, ed. Jeffrey L.
 Cruikshank and Pam Korza (Amherst, Mass., 1988), pp. 268–79
Buchloh, Benjamin H. D., 'Vandalismus von oben. Richard Serras *Tilted Arc* in New York', in
 Unerwünschte Monumente. Moderne Kunst im Stadtraum, ed. Walter Grasskamp (Munich,
 1989), pp. 103–19
Crimp, Douglas, 'Serra's Public Sculpture: Redefining Site Specificity', in *Richard Serra /
 Sculpture*, ed. Rosalind E. Krauss (New York, 1986), pp. 41–57
Senie, Harriet, 'Richard Serra's "Tilted Arc": Art and Non-Art Issues', *Art Journal*, XLVIII/44
 (Winter 1989), pp. 298–302
Storr, Robert, ' "Tilted Arc": Enemy of the People?', *Art in America* (September 1985), pp. 90–97
Weyergraf-Serra, Clara, and Martha Buskirk, *The Destruction of 'Tilted Arc': Documents*
 (Cambridge, Mass., and London, 1991)

F. ASSAULTS IN MUSEUMS, PSYCHOPATHOLOGY

Chartier, Didier A., *Les créateurs d'invisible. De la destruction des œuvres d'art* (Synapse, 1989)
Fromm, Erich, *The Anatomy of Destructiveness* (Harmondsworth, 1990; 1st edn 1973)

Keck, Caroline, 'On Conservation', *Museum News. The Journal of the American Association of Museums*, L (May 1972), p. 9

Pickshaus, Peter Moritz, *Kunstzerstörer. Fallstudien: Tatmotive und Psychogrammen* (Reinbek bei Hamburg, 1988) [presented 1995 as a PhD dissertation at the Freie Universität in Berlin with an unpublished 'Aktualisierung']

Rosolato, Guy, 'Notes psychanalytiques sur le vol et la dégradation des œuvres d'art', *Museum*, XXVI/1 (1974), pp. 21–25

Teunissen, John J., and Evelyn J. Hinz, 'The Attack on the Pietà: An Archetypal Analysis', *Journal of Aesthetics*, XXXIII/1 (1974–5), pp. 42–50

G. 'EMBELLISHING VANDALISM' AND HERITAGE

Awada Jalu, Sawsan, 'Patrimoine et reconstruction: le cas de Beyrouth', papers of the international conference *Le patrimoine et la cité*, Annecy, 28–30 September 1995 (forthcoming)

Caso, Jacques de, 'Alors, on ne jette plus ?', in *La sculpture du XIXe siècle, une mémoire retrouvée. Les fonds de sculpture* (Paris, 1986), pp. 18–21

Cervellati, Pier Luigi, ' "L'artiste démolisseur": G. E. Haussmann', in *La cultura della conservazione* (Milan, 1993), pp. 371–8

Chastel, André, and Jean-Pierre Babelon, 'La notion de patrimoine', *Revue de l'Art*, no. 49 (1980), pp. 5–32

Choay, Françoise, *L'allégorie du patrimoine* (Paris, 1992)

Conventions and Recommendations of Unesco Concerning the Protection of the Cultural Heritage (Paris, 1985)

Haskell, Francis, *Rediscoveries in Art: Some Aspects of Taste, Fashion and Collecting in England and France* (Oxford, 1976)

Hugo, Victor, 'Guerre aux démolisseurs', *Revue des Deux Mondes*, V (1832), pp. 607–22

Lowenthal, David, 'Material Preservation and its Alternatives', *Perspecta. The Yale Architectural Journal*, XXV (1989), pp. 67–77

——, 'Memory and Oblivion', *Museum Management and Curatorship*, XII (1993), pp. 171–82

——, *Possessed by the Past: The Heritage Crusade and the Spoils of History* (New York and London, 1996)

Martindale, Andrew, 'Iconoclasm or Apathy? The Vanishing Past', in *Les iconoclasmes*, ed. Sergiusz Michalski (Strasburg, 1992), pp. 229–36

Moos, Stanislaus von, 'Le Corbusier, The Monument and the Metropolis', *Columbia Documents of Architecture and Theory*, III (1993), pp. 115–37

Montalembert, Charles de, 'Du vandalisme en France. Lettre à M. Victor Hugo', *Revue des Deux Mondes*, n.s., I (1833), pp. 477–524

Pevsner, Nikolaus, 'Scrape and Anti-Scrape', in *The Future of the Past: Attitudes Towards Conservation*, ed. Janet Fawcett (London, 1976), pp. 33–53, 154–5

Pingeot, Anne, 'La sculpture du XIXe siècle. La dernière décennie', *Revue de l'art*, no. 104 (1994), pp. 5–7

Poulot, Dominique, 'Le sens du patrimoine: hier et aujourd'hui (note critique)', *Annales ESC*, XLVIII (1993), pp. 1601–13

Ridley, Ronald T., 'Augusti Manes Volitant Per Auras: The Archaeology of Rome under the Fascists', *Xenia*, 11 (1986), pp. 19–46

Ryckmans, Pierre, 'The Chinese Attitude Toward the Past', in *World Art: Themes of Unity in Diversity. Acts of the XXVIth International Congress of the History of Art*, ed. Irving Lavin (University Park, Pa, and London, 1989), III, pp. 809–12

Riegl, Alois, *Der moderne Denkmalkultus. Sein Wesen und seine Entstehung* (Vienna, 1903); reprinted in Georg Dehio, A. Riegl, *Konservieren, nicht restaurieren: Streitschriften zur Denkmalpflege um 1900* (Braunschweig–Wiesbaden, 1988)

Wohlleben, Marion, *Konservieren oder restaurieren? Zur Diskussion über Aufgaben, Ziele und Probleme der Denkmalpflege um die Jahrhundertwende* (Zurich, 1989)

Chazal, Gilles, 'L'art dans l'Eglise après Vatican II', *Revue de l'art*, no. 24 (1974), pp. 72–80

Fouilloux, Etienne, 'Autour de Vatican II: crise de l'image religieuse ou crises de l'art sacré ?', papers of the international conference *Crises de l'image religieuse – Krisen religiöser Kunst*, Göttingen, 18–20 March 1994 (Paris, forthcoming)

Froeschlé-Chopard, Marie-Hélène, 'L'événement Vatican II: étude iconographique' in *L'événement* (Aix-en-Provence and Marseille, 1986), pp. 7–23; reprinted in M.-H. Froeschlé-Chopard, *Espace et Sacré en Provence (XVIe-XXe siècle)* (Paris, 1994), pp. 383–94

Knoepfli, Albert, 'Abkehr vom und Rückkehr zum 19. Jahrhundert. Kirchenrenovation im 19. Jahrhundert – Restaurierung von Kirchen des 19. Jahrhunderts', *Unsere Kunstdenkmäler / Nos monuments d'art et d'histoire*, XXXVI/1 (1985), pp. 17–24

Gamboni, Dario, ' "The Baptism of Modern Art"? Maurice Denis and Religious Art', in *Maurice Denis 1870-1943*, exhibition catalogue: Musée des Beaux-Arts, Lyon; Wallraf-Richartz Museum, Cologne; Walker Art Gallery, Liverpool; Van Gogh Museum, Amsterdam (Ghent, 1994), pp. 74–93

Howoldt, Jenns Eric, 'Der Kruzifixus von Ludwig Gies. Ein Beispiel "entarteter Kunst" in Lübeck', *Der Waagen. Ein lübeckisches Jahrbuch* (1988), pp. 164–74

Lavergne, Sabine de, *Art sacré et modernité. Les grandes années de la revue 'l'Art Sacré'* (Namur, 1992)

Menozzi, Daniele, *Les images. L'Eglise et les arts visuels* (Paris, 1991)

Rinuy, Paul-Louis, 'La sculpture dans la "querelle de l'Art Sacré" (1950-1960)', *Histoire de l'art*, no. 28 (December 1994), pp. 3–16

Savart, Claude, 'A la recherche de l'"art" dit de Saint-Sulpice', *Revue d'histoire de la spiritualité*, LII (1976), pp. 265–82

I. MODERN ART AND ICONOCLASM

i. Marcel Duchamp

Camfield, William, *Marcel Duchamp / Fountain* (Houston, 1989)

Daniels, Dieter, *Duchamp und die anderen: Der Modellfall einer künstlerischen Wirkungsgeschichte in der Moderne* (Cologne, 1992)

Duchamp, Marcel, *Salt Seller: The Writings of Marcel Duchamp (Marchand du Sel)*, ed. Michel Sanouillet and Elmer Peterson (New York, 1973)

Duve, Thierry de, *Nominalisme pictural. Marcel Duchamp, la peinture et la modernité* (Paris, 1984)

——, *Résonances du readymade. Duchamp entre avant-garde et tradition* (Nîmes, 1989)

Hamilton, George Heard, 'In Advance of Whose Broken Arm?', *Art and Artists*, 1/4 (July 1966), pp. 29–31

Heinich, Nathalie, 'C'est la faute à Duchamp ! D'urinoir en pissotière, 1917–1993', *Giallu. Revue Art Sciences humaines*, no. 2 (1994), pp. 7–24

Übrigens sterben immer die anderen: Marcel Duchamp und die Avantgarde seit 1950, exhibition catalogue: Museum Ludwig, Cologne (Cologne, 1988)

ii. General Studies and Other Artists

Althöfer, Heinz, 'Besucher als Täter. Über Vandalismus gegen die moderne Kunst', *Frankfurter Allgemeine Zeitung* (2 November 1993)

Am Ende, Johannes, *et al.*, *Joseph Beuys und die Fettecke: Eine Dokumentation zur Zerstörung der Fettecke in der Kunstakademie Düsseldorf* (Heidelberg, 1987)

Blotkamp, Carel, *Mondrian: The Art of Destruction* (London, 1994)

Diers, Michael, ed., *Mo(nu)mente. Formen und Funktionen ephemerer Denkmäler* (Berlin, 1993)

Gamboni, Dario, 'Art contemporain et destruction des œuvres' in *Universalia 1985* (Paris, 1985), pp. 428–430

Gombrich, Ernst H., *The Ideas of Progress and their Impact on Art* (New York, 1971)

Grasskamp, Walter, *Die unbewältigte Moderne: Kunst und Öffentlichkeit* (Munich, 1989)

Hoffmann, Justin, *Destruktionskunst: Der Mythos der Zerstörung in der Kunst der frühen sechziger Jahre* (Munich, 1995)

Kersten, Wolfgang, *Paul Klee – 'Zerstörung der Konstruktion zuliebe?'* (Marburg, 1987)

Lista, Giovanni, *Futurisme. Manifestes, proclamations, documents* (Lausanne, 1973)

Melly, George, and J. R. Glaves-Smith, *A Child of Six Could Do It! Cartoons about Modern Art*, exhibition catalogue: London, Tate Gallery (London, 1973)

Nochlin, Linda, 'Museums and Radicals: A History of Emergencies', *Art in America*, LIX/4 (1971), pp. 26–39

Soulillou, Jacques, *L'impunité de l'art* (Paris, 1995)

Stiles, Kristine, 'Introduction to the Destruction in Art Symposium: DIAS', *Link* (Cardiff), no. 52 (September–October 1986), pp. 4–8

'Excerpts from selected papers presented at the 1966 Destruction in Art Symposium', *Studio International*, CLXXII/884 (1966), pp. 282–3.

Photographic Acknowledgements

The author and publishers wish to thank the following sources of illustrative material and/or permission to reproduce it (excluding those sources credited in the picture captions):

© ADAPG, Paris, and DACS, London 1996: 150; Agence France-Presse: 48; ANP Foto: 83; Julius Appel/Museum für Kunst und Kulturgeschichte der Hansestadt Lübeck: 102; Archives of Armand P. Arman, New York: 116; Archives Horus, Budapest: 24; the author: 34, 38, 39, 82, 99, 100, 146; Bayerische Staatsgemäldesammlungen, Munich: 84; Bibliothèque nationale de France, Paris: 8, 101; Bildarchiv Preußischer Kulturbesitz, Berlin: 20; © René Burri/Magnum Photos: 111; Jeanne Chevalier: 73-80; Conway Library, Courtauld Institute, London: 66, 67; © Daily Mail/Solo, London: 16; Richard Decker/Dr Luciano Cheles: 46; B. Delessert/Bibliothèque Cantonale et Universitaire, Lausanne: 90, 103, 104; André Deutsch: 50; Gabi Dolff-Bonekämper: 40; Deutsche Presse-Agentur (© ARS, New York, and DACS, London 1996): 89; Lucienne Bloch Dimitroff/Old Stage Studios: 64; Mauricio Duarte/WochenZeitung, Zürich: 49; J.-C. Ducret: 56; EPA/Popperfoto: 86; Farabolafoto: 92; Alain Franchella: 105, 106, 109, 110; Louise-Marie Fritsch: 15; Galleria Schwarz, Milan/Attilio Bacci (© Man Ray Trust/ADAPG, Paris, and DACS, London 1996): 124; Walter Grasskamp: 59; Marianne Haas: 143; Gerhard Howald/Denkmalpflege der Stadt Bern: 44; Hulton Deutsch: 47, 65; Institut Suisse pour L'Etude de l'Art, Zürich: 126; John Weber Gallery, New York: 72, 122; Journal du Jura, Bienne: 127; William Klein: 41; Barbara Klemm/Karin Kramer Verlag, Berlin: 33; KLM Aerocarto: 93; Ute Klophaus/private collection, Cologne (© DACS, London 1996): 134-6; Landesbildstelle Berlin: 27, 28, 31, 32, 37, 58, 60, 61, 63; Hans-Jürgen Lange/Neues Deutschland, Berlin: 35; Legújabbkori Történeti Múzeum Fényképtára, Budapest: 25; Leo Castelli Gallery, New York (© Robert Rauschenberg/DACS, London/VAGA, New York 1996): 117; Roland Liot: 96; Jim McEwan: 81; © Man Ray Trust/ADAPG, Paris, and DACS, London 1996: 125; Jack Manning/NYT Pictures: 69; Eva Mendgen: 147; François Morellet: 118; Musée Albert-Kahn, Boulogne-Billancourt/Auguste Léon: 21; Musée historique de Lyon/Alain Basset: 6; Musée de la Publicité, Paris: 112; Museum of Modern Art, New York (Gift of Philip Johnson: 148, 149); National Gallery of Art, Washington, DC: 12, 13, 43, 57, 97, 107, 140, 142; Bernhard Neubauer: 137; Pace Gallery, New York (© ARS, New York, and DACS, London 1996): 70; Emanuel Pârvu: 30; Philadelphia Museum of Art (The Louise and Walter Arensberg Collection: 113, 131, 132, and Gift of Virginia and William Camfield: 119, 151); Photothèque des Musées de la Ville de Paris (© DACS, London 1996): 11; Photothèque des Musées de la Ville de Paris/Toumazet (© DACS, London 1996): 7, 10; Popperfoto: 29; S. Rebsamen/Bernisches Historisches Museum/Swiss National Library, Berne: 94; Réunion des Musées Nationaux, Paris: 9; Wolfgang Reuß/Landesdenkmalamt Berlin: 62; Burt Roberts/Pace Gallery, New York: 68; Lynn Rosenthal: 113; SADE Archives/Attilio Bacci: 115, Seeberger, C.N.M.H.S., © Archives photographiques, Paris/SPADEM: 98; Sidney Janis Gallery, New York: 123; Francis Siegfried: 128, 129, 130; Pavel Šima: 26; Staatliche Museen zu Berlin - Preußischer Kulturbesitz/Jörg P. Anders: 1; Stadtarchiv, Munich: 19; Stadtpolizei Bern/Denkmalpflege der Stadt Bern: 45; Statens Konstmuseer, Stockholm: 133; Stedelijk Museum, Amsterdam (© ARS, New York,

Index